Methods in Cell Biology
Quantitative Imaging in Cell Biology

Volume 123

Series Editors

Leslie Wilson
Department of Molecular, Cellular and Developmental Biology
University of California
Santa Barbara, California

Phong Tran
Department of Cell and Developmental Biology
University of Pennsylvania
Philadelphia, Pennsylvania

Methods in Cell Biology
Quantitative Imaging in Cell Biology

Volume 123

Edited by

Jennifer C. Waters
Department of Cell Biology,
Harvard Medical School,
Boston, Massachusetts, USA

Torsten Wittmann
Department of Cell and Tissue Biology,
University of California,
San Francisco, USA

AMSTERDAM · BOSTON · HEIDELBERG · LONDON
NEW YORK · OXFORD · PARIS · SAN DIEGO
SAN FRANCISCO · SINGAPORE · SYDNEY · TOKYO
Academic Press is an imprint of Elsevier

Academic Press is an imprint of Elsevier
525 B Street, Suite 1800, San Diego, CA 92101-4495, USA
225 Wyman Street, Waltham, MA 02451, USA
The Boulevard, Langford Lane, Kidlington, Oxford, OX5 1GB, UK
32 Jamestown Road, London NW1 7BY, UK
Radarweg 29, PO Box 211, 1000 AE Amsterdam, The Netherlands

First edition 2014

Copyright © 2014 Elsevier Inc. All rights reserved

No part of this publication may be reproduced, stored in a retrieval system or transmitted in
any form or by any means electronic, mechanical, photocopying, recording or otherwise
without the prior written permission of the publisher

Permissions may be sought directly from Elsevier's Science & Technology Rights
Department in Oxford, UK: phone (+44) (0) 1865 843830; fax (+44) (0) 1865 853333;
email: permissions@elsevier.com. Alternatively you can submit your request online by
visiting the Elsevier web site at http://elsevier.com/locate/permissions, and selecting
Obtaining permission to use Elsevier material

Notice
No responsibility is assumed by the publisher for any injury and/or damage to persons or
property as a matter of products liability, negligence or otherwise, or from any use or
operation of any methods, products, instructions or ideas contained in the material herein.
Because of rapid advances in the medical sciences, in particular, independent verification of
diagnoses and drug dosages should be made

ISBN: 978-0-12-420138-5
ISSN: 0091-679X

For information on all Academic Press publications visit
our website at store.elsevier.com

Contents

Contributors .. xiii
Preface .. xix

CHAPTER 1 Concepts in Quantitative Fluorescence Microscopy .. 1
Jennifer C. Waters, Torsten Wittmann
1.1 Accurate and Precise Quantitation ... 2
1.2 Signal, Background, and Noise .. 3
1.3 Optical Resolution: The Point Spread Function 7
1.4 Choice of Imaging Modality ... 7
1.5 Sampling: Spatial and Temporal .. 8
1.6 Postacquisition Corrections .. 12
1.7 Making Compromises .. 15
1.8 Communicating Your Results ... 16
Acknowledgment .. 16
References .. 16

CHAPTER 2 Practical Considerations of Objective Lenses for Application in Cell Biology 19
Stephen T. Ross, John R. Allen, Michael W. Davidson
Introduction ... 20
2.1 Optical Aberrations ... 20
2.2 Types of Objective Lenses .. 22
2.3 Objective Lens Nomenclature .. 25
2.4 Optical Transmission and Image Intensity 25
2.5 Coverslips, Immersion Media, and Induced Aberration 27
2.6 Considerations for Specialized Techniques 31
2.7 Care and Cleaning of Optics .. 32
Conclusions .. 34
References .. 34

CHAPTER 3 Assessing Camera Performance for Quantitative Microscopy ... 35
Talley J. Lambert, Jennifer C. Waters
3.1 Introduction to Digital Cameras for Quantitative Fluorescence Microscopy ... 36
3.2 Camera Parameters ... 37
3.3 Testing Camera Performance: The Photon Transfer Curve 44
References .. 52

v

CHAPTER 4 A Practical Guide to Microscope Care and Maintenance .. 55
Lara J. Petrak, Jennifer C. Waters
Introduction .. 56
4.1 Cleaning .. 58
4.2 Maintenance and Testing ... 66
4.3 Considerations for New System Installation 74
Acknowledgments .. 75
References .. 75

CHAPTER 5 Fluorescence Live Cell Imaging 77
Andreas Ettinger, Torsten Wittmann
5.1 Fluorescence Microscopy Basics 78
5.2 The Live Cell Imaging Microscope 79
5.3 Microscope Environmental Control 83
5.4 Fluorescent Proteins ... 87
5.5 Other Fluorescent Probes .. 92
Conclusion .. 93
Acknowledgments .. 93
References .. 93

CHAPTER 6 Fluorescent Proteins for Quantitative Microscopy: Important Properties and Practical Evaluation .. 95
Nathan Christopher Shaner
6.1 Optical and Physical Properties Important for Quantitative Imaging ... 96
6.2 Physical Basis for Fluorescent Protein Properties 99
6.3 The Complexities of Photostability 101
6.4 Evaluation of Fluorescent Protein Performance *in Vivo* 106
Conclusion .. 108
References .. 109

CHAPTER 7 Quantitative Confocal Microscopy: Beyond a Pretty Picture .. 113
James Jonkman, Claire M. Brown, Richard W. Cole
7.1 The Classic Confocal: Blocking Out the Blur 114
7.2 You Call that Quantitative? 118
7.3 Interaction and Dynamics .. 123
7.4 Controls: Who Needs Them? 125
7.5 Protocols ... 127
Conclusions .. 133
References .. 133

CHAPTER 8 Assessing and Benchmarking Multiphoton Microscopes for Biologists 135
Kaitlin Corbin, Henry Pinkard, Sebastian Peck,
Peter Beemiller, Matthew F. Krummel

 Introduction: Practical Quantitative 2P Benchmarking 136
- 8.1 Part I: Benchmarking Inputs 136
- 8.2 Part II: Benchmarking Outputs 144
- 8.3 Troubleshooting/Optimizing 150
- 8.4 A Recipe for Purchasing Decisions 150
 Conclusion 151
 Acknowledgments 151
 References 151

CHAPTER 9 Spinning-disk Confocal Microscopy: Present Technology and Future Trends 153
John Oreopoulos, Richard Berman, Mark Browne

- 9.1 Principle of Operation 153
- 9.2 Strengths and Weaknesses 155
- 9.3 Improvements in Light Sources 157
- 9.4 Improvements in Illumination 157
- 9.5 Improvements in Optical Sectioning and FOV 162
- 9.6 New Detectors 166
- 9.7 A Look into the Future 167
 References 171

CHAPTER 10 Quantitative Deconvolution Microscopy 177
Paul C. Goodwin

 Introduction 178
- 10.1 The Point-spread Function 180
- 10.2 Deconvolution Microscopy 182
- 10.3 Results 187
 Conclusion 191
 References 191

CHAPTER 11 Light Sheet Microscopy 193
Michael Weber, Michaela Mickoleit, Jan Huisken

 Introduction 194
- 11.1 Principle of Light Sheet Microscopy 195
- 11.2 Implementations of Light Sheet Microscopy 198
- 11.3 Mounting a Specimen for Light Sheet Microscopy 203
- 11.4 Acquiring Data 205
- 11.5 Handling of Light Sheet Microscopy Data 210
 References 212

CHAPTER 12 DNA Curtains: Novel Tools for Imaging Protein–Nucleic Acid Interactions at the Single-Molecule Level .. 217
Bridget E. Collins, Ling F. Ye, Daniel Duzdevich, Eric C. Greene

 Introduction ... 218
 12.1 Overview of TIRFM ... 219
 12.2 Flow Cell Assembly .. 220
 12.3 Importance of the Lipid Bilayer 221
 12.4 Barriers to Lipid Diffusion ... 222
 12.5 Different Types of DNA Curtains 223
 12.6 Using DNA Curtains to Visualize Protein–DNA Interactions .. 226
 12.7 Future Perspectives ... 232
 Acknowledgments ... 232
 References .. 232

CHAPTER 13 Nanoscale Cellular Imaging with Scanning Angle Interference Microscopy .. 235
Christopher DuFort, Matthew Paszek

 Introduction ... 236
 13.1 Experimental Methods and Instrumentation 241
 13.2 Image Analysis and Reconstruction 250
 Conclusion .. 250
 Acknowledgments ... 251
 References .. 251

CHAPTER 14 Localization Microscopy in Yeast 253
Markus Mund, Charlotte Kaplan, Jonas Ries

 Introduction ... 254
 14.1 Preparing the Yeast Strain .. 256
 14.2 Considerations for the Choice of a Labeling Strategy .. 257
 14.3 Preparing the Sample .. 260
 14.4 Image Acquisition .. 264
 14.5 Results ... 265
 Summary ... 267
 Acknowledgments ... 269
 References .. 269

CHAPTER 15 Imaging Cellular Ultrastructure by PALM, iPALM, and Correlative iPALM-EM .. 273
Gleb Shtengel, Yilin Wang, Zhen Zhang, Wah Ing Goh, Harald F. Hess, Pakorn Kanchanawong

 Introduction ... 274

15.1	Principles	275
15.2	Methods	277
15.3	Future Directions	290
	Acknowledgments	291
	References	292

CHAPTER 16 Seeing More with Structured Illumination Microscopy ... 295
Reto Fiolka

	Introduction	296
16.1	Theory of Structured Illumination	297
16.2	3D SIM	302
16.3	SIM Imaging Examples	307
16.4	Practical Considerations and Potential Pitfalls	310
16.5	Discussion	311
	References	312

CHAPTER 17 Structured Illumination Superresolution Imaging of the Cytoskeleton ... 315
Ulrike Engel

	Introduction	316
17.1	Instrumentation for SIM Imaging	316
17.2	Sample Preparation	322
17.3	Minimizing Spherical Aberration	324
17.4	Multichannel SIM	327
17.5	Live Imaging with SIM	330
	Acknowledgments	331
	References	331

CHAPTER 18 Analysis of Focal Adhesion Turnover: A Quantitative Live-Cell Imaging Example ... 335
Samantha J. Stehbens, Torsten Wittmann

	Introduction to Focal Adhesion Dynamics	335
18.1	FA Turnover Analysis	337
	Acknowledgments	346
	References	346

CHAPTER 19 Determining Absolute Protein Numbers by Quantitative Fluorescence Microscopy ... 347
Jolien Suzanne Verdaasdonk, Josh Lawrimore, Kerry Bloom

	Introduction	348
19.1	Methods for Counting Molecules	348
19.2	Protocol for Counting Molecules by Ratiometric Comparison of Fluorescence Intensity	356

Conclusions ... 361
References ... 361

CHAPTER 20 High-Resolution Traction Force Microscopy 367
Sergey V. Plotnikov, Benedikt Sabass, Ulrich S. Schwarz,
Clare M. Waterman
Introduction .. 368
20.1 Materials .. 374
20.2 Methods ... 381
References ... 392

CHAPTER 21 Experimenters' Guide to Colocalization Studies: Finding a Way Through Indicators and Quantifiers, in Practice ... 395
Fabrice P. Cordelières, Susanne Bolte
Introduction .. 396
21.1 An Overview of Colocalization Approaches 397
Conclusion ... 406
References ... 407

CHAPTER 22 User-Friendly Tools for Quantifying the Dynamics of Cellular Morphology and Intracellular Protein Clusters ... 409
Denis Tsygankov, Pei-Hsuan Chu, Hsin Chen,
Timothy C. Elston, Klaus M. Hahn
Introduction .. 410
22.1 Automated Classification of Cell Motion Types 411
22.2 GUI for Morphodynamics Classification and Ready Representation of Changes in Cell Behavior Over Time .. 415
22.3 Results of Morphodynamics Classification 417
22.4 Geometry-based Segmentation of Cells in Clusters 418
22.5 GUI for Cell Segmentation and Quantification of Protein Clusters ... 421
22.6 Results for Quantifying Protein Clusters 424
22.7 Discussion ... 424
Acknowledgments .. 426
References ... 426

CHAPTER 23 Ratiometric Imaging of pH Probes 429
Bree K. Grillo-Hill, Bradley A. Webb, Diane L. Barber
Introduction .. 430
23.1 Currently Used Ratiometric pH Probes 430

	23.2	Applications .. 435
	23.3	Protocols .. 438
		Acknowledgments ... 445
		References ... 445

CHAPTER 24 Toward Quantitative Fluorescence Microscopy with DNA Origami Nanorulers .. 449

Susanne Beater, Mario Raab, Philip Tinnefeld

	Introduction .. 450
24.1	The Principle of DNA Origami ... 452
24.2	Functionalizing DNA Origami Structures 452
24.3	DNA Origami as Fluorescence Microscopy Nanorulers ... 455
24.4	Brightness References Based on DNA Origami 457
24.5	Applications of DNA Origami Nanorulers for Visualizing Resolution ... 458
24.6	How to Choose an Appropriate Nanoruler for a Given Application .. 461
	References ... 463

CHAPTER 25 Imaging and Physically Probing Kinetochores in Live Dividing Cells .. 467

Jonathan Kuhn, Sophie Dumont

	Introduction .. 468
25.1	Spindle Compression to Image and Perturb Kinetochores ... 469
25.2	Imaging Kinetochore Dynamics at Subpixel Resolution Via Two-Color Reporter Probes ... 477
	Conclusion and Outlook ... 484
	Acknowledgments ... 485
	References ... 485

CHAPTER 26 Adaptive Fluorescence Microscopy by Online Feedback Image Analysis ... 489

Christian Tischer, Volker Hilsenstein, Kirsten Hanson, Rainer Pepperkok

	Introduction .. 490
26.1	Requirements for Adaptive Feedback Microscopy 492
26.2	Selected Applications .. 493
	Acknowledgments ... 501
	References ... 501

CHAPTER 27 Open-Source Solutions for SPIMage Processing.......505
Christopher Schmied, Evangelia Stamataki,
Pavel Tomancak

 Introduction..506
27.1 Prerequisites ..509
27.2 Overview of the SPIM Image-Processing Pipeline....................512
27.3 Bead-Based Registration..513
27.4 Multiview Fusion..518
27.5 Processing on a High-Performance Cluster524
27.6 Future Applications..525
 References..527

CHAPTER 28 Second-Harmonic Generation Imaging of Cancer.....531
Adib Keikhosravi, Jeremy S. Bredfeldt, Md. Abdul Kader
Sagar, Kevin W. Eliceiri

 Introduction..532
28.1 SHG Physical and Chemical Background..................................532
28.2 SHG Instrumentation ..533
28.3 Collagen Structure as a Biomarker ..533
28.4 SHG in Cancer Research ..535
28.5 Quantitative Analysis of SHG Images541
 Conclusion..541
 References..542

Index..547

Contributors

John R. Allen
National High Magnetic Field Laboratory and Department of Biological Science, The Florida State University, Tallahassee, Florida, USA

Diane L. Barber
Department of Cell and Tissue Biology, University of California, San Francisco, California, USA

Susanne Beater
Braunschweig University of Technology, Institute for Physical & Theoretical Chemistry and Braunschweig Integrated Centre of Systems Biology, Braunschweig, Germany

Peter Beemiller
Department of Pathology, University of California, San Francisco, California, USA

Richard Berman
Spectral Applied Research, Richmond Hill, Ontario, Canada

Kerry Bloom
Department of Biology, University of North Carolina at Chapel Hill, Chapel Hill, North Carolina, USA

Susanne Bolte
Sorbonne Universités—UPMC Univ Paris 06, Institut de Biologie Paris-Seine—CNRS FR 3631, Cellular Imaging Facility, Paris Cedex, France

Jeremy S. Bredfeldt
Laboratory for Optical and Computational Instrumentation, University of Wisconsin at Madison, Madison, USA

Claire M. Brown
McGill University, Life Sciences Complex Advanced BioImaging Facility (ABIF), Montreal, Québec, Canada

Mark Browne
Andor Technology, Belfast, United Kingdom

Hsin Chen
Department of Pharmacology and Cancer Biology, Duke University, Durham, North Carolina, USA

Pei-Hsuan Chu
Department of Pharmacology, University of North Carolina, Chapel Hill, North Carolina, USA

Richard W. Cole
Wadsworth Center, New York State Department of Health, P.O. Box 509, and Department of Biomedical Sciences, School of Public Health State University of New York, Albany New York, USA

Bridget E. Collins
Department of Biological Sciences, Columbia University, New York, USA

Kaitlin Corbin
Biological Imaging Development Center and Department of Pathology, University of California, San Francisco, California, USA

Fabrice P. Cordelières
Bordeaux Imaging Center, UMS 3420 CNRS—Université Bordeaux Segalen—US4 INSERM, Pôle d'imagerie photonique, Institut François Magendie, Bordeaux Cedex, France

Michael W. Davidson
National High Magnetic Field Laboratory and Department of Biological Science, The Florida State University, Tallahassee, Florida, USA

Christopher DuFort
Department of Surgery, and Department of Orthopaedic Surgery, University of California, San Francisco, California, USA

Sophie Dumont
Department of Cell & Tissue Biology; Tetrad Graduate Program, and Department of Cellular & Molecular Pharmacology, University of California, San Francisco, California, USA

Daniel Duzdevich
Department of Biological Sciences, Columbia University, New York, USA

Kevin W. Eliceiri
Laboratory for Optical and Computational Instrumentation, University of Wisconsin at Madison, Madison, USA

Timothy C. Elston
Department of Pharmacology, University of North Carolina, Chapel Hill, North Carolina, USA

Ulrike Engel
Center for Organismal Studies and Nikon Imaging Center, Bioquant, University of Heidelberg, Heidelberg, Germany

Andreas Ettinger
Department of Cell and Tissue Biology, University of California, San Francisco, USA

Reto Fiolka
Department of Cell Biology, UT Southwestern Medical Center, Dallas, Texas, USA

Wah Ing Goh
Mechanobiology Institute, National University of Singapore, Singapore

Paul C. Goodwin
GE Healthcare, Issaquah, and Department of Comparative Medicine, University of Washington, Seattle, Washington, USA

Contributors

Eric C. Greene
Department of Biochemistry and Molecular Biophysics, and Howard Hughes Medical Institute, Columbia University, New York, USA

Bree K. Grillo-Hill
Department of Cell and Tissue Biology, University of California, San Francisco, California, USA

Klaus M. Hahn
Department of Pharmacology, and Lineberger Cancer Center, University of North Carolina, Chapel Hill, North Carolina, USA

Kirsten Hanson
Instituto de Medicina Molecular, Lisboa, Portugal

Harald F. Hess
Howard Hughes Medical Institute, Janelia Farm Research Campus, Ashburn, Virginia, USA

Volker Hilsenstein
European Molecular Biology Laboratory, Heidelberg, Germany

Jan Huisken
Max Planck Institute of Molecular Cell Biology and Genetics (MPI-CBG), Dresden, Germany

James Jonkman
Advanced Optical Microscopy Facility (AOMF), University Health Network, Toronto, Ontario, Canada

Pakorn Kanchanawong
Mechanobiology Institute, and Department of Biomedical Engineering, National University of Singapore, Singapore

Charlotte Kaplan
Institute of Biochemistry, ETH Zurich, Switzerland

Adib Keikhosravi
Laboratory for Optical and Computational Instrumentation, University of Wisconsin at Madison, Madison, USA

Matthew F. Krummel
Biological Imaging Development Center and Department of Pathology, University of California, San Francisco, California, USA

Jonathan Kuhn
Department of Cell & Tissue Biology, and Tetrad Graduate Program, University of California, San Francisco, California, USA

Talley J. Lambert
Harvard Medical School, Boston, Massachusetts, USA

Josh Lawrimore
Department of Biology, University of North Carolina at Chapel Hill, Chapel Hill, North Carolina, USA

Michaela Mickoleit
Max Planck Institute of Molecular Cell Biology and Genetics (MPI-CBG), Dresden, Germany

Markus Mund
European Molecular Biology Laboratory, Cell Biology and Biophysics Unit, Heidelberg, Germany

John Oreopoulos
Spectral Applied Research, Richmond Hill, Ontario, Canada

Matthew Paszek
School of Chemical and Biomolecular Engineering, Cornell University, and Kavli Institute at Cornell for Nanoscale Science, Ithaca, New York, USA

Sebastian Peck
Biological Imaging Development Center and Department of Pathology, University of California, San Francisco, California, USA

Rainer Pepperkok
European Molecular Biology Laboratory, Heidelberg, Germany

Lara J. Petrak
Departments of Cell Biology, Departments of Systems Biology, Harvard Medical School, Boston, Massachusetts, USA

Henry Pinkard
Biological Imaging Development Center and Department of Pathology, University of California, San Francisco, California, USA

Sergey V. Plotnikov
National Heart, Lung, and Blood Institute, National Institutes of Health, Bethesda, Maryland, USA

Mario Raab
Braunschweig University of Technology, Institute for Physical & Theoretical Chemistry and Braunschweig Integrated Centre of Systems Biology, Braunschweig, Germany

Jonas Ries
European Molecular Biology Laboratory, Cell Biology and Biophysics Unit, Heidelberg, Germany

Stephen T. Ross
Nikon Instruments, Inc., Melville, New York, USA

Benedikt Sabass
Institute for Theoretical Physics and BioQuant, Heidelberg University, Heidelberg, Germany

Md. Abdul Kader Sagar
Laboratory for Optical and Computational Instrumentation, University of Wisconsin at Madison, Madison, USA

Christopher Schmied
Max Planck Institute of Molecular Cell Biology and Genetics, Dresden, Germany

Ulrich S. Schwarz
Institute for Theoretical Physics and BioQuant, Heidelberg University, Heidelberg, Germany

Nathan Christopher Shaner
The Scintillon Institute, San Diego, California, USA

Gleb Shtengel
Howard Hughes Medical Institute, Janelia Farm Research Campus, Ashburn, Virginia, USA

Evangelia Stamataki
Max Planck Institute of Molecular Cell Biology and Genetics, Dresden, Germany

Samantha J. Stehbens
Institute of Health Biomedical Innovation (IHBI), Queensland University of Technology Translational Research Institute, Brisbane, Queensland, Australia

Philip Tinnefeld
Braunschweig University of Technology, Institute for Physical & Theoretical Chemistry and Braunschweig Integrated Centre of Systems Biology, Braunschweig, Germany

Christian Tischer
European Molecular Biology Laboratory, Heidelberg, Germany

Pavel Tomancak
Max Planck Institute of Molecular Cell Biology and Genetics, Dresden, Germany

Denis Tsygankov
Department of Pharmacology, University of North Carolina, Chapel Hill, North Carolina, USA

Jolien Suzanne Verdaasdonk
Department of Biology, University of North Carolina at Chapel Hill, Chapel Hill, North Carolina, USA

Yilin Wang
Mechanobiology Institute, National University of Singapore, Singapore

Clare M. Waterman
National Heart, Lung, and Blood Institute, National Institutes of Health, Bethesda, Maryland, USA

Jennifer C. Waters
Department of Cell Biology, Harvard Medical School, Boston, Massachusetts, USA

Bradley A. Webb
Department of Cell and Tissue Biology, University of California, San Francisco, California, USA

Michael Weber
Max Planck Institute of Molecular Cell Biology and Genetics (MPI-CBG), Dresden, Germany

Torsten Wittmann
Department of Cell and Tissue Biology, University of California, San Francisco, USA

Ling F. Ye
Department of Biological Sciences, Columbia University, New York, USA

Zhen Zhang
Mechanobiology Institute, National University of Singapore, Singapore

Preface

Almost 400 years ago, Robert Hooke and Antonie van Leeuwenhoek first viewed individual cells through their early microscopes and with careful observation laid the foundation of modern cell biology. Since then, optical microscopy has been a major driving force of biological discovery. For the longest time, microscopy was limited by the inability to acquire reproducible images—not too long ago microscopic observation could only be documented by manual drawing, which requires a specialized skill set and is arguably highly subjective. Even micrography on photographic film has only limited quantitative value. Over the last two decades, however, ever-accelerating advances in optics, electronics, and digital camera technology in combination with the rise of fluorescent proteins have transformed fluorescence light microscopy from a descriptive, observational tool to a truly quantitative method.

Digital cameras are now more sensitive than the human eye, and fluorescence from individual molecules can routinely be detected. The dynamics of movement, intensity fluctuations, or distribution of fluorescently labeled structures in living cells or organisms can be measured providing important information about biological processes. This is the exciting new world of quantitative cell biology, and ideally scientific conclusions will continue to rely less and less on "representative images," but instead on quantitative analysis of digital data. Although microscopy is one of the most direct tools available to ask a scientific question, images can also be dangerously deceiving. In our modern world, the deceptive nature of images is all around us from advertising to the daily news, but in science, we must learn to objectively analyze the underlying data instead of blindly believing what we think we can see. Any digital photomicrograph is only a representation of reality that needs to be carefully scrutinized and interpreted in order to reach valid conclusions, and any analysis can only be as good as the original data.

The goals of this book are to provide the reader with a practical understanding of how digital image data are generated by modern fluorescence microscopy modalities, to outline technical and fundamental reasons that limit the accuracy and precision with which these data can be analyzed, and to provide guidance into cutting-edge technologies and image analysis that are expanding the abilities of traditional microscopy. Chapters 1–6 cover basic principles of quantitative fluorescence microscopy as well as technical aspects of objective lenses, cameras, microscope maintenance, modern live-cell imaging setups, and the properties of fluorescent proteins. Chapters 7–17 give an overview of different fluorescence microscopy techniques ranging from more established confocal imaging to state-of-the-art super-resolution strategies that circumvent the diffraction limit, and light-sheet microscopy allowing unparalleled isotropic observation of biological specimens in three dimensions. Finally, the remaining chapters describe more specific and advanced microscopy and image analysis methods. We were striving for a balanced mixture of basic information and more advanced topics, and hope that this collection will be a useful resource to anyone who wishes to venture into the brave new world of

quantitative fluorescence microscopy. We would like to thank the students of the Quantitative Imaging: From Cells to Molecules course at Cold Spring Harbor Laboratory for many inspiring discussions. Last but not least, we thank all the authors who have contributed their expertise to this volume.

Jennifer C. Waters
Harvard Medical School

Torsten Wittmann
University of California, San Francisco

CHAPTER

Concepts in quantitative fluorescence microscopy

1

Jennifer C. Waters*, Torsten Wittmann[†]

*Department of Cell Biology, Harvard Medical School, Boston, Massachusetts, USA
[†]Department of Cell and Tissue Biology, University of California, San Francisco, USA

CHAPTER OUTLINE

1.1 Accurate and Precise Quantitation .. 2
1.2 Signal, Background, and Noise .. 3
1.3 Optical Resolution: The Point Spread Function ... 7
1.4 Choice of Imaging Modality .. 7
1.5 Sampling: Spatial and Temporal ... 8
 1.5.1 2D Sampling ... 10
 1.5.2 3D Sampling ... 11
 1.5.3 Temporal Sampling .. 12
1.6 Postacquisition Corrections .. 12
 1.6.1 Background Subtraction ... 12
 1.6.2 Flat-field Correction ... 13
 1.6.3 Photobleaching ... 14
 1.6.4 Storing and Processing Images for Quantitation 14
1.7 Making Compromises .. 15
1.8 Communicating Your Results ... 16
Acknowledgment ... 16
References ... 16

Abstract

In recent years, there has been an enormous increase in the publication of spatial and temporal measurements made on fluorescence microscopy digital images. Quantitative fluorescence microscopy is a powerful and important tool in biological research but is also an error-prone technique that requires careful attention to detail. In this chapter, we focus on general concepts that are critical to performing accurate and precise quantitative fluorescence microscopy measurements.

1.1 ACCURATE AND PRECISE QUANTITATION

Designing and implementing a quantitative fluorescence microscopy experiment is most often an iterative and tedious process (Pawley, 2000). Image acquisition settings and analysis tools usually need to be designed and tested multiple times until a reproducible protocol is validated. With each experimental attempt, you are likely to learn something about your specimen, imaging system, or analysis protocol that you can apply to the next round.

Researchers sometimes make the mistake of trying to take the prettiest picture when acquiring microscopy images for quantitation. In quantitative microscopy, it is best to stop thinking about how the image looks and start thinking about the *numbers* associated with the image. A good quantitative fluorescence microscopy experiment is performed with the goal of defining an event or object of interest with numbers, which most often represent fluorescence intensity associated with spatial or temporal measurements. We want our measurements to represent the ground truth (i.e., the reality) of our specimen with high *accuracy* and *precision* (Fig. 1.1; Waters, 2009). Pretty pictures might get you a journal cover, but to obtain reproducible and biologically relevant numbers from live specimens, image quality must be balanced with keeping phototoxicity and photobleaching to a minimum. Therefore, one should identify and use the minimum image quality necessary to satisfy the requirements of the experiment and image analysis protocol, while making every effort to optimize image acquisition to maximize accuracy and precision.

What numbers should you be looking at? A digital image is a grid of pixels, and each pixel has two numbers associated with it: (1) an intensity (aka gray scale) value and (2) a finite-sized area of the specimen that the pixel represents, often called the pixel size (Pawley, 2006). Pixel intensity values are critical. They are not only used as a measure of fluorescence intensity, but they are also used to define objects and to segment the parts of an image to be analyzed. The pixel size determines resolution in the digital image (Stelzer, 1998) and is also important for distance calibration. Other numbers may come into play as well: spacing between images in a *z*-stack or how

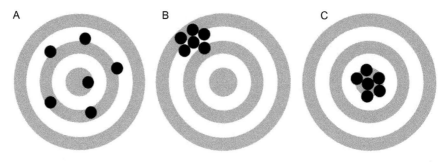

FIGURE 1.1

Accuracy and precision. A cartoon of a target and shots demonstrating the difference between (A) imprecision, (B) inaccuracy, and (C) accuracy and precision.

often an image is collected in a time-lapse experiment, for example. In this chapter, we discuss the various numbers associated with digital images and how to use them to design a quantitative fluorescence microscopy experiment. We begin with three critical numbers present in every digital image: signal, background, and noise.

1.2 SIGNAL, BACKGROUND, AND NOISE

A fundamental assumption underlying every scientific experiment is that some ground truth exists that we hope to reveal when making measurements. In quantitative fluorescence microscopy, we measure intensity values of pixels in the digital image in an attempt to reveal ground truths about the localization or quantity of fluorescence in the specimen. For the purpose of understanding the relationships between signal, background, and noise, we will refer to the fluorescence we wish to measure as the *signal* (Fig. 1.2A). The accuracy and precision of intensity values in a digital image used to measure the signal is degraded, or can even be destroyed, by *background* and *noise* (Fig. 1.2B and C; Murray, Appleton, Swedlow, & Waters, 2007; Swedlow, Hu, Andrews, Roos, & Murray, 2002; Waters, 2009). It is therefore critical to understand the sources of background and noise in digital images of

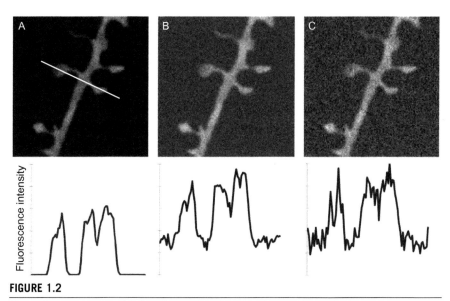

FIGURE 1.2

Signal, background, and noise. Simulated images and corresponding line scans with (A) signal of 150 photons/pixel and Poisson noise, (B) signal of 150 photons/pixel, 50 photons/pixel background and Poisson noise, and (C) signal of 150 photons/pixel, 50 photons/pixel background, Poisson noise, and 10 e$^-$ RMS read noise. Line scans represent the same pixels in each image (white line in A).

fluorescent specimens, the effect they have on measurements of intensity values, and what can be done about it.

Background *adds* to the signal of interest, such that the intensity values in the digital image are equal to the signal *plus* the background (Fig. 1.2B). Background in a digital image of a fluorescent specimen can come from a variety of sources, including ambient light in the microscope room, but the most significant source of diffuse background is usually the specimen itself, for example, fluorescence in the specimen mounting media (e.g., B vitamins, serum, phenol red, and glutaraldehyde-induced autofluorescence) or fluorescence emitted from out-of-focus fluorophores in the specimen (which appears as out-of-focus blur in the image). To quantify a signal, the intensity of background *must* also be measured and subtracted from the intensity values in the pixels containing the signal of interest (more on background subtraction in Section 1.6.1 and in Chapter 18). It is also important to note that all digital cameras have a certain offset value (Chapter 3); that is, even in complete darkness, pixel intensity values are not zero. Although this "background" is not contributed by specimen fluorescence, it still needs to be removed before quantification.

Before we can understand the full effect of background on measurements of fluorescence intensity, we must also consider *noise*. *Noise* is present, to some extent, in every digital image (Chapter 3). Noise causes variation in pixel intensity values from one pixel to the next in each digital image (Fig. 1.2C). Noise causes imprecision in measurements of pixel intensity values and therefore a level of uncertainty in the accuracy of the measurements (Fig. 1.1). To detect the presence of a signal, the signal must be significantly higher than the noise in the digital image. If the signal is within the range of the noise, the signal will be indistinguishable from noise (Fig. 1.3). As the signal increases relative to the noise, measurements of the signal become more precise. The precision of quantitative microscopy measurements is therefore limited (at least) by the *signal-to-noise ratio* (SNR) of the digital image.

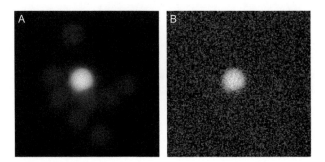

FIGURE 1.3

Lost in the noise. (A) A high SNR ratio image of fluorescence beads of two different intensities. Both the bright bead in the center and the surrounding weak intensity beads are visible. (B) Noise was added to the image in shown in (A) using image processing software. The weaker intensity beads are no longer visible, due to the decrease in SNR.

There are multiple sources of noise in fluorescence digital images. We briefly review the most common sources of noise here; they are discussed in more detail in Chapter 3. Counting stochastic quantum events, such as the arrival of emitted photons at the digital camera's detector, is fundamentally limited by Poisson counting statistics. Poisson noise (aka shot noise) is therefore always present in digital images. If you were to make repeated intensity measurements of the same ideal, unchanging specimen, then you would find that the set of measurements would not be identical, but would instead have a Poisson distribution. Poisson noise results in a standard deviation in the number of counted photons that is equal to the square root of the total number of detected photons. Note that this formula applies to the number of photons detected, *not* the arbitrary intensity values reported by detectors; Chapter 3 explains how to convert intensity values to photons. Digital images are further degraded by various sources of noise generated by the detector (Chapter 3). These different sources of noise are summed (as the square root of the sum of squares) in the final digital image. The total noise in the digital image defines a minimum *expected* variance in measurements of intensity values. Differences in measurements that lie within this expected variance due to noise thus *cannot be attributed to the specimen.*

With an understanding of noise, we can now gain a full appreciation of the detrimental effect of background fluorescence on quantitation of signal intensity. The presence of background decreases the image SNR because Poisson noise is equal to the square root of *all* detected photons—signal *and* background. Noise is not a constant and therefore cannot be simply subtracted from the image. While background can be (and must be) carefully measured and subtracted from an image, the Poisson noise resulting from background photons remains and decreases the precision of your measurements.

In addition to degrading the SNR, background in a fluorescence image also effectively reduces the detector capacity. Charge-coupled device (CCD) and scientific complementary metal-oxide-semiconductor (sCMOS) cameras, for example, have a limited capacity to collect photons. If capacity is reached for a given pixel, this pixel will be saturated in the digital image (Chapter 3). Since background photons use up the detector capacity, this limits the total number of photons that can be collected before the detector saturates. Saturation destroys the linear relationship between the number of photons arriving at the detector and the intensity values in the image and therefore must be avoided in quantitative microscopy experiments.

While noise cannot be subtracted from the image, if multiple images of the same unchanging field of view are collected and averaged together (called frame averaging), the noise can be averaged out. Frame averaging can be very useful when imaging fixed specimens but is usually impractical for quantitative imaging of live fluorescent specimens (Chapter 5) that are both dynamic and susceptible to phototoxicity and photobleaching. For quantitative fluorescence imaging, image noise should be reduced as much as possible through optimization of detector and acquisition settings (Chapters 3 and 5).

How should you use this knowledge to improve your quantitative microscopy experiments? Image acquisition software packages used for microscopy applications

6 CHAPTER 1 Quantitative microscopy

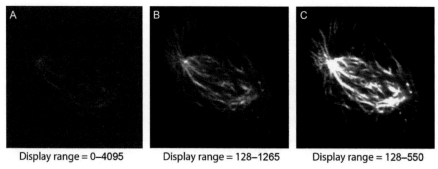

FIGURE 1.4

Image intensity values versus image display. Monitors display monochrome images on an 8-bit scale. When displaying images of higher bit depth, imaging scaling is often used to select a subset of the image intensity values to display. However, if used incorrectly or when the image display is used *in lieu* of looking at image intensity values, image scaling can cause confusion. (A–C) Identical 12-bit images with intensity values ranging from 128 to 1265. (A) The image displayed at "full scale," in which pixels with intensity values of 0 are displayed as black and pixels with intensity values of 4095 are white. Since the maximum intensity value in the image is 1265, the image appears dark. (B) The image displayed using "autoscaling," in which the lowest intensity value (128) is displayed as black and the highest intensity value (1265) is displayed as white. When autoscaling is active, each image acquired will contain black and white pixels (and the full range of gray in between), *regardless* of the actual intensity values in the image. (C) The image displayed with scaling from 128 to 550, which makes image *appear* to be saturated, since all pixels with values of 550 or higher are displayed as white.

have multiple tools to look at the intensity values within the image: pixel intensity histograms, and image or region of interest intensity value statistics (i.e., mean intensity, standard deviation, and min/max intensity). Find these tools, and use them routinely. Looking only at the image displayed on the computer screen can be extremely deceptive because all imaging software packages map the acquired image to 2^8 (256) gray levels for display (Cox, 2006), while images acquired for quantitation usually have 2^{12} (4096) or 2^{14} (16384) gray levels. This mapping can be scaled in various ways, which greatly influences how an image looks on the computer screen (Fig. 1.4).

When assessing image quality, look at the intensity values in a region in the background where there is no specimen. How high is your background compared with the camera offset? Is there anything you can do to your specimen to reduce fluorescent background? Compare the background values to the area of the specimen you intend to measure. How many intensity values above background is your signal? Always keep specimen health in mind. If your analysis looks good but your cells look sickly after acquisition, lower illumination intensity or exposure time while monitoring the intensity of the signal of interest above background (Chapter 5). As you go back and forth between acquiring and analyzing images, pay attention to how the SNR and background in the images affects your results.

1.3 OPTICAL RESOLUTION: THE POINT SPREAD FUNCTION

Resolution is the ability to distinguish objects that are separate in the specimen as separate from one another in the *image* of the specimen. The point spread function (PSF) describes how diffraction of light in the microscope limits resolution and is described in detail in Chapter 10 (Hiraoka, Sedat, & Agard, 1990; Inoué, 1989; Inoué & Spring, 1997). The equations for resolution of the light microscope assume that you are imaging an ideal object that is directly attached to the coverslip and does not scatter or refract light (Chapter 10; Hell, Reiner, Cremer, & Stelzer, 2011), and do not account for aberrations that may be introduced by the optics in the microscope (Chapter 2; Arimoto & Murray, 2004) or limited SNR in the digital image (Chapter 3; Stelzer, 1998). These ideal conditions are almost never met in reality, making it difficult to achieve the theoretical resolution limit. Each lens is different, so empirically measuring the PSF is the best way to determine the resolution limit of your microscope optics (Chapter 10; Cole, Jinadasa, & Brown, 2011; Hiraoka et al., 1990). DNA origami can also be used to make test specimens for measuring resolution, as described in Chapter 25 (Schmied et al., 2012). Methods of correcting for aberrations induced by the specimen are worth considering as well (Fuller & Straight, 2012; Joglekar, Salmon, & Bloom, 2008).

1.4 CHOICE OF IMAGING MODALITY

Your choice of fluorescence imaging modality (e.g., wide-field fluorescence, spinning disk confocal, point scanning confocal, or TIRF) will affect your quantitative measurements. There is no "best" modality for quantifying fluorescent specimens; instead, the most appropriate choice depends on your specimen and what you are trying to measure.

The purpose of confocal microscopy is to reduce out-of-focus fluorescence in the image of your specimen (Chapters 7 and 9; Conchello & Lichtman, 2005). A common misconception is that confocal microscopy provides higher resolution than wide-field fluorescence microscopy (Cox & Sheppard, 2004). Increasing resolution with a confocal microscope is possible but requires setting the pinhole size to be much smaller than the diameter of the PSF (i.e., much smaller than is necessary to reduce out-of-focus fluorescence). Closing the pinhole to the extent that will (in theory) increase resolution in the image is impractical with most biological specimens, since it also severely limits the number of photons collected from the focal plane and therefore reduces the image SNR. One should not think of a confocal as a method of increasing resolution as compared to wide-field fluorescence microscopy, but instead as a method of *getting closer* to the theoretical resolution limit when imaging specimens that have significant out-of-focus fluorescence. As explained early in this chapter, background fluorescence reduces the image SNR, and sufficient SNR is necessary to achieve theoretical resolution (Stelzer, 1998). Therefore, in quantitative microscopy, the best reason to use a confocal microscope is to reduce out-of-focus fluorescence in order to increase the image SNR.

What is the harm in going straight to a confocal? Point scanning confocal microscopes are ~200× less efficient than wide-field microscopes at collecting and detecting fluorescence from your specimen. Spinning disk confocal microscopes are far more light efficient than point scanning confocal microscopes but still ~2–4× less efficient than wide-field microscopes. Therefore, imaging specimens with a confocal microscope that *do not have* significant out-of-focus fluorescence will result in *lower* SNR images, assuming the same illumination intensity and duration are used (Murray et al., 2007).

Total internal reflection fluorescence (TIRF) microscopy uses oblique illumination to generate an evanescent field at the interface between the coverslip and a lower refractive index specimen (e.g., cells in tissue culture media; Chapter 12, Axelrod, 2001). The evanescent field decreases in power quickly with distance from the coverslip, such that only fluorophores that reside within ~100 nm of the coverslip surface are excited and emit photons. TIRF can provide a ~6–7× thinner optical section compared with confocal, leading to a dramatic reduction in background fluorescence and increase in axial resolution, with the critical caveat that TIRF is only useful for imaging the part of the specimen that is within ~100 nm of the coverslip. For specimens that do reside within the evanescent field (focal adhesions, membrane proteins, endo/exocytosis, *in vitro* assays, etc.), TIRF is an excellent option. A downside of TIRF for quantitative measurements of fluorescence intensity is the typically highly uneven illumination (due to both the Gaussian laser profile and interference patterns generated by refraction of coherent laser light on dust particles and filter surfaces). With care, a flat-field correction (explained in detail in Section 1.6.2) can be used to correct for uneven illumination in TIRF. Recent approaches to greatly reduce interference patterns include Ring-TIRF (Applied Precision) in which the entire periphery of the back aperture of the objective is illuminated.

There are a wide range of additional fluorescence imaging modalities that may be used for quantitative microscopy, many of which are discussed in this volume: multiphoton (Chapter 8), deconvolution (Chapter 10), light sheet microscopy (Chapter 11), scanning angle interference microscopy (Chapter 13), and superresolution techniques (Chapters 14–17) to name a few. Each of these modalities comes with their own advantages, disadvantages, and requirements when used for quantitative imaging.

1.5 SAMPLING: SPATIAL AND TEMPORAL

Sampling is collecting a subset of information about the specimen that is then used to represent the whole (Fig. 1.5). We sample our specimen both spatially and temporally in the course of a live quantitative microscopy experiment. In time-lapse experiments, we sample the dynamics of our specimen over time by collecting images at regular, discrete time points (Fig. 1.5 A–D). We sample the optical image created by the microscope with a limited number of finite-sized pixels to generate a digital

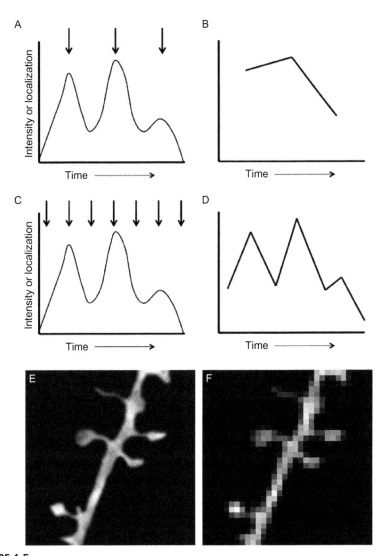

FIGURE 1.5

Sampling. During a typical time-lapse imaging experiment, images are collected at discrete time points with an interval of time between each image. (A) An object of interest is changing in intensity and/or location over time. If an image is collected at the time points indicated by arrows, the (B) analysis of the location/intensity of the object would not accurately represent the changes over time. (C) Increasing the rate of sampling (arrows) results in more accurate analysis (D). (E–F) A simulated image with a small (E) and large (F) pixel size, illustrating aliasing and loss of information as a result of spatial undersampling.

image (Fig. 1.5E and F). In addition, we may sample our specimen in 3D by collecting a *z*-series with a constant spacing between 2D images. In all of these dimensions, it is essential to sample with a sufficiently high frequency so that the collected digital image or image sequence can adequately represent the spatial and temporal information that is to be analyzed. Undersampling can result in loss of information (Fig. 1.5B and F), while oversampling can result in unnecessary specimen damage without providing additional data. Ideal sampling is rarely possible when imaging live, dynamic, photosensitive specimens. We may be limited, for example, by the rate of photobleaching or by how fast the motorized components of the imaging system can move.

1.5.1 2D SAMPLING

As discussed in the preceding text, resolution of the optical image generated by the microscope is limited by the PSF. Resolution in the digital image (on which we make our measurements) may be further limited by the sampling of the optical image with

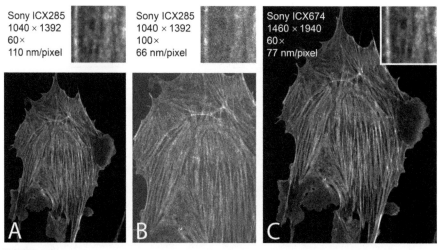

FIGURE 1.6

Pixel size, SNR, and resolution. Comparison of images of the same phalloidin-stained cell acquired with identical exposure settings, using different magnifications and different CCD cameras. Images collected with a (A) 60× 1.4 NA objective lens and (B) a 100× 1.4 NA objective lens, using the same interline CCD camera based on the Sony ICX285 chip (6.45 μm × 6.45 μm pixels) that has been central to CCD cameras from many different manufacturers for well over a decade. Larger magnification (B) results in spreading of light over a larger area, thus less signal and higher noise. (C) Image acquired with a next-generation CCD camera (Sony ICX674 chip) with smaller (4.54 μm × 4.54 μm) pixels illustrating an apparent increase in SNR and image resolution. Images at the top (inset in C) show a zoomed region of interest from each of the full-frame images illustrating sampling of the specimen by the different effective pixel sizes. Text refers to the following (from top to bottom): CCD chip, size of CCD array in pixels, objective magnification, and effective pixel size.

the detector (Stelzer, 1998). The resolution of a digital image acquired with a CCD or sCMOS camera depends on the physical size of the photodiodes that make up the chip, while the resolution of digital images created with point scanning confocal microscopes is determined by the area of the specimen that is scanned per pixel. In either case, if the pixel size is too large relative to the size of the object of interest, the optical image will be undersampled and detail will be lost (Fig. 1.5E and F). When using detectors with detector elements of fixed size, magnification in the microscope or in front of the detector can be used to adjust the pixel size. However, there is a trade-off between resolution of the digital image and signal intensity, since increasing magnification alone decreases image intensity as smaller pixels generally collect fewer photons (Fig. 1.6). In live cell imaging, depending on the experimental question, it can be favorable to sacrifice resolution to increase image SNR and/or decrease phototoxicity (Chapter 5).

How does the optical resolution limit affect our ability to quantify in fluorescence microscopy? The size of an object that is below the resolution limit cannot be accurately measured with the light microscope. However, objects that are below the resolution limit can be detected and an image of the object formed by the microscope if the imaging system is sensitive enough and the object is bright enough (Inoué, 1989). While the size of the object in the image will be inaccurate, the centroid of a high SNR image of the object can be used to locate the object with nanometer precision, far beyond the resolution limit (Inoué, 1989; Yildiz & Selvin, 2009). This concept is the basis for superresolution localization microscopy methods such as PALM and STORM (Chapters 14 and 15; Dempsey, 2013). In fluorescence microscopy, the resolution limit does not limit our ability to accurately count fluorescently labeled objects, even if the objects are below the resolution limit (Joglekar et al., 2008; Wu, 2005). If the objects are all of similar size and the intensity of one object can be accurately determined, then intensity values can be used to count multiple objects that are too close to one another to spatially resolve (Chapter 19).

1.5.2 3D SAMPLING

When making measurements of diffraction-limited objects (objects whose size is at or below the resolution limit of the microscope), small changes in focus will have a dramatic effect on the intensity of the object (Hiraoka et al., 1990; Stelzer, 1998). The image of a diffraction-limited object will have a Gaussian distribution of intensity along the optical axis of the microscope due to the PSF, with the width of the Gaussian decreasing with objective NA and wavelength of light (Chapter 10). When using a high NA objective lens to image a diffraction-limited object attached to the coverslip surface, focusing only 100 nm away from the peak of the Gaussian will result in $\sim 10 \times$ decrease in maximum intensity of the object, clearly an unacceptable level of error (Joglekar et al., 2008; Stelzer, 1998). The ideal approach to accurately measuring the intensity of diffraction-limited objects is to collect a 3D z-series of images with a very small step size (e.g., 50 nm) using a high NA objective lens (Chapter 2). Specimen dynamics, photobleaching, and phototoxicity often make this approach impossible for live cell work. However, if a sufficient number of diffraction-limited

objects are sampled with a larger step size and averaged together, the error in intensity measurements can be reduced to an acceptable level (Joglekar et al., 2008).

1.5.3 TEMPORAL SAMPLING

To accurately measure changes in intensity or localization of objects over time, one must consider temporal sampling. There are two issues to consider with regard to temporal sampling. The first is how frequently an image is collected during the course of a time-lapse acquisition. The same principles as in spatial sampling apply. If dynamics are temporally undersampled, changing the rate of acquisition will change the results of your analysis quite dramatically (Fig. 1.5). A good example is the acquisition rate dependency of microtubule polymerization dynamics measurements (Gierke, Kumar, & Wittmann, 2010). An ideal solution to this problem would be to decrease the time between acquisitions until a point is reached at which analysis results no longer change. Unfortunately, as in spatial sampling, this is often not possible. Temporal oversampling (i.e., taking images too frequently) is also problematic as it can become very difficult to detect rare events because the specimen may photobleach before an event occurs.

The second issue with regard to temporal sampling is how long it takes to collect images at each time point. Each image is essentially a temporal integral of specimen dynamics over the exposure time. Objects that move in one direction during the course of the exposure time, for example, will appear elongated on the image; for example, spherical vesicles can appear tubular. In addition, the fluorescence intensity of the elongated object will be lower, since it will be spread out over more pixels than if the object had remained stationary. Thus, especially for rapid processes, it is beneficial to decrease exposure time as much as possible, which may require increased excitation light intensity (Chapter 5). Temporal averaging is particularly important to think about when collecting *z*-series of moving objects over time.

1.6 POSTACQUISITION CORRECTIONS
1.6.1 BACKGROUND SUBTRACTION

The pixel intensity values in a digital image of a fluorescent specimen are a sum of both the signal and the background coming from that region of the specimen (Fig. 1.2B). In addition, detectors apply a constant offset value to each pixel in the image to avoid signal clipping due to image noise (Chapter 3). To make an accurate measurement of the signal of interest, background *must* be subtracted. The best approach to determining the background depends on the specimen, but in most cases, a local background measurement will give the most accurate results. In a local background subtraction, the background is measured in a region directly adjacent to or surrounding each region of interest (ROI; see Chapter 18 for an example), as opposed to making one measurement of background and subtracting this value from all ROIs. Local background measurements minimize error due to

inhomogeneity in the intracellular background levels (for subcellular measurements) or in the medium surrounding the cells (for whole cell measurements). Background measurements should be made on a large enough number of pixels to average out variation and noise; try various size regions to see how the average value changes. Precise background subtraction is especially crucial in ratiometric imaging (e.g., FRET or ratiometric probes measurements of Ca^{2+} or pH; Chapter 24) because

$$\frac{I_{\lambda 1}}{I_{\lambda 2}} \neq \frac{(I_{\lambda 1} - I_{bkg})}{(I_{\lambda 2} - I_{bkg})}$$

Background subtraction should not be done by image arithmetic because intensity variations due to noise will result in pixels with negative values, which cannot be represented in most image formats and will result in signal clipping (i.e., the value of negative pixels will become zero). This results in distortion of intensity measurements. It is best to separately determine the intensities of ROIs and background regions and export these values to a spreadsheet program for calculations.

1.6.2 FLAT-FIELD CORRECTION

Fluorescence intensity is proportional to the intensity of illumination (until illumination intensity is high enough that fluorophore ground-state depletion is reached). Therefore, uneven illumination across the field of view of the microscope will result in uneven fluorescence and thus in irreproducible intensity measurements at different positions within the image. The intensity of illumination across the field of view can be measured using established protocols (Model, 2006). If the level of unevenness of illumination is unacceptable, then effort should be made to align the illumination light source (Salmon & Canman, 2001). Despite best efforts at alignment, however, the evenness of illumination in most microscopes will be less than ideal (Chapter 9) and sometimes to an extent that may introduce significant error in measurements of fluorescence intensity.

Flat-field correction (*aka* shading correction) can be used to correct for uneven illumination across the field of view but requires a good reference image, I_{ref}, of an evenly fluorescent specimen. Saturated fluorescent dye solutions can be used for this purpose (Model, 2006; Model & Blank, 2008), but great care must be taken to ensure that the reference image represents the illumination pattern and *not* inhomogeneity in the dye solution, or imperfect alignment of the test slide perpendicular to the optical axis. Averaging many different fields of view together can be helpful in creating an accurate reference image.

Flat-field correction normalizes all pixels in an image to a reference value by division of each pixel intensity value of the acquired image, I_{image}, by the corresponding pixel intensity value of the reference image, I_{ref}. Both pixel intensities need to be background-corrected, where I_{bkg} is a dark image collected without any light sent to the camera (see Chapter 3). Finally, the resulting pixel intensity is multiplied with a

scaling factor (e.g., the average background-corrected intensity of I_{ref}) in order to obtain a similar range of intensity values as in the original image:

$$I(x,y) = \frac{I_{\text{image}}(x,y) - I_{\text{bkg}}(x,y)}{I_{\text{ref}}(x,y) - I_{\text{bkg}}(x,y)} \times \frac{\sum_{x,y}(I_{\text{ref}}(x,y) - I_{\text{bkg}}(x,y))}{xy}$$

The entire calculation needs to be done in floating point math for each pixel before outputting the corrected image, to avoid data distortion due to negative pixel values in the background subtraction steps as well as rounding errors. Thus, this is quite complicated to do right on a routine basis. However, flat-field correction is not always necessary. In practice, other sources of error frequently influence intensity measurements in biological specimens more severely than uneven illumination. Thus, it may be acceptable to restrict intensity measurements to similar areas near the center of the detector field of view where illumination variations are small, measure many specimens, and accept the resulting variation as part of the measurement error.

1.6.3 PHOTOBLEACHING

Photobleaching is the irreversible destruction of a fluorophore, which occurs when the fluorophore is in the excited state. When making measurements over time, every effort should be made to minimize photobleaching over the course of the acquisition, but this is likely not completely possible. Photobleaching can be measured and if necessary corrected for by normalizing measured intensities to the intensity of a known structure. In the simplest case, this can be the intensity of the entire cell, I_{cell}:

$$I(t) = I_{\text{image}}(t) \times \frac{I_{\text{cell}}(0)}{I_{\text{cell}}(t)}$$

However, this assumes that there is no significant change of the total cell fluorescence due to other reasons (e.g., focus drift or the cell moving in or out of the field of view).

1.6.4 STORING AND PROCESSING IMAGES FOR QUANTITATION

Images to be used for quantitation should be stored in the original file format generated by the image acquisition software (Cox, 2006). This file format will contain all of the metadata on acquisition parameters that can be very useful to have on hand during processing and analysis. Metadata may not match the acquisition settings you entered into the software. For example, you may find that the actual time between images acquired during a time-lapse experiment or the spacing between planes in a *z*-series is different than the interval you set, due to speed or variability of the hardware. However, it is important not to blindly trust metadata. Imaging software does not *a priori* know most hardware settings, so they must be set up and maintained correctly. For example, pixel sizes measured for a particular objective lens will only

be correct if that objective lens was screwed into the position in the objective turret associated with the pixel size calibration file for this objective.

If you find it necessary to convert from a proprietary file type to a standard file type, be sure to choose a standard file type that preserves the bit depth of the original file and *does not* use lossy compression (Cox, 2006). Tagged image file format (TIFF) is a standard format that can be read by any imaging software. Avoid file types that change intensity values in the image (e.g., JPEG), thereby rendering your images useless for quantitation. Be careful with pseudocoloring as well; depending on how the pseudocoloring is applied, it may change the intensity values in an image. For example, when creating a 24-bit color image from three 12-bit monochrome images, intensity values are changed as each monochrome image is converted from 12 bit to 8 bits. When image processing, filtering, etc., are used to aid in image segmentation (identification of the pixels in the image that will be measured), intensity measurements should still be made on the original or corrected (e.g., flat-field) files.

1.7 MAKING COMPROMISES

While testing acquisition parameters, you may find it impossible to do the experiment you imagined. In nearly every quantitative fluorescence microscopy experiment, compromises must be made. The key is to make deliberate and thoughtful compromises that minimize impact on the experimental results.

Let us say you want to measure changes in mitochondria content in cells. One approach would be to collect high-resolution 3D *z*-series images of cells, to segment individual mitochondria in each focal plane, and to measure the size/shape/intensity of each. This approach values spatial resolution over temporal resolution and minimizing photodamage. Another approach would be to collect single 2D lower-resolution images and to measure the area/intensity of the mitochondria in mass. This approach sacrifices measurements on individual mitochondria to gain higher temporal resolution and lessen photodamage.

But what if you want it all—high spatial and temporal resolution—in a specimen that will not allow it? This can sometimes be achieved by performing different sets of experiments using different sets of compromises and then combining the results after analysis.

Never compromise when it comes to health of the specimen. Biologically relevant measurements simply cannot be made on cells that are highly stressed or dying, and fluorescence illumination in combination with biproducts of the fluorescence reaction can easily lead to both (Artifacts of light, 2013). Monitor the health of the specimen using *transmitted light* microscopy (e.g., phase or DIC), either by collecting a transmitted light image at each time point (if time allows) or by carefully inspecting the cells before and after imaging. Transmitted light microscopy is preferable since the fluorescence channel is reporting only the labeled protein. However, the localization of a single protein may appear to be "normal" even while a cell is blebbing, retracting, and dying.

1.8 COMMUNICATING YOUR RESULTS

Every quantitative measurement has a level of uncertainty that must be reported (Krzywinski & Altman, 2013a). Never present a histogram or graph without also including appropriate statistics, and also be sure to report what type of statistics you are showing (Dukes & Sullivan, 2008; Krzywinski & Altman, 2013c, 2014a). Best practice is to include as much information as possible in the reported data and show either a scatter plot of the entire data set, or if this is impractical, show box-and-whisker plots that allow the reader to evaluate the underlying data distribution (Krzywinski & Altman, 2014b). The common bar graph with standard error of the mean error bars achieves the opposite and highlights small and possibly unimportant differences of the mean while obfuscating the true nature of the underlying data (Cumming, Fidler, & Vaux, 2007). If inferential error bars are used, confidence intervals are the most informative (Krzywinski & Altman, 2013b). It is also important to note that more frequently than not, data from quantitative imaging experiments are not normal distributed (Krzywinski & Altman, 2013a). It can thus be quite meaningless to show means and standard deviations. As quantitation has become increasingly more important for biological research, several journals have responded by providing excellent reviews on error and basic statistics. The Nature Methods "Points of Significance" series is a particularly useful set of reviews (referenced throughout this paragraph).

ACKNOWLEDGMENT

The authors thank Talley Lambert (Harvard) for the help with figures and critical reading of this chapter.

REFERENCES

Arimoto, R., & Murray, J. M. (2004). A common aberration with water-immersion objective lenses. *Journal of Microscopy, 216*(Pt 1), 49–51.

Artifacts of light (2013). Artifacts of light. *Nature Chemical Biology, 10*(12), 1135–1253.

Axelrod, D. (2001). Total internal reflection fluorescence microscopy in cell biology. *Traffic (Copenhagen, Denmark), 2*(11), 764–774.

Cole, R. W. R., Jinadasa, T. T., & Brown, C. M. C. (2011). Measuring and interpreting point spread functions to determine confocal microscope resolution and ensure quality control. *Nature Protocols, 6*(12), 1929–1941.

Conchello, J.-A., & Lichtman, J. W. (2005). Optical sectioning microscopy. *Nature Methods, 2*(12), 920–931.

Cox, G. (2006). Mass storage, display, and hard copy. In J. B. Pawley (Ed.), *Handbook of biological confocal microscopy* (pp. 580–594) (3rd ed.). New York, NY: Springer.

Cox, G., & Sheppard, C. J. R. (2004). Practical limits of resolution in confocal and non-linear microscopy. *Microscopy Research and Technique, 63*(1), 18–22.

References

Cumming, G., Fidler, F., & Vaux, D. L. (2007). Error bars in experimental biology. *The Journal of Cell Biology, 177*(1), 7–11.

Dempsey, G. T. (2013). A user's guide to localization-based super-resolution fluorescence imaging. *Methods in Cell Biology, 114*, 561–592.

Dukes, K. A., & Sullivan, L. M. (2008). A review of basic biostatistics. In D. Zuk (Ed.), *Evaluating techniques in biochemical research* (pp. 50–56). Cambridge, MA: Cell Press.

Fuller, C. J., & Straight, A. F. (2012). Imaging nanometre-scale structure in cells using in situ aberration correction. *Journal of Microscopy, 248*(1), 90–101.

Gierke, S., Kumar, P., & Wittmann, T. (2010). Analysis of microtubule polymerization dynamics in live cells. *Methods in Cell Biology, 97*, 15–33.

Hell, S., Reiner, G., Cremer, C., & Stelzer, E. H. K. (2011). Aberrations in confocal fluorescence microscopy induced by mismatches in refractive index. *Journal of Microscopy, 169*(3), 391–405.

Hiraoka, Y., Sedat, J. W., & Agard, D. A. (1990). Determination of three-dimensional imaging properties of a light microscope system. Partial confocal behavior in epifluorescence microscopy. *Biophysical Journal, 57*(2), 325–333.

Inoué, S. (1989). Imaging of unresolved objects, superresolution, and precision of distance measurement with video microscopy. *Methods in Cell Biology, 30*, 85–112.

Inoué, S., & Spring, K. R. (1997). *Video microscopy* (2nd ed.). New York, NY: Plenum Press.

Joglekar, A. P., Salmon, E. D., & Bloom, K. S. (2008). Counting kinetochore protein numbers in budding yeast using genetically encoded fluorescent proteins. *Methods in Cell Biology, 85*, 127–151.

Krzywinski, M., & Altman, N. (2013a). Points of significance: Importance of being uncertain. *Nature Methods, 10*(9), 809–810.

Krzywinski, M., & Altman, N. (2013b). Points of significance: Power and sample size. *Nature Methods, 10*(12), 1139–1140.

Krzywinski, M., & Altman, N. (2013c). Points of significance: Significance, P values and t-tests. *Nature Methods, 10*(11), 1041–1042.

Krzywinski, M., & Altman, N. (2014a). Points of significance: Comparing samples—Part I. *Nature Methods, 11*(3), 215–216.

Krzywinski, M., & Altman, N. (2014b). Points of Significance: Visualizing samples with box plots. *Nature Chemical Biology, 11*(2), 119–120.

Model, M. A. M. (2006). Intensity calibration and shading correction for fluorescence microscopes. *Current Protocols in Cytometry, 10*, 10–14.

Model, M. A., & Blank, J. L. (2008). Concentrated dyes as a source of two-dimensional fluorescent field for characterization of a confocal microscope. *Journal of Microscopy, 229*(Pt 1), 12–16.

Murray, J. M., Appleton, P. L., Swedlow, J. R., & Waters, J. C. (2007). Evaluating performance in three-dimensional fluorescence microscopy. *Journal of Microscopy, 228*(Pt 3), 390–405.

Pawley, J. (2000). The 39 steps: A cautionary tale of quantitative 3-D fluorescence microscopy. *BioTechniques, 28*(5), 884–888.

Pawley, J. B. (2006). Points, pixels, and gray levels: Digitizing image data. In J. B. Pawley (Ed.), *Handbook of biology confocal microscopy* (pp. 59–79) (3rd ed.). New York, NY: Springer (Chapter 4).

Salmon, E. D., & Canman, J. C. (2001). Proper alignment and adjustment of the light microscope. *Current Protocols in Cell Biology*, 4.1.1–4.1.26.

Schmied, J. J., Gietl, A., Holzmeister, P., Forthmann, C., Steinhauer, C., Dammeyer, T., et al. (2012). Fluorescence and super-resolution standards based on DNA origami. *Nature Chemical Biology*, *9*(12), 1133–1134.

Stelzer, E. (1998). Contrast, resolution, pixelation, dynamic range and signal-to-noise ratio: Fundamental limits to resolution in fluorescence light microscopy. *Journal of Microscopy*, *189*(1), 15–24.

Swedlow, J. R., Hu, K., Andrews, P. D., Roos, D. S., & Murray, J. M. (2002). Measuring tubulin content in Toxoplasma gondii: A comparison of laser-scanning confocal and wide-field fluorescence microscopy. *Proceedings of the National Academy of Sciences of the United States of America*, *99*(4), 2014–2019.

Waters, J. C. (2009). Accuracy and precision in quantitative fluorescence microscopy. *The Journal of Cell Biology*, *185*(7), 1135–1148.

Wu, J. Q. (2005). Counting cytokinesis proteins globally and locally in fission yeast. *Science*, *310*(5746), 310–314.

Yildiz, A., & Selvin, P. R. (2009). Fluorescence imaging with one nanometer accuracy: Application to molecular motors. *Accounts of Chemical Research*, *185*(7), 1135–1148.

CHAPTER

Practical considerations of objective lenses for application in cell biology

2

Stephen T. Ross*, John R. Allen[†], Michael W. Davidson[†]

**Nikon Instruments, Inc., Melville, New York, USA*
[†]*National High Magnetic Field Laboratory and Department of Biological Science, The Florida State University, Tallahassee, Florida, USA*

CHAPTER OUTLINE

Introduction .. 20
2.1 Optical Aberrations ... 20
 2.1.1 On-axis Aberrations ... 22
 2.1.2 Off-axis Aberrations ... 22
2.2 Types of Objective Lenses ... 22
 2.2.1 Optical Corrections .. 23
 2.2.2 Numerical Aperture ... 25
2.3 Objective Lens Nomenclature .. 25
2.4 Optical Transmission and Image Intensity .. 25
2.5 Coverslips, Immersion Media, and Induced Aberration 27
 2.5.1 Optical Path Length ... 27
 2.5.2 Correction Collars ... 28
 2.5.3 Cover Glass ... 29
 2.5.4 Immersion Media ... 30
2.6 Considerations for Specialized Techniques ... 31
2.7 Care and Cleaning of Optics .. 32
Conclusions .. 34
References ... 34

Abstract

For nearly a century, examination of biological phenomena on a microscopic level has depended on carefully calibrated optical systems, with the objective lens being regarded as the critical determinant of image quality. In this modern day, a wide variety of high-quality objectives exist, many with highly specialized functions and all requiring at least a certain base level of knowledge on the part of the imager in order to realize their full potential. A good

working knowledge of objective construction, proper use, specialized applications, and care goes a long way toward obtaining quality results. Presented here is a practical guide to choosing, using, and maintaining the proper objective for a given biological imaging application.

INTRODUCTION

The objective lens is arguably the most critical component of any optical imaging system for biological investigation. The objective lens acts as a crucial liaison between the carefully calibrated optical imaging system and the optically imperfect imaging environment inherent in biological specimens. Fluorescence imaging applications have become increasingly more sophisticated; due to this trend, correct choice of objective and proper imaging conditions is critical. As in the past, magnification and numerical aperture (NA) are key factors with respect to fluorescence but represent just a small minority of the conditions that must be considered. Such considerations include the optical corrections of the objective lens necessary for a given application and the trade-offs made to implement those corrections. This entails not only proper selection of objective for the experiment at hand but also other pertinent variables such as choice of immersion medium, cover glass, and mounting medium. Such considerations must be thoroughly evaluated, especially if the scientific question requires optimal resolution and performance.

Biological imaging often requires very careful regulation of the environmental conditions. Changes in such conditions play a significant role in determining the quality of the results that can be expected when running sensitive fluorescence imaging experiments. Perhaps the most crucial factor requiring regulation is temperature, which affects not only the noise generated by imaging devices but also the refractive index and viscosity of the immersion medium being used.

2.1 OPTICAL ABERRATIONS

One of the major differences between very low-cost objective lenses, as employed by basic student microscopes, and much more expensive objective lenses for advanced research microscopes is in the correction for optical aberrations. In this section, we briefly cover the principal intrinsic aberrations seen in objective lenses that arise due to the volume, material, and spherical surfaces of the lenses themselves. Although aberrations such as coma, astigmatism, field curvature, and distortion are concerns in optical systems (Fig. 2.1), beyond the corrections that are made in the optical design to minimize these, there is little that can be done to change them. However, we will discuss in greater detail spherical aberration and chromatic aberration, as these aberrations are often induced by the imaging conditions. Having a greater understanding of the induction of chromatic and spherical aberrations, as well as the methods for and limits of correction, can greatly improve the results obtained in critical fluorescence imaging applications.

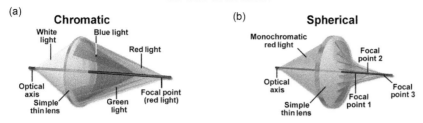
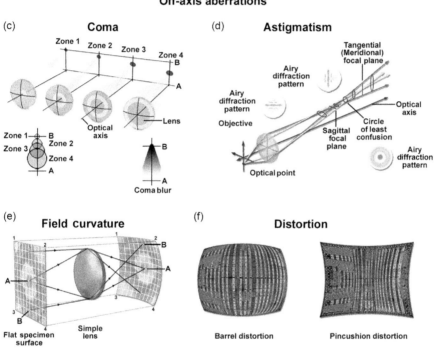

FIGURE 2.1

Different types of optical aberrations commonly encountered in light microscopy grouped by on-axis or off-axis occurrence. (a) Chromatic aberration: note how blue-shifted light is refracted differently than red-shifted light. (b) Spherical aberration: monochromatic light incident on different parts of a lens are dispersed at different angles, with peripheral and central rays coming to focus at different points along the optical axis. (c) Coma: light originating from an object displaced from the center of the optical axis comes to focus in several lateral positions (zones), resulting in a comet-like appearance. (d) Astigmatism: rays from any off-axis point emitter form an ellipse on the lens surface, resulting in tangential and sagittal rays coming into focus at different points along the optical axis. The airy pattern of a hypothetical point emitter appears stretched either horizontally or vertically, dependent on the focal plane. (e) Field curvature: when light is focused through a curved lens, the resulting image plane will also be curved, not planar. (f) Distortion: positive (pincushion) distortion results in image magnification decreasing with increasing off-axis distance, while negative (barrel) distortion results in image magnification increasing with decreasing off-axis distance. (See the color plate.)

This figure is reprinted with permission from Murphy and Davidson (2012).

2.1.1 ON-AXIS ABERRATIONS

In reviewing optical aberrations, those considered "on-axis" aberrations occur with respect to light incident to the lens parallel with the optical axis. Chromatic aberration is observed as a differential focus of polychromatic light (Fig. 2.1a) and results from the property of dispersion of the glass material. Dispersion is defined as the wavelength-dependent refractive index of the material, which causes rays of light of various wavelengths to be bent (refracted) to a different degree when entering the lens. In general, shorter wavelength blue light is bent to a greater extent, coming to focus closer to the lens than longer wavelength green or red light. Spherical aberration occurs similarly, where monochromatic light incident parallel with the optical axis focuses differentially due to the curved surfaces of the lens itself (Fig. 2.1b). This results in an axial stretch of the image of point sources of light.

2.1.2 OFF-AXIS ABERRATIONS

In contrast to "on-axis" aberrations, "off-axis" aberrations affect the focus of tangential light incident at an angle to the optical axis. Examples of off-axis aberrations are coma, where light from different circular "zones" varying in distance from the lens center comes to focus in different lateral positions with respect to the optical axis (Fig. 2.1c). Coma appears as a comet-like blurring of point sources in the image spreading out toward the periphery of the field of view. Astigmatism is another off-axis aberration that causes variation in the horizontal image of objects relative to the vertical image (Fig. 2.1d). This stretch of objects switches from vertical to horizontal as the object passes through focus. Field curvature is another off-axis aberration, which is observed as a curved surface of the field of view, where the center or periphery can come to focus, but not simultaneously (Fig. 2.1e).

The last aberration to be discussed is distortion, which is more commonly an issue in stereo microscopes, which have parallel optical paths. Distortion is present when there is a lateral shift in the focus that increases as one moves further laterally from the optical axis (Fig. 2.1f). This is generally described by either "pincushion" or "barrel" distortion.

2.2 TYPES OF OBJECTIVE LENSES

There are several general categories for objective lenses delineated based upon their respective aberration corrections. In general, the more highly corrected a lens is, the more optical elements and air/glass surfaces there are in the optical design. This is one of the fundamental trade-offs when incorporating corrective elements, as increasing the number of corrective elements tends to decrease the overall transmission of light. Several of the most popular classes of objectives that will be discussed are illustrated in Fig. 2.2, including the achromats, fluorites, and apochromats.

2.2 Types of objective lenses

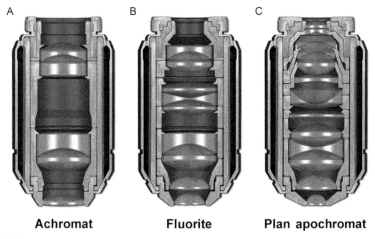

FIGURE 2.2

"Cutaway" view of three of the most popular classes of objectives, providing a representative view of the number of corrective elements in each. (A) Achromat objectives are the simplest, correcting only for chromatic aberration. (B) Fluorite objectives have increased chromatic aberration correction compared to achromats and additionally correct for spherical aberration. Note that this type of objective also has high UV transmission. (C) Plan apochromat (aka "Plan Apo") objectives are the most highly corrected for chromatic and spherical aberration. Furthermore, they are corrected for field curvature, denoted by the "Plan" in the name.

This figure is reprinted with permission from Murphy and Davidson (2012).

2.2.1 OPTICAL CORRECTIONS

Achromat lenses are the simplest of these general categories (Fig. 2.2A) and consist of at least two lenses, generally constructed of crown glass and flint glass, and are corrected for axial chromatic aberration for blue and red lights (486 and 656 nm wavelengths, respectively). The chromatic correction is accomplished using "achromatic doublets," which consist of a biconvex relatively low dispersion, low refractive index lens made of crown glass, optically cemented to a plano-concave or concave–convex lens made of relatively high dispersion, high refractive index flint glass. Additionally, spherical aberration has been corrected in green in other designs. As the class of lenses with the least correction, they are generally inexpensive and also have a relatively low number of lens elements, resulting in higher transmission.

The next level of objective lens with respect to increased optical correction is the Plan Achromat lenses. As implied by the name of this class of lenses, they have the same level of correction for chromatic and spherical aberration as the achromat lenses but have additional correction for field curvature, exhibited as an inability to focus the center and periphery of the field of view simultaneously. The Plan

designation indicates that the field of view will be flat from edge to edge within its specification, which in modern lenses is designated by the field number.

Fluor lenses are regarded as the next level of lenses and have increased chromatic and spherical aberration correction. Fluor lenses are typically corrected for axial chromatic aberration in the blue, green, and red regions, as well as broader correction for spherical aberration compared to achromat lenses. Fluor lenses contain calcium fluoride (CaF_2), fluorspar, or synthetic lanthanum fluorite, which has very high transmission, especially in the ultraviolet (UV) region. This class of objectives generally has high transmission as well as great correction for quantitative fluorescence applications. The relatively high UV transmission also makes them suitable for ratiometric calcium imaging, as well as caged compound work and applications requiring UV–violet photoactivation of probes. Additionally, low-strain fluor lenses are well suited to polarized light and differential interference contrast (DIC) microscopy. There are variants of these lenses with trade-offs for specific applications. The majority of fluor lenses are Plan Fluors that, like Plan Achromats, incorporate additional optical elements to correct for field curvature. However, for applications that demand even higher transmission, especially in the UV, there are Super Fluor variants, which offer enhanced transmission at the expense of flat-field correction. The maximum NA of fluor lenses is approximately 1.3.

Classically, apochromat lenses as a class offer the highest level of correction for axial chromatic aberration, corrected minimally for blue, green, and red light. They are also corrected for spherical aberration at three wavelengths. Plan apochromat lenses are also corrected for field curvature over a large field of view. These lenses are the most complex optically, often containing 16 or more lenses in multiple optical groups. Although very good with respect to optical transmission, these lenses are generally not a good choice for UV applications such as calcium imaging, as transmission drops off dramatically below 360 nm, with the exception of water immersion variants. Apochromats include most the highest commercially available NAs available, up to 1.49 without using specialized materials. Objectives with NAs exceeding 1.49 are available but require expensive custom high NA cover glass and immersion media. Optical corrections in modern lenses today are pushing the limits of design and manufacturing beyond what was available previously, including the tailoring of custom glass formulations to achieve very precise application-specific corrections.

Many of the current lenses for high-performance microscopy are designed based on changes in the requirements for experimental application. One such change is expanded and custom-tailored chromatic correction, such as seen in the Plan Apo Lambda S series lenses, which, in addition to enhanced transmission due to new coating technologies, have chromatic correction designed for combined applications such as photoactivation and confocal or multiphoton (MP) imaging, requiring chromatic correction through most of the visible spectrum (approximately 405–950 nm). Another example of optical correction custom-tailored for a specific application is in the case of the Apo TIRF 1.49 NA lenses, which are designed for TIRF and single-molecule imaging and have chromatic correction from the violet to 1064 nm in the infrared (IR), which is the most common wavelength for optical trapping (using an NdYag laser), a common coincident technique in biophysics.

2.2.2 NUMERICAL APERTURE

NA is generally considered to be the most important specification of an objective lens. The NA determines the resolving power of the lens and directly describes the cone of acceptance and illumination of the lens. The NA of an objective is found by multiplying the refractive index of the imaging medium by the sine of the collection ½ angle as given by Eq. (2.1) and illustrated by Fig. 2.3:

$$\mathrm{NA} = n\sin(\theta) \qquad (2.1)$$

2.3 OBJECTIVE LENS NOMENCLATURE

Critical information is engraved onto the objective lens describing the magnification, NA, immersion media required, and specialized techniques that the lens is suitable for. Additionally, there is a color code system to make deciphering some of this information simpler and faster, as illustrated by Fig. 2.4.

2.4 OPTICAL TRANSMISSION AND IMAGE INTENSITY

The brightness or intensity of a fluorescence image is based upon several factors, including the NA of the lens, the magnification, and the transmission of the lens at the wavelengths of fluorescence emission. Ideally, the best lens

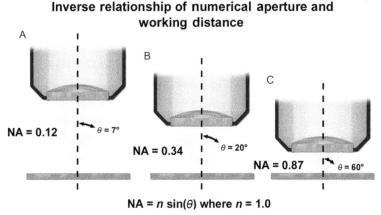

FIGURE 2.3

Illustration of the relationship between the collection half angle, numerical aperture, and working distance of a microscope objective. (A) A long working distance objective, with a correspondingly small collection half angle. (B) A shorter working distance, higher numerical aperture, objective. (C) A short working distance, high numerical aperture objective. Note the correlation between numerical aperture and relative working distance.

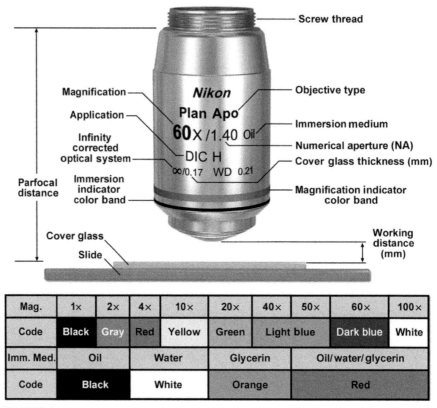

FIGURE 2.4

Objective color-coding and labeling guide. Microscope objectives include color-coded stripes for quick communication of information about the objective magnification and immersion medium requirements. The stripe furthest from the aperture is the magnification indicator color band, with the magnification color-coded as described. The stripe closest to the aperture is the immersion indicator and codes for the appropriate type of immersion medium. Note that this stripe does not indicate anything about the refractive index, viscosity, etc., of the immersion medium but rather its composition.

This figure is reprinted with permission from Murphy and Davidson (2012).

for brightness irrespective of spectral transmission will be the lens with the highest NA and lowest magnification that is suitable for the experiment. Using Eq. (2.2), the overall arbitrary intensity of lenses can be compared. Then, by multiplying the result by the transmission of specific lenses by their transmission at the fluorophore emission wavelength, it is possible to determine the brightest lens for a given experiment. These values can be determined by Eqs. (2.2) and (2.3), respectively:

$$I(\text{arbitrary image intensity}) = \text{NA}^4/\text{magnification}^2 \qquad (2.2)$$

$$\text{Brightness} = (I) \times \text{objective transmission at emission wavelength} \qquad (2.3)$$

2.5 COVERSLIPS, IMMERSION MEDIA, AND INDUCED ABERRATION

2.5.1 OPTICAL PATH LENGTH

As mentioned previously, it is critical to be mindful of induced aberrations. As a first step in this direction, it is important to discuss in a bit more detail spherical aberration. Simply put, spherical aberration, the stretching of axial focus due to light from the periphery of a lens, where the curvature of the surface is greater, focusing closer to the lens than the focus of light closer to the axis, is corrected as discussed. However, the ability to correct for spherical aberration is for a very specific set of conditions. In general, when designing a lens that has a complex design to correct for many of the aberrations discussed previously, it is necessary that optical designers know the optical path length with very high precision to calculate the optical prescription of the lens. In order to do this, the designers must make certain assumptions: (1) cover glass is exactly 170 μm thick, (2) the lens will image precisely at the surface of the coverslip, (3) only the wavelengths corrected for in the design will be used for imaging, and (4) the refractive index of the immersion media is constant. However, in application, these criteria are very rarely met. Optical path length is considered the physical length of each element in the optical path multiplied by its refractive index (Formula 2.4):

$$\text{OPL} = (L_1 \times n_1) + (L_2 \times n_2) + \cdots (L_n \times n_n) \qquad (2.4)$$

Although the thickness of each element within the optical system and their refractive index are known to very high precision, there are variables that can change in the equation, which will change the optical path length and induce spherical aberration. First of all is coverslip thickness. If typical coverslips are measured for thickness, it will be observed that there is a significant variance, as much as ±10%. Second, immersion media is a variable, as immersion oil decreases in refractive index as it increases in temperature. Most immersion media refractive index is determined for a single wavelength of green light and at a "room temperature" of 25 °C. It is possible to minimize these variables to decrease spherical aberration. Coverslips are now commercially available that have higher precision for thickness, and if it is very critical, some scientists measure coverslip thickness and discard those that are out of an acceptable range. Also, there are now immersion oils that can be purchased that will have the appropriate refractive index at variable temperatures, such as immersion oil that has a refractive index of 1.515 at 37 °C rather than 25 °C. Furthermore, attempting to work as closely as possible to the coverslip will greatly reduce spherical

FIGURE 2.5

Illustration of the effect of correction collar adjustment on aberration correction and image quality. The images in panels (A–C) were taken using a Nikon Plan Apo 40× NA 0.95 dry objective at each of the different indicated correction collar settings. The image is of LaminB1 immunolabeled with Alexa Fluor 488 in fixed HeLa (S_3) cells mounted in Opti-Bryt mounting medium ($n \sim 1.5$) beneath a low size variability #1.5 coverslip (width = 0.17 ± 0.005 mm). (A) Correction collar is set to 0.11 mm, note the extreme upward position of the movable lens group and the corresponding poor image quality. (B) Correction collar is set to the optimum value of 0.17 mm, note the enhanced image contrast compared to panels (A and C). (C) Correction collar is set to 0.22 mm; image is aberrated to a similar degree as (A) and movable lens group is in extreme downward position.

aberration. In some critical applications, spherical aberration is corrected by evaluating performance at the depth and under experimental conditions with a series of oils and choosing the best for the conditions.

2.5.2 CORRECTION COLLARS

One of the simplest ways to correct for spherical aberration is the use of a lens with a correction collar, which varies the spacing of optical groups inside the objective lens in a location that causes maximal change in the angles of peripheral versus axial rays in the lens. Correction collar adjustment and its effect on image quality are illustrated by Fig. 2.5.

2.5.3 COVER GLASS

As stated, most objectives are designed for use with coverslips of thickness 0.17 mm, commonly specified by the grade #1.5. Many researchers will simply set the correction collar to the idealized value of 0.17 without determining the optimum position. However, the aforementioned variation in thickness still makes the use of a correction collar pivotal for experiments where resolution needs to be optimized. Many vendors offer "high-performance" coverslips exhibiting a lesser degree of thickness variation but at a premium cost. A variety of alternative coverslip thickness grades are available, including #0 (\sim83–130 µm), #1 (130–160 µm), #1.5 (160–190 µm), and #2 (190–250 µm). #1.5 Coverslips are considered standard, but alternative coverslip grades are often considered superior for certain specialized applications. For example, researchers often use #0 or #1 coverslips if the application requires coating the coverslip (e.g., with collagen or polylysine for adherent cell cultures), thus increasing the thickness and optical path length of the entire preparation. Furthermore, the mounting medium itself may increase the distance between the specimen and the objective lens. Correction collars are not as important for objectives with NA $<$ 0.4 because aberration does not seriously degrade image quality. However, correction collar adjustment is especially important for high-NA, "high-dry" objectives because they are prone to spherical aberration. Some objectives now come with correction collar settings that also vary with temperature, making correction even more robust. It is thus of utmost importance that the optimal setting be determined experimentally by the user. The following step-by-step method should be helpful for practically determining optimal collar position for the actual optical path length:

1. Set the collar to the default position corresponding to 0.17 mm.
2. Focus on a very fine specimen detail.
3. Rotate the correction collar by very small increments and refocus. If image quality is improved, continue to adjust the collar in the same direction while refocusing until image quality degrades.
4. If quality decreases, adjust the collar in the opposite direction while refocusing. Generally, start by shifting the correction collar toward larger values (0.17–0.22 mm). This is due to the fact that the cover glass-medium combination is thicker than the cover glass alone.

Optimum resolution is obtained when the refractive indices of all the components in the optical path are identical. Dry objectives collect the smallest angle of light from a hypothetical point emitter mounted in a standard mounting medium-coverslip combination. Light traveling through the cover glass ($n \sim 1.5$) into air ($n \sim 1$) has a much smaller critical angle than that traveling through the cover glass into water ($n \sim 1.33$) or oil ($n \sim 1.52$). For dry objectives in this type of setup, light incident at an angle greater than approximately 40° from the normal is reflected; this value is closer to 60° for water immersion objectives. The relationship between the refractive indices of the cover glass and immersion medium and the cone of acceptance of the objective are explored in Fig. 2.6, which illustrates the light lost from high refractive index specimens with dry and water immersion objectives.

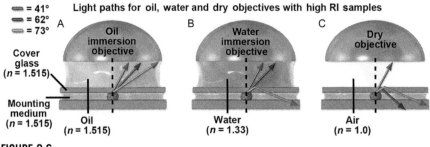

FIGURE 2.6

Comparison of light acceptance in dry, water, and oil immersion objectives with high refractive index specimens. Values given for the illustrated light angles are from the normal (represented by a dashed line). (a) Oil immersion objectives collect the widest angles of light from point emitters by maximizing refractive index and preventing a decrease in refractive index with the potential to cause reflection instead of refraction. (B) Some light from a high refractive index emitter ($n \sim 1.5$) is lost when imaged with a water immersion objective due to the decrease in refractive index to ~ 1.33, causing some light to be reflected and some refracted outside of the detection cone. (C) Dry objectives collect the least amount of light from a specimen where $n \sim 1.5$, with a significantly smaller critical angle than water immersion objectives. (See the color plate.)

2.5.4 IMMERSION MEDIA

Choice of immersion oil should be considered carefully by the investigator, a large variety of types from a multitude of vendors exist, making identification of suitable oils sometimes difficult. In general, high-quality oil will have a refractive index of approximately 1.515–1.518, matching the index of typical cover glass. It is important that the refractive index of the oil remains stable with varying environmental conditions and similar over a wide range of the visible spectrum. Generally, both the refractive index and viscosity of immersion oils change with temperature, making its use sometimes problematic for live-cell imaging applications.

Most commercial microscope vendors have their own immersion oils, but third-party companies also produce oil, a popular vendor being Cargille–Sacher Laboratories Inc. General types of oil for most optical imaging applications are types A and B. Type A has a higher viscosity (~ 150 cSt), resulting in a reduced tendency to trap air bubbles. Type B is significantly more viscous (~ 1250 cSt), making it easier to use the same oil application to view multiple slides sequentially, thus saving time with high-content applications. Specialized high-viscosity oils are also available for use with inverted microscopes and other systems where "runoff" may be a concern or where there exists a long distance between cover glass/objective and slide/condenser. An important factor to keep in mind when selecting oil for fluorescence studies is the amount of intrinsic autofluorescence created by illumination of the oil itself at varying wavelengths. Low to nonfluorescent oils specifically for fluorescence microscopy are available, such as sandalwood oil and synthetic types

LDF, HF, and FF (Cargille). However, for most applications, types A and B are more than suitable.

Immersion medium for water objectives differs from that for standard oil immersion objectives. First, it has a lower refractive index, generally of ~1.33, matching the refractive index of water. It is important that the user use a nonevaporating medium, especially if working over long periods of time or if temperature is maintained at physiological levels. Because of the lower refractive index, the NA of water immersion objectives does not usually exceed ~1.2. However, water immersion objectives tend to have longer working distances than their oil immersion relatives and are ideally suited for imaging in aqueous media, as required for live-cell imaging applications. Furthermore, if there is an appreciable amount of aqueous media between the sample and the cover glass, water immersion objectives suffer from significantly less spherical aberration than oil immersion.

2.6 CONSIDERATIONS FOR SPECIALIZED TECHNIQUES

There exist a variety of specialized biological imaging techniques that have not yet been addressed, a number of which require even more highly specialized objectives. There exist quite a variety of objectives highly tailored toward more specific imaging applications.

One popular type of specialized objective are the "water-dipping" objectives, where the aperture is directly immersed into the imaging medium, for example, exposed living tissue or in a brain slice perfusion chamber. One benefit of a water-dipping lens as compared to a standard water immersion objective is that the user does not have to compensate for the change in refractive index presented by the glass coverslip, reducing the number of variables that must be accounted for in the optical path. Additionally, water-dipping objectives tend to have relatively long working distances and are thus considered ideal for live-cell/deep tissue imaging, as well as for applications exploiting micromanipulation (e.g., electrophysiology).

One popular technique often used in conjunction with fluorescence imaging is Nomarski or DIC imaging, a bright-field technique whereby gradients in optical path lengths are visualized. The technique is popular from routine examination of cell cultures to much more advanced applications, such as optical sectioning. Specialized objectives are available for DIC imaging. DIC objectives do not generally require any internal modification, but are designed for use in conjunction with a Nomarski or Wollaston prism in the light path. Additionally, DIC is a technique premised upon using polarized light and as such needs to be performed with low-strain optics, as strained optical glass can create spurious artifacts when illuminated with polarized light. Objectives for use in conjunction with polarized light are generally marked with a P, PO, or Pol on the barrel.

MP and more general IR imaging applications are popular techniques for deep tissue imaging, longer wavelengths are less scattered by biological specimens, and furthermore, MP is a powerful technique for optical sectioning of thick samples.

These methods are unique in that they require optical components with high transmission in the near-IR and IR portion of the EM spectrum. Specialized objectives with high IR transmission are available for these techniques. Generally, high-NA, low-magnification objectives are preferred for these applications.

Another popular fluorescence imaging application is the use of focused laser radiation to perform optical trapping, also known as optical tweezers. The radiation pressure from a focused laser beam has the ability to trap particles ranging in size from approximately 10 to 100 nm. Applications include trapping of live cells, organelles, viruses, etc. IR lasers are generally preferred; thus, objectives for this application should have high IR transmission. In order to be used for trapping, objectives also need to have a high NA, typically ~1.2–1.4. A 1.27 NA long working distance water immersion objective is available with 70% transmission and chromatic aberration correction as far out as 1064 nm, ideally suited for this type of application.

Specialized multi-immersion objectives are available; these "catch-all" objectives are compatible with a number of different immersion media, generally including oil, water, glycerin, and other substances. These objectives are especially useful for imaging specimen features significantly removed from the cover glass interface where the optimum immersion medium is not immediately obvious.

2.7 CARE AND CLEANING OF OPTICS

Microscope objectives are often one of the most expensive (and important) accessories required for high-performance imaging applications. Thus, proper care and cleaning of not only the microscope but also the objectives and other optics should be of utmost importance. For a more detailed treatment of microscope cleaning, refer to the works of James and Tanke (1991) and Inoué and Spring (1997). The user must be vigilant with respect to fundamental aspects of optics care.

The microscope stand should be shielded from dust when not in use (e.g., with a cloth or plastic cover) and the internal components protected from the outside environment by capping all unoccupied objective ports, camera mounts, and ocular sleeves. Accumulations of dust on nonoptical components of the microscope can generally be removed with a slightly moist cloth. However, dust, in addition to eyelashes, facial oils, and other debris, has an increased tendency to accumulate on frequently used oculars. Such debris can be simply removed by gently wiping with a cotton swab in the manner shown by Fig. 2.7. Loose dust on objectives can be removed by gently blowing with an air bulb. When not in use, objectives should be either protected from dust or stored in a screw-cap plastic case.

Immersion oil should always be removed from objectives when not in use. Exposed oil on an objective is prone to catching dust and other particulate matter with potential to cause damage to the glass if not properly removed. Additionally, immersion oil acts as a very mild solvent, weakening the seal surrounding the front lens element over extended periods of time. Oil should be gently removed with a quality lint and abrasive-free lens paper, taking care not to apply direct pressure with the

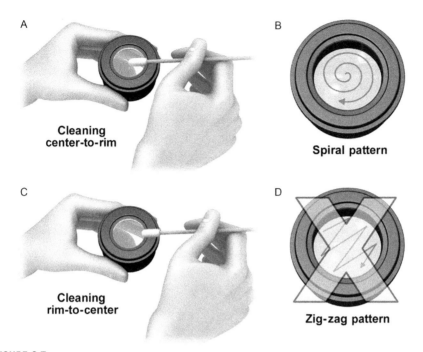

FIGURE 2.7

Method for removing dust and other debris from microscope oculars. (A) Very gently wipe the ocular using a cotton swab moistened with a commercial lens cleaning formulation in a spiral pattern, working from the center toward the periphery as shown by (B) and not "outside-in" as illustrated by (C) or using a zig-zag pattern (D).

This figure is reprinted with permission from Murphy and Davidson (2012).

potential to grind any particulate matter against the lens. Damage to the glass may not be immediately obvious, but can degrade image quality permanently. Once the majority of the oil is gently removed with lens paper, the rest can be taken cared of using lens paper wetted using a commercial objective lens cleaner. Never apply excess pressure or cleaner, and swipe only once in a single direction with a new portion of lens paper for several iterations so as to work the oil off of the lens rather than spreading it around. Other suitable solvents include pure ethanol and ethyl ether, both of which work well on particularly significant deposits. Commercial glass cleaners should be avoided.

If possible, the objective should remain attached to the turret so as to avoid any potential mishandling. Always remember to clean oil, spilled culture medium, and other fluids present on the microscope; this is of particularly for inverted microscopes. If such fluids come in contact with the base of the objective, it can become virtually sealed in place. If this is the case, apply a small amount of water (to dissolve salts) and/or an oil-penetrating agent at the base of the objective meeting the turret. Remember never to apply mechanical strain when removing or handling an objective

as this can easily and permanently damage the internal optics and thus ruin performance. Additionally, it should be noted that objectives are sensitive to the ambient humidity and temperature conditions. Specifically, large temperature fluctuations should be avoided as sudden change can introduce strain.

CONCLUSIONS

More than ever, a solid working knowledge of microscope objectives and their proper use and care are necessary for the high-sensitivity imaging applications becoming increasingly popular today. The ready availability of high-quality objectives should not act as an excuse for ignorance on the part of the user, but rather as an opportunity to fine-tune the sensitivity and resolution of the application in question. Using this chapter as a guide, the imager should be able to get more out of their imaging time while maintaining the performance of their objectives.

REFERENCES

Inoué, S., & Spring, K. (1997). *Video microscopy: The fundamentals.* New York, NY: Plenum Press.

James, J., & Tanke, H. J. (1991). *Biomedical light microscopy.* Boston, MA: Kluwer Academic Publishers.

Murphy, D. B., & Davidson, M. W. (2012). *Fundamentals of light microscopy and electronic imaging* (2nd ed.). New York, NY: John Wiley & Sons.

CHAPTER

Assessing camera performance for quantitative microscopy

3

Talley J. Lambert, Jennifer C. Waters

Harvard Medical School, Boston, Massachusetts, USA

CHAPTER OUTLINE

3.1 Introduction to Digital Cameras for Quantitative Fluorescence Microscopy	36
3.2 Camera Parameters	37
3.2.1 Quantum Efficiency	37
3.2.2 Noise	37
3.2.3 Poisson Noise	37
3.2.4 Camera Noise	39
3.2.5 Fixed-Pattern Noise	39
3.2.6 Digitization, Bit Depth, and Dynamic Range	40
3.2.7 Amplification	41
3.2.8 sCMOS Considerations	43
3.3 Testing Camera Performance: The Photon Transfer Curve	44
3.3.1 Photon Transfer Theory	44
3.3.2 PTC Collection Protocol	46
References	52

Abstract

Charge-coupled device and, increasingly, scientific complementary metal oxide semiconductor cameras are the most common digital detectors used for quantitative microscopy applications. Manufacturers provide technical specification data on the average or expected performance characteristics for each model of camera. However, the performance of individual cameras may vary, and many of the characteristics that are important for quantitation can be easily measured. Though it may seem obvious, it is important to remember that the digitized image you collect is merely a *representation* of the sample itself—and no camera can capture a perfect representation of an optical image. A clear understanding and characterization of the sources of noise and imprecision in your camera are important for rigorous quantitative analysis of digital images. In this chapter, we review the camera performance characteristics that are most critical for generating accurate and precise quantitative data and provide a step-by-step protocol for measuring these characteristics in your camera.

3.1 INTRODUCTION TO DIGITAL CAMERAS FOR QUANTITATIVE FLUORESCENCE MICROSCOPY

For all of their technical complexities, the core function of the charge-coupled device (CCD) and scientific complementary metal oxide semiconductor (sCMOS) digital cameras used for microscopy applications can be stated simply: digital cameras convert the optical image generated by your microscope into a digital image that can be used for quantitative measurements (Aikens, Agard, & Sedat, 1989; Spring, 2001). A digital image is an array of pixels, with each pixel representing a finite area of your sample and possessing a grayscale value (a.k.a. intensity value or digital number) that is meant to reflect the flux of photons originating from that area. The grayscale values in a digital image of a fluorescent specimen can be used to determine the location and amount of fluorophore in your sample. To understand the correlation between gray values in the digital image and photons emitted by the sample, one must understand the fundamental properties and function of the camera used to form the digital image (Janesick, 2007). To the extent that the gray values in your image fail to represent the "truth" of your sample, any quantitative analysis of the image will be equally inaccurate (Waters, 2009).

CCD and CMOS cameras contain a silicon-based "chip" composed of an array of light-sensitive photodiodes and associated electronics (Aikens et al., 1989; Pawley, 2006a). Each photodiode on the camera chip can form one pixel in a digital image. Conversion from photons to gray values occurs in two stages. First, upon hitting a photodiode, a photon causes the release of an electron in a probabilistic phenomenon called the photoelectric effect (Einstein, 1905; electrons released in response to photons are referred to as "photoelectrons"). Each photodiode on the chip serves as a photoelectron "bucket," collecting charge over the duration of the camera exposure (Inoué & Spring, 1997). Photodiodes can hold a limited number of photoelectrons, referred to as the full well capacity (FWC); photodiodes that reach FWC during an exposure cease to increase their accumulated charge in response to additional photons and result in a saturated pixel in the digital image. At the end of the exposure time, the second stage begins: the accumulated charge in each photodiode (referred to as a "charge packet") is measured or "read out" and converted into a gray value. The charge packet is transferred to a "read node" (the method of transferring the charge varies depending on the camera; Aikens et al., 1989; Inoué & Spring, 1997) where the voltage of each charge packet is amplified by a read amplifier to a range appropriate for digitization (conversion to a gray value) by the analog-to-digital converter (ADC)(Pawley, 2006a).

The cameras most often used in quantitative fluorescence microscopy fall into one of two categories: CCD or sCMOS. The differences between these two technologies are numerous (for reference, see: Baker, 2011; Moomaw, 2013; Saurabh, Maji, & Bruchez, 2012), but perhaps the most significant difference is in how the chips are read. While CCDs have a single read amplifier and ADC to which all photoelectron charge packets must be transferred for digitization, CMOS chips are active-pixel sensors, meaning each photodiode on the chip has its own amplifier and each chip has multiple ADCs. This parallelization of the readout process impacts

a number of camera characteristics, which we will discuss throughout this chapter. sCMOS cameras contain CMOS chips that have performance characteristics suitable for scientific applications (Fowler et al., 2010).

3.2 CAMERA PARAMETERS

When assessing a camera, one should begin with the technical specification sheet provided by the manufacturer (usually available online). In this section, we will examine some of the critical characteristics listed on these specification sheets and how they limit camera performance and digital image quality.

3.2.1 QUANTUM EFFICIENCY

In a perfect world, every photon that hits the camera chip would result in a photoelectron. Unfortunately, this is not the case: Some photons hit the electrical circuitry on the chip, some are absorbed by structural material, and some of the photons that hit the light-sensitive region of the photodiode simply fail to elicit a photoelectron. The average percentage of photons hitting the chip that generate photoelectrons is referred to as the quantum efficiency (QE) of the camera (Pawley, 2006a; Rasnik, French, Jacobson, & Berland, 2007; Spring, 2007). QE varies as a function of the wavelength of light and, to a lesser degree, temperature. Higher QE results in the collection of more photons from your sample and may well be the one camera property that does not bring with it an implicit compromise.

3.2.2 NOISE

If you were to repeatedly image an unchanging sample with the exact same camera and settings, every exposure would yield an image with slightly different gray values. This variation in pixel intensity values is called noise (Chapter 1). The goal of quantitative microscopy is to form an accurate digital representation of the sample, and noise hinders this goal by introducing uncertainty in the intensity values, which both degrades image quality and limits our ability to detect small changes in fluorescence in the sample (Waters, 2009; Wolf, Samarasekera, & Swedlow, 2007). An important property of digital images is the signal-to-noise ratio (SNR). Formally, SNR is defined as the ratio of the signal (in photoelectrons) to the sum of all sources of noise (in electrons) in the digital image (Moomaw, 2013; Rasnik et al., 2007; Sheppard, Gan, Gu, & Roy, 2006). There are four dominant sources of noise in a digital image: Poisson noise, read noise, dark current, and fixed-pattern noise (Janesick, 2007). Later in this chapter, we will outline a protocol for directly measuring these sources of noise in your camera.

3.2.3 POISSON NOISE

Poisson noise (a.k.a. shot or photon noise) arises from the fact that the arrival of photons at the camera chip is a stochastic process and follows Poisson counting statistics (Schottky, 1918; Sheppard et al., 2006). Imagine, for example, that you are counting

photons from a light source that emits an average of 100 photons per second. If you were to collect photons from this light source multiple times, for precisely 1 s each time, you would get a range of different photon counts with a mean of 100 photons. The photon counts would have a Poisson distribution with a standard deviation equal to the square root of the measured number of photons (10, in our example).

There is nothing that can be done to eliminate Poisson noise. One can, however, minimize the detrimental impact of Poisson noise on the total SNR in the image by collecting more photons. Figure 3.1A–D depicts a simulation of a neuron imaged with a theoretical *ideal* camera that has 100% QE and contributes no additional noise to the image. The only noise present in these simulated images is Poisson noise, equal to the square root of the number of photons collected. As more photons are collected (by increasing the exposure time), the SNR of the image increases.

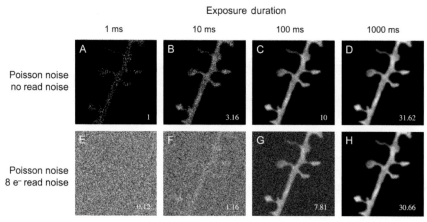

FIGURE 3.1

Noise in simulated images of a neuron. Columns from left to right simulate increasing exposure times of a sample emitting on average 1000 photons/s at the brightest point. SNR is displayed in the bottom right corner of each image, where $SNR = signal(e^-)/\sqrt{signal(e^-) + \sigma_{read}^2}$. *All images are autoscaled to the brightest and dimmest pixels.* Panels A–D show the effect of Poisson noise in a sample imaged with a theoretical *ideal* camera that contributes no additional noise to the image. Poisson noise is more noticeable at shorter exposure times when fewer photons are detected. Panels E–H simulate a camera with 8 electrons read noise (r.m.s.). Read noise was simulated in each pixel by adding a random number pulled from a Gaussian distribution with a standard deviation equal to the read noise and a mean of 0. With lower signal levels in shorter exposure durations (read noise regime, Fig. 3.4), read noise obscures the signal and dominates the SNR. At higher exposure durations (Poisson noise regime, Fig. 3.4), the contribution of read noise becomes less significant and the SNR approaches that of the "ideal" camera where Poisson noise is the only significant source of noise.

3.2.4 CAMERA NOISE

Ideally, the number of photoelectrons collected in each photodiode during the exposure time would result in a predictable gray value in the image. However, there are additional sources of noise generated by the camera that cause variation in the gray values in the image (Janesick, 2007; Pawley, 1994, 2006a). On the manufacturer's specification sheet, the different sources of camera noise are reported in electrons, not gray values; this allows for easy comparison of noise between cameras that may have different electron to grayscale conversion factors.

The dominant source of noise in cameras commonly used for quantitative microscopy is read noise. Read noise results primarily from imprecision in the measurement of each photoelectron charge packet by the read amplifier. Camera noise, including read noise, can be seen by acquiring a "dark image," that is, an image in which no light is delivered to the camera. Dark images will have a distribution of pixel intensities centered on an *average* gray value corresponding to zero photons (called the camera "offset," defined in the succeeding text), and the standard deviation of this distribution is proportional to the read noise. On CCD specification sheets, read noise is reported in units of electrons root mean square (r.m.s.). sCMOS camera specification sheets often report the *median* pixel read noise value, which is typically lower than the r.m.s. value. Read noise typically increases as a function of readout speed: the faster the camera measures each charge packet, the less precise the measurements will be (Rasnik et al., 2007). While read noise may vary with readout rate, it is *independent* of exposure time and of the number of photons collected. Thus, just as with Poisson noise, collecting more photons increases the signal-to-read noise ratio (Waters, 2009). Figure 3.1E–H shows a series of simulated fluorescence images with constant signal, no background fluorescence, and a read noise of 8 electrons r.m.s. At lower signal levels, read noise dominates the noise in the image. This demonstrates that whenever possible, it is preferable to collect sufficient signal to escape the read noise and work in the Poisson noise regime.

Thermal noise (a.k.a. dark current or dark noise) is a result of heat-induced release of electrons from the silicon chip. Thermal noise is typically reported on camera specification sheets in electrons/pixel/s. The buildup of thermally generated electrons is directly correlated with the temperature of the chip, and cooling the chip dramatically decreases thermal noise. The best CCD cameras for quantitative microscopy cool the chip to a temperature (typically $-30\,°C$ or less) such that the thermal noise is negligible for the range of exposure times typically used (e.g., $\ll 0.05$ e$^-$/pix/sec). Minimizing thermal noise is paramount in electron-multiplying CCDs (EMCCDs), where thermally generated electrons may be amplified exponentially. EMCCDs are discussed further in the succeeding text.

3.2.5 FIXED-PATTERN NOISE

During the camera exposure time, each photodiode must collect and hold the photoelectrons generated. However, not all photodiodes collect this charge with the same efficiency and this leads to differences between pixels that persist across exposures

(Janesick, 2007). Because this pattern of variable sensitivity is spatially consistent from image to image, it is termed "fixed-pattern noise." Fixed-pattern noise increases in direct proportion to the signal. It should be noted that fixed-pattern noise can arise from sources unrelated to the detector itself, such as dust particles stuck on the camera window, or elsewhere in the light path. Consistently uneven illumination or image vignetting can also be considered sources of fixed-pattern noise. Fortunately, fixed-pattern noise can often be corrected after image acquisition using flat-field correction methods (Chapter 1; Wolf et al., 2007).

In sCMOS cameras, fixed-pattern noise may also arise from pixel-to-pixel and column-to-column variations in the gain of the different amplifiers. For this reason, fixed-pattern noise is frequently much more noticeable in CMOS cameras than in CCD cameras, though recent improvements in sCMOS design have helped to reduce fixed-pattern noise (El Gamal, Fowler, & Min, 1998; Snoeij, Theuwissen, Makinwa, & Huijsing, 2006).

3.2.6 DIGITIZATION, BIT DEPTH, AND DYNAMIC RANGE

Once the photoelectron charge packet has been transferred to the read amplifier and converted into a voltage, the voltage must be digitized by the ADC in order to be stored on a computer hard drive and displayed on a monitor. At the ADC, the voltage from each photodiode is converted to a digital gray value corresponding to signal amplitude (Pawley, 2006b). For a given camera configuration, there is a conversion factor (which we will calculate in the following section) that can be used to convert gray values to photoelectrons (Janesick, 1997, 2007). The maximum possible gray value typically corresponds to the FWC (the maximum charge in electrons that each photodiode can store). The lowest possible gray value (representing zero signal), however, will not be 0. Rather, most cameras are set with a baseline camera offset value in order to capture noise-induced fluctuations that would otherwise be cut off, since gray values do not go below zero.

The bit depth of the camera digitizer determines the number of distinct possible gray values in each pixel. A pixel in a 12-bit camera, for instance, can have one of 2^{12} (4096) possible intensity values. The higher the bit depth, the more gray value steps there are between absolute 0 (black) and saturation (white). This is demonstrated in Fig. 3.2, in which higher bit depths provide finer gradations of gray values. However, there is a point at which higher bit depths cease to provide any additional information about the image.

In a CCD, dynamic range is typically defined as the ratio of the theoretical maximum measurable signal to the minimum measurable signal (Moomaw, 2013; Stelzer, 1998). On a camera specification sheet, dynamic range is expressed as the ratio of FWC (the maximum possible signal) to the read noise (which can be considered a lower bound on the minimal detectable signal). So, a camera with a FWC of 18,000 electrons and a read noise of 6 electrons r.m.s. would have a dynamic range of 3000:1. This implies that the camera can discern about 3000 different intensity values. For such a camera, a bit depth of 12 (4096 possible gray values) would be

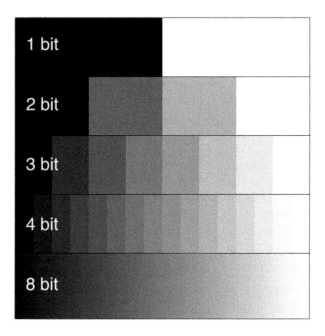

FIGURE 3.2

The same signal gradient digitized at five different bit depths. The 8-bit image shows a smooth ramp of 256 (2^8) gray values from black to white. At lower bit depths, discrete steps in gray values are perceivable. In a 1 bit image, there are only two possible gray values.

more than enough to sufficiently sample the intensity information. A higher bit depth would simply oversample the intensity data, creating larger file sizes with minimal analytic benefit. It should be noted that, in practice, the *usable* dynamic range of a CCD is often quite smaller than the ratio of FWC to read noise, due to CCD nonlinearity as the signal strength approaches the FWC, as well as the fact that the minimum *quantifiable* signal intensity in photoelectrons is actually well above the read noise level.

3.2.7 AMPLIFICATION

To detect a signal in a digital image, the signal must be greater than the noise; signal that is within the range of the noise will be indistinguishable from noise. In applications such as single-molecule imaging (specimens that emit a very limited number of photons) or high-speed imaging (where very short exposure times limit the number of photons that can be collected), the signal is often within the noise range of a standard cooled CCD camera. Modern sCMOS cameras with very low read noise (≤ 1 e$^-$ r.m.s) provide one possible solution to this problem. Another solution, provided by electron-multiplying CCDs (EMCCDs), is to amplify the photoelectron packet *before* it is read by the charge amplifier (i.e., before read noise is added; Moomaw, 2013).

When considering using an EMCCD camera for quantitation of fluorescence intensities, it is important to understand how amplification affects the image SNR.

EMCCD cameras use CCD chips with an extended multiplication (a.k.a. gain) register that is used to amplify photoelectrons before they reach the readout amplifier (Jerram, Pool, & Bell, 2001; Mackay, Tubbs, & Bell, 2001). This multiplication register consists of many hundreds of photodiodes with high FWC. Photoelectrons are accelerated through the photodiodes in the multiplication register using large voltage gradients. With a very small probability, this can lead to a phenomenon known as "impact ionization": the release of additional electrons from the photodiode upon impact of the photoelectron. This mechanism results in the amplification of the charge packet several thousandfold, bringing the signal above the read noise.

Amplifying the signal to levels above the read noise can be extremely useful for low-light or high-speed imaging. Nonetheless, there are some important caveats to keep in mind when considering using an EMCCD camera for quantitative microscopy. Most importantly, the electron multiplication register adds a unique type of excess noise to the image referred to as multiplicative noise (Moomaw, 2013; Pawley, 2006a; Robbins & Hadwen, 2003). As mentioned earlier, impact ionization may occur at each photodiode in the multiplication register, but with a very small probability. Over the hundreds of photodiodes in the multiplication register, the probabilistic nature of impact ionization leads to high levels of uncertainty regarding the total amount of amplification that may result from a given charge packet (Lantz, Blanchet, Furfaro, & Devaux, 2008). The probability distribution of output electrons given a certain number of input electrons is shown in Fig. 3.3. When looked at conversely, the problem becomes apparent: It is *impossible* to predictably correlate a given number of output electrons with a specific number of input electrons. Therefore, the amplification used by EMCCDs makes it possible to detect low levels of photons that would otherwise be lost in the read noise, but the precision with which we can determine the number of photons that hit the chip is compromised.

Multiplicative noise effectively magnifies Poisson noise; the intrinsic variability in the signal is amplified and the degree of certainty regarding the "ground truth" of the signal decreases (Pawley, 2006a). This makes EM gain less than ideal for quantitative microscopy when signal levels are high enough that Poisson noise is the dominant source of noise in the image. Furthermore, in samples that have significant background (from tissue culture media, out-of-focus fluorescence, etc.), amplification of photoelectrons from the background (and the associated Poisson noise) further degrades the image SNR. This makes EMCCDs more suited to situations in which background can be reduced to extremely low levels (e.g., total internal reflection fluorescence microscopy). Most EMCCDs come with a second traditional serial register that allows the camera to be used without amplification when signal levels are high. In addition, because EMCCDs are designed for applications requiring high sensitivity, they typically have larger pixel sizes and therefore produce images with reduced spatial sampling. Thus, EMCCDs offer amplification that effectively reduces read noise and enables fast acquisition rates and can be extremely useful for imaging samples with low signal and low background. However, due to the

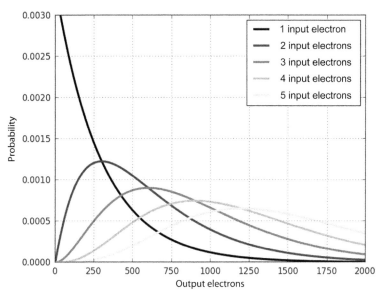

FIGURE 3.3

The probability of observing a certain number of output electrons at the read amplifier given a known number of input photoelectrons (represented by the five different lines) and a simulated EM gain of 300. A given number of output electrons recorded at the read amplifier can result from a large range of possible input electrons, making it difficult to determine how many photoelectrons were generated in each photodiode.

inherent trade-off of multiplicative noise, it is best to optimize the specimen and microscope to ensure maximal photon collection before resorting to a camera that amplifies the signal.

3.2.8 sCMOS CONSIDERATIONS

One consequence of the parallelization of readout electronics in sCMOS cameras is the ability to simultaneously drive each read amplifier much slower, thereby decreasing read noise while achieving much faster readout rates, often with more total pixels and an increased field of view. This "no compromise" promise has led to a rapid rise in the marketing and use of sCMOS cameras for microscopy in recent years. Certainly, sCMOS represents an exciting addition to the imaging options available to microscopists, but there are a few important points to understand when considering sCMOS cameras for quantitative microscopy. In a CCD camera, all pixels share the same read amplifier circuitry, and the read noise is therefore constant across all pixels. In sCMOS cameras, on the other hand, each individual photodiode has its own noise and gain characteristic, resulting in dramatic pixel-to-pixel variation. While the *average* photodiode read noise of a sCMOS camera is typically lower than a CCD, read noise is no longer constant across the chip. This can be important to keep

in mind when using conventional image analysis algorithms (which assume uniform chip-wide Gaussian read noise) on images acquired with sCMOS cameras (Huang et al., 2013). Another unique characteristic of sCMOS architecture is "rolling shutter" readout option, in which different rows of the pixel array are both exposed and read at different times. As a result, different parts of the image are acquired at different absolute moments in time. With highly dynamic samples, it is important to confirm that rolling shutter mode is not introducing artifacts or distortions that may compromise the interpretation of your data.

3.3 TESTING CAMERA PERFORMANCE: THE PHOTON TRANSFER CURVE

Camera specification sheets are the best place to begin when looking for a camera that fits the imaging requirements of your experiment. But specification sheets represent a best- or average-case scenario, not a guarantee, and two cameras with similar looking specs can perform quite differently when compared side by side. There is also some amount of camera-to-camera variation even within a specific camera model from a single manufacturer. Finally, differences in software and driver configurations can cause the same camera to behave differently between systems. For these reasons, it is important to have a method to assess camera performance on your own microscope, with your own acquisition software. Fortunately, a very clever method known as the photon transfer curve (PTC) was developed by NASA decades ago and applied to CCDs by Jim Janesick in the 1970s. An exhaustive analysis of CCD performance requires specialized equipment such as integrating spheres and calibrated photodiodes. However, without any special equipment, a carefully acquired PTC provides an empirical measure of critical camera performance characteristics including read noise, FWC, dynamic range, pixel nonuniformity, dark noise, and a conversion factor that can be used to convert arbitrary gray values to photons. Janesick's book on photon transfer is a wonderful resource for those looking for a complete treatment of the topic (Janesick, 2007). In this section, we will begin with an explanation of PTC theory and then walk through a protocol for assessing your camera using a basic photon transfer analysis (Janesick, 1997).

3.3.1 PHOTON TRANSFER THEORY

A PTC is a log–log plot of total image noise (the standard deviation of pixel intensity values) as a function of signal intensity (the average pixel intensity value) of a uniform light stimulus (Fig. 3.4). This plot reveals four distinct noise "regimes," defined by the signal intensity: (1) the read noise regime, representing the minimum level of noise achievable; (2) the Poisson noise regime, in which Poisson noise from the sample is the dominant source of noise; (3) the fixed-pattern noise (FPN) regime, in which fixed-pattern noise (pixel nonuniformity) dominates the noise; (4) and the full well regime, where FWC is reached and there is a precipitous drop in pixel intensity variation as all pixels become saturated. Figure 3.4 displays a PTC collected with an interline CCD camera using the protocol presented in this chapter.

FIGURE 3.4

Representative photon transfer curve generated with a 12-bit interline CCD. Total noise is composed of three individual sources of noise: read noise, Poisson noise, and fixed-pattern noise (FPN). On a log–log plot, read noise is constant and has a slope of 0; Poisson noise scales with the square root of the signal and has a slope of 0.5; fixed-pattern noise is proportional to the signal and has a slope of 1. The three noise regimes are defined by the dominant source of noise over a given range of signal intensity. Note, in this camera, FPN is low enough that the full well regime (pixel saturation) was reached before the fixed-pattern noise regime. Important calculated values are indicated on the graph. GV = gray value; K = electron conversion factor; P_N = FPN quality factor; see Section 3.3.2 for details.

A primary goal of photon transfer analysis is to calculate a conversion factor (K) that relates photoelectrons (e^-) in the chip to the gray values (GV) in our image (i.e., $K = e^-/\text{GV}$). The fundamental relationship between photoelectrons and Poisson noise can be leveraged to calculate this conversion factor, *without* a priori knowledge of the number of photons hitting the detector. Recall that Poisson noise is always equal to the square root of the photoelectrons generated (S):

$$\sigma_{\text{Poisson}}(e^-) = \sqrt{S(e^-)} \qquad (3.1)$$

By introducing the conversion factor (K), Eq. (3.1) can be expressed in units of gray values (GV) output by the camera, instead of photoelectrons:

$$K \times \sigma_{\text{Poisson}}(\text{GV}) = \sqrt{K \times S(\text{GV})} \qquad (3.2)$$

where $\sigma_{\text{Poisson}}(\text{GV})$ is the Poisson noise in units of gray values and $S(\text{GV})$ is the signal measured in gray values. Simplifying Eq. (3.2), it becomes clear that by isolating Poisson noise at a given signal intensity, we can calculate the conversion factor

$$K = \frac{S(\text{GV})}{\sigma_{\text{Poisson}}(\text{GV})^2} \qquad (3.3)$$

Photon transfer analysis is based upon the assumption that total noise in the digital image results from one of three sources: readout noise (σ_{read}), Poisson noise (σ_{Poisson}), and fixed-pattern noise (σ_{FP}); dark noise is typically negligible in cooled CCD cameras at the exposure times used here. The various sources of noise in the image sum as

$$\sigma_{\text{tot}} = \sqrt{\sigma_{\text{read}}^2 + \sigma_{\text{Poisson}}^2 + \sigma_{\text{FP}}^2} \qquad (3.4)$$

where total noise (σ_{tot}) is defined as the standard deviation of pixel intensities in the image. In the following photon transfer protocol, we begin by measuring read noise and correcting for fixed-pattern noise. This will allow us to isolate Poisson noise and calculate the conversion factor K.

Read noise can be directly measured from the standard deviation of pixel intensities in an image collected with no light hitting the camera, called a dark image:

$$\sigma_{\text{read}} = \sigma_{\text{tot}}(\text{Dark}) \qquad (3.5)$$

Next, because fixed-pattern noise is spatially constant from image to image, we can remove it by subtracting, pixel-by-pixel, two evenly illuminated images taken back-to-back at the same exposure level, yielding a "difference image" that has only *random* sources of noise: specifically, read noise and Poisson noise ($\sigma_{\text{read+poisson}}$). With that value, the amount of Poisson noise present at any given signal level (i.e., exposure time) can be calculated as

$$\sigma_{\text{Poisson}} = \sqrt{\sigma_{\text{read+Poisson}}^2 - \sigma_{\text{read}}^2} \qquad (3.6)$$

With Poisson noise isolated, we can return to Eq. (3.3) and measure the conversion factor K.

Using this conversion factor, we can express any of the values that we measure in gray values (e.g., signal, read noise, and FWC) in terms of photoelectrons. To estimate the number of photons that *arrived* at the detector (as opposed to the photons that were *detected*), one can divide by the QE of the camera at the wavelength of light expected, using the QE graph provided in the manufacturers specification sheet.

Optionally, with read noise and Poisson noise measured, we can return to Eq. (3.4) and quantify the remaining component of noise in our image, fixed-pattern noise:

$$\sigma_{\text{FP}} = \sqrt{\sigma_{\text{tot}}^2 - \sigma_{\text{read}}^2 - \sigma_{\text{Poisson}}^2} \qquad (3.7)$$

3.3.2 PTC COLLECTION PROTOCOL

Figure 3.4 and Table 3.1 demonstrate a representative dataset collected with the following protocol. Inset bullets in the protocol in the succeeding text are specific

instructions for doing the analysis using the free programs ImageJ or Fiji (http://imagej.nih.gov/ij/; http://fiji.sc/Fiji; Schindelin et al., 2012). For additional considerations when collecting a PTC using an EMCCD or sCMOS camera, see DeWeert, Cole, Sparks, and Acker (2004) and Long, Zeng, and Huang (2012):

1. Block all light to the camera by either removing it from the microscope and using the camera cap provided by the manufacturer or turning off all illumination light sources and setting the camera port selection on the microscope to go to the eyepieces. The former is necessary for EMCCDs due to their high sensitivity. Set the exposure time to the lowest setting your software allows (≤ 1 ms) and acquire *two* dark images.
2. Calculate the mean grayscale value of all pixels in one of the dark images. This mean is the camera offset (Table 3.1, col. B). Next, in order to remove any fixed-pattern noise in the dark image (which is particularly important for sCMOS cameras), create a "difference image" by subtracting one dark image from the other (see Box 3.2). To prevent data clipping, add a constant value to each pixel, or use a 32-bit floating-point image if available in your software. Calculate the standard deviation of the gray values in the difference image and divide this number by $\sqrt{2}$ to yield read noise (Table 3.1, col. F):
 - Open both dark images in ImageJ/Fiji.
 - Chose Analyze → Set Measurements. Verify that the boxes for "Mean gray value" and "Standard deviation" are checked, and click OK.
 - With one dark image selected, select AnalyzeMeasure. The results will appear in a new table. The mean is the camera offset.
 - Create a difference image by subtracting the two dark images using Process → Image Calculator, checking the box for 32-bit (float) result.
 - With the difference image selected, Select Analyze → Measure. The results will appear in a new table. Calculate the read noise by dividing the standard deviation of the difference image by $\sqrt{2}$.
3. Delivering even illumination to your camera (see Box 3.1), set the exposure time to the shortest possible duration and acquire *two* back-to-back images. Next, gradually (ideally, exponentially) increase the exposure time on the camera, acquiring two images at each exposure time, until the exposure time required for pixel saturation has been exceeded. Set your exposure time increments so as to acquire at least 50 different exposure times before reaching saturation (for a total of 100 images, 2 for each exposure time).[1] For the most accurate measurements of FWC, capture finer increments of exposure times around the saturation point. Collecting these images into an image stack will facilitate later analysis. (These images will be referred to as the "raw PTC

[1]Tip: to quickly calculate an exponential series of exposure times from shortest exposure (min) to longest exposure (max) with n total steps, use an exponential growth equation: $Exp(f) = min*e^{rf}$ where $Exp(f)$ is the exposure duration in frame f (the first frame is frame 0) and rate constant $r = \dfrac{\ln\left(\dfrac{max}{min}\right)}{(n-1)}$.

Table 3.1 Representative Numbers Collected in the Generation of the Photon Transfer Curve Shown in Fig. 3.4

A	B	C	D	E	F	G	H
Raw signal	Offset	Signal	σ_{Total}	$\sigma_{Read+Poisson}$	σ_{Read}	$\sigma_{Poisson}$	σ_{FP}
205.138	204.802	0.336	2.014	2.003	2.002	0.046	0.215
205.894	204.802	1.092	2.048	2.042	2.002	0.403	0.155
206.991	204.802	2.189	2.106	2.101	2.002	0.637	0.148
209.001	204.802	4.199	2.203	2.194	2.002	0.898	0.197
215.723	204.802	10.921	2.483	2.478	2.002	1.460	0.162
229.445	204.802	24.643	2.970	2.966	2.002	2.189	0.148
259.096	204.802	54.294	3.861	3.851	2.002	3.290	0.279
336.539	204.802	131.737	5.516	5.470	2.002	5.091	0.710
492.331	204.802	287.529	7.938	7.811	2.002	7.551	1.412
1243.454	204.802	1038.652	15.473	14.633	2.002	14.495	5.029
2740.789	204.802	2535.987	25.827	22.871	2.002	22.784	11.997
4016.096	204.802	3811.294	32.399	27.015	2.002	26.941	17.885

All numbers are in units of gray values (GV).

> **BOX 3.1 GENERATING IMAGES WITH UNIFORM ILLUMINATION**
>
> When collecting a photon transfer curve, the illumination light should be *greater than 99% uniform*, or the fixed-pattern noise measurements will be in error. To make measurements across the entire camera field of view, an integrating sphere is required to deliver sufficiently uniform illumination. However, a cheap and effective alternative is to use a smartphone with a high-resolution screen and display a blank white screen. Remove the objective from your microscope and place the screen in the sample holder or directly over the objective turret. You can also remove the camera from the microscope and deliver a dim, diffuse light source directly to the camera—such as a white smartphone screen through a diffuser. For the most accurate measurements, you will likely *still* need to select a subarray of pixels that display the most uniform illumination. However, the accuracy of PTC measurements is proportional to the square root of the number of pixels sampled, so try to collect the largest chip area possible while maintaining uniform illumination.

images.") *Note: This method assumes that the contribution of dark noise is negligible (i.e., $<<1$ e^-) for the exposure times used; check the manufacturers specification sheet to make sure this is expected for your camera. For cameras with significant dark noise, a neutral density step wedge can be used to vary illumination intensity while keeping exposure time constant.*

4. Using one of the brighter (but not saturated) images, evaluate the uniformity of illumination as described in Box 3.1. If a region with uniform illumination *cannot* be found, this protocol can still be used to evaluate the conversion factor K, but the nonuniform illumination will erroneously increase the fixed-pattern noise measurement:
 - Using the measurement tools outlined in step 2, select a rectangular subregion of the image in which the mean pixel intensity is at least 100 times the standard deviation.
 - Crop the raw PTC images to include only this region by selecting Image → Crop.
5. For each exposure time, calculate mean pixel intensity (raw signal intensity; Table 3.1, col. A) and standard deviation (total noise; Table 3.1, col. D) for one of the two raw PTC images, following the method used in step 2.
 - If you have all of the images in your PTC in an image stack, Fiji supplies a tool called "ROI manager" that facilitates measuring statistics for all of the images in a stack:
 i. Select Analyze → Tools → ROI Manager.
 ii. Create a region encompassing the entire image (Edit → Selection → Select All), and click "Add" in the ROI manager window.
 iii. In ROI manager, click "More >>" and then select "Multi Measure."
 iv. Click "OK." The statistics for all images in the stack will appear in a new table.

6. Calculate corrected signal levels (Table 3.1, col. C) by subtracting the offset (measured in step 2) from the signal at each exposure time (measured in step 4). This step is easiest to perform in a spreadsheet program such as Excel:
 - *For CMOS cameras only*: Because CMOS cameras use active-pixel sensors, the offset value may vary between pixels. Therefore, instead of subtracting a constant offset value from all pixels in the image, an offset correction image must be generated and subtracted:
 i. Collect a stack of 100 dark images.
 ii. Open the stack in ImageJ/FIJI and calculate the stack average using Image → Stacks → Z Project, and chose "Average Intensity" as the "Projection Type."
 iii. Subtract the resulting offset correction image from each of the raw PTC images using Process → Image Calculator, checking the box for 32-bit (float) result. This step can be simplified by combining the PTC images into a single stack and subtracting the dark average projection image from every image in the raw PTC stack.
7. *For each exposure time in the PTC*, create a "difference image" by subtracting one of the two images from the other (see Box 3.2). To prevent data clipping, add a constant value to each pixel in the image, or use a 32-bit floating-point image if available in your software. This subtraction step removes fixed-pattern noise (which is constant from frame to frame), leaving a "difference image" that contains only read noise and Poisson noise:
 - For each exposure time, create a difference image by subtracting the two images using Process → Image Calculator, checking the box for 32-bit (float) result. This step is simplified if the PTC images are collected or separated into two image stacks (one stack for each of the two images taken at every exposure time) and performing stack arithmetic.

BOX 3.2 IMAGE ARITHMETIC

Many of the steps in this photon transfer curve analysis use various types of image arithmetic. Some steps make measurements on pixel intensities *within a single image*, for instance: we can calculate the mean gray value or the standard deviation of all pixels in a single image. In ImageJ/FIJI, this is done by selecting a region of interest in an image and choosing "measure" from the Analyze menu (the specific measurements performed are dictated by the "Set measurements" command in the same menu). Other steps perform measurements of a single pixel *across multiple images*. For instance, one can calculate the average intensity value of a specific pixel in the field of view over many images. Or we may subtract one image from another: this entails subtracting the gray value intensity from a single pixel on one image from the corresponding pixel at the same XY location on another image, for each pixel in the image. A new image is created in the process, referred to in our protocol as the "difference image." In ImageJ/FIJI, these functions are performed with the "Image calculator" function in the "Process" menu. Because most image files cannot handle negative gray values (with the exception of "floating-point" TIFF files), it is sometimes necessary to add a constant offset to each pixel to prevent data clipping during image subtraction.

8. Calculate $\sigma_{\text{read+poisson}}$ (Table 3.1, col. E) by measuring the standard deviation of pixel intensities for each of the difference images created in the previous step. The process of subtracting one image from another increases the random noise component by $\sqrt{2}$, so divide this number by $\sqrt{2}$:
 - For each difference image, calculate the standard deviation of all pixel intensities in ImageJ using Analyze → Measure, and then divide the resulting number by $\sqrt{2}$.
 - This step is simplified using Fiji ROI Manager, as in step 5.
9. Using the values recorded in step 2 (σ_{read}) and step 8 ($\sigma_{\text{read+Poisson}}$), calculate the Poisson noise component for each exposure duration in the PTC as follows (Table 3.1, col. G):

$$\sigma_{\text{Poisson}} = \sqrt{\sigma_{\text{read+Poisson}}^2 - \sigma_{\text{read}}^2}$$

10. Having measured read noise and Poisson noise, we can now calculate the amount of fixed-pattern noise present in each image according to Eq. (3.7) (Table 3.1, col. H):

$$\sigma_{\text{FP}} = \sqrt{\sigma_{\text{tot}}^2 - \sigma_{\text{read}}^2 - \sigma_{\text{Poisson}}^2}$$

11. The FPN "quality factor" (P_N) is calculated as FPN divided by signal. P_N is best calculated by measuring the X-intercept ($y=1$) of a power regression line through the calculated FPN values at all signal levels (a line with slope 1 on the log–log PTC plot; Fig. 3.4). A P_N value of 0.01 implies that the r.m.s. FPN is 1% of the mean signal level.
12. The electron conversion factor K can be quickly *estimated* using any data point in the Poisson noise regime by dividing the offset-corrected signal intensity calculated in step 6 by the square of the Poisson noise calculated in step 9 (Eq. 3.3). However, K is most accurately calculated by measuring the X-intercept ($y=1$) of a power regression line through the calculated Poisson noise for all signal levels in the Poisson noise regime (a line with slope 0.5 on the log–log PTC plot; Fig. 3.4).
13. Convert the read noise to units of electrons r.m.s. by multiplying the read noise in gray values measured from the dark image in step 2 by the conversion factor K calculated in step 12.
14. Calculate FWC in electrons by multiplying the corrected signal intensity from the last frame before the precipitous drop in noise (the frame with the greatest total noise) by the conversion factor K.
15. Calculate the dynamic range of the camera by dividing the FWC from step 14 by the read noise calculated in step 13.

REFERENCES

Aikens, R. S., Agard, D. A., & Sedat, J. W. (1989). Solid-state imagers for microscopy. In Y. Wang, D. L. Taylor, & K. W. Jeon (Eds.), *Methods in Cell Biology: Vol. 29. Fluorescence microscopy of living cells in culture part A* (pp. 291–313). San Diego, CA: Academic Press.

Baker, M. (2011). Faster frames, clearer pictures. *Nature Methods*, *8*(12), 1005–1009.

DeWeert, M. J., Cole, J. B., Sparks, A. W., & Acker, A. (2004). Photon transfer methods and results for electron multiplication CCDs. In *Proc. SPIE 5558, applications of digital image processing XXVII* (pp. 248–259).

Einstein, A. (1905). Über einen die erzeugung und verwandlung des lichtes betreffenden heuristischen gesichtspunkt. *Annalen der Physik*, *17*, 132–148.

El Gamal, A., Fowler, B. A., & Min, H. (1998). Modeling and estimation of FPN components in CMOS image sensors. *Proceedings of SPIE*, *3301*, 168–177.

Fowler, B., Liu, C., Mims, S., Balicki, J., Li, W., Do, H., et al. (2010). A 5.5 Mpixel 100 frames/sec wide dynamic range low noise CMOS image sensor for scientific applications. In *Proc. SPIE 7536, sensors, cameras, and systems for industrial/scientific applications XI*.

Huang, F., Hartwich, T. M. P., Rivera-Molina, F. E., Lin, Y., Duim, W. C., Long, J. J., et al. (2013). Video-rate nanoscopy using sCMOS camera-specific single-molecule localization algorithms. *Nature Methods*, *10*(7), 653–658.

Inoué, S., & Spring, K. R. (1997). *Video microscopy: The fundamentals* (2nd ed.). New York, NY: Plenum Press.

Janesick, J. R. (1997). CCD transfer method: Standard for absolute performance of CCDs and digital CCD camera systems. *Proceedings of SPIE*, *3019*, 70–102.

Janesick, J. R. (2007). In *Photon transfer: Vol. PM170*. Bellingham, WA: SPIE Press.

Jerram, P., Pool, P. J., & Bell, R. (2001). The LLCCD: Low-light imaging without the need for an intensifier. *Proceedings of SPIE*, *4306*, 178–186.

Lantz, E., Blanchet, J. L., Furfaro, L., & Devaux, F. (2008). Multi-imaging and Bayesian estimation for photon counting with EMCCDs. *Monthly Notices of the Royal Astronomical Society*, *386*(4), 2262–2270, Oxford University Press.

Long, F., Zeng, S., & Huang, Z.-L. (2012). Localization-based super-resolution microscopy with an sCMOS camera part II: Experimental methodology for comparing sCMOS with EMCCD cameras. *Optics Express*, *20*(16), 17741–17759.

Mackay, C. D., Tubbs, R. N., & Bell, R. (2001). Subelectron read noise at MHz pixel rates. *Proceedings of SPIE*, *4306*, 289–298.

Moomaw, B. (2013). Camera technologies for low light imaging: Overview and relative advantages. In G. Sluder & D. E. Wolf (Eds.), *Methods in Cell Biology: Vol. 114. Digital microscopy* (pp. 243–283) (4th ed.). San Diego, CA: Academic Press.

Pawley, J. B. (1994). The sources of noise in three-dimensional microscopical data sets. In J. K. Stevens, L. R. Mills, & J. E. Trogadis (Eds.), *Three-dimensional confocal Microscopy: Volume investigation of biological specimens* (pp. 47–94). San Diego, CA: Academic Press.

Pawley, J. B. (2006a). More than you ever really wanted to know about charge-coupled devices. In J. B. Pawley (Ed.), *Handbook of biological confocal microscopy* (pp. 918–931) (3rd ed.). New York, NY: Springer.

Pawley, J. B. (2006b). Points, pixels, and gray levels: Digitizing image data. In J. B. Pawley (Ed.), *Handbook of biological confocal microscopy* (pp. 59–79) (3rd ed.). New York, NY: Springer.

Rasnik, I., French, T., Jacobson, K., & Berland, K. (2007). Electronic cameras for low-light microscopy. In G. Sluder & D. E. Wolf (Eds.), *Methods in Cell Biology: Vol. 81. Digital microscopy* (pp. 219–249) (3rd ed.). San Diego, CA: Academic Press.

Robbins, M. S., & Hadwen, B. J. (2003). The noise performance of electron multiplying charge-coupled devices. *IEEE Transactions on Electron Devices*, *50*, 1227–1232.

Saurabh, S., Maji, S., & Bruchez, M. P. (2012). Evaluation of sCMOS cameras for detection and localization of single Cy5 molecules. *Optics Express*, *20*(7), 7338–7349.

Schindelin, J., Arganda-Carreras, I., Frise, E., Kaynig, V., Longair, M., Pietzsch, T., et al. (2012). Fiji: An open-source platform for biological-image analysis. *Nature Methods*, *9*(7), 676–682.

Schottky, W. (1918). Über spontane stromschwankungen in verschiedenen elektrizitätsleitern. *Annalen der Physik*, *362*, 541–567.

Sheppard, C. J. R., Gan, X., Gu, M., & Roy, M. (2006). Signal-to-noise in confocal microscopes. In J. B. Pawley (Ed.), *Handbook of biological confocal microscopy* (pp. 442–452) (3rd ed.). New York, NY: Springer.

Snoeij, M. F., Theuwissen, A. J. P., Makinwa, K. A. A., & Huijsing, J. H. (2006). A CMOS imager with column-level ADC using dynamic column fixed-pattern noise reduction. *IEEE Journal of Solid-State Circuits*, *41*(12), 3007–3015, IEEE.

Spring, K. R. (2001). Detectors for fluorescence microscopy. In A. Periasamy (Ed.), *Methods in cellular imaging* (pp. 40–52). New York, NY: Springer.

Spring, K. R. (2007). Cameras for digital microscopy. In G. Sluder & D. E. Wolf (Eds.), *Methods in Cell Biology: Vol. 81. Digital microscopy* (pp. 171–186) (3rd ed.). San Diego, CA: Academic Press.

Stelzer, E. (1998). Contrast, resolution, pixelation, dynamic range and signal-to-noise ratio: Fundamental limits to resolution in fluorescence light microscopy. *Journal of Microscopy*, *189*, 15–24.

Waters, J. C. (2009). Accuracy and precision in quantitative fluorescence microscopy. *The Journal of Cell Biology*, *185*(7), 1135–1148, Rockefeller Univ Press.

Wolf, D. E., Samarasekera, C., & Swedlow, J. R. (2007). Quantitative analysis of digital microscope images. In G. Sluder & D. E. Wolf (Eds.), *Methods in Cell Biology: Vol. 81. Digital microscopy* (pp. 365–396) (3rd ed.). San Diego, CA: Academic Press.

CHAPTER

A Practical guide to microscope care and maintenance

4

Lara J. Petrak, Jennifer C. Waters

Departments of Cell Biology, Departments of Systems Biology, Harvard Medical School, Boston, Massachusetts, USA

CHAPTER OUTLINE

Introduction	56
4.1 Cleaning	**58**
4.1.1 Before Cleaning	58
4.1.2 Objectives	59
4.1.2.1 Proper Use of Objective Lenses	*59*
4.1.2.2 Objective Lens Inspection and Cleaning	*60*
4.1.2.3 Temperature	*62*
4.1.3 Fluorescence Filters	62
4.1.3.1 Excitation and Emission Filters	*63*
4.1.3.2 Mirrors	*64*
4.1.4 Camera	64
4.1.5 The Dust is Still There!	65
4.2 Maintenance and Testing	**66**
4.2.1 Computer Maintenance	66
4.2.2 Check the Transmitted Light Pathway	66
4.2.3 Measure Intensity of Fluorescence Light Sources	67
4.2.4 Flatness of Fluorescence Illumination	71
4.2.5 Color Registration	71
4.2.6 Vibration	72
4.2.7 Measure the Point Spread Function	73
4.2.8 Test Performance of Motorized Components and Software	73
4.3 Considerations for New System Installation	**74**
Acknowledgments	75
References	75

Abstract

Optimal microscope performance requires regular maintenance and quality control testing. This chapter is a practical guide to microscope care with an emphasis on preventing, identifying and troubleshooting common issues.

INTRODUCTION

The purchase price of a light microscope system usually includes installation and limited initial testing. The modern light microscope, however, requires a great deal of attention following the initial setup and throughout its lifetime to maintain optimal performance (Inoué & Spring, 1997; Schalck, 2013). The more components a system has, the more likely it is to require frequent troubleshooting and repairs beyond the scope of what the manual and vendors can reasonably provide. Therefore, it is advantageous to designate a microscope manager as responsible for performing routine maintenance.

Routine microscope checks can uncover issues that might otherwise go undetected and affect the quality of data acquired with the instrument. Something as minor as a smear of immersion oil inadvertently applied to a dry objective lens dramatically reduces optical performance and may be misconstrued as a problem with the sample (Fig. 4.1). Other problems that adversely affect image quality may not be at all obvious during routine image collection. Unfortunately, it is all too common for costly equipment to underperform due to lack of proper maintenance.

This chapter provides a practical, comprehensive plan for a microscope manager to keep their system in optimal working order. We begin with instructions on the proper cleaning of common microscope components. Second, we provide a checklist for routine testing and troubleshooting. Finally, we discuss some important factors to consider during the installation of a new microscope system. With some advanced planning and a relatively small financial investment (Table 4.1), one can save time and money, reduce frustration and equipment downtime, and enable more reliable data collection.

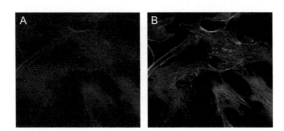

FIGURE 4.1

Dirty optics result in loss of image quality. (A) Fluorescence image of cells labeled for actin collected with a dirty Plan Apo 20× 1.4NA lens and (B) again with the same lens after cleaning. Images were acquired using the same camera parameters and have been scaled identically.

Table 4.1 Recommended Microscope Maintenance Supplies

Product	Used for	Sources
Lens tissue	Cleaning objective lenses, camera front window	
Laboratory wipe tissues	Surface cleaning, absorbing excess oil (do not use on delicate optics)	
PEC*PADs	Cleaning filters and camera front window	www.photosol.com/product-category/pecpads
Powder-free latex or nitrile gloves	Protecting optics from fingerprints during cleaning	
Fine forceps	Filter removal/insertion	
Flat polyester swabs	Cleaning filters	#TWTX762, www.vwr.com
Adhesive-free cotton swabs	Cleaning objective lenses	#10806-005, www.vwr.com
Manual air blower (Rocket)	Dust removal	#AA1900, www.giottosusa.com/rocket-blasters
Pressurized air can	Dust removal (use cautiously, only if manual blower is insufficient)	Whoosh-Duster, #3117, www.control3.com/3117p.htm
Dust-trapping cloths	Surface dust removal (do not use on delicate optics)	Swiffer Dry Cloths, www.pgpro.com
Parafilm	Covering microscope openings to block dust	
Sparkle brand glass cleaner	Cleaning objective lenses and other optics	#50104, www.glasscleaner.com
Ethanol, methanol, isopropyl alcohol, chloroform, xylene	Cleaning objective lenses and other optics	
First Contact polymer cleaner	Cleaning camera front window and other optics	www.photoniccleaning.com
Desiccant in tightly capped jar	Keeping an anhydrous supply of solvents for filter cleaning	
Strap wrench	Removing stuck objective lenses	#54325A61, www.mcmaster.com
Stage micrometer	Spatial calibration	#12-561-SM1, www.fishersci.com
H&E-stained tissue slide	Microscope inspection (transmitted, fluorescence)	#313256, www.carolina.com
Fluorescent test specimens	Microscope inspection (fluorescence)	FluoCells Prepared Slides, www.lifetechnologies.com

Continued

Table 4.1 Recommended Microscope Maintenance Supplies—cont'd

Product	Used for	Sources
Uniformly fluorescent slide	Checking flatness of fluorescence illumination	See Model and Blank (2008)
TetraSpeck fluorescent microspheres	Measuring color registration for colocalization analysis	#T-7280, www.lifetechnologies.com
PS-Speck fluorescent microspheres	Measuring point spread function, checking for vibration	#P-7220, www.lifetechnologies.com
Light meter	Measuring light intensity	X-Cite XR2100 and XP750, www.ldgi.com
Spectrometer	Checking filter spectral characteristics	LumaSpec 800, www.prior.com
Temperature and humidity logger	Troubleshooting drift and specimen issues	#3272K47, www.mcmaster.com

4.1 CLEANING

Microscope optics perform best when clean, but routine cleaning is often ignored. Optics can be expensive, delicate, and sometimes difficult to clean, so researchers may forgo this step for fear of "making it worse." However, microscopes must be cleaned regularly or image quality will degrade. Total internal reflection fluorescence (TIRF) microscopes are especially sensitive to dust, which can result in interference patterns in the image. If your microscope has not been cleaned in a long time (or ever!), we recommend paying to have your microscope manufacturer or local microscope dealer perform a thorough initial cleaning before beginning your own regular maintenance. During the initial cleaning, ask your microscope representative about the recommended solvents and cleaning supplies to use on each optical component. We give examples of commonly used solvents in this chapter, but it is always best to double check with the manufacturer to ensure that you avoid solvents that could damage the optics. To help prevent the accumulation of dust in your microscope, keep it covered (with the dust cover provided by the manufacturer) when not in use.

4.1.1 BEFORE CLEANING

Prior to cleaning individual components, it is recommended that you start the procedure in a clean environment; that is, clean the microscope body and surrounding area to prevent further dust contamination when removing and reinstalling optics. Cap any openings in the microscope including unused camera ports and empty nosepiece positions. If you don't have the caps and plugs originally provided with the microscope, use Parafilm® or lab tape. Wipe down all hard surfaces using a dust-trapping cloth. Avoid cleaning these surfaces with pressurized air, which will simply redistribute dust particles.

Recommended cleaning supplies are given in Table 4.1. At a minimum, you will need lens paper and a range of solvents. Distilled water, commercial lens cleaners,

and the ammonia-free glass cleaner Sparkle® are useful for removing water-soluble materials such as dried culture media or buffers. Chloroform, benzene, xylene, ethanol, and methanol are commonly used solvents for removing oils such as immersion oil and fingerprints (Inoué & Spring, 1997; Schalck, 2013).

4.1.2 OBJECTIVES

A well-maintained objective lens is absolutely essential for image quality (Fig. 4.1; Chapter 2). Importantly, one must strike a balance between cleaning the lens often enough to maintain optical performance and over cleaning, which can, over time, strip antireflective coatings or loosen the adhesive that holds the top lens (Fig. 4.2) in place. The best practice is to minimize contamination of the lens during use, inspect it frequently, and clean as needed.

4.1.2.1 Proper use of objective lenses

Perhaps the most important rule of objective lens care is to clean the surface of the specimen closest to the objective lens (most commonly, the coverslip) *just before* placing it on the microscope. This will not only help to keep the lens clean but also result in the best image quality. *Never* use an oil immersion objective with a specimen that has not been cleaned. Any dust, fingerprints, residual buffer, etc., on the coverslip will mix with the immersion oil and wind up on your lens. Use cotton swabs and a solvent to wipe the coverslip until it is perfectly clean.

Immersion oil should never be applied to a dry (i.e., air) lens, as it will degrade image quality. With immersion objectives (oil, glycerol, and water), use the immersion media specified by the manufacturer, and use the minimum amount required; a small drop that just covers the exposed lens is sufficient. Excess immersion media should be removed using lens paper at the end of each imaging session or when

FIGURE 4.2

Objective lens. (A) The metal spring-mounted head holds (B) the exposed objective top lens. Oil can accumulate in (C) the area between the inner barrel and (D) the outer barrel of the lens. When pressed down, the inner barrel recesses into the outer barrel.

Photo by Gintas Sekmokas, Harvard Medical School.

changing specimens if the immersion oil begins dripping down the barrel of the objective, as commonly occurs on an inverted microscope stand. When switching between oil and dry objective lenses with the same specimen, every trace of immersion oil must be cleaned from the coverslip before using the dry lens.

When imaging slides with coverslips mounted in a media, be sure to wick any excess mounting media from the edges of the coverslip; a torn piece of Whatman® paper works well for this purpose. Also, carefully seal the slide to the coverslip to prevent mounting media from contacting the lens or lens immersion media. When using sealants such as nail polish to mount coverslips, be sure the sealant is completely dry before placing the sample on the microscope. Take care when scanning a slide to avoid contact between the lens and dried sealant, which could scratch or otherwise damage the lens.

4.1.2.2 Objective lens inspection and cleaning

To ensure complete inspection and cleaning, an objective lens should be removed from the microscope by unscrewing the lens from the nosepiece thread mount. To avoid dropping the lens, use one hand to unscrew the lens while keeping your second hand on the lens. Regular unthreading will greatly reduce the possibility of the objective getting stuck in the nosepiece. This problem is exacerbated by heat (e.g., microscope incubator enclosures) and by media or oil seeping into the threads and left to dry. Once a lens becomes stuck, the safest way to remove it is with a strap wrench (Table 4.1). Using excess force with your hands puts an undue amount of strain on the optics within the objective and should be avoided. If a strap wrench fails to remove the objective, consult your microscope manufacturer.

Inspect the lens and the microscope nosepiece for excess immersion oil, cell culture media residue, and pieces of broken coverslip/slide. Clean the metal components on both the lens and the microscope nosepiece (Figs. 4.2 and 4.3) with a laboratory wipe

FIGURE 4.3

Objective lens inspection and cleaning. (A) A standard microscope eyepiece can be used as a magnifying loupe during objective inspection. Notice the reversed orientation of the eyepiece relative to the observer's eye. (B) The "drop and drag" method for cleaning an objective lens. (C) Corrosion of the metal objective mount (arrow) on a nosepiece, caused by media spills that were not cleaned properly.

Photos by Gintas Sekmokas, Harvard Medical School.

and, if necessary, a solvent. Salt contained in culture media will corrode the metal components (Fig. 4.3C) and should therefore be cleaned as soon as possible following a spill. Use a laboratory wipe to clean the threads of the objective and nosepiece.

Most objective lenses have a spring-mounted head that recesses into the barrel of the lens to help prevent sample breakage if the lens is pushed against the sample when focusing (Fig. 4.2). Test the objective lens spring mount by gently pressing on the metal surface surrounding the top lens (never touch the top lens itself!). The spring mount should easily move in and out of place without much resistance. If the spring mount of an oil immersion objective lens on an inverted microscope stand gets stuck, it is likely that excess immersion oil has seeped between the inner and outer objective barrels. Wick away as much of this immersion oil as possible by repeatedly inserting a clean corner of an absorbent tissue between the inner and outer objective barrels (Fig. 4.2).

Inspect the objective top lens to assess whether it needs cleaning. Magnify the surface using an inverted microscope eyepiece as a loupe (Fig. 4.3A; Inoué & Spring, 1997) and bright overhead room light or a lamp. Tilt the lens back and forth, until the lights reflect off the surface of the top lens. The lens should be perfectly clear and free of streaks, moisture, oil, and particulates. If the lens is clean, inspect it thoroughly for scratches, cracks, or oil under the top lens (Fig. 4.4). If you find damage, assess the lens performance as described in the succeeding text. Turn the objective around, and inspect the exposed back surface of the lens as well. If you find that the front or back lens of the objective lens needs to be clean, follow the instructions in the succeeding text.

Begin cleaning the objective top lens by gently removing any dust with an air blower. There are two types of air blowers that can be used to clean optics. The safest air blower is the simple rubber squeeze style ("Rocket"; Table 4.1), but this provides limited force to remove dust. Pressurized air cans can work well, but one must use caution to avoid blowing particulates from the can onto the optical surface. If using

FIGURE 4.4

Oil under a damaged objective top lens. Immersion oil has seeped underneath the top lens of the objective on the right, which appears highly reflective relative to the undamaged lens on the left.

Photo by Gintas Sekmokas, Harvard Medical School.

a pressurized air can (Table 4.1), always hold the can upright, never shake it, and depress the nozzle in several quick bursts rather than discharging the contents for several seconds.

If you see large debris (e.g., glass after breaking a slide), it should be removed with extreme care to avoid damage to the top lens. Set the objective on a clean workbench, dampen a piece of lens tissue, hold it taut, and slowly lower it down onto the top lens, barely touching it and immediately lifting straight up. The debris should stick to the tissue and be removed without having to drag it across the delicate top lens. Use lens tissue (dry or with a solvent) to wipe any excess immersion oil from the metal surrounding the top lens, being very careful not to touch the top lens itself. Never use all-purpose laboratory wipes, facial tissues, or paper towels to clean an objective; they are abrasive and can damage the top lens.

You are now ready to clean the top lens of the objective using lens paper and a solvent, using the "drop and drag" method (Fig. 4.3B; Inoué & Spring, 1997). Place a drop of the solvent onto a piece of lens paper. Lower the drop of solvent hanging from the lens paper onto the lens. Slowly drag the solvent over the lens *without applying any pressure* to the lens. Use small volumes of solvent, such that the solvent evaporates quickly from the lens after the lens paper is removed. *Never* soak a lens in solvent. Inspect the lens again, and repeat as necessary. Do not use the same area of the lens tissue more than once, to prevent recontamination of the lens. Cleaning a lens properly takes patience; avoid the temptation to scrub the lens clean. While this process can be time-consuming, it will help to preserve the lens' antireflective coatings and prevent the mounting adhesives from dissolving. The better the lens is cared for between regular cleanings, the quicker this process will be.

4.1.2.3 Temperature

Live cell imaging experiments often require heating the objective lens to maintain temperature of the specimen (Chapter 5). Repeated heating and cooling of an objective lens may cause the elements within the lens to loosen over time and decrease lens performance. Objectives housed in an incubator enclosure should remain inside as much as possible. When it becomes necessary to remove the lenses for an extended period of time (e.g., during repair of the microscope), move them to another incubator. If placing them in a humidified tissue culture incubator, be aware that it is very important to protect them from excess humidity to avoid permanent damage. Store them, tightly capped, in the plastic case that was provided when the lens was purchased.

4.1.3 FLUORESCENCE FILTERS

A carefully selected set of fluorescence filters can become a detriment if installed incorrectly or allowed to deteriorate. Fluorescence filters have a finite lifetime and must be inspected regularly and cleaned or replaced as needed in order to ensure the desired spectral characteristics.

A typical fluorescence filter set consists of three filters: an exciter, an emitter (*aka* barrier), and a dichroic (or polychroic) mirror (Lichtman & Conchello, 2005;

Reichman, 2010; Webb & Brown, 2013). These filters can be found in several locations in your microscope. Most commonly, all three are mounted within a single cube or housing in the fluorescence filter turret, found under the nosepiece in an inverted microscope stand. Alternatively, the exciter could be housed inside the light source, or the exciter and/or emitter could be found in motorized wheels. Consult your microscope representative for a lesson on disassembling and reassembling a filter cube or accessing filters from a wheel or light source.

4.1.3.1 Excitation and emission filters
To inspect a filter, begin by removing it from the wheel or cube. When handling a filter, wear powder-free gloves to avoid fingerprints. Excitation and emission filters, whether mounted in a cube or wheel, are usually enclosed in a plastic outer ring that should be used for handling the filter; touch only this ring and not the filter itself. Use a pair of fine forceps to grasp the plastic outer ring when manipulating filters in and out of their mounts. Removal allows for a more thorough inspection and cleaning, as well as verification of the filter part number, lot, and transmission specifications, which are typically stamped on the outer ring. If these markings are not present, a spectrophotometer (Table 4.1) can be used to measure the spectral characteristics of the filter.

Check the filter for dust, cracks, holes, or delamination (Fig. 4.5A and B) by viewing bright room light through the filter. Carefully view both sides of the filter at various angles, allowing the room light to reflect off the surface of the filter. Some types of filter damage, such as cracks and burn marks (usually resulting from heat from the illumination light source), are easy to spot (Fig. 4.5A). Delamination—the separation of the layers of materials coating the filter—can range in severity and most often results from exposure to humidity/moisture. Delamination typically begins at the periphery of the filter and over time moves toward the center of the filter. Delamination appears as an uneven pattern on the surface of the filter (Fig. 4.5B). Damaged or delaminated filters should be discarded and replaced, as they may exhibit unwanted changes in spectral and/or transmission characteristics.

FIGURE 4.5

Fluorescence filters. (A) A filter with a vertical crack and a burn mark in the center. (B) A delaminated filter. (C) Cleaning a filter, using a flat swab (Table 4.1) and a spiral motion.

Photos by Gintas Sekmokas, Harvard Medical School.

Fluorescence filters are made using at least two types of manufacturing processes, resulting in "soft-coated" or "hard-coated" filters (Webb & Brown, 2013). Hard-coated filters are much less prone to delamination and easier to clean. Changes in production technologies, including a reduction in the number of coating runs, result in harder surfaces that are much more resilient to environmental factors. In addition, these filters generally have higher transmission and better blocking than traditional filters. Hard-coated filters are more expensive than soft-coated ones and are not available in all spectral ranges; however, we recommend purchasing hard-coated whenever possible. Hard-coated filters should be inspected every 6–12 months, while soft-coated filters should be inspected at least every 2 months.

To clean fluorescence excitation and emission filters, begin by removing loose dust using an air blower. Stubborn dust particles, fingerprints, or other residue may require cleaning with a solvent. Most excitation and emission filters can be cleaned with anhydrous ethanol or isopropyl alcohol; to be safe, verify the appropriate cleaning solvent with the filter or microscope manufacturer. Anhydrous alcohols used for cleaning filters are best stored in desiccant since water applied to the filter surface can encourage delamination. Place a single drop of solvent on a flathead, adhesive-free swab or a PEC*PAD® (Table 4.1), dab the swab on a laboratory wipe to remove excess, and then sweep the filter surface in one continuous motion, using a spiral pattern (Fig. 4.5C). Repeat as necessary until the surface is free of streaks, using a new swab with each pass.

Fluorescence filters are designed to work in only one orientation relative to the light source; turning the filter 180° relative to the illumination light can change its spectral characteristics. After inspection and/or cleaning a filter, it must be reinstalled in the correct orientation in the light path for proper performance. There should be an indicator on the filter edge—often a caret (arrow) stamped onto the ring or a beveled edge—that indicates proper orientation in the light path. Unfortunately, different filter manufacturers use different standards, so consult the filter manufacturer website or your microscope representative for clarification.

4.1.3.2 Mirrors

Dichroic/polychroic mirrors (Webb & Brown, 2013) should be handled and cleaned differently than excitation and emission filters. Many dichroic mirrors have exposed filter coatings that are easily removed with the common solvents listed in Table 4.1; *always* consult with the filter or microscope manufacturer before using a solvent to clean a dichroic. Take great care when handling dichroics to avoid fingerprints. It is generally recommended that you leave dichroic mirrors installed in their mount and simply use an air blower to remove dust.

4.1.4 CAMERA

Another common location for dust is the front window of a CCD or CMOS camera (Chapter 3) used to acquire images from the microscope (Inoué & Spring, 1997). The front window is the exposed surface of the camera in front of the (usually

hermetically sealed) space enclosing the camera chip. If dark spots are visible in transmitted light images collected with the camera that are not visible through the eyepiece, they may be on the camera faceplate. Microscopic dust can be difficult to clean from the front window without adding more dust, so only attempt to clean the front window after you're convinced the dust in your digital images is located there. To prove the dust is located on the camera front plate, loosen the screws that hold the camera mount onto the microscope. While viewing a live camera image on the computer monitor, rotate the camera ~45° in either direction. If the dust is on the camera front window, you will see the image of your specimen move *but the dark spots will not move*. At first this may seem counterintuitive, but because dust on the camera is fixed relative to the camera's field of view, its position within the digital image will not change.

To clean the camera front window, begin with an air blower to remove as much dust as possible. Remount the camera onto the microscope and check the image, repeating the process several times if necessary. If forced air isn't sufficient to remove dust, wrap a piece of lens paper or PEC*PAD® around an adhesive-free cotton swab, add a drop of lens cleaner, and gently wipe over the front window. First Contact® can also be used to clean most camera front windows (check with the camera manufacturer first). First Contact® is a polymer solution that is painted on, allowed to dry, and then peeled off to remove dust. If stubborn dust remains, contact the camera manufacturer for further advice. It is often difficult to remove all dust from the camera front window. If desired, a background subtraction can be used to reduce/remove the image of the dust in the final digital image.

4.1.5 THE DUST IS STILL THERE!

It's simple to determine if dust in an image is within the specimen itself; if this is the case, the dust and the specimen will move together while moving the specimen. If the dust is not part of the specimen and is visible with transmitted but not fluorescence illumination, perform Koehler alignment of the transmitted pathway (Salmon & Canman, 2001). If the dust resides on any of the transmitted optics outside of the image planes in the microscope, it will be out of focus and therefore less visible (or invisible) when the microscope is aligned properly.

Additional optical surfaces that should be inspected and cleaned include the transmitted light condenser lens, the eyepieces, neutral density filters, and differential interference contrast (DIC) prisms and polarizers (Inoué & Spring, 1997; Salmon & Canman, 2001). Begin by removing dust with an air blower. If a solvent is needed to remove fingerprints, immersion oil, etc., consult your microscope representative for the recommended cleaning procedure, particularly with DIC optics. If DIC components are removed from the microscope for cleaning, be aware that the polarizer and analyzer must be remounted with the correct rotational orientations.

If dust is still present in the image, remove or swap out each surface in the affected light path, one by one. This includes all filters, mirrors for hardware autofocusing systems, the objective lens, and fiber-optic cables/liquid light guides (LLG). Never remove a fiber-optic cable unless you have been trained to do so

by the microscope representative and have received the appropriate laser safety training provided by your institution. To check for dust on the tip of a fiber-optic cable or LLG, slightly loosen the end attached to the microscope (without removing it) and rotate or wiggle it slightly. If the dust moves with it, the fiber tip likely needs to be cleaned or replaced; consult your microscope representative for instructions on how to clean the fiber. If you have been trained to remove and reinstall the fiber-optic cable, turn off all lasers, remove the fiber, and wipe the tip gently with EtOH and lens paper using the same "drop and drag" method used for cleaning objective lenses (Fig. 4.3B).

4.2 MAINTENANCE AND TESTING

Preventative maintenance of a light microscope system is well worth the investment in time. While a service technician can be called in to perform maintenance, there are many tests that are better carried out by the microscope manager in order to establish a history of performance. In this section, we provide a suggested workflow with detailed instructions on recommended testing procedures.

Prior to performing the following tests, we suggest that you clean and inspect all optics following the protocols in the previous section of this chapter. Dirty or damaged optics will affect many of the measurements and tests in the succeeding text.

4.2.1 COMPUTER MAINTENANCE

Computers are often overlooked during routine microscope maintenance. This is unfortunate, since neglect can lead to problems including software crashes and reduction in speed. On a regular basis, back up any important software configuration files to a remote location. Clear the computer hard drive(s) of any data that have already been backed up to another source. Next, check the configuration of operating system updates and antivirus software. In some cases, automatic updates and virus scans can lead to intermittent reduction in acquisition speed and/or spontaneously triggered computer reboots during an experiment, making manual updates preferable. Computer operating system updates can occasionally conflict with microscope hardware or software; for this reason, apply these updates at the beginning of your maintenance procedure. Use of the hardware and software during the tests in the succeeding text will likely expose any conflicts.

4.2.2 CHECK THE TRANSMITTED LIGHT PATHWAY

View a sample with transmitted light and a low-magnification objective. H&E-stained tissue slides (Table 4.1) are quick and easy to get into focus. Perform Koehler alignment of the illumination light path (Salmon & Canman, 2001). The condenser turret should move easily both axially and laterally. If you find it is hard to move or feels "sticky," the turret may need to be removed and reseated. After performing

Koehler alignment, illumination should be even across the field of view. If it is not, make sure that a diffuser filter is inserted in the light path and look for parts that may be partially inserted into the light path.

Check the alignment of any phase rings in the transmitted condenser turret (Inoué & Spring, 1997; Salmon & Canman, 2001). When viewing the back focal plane of the objective, the phase ring in the objective should perfectly overlap with the phase annulus in the condenser. Consult your microscope manual for instructions on alignment of the phase rings. If your microscope includes DIC optics, place them in the light path and check that a good DIC image is obtainable (Inoué & Spring, 1997; Salmon & Canman, 2001). All DIC components (polarizer, objective prism, condenser prism, and analyzer) and a strain-free objective lens (usually marked DIC or Pol on the barrel of the lens) are necessary to generate a DIC image. The objective and condenser prisms are specific to the objective lens; make sure you have the correct parts if the image quality is poor. Plastic dishes, including the plastic top on a coverslip-bottom dish, will depolarize light and degrade the DIC image.

4.2.3 MEASURE INTENSITY OF FLUORESCENCE LIGHT SOURCES

There are several benefits to regularly measuring and recording the intensity of fluorescence light sources (Grünwald, Shenoy, Burke, & Singer, 2008). The expected intensity changes of fluorescence light sources over their lifetime vary widely (Pawley, 2010; Webb & Brown, 2013; Wessels, Pliquett, & Wouters, 2012). Mercury, xenon, and metal halide light sources change intensity dramatically throughout their lifetime, while light sources that use LEDs are far more stable. Gas lasers are far less stable over time than solid-state lasers. Keeping records of intensity of the illumination sources allows you to identify patterns and to anticipate when the light source may need to be changed or serviced—before it begins affecting your imaging data. Measuring the intensity of the light source is useful in determining whether a sudden reduction in image intensity is due to the sample or microscope. Additionally, it is valuable to have a log of regular and consistently performed measurements when negotiating service with vendors.

For ease and repeatability, we recommend using a meter designed to measure intensity out of an objective lens at the specimen level (Table 4.1). Use the same (clean) objective lens for each reading. Focal position may significantly affect the intensity measurements, so focus on a standard slide before placing the light sensor on the stage. Remove the standard slide, replace it with the light sensor without changing the focus position, and acquire the intensity measurement at the desired wavelengths. Note that standard light meters (e.g., X-Cite XR2100 and XP750; Table 4.1) *do not* measure wavelength of the light. However, the sensors in the light meters are calibrated to correct for differences in sensitivity to wavelength, making it important to enter the wavelength of light you are measuring into the meter to yield the correct reading. The Prior LumaSpec 800 (Table 4.1) can be used to measure both intensity and wavelength of the illumination light source.

To ensure validity and consistency, always follow the same protocol when taking the measurements. Remove all neutral density filters from the light path, and fully open the field and aperture diaphragms. If the light source intensity is adjustable, take all measurements at the same power level. If the light source takes time to stabilize after turning it on (e.g., mercury bulbs or gas lasers), use a standard warm-up time (e.g., 1 h) before making measurements. For each light source, take baseline time-lapse readings to get a sense of short-term stability. If there is a large amount of variance over the course of a few minutes, expect less precision in weekly readings.

If you observe a sudden unexplained drop in intensity, there are several avenues for troubleshooting (Table 4.2). One possible cause is damage or deterioration of the LLG commonly used with metal halide or "light engine" illuminators. LLGs, like fiber-optic cables, can be damaged if they are pinched or bent at sharp angles. Even without physical trauma, LLGs have a limited lifetime and can deteriorate or develop bubbles within the liquid. To inspect a LLG, turn off the light source and disconnect the LLG from the microscope and light source. Point one end of the LLG toward the room lights and view the light passing through the opposite end. The light should

Table 4.2 Troubleshooting Guide

Problem	Possible causes (in order of likelihood)	Try this
Unable to get image into sharp focus	Dirty objective lens	Clean objective lens
	Incorrect immersion media used with objective	Check objective specifications
	Objective turret not seated properly	Reseat objective turret
	Dirty sample	Clean coverslip
Sudden drop in fluorescence illumination intensity	Filter or blockage in light path	Check fluorescence light path
	Dirty objective lens	Clean objective lens
	Damaged liquid light guide (LLG) or laser fiber	Remove and check LLG/fiber; replace if needed
	Laser misalignment	Place a service call
Gradual drop in fluorescence illumination intensity	Laser misalignment	Place a service call
	Aging LLG	Check LLG; replace if needed
	Damaged or aging fluorescence filters	Clean/replace filters
	Light source reaching end of lifetime	Check manual/place a service call
Dark spots in image	Dust on specimen or in light path	Refer to procedures in this chapter to identify location and clean, and/or perform background subtraction

Table 4.2 Troubleshooting Guide—cont'd

Problem	Possible causes (in order of likelihood)	Try this
Uneven fluorescence illumination	Filter partially in place	Check fluorescence light path
	Shutter not opening completely	Remove shutter for testing
	Damaged LLG	Check LLG; replace if needed
	Distortion caused by optics in fluorescence pathway	Remove/rotate each component one by one and recheck flatness of field
	Misaligned collimator	Align or call service rep
Uneven transmitted illumination	System not aligned	Perform Koehler alignment
	Filter partially in place	Check transmitted light path
	Shutter not opening completely	Remove shutter for testing
Inability to achieve Koehler alignment	Objective turret not seated properly	Reseat objective turret
	Condenser module not seated properly	Loosen and reseat condenser module
Bad phase images (after performing Koehler alignment)	Phase rings mismatched or misaligned	Check/align rings
Bad DIC images (after performing Koehler alignment)	Missing one or more necessary DIC optics	Check for missing/incompatible DIC components
	Birefringent material in light path (e.g., culture dish lid)	Remove birefringent material
Problems with image stitching	Uneven illumination (transmitted)	Perform Koehler alignment; turn off room lights/use blackout curtains
	Uneven illumination (fluorescence)	Check flatness of fluorescence illumination
	Camera angle misaligned	Level camera relative to microscope stage; calibrate camera angle in software
Vibration in system	Antivibration table	Verify that tabletop is floating and wheels (if any) are not touching floor
	Contact between electronic components and tabletop or microscope	Check for free space between shelves and tabletop; ensure that controllers are not directly on tabletop
	Moving components (e.g., fans)	Test camera fan; check for contact between heating/cooling fans and microscope or incubator

Continued

Table 4.2 Troubleshooting Guide—cont'd

Problem	Possible causes (in order of likelihood)	Try this
Compromised spatial resolution	Mechanical shutter attached to microscope	Remove shutter or increase shutter delay time
	Microscope incorrectly or loosely assembled	Dismantle and reassemble microscope
	Fluctuations in temperature/humidity	Monitor these factors to check for correlation with vibration
	Dirty objective lens	Clean objective lens
	Vibration in system	Check for vibration (see succeeding text)
	Damaged objective lens	Place a service call
Acquisition is slow	Computer	Check RAM, disable automatic antivirus scans, defragment hard drive, and save data locally rather than to a remote location
	Camera	Check all camera settings, verify driver/software compatibility
	Communication issues between microscope hardware and software	Check component settings in software; disable components one by one and note effect
Lateral (XY) or focal (Z) drift	Temperature instability due to microscope incubator system	Close all incubator doors and allow temperature to stabilize before imaging
	Temperature/humidity instability in microscope room	Measure ambient conditions over time and address any heating/cooling issues
	Stage linear encoders (if lateral drift)	Verify that encoders are connected and enabled
	Microscope's autofocusing system not working properly (if focal drift)	Consult microscope manual for troubleshooting tips/place a service call if necessary
Imprecision in z-step size	Sample not secured to stage	Check placement of sample in stage adapter; secure adapter to stage with screws
	z-Motor moving in the wrong direction	Change settings so that focus motor moves up (against gravity) during stack collection
	Incorrect z-motor settings	Check device settings in software; choose lower tolerance and/or speed
Z-stepping speed too slow, or large variance in time between steps	Microscope's autofocusing system is interfering with z-motor	Disable autofocusing system
	Incorrect z-motor settings	Check device settings in software
Inability to remove components	Neglected microscope or inexperience	Place a service call

appear bright and even as you tilt the light guide slightly to observe different angles. If you see dark lines or spots, it may help to very gently shake the LLG to dislodge air bubbles. If dark lines or spots remain, the LLG needs to be replaced.

4.2.4 FLATNESS OF FLUORESCENCE ILLUMINATION

To check for evenness of illumination across the field of view (Zwier, Van Rooij, Hofstraat, & Brakenhoff, 2004), view a uniformly fluorescent sample. We recommend preparing a slide composed of a highly concentrated fluorophore solution with high optical density (Model & Blank, 2008), which mimics a thin fluorescent film. Focus on the slide just below the coverslip. The wide-field fluorescence field diaphragm sits in a position conjugate to the image focal plane and can therefore be used to find focus; close the field diaphragm and focus on the edge of the diaphragm. Adjust camera exposure to use the full dynamic range of the camera without saturation. Acquire several images from different fields and average the images in your image acquisition/processing software. Minor inhomogeneity in the sample is reduced by averaging images of different fields of view together, resulting in an image that represents the illumination pattern in the microscope. Apply a heat map lookup table to easily visualize intensity flatness in the image and plot a line scan diagonally across the image in both directions and view the intensity profile. Save a copy of your flat field image so you can compare it the next time you check the microscope. If you find a sudden inhomogeneity in the field, consult Table 4.2 for troubleshooting advice. It is rare to find completely homogenous illumination in any fluorescence microscope light source; consult your microscope representative if you find yours is particularly bad.

4.2.5 COLOR REGISTRATION

Registration between fluorescent wavelengths should be checked regularly, particularly if performing colocalization analysis (Adler & Parmryd, 2013; Dunn, Kamocka, & Mcdonald, 2011; Chapter 21). Axial color registration varies with different levels of chromatic correction in objective lenses (Dunn & Wang, 2000; Chapter 2). Lateral chromatic shifts can be introduced when changing between different dichroic mirrors or emission filters, as is commonly the case in multi-color fluorescence imaging. Always recheck registration if any one filter in the fluorescence filter set is replaced.

Prepare a slide using TetraSpeck beads (Table 4.1) and acquire images at the desired wavelengths. Digitally pseudocolor and overlay two images at a time. Using a high digital zoom factor, view several sets of beads, and measure the X, Y pixel shift between the two wavelengths. Apply the X, Y shifts to future images using the image alignment tool in your software package. Note that color registration will differ across the field of view, with chromatic shift typically being more prominent around the image peripheries. In this case, the calculated chromatic shift will only apply to particular segments of the camera field. Image warping

algorithms can be used to correct for varying chromatic shifts across the field of view (Wolf, Samarasekera, & Swedlow, 2007).

4.2.6 VIBRATION

Vibration in a microscope can sabotage data quality. It is important to regularly check for vibration, particularly when imaging objects that are near the optical resolution limit. Vibration can result in blurry images and decreased image intensity; when collecting an image of a vibrating object, the image will spread over additional pixels (Fig. 4.6).

To check for vibration, prepare a slide of subresolution fluorescent beads (Table 4.1). Using the highest available magnification, remove the DIC objective prism (if present) and focus on a field of beads. Set camera binning to 1×1 for both the live view and acquired images. Observe a live scan using a very short camera exposure (5–10 ms) to see if the image of the beads is vibrating. Comparing images collected using short and long exposures (e.g., 5 and 500 ms, adjusting illumination intensity to compensate for different exposure times) can also expose vibration; vibration can cause the image of the beads in the longer exposure to appear smeared or oblong (Fig. 4.6B).

While vibration in a system is relatively easy to identify, it can sometimes be quite difficult to solve. The first step in troubleshooting vibration is to verify that the microscope is mounted on an antivibration table that is working properly. Be sure that all corners of the air tabletop are floating, and if the table has wheels that can be lowered for moving the table, they should not be in contact with the ground. Electronic power supplies that contain fans or other sources of vibration should never be kept on the floating air table. If there is a fan anywhere in or near the system, such as in a heating system or a cooled CCD camera, observe a live view of the vibrating sample while turning the fan on and off. If you find that the vibration comes and goes over time, placing a temperature/humidity recorder (Table 4.1) in the room over the

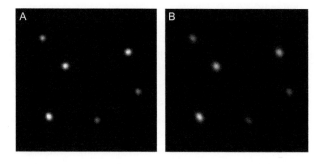

FIGURE 4.6

The effect of vibration on image quality. 100 nm beads (see Table 4.1) and high magnification can be used to check for vibration in the microscope system. (A) No vibration. (B) Vibration causes blurring of the image of the beads.

course of several days and checking for vibration frequently may help you determine if the temperature control in the room is inadequate for high-resolution imaging. See Table 4.2 for more tips on isolating and correcting the source of a vibration. If you cannot get rid of the vibration on your own, it may be necessary to request that your microscope representative take apart and reassemble the microscope or help identify a specific hardware configuration that is sensitive to vibration.

4.2.7 MEASURE THE POINT SPREAD FUNCTION

Keep the submicron bead slide in place and use it to measure the point spread function (PSF) of your microscope. The PSF is an empirical measure of the microscope's resolution and aberrations (Cole, Jinadasa, & Brown, 2011; Goodwin, 2013; Hiraoka, Sedat, & Agard, 1990). Remove the objective DIC prism from the light path before measuring the PSF. Also, be sure that the coverslip is securely mounted to the slide and that slide is securely mounted to the microscope stage—any movement of the sample during acquisition will compromise the PSF. After placing the slide securely on the microscope stage, allow it to "settle" for 10–20 min before acquiring the PSF. Follow the protocol outlined in Cole et al. (2011) for collecting and analyzing PSFs using a readily available software plug-in.

Be aware that PSF measurements are sensitive and error-prone. Repeat the PSF multiple times, with different bead slides, and consider the best PSF you collect to be the most representative of your imaging system. Measure the PSF regularly for all high-numerical aperture objectives. It is very useful to have baseline PSFs available if an objective is scratched or otherwise damaged, to help determine if the damage affects image quality.

4.2.8 TEST PERFORMANCE OF MOTORIZED COMPONENTS AND SOFTWARE

Motorized components can perform suboptimally due to a number of common mechanical issues; likewise, software performance can change and problems can arise due to application or operating system updates or to computer-related problems (Biehlmaier, Hehl, & Csucs, 2010). Therefore, it is recommended that you perform routine test experiments to ensure that the speed, accuracy, and reliability of all components are maintained.

Perform a time-lapse that includes multiple wavelengths using many or all of your motorized components: all light sources (transmitted, wide-field fluorescence, lasers) and shutters, multiple stage positions, and the hardware real-time focusing mechanism or software autofocus. View each stage position over time and check for lateral or focal drift. After acquisition, view the image metadata to check that the time between images is as expected. Next, acquire a z-stack time-lapse to assess performance of the focus motor. Use the image metadata to check that the z-step accuracy is within the expected tolerance specified by the manufacturer and that it stays consistent over time. Finally, test the speed of the system by acquiring a single

wavelength time-lapse with no delay between time points. The time between frames should be consistent and without unexpected delays.

4.3 CONSIDERATIONS FOR NEW SYSTEM INSTALLATION

When installing a new microscope system, take advantage of the opportunity to make good choices regarding environment, accessibility, and ergonomics. There are a number of factors to consider during the initial setup that will make maintenance and troubleshooting easier and can enhance the performance of your light microscope.

As discussed previously, vibration in the optical system can significantly degrade image quality (Fig. 4.6). If the option is available, house your microscope on the ground floor or basement of a building, as upper floors can be more sensitive to vibration. No matter where your microscope is to be located, purchase a high-quality vibration isolation table and ample shelving for accessories such as power supplies, focus knobs, and control pads so that they are not sitting directly on the floating air tabletop. Positioning of the microscope within the room is important to consider. Take care to avoid setting up your microscope directly under anything that may leak: HVAC systems, sprinklers, valves, or drip pans. If there are potential sources of dust nearby, such as construction or carpeting, consider purchasing a HEPA filter for the room. Be sure that the room has the appropriate grounded electrical requirements for the equipment, and use surge protectors.

Another factor to consider during setup is the room lighting. In order to block unwanted light in a shared space, install blackout curtains around the microscope area. Additionally, walls may be painted black to further reduce ambient light reflection. Also ensure that bright overhead light, lamps, etc., are available for ample visibility during experimental setup, microscope maintenance, repair, and disassembly.

Another important room requirement to consider is temperature control and stability. Fluctuations in room temperature cause lateral and axial microscope drift. Be sure that the temperature control system can handle the maximum heat load of the equipment and that the thermostat is located in the microscope room itself. If possible, avoid placing the microscope directly in the path of airflow from vents, or install baffles to distribute air away from the microscope.

Finally, configure the workstation area to allow easy access to all cables, controllers, and computer ports. Ideally, there will be enough space to be able to walk completely around the microscope table, and control boxes can be situated in such a way as to facilitate easy removal and cable rearrangement. Hardware will need to be moved and replaced with surprising frequency over the years of normal use, so allowing for easy access is important.

In conclusion, there are a number of simple steps that a microscope manager can take to enhance performance and increase the longevity of their imaging system. The process of regular maintenance and troubleshooting can be expedited significantly if the proper tools are readily available and the microscope is configured in a way that maximizes performance and minimizes downtime.

ACKNOWLEDGMENTS

We thank Talley Lambert and Torsten Wittmann for their helpful comments on this chapter and Gintas Sekmokas for his photography.

REFERENCES

Adler, J., & Parmryd, I. (2013). Colocalization analysis in fluorescence microscopy. *Methods in Molecular Biology (Clifton, N.J.)*, *931*, 97–109. http://dx.doi.org/10.1007/978-1-62703-056-4_5.

Biehlmaier, O., Hehl, J., & Csucs, G. (2010). Acquisition speed comparison of microscope software programs. *Microscopy Research and Technique*, *74*(6), 539–545. http://dx.doi.org/10.1002/jemt.20944.

Cole, R. W. R., Jinadasa, T. T., & Brown, C. M. C. (2011). Measuring and interpreting point spread functions to determine confocal microscope resolution and ensure quality control. *Nature Protocols*, *6*(12), 1929–1941. http://dx.doi.org/10.1038/nprot.2011.407.

Dunn, K. W., Kamocka, M. M., & Mcdonald, J. H. (2011). A practical guide to evaluating colocalization in biological microscopy. *American Journal of Physiology - Cell Physiology*, *300*(4), C723–C742. http://dx.doi.org/10.1152/ajpcell.00462.2010.

Dunn, K. W., & Wang, E. (2000). Optical aberrations and objective choice in multicolor confocal microscopy. *BioTechniques*, *28*(3), 542-4-546-548-50.

Goodwin, P. C. (2013). Evaluating optical aberrations using fluorescent microspheres: Methods, analysis, and corrective actions. *Methods in Cell Biology*, *114*, 369–385. http://dx.doi.org/10.1016/B978-0-12-407761-4.00015-4.

Grünwald, D., Shenoy, S. M., Burke, S., & Singer, R. H. (2008). Calibrating excitation light fluxes for quantitative light microscopy in cell biology. *Nature Protocols*, *3*(11), 1809–1814. http://dx.doi.org/10.1038/nprot.2008.180.

Hiraoka, Y., Sedat, J. W., & Agard, D. A. (1990). Determination of three-dimensional imaging properties of a light microscope system. Partial confocal behavior in epifluorescence microscopy. *Biophysical Journal*, *57*(2), 325–333. http://dx.doi.org/10.1016/S0006-3495(90)82534-0.

Inoué, S., & Spring, K. R. (1997). *Video microscopy.* New York and London: Plenum Press.

Lichtman, J. W., & Conchello, J.-A. (2005). Fluorescence microscopy. *Nature Methods*, *2*(12), 910–919. http://dx.doi.org/10.1038/nmeth817.

Model, M. A., & Blank, J. L. (2008). Concentrated dyes as a source of two-dimensional fluorescent field for characterization of a confocal microscope. *Journal of Microscopy*, *229*(Pt 1), 12–16. http://dx.doi.org/10.1111/j.1365-2818.2007.01880.x.

Pawley, J. (2010). *Handbook of biological confocal microscopy.* New York, NY: Springer.

Reichman, J. (2010). *Handbook of optical filters for fluorescence microscopy.* Chroma.com, http://www.chroma.com/sites/default/files/uploads/files/HandbookofOpticalFilters_0.pdf, Accessed 19 February 2014.

Salmon, E. D., & Canman, J. C. (2001). Proper alignment and adjustment of the light microscope. *Current Protocols in Cell Biology*, http://dx.doi.org/10.1002/0471143030.cb0401s00, Editorial Board, Juan S. Bonifacino, et al., Chapter 4, Unit 4.1–Uni1.

Schalck, R. (2013). *The proper care of optics.* Bellingham, WA: SPIE Press.

Webb, D. J., & Brown, C. M. (2013). Epi-fluorescence microscopy. *Methods in Molecular Biology (Clifton, N.J.)*, *931*, 29–59. http://dx.doi.org/10.1007/978-1-62703-056-4_2.

Wessels, J. T., Pliquett, U., & Wouters, F. S. (2012). Light-emitting diodes in modern microscopy—From David to Goliath? *Cytometry Part A: The Journal of the International Society for Analytical Cytology*, *81*(3), 188–197. http://dx.doi.org/10.1002/cyto.a.22023.

Wolf, D. E., Samarasekera, C., & Swedlow, J. R. (2007). Quantitative analysis of digital microscope images. *Methods in Cell Biology*, *81*, 365–396.

Zwier, J. M., Van Rooij, G. J., Hofstraat, J. W., & Brakenhoff, G. J. (2004). Image calibration in fluorescence microscopy. *Journal of Microscopy*, *216*(Pt 1), 15–24. http://dx.doi.org/10.1111/j.0022-2720.2004.01390.x.

CHAPTER

Fluorescence live cell imaging

Andreas Ettinger, Torsten Wittmann
Department of Cell and Tissue Biology, University of California, San Francisco, USA

CHAPTER OUTLINE

- 5.1 Fluorescence Microscopy Basics ... 78
- 5.2 The Live Cell Imaging Microscope ... 79
- 5.3 Microscope Environmental Control ... 83
 - 5.3.1 Temperature .. 83
 - 5.3.2 Media Composition and pH ... 84
 - 5.3.3 Imaging Chambers .. 85
- 5.4 Fluorescent Proteins ... 87
 - 5.4.1 Protocol for Analyzing FP Photobleaching 90
- 5.5 Other Fluorescent Probes ... 92
- Conclusion .. 93
- Acknowledgments .. 93
- References ... 93

Abstract

Fluorescence microscopy of live cells has become an integral part of modern cell biology. Fluorescent protein (FP) tags, live cell dyes, and other methods to fluorescently label proteins of interest provide a range of tools to investigate virtually any cellular process under the microscope. The two main experimental challenges in collecting meaningful live cell microscopy data are to minimize photodamage while retaining a useful signal-to-noise ratio and to provide a suitable environment for cells or tissues to replicate physiological cell dynamics. This chapter aims to give a general overview on microscope design choices critical for fluorescence live cell imaging that apply to most fluorescence microscopy modalities and on environmental control with a focus on mammalian tissue culture cells. In addition, we provide guidance on how to design and evaluate FP constructs by spinning disk confocal microscopy.

5.1 FLUORESCENCE MICROSCOPY BASICS

Fluorescence imaging relies on illumination of fluorescently labeled proteins or other intracellular molecules with a defined wavelength of light ideally near the peak of the fluorophore excitation spectrum and detection of light emitted at a longer wavelength. An important question is how much excitation light is actually needed to obtain a useful image. At the objective front lens, the light power of our spinning disk confocal microscope with a 100-mW 488-nm solid-state laser at 100% illumination is approximately 6 mW (measured with an X-Cite XR2100 light power meter, EXFO Photonic Solutions; Chapter 4). Divided by the area of the spinning disk aperture of \sim6000 μm^2 at 100× magnification, this results in an irradiance of \sim100 W cm^{-2}. At lower magnification, the excitation light is spread over a larger area; thus, the irradiance decreases proportional to the square of the magnification ratio (i.e., \sim36 W cm^{-2} for 60×). For comparison, the direct solar irradiance at ground level on a bright sunny day at noon is \sim1000 W m^{-2} (i.e., 0.1 W cm^{-2}) across all wavelengths or \sim1–1.5 W m^{-2} nm^{-1} for specific wavelengths within the visible part of the spectrum.[1] Although this should be considered a rough estimate, it shows that the maximum light intensity in a spinning disk confocal microscope is \sim1000 times higher compared with the total irradiance of direct sunlight and one million times higher at a specific excitation wavelength. Similar calculations can be made for wide-field epifluorescence illumination and result in similar values depending on the light source. Because laser scanning confocal microscopes utilize a focused beam to illuminate a very small area at a time, typical irradiance values can be several orders of magnitude higher.

This difference in specimen irradiance between spinning disk and laser scanning confocal microscopes explains partly why spinning disk confocal microscopes are the better choice for live cell imaging. Fluorescence emission is linearly related to the excitation light intensity as long as the majority of fluorescent molecules in a population are not in the excited state. At higher rates of photon flux, however, that are quite easily reached in laser scanning confocal microscopes, a large proportion of fluorophores populate the excited state and thus can no longer absorb additional photons (Wang, Babbey, & Dunn, 2005). This is referred to as ground-state depletion, and additional excitation light will only yield subproportional increases in fluorescence signal but still contribute to photodamage. In spinning disk confocal microscopes, ground-state depletion is not reached even with high power excitation lasers (> 100 mW) because the excitation light is spread over thousands of pinholes that scan across the specimen rapidly (Chapter 9). It is interesting to note that ground-state depletion can be used to achieve PALM/STORM-type superresolution (Lalkens, Testa, Willig, & Hell, 2012).

Although high-intensity light itself is damaging to cells (especially in the near-UV range that can induce DNA damage), the main phototoxic effects in live cell

[1]Based on the American Society for Testing and Materials (ASTM) Terrestrial Reference Spectra.

fluorescence microscopy result from fluorophore photobleaching. Each time a fluorescent sample is illuminated, a fraction of the fluorophore population will be irreversibly destroyed. In addition to decreasing the available fluorescence signal with each exposure, photobleaching generates free radicals and other highly reactive breakdown products (a fact exploited in photoinactivation techniques such as CALI; Jacobson, Rajfur, Vitriol, & Hahn, 2008). The degree of phototoxicity depends to a large extent on the fluorophore. For example, fluorescent proteins (FPs) tend to be less phototoxic compared with chemical fluorescent dyes because the photobleaching chemistry is contained within the β-barrel protein structure. The only certain way to reduce photobleaching and associated photodamage is to reduce excitation light exposure by limiting exposure time and light intensity as much as possible while retaining a useful signal-to-noise ratio required for the specific experimental question (Fig. 5.1).

The traditional fluorescence microscope design utilizing the same lens system as both condenser and objective is suboptimal in limiting light exposure of the specimen. Even in a confocal setup in which emitted out-of-focus light is rejected, the specimen above and below the focal plane is still illuminated and thus subjected to photobleaching and toxicity. This greatly limits the number of images that can be acquired and in many cases makes it impossible to acquire high-resolution, time-lapse series of 3D volumes. It will be exciting to see whether recent light sheet microscopy approaches (Chapter 11) in which excitation is limited to the focal plane that is currently imaged can revolutionize live imaging in cell biology as they have done in developmental biology. Most light sheet microscope designs are limited to low-NA, low-magnification objectives, which are sufficient to image cell movements in developmental processes, but do not routinely allow high-resolution imaging of intracellular dynamics. Recent advances such as Bessel beam microscopy show great promise (Gao et al., 2012) but are currently only available to specialist labs, and this chapter focuses on more traditional fluorescence microscopy technology.

5.2 THE LIVE CELL IMAGING MICROSCOPE

Most modern wide-field epifluorescence, spinning disk confocal, or TIRF microscope setups rely on a similar set of optical and mechanical components, and all imaging modalities are often used for live cell imaging. In the following, we give a short overview of the most critical parameters when designing or optimizing a system for fluorescence live cell microscopy. While it may not be possible to optimize all components of a specific fluorescence microscope setup depending on the imaging modality and experiment, we outline important hardware factors that should be considered in the design of a live cell imaging microscope to limit light exposure as much as possible:

- *Excitation and emission light path*: The wavelengths of excitation and emission filters should be optimized to match the fluorophore used to limit unnecessary light exposure and optimize detection of fluorophore emission (see more in section 5.4). Remove all unnecessary optical components from the light path.

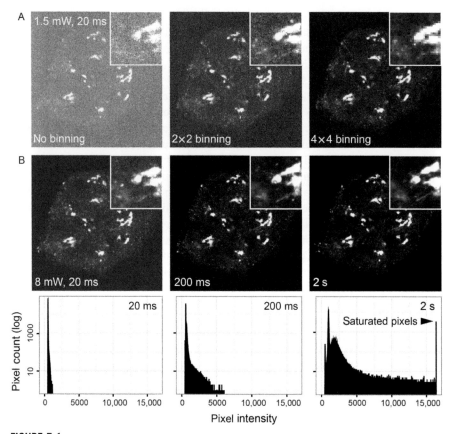

FIGURE 5.1

Dependence of signal-to-noise on effective pixel size and exposure. Spinning disk confocal images of HaCaT cells expressing EGFP-Rab6A that localizes to the Golgi apparatus and intracellular vesicles acquired with 488 nm excitation and a 525/50-nm band-pass emission filter using a Nikon 60× CFI Apo TIRF NA 1.49 oil immersion objective. (A) Images acquired with different camera binnings, but otherwise identical exposure settings (∼1.5 mW light power at the objective; 20-ms exposure time). Although binning drastically increases signal-to-noise, it also decreases resolution. (B) Images with no binning at ∼8 mW light power acquired at different exposure times. The graphs below show corresponding histograms of pixel intensities. At sufficient signal-to-noise ratio (somewhere between 20 and 200 ms; magnified insets) details such as EGFP-Rab6 tubules become visible representing optimal exposure settings for this specimen Longer exposure times (2 s) result in unnecessary photobleaching, blurring of fast-moving vesicles, and camera saturation without a useful increase in signal-to-noise.

For example, a forgotten polarizer in the emission path will cut the signal reaching the camera in half. It is also important to reduce background light by turning off the room lights and minimize scattered light in wide-field imaging by closing the field diaphragm as much as possible.

- *Shutters*: Fast, motorized shutters should be used to turn off the excitation light when not needed to take an image. It is particularly important to note that software-controlled shutters often have a significant overhead. Because of computer-induced delays in sending commands (and sloppy programming in almost all modern commercial software), shutters can open and close hundreds of milliseconds before and after an image is actually taken. Ideally, shutters are directly hardware-triggered by the camera. Most camera and shutter manufacturers support this option using a simple coaxial TTL trigger cable, but it is often not implemented by default. It is also important to note that switching between wavelengths will require some additional hardware to combine the camera trigger with a wavelength selection signal from the imaging software (Stehbens, Pemble, Murrow, & Wittmann, 2012). In the absence of significant shutter overhead and at excitation light intensities well below fluorophore ground-state depletion, the recorded signal and the degree of photobleaching should only depend on the total amount of light received by the specimen (i.e., 100 ms exposure at 10 mW should be the same as 1 s exposure 1 mW excitation light power). Of note, LED-based light engines are becoming more and more common. An important advantage of LEDs is that they can be switched on and off very rapidly and may thus not require additional mechanical shutters.
- *Objective lens*: As outlined earlier, specimen irradiance increases drastically with magnification. Thus, to limit photodamage to the specimen, the lowest magnification should be used as determined by the experimental question. However, it is important to note that sufficient sampling of the microscope optical resolution in many cases requires $100\times$ magnification (Stehbens et al., 2012). Depending on how low of a fluorescent signal needs to be observed, one should also try to select the brightest possible objective. For example, phase contrast objectives transmit $\sim 5\%$ less light. We routinely use Nikon $60\times$ and $100\times$ 1.49 NA CFI Apochromat TIRF objectives for spinning disk confocal microscopy to maximize light collection using standard immersion oil. For a more detailed discussion of objective lens characteristics see Chapter 2.
- *Camera*: To detect dim fluorescent signals, it is essential to use cooled scientific-grade cameras with the lowest readout noise available. Lower noise allows detection of dimmer signal. While interline CCD cameras have historically shown the best performance for live cell imaging, the camera field has developed rapidly in the recent years (see Chapter 3), and it is difficult to make a general recommendation. Ideally, different types of cameras should be tested with the specimen of interest before a purchasing decision is made to find the best compromise between price and performance. There is a note of caution regarding EM-CCD cameras that are often pushed for live cell imaging: the electron multiplication feature only discriminates against camera-inherent noise

and thus only makes sense with specimens that have low signal and essentially no background fluorescence. For this reason, EM-CCDs are very powerful in single molecule imaging approaches. However, this is not the case for most live cell imaging experiments in which a substantial fluorescent background exists, for example, from the pool of cytoplasmic protein. In this case, both the fluorescent background and the signal are amplified equally resulting in larger pixel intensity values, but essentially the same signal-to-noise ratio. Apparent gain in signal-to-noise compared with interline CCD cameras largely results from the larger pixel size in EM-CCD cameras (the most commonly used EM-CCD chips have a 6 × larger pixel area compared with interline CCDs). Without having done a direct comparison, a very similar increase in signal-to-noise ratio (with an associated decrease in image resolution owing to the larger pixel size) can likely be achieved by binning of a regular CCD camera for a much lower cost (Fig. 5.1; more on cameras in Chapter 3).

Although these considerations on minimizing light exposure of fluorescent specimens also apply to nonfluorescent, transmitted light microscopy, light intensities in phase contrast or DIC are much lower and rarely problematic as long as heat-cutting filters and shutters to turn off illumination between exposures are used. Environmental control of the specimen becomes much more important to ensure viability in time-lapse experiments monitoring long-term cell dynamics.

Microscope automation that is equally useful for both fluorescent and transmitted live cell microscopy includes the following:

- *Hardware autofocus*: Focus drift is a notorious problem in high-resolution time-lapse imaging. To some extent, focus drift can be minimized by using good experimental practice. For example, by making sure that the specimen is securely seated on the stage and allowing a sufficient period of time for thermal equilibration before starting a time-lapse experiment. However, in experiments that last longer than a few minutes, this will likely not be enough. Hardware autofocus systems mostly rely on detecting a reflection of a near-IR light beam from the interface between coverslip glass and tissue culture medium and using drift of this reflection as a feedback for the motorized focus drive. This principle, similar to TIRF, relies on a sufficient refractive index mismatch at the interface and can maintain satisfactory focus even at high magnification for days (Haynes, Srivastava, Madson, Wittmann, & Barber, 2011). Software autofocus may be used on a transmitted light image, but not in a fluorescence channel, because the focusing algorithms will need to acquire multiple additional images per time point to determine focus, thus resulting in rapid photobleaching.
- *Motorized stage*: Multipoint acquisition allows parallel data collection from many fields of view, which is especially important for longer time-lapse experiments or drug treatments that can only be done once per specimen. For high-magnification experiments, the accuracy with which a motorized stage returns to a previous position is key. In high-precision stages equipped with linear encoders to measure stage position independent of the stepper motor, this

repeatability should be in the order of hundreds of nanometers. Thus, at high magnification, some inaccuracy in returning to previous positions is inevitable and will be visible as slight jitter in time-lapse sequences. However, this can often be corrected by correlation-based image alignment algorithms.

5.3 MICROSCOPE ENVIRONMENTAL CONTROL

Cultured cells and tissues will only behave normally in a physiological environment, and control of factors such as temperature and tissue culture medium composition is thus critically important to obtaining meaningful data in live cell imaging experiments. The conditions required to successfully maintain cell health on the microscope stage obviously depend on the organism, and in this section, we provide a general overview of options available to maintain environmental control with a focus on live cell imaging of mammalian cell types.

5.3.1 TEMPERATURE

The most basic level of environmental control is maintaining correct temperature to ensure that observed cell dynamics are an accurate representation of *in vivo* cell behavior. For cells from warm-blooded animals, the specimen thus needs to be warmed. Although the most commonly used temperature is 37 °C for mammalian cell lines, it should be noted that physiological body temperatures can vary considerably (i.e., 42 °C in chickens), and depending on the experiment, one may want to take this into consideration. In contrast, *Drosophila* cells will not behave normally or even survive at 37 °C. In general, biochemical reaction kinetics are temperature-dependent, and one would expect that most dynamic cell processes occur at slower rates at lower temperature. Thus, in addition to maintaining cell health, accurate temperature control will also limit variability between experiments. Each of the designs used to achieve temperature control has its advantages and disadvantages, and the choice of equipment will be determined by experimental question and type of specimen:

- *Air stream incubators*: The simplest way to control temperature is by blowing warm air across the specimen. Such glorified hair dryers with highly accurate temperature control are available commercially (Nevtek) but can also be homemade. While this design has the advantage of being compatible with virtually any microscope stage and specimen, it is difficult to precisely control temperature at the specimen. In addition, heat fluctuations and vibration negatively influence focus stability, and the stream of warm air will very rapidly evaporate tissue culture media from open cell culture dishes.
- *Stage-top incubators*: Heated stage incubators are available from many manufacturers and are growing in popularity. These range from relatively simple heated inserts for existing microscope stages to more complex incubation chambers that combine temperature and gas control and also allow perfusion of

different types of media (Okolab, Tokai Hit, Warner Instruments, and others). A general problem with this design is that the central hole in the heated plate through which the specimen is observed is not heated. For long working distance air objectives, transparent, warmed bottom plates are available. However, this does not work with high-NA oil objectives, which are thermally coupled to the coverslip by the immersion oil. The objective acting as a heat sink will especially cool the spot that is currently under observation, generating temperature gradients of unknown magnitude. To alleviate this problem, stage-top incubators are often used in combination with heated collars around the objective. A troubling aspect of this design is temperature fluctuations and gradients generated in the objective. Heating the front lens to 37 °C will require a much higher temperature of the heating collar. In addition, glass and metal have very different thermal expansion coefficients, and it is easy to imagine how temperature gradients and repeated heating and cooling will negatively affect optical performance and lifetime of these very expensive, precision-engineered compound objective lenses.

- *Full microscope enclosures*: For dedicated live cell imaging systems, we therefore find that a full heated enclosure that contains specimen, stage, objective turret, and parts of the microscope body to be the preferred solution. Such enclosures are mostly made from acrylic glass. One disadvantage is that these need to be custom-designed to fit around specific imaging systems and allow for sufficient space for cameras, filter wheels, and other peripheral devices. This may also make it more difficult to change components at a later time. Advantages are that full enclosures allow the best thermal equilibration. We always leave our system set to 37 °C because it will take several hours for full temperature equilibration. This also reduces focus drift and minimizes thermal cycling experienced by optical and mechanical components. In addition, the microscope stage remains free and there are no limitations to the type of sample chambers that can be used.

5.3.2 MEDIA COMPOSITION AND PH

Most tissue culture media are buffered to physiological pH by sodium bicarbonate and 5% CO_2. Thus, pH in an open tissue culture dish on a microscope stage will rapidly increase and leave the physiological range within minutes as CO_2 outgases into the atmosphere. One common approach to control pH is the use of CO_2-independent media or addition of 10–25 mM HEPES to increase buffering capacity. However, HEPES alone will not completely control long-term alkalization of bicarbonate-buffered media, and it is also important to test how changing to a different imaging medium or HEPES addition affects the process under investigation. For example, bicarbonate transporters are principal regulators of intracellular pH in animal cells, which will not function correctly in bicarbonate-free media or buffers such as PBS. A better, but technically more involved approach is to control CO_2 concentration such that regular tissue culture medium can be used, which can be especially important for long-term imaging experiments. Most high-endstage-top

incubators have the option of active CO_2 control in which a sensor, ideally placed near the specimen, measures CO_2 concentration providing a feedback signal to an active gas mixer. However, active CO_2 controllers are unreasonably expensive and not without trouble, and a malfunctioning sensor can offer a false sense of security.

Alternatively, passive control of CO_2 concentration can be achieved by using premixed 5% CO_2 (often sold as biological atmosphere) or produced by passive volumetric mixing. 5% CO_2 can then be streamed slowly onto the specimen covered, for example, with a very low-cost inverted plastic dish to minimize gas leakage. In our hands, this has been effective to control pH for days. Of note, it is not feasible and likely dangerous to fill a full microscope enclosure with 5% CO_2. For live imaging of tissue slices, more complex gas control including increased oxygen supply may be necessary (e.g., 40% oxygen, 5% CO_2, and 55% N_2; Attardo, Calegari, Haubensak, Wilsch-Brauninger, & Huttner, 2008). In any case, to prevent evaporation of cell culture medium during imaging, it is necessary to humidify the gas mixture. This can be achieved by bubbling gas through a bottle with sterile deionized water or by channeling through semipermeable tubing immersed in water. The latter solution is preferable as it introduces less vibration and results in better humidification. To maintain sample temperature, humidifiers should be either warmed or placed inside the heated microscope enclosure. If necessary, additional humidification can be provided by placing wet tissue paper inside the imaging chamber.

Of note, most tissue culture medium contains fluorescent compounds such as phenol red. In our hands, background fluorescence of regular DMEM or similar tissue culture media is negligible on our spinning disk confocal setup at 488 or 561 nm excitation with optimized filter sets. However, phenol red is highly fluorescent when excited at 440 nm, and phenol red-free medium has to be used for imaging of cyan FPs.

5.3.3 IMAGING CHAMBERS

For live cell microscopy, cells are typically grown on coverslips and viewed with an inverted microscope from below. Most microscope objectives are designed for no. 1.5 coverslips (0.17 mm thick), and use of coverslips of a different thickness will result in spherical aberration. However, practical considerations can sometimes demand the use of thinner coverslips. For example, we have used no. 1 coverslips for high-resolution imaging of epithelial organoids embedded in a 3D extracellular matrix to increase the usable working distance of high-NA oil objectives (Gierke & Wittmann, 2012). Coverslips should be cleaned well before seeding cells, for example, by using the "squeaky clean" coverslip cleaning protocol outlined in Chapter 20. It may also be necessary to coat coverslips with appropriate extracellular matrix molecules to improve adhesion and promote normal cell dynamics.

Stage-top incubators often come with dedicated live cell imaging and perfusion chambers for mounting coverslips, but it is important to consider whether a complicated imaging chamber is necessary for a particular experiment. Imaging chambers

can be arbitrarily complex requiring assembly of multiple O-rings, spacers, and screws, which increases the risk of leakage, contamination, or drying of the specimen. It is also important to note that imaging chambers with bottom parts thicker than the working distance of a high-NA oil objective, which is typically in the range of 0.1–0.2 mm, have to be used very carefully to avoid damage to the objective front lens. Chambers with thick bottom assemblies can also significantly limit the observable coverslip area.

Alternative solutions are disposable cell culture dishes in which a coverslip is glued to the bottom of a plastic tissue culture dish. Several variations of this theme are commercially available such as 35-mm round dishes (Matek, Cat. No. P35G-1.5-14-C; In Vitro Scientific, Cat. No. D35-10-1.5-N) or rectangular formats (Lab-Tek, Nunc Cat. No.155361). Although supplied in sterile packaging, these commercial dishes are often not as clean as one would like them to be for live cell imaging. Glass bottom dishes can be self-made by drilling a hole into a plastic tissue culture dish and gluing matching coverslips onto the bottom by using UV-hardened glue. If the necessary equipment is available, this can be a good cost-effective alternative to commercial products. In an open tissue culture dish at 37 °C, a significant amount of water will evaporate within minutes, which increases the osmolarity of the tissue culture medium much more rapidly than one might anticipate and may negatively affect cell dynamics in the absence of an apparent change in medium volume. Thus, even in relatively short experiments, glass-bottom dishes should be sealed. This can be done by running a bead of silicon grease around the inner edge of the lid before closing the dish. If drugs need to be added during the experiment, a small glass plate on top of the dish will also help to reduce evaporation. Alternatively, a layer of mineral oil can be overlaid on top of the medium.

In experiments during which cells do not need to be accessed during imaging, we have been quite successful using simple, reusable anodized aluminum slides that can be easily custom-made (e.g., online at www.emachineshop.com). These slides have a hole and counterbore on each side (Fig. 5.2A). A clean 15-mm round coverslip (Warner, CS-15R15, Cat. No. 64-0713) and one with the cultured cells are attached to the ledge of the counterbore on either side with silicon grease (Dow Corning High Vacuum Grease), which creates a seal that eliminates evaporation and restricts gas exchange. After assembly, it is important to clean the outside of the coverslip carrying the cells with ethanol to remove any trace of silicon grease that will contaminate the immersion oil and deteriorate image quality. Despite the small media volume (∼200 µl), cell health in these chambers is usually excellent, and we have, for example, imaged F-actin dynamics during epithelial-to-mesenchymal transition for up to 48 h using these slides (Haynes et al., 2011). After use, we clean the slides by several washes and short sonication in soapy water, deionized water, and ethanol. For special applications such as chemotaxis assays, different designs of disposable microfluidic chambers are available (e.g., from ibidi). To allow high-resolution imaging, these chambers use plastic coverslips with a refractive index that matches glass. It is important to note that organic solvents in different types of immersion oils may dissolve this plastic, and it is thus important to test compatibility.

FIGURE 5.2

Diagram of reusable aluminum slides. (A) Example dimensions for a slide made to fit 15-mm round coverslips. All dimensions are in mm and can be adapted to fit different microscope stages. (B) Assembly of metal slides: A bead of silicon grease is distributed on one side of the slide with a small spatula and a clean cover slip is attached (1); after turning the slide (2), a thin layer of silicon grease is likewise spread on the other side (3), a drop of cell culture medium is added (4), and a cover glass with cells is mounted with the cells facing inside (5). Before imaging, the outside of the coverslip needs to be cleaned thoroughly to avoid contamination of the immersion oil.

5.4 FLUORESCENT PROTEINS

The strength of live cell fluorescence imaging is in the specificity with which proteins and cellular structures can be labeled, imaged, and analyzed. Genetically encoded FP tags have revolutionized the analysis of intracellular dynamics and are now the most commonly used. In the last decades, dozens of different types of FPs have been cloned, engineered, and optimized, and Chapter 6 provides an overview of recent FP developments. Here, we briefly summarize important considerations that should enter the design of live cell imaging experiments using FPs:

- *Matching FP spectra and fluorescence filter sets*: Excitation and emission spectra of modern FP variants cover almost the entire visible spectrum. However, in reality, the usefulness of specific FPs will be determined largely by the available excitation and emission bands in a live cell imaging system. To deliver the correct wavelength of light and collect as much signal as possible, excitation and emission filter sets need to be optimized. While epifluorescence filter sets can easily be adapted for different wavelengths, spinning disk confocal microscopes are much less flexible. Excitation and emission bands in a spinning disk confocal microscope are largely determined by the dichroic beam splitter in the spinning disk head. Because these beam splitters operate in reverse (the emission light is reflected) compared with beam splitters in epifluorescence filter

cubes (in which the excitation light is reflected), fewer choices are available. In addition, excitation wavelengths in spinning disk confocal microscopes and other laser-based systems are limited to a relatively small number of available laser lines with sufficient power. For example, while 488 nm is almost optimal for EGFP excitation, it is not for red-shifted brighter variants such as Clover (Lam et al., 2012). Similarly, to optimize the yield of emitted fluorescence, it is essential to match emission filters to the FP emission spectrum. In general, FP emission spectra are broad. Thus, in single wavelengths experiments, long-pass emission filters are preferable to collect as many emitted photons as possible. Ideally, band-pass emission filters should only be used in experiments with multiple FPs, and band-pass filters with the widest permissible transmission bands to avoid cross talk between channels should be selected. Narrower emission bands may be required in specimens with high autofluorescence, and optimized filters sets should be determined empirically. If emitted light is detected inefficiently, higher excitation light intensity will be needed to achieve the same signal-to-noise ratio, which increases photobleaching and phototoxicity.

- *Other factors influencing FP choice*: While fluorescence properties are obviously important for successful live cell imaging, in choosing a specific FP, one should also consider its performance in a specific biological system. This includes the FP tendency to dimerize or aggregate, which will depend on multiple parameters such as temperature, and an FP that works well in yeast may aggregate in mammalian cells. Especially for newer FP variants where reports from the literature may be scarce, it is advisable to test cells for toxic effects and unspecific aggregation when expressing fusion constructs. Finally, maturation time of the fluorophore varies widely between FPs and has to be considered together with FP stability when FP reporters are used to assess protein turnover or rapid gene expression changes.
- *Placement of the FP tag*: We will not cover details of cloning of FP constructs, but it is important to devise a tagging strategy in which the relatively large FP moiety will interfere least with endogenous protein function. FP tags are most commonly placed at the N- or C-termini of the protein of interest but can also be inserted in intrinsically disordered protein regions between folded domains. Immunofluorescence of the endogenous protein as well as functional assays should be used to test to what extent addition of the FP tag interferes with protein localization and function. It is also important to note that different FPs can have very different effects on different proteins of interest. Figure 5.3 shows an example of two FP-tagged constructs of the membrane type 1 matrix metalloprotease (MT1-MMP) that have both been used in a number of publications (Sakurai-Yageta et al., 2008; Wang & McNiven, 2012), and these two constructs label almost entirely different intracellular compartments. Intracellular MT1-MMP transport is complex, and it is possible that differential inhibition of targeting signals enriches FP-tagged MT1-MMP in different transport compartments. This example underscores the importance of testing

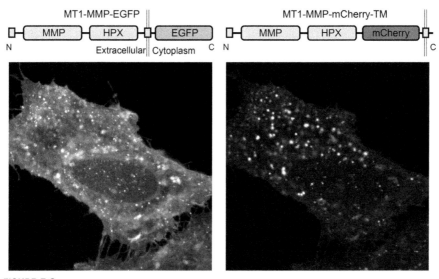

FIGURE 5.3

Influence of tagging strategy on the apparent localization of FP-tagged MT1-MMP. HeLa cells were cotransfected with the constructs indicated. The two constructs localize to mostly distinct intracellular compartments.

different constructs and understanding the underlying biology. If a protein tolerates FP fusion, we have been successful in doubling up EGFP tags to increase brightness and avoid overexpression artifacts. For example, the microtubule plus end-tracking protein EB1 tends to bind along microtubules at high expression levels, which can be minimized by using two tandem EGFP tags resulting in increased signal-to-noise ratio at lower expression levels and lower excitation light intensity (Gierke & Wittmann, 2012).

- *FP photobleaching*: Unfortunately, photobleaching is unavoidable and is often the limiting factor that determines how many images can be acquired. FP photobleaching results from a complex combination of mechanisms specific to different FPs, and currently there is no simple solution to eliminate photobleaching. Although recent reports propose that FP photobleaching in biological media is reduced in the absence of vitamins that can act as electron acceptors (Bogdanov et al., 2009), in our hands, the use of vitamin-free media did not significantly improve EGFP photostability. The origin of this variability is unclear, but it is possible that intracellular concentrations of relevant compounds are different in different cell types. In addition, the characteristics of the imaging system, that is, the specifics of excitation and emission bands, and intracellular environment will influence the apparent brightness and thus apparent photobleaching of specific FPs.

5.4.1 PROTOCOL FOR ANALYZING FP PHOTOBLEACHING

Spinning disk confocal microscopy is the most prominent method of high-resolution live cell imaging of intracellular dynamics using FPs. Yet, the performance of different FPs is rarely examined by spinning disk confocal microscopy. Although FP photobleaching dynamics are complex and discussed in more detail in Chapter 6, we included a specific protocol and results of comparing a variety of different FPs on our spinning disk microscope setup that can be adapted to other microscopes:

- Transfect cells with FP expression constructs. We used a number of different green and red FPs in the same vector backbone based on Clontech's original EGFP-N1 plasmid transfected into immortalized mouse embryonic fibroblasts on 35-mm glass-bottom dishes using FuGENE 6 (Promega) following the manufacturer's instructions.
- Image cells the following day. Locate expressing cells by epifluorescence illumination taking care to minimize light exposure, and let cells recover in the dark for a few minutes before imaging. We imaged cells in 2 ml DMEM containing 20 mM HEPES in dishes sealed with vacuum grease at 37 °C using a Nikon 40× CFI S Plan Fluor N.A. 0.6 air objective to mimic realistic light exposure during a live cell imaging experiment as close as possible. Spinning disk confocal images were taken every 500 ms using a 300 ms exposure with continuous illumination (i.e., shutter remained open between exposures) for several minutes. For the GFP channel, the excitation wavelength was 488 nm, and images were collected through a 505-nm long-pass filter. For RFP variants, excitation was 561 nm and a 575-nm long-pass emission filter.
- Calculate normalized photobleaching kinetics R by dividing the mean background-corrected fluorescence intensity I in an intracellular region of interest (ROI) in each frame by the intensity in the first frame (Fig. 5.4A): $R = (I_{ROI}(n) - I_{BKG})/(I_{ROI}(1) - I_{BKG})$. It is important to calculate such normalized photobleaching curves because FP expression levels in different cells will vary, thus precluding direct comparison of absolute fluorescence of different constructs (Fig 5.4C). To perform this analysis in open-source image analysis software such as ImageJ or Fiji (http://fiji.sc/Fiji; Schindelin et al., 2012), one can use the "multimeasure" function that is accessed via the "ROI Manager" tool, which will measure the average intensity and other parameters in a selected area for every image, and the output can be saved as text file and analyzed as described.

This experiment had the somewhat surprising outcome that both old-fashioned EGFP and mCherry performed better compared with all of the newer FP variants tested. Although initially brighter, Clover fluorescence decreased significantly more rapidly compared with EGFP at both excitation power levels tested (Fig. 5.4B). Similarly, mCherry was not the brightest red FP (Fig. 5.4C), but displayed the slowest photobleaching compared with five other red and orange FPs tested (Fig. 5.4D). This is not easily explained and does not completely reflect what one would expect from

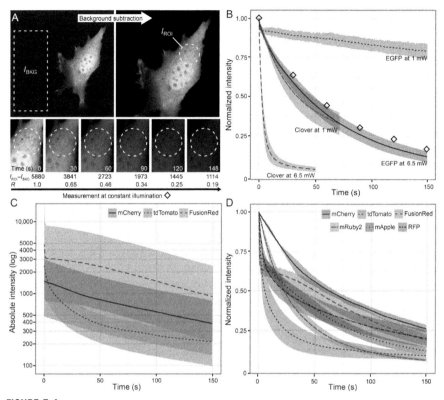

FIGURE 5.4

FP photobleaching characterization on a spinning disk confocal microscope. (A) Example time-lapse sequence of an EGFP-expressing cell illustrating calculation of normalized photobleaching curves. See text for details. (B) Normalized photobleaching curves for Clover and EGFP with continuous 488 nm excitation at two different light power settings. Diamonds correspond to panels and values in (A). (C) Absolute background-corrected fluorescence intensities measured for three different red FPs at the same ~8 mW, 561 nm excitation, illustrating the large variation of absolute intensities in different cells, which is likely due to different expression levels. (D) Normalized photobleaching curves showing widely different photobleaching kinetics for five different red FPs. The normalized curves for mCherry, tdTomato, and FusionRed photobleaching correspond to the absolute intensities shown in (C). Solid and dotted lines in (B–D) represent mean values of five cells. Shaded areas in (B) and (D) are 95% confidence intervals; shaded areas in (C) represent the range of measurements.

reported fluorescence spectra, extinction coefficients, and quantum efficiencies of purified FPs *in vitro*. tdTomato (peak excitation: $\lambda_{Ex} = 554$ nm; peak emission: $\lambda_{Em} = 581$ nm) is not a good match for a typical spinning disk illumination setup (Shaner et al., 2004). A significant part of the emission spectrum is cut off by the

575-nm long-pass filter. Accordingly, tdTomato fluorescence is not imaged efficiently and as expected displays a very high apparent photobleaching rate. In contrast, mRuby ($\lambda_{Ex} = 558$ nm; $\lambda_{Em} = 605$ nm; Kredel et al., 2009) is theoretically a much better match to our illumination setup compared with mCherry ($\lambda_{Ex} = 587$ nm/$\lambda_{Em} = 610$ nm; Shaner et al., 2004) but still bleaches much more rapidly. This comparison further highlights the importance of testing FP performance in the experimental system and imaging setup to be used. It also reaffirms our more qualitative impression that EGFP and mCherry are possibly still the best FP protein pair for spinning disk confocal imaging with commonly available filter sets although we have certainly sampled only a small set of the available range of green and red FPs.

5.5 OTHER FLUORESCENT PROBES

Although genetically encoded FP tags are the most popular and straightforward choice, other methods to label intracellular structures or specific proteins with chemical fluorophores exist. Many modern fluorescent dyes, such as the series of Alexa dyes, have evolved through derivatization of earlier fluorescent molecules such as fluorescein or rhodamine. These modern dyes have advantages such as better quantum efficiency and brightness compared with FPs, which can be essential for certain techniques. For example, fluorescent speckle microscopy relies on a high signal-to-noise ratio of clusters of few fluorescent molecules in F-actin networks or microtubules and works best with fluorophore-conjugated actin or tubulin (Mendoza, Besson, & Danuser, 2012). A disadvantage of direct chemical fluorophore conjugation is the need for significantly more complicated experimental protocols including purification, fluorescent labeling, and microinjection of the labeled protein that in many cases may not be feasible. Hybrid systems that combine genetic encoding and chemistry such as the SNAP-, CLIP-, and Halo-tags (Stagge, Mitronova, Belov, Wurm, & Jakobs, 2013) are growing in popularity and utilize nonfluorescent genetically encoded enzyme tags that can specifically react with cell-permeable fluorogenic molecules. However, potential background fluorescence and unspecific sticking of hydrophobic fluorogenic molecules to cell membranes may limit the usefulness of these systems for live cell imaging, although almost no direct comparison of SNAP-, CLIP-, or Halo-tags with FP-tagged proteins is available. In contrast to FPs, oxidative photobleaching of many fluorescent dyes can be reduced by oxygen depletion of the imaging medium, for example, by the addition of Oxyrase (Oxyrase Inc.), a proprietary enzyme system, to the imaging medium that oxidizes lactate and other organic acids (Wittmann, Bokoch, & Waterman-Storer, 2003). This only works in well-sealed imaging chambers that effectively prevent gas exchange with atmospheric oxygen. However, photobleaching of chemical fluorescent dyes also tends to be more cytotoxic possibly because the cytoplasm is less protected from reactive free radical breakdown products compared with FPs in which the fluorophore is isolated from the cytoplasm by the FP β-barrel structure.

Finally, a variety of cell-permeable fluorescent molecules are available that more or less specifically label intracellular organelles. These include intercalating DNA dyes such DAPI, molecules that become trapped in specific organelles after chemical modification such as MitoTracker (Invitrogen), which is oxidized and retained in mitochondria, or fluorescent molecules that preferentially bind to specific membrane compositions. Although many of these probes are marketed as live cell imaging reagents, it is important to note that imaging of these molecules often rapidly produces highly cytotoxic breakdown products. This light-induced cytotoxicity is easily observed in MitoTracker-labeled cells in which mitochondria swell rapidly during illumination. Of note, many small molecule inhibitors used in cell biology research are also highly fluorescent and in addition to increasing background fluorescence can generate extremely cytotoxic breakdown products. Thus, special care should be taken to ensure cell health when using any of these vital dye fluorescent probes or potentially fluorescent small molecule compounds.

CONCLUSION

Photobleaching is a fact of life. Even the best fluorescent molecule converts only a fraction of absorbed energy into fluorescence. Some of this energy will inevitably be channeled into chemical reactions that result in fluorophore breakdown. Thus, in addition to maintaining a physiological environment and confirming specific labeling and function of the protein or organelle of interest, the single most important factor to successful live cell imaging and meaningful data is to limit excitation light as much as possible. This requires an in-depth understanding of the microscope used and optimization of the components that control exposure, wavelengths selection, and collection of emitted photons. Similarly important is a good practice in setting up experiments. Wait for dark adaptation of the visual system before attempting to find a dim sample. Modern cameras are much more sensitive than the human eye, and it is often better to take quick snapshots to locate areas of interest rather than staring through the eyepiece for an extended period of time. However, never use live camera modes to find your sample. Every photon is sacred.

ACKNOWLEDGMENTS

This work was supported by the National Institutes of Health Grants R01 GM079139, R01 GM094819 and Shared Equipment Grant S10 RR26758.

REFERENCES

Attardo, A., Calegari, F., Haubensak, W., Wilsch-Brauninger, M., & Huttner, W. B. (2008). Live imaging at the onset of cortical neurogenesis reveals differential appearance of the neuronal phenotype in apical versus basal progenitor progeny. *PLoS One*, *3*, e2388.

Bogdanov, A. M., Bogdanova, E. A., Chudakov, D. M., Gorodnicheva, T. V., Lukyanov, S., & Lukyanov, K. A. (2009). Cell culture medium affects GFP photostability: A solution. *Nature Methods*, *6*, 859–860.

Gao, L., Shao, L., Higgins, C. D., Poulton, J. S., Peifer, M., Davidson, M. W., et al. (2012). Noninvasive imaging beyond the diffraction limit of 3D dynamics in thickly fluorescent specimens. *Cell*, *151*, 1370–1385.

Gierke, S., & Wittmann, T. (2012). EB1-recruited microtubule+TIP complexes coordinate protrusion dynamics during 3D epithelial remodeling. *Current Biology*, *22*, 753–762.

Haynes, J., Srivastava, J., Madson, N., Wittmann, T., & Barber, D. L. (2011). Dynamic actin remodeling during epithelial-mesenchymal transition depends on increased moesin expression. *Molecular Biology of the Cell*, *22*, 4750–4764.

Jacobson, K., Rajfur, Z., Vitriol, E., & Hahn, K. (2008). Chromophore-assisted laser inactivation in cell biology. *Trends in Cell Biology*, *18*, 443–450.

Kredel, S., Oswald, F., Nienhaus, K., Deuschle, K., Rocker, C., Wolff, M., et al. (2009). mRuby, a bright monomeric red fluorescent protein for labeling of subcellular structures. *PLoS One*, *4*, e4391.

Lalkens, B., Testa, I., Willig, K. I., & Hell, S. W. (2012). MRT letter: Nanoscopy of protein colocalization in living cells by STED and GSDIM. *Microscopy Research and Technique*, *75*, 1–6.

Lam, A. J., St-Pierre, F., Gong, Y., Marshall, J. D., Cranfill, P. J., Baird, M. A., et al. (2012). Improving FRET dynamic range with bright green and red fluorescent proteins. *Nature Methods*, *9*, 1005–1012.

Mendoza, M. C., Besson, S., & Danuser, G. (2012). Quantitative fluorescent speckle microscopy (QFSM) to measure actin dynamics. *Current Protocols in Cytometry*, 2.18.1–2.18.26 (Chapter 2: 2.18.1 - 2.18.26).

Sakurai-Yageta, M., Recchi, C., Le, D. G., Sibarita, J. B., Daviet, L., Camonis, J., et al. (2008). The interaction of IQGAP1 with the exocyst complex is required for tumor cell invasion downstream of Cdc42 and RhoA. *Journal of Cell Biology*, *181*, 985–998.

Schindelin, J., Arganda-Carreras, I., Frise, E., Kaynig, V., Longair, M., Pietzsch, T., et al. (2012). Fiji: An open-source platform for biological-image analysis. *Nature Methods*, *9*, 676–682.

Shaner, N. C., Campbell, R. E., Steinbach, P. A., Giepmans, B. N., Palmer, A. E., & Tsien, R. Y. (2004). Improved monomeric red, orange and yellow fluorescent proteins derived from Discosoma sp. red fluorescent protein. *Nature Biotechnology*, *22*, 1567–1572.

Stagge, F., Mitronova, G. Y., Belov, V. N., Wurm, C. A., & Jakobs, S. (2013). SNAP-, CLIP- and halo-tag labelling of budding yeast cells. *PLoS One*, *8*, e78745.

Stehbens, S., Pemble, H., Murrow, L., & Wittmann, T. (2012). Imaging intracellular protein dynamics by spinning disk confocal microscopy. *Methods in Enzymology*, *504*, 293–313.

Wang, E., Babbey, C. M., & Dunn, K. W. (2005). Performance comparison between the high-speed Yokogawa spinning disc confocal system and single-point scanning confocal systems. *Journal of Microscopy*, *218*, 148–159.

Wang, Y., & McNiven, M. A. (2012). Invasive matrix degradation at focal adhesions occurs via protease recruitment by a FAK-p130Cas complex. *Journal of Cell Biology*, *196*, 375–385.

Wittmann, T., Bokoch, G. M., & Waterman-Storer, C. M. (2003). Regulation of leading edge microtubule and actin dynamics downstream of Rac1. *Journal of Cell Biology*, *161*, 845–851.

Fluorescent proteins for quantitative microscopy: Important properties and practical evaluation

CHAPTER 6

Nathan Christopher Shaner

The Scintillon Institute, San Diego, California, USA

CHAPTER OUTLINE

6.1 Optical and Physical Properties Important for Quantitative Imaging 96
 6.1.1 Color and Brightness.. 96
 6.1.2 Photostability.. 98
 6.1.3 Other Properties ... 98
6.2 Physical Basis for Fluorescent Protein Properties ... 99
 6.2.1 Determinants of Wavelength .. 99
 6.2.2 Determinants of Brightness ... 100
6.3 The Complexities of Photostability ... 101
 6.3.1 Multiple Photobleaching Pathways ... 102
 6.3.2 Photobleaching Behaviors ... 102
 6.3.3 Reporting Standards for FP Photostability................................. 106
6.4 Evaluation of Fluorescent Protein Performance *in Vivo* 106
 6.4.1 Cell-line-specific Photostability and Contrast Evaluation 107
 6.4.2 Fusion Protein-specific FP Evaluation 108
Conclusion .. 108
References .. 109

Abstract

More than 20 years after their discovery, fluorescent proteins (FPs) continue to be the subject of massive engineering efforts yielding continued improvements. Among these efforts are many aspects that should be of great interest to quantitative imaging users. With new variants frequently introduced into the research community, "tried and true" FPs that have been relied on for many years may now be due for upgrades to more modern variants. However, the dizzying array of FPs now available can make the initial act of narrowing down the potential choices an intimidating prospect. This chapter describes the FP properties that most strongly

impact their performance in quantitative imaging experiments, along with their physical origins as they are currently understood. A workflow for evaluating a given FP in the researcher's chosen experimental system (e.g., a specific cell line) is described.

6.1 OPTICAL AND PHYSICAL PROPERTIES IMPORTANT FOR QUANTITATIVE IMAGING

The breadth of properties in currently available FP variants (Chudakov, Matz, Lukyanov, & Lukyanov, 2010; Shaner, Patterson, & Davidson, 2007) is frequently a source of confusion and frustration among researchers simply wishing to choose the best FP for their particular experiment. Unfortunately, the default position is often to fall back to old FP constructs that are unlikely to provide optimal performance, especially for quantitative fluorescence experiments. At the same time, evaluation of all possible FPs in each experimental context is highly impractical given the huge number of options. The following section enumerates several of the most important properties to consider when narrowing down candidates for use in quantitative microscopy. A listing of the physical and optical properties of some of the most favorable FP choices for quantitative fluorescence imaging is shown in Table 6.1, along with comments on specific advantages and disadvantages of particular variants.

6.1.1 COLOR AND BRIGHTNESS

Foremost among the properties usually noted for FPs are color (excitation and emission wavelength) and brightness (determined by extinction coefficient and quantum yield). Both of these can significantly impact quantitative imaging performance.

The FP color should be chosen carefully to avoid interference from cellular autofluorescence. In general, for mammalian cells, autofluorescent emission is primarily confined to the blue to yellow region of the spectrum, with excitation up to about 500 nm (Aubin, 1979). Thus, for mammalian systems, FPs with longer excitation and emission wavelengths will increase contrast with autofluorescent background. In other systems with a greater number of photoactive components, the situation is more complicated. In plant cells, it is often the shorter-wavelength FPs such as blue emitters that are the most favorably placed relative to autofluorescence (and in some cases, red-orange emitters) (Roshchina, 2012). In any case, it is important to evaluate control (nonexpressing) cells for the intensity and wavelength distribution of autofluorescence prior to performing quantitative image analysis. Brightness of the FP variant used for a quantitative experiment also comes into play in this analysis, since the brighter the FP, the greater the contrast will be, relative to any autofluorescence that is present in a given cell type.

As with most imaging experiments, brighter FPs, provided that their other properties are favorable, are usually preferable choices. Luckily, very bright FPs across most of the visual spectrum are now available, though those at the red end of the

Table 6.1 Optical and physical properties of selected FPs useful in quantitative imaging

Protein name[a]	λ_{ex}[b]	λ_{em}[c]	ε[d]	Φ[e]	Photostability (wide-field)[f]	Comments
mTurquoise2[g]	434	474	30,000	0.93	90	Highest QY true cyan monomer
mTFP1[h]	462	488	64,000	0.85	110	Single-peak "teal" monomer
mEGFP[i]	488	507	56,000	0.60	150	Monomeric variant of EGFP
mEmerald[j]	487	509	57,000	0.68	101[k]	Fast initial bleaching component
mWasabi[l]	493	509	70,000	0.80	93	Brightest "green" monomer
mNeonGreen[m]	506	517	116,000	0.80	158	Brightest monomer
Clover[n]	505	515	111,000	0.76	50	Weak dimer
mVenus[o]	515	528	92,000	0.57	15	Faster maturation, more acid-sensitive
mCitrine[p]	516	529	77,000	0.76	49	Brightest YFP variant
mOrange2[q]	549	565	58,000	0.60	228	Slow maturation
TagRFP-T[q]	555	584	81,000	0.41	337	Most photostable monomer
mRuby2[n]	559	600	113,000	0.38	123	Brightest red monomer
mCherry[r]	587	610	72,000	0.22	96	Simple photobleaching curve
mKate2[s]	588	633	62,500	0.40	118	Brightest long-wavelength

[a]All proteins shown in this table are monomeric unless otherwise noted.
[b]Major excitation peak (nm).
[c]Major emission peak (nm).
[d]Extinction coefficient (M^{-1} cm^{-1}).
[e]Fluorescence quantum yield.
[f]Time to reach half of initial fluorescence output at a wide-field illumination intensity giving an initial fluorescence output of 1000 photons per second per chromophore (Shaner, Steinbach, & Tsien, 2005).
[g]Goedhart et al. (2012).
[h]Ai, Henderson, Remington, and Campbell (2006).
[i]Shaner et al. (2007) and Zacharias, Violin, Newton, and Tsien (2002).
[j]Cubitt, Woolleweber, and Heim (1999) and Zacharias et al. (2002).
[k]Measured in cells as H2B fusion; due to fast initial bleaching component, the photostability of Emerald variants is difficult to measure precisely (Shaner et al., 2005, 2007).
[l]Ai, Olenych, Wong, Davidson, and Campbell (2008).
[m]Shaner et al. (2013).
[n]Lam et al. (2012).
[o]Nagai et al. (2002) and Zacharias et al. (2002).
[p]Griesbeck, Baird, Campbell, Zacharias, and Tsien (2001) and Zacharias et al. (2002).
[q]Shaner et al. (2008).
[r]Shaner et al. (2004).
[s]Shcherbo et al. (2009).

spectrum have still not caught up to the brightest green and yellow variants. Brightness is largely determined by the inherent optical properties of the folded FP (quantum yield and extinction coefficient) but can also be heavily influenced by the folding efficiency of a given FP variant in a particular cell line. Most modern FPs fold quickly and efficiently in most systems, but it is still important to consider this as a potential factor when comparing FPs for use in a specific experiment. Several comprehensive reviews of FPs have been published over the years, many of which provide in-depth information about various aspects of FP engineering and expression (among many helpful reviews, Chudakov et al., 2010; Miyawaki, 2011; Shaner et al., 2005, 2007; Tsien, 1998; Wachter, Watkins, & Kim, 2010).

6.1.2 PHOTOSTABILITY

Photostability is among the most critical parameters to consider when choosing FPs for quantitative imaging experiments. Even the most photostable FP variants do undergo some degree of photobleaching during the course of most experiments, and so even when choosing high-stability variants, it is important to understand and correct for this behavior in order to obtain quantitative image data. Because FP behavior may be altered depending on localization (e.g., photobleaching may be faster when localized to oxidative organelles such as the ER), culture conditions, or specific illumination source and intensity used for a particular experiment, it is essential to measure this behavior in the specific context planned for a given experiment. In Section 6.4, we describe a workflow for determining the photobleaching curve for specific FP fusions in your system of choice.

6.1.3 OTHER PROPERTIES

Several other properties come into play when choosing an FP variant for quantitative imaging. Among these are ion and pH sensitivity (Griesbeck et al., 2001), tendency to dimerize or form higher-order oligomers (Campbell et al., 2002; Yarbrough, Wachter, Kallio, Matz, & Remington, 2001; Zacharias et al., 2002), folding efficiency (Nagai et al., 2002), and tendency to disrupt the localization or behavior of fusion partners. Ion sensitivity is no longer a common problem in modern FP variants, since they are commonly screened for this behavior during the engineering process. When selecting an FP to target to acidic compartments or to a subcellular environment whose pH may not be stable, one must take into account the fluorescence pKa of the FP to ensure that its output will not be impacted by this environment. Generally, cyan, green, and yellow FPs tend to be more pH-sensitive than red FPs, but there is wide variation in this property among available variants.

For the majority of applications, truly monomeric fluorescent proteins are the best choice as a fusion tag, since they are the least likely to cause aberrant behavior or localization of their fusion partner. Unfortunately, many FP variants that have been

previously described as "monomeric" continue to display a small tendency to dimerize under conditions of high local concentration. Only more recently have functional tests such as the OSER assay (Costantini, Fossati, Francolini, & Snapp, 2012) been employed to evaluate the "monomericness" of FPs inside mammalian cells (Shaner et al., 2013), and so for older FPs, such data may not be available. Likewise, the standard of testing many different fusions to a novel FP variant for its initial publication is fairly new, and systematic data on fusion tag performance are sorely lacking for many older or less commonly used FPs. Thus, it is important to carefully evaluate a given FP variant for signs of interference with native function and localization of its fusion partner.

6.2 PHYSICAL BASIS FOR FLUORESCENT PROTEIN PROPERTIES

In the many years since they were first discovered, our knowledge of the complex posttranslational chemistry that takes place in FPs has steadily accumulated. The origins of many important FP optical and physical properties are now well understood.

6.2.1 DETERMINANTS OF WAVELENGTH

All naturally occurring FPs share the same general three-dimensional structure and the same core p-hydroxybenzylidene-imidazolinone chromophore structure, which is formed autocatalytically from the peptide backbone by cyclization and oxidation of an X-Tyr-Gly tripeptide. This basic chromophore absorbs either near-UV (~400 nm) or blue (~488 nm) depending on the protonation state of the phenolate moiety and emits green (~510 nm) (Tsien, 1998). Modifications to this chromophore structure that increase or reduce the number of conjugated double bonds lead to red- and blue-shifted excitation and emission spectra, respectively (Miyawaki, Shcherbakova, & Verkhusha, 2012; Shu, Shaner, Yarbrough, Tsien, & Remington, 2006; Tsien, 1998). Other factors, such as charge interactions or pi-orbital stacking, have significant (but usually smaller) impacts on excitation and emission wavelength.

The first synthetic modifications to the core chromophore structures were substitutions of the central tyrosine for other aromatic amino acids, producing cyan (Tyr → Trp) and blue (Tyr → His) variants of GFP (Tsien, 1998). The chromophore within DsRed, the first of many red-emitting FPs to be discovered (Matz et al., 1999), is extended by two additional double bonds through an additional oxidation of the main peptide backbone, producing an acylimine moiety (Gross, Baird, Hoffman, Baldridge, & Tsien, 2000; Yarbrough et al., 2001). Since these two types of chromophore variant were discovered, many other variations have been identified in naturally occurring FPs or engineered through rational design, producing FPs that span practically the entire visible spectrum in emission wavelengths (Ai, Shaner, Cheng, Tsien, & Campbell, 2007; Shaner et al., 2004; Shcherbo et al., 2009).

6.2.2 DETERMINANTS OF BRIGHTNESS

The brightness of an FP is determined by how effectively its chromophore absorbs incoming light and how efficiently this absorbed energy is converted back into emitted fluorescence. These two factors are known as extinction coefficient and quantum yield.

The peak molar extinction coefficient is related to the absorbance cross section of the FP chromophore and essentially describes how strongly the chromophore absorbs light at its peak absorbance wavelength. Extinction coefficient in FPs can be viewed in two different ways, both of which are useful when evaluating an FP for practicality. The *absolute extinction coefficient* is an intrinsic property of the chromophore, while the *effective extinction coefficient* is additionally influenced by folding and maturation efficiency of the FP.

First, one may consider the absolute extinction coefficient of a properly folded FP molecule with a mature chromophore, at its peak absorbance wavelength. This is the parameter reported in the primary literature for FPs, because it is very easy to measure and does not vary between systems (e.g., the measured value will be the same in protein purified from *E. coli* or in mammalian cells). The absolute extinction coefficient is usually measured by comparing absorbance spectra of the FP before and after denaturation by sodium hydroxide, which unfolds the protein and converts most chromophores into a "universal" form with a known extinction coefficient (Chalfie & Kain, 2006). This value is a best-case scenario for FP performance, because it does not take into consideration the folding efficiency of the FP.

The second way to view FP extinction coefficient is the effective extinction coefficient of the entire population of expressed FP (either alone or as a fusion to another protein). In this case, the protein concentration is determined through a quantitative means (such as absorbance at 280 nm or Bradford assay). This effective extinction coefficient is always lower than the absolute extinction coefficient because no population of FP molecules will exhibit 100% folding and maturation efficiency in any system. This parameter may, in fact, differ very greatly between expression systems and thus can be a major determinant of the practicality of a particular FP in a specific experiment. Unfortunately, because its value is generally idiosyncratic to the specific expression system and fusion partner, it is necessary to determine it empirically for each new experiment, and quantitative data are scarce on how effective extinction coefficient varies between systems for different FPs.

Beyond the simplified "peak extinction coefficient," it may also be useful to consider the peak shape and area under the curve for absorbance spectra of individual FP variants. In general, FPs with relatively narrow absorbance peaks have higher extinction coefficients, while FPs with broader absorbance peaks have lower extinction coefficients. However, differences in extinction coefficient cannot be entirely explained by peak shape. While for most practical purposes it is possible to compensate for differences in peak shape or even in absolute extinction coefficient, by adjusting illumination intensity and/or using different filter sets, in some cases, peak shape becomes important and must be taken into account when designing an experiment (particularly when using multiple labels, to minimize overlap in excitation). Figure 6.1 illustrates the diversity of absorbance peak shapes and extinction coefficients among FPs.

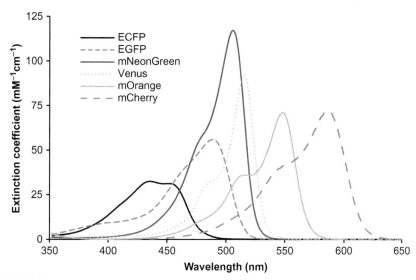

FIGURE 6.1

Absorbance spectra of the representative FPs ECFP (Cubitt et al., 1999), EGFP (Tsien, 1998), mNeonGreen (Shaner et al., 2013), Venus (Nagai et al., 2002), mOrange (Shaner et al., 2004), and mCherry (Shaner et al., 2004), in order from lowest to highest absorbance peak wavelength. Absolute absorbance curves for each FP are scaled to their peak extinction coefficients, illustrating the wide variations in peak shape and area under the curve (AUC) for various FPs. Among the FPs shown, mNeonGreen displays the largest AUC (100%), followed by mCherry (95%), EGFP (73%), mOrange (72%), Venus (66%), and ECFP (45%).

The quantum yield of a particular FP, unlike the effective extinction coefficient, rarely varies between expression systems. Quantum yield is simply the fraction of absorbed photons that lead to emitted fluorescence. When a chromophore absorbs an incoming photon, it enters an excited state that can typically return to the ground state via several parallel mechanisms, one of which is emission of a photon (fluorescence). The fraction of excited state chromophores returning to the ground state via the emissive pathway is the quantum yield. Other pathways for relaxation to the ground state involve energy transfer to other parts of the protein (as heat), and so FPs with fewer options for nonemissive relaxation have higher quantum yields. One of the major determinants of this is the planarity of the chromophore, with more planar chromophores generally displaying higher quantum yields (Shu et al., 2006).

6.3 THE COMPLEXITIES OF PHOTOSTABILITY

Photostability is among the most important FP properties to consider when choosing a variant for quantitative imaging. Fluorescent proteins are frequently described as "highly photostable" or "poorly photostable," but this superficial

description says very little about this potentially very complex behavior. Described in the succeeding text are several important factors to consider when evaluating the photostability of a given fluorescent protein.

6.3.1 MULTIPLE PHOTOBLEACHING PATHWAYS

Photobleaching in fluorescent proteins is rarely observed as a single-exponential decay of emitted fluorescence. This is primarily due to the presence of multiple pathways capable of deactivating the fluorescence (either permanently or transiently) of the chromophore. Known and theorized pathways for photobleaching include (1) *cis* to *trans* isomerization of the double bond adjacent to the chromophore phenolate, (2) photochemical decarboxylation of glutamate or aspartate side chains in the vicinity of the chromophore, (3) oxidative modification of side chains proximal to the chromophore, (4) oxidative modification of the chromophore itself, (5) temporary but long-lived chromophore protonation, (6) other photochemical reactions leading to cleavage or modification of the chromophore, and (7) entry of the excited state chromophore into a triplet state via a "forbidden" singlet-to-triplet transition, followed by relaxation to the ground state with a long half-life (Chalfie & Kain, 2006; Chapagain, Regmi, & Castillo, 2011; Dean et al., 2011; Duan et al., 2013; McAnaney et al., 2005; Regmi, Bhandari, Gerstman, & Chapagain, 2013; Shaner et al., 2008; Sinnecker, Voigt, Hellwig, & Schaefer, 2005). Some of these processes (2, 3, 4, and 6) may lead to permanent bleaching or other permanent changes in the optical characteristics of the FP. Others (1, 5, and 7) are generally reversible and/or temporary. This mix of potential bleaching pathways begets the complex bleaching curves observed for most FPs.

Controllable reversible conversion to a dark state (often termed "photoswitching") is a highly useful property for specialized applications such as single-molecule super-resolution microscopy (Patterson, Davidson, Manley, & Lippincott-Schwartz, 2010). However, for the purposes of this discussion, we will exclude photoswitchable and photoconvertible FP variants and focus instead on "traditional" FPs with simpler photobleaching decay curves.

6.3.2 PHOTOBLEACHING BEHAVIORS

Most fluorescent proteins display at least two major photobleaching components, each with a different half-time of roughly exponential decay. These components (both their magnitude and half-times) are individual to each fluorescent protein variant and have been fully characterized for very few variants to date. To complicate matters, one or both of these major components may be partly or fully reversible, meaning that if not left under constant illumination, some portion of the fluorescence will recover in the dark with its own half-time (which may additionally be temperature dependent, among other things) (Shaner et al., 2008; Sinnecker et al., 2005). Many fluorescent proteins also display some degree of photoactivation upon

illumination, which may temporarily increase their fluorescence emission until the entire population of chromophores has been activated and bleaching becomes dominant. One or more photobleaching or photoactivation components may also be oxygen-dependent (Regmi et al., 2013; Shaner et al., 2008).

Some examples of complex photobleaching curves for common fluorescent proteins are shown in Fig. 6.2, illustrating the different behaviors observed depending on the dominant components of photobleaching. Of particular note are the large differences in behavior observed between continuous illumination (the standard method of measuring photostability) and intermittent illumination (the standard method of performing real-world imaging experiments) (Fig. 6.3), which can be partially explained by the phenomenon of reversible dimming (Fig. 6.4).

The simplest expectation of photobleaching is that the rate of a given component will scale linearly with the illumination intensity (or equivalently, the initial light output of the FP population). Indeed, photobleaching rates are usually roughly linearly proportional to illumination intensity within ~1 order of magnitude of the intensity used for measurement. However, when illumination intensity is much higher or lower than that used for measurement, photobleaching behavior is frequently very different. This may be due in part to rate-limiting factors such as oxygen diffusion that favor nonoxidative photobleaching pathways

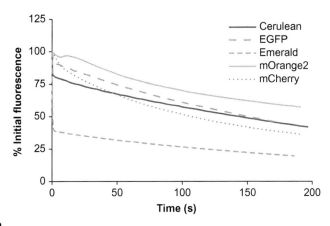

FIGURE 6.2

Wide-field photobleaching curves of the representative FPs Cerulean (Markwardt et al., 2011), EGFP (Tsien, 1998), Emerald (Tsien, 1998), mOrange2 (Shaner et al., 2008), and mCherry (Shaner et al., 2004). Several types of multicomponent fluorescence decay curves are illustrated from these examples, including fast early bleaching (Emerald and Cerulean) and photoactivation (mOrange2). Both EGFP and mCherry have simpler curves than many other FPs. The timescale is adjusted such that each curve represents an initial output of 1000 photons per second per chromophore under continuous illumination (Shaner et al., 2005).

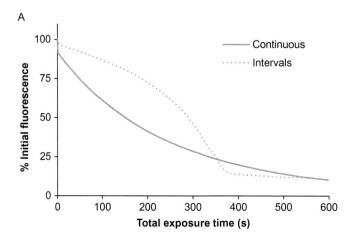
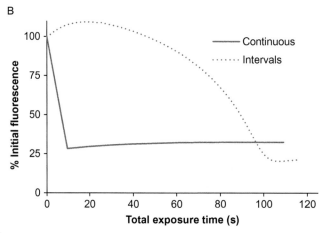

FIGURE 6.3

Photobleaching behavior differs depending on exposure regimen. Two notable examples are shown here: (A) EGFP (Tsien, 1998) displays markedly nonexponential fluorescence decay when imaged intermittently, compared to an almost-exponential decay curve under continuous illumination; (B) mApple (Shaner et al., 2008) displays a very fast initial bleaching component followed by a prolonged plateau under continuous illumination but appears far more photostable (but highly nonexponential) when imaged intermittently. The timescale is adjusted such that each curve represents an initial output of 1000 photons per second per chromophore. Intermittent illumination curves were obtained using a 200-ms exposure every 10 s; the timescale for intermittent illumination represents the cumulative exposure time (i.e., not counting the periods between exposures).

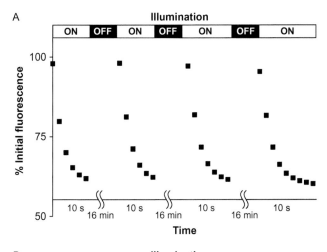
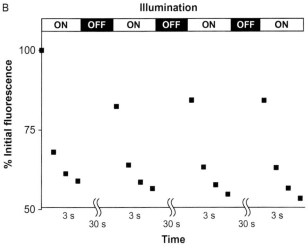

FIGURE 6.4

Reversible dimming in FPs. Many commonly used FPs display a behavior similar to photochromism in which they reversibly lose fluorescence under continuous illumination. Among the many examples, (A) Cerulean (Rizzo, Springer, Granada, & Piston, 2004) loses ~40% of its initial fluorescence upon continuous exposure to high-intensity wide-field illumination for 10 s but recovers nearly all of this emission brightness if left in the dark for approximately 16 min (Shaner et al., 2008); (B) mApple (Shaner et al., 2008) displays even faster kinetics for reversible dimming, losing nearly half of its initial brightness within ~3 s and regaining 80% or more after only 30 s in the dark. Whether this process is similar to photoswitching in other FPs (such as Dronpa; Ando, Mizuno, & Miyawaki, 2004) remains unclear.

under very high illumination intensities (Duan et al., 2013). As a result, the relative photostabilities of different FPs measured using wide-field arc-lamp illumination typically bear little relation to those observed for laser-scanning confocal illumination.

Due to these many complexities, it is critical to evaluate photostability of an FP in as close to the same illumination regime as will be used experimentally, taking into account the intensity, duration, and interval of illumination in order to determine which bleaching behaviors will contribute to changes in fluorescence over the course of an experiment. By carefully measuring these effects, it is possible to correct for even the most complex FP photobleaching behaviors.

6.3.3 REPORTING STANDARDS FOR FP PHOTOSTABILITY

Unfortunately, despite years of discussion among the scientific community, there remains no set standard for measuring and reporting FP photostability in the literature. Since most photobleaching behavior is nonexponential and contains multiple components with different time constants, expressing FP photostability as a single-exponential time constant is not very meaningful. Increasingly, journals expect authors to provide full photobleaching curves for novel FPs, which is helpful only if these curves are measured in a way that allows for direct comparison to other FPs. It is this author's opinion that the most reliable way to compare FP photostabilities is to (1) measure them in living cells, (2) normalize to a standard of known half-time (EGFP, e.g., loses 50% of its initial fluorescence in 150 s under an illumination intensity that produces 1000 emitted photons per second per chromophore; Shaner et al., 2007), and (3) verify all photobleaching behaviors under a variety of illumination intensities and intervals. Until a universally accepted standard for literature reporting of FP photostability materializes (an unlikely possibility), researchers would be well advised to rely primarily on their own real-world comparisons of FP performance, as described in the next section.

6.4 EVALUATION OF FLUORESCENT PROTEIN PERFORMANCE *IN VIVO*

Among the most critical prerequisites for performing quantitative fluorescence microscopy is a thorough understanding of the behavior of one's chosen fluorescent protein probe(s) in the system of interest. While the basic physical and optical characterization data presented in most primary fluorescent protein literature provide a broad view of the performance of individual variants, there are too many potentially complicating factors to predict with high confidence whether a given variant will perform well in a specific experiment. Because of this unfortunate reality, the best approach is generally to evaluate each potential FP tag in a context as similar as possible to the intended experiment. Among the factors that should be considered are (1) cell type; (2) culture conditions; (3) cameras, microscope optics, and filter sets;

(4) illumination intensity; (5) exposure duration and frequency; and (6) subcellular environment experienced by the FP fusion.

6.4.1 CELL-LINE-SPECIFIC PHOTOSTABILITY AND CONTRAST EVALUATION

Several factors can improve the quality of data collected to evaluate the performance of one or many fluorescent proteins in a given cell line of interest. Confining the FP to a subcellular compartment such as the nucleus generally produces much less cell-to-cell variation than expression of an unfused FP that will be present mainly in the cytoplasm. Analysis can be simplified further by fusion of the FP to a relatively non-diffusible protein such as histone 2B (H2B) (Shaner et al., 2007). Fusion to H2B holds the additional advantage of allowing the observation of mitosis in the target cell line, in order to determine whether the FP interferes with the function of its fusion partner.

This evaluation workflow allows for the comparison of fluorescent proteins of any wavelength class for practicality in a given imaging setup and cell type. To rank FPs for their usefulness in a given quantitative imaging experiment, it is most important to consider (1) the contrast of FP fluorescence versus cellular autofluorescence and (2) the FP's general photostability and photobleaching decay curve under experimental conditions. In theory, it is possible to correct for both of these effects if careful measurements are taken using the appropriate controls.

PROTOCOL
1. Construct expression plasmids encoding H2B fusions to each FP (both N- and C-terminal fusions of H2B behave similarly, but both can be tested if desired).
2. Transfect cultured cells in No. 1.5 coverslip bottom dishes with H2B fusions and incubate 24–48 h under normal culture conditions; keep several nontransfected controls under identical growth conditions.
3. For each FP, choose filter sets appropriate to the excitation and emission spectra. If no specific filter set is described in the primary literature on the FP, consult filter manufacturers, who frequently have online tools for comparing spectra and recommending filter sets. If all else fails, contact the author of the primary publication for advice on choosing the best filter set.
4. Conduct imaging using the same microscope, objective, filter set, temperature, and atmosphere intended for later experiments. Ensure that all microscope components and culture dishes have equilibrated to the experimental temperature and atmosphere prior to commencing imaging.
5. Adjust neutral density filters to achieve the lowest illumination intensity possible while scanning the culture dish for a suitable field of cells to image—this minimizes "prebleaching" that will confound analysis later.
6. Once a suitable field of cells for imaging has been identified and the microscope focused, immediately discontinue illumination for at least 5 min prior to commencing photobleaching experiments—this will allow most reversible dimming to recover prior to measurement. If focus drifts significantly

during the waiting period, this generally indicates that one or more components (microscope objective, culture dish, etc.) have not yet equilibrated to temperature.
7. Image cells using exposure times, illumination intensity, and interexposure intervals similar to those planned for the intended experiments. It may be useful to perform a range of exposure regimens to cover the most likely range of intensities, on times, and off intervals to be used later. Ensure that at least 10–20 cells are imaged for each regimen in one or multiple fields.
8. Analyze intensity data for as many cells as possible in the field of view for each run. Large variances in measured photobleaching curves may indicate nonuniformity in illumination over the field of view. Average photobleaching curves for each illumination regimen can then be used as calibration standards to correct for photobleaching in experimental data obtained under identical regimens.
9. Image nontransfected cells using identical illumination and exposure settings to those used for transfected cells for several frames; this will provide a basis for determining FP contrast with autofluorescence, which may also photobleach over time.

6.4.2 FUSION PROTEIN-SPECIFIC FP EVALUATION

Once the list of FP candidates for a given experiment has been narrowed down, it can be highly useful to perform additional evaluation of each FP in a context more similar to the ultimate experimental system. Several factors are important to note, including whether the FP perturbs localization or function of the fusion partner and whether the specific subcellular milieu of the fusion partner affects the fluorescence or photostability of the FP. This evaluation should follow the general workflow of the previous section, using the fusion(s) in question under well-controlled conditions. To verify correct localization of FP fusions, it can be helpful to use immunofluorescence staining in transfected and identical nontransfected cells as a reference.

CONCLUSION

Careful evaluation of FPs is a critical step prior to gathering important data in quantitative fluorescence microscopy experiments. Several factors influence the performance of a given FP in each experimental system, and no single FP can be classified as the "best choice" for all experiments. By following the guidelines described here, it is possible to determine which among the ever more numerous FP variants are most likely to perform well in a given context and to produce useful data to correct for photobleaching artifacts and autofluorescence. This workflow can be further extended to determine more complex photobleaching behavior in multilabeling and FRET experiments.

REFERENCES

Ai, H.-W., Henderson, J. N., Remington, S. J., & Campbell, R. E. (2006). Directed evolution of a monomeric, bright and photostable version of Clavularia cyan fluorescent protein: Structural characterization and applications in fluorescence imaging. *Biochemical Journal*, *400*(3), 531–540. http://dx.doi.org/10.1042/BJ20060874.

Ai, H.-W., Olenych, S. G., Wong, P., Davidson, M. W., & Campbell, R. E. (2008). Hue-shifted monomeric variants of Clavularia cyan fluorescent protein: Identification of the molecular determinants of color and applications in fluorescence imaging. *BMC Biology*, *6*, 13. http://dx.doi.org/10.1186/1741-7007-6-13.

Ai, H.-W., Shaner, N. C., Cheng, Z., Tsien, R. Y., & Campbell, R. E. (2007). Exploration of new chromophore structures leads to the identification of improved blue fluorescent proteins. *Biochemistry*, *46*(20), 5904–5910. http://dx.doi.org/10.1021/bi700199g.

Ando, R., Mizuno, H., & Miyawaki, A. (2004). Regulated fast nucleocytoplasmic shuttling observed by reversible protein highlighting. *Science*, *306*(5700), 1370–1373. http://dx.doi.org/10.1126/science.1102506.

Aubin, J. E. (1979). Autofluorescence of viable cultured mammalian cells. *Journal of Histochemistry and Cytochemistry: Official Journal of the Histochemistry Society*, *27*(1), 36–43.

Campbell, R. E., Tour, O., Palmer, A. E., Steinbach, P. A., Baird, G. S., Zacharias, D. A., et al. (2002). A monomeric red fluorescent protein. *Proceedings of the National Academy of Sciences of the United States of America*, *99*(12), 7877–7882. http://dx.doi.org/10.1073/pnas.082243699.

Chalfie, M., & Kain, S. R. (2006). *Green fluorescent protein: Properties, applications, and protocols*. Hoboken, NJ: Wiley-Interscience.

Chapagain, P. P., Regmi, C. K., & Castillo, W. (2011). Fluorescent protein barrel fluctuations and oxygen diffusion pathways in mCherry. *Journal of Chemical Physics*, *135*(23), 235101. http://dx.doi.org/10.1063/1.3660197.

Chudakov, D. M., Matz, M. V., Lukyanov, S., & Lukyanov, K. A. (2010). Fluorescent proteins and their applications in imaging living cells and tissues. *Physiological Reviews*, *90*(3), 1103–1163. http://dx.doi.org/10.1152/physrev.00038.2009.

Costantini, L. M., Fossati, M., Francolini, M., & Snapp, E. L. (2012). Assessing the tendency of fluorescent proteins to oligomerize under physiologic conditions. *Traffic (Copenhagen, Denmark)*, *13*(5), 643–649. http://dx.doi.org/10.1111/j.1600-0854.2012.01336.x.

Cubitt, A. B., Woollenweber, L. A., & Heim, R. (1999). Understanding structure-function relationships in the Aequorea victoria green fluorescent protein. *Methods in Cell Biology*, *58*, 19–30.

Dean, K. M., Lubbeck, J. L., Binder, J. K., Schwall, L. R., Jimenez, R., & Palmer, A. E. (2011). Analysis of red-fluorescent proteins provides insight into dark-state conversion and photodegradation. *Biophysical Journal*, *101*(4), 961–969. http://dx.doi.org/10.1016/j.bpj.2011.06.055.

Duan, C., Adam, V., Byrdin, M., Ridard, J., Kieffer-Jaquinod, S., Morlot, C., et al. (2013). Structural evidence for a two-regime photobleaching mechanism in a reversibly switchable fluorescent protein. *Journal of the American Chemical Society*, *135*(42), 15841–15850. http://dx.doi.org/10.1021/ja406860e.

Goedhart, J., von Stetten, D., Noirclerc-Savoye, M., Lelimousin, M., Joosen, L., Hink, M. A., et al. (2012). Structure-guided evolution of cyan fluorescent proteins towards a quantum yield of 93%. *Nature Communications*, *3*, 751. http://dx.doi.org/10.1038/ncomms1738.

Griesbeck, O., Baird, G. S., Campbell, R. E., Zacharias, D. A., & Tsien, R. Y. (2001). Reducing the environmental sensitivity of yellow fluorescent protein. Mechanism and applications. *Journal of Biological Chemistry, 276*(31), 29188–29194. http://dx.doi.org/10.1074/jbc.M102815200.

Gross, L. A., Baird, G. S., Hoffman, R. C., Baldridge, K. K., & Tsien, R. Y. (2000). The structure of the chromophore within DsRed, a red fluorescent protein from coral. *Proceedings of the National Academy of Sciences of the United States of America, 97*(22), 11990–11995. http://dx.doi.org/10.1073/pnas.97.22.11990.

Lam, A. J., St-Pierre, F., Gong, Y., Marshall, J. D., Cranfill, P. J., Baird, M. A., et al. (2012). Improving FRET dynamic range with bright green and red fluorescent proteins. *Nature Methods, 9*(10), 1005–1012. http://dx.doi.org/10.1038/nmeth.2171.

Markwardt, M. L., Kremers, G.-J., Kraft, C. A., Ray, K., Cranfill, P. J. C., Wilson, K. A., et al. (2011). An improved cerulean fluorescent protein with enhanced brightness and reduced reversible photoswitching. *PLoS One, 6*(3), e17896.

Matz, M. V., Fradkov, A. F., Labas, Y. A., Savitsky, A. P., Zaraisky, A. G., Markelov, M. L., et al. (1999). Fluorescent proteins from nonbioluminescent Anthozoa species. *Nature Biotechnology, 17*(10), 969–973. http://dx.doi.org/10.1038/13657.

McAnaney, T. B., Zeng, W., Doe, C. F. E., Bhanji, N., Wakelin, S., Pearson, D. S., et al. (2005). Protonation, photobleaching, and photoactivation of yellow fluorescent protein (YFP 10C): A unifying mechanism. *Biochemistry, 44*(14), 5510–5524. http://dx.doi.org/10.1021/bi047581f.

Miyawaki, A. (2011). Development of probes for cellular functions using fluorescent proteins and fluorescence resonance energy transfer. *Annual Review of Biochemistry, 80*, 357–373. http://dx.doi.org/10.1146/annurev-biochem-072909-094736.

Miyawaki, A., Shcherbakova, D. M., & Verkhusha, V. V. (2012). Red fluorescent proteins: Chromophore formation and cellular applications. *Current Opinion in Structural Biology*. http://dx.doi.org/10.1016/j.sbi.2012.09.002.

Nagai, T., Ibata, K., Park, E. S., Kubota, M., Mikoshiba, K., & Miyawaki, A. (2002). A variant of yellow fluorescent protein with fast and efficient maturation for cell-biological applications. *Nature Biotechnology, 20*(1), 87–90. http://dx.doi.org/10.1038/nbt0102-87.

Patterson, G., Davidson, M., Manley, S., & Lippincott-Schwartz, J. (2010). Superresolution imaging using single-molecule localization. *Annual Review of Physical Chemistry, 61*, 345–367. http://dx.doi.org/10.1146/annurev.physchem.012809.103444.

Regmi, C. K., Bhandari, Y. R., Gerstman, B. S., & Chapagain, P. P. (2013). Exploring the diffusion of molecular oxygen in the red fluorescent protein mCherry using explicit oxygen molecular dynamics simulations. *Journal of Physical Chemistry B, 117*(8), 2247–2253. http://dx.doi.org/10.1021/jp308366y.

Rizzo, M. A., Springer, G. H., Granada, B., & Piston, D. W. (2004). An improved cyan fluorescent protein variant useful for FRET. *Nature Biotechnology, 22*(4), 445–449. http://dx.doi.org/10.1038/nbt945.

Roshchina, V. V. (2012). Vital autofluorescence: Application to the study of plant living cells. *Journal of Biomedicine and Biotechnology, 2012*(1), 1–14. http://dx.doi.org/10.1007/978-3-540-95894-9_8.

Shaner, N. C., Campbell, R. E., Steinbach, P. A., Giepmans, B. N. G., Palmer, A. E., & Tsien, R. Y. (2004). Improved monomeric red, orange and yellow fluorescent proteins derived from Discosoma sp. red fluorescent protein. *Nature Biotechnology, 22*(12), 1567–1572. http://dx.doi.org/10.1038/nbt1037.

Shaner, N. C., Lambert, G. G., Chammas, A., Ni, Y., Cranfill, P. J., Baird, M. A., et al. (2013). A bright monomeric green fluorescent protein derived from Branchiostoma lanceolatum. *Nature Methods*. http://dx.doi.org/10.1038/nmeth.2413.

Shaner, N. C., Lin, M. Z., Mckeown, M. R., Steinbach, P. A., Hazelwood, K. L., Davidson, M. W., et al. (2008). Improving the photostability of bright monomeric orange and red fluorescent proteins. *Nature Methods*, 5(6), 545–551. http://dx.doi.org/10.1038/nmeth.1209.

Shaner, N. C., Patterson, G. H., & Davidson, M. W. (2007). Advances in fluorescent protein technology. *Journal of Cell Science*, 120(Pt 24), 4247–4260. http://dx.doi.org/10.1242/jcs.005801.

Shaner, N. C., Steinbach, P. A., & Tsien, R. Y. (2005). A guide to choosing fluorescent proteins. *Nature Methods*, 2(12), 905–909. http://dx.doi.org/10.1038/nmeth819.

Shcherbo, D., Murphy, C. S., Ermakova, G. V., Solovieva, E. A., Chepurnykh, T. V., Shcheglov, A. S., et al. (2009). Far-red fluorescent tags for protein imaging in living tissues. *Biochemical Journal*, 418(3), 567–574. http://dx.doi.org/10.1042/BJ20081949.

Shu, X., Shaner, N. C., Yarbrough, C. A., Tsien, R. Y., & Remington, S. J. (2006). Novel chromophores and buried charges control color in mFruits. *Biochemistry*, 45(32), 9639–9647. http://dx.doi.org/10.1021/bi060773l.

Sinnecker, D., Voigt, P., Hellwig, N., & Schaefer, M. (2005). Reversible photobleaching of enhanced green fluorescent proteins. *Biochemistry*, 44(18), 7085–7094. http://dx.doi.org/10.1021/bi047881x.

Tsien, R. Y. (1998). The green fluorescent protein. *Annual Review of Biochemistry*, 67, 509–544. http://dx.doi.org/10.1146/annurev.biochem.67.1.509.

Wachter, R. M., Watkins, J. L., & Kim, H. (2010). Mechanistic diversity of red fluorescence acquisition by GFP-like proteins. *Biochemistry*, 49(35), 7417–7427. http://dx.doi.org/10.1021/bi100901h.

Yarbrough, D., Wachter, R. M., Kallio, K., Matz, M. V., & Remington, S. J. (2001). Refined crystal structure of DsRed, a red fluorescent protein from coral, at 2.0-A resolution. *Proceedings of the National Academy of Sciences of the United States of America*, 98(2), 462–467. http://dx.doi.org/10.1073/pnas.98.2.462.

Zacharias, D. A., Violin, J. D., Newton, A. C., & Tsien, R. Y. (2002). Partitioning of lipid-modified monomeric GFPs into membrane microdomains of live cells. *Science*, 296(5569), 913–916. http://dx.doi.org/10.1126/science.1068539.

CHAPTER

Quantitative confocal microscopy: Beyond a pretty picture

7

James Jonkman*, Claire M. Brown[†], Richard W. Cole[‡,§]

**Advanced Optical Microscopy Facility (AOMF), University Health Network, Toronto, Ontario, Canada*
[†]McGill University, Life Sciences Complex Advanced BioImaging Facility (ABIF), Montreal, Québec, Canada
[‡]Wadsworth Center, New York State Department of Health, P.O. Box 509, Albany, New York, USA
[§]Department of Biomedical Sciences, School of Public Health State University of New York, Albany New York, USA

CHAPTER OUTLINE

7.1 The Classic Confocal: Blocking Out the Blur	114
7.2 You Call That Quantitative?	118
7.2.1 Quantitative Imaging Toolkit	118
7.2.2 Localization and Morphology	119
7.2.3 Quantifying Intensity	120
7.2.3.1 Aspects of the Microscope	120
7.2.3.2 Aspects of the Sample	121
7.3 Interaction and Dynamics	123
7.3.1 Cross Talk	123
7.3.2 Time-lapse Imaging	124
7.3.3 Spectral Imaging	125
7.4 Controls: Who Needs Them?	125
7.4.1 Unlabeled Sample	125
7.4.2 Nonspecific Binding Controls	125
7.4.3 Antibody Titration Curves	125
7.4.4 Isotype Controls	126
7.4.5 Blind Imaging	127
7.4.6 Fluorescent Proteins	127
7.4.7 Flat-field Images	127
7.4.8 Biological Control Samples	127
7.5 Protocols	127
7.5.1 Protocol 1: Measuring Instrument PSF (Resolution and Objective Lens Quality)	127
7.5.2 Protocol 2: Testing Short-term and Long-term Laser Power Stability	129

7.5.3 Protocol 3: Correct Nonuniform Field Illumination............................ 129
7.5.4 Protocol 4: Coregistration of TetraSpeck Beads 130
7.5.5 Protocol 5: Spectral Accuracy.. 130
7.5.6 Protocol 6: Spectral Unmixing Algorithm Accuracy 131
 7.5.6.1 Channel (Multi-PMT) Method ..131
 7.5.6.2 Separation (Unmixing)..132
 7.5.6.3 Spectral Detection Method ..132
Conclusions.. **133**
References .. **133**

Abstract

Quantitative optical microscopy has become the norm, with the confocal laser-scanning microscope being the workhorse of many imaging laboratories. Generating quantitative data requires a greater emphasis on the accurate operation of the microscope itself, along with proper experimental design and adequate controls. The microscope, which is more accurately an imaging system, cannot be treated as a "black box" with the collected data viewed as infallible. There needs to be regularly scheduled performance testing that will ensure that quality data are being generated. This regular testing also allows for the tracking of metrics that can point to issues before they result in instrument malfunction and downtime. In turn, images must be collected in a manner that is quantitative with maximal signal to noise (which can be difficult depending on the application) without data clipping. Images must then be processed to correct for background intensities, fluorophore cross talk, and uneven field illumination. With advanced techniques such as spectral imaging, Förster resonance energy transfer, and fluorescence-lifetime imaging microscopy, experimental design needs to be carefully planned out and include all appropriate controls. Quantitative confocal imaging in all of these contexts and more will be explored within the chapter.

7.1 THE CLASSIC CONFOCAL: BLOCKING OUT THE BLUR

Widefield microscopy can often provide acceptable resolution, reasonable contrast, and fast acquisition rates. However, if the sample thickness is more than 15–20 μm, then in-focus features are obscured by blur from out-of-focus regions of the sample. By imaging through a well-placed pinhole, a confocal microscope blocks the out-of-focus light coming from above and below the plane of focus, thereby reducing blur and producing a sharp image of the sample (Fig. 7.1). For thick samples, this optical sectioning property is the confocal's main advantage. Its ability to reject the out-of-focus light and build high-resolution, high-signal-to-background, 3D image stacks of thick samples (>20 μm) makes the confocal laser-scanning microscope (CLSM) a crucial tool for life sciences researchers.

The confocal principle is shown schematically in Fig. 7.2. The excitation and emission light paths use the example of a green fluorophore (e.g., EGFP or FITC).

7.1 The classic confocal: Blocking out the blur

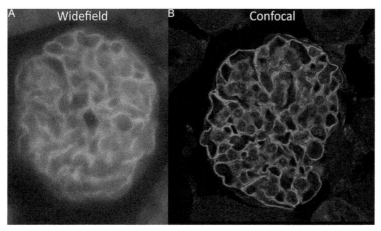

FIGURE 7.1

A confocal microscope allows you to do optical sectioning in thick specimens by removing the out-of-focus blur. This 15 μm thick mouse kidney tissue was imaged with equivalent 63×/1.4 NA oil objectives on both (A) a widefield and (B) a laser-scanning confocal microscope. (See the color plate.)

A collimated laser beam ($\lambda = 488$ nm to excite EGFP) is reflected by a dichroic beam splitter and then focused by an objective lens to a diffraction-limited spot in the sample (Fig. 7.2A). Fluorescence is generated within the cone of illumination that includes but is not limited to the focused spot. The objective lens collects the fluorescence signal emitting from excited fluorophores from within the focal plane and forms a collimated beam, which passes back through the dichroic beam splitter and is focused through a pinhole onto a detector (Fig. 7.2B, green lines). Fluorescence from outside the focal point (e.g., from the surface of the sample) is not collimated by the objective so it will not be focused through the pinhole and is therefore blocked (Fig. 7.2B, gray dashed line). This confocal arrangement collects the fluorescence signal from a single point at a time from within the sample, thus generating the image one pixel at a time. In the classic CLSM, the laser beam is scanned across the sample in a raster pattern and the computer assembles the pixels to form a 2D image. This image is a single "optical slice" of the specimen. For a given objective lens and fluorophore emission wavelength, the thickness of the slice depends on the size of the pinhole that is used. As the pinhole diameter increases, the optical sectioning ability of the microscope decreases and approaches the performance of a widefield microscope, whereas if the pinhole is closed too far, too much light is rejected and a high-signal-to-noise (S/N) fluorescence image can no longer be generated. Theoretically, the optimal diameter for the pinhole is achieved when it matches the diameter of the central peak of the Airy disk (the concentric ring pattern generated by the diffraction of light; see Cole, Jinadasa, and Brown (2011) for more details); this optimal pinhole size is referred to as 1 Airy unit (AU). In practice,

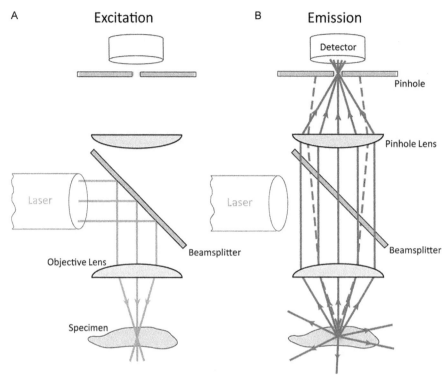

FIGURE 7.2

The confocal principle, with the (A) excitation and (B) emission light paths separated out for clarity. (A) A laser beam (blue lines) is focused down to a diffraction-limited spot in the specimen, exciting fluorescence in the entire cone of illumination. (B) Fluorescence from the focus (green lines) is collimated by the objective lens and focused by a second lens through a pinhole onto the detector. Fluorescence that originates from outside the focus (e.g., from the surface of the specimen—gray dashed lines) is not imaged through the pinhole and is therefore largely blocked.

however, opening the pinhole slightly to ~1.25 AU produces ~30% more signal for only a nominal increase in slice thickness. For many samples, such as the 15 μm thick tissue section shown in Fig. 7.3, the difference in slice thickness is almost indistinguishable when visualizing the images. In a similar way, the pinhole size can be set to 1 AU to obtain the best resolution for a fixed slide or opened somewhat to increase photon throughput and thereby decrease phototoxicity for live-cell imaging experiments. It is possible to achieve a lateral resolution of ~0.2 μm using a high numerical aperture (NA) objective lens (e.g., 60×/1.4 NA oil immersion objective) and a section thickness of ~0.8 μm.

Once the settings are optimized for the collection of an image of a single slice, the microscope's motorized focus is used to move through the specimen, taking

7.1 The classic confocal: Blocking out the blur

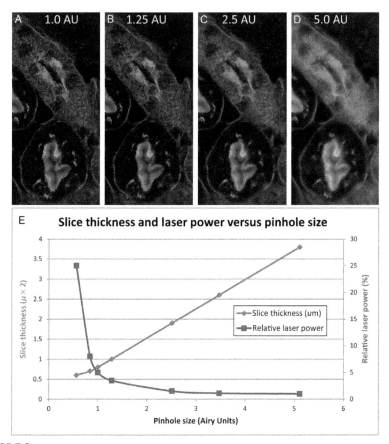

FIGURE 7.3

A 15 μm thick tissue section imaged on a CLSM with a 63×/1.4 NA oil objective with varying pinhole settings. As the pinhole was varied from (A) 1 AU to (D) 5 AU, the laser power was lowered to keep the intensity of the image the same. A considerable amount of blur is evident in (D), but there is nearly no discernible difference in blur between (A) 1 AU and (B) 1.25 AU, despite the fact that the latter allows for a reduction in laser power of about 30%. (B) The slice thickness (blue line, left axis) and relative laser power required to produce equivalent intensity image (red line, right axis) versus pinhole size, as measured on a CLSM. The slice thickness is calculated in and reported by the software, and the laser power was adjusted for each pinhole size to produce the same image intensity for all images. (See the color plate.)

additional image slices at each focus position. In order to adequately represent the specimen, it must be sampled at approximately 3× higher frequency than the smallest feature that needs to be resolved (Nyquist theorem). So to create an accurate 3D rendering and/or perform 3D measurements, a focus step size of about one-third of the confocal slice thickness needs to be chosen (0.3–0.5 μm in our example for the 63× objective lens earlier in the text).

Early CLSM designs were focused on optimizing the light path and pinhole setting to minimize out-of-focus light and attain the best possible resolution. The advent of genetically encoded fluorescent proteins opened up the CLSM for diverse applications in live imaging that had never been imagined when these instruments were first designed. This led to a focus on increasing speed and sensitivity in order to minimize photodamage and to accommodate rapid multicolor imaging of dynamics within living samples. Imaging speeds and instrument sensitivity are very much intertwined. In order to go fast, the instrument must collect and detect enough light in a short period of time. Thus, an increase in sensitivity will also increase achievable imaging speeds. Improved speed and sensitivity of detection have been made possible with advances such as acousto-optic devices (e.g., AOTF and AOBS), rapidly scanning resonant galvanometric mirrors, GaAsP photomultiplier tubes (PMTs), and hybrid detectors (HyDs). Spectral array detectors have improved in sensitivity and allow the rapid collection of the entire sample emission spectra with one sweep of the excitation lasers.

7.2 YOU CALL THAT QUANTITATIVE?

The modern CLSM is designed and built as an expansive quantitative device. Virtually all questions researchers are asking today require a rigorous quantitative method of analysis, even for straightforward intensity or morphometric measurements. In the following sections, specific areas of quantification will be examined along with recommendations for CLSM performance tests and metrics.

7.2.1 QUANTITATIVE IMAGING TOOLKIT

1. *Chroma slides:* These colored plastic microscope slides (www.chroma.com) have broad excitation spectra, are bright and homogenous, and are photostable. This makes them ideal specimens for quality control testing including checking and/or correcting for nonuniform illumination.
2. *Power meter:* It can be helpful to directly measure the illumination intensity, both accurately and reproducibly, without depending on the microscope's detection system. There are many different types of power meters, but a good choice is one that has a sensor shaped like a microscope slide (www.ldgi.com/x-cite) for easy and reproducible placement on both inverted and upright microscopes.
3. *Subresolution microsphere slide:* Slides containing subresolution microspheres are needed to measure the instrument's point-spread function (PSF) and determine maximum resolution and objective lens quality. Detailed instructions for how to prepare such slides can be found in Cole et al. (2011).
4. *TetraSpeck microsphere slide:* TetraSpeck microspheres contain four fluorophores from blue to far red in color. They are available in many sizes for testing and calibrating the coregistration of CLSM image channels. The microsphere slide preparation in Cole et al. (2011) can also be used for preparing

TetraSpeck slides; however, the microsphere solution is not diluted (Life Technologies, Grand Island, NY, Cat. # T7284).
5. *Mirror slide:* A mirror slide is helpful for testing the spectral accuracy of any spectral imaging CLSM (Cole et al., 2013). Mirror slides can be made by evaporating gold onto a microscope slide or a coverslip. They can also be purchased (Carl Zeiss, Jena, Germany, Cat. #000000-1182-440).
6. *Micrometer:* It is advisable to have a micrometer slide for initial microscope spatial calibration and to periodically verify instrument calibrations. They can be purchased from a number of sources (NY Microscope Company, Hicksville, NY, Cat. # A3145, and VWR International, Radnor, PA, Cat. #470175-914).
7. *Familiar test slide:* Hematoxylin and eosin (H&E)-stained tissues are excellent test specimens for checking fluorescently equipped microscopes, especially confocal microscopes. The staining is robust, the material is easy to obtain, and they have very broad excitation and emission spectra, are stable over the long term, and have low photobleaching. Pathology departments or histology cores will often give away H&E-stained specimens that have already been imaged and archived and are no longer of use. Prepared H&E-stained liver section microscope slides can also be purchased for ∼$5.00 (www.carolina.com). Note that since these types of sections are mostly prepared for histological studies, they are not suitable for checking the resolution of the system. Begin troubleshooting any problem with the microscope in bright field with the H&E specimen. This will point to any issues with the objective lens or within the light path (e.g., filter in place or a partially closed shutter). If the bright-field image is clear, the H&E slide can also be used to test the fluorescence CLSM light path. Molecular probes also sell thin (FluoCells prepared slide #1, Cat. #F36924, BPAE cells) and thick (FluoCells prepared slide #3, Cat. #F24630, kidney section) fluorescently labeled test slides.

In the following sections, we will present specific factors to keep in mind when performing quantitative imaging. Brief protocols for instrument testing or image analysis are found at the end of the chapter while more in-depth protocols can be found in several publications (Cole et al., 2011, 2013).

7.2.2 LOCALIZATION AND MORPHOLOGY

At first glance, these areas may seem too simple to be included in a serious discussion of quantification; however, these are some of the most common imaging and analysis experiments. High-quality data rely not only on the sample preparation and adequate controls but also on the instrument operating as designed. The objective lens is one of the most crucial parts of the imaging pathway. Any deterioration and/or aberration(s) resulting from the objective lens is propagated along the light path and cannot be compensated for downstream. It is therefore imperative that the objective lens in use is adequately tested by examining the PSF at the time of purchase and then on a routine bases. The PSF measured with subresolution microspheres (see Section 7.2.1) will provide information on the system resolution,

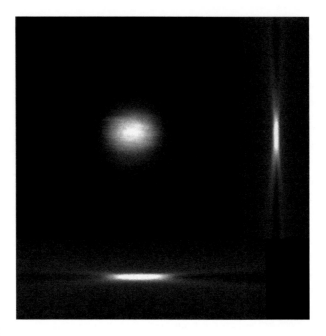

FIGURE 7.4

X–Y and X–Z and Y–Y orthogonal views of subresolution (0.17 μm) bead imaged on CLSM with a 63 × 1.4 NA lens with 32 × zoom. The orthogonal views are typical referred to as the point-spread function (PSF).

and the shape of the PSF is a good metric for objective lens quality (Fig. 7.4; see Section 7.5.1 for further details, Cole et al. (2013)).

7.2.3 QUANTIFYING INTENSITY

In order to accurately measure fluorescence intensities to ascertain relative fluorophore concentrations or levels of protein expression, it is important that CLSM images are collected in a quantitative manner. This includes (1) *aspects of the microscope* (laser stability, nonuniform field illumination, setting detector offsets properly, and avoiding saturation), (2) *aspects of the sample* (mounting media, coverslip thickness, labeling protocols, and fluorophore stability), and (3) *image processing and analysis steps* (background intensity corrections).

7.2.3.1 Aspects of the microscope

Laser stability: The need to have a stable illumination system for quantitative imaging is apparent. While laser outputs should be stable to <1% drift after warm-up, the observed stability is often lower. In addition to instability from lasers themselves, image intensity instability can result from other microscope subsystems. For example, problems with the detection system (e.g., PMTs), AOTF, stage drift along the

X-, Y-, or Z-axis, and photobleaching of the test slide can all contribute to poor overall performance (Pawley, 2000; Zucker, 2006; Zucker & Price, 2001). A common acceptance criteria for illumination stability is <10% variability over the long term (e.g., 3 h) or <3% variability over the short term (e.g., 5 min) (Stack et al., 2011). Unfortunately, the failure rate for CLSM lasers is higher than one might expect, and aside from regular quality control tests, it is unlikely that the microscope users would suspect a problem. Figure 7.5A shows the intensity of the four lasers, measured by a power meter (X-Cite, model XR2000+sensor XP750) over a 3-h period starting 15 min after the lasers were turned on. Three of the lasers were stable, but the 488 nm laser power systematically increased in intensity by more than 15%. If one carefully measures control samples at the start of the imaging session and then various experimental conditions throughout a 3-h imaging session, they might conclude that some conditions yielded significantly higher fluorescence intensities when in reality they were just tracking a systematic increase in the laser power. The authors of this chapter found three more problem lasers (Fig. 7.5B) on their confocal microscopes, all of them under 5 years old, suggesting that the chance of having a defunct laser is high. CLSM users can avoid this problem by repeating experiments and routinely measuring control samples at the beginning and the end of microscope imaging sessions (see Section 7.5.2 for further details).

Offsets and saturation: It is important when collecting quantitative fluorescence that PMT offsets or black levels are set so that no pixels within the image read zero. Background can be corrected for after the fact by subtracting the average intensity of a region of interest where there is no sample signal in the image from each pixel. It is equally important to ensure that the PMT detectors are not saturated with signal, thus causing a loss of information in the brightest regions of the sample. Most CLSM software programs have image lookup table (LUT) setting so that pixels with zero intensity show up one color (e.g., blue) and saturated pixels another color (e.g., red). When setting up instrument parameters, these LUTs are useful for ensuring that the intensity data are quantitative.

Nonuniform field illumination: Due to the optical elements in place and the coupling of the light source to the microscope, the illumination intensity across the field of view of the microscope is rarely uniform. An image of a uniform piece of fluorescent plastic (see Section 7.2.1) can be collected and this "flat-field" image used to correct differences in illumination across the image. Some software programs have a module to do this, but basically, one needs to divide the image of the specimen by the image of the uniform sample. Care must be taken to do this correction in the same way for all samples to avoid introducing artifacts in the measured image intensities (see Section 7.5.3).

7.2.3.2 Aspects of the sample
7.2.3.2.1 Mounting media
Low-fluorescence mounting media is important. Media containing DAPI is not recommended as it can give rise to a high green background of fluorescence. Test hardening mounting media as it can cause some shrinkage of thick samples over time as it cures.

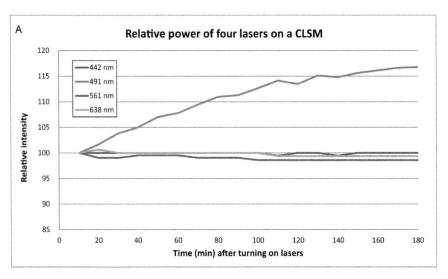
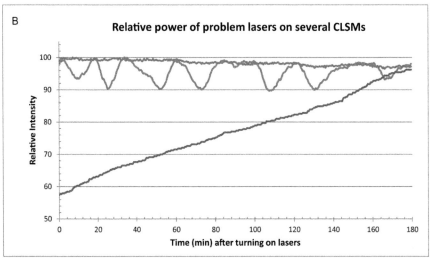

FIGURE 7.5

(A) Intensity of the four lasers on a heavily used confocal microscope, starting 15 min after the lasers were turned on, as measured by a power meter over a 3 h period. (B) Laser instability was discovered on three more of the author's confocal microscopes, ranging from rhythmic fluctuations of 10% magnitude to systematic increases and decreases in power of as much as 60% of the starting power.

7.2.3.2.2 Coverslips
The #1.5 coverslips of 0.170 mm thickness should always be used with high-resolution immersion objective lenses as these lenses are specifically corrected for this thickness. Thinner or thicker coverslips will result in lower-quality images.

7.2.3.2.3 Sample labeling
Antibodies should be validated for their target. In fact, antibody companies have highly variable standards for testing antibody specificity. Often, antibodies are only tested for Western blot analysis where the protein is highly denatured and may not be suitable for immunofluorescence work. Batch to batch variation, nonspecific binding, and reproducibility of labeling protocols can be problematic (see the work of Rimm et al. for an in-depth review of antibody validation (Bordeaux et al., 2010)). For quantitative imaging, care must be taken to only look for intensity differences on the order of 50% or higher with antibody staining. This is because polyclonal antibody numbers per target protein can vary dramatically, each antibody has a variable number of fluorophores on it, and nonspecific binding can vary across and between samples. Fluorescent proteins have the advantage of having one fluorophore per protein. However, assure that the monomeric versions of fluorescent proteins are used (Kredel et al., 2009; Shaner et al., 2004) including monomeric point mutations (A206K) for the EGFP-derived fluorescent protein constructs (Shaner, Steinbach, & Tsien, 2005). In addition, expression levels have to be near endogenous levels to minimize overexpression artifacts. In any case, always minimize incident light intensity to preserve the fluorophore and avoid photobleaching.

7.3 INTERACTION AND DYNAMICS
7.3.1 CROSS TALK
For any experiments that are designed to look at interactions between labeled molecules, cross talk must be corrected for. Excitation cross talk results when two or more dye molecules are excited by the same wavelength of laser light. So when imaging a green emission dye, it is possible that a red emission dye is also excited. Emission cross talk is more common and results when fluorophores emit at the same wavelengths or their emission spectra overlap. The ideal way to get rid of cross talk is to ensure all fluorophores in the image have similar intensities and then image each fluorophore sequentially. However, this will not always omit cross talk if there are both excitation cross talk and emission cross talk between fluorophores. Single-fluorophore controls can be imaged and correction factors can be used to correct for cross talk. The best way to deal with cross talk is through spectral imaging and unmixing. This allows the instrument to collect all of the light emitted from all of the fluorophores increasing sensitivity. Then, spectral unmixing can be used to determine how much signal in each pixel location was emitted from each fluorophore. Of course, adequate controls must be used to ensure that the unmixing algorithms perform as expected (Cole et al., 2013).

7.3.2 TIME-LAPSE IMAGING

In order to accurately measure dynamics over time, it is important to apply Nyquist sampling. If a process is occurring on the minute's timescale, such as focal adhesion turnover, then images need to be collected every 20 s in order to accurately measure adhesion assembly and disassembly rates (Lacoste, Young, & Brown, 2013). For a slower process such as cell migration, images could be collected every 5 min in order to track cell movement (depending on the cell type and migration speed). Individual cells can be tracked using manual, semimanual, or automated software programs. Track displacements can then be normalized for each cell track by setting the initial x-, y-position to zero. Track displacement is then calculated relative to the starting position. These tracking measurements are then plotted as a Rose plot (Fig. 7.6). If movements are random, then tracks move out in all directions from the plot origin. If there is any preferred direction such as to a chemotactic gradient, tracks will indicate that cells are moving preferentially in one direction. Differences in cell speed

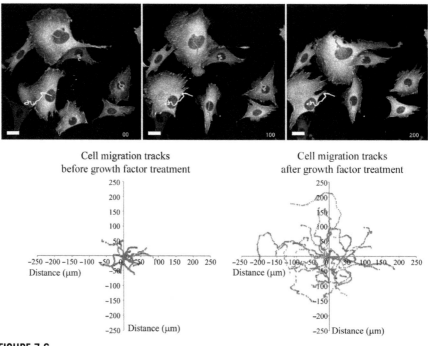

FIGURE 7.6

Chinese hamster ovary (CHO) cells expressing paxillin–EGFP were grown on fibronectin-coated glass bottom 35 mm dishes and imaged on a Zeiss LSM 710 over time. Cells were tracked with a semiautomated object tracking module using MetaXpress 5 software (Molecular Devices, Sunnyvale, CA). Tracks are shown for several cells. Scale bars are 20 μm and elapsed time is shown in minutes. Rose plots show tracks from mouse mammary epithelial cells. Tracks were normalized to the initial x,y starting point for each cell and plotted on a Rose plot. Cells were tracked before and after the addition of a growth factor to the cells.

following growth factor addition are readily apparent from Rose plots. For live-cell imaging, it is important to minimize light exposure to minimize phototoxicity, minimize the number of fluorescent probes, and keep the sample in a stable environmentally controlled setting on the microscope (Frigault, Lacoste, Swift, & Brown, 2009; Lacoste et al., 2013).

7.3.3 SPECTRAL IMAGING

In order to use spectral imaging for quantitative microscopy, the instrument must measure the spectrum accurately and the unmixing algorithm must be tested. In addition, if absolute spectra and spectral shifts are to be measured, then the system must be carefully calibrated for intensity across the spectrum (Zucker et al., 2007; see Section 7.5.5 for more details). If the peak intensity of the laser is at 500 nm on the CLSM, it should also be at 500 nm on a spectrophotometer. Signal unmixing algorithms should also be properly tested and verified (Fig. 7.7; Cole et al., 2013; see Sections 7.5.5 and 7.5.6 for further details).

7.4 CONTROLS: WHO NEEDS THEM?

Controls might not be the most fun to prepare or to image; however, they are vital to *all* experiments. While controls are rarely published, they do provide the foundation for the quantitative experimental results that are published.

7.4.1 UNLABELED SAMPLE

A sample of unlabeled cells or tissue (processed up to the point of labeling) should always be imaged with the same settings as the stained samples to ensure data do not need to be corrected for cellular autofluorescence. As a rule of thumb, autofluorescence should be below 5% of the specific signal for each fluorescent probe and should not be present in organized structures within the cell. Most cell types will show some autofluorescence in the perinuclear region of the cell (Broussard, Rappaz, Webb, & Brown, 2013).

7.4.2 NONSPECIFIC BINDING CONTROLS

For antibody-stained samples, cells stained with just secondary antibodies should be imaged with the same settings as the stained samples to ensure adequate blocking and minimal nonspecific antibody staining.

7.4.3 ANTIBODY TITRATION CURVES

For any antibody staining protocol, all primary and secondary antibodies should be titrated. Quantitative imaging should be used to determine the maximum amount of fluorescence staining with the minimal amount of antibody. With increasing antibody concentrations, nonspecific binding quickly becomes problematic.

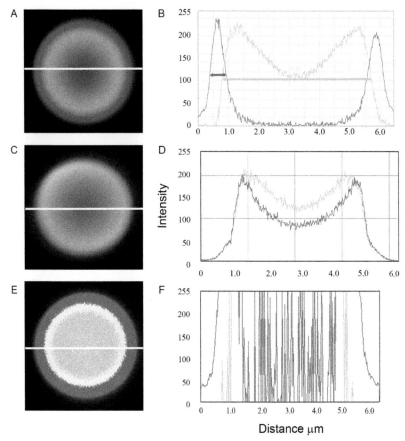

FIGURE 7.7

Spectral unmixing data summary: (A) overlay image and (B) intensity profile (along white line) of spectrally separated double orange microsphere with 5.5 μm diameter core (center) and 0.5 μm diameter ring (outer ring). The smaller double arrow in (B) shows the ring full width at half maximum (FWHM); The longer double arrow in (B) shows the core FWHM. (C) Same bead as in (A) but the algorithm gave poor quality unmixing where pixels in the core were incorrectly assigned to both dyes. (E): Overlay image of saturated intensity bead data and (F) intensity profile. (See the color plate.)

Adapted from Cole et al. (2013).

7.4.4 ISOTYPE CONTROLS

For any antibody staining protocol, samples should be prepared and imaged in parallel with isotype control antibodies matched to each primary antibody's host species and isotype. The same antibody concentration should be used for the primary antibody and the isotype control.

7.4.5 BLIND IMAGING

Samples should be prepared and labeled by one person and imaged blind by another to avoid systematic bias in choosing cells to image and quantify. Alternatively, the entire slide or a very large area of the slide could be imaged and quantified rather than cells that are handpicked for imaging by one person.

7.4.6 FLUORESCENT PROTEINS

When working with expressed fluorescent protein constructs, they should be expressed as close to endogenous levels as possible. Endogenous proteins can be knocked down using RNAi techniques and then fluorescent protein constructs expressed at endogenous levels. Alternatively, fluorescent proteins of interest can be expressed and studied in cell lines that have low or no expression of the protein of interest. For example, express a neuronal-specific protein in a non-neuronal cell line. Fluorescent protein localization should be verified by antibody staining of endogenous proteins, and cellular behavior (e.g., migration, division, and propagation) with and without the expression of fluorescent proteins should be compared to ensure that there are no secondary effects of the protein expression.

7.4.7 FLAT-FIELD IMAGES

It is always advisable to take flat-field images of fluorescent plastic slides at the same zoom and resolution as sample images.

7.4.8 BIOLOGICAL CONTROL SAMPLES

It is useful to collect images of biological control slides at the beginning and end of every imaging session. These images can identify problems with the instrument such as laser power changes over time, they provide an internal control in the dataset, and they can be used as a control between imaging sessions if instrument settings are changed (e.g., new light source or an system alignment service call).

7.5 PROTOCOLS

7.5.1 PROTOCOL 1: MEASURING INSTRUMENT PSF (RESOLUTION AND OBJECTIVE LENS QUALITY)

Imaging
- Prepare a slide of subresolution microspheres (≤ 0.175 μm for ≥ 0.6 NA lens or 0.5 μm for ≤ 0.6 NA lens; see Section 7.2.1).
- Turn on the microscope and allow the laser to warm up for 1 h.
- Ensure that all DIC optical elements are removed from the light path.

- Clean the objective lens.
- If the lens has a correction collar, ensure that it is properly adjusted.
- If the confocal pinhole is user-adjustable, then use a green fluorescent plastic slide to align it. If it is not user-adjustable, ensure it is aligned regularly by the company service engineer.
- Set the confocal up to image a green dye (e.g., FITC or EGFP).
- Focus on the microsphere sample.
- Set up the confocal light path for imaging a green dye.
- Set the image acquisition to a scan of 1024×1024 pixels at a moderate scan speed (pixel dwell time of 5–25 µs per pixel). For optimal intensity information, it is best to collect 12-bit or higher images. Line or frame averaging can be used to reduce pixel noise.
- Set the instrument for unidirectional scanning, not bidirectional or raster scanning.
- Zoom in on the microspheres at the center of the field of view for the best PSF characterization.
- Set the PMT detector offset so that no pixel within the image reads zero intensity units.
- Adjust the PMT detector gain and laser power so that the average microsphere intensity is approximately 75% of the maximum image intensity (~190 for an 8-bit image and ~3000 for a 12-bit image). Choose the 488 nm laser line and start with a laser power of ~0.5%.
- Set the pinhole to 1 AU.
- Crop, zoom, or use a region of interest to choose a single microsphere. Collect images with the proper sampling frequencies in x, y, and z. In order to accurately measure the PSF, the pixel size needs to be ~3× smaller than the theoretical resolution of the objective lens.
- A high S/N ratio is helpful for visualizing and interpreting the PSF; therefore, lower detector gain and higher laser power settings than typically used for imaging biological samples may be required.
- Avoid imaging brighter spots that correspond to aggregates of microspheres.
- Collect data for at least five individual microspheres.

Data analysis

Open the z-stack data files in Fiji and use the MetroloJ plug-in to analyze the PSF data. Fiji is freely available and is updated regularly. It can be downloaded at http://fiji.sc/fiji. A report will be generated that shows the lateral and axial views of the microsphere. A summary table in the report gives the theoretical resolution of the lens and the resolution calculated along the x-, y-, and z-axes. Plots of the intensity data from a line through the center of the microsphere along the x-, y-, and z-axes with the curve fitting and the fitting statics are also included in the report. The shape of the PSF should be symmetric in xy, xz, and yz (Cole et al., 2013).

7.5.2 PROTOCOL 2: TESTING SHORT-TERM AND LONG-TERM LASER POWER STABILITY

These tests are designed to measure the stability of the complete illumination system. The long-term test is meant to verify the stability of the laser during a single imaging session with multiple samples. The short-term test is meant to verify the stability of the laser during the collection of a short time series or a z-stack of images.

Slide
- Fluorescent plastic slides (see Section 7.2.1).

Data Collection
- Ideally, the laser(s) or illumination source should be warmed up for a minimum of 1 h.
- Image the fluorescent plastic slide with a $10\times$ or $20\times$ microscope objective lens and relatively low laser power to avoid photobleaching. The red slide is the best choice since it will fluoresce following excitation from most laser lines (largest excitation/emission range).
- Focus on a scratch on the surface of the slide, and then focus ~ 20 μm into the slide.
- Set the detector gain and offset of each PMT detector in a similar manner as for the PSF measurements in Protocol 1.
- Collect images every 30 s for 3 h (long-term stability) or every 0.5 s for 5 min (short-term stability).

Data Analysis
- Measure the intensity of a region of interest within each image in the time series.
- Determine the percent variability in intensity for each laser line and ensure it is within the test criteria of 10% for long-term stability and 3% for short-term stability.

7.5.3 PROTOCOL 3: CORRECT NONUNIFORM FIELD ILLUMINATION

Slide
- Fluorescent plastic slides (see Section 7.2.1).

Data Collection
- Take an image of a uniform fluorescent plastic slide using the same objective lens and resolution as used for the specimen. Use a slower scan speed and line or frame averaging to maximize S/N.

Data Analysis
- Use a low-pass filter to smooth the image of the specimen and the image of the plastic slide.
- Record the maximum intensity of the specimen image and the plastic slide image.

- Calculate a normalization factor for the original specimen and the plastic slide image by taking the maximum image intensity and dividing by 1000 (e.g., if the maximum intensity is 2540, then divide the image by 2.540).
- Normalize the images by dividing the original specimen image (not filtered) and filtered plastic slide image by their respective normalization factors.
- Divide the normalized specimen image by the normalized plastic slide image.
- Readjust the intensity of the sample image by multiplying the corrected specimen image by its normalization factor.
- Repeat this process for all images in the dataset to correct for nonuniform illumination.

7.5.4 PROTOCOL 4: COREGISTRATION OF TETRASPECK BEADS

Slide
- 4.0 μm TetraSpeck beads (blue, green orange, and dark red; see Section 7.2.1).

Data Collection
- Use a high NA (>1.2) objective lens.
- Choose a small pixel size. Typically, a zoom factor of 10 is required.
- Use a standard multicolor image acquisition setup.
- Collect a z-stack series of images using sequential scans of two or more dyes.

Data Analysis
- Crop datasets of single bead z-stacks.
- Using a line scan function, plot the intensity across the bead for each slice in the z-stack of images.
- Determine the brightest in-focus slice. Ideally, this should be the same z-position for all dyes.
- Use the ImageJ measurement function to determine the center of mass for the in-focus slice for all of the dye images.
- Determine the displacement among the different detection channels.
- Perform this on at least five different microspheres to separate out any aberrant beads.

7.5.5 PROTOCOL 5: SPECTRAL ACCURACY

Slides
- Mirror slide prepared by depositing a ~1 μm thick gold layer onto cleaned #1.5 coverslips (see Section 7.2.1).
- Coverslip is then mounted with the gold surface down onto standard microscope slides with 8 μl of ProLong® Gold.

Data Collection
- Turn on the microscope and ideally let the laser to warm up for 1 h.

- Image the mirror slide using a 10× lens.
- Spectral (i.e., lambda) detection settings are chosen and the wavelength range set to detect the range of lasers on the system (e.g., 440–650 nm for a 488 laser).
- Set the spectral resolution to the highest resolution achievable.
- Images of 128 × 128 pixels are collected.
- The detector gain is set to 200–400.
- The laser power for each laser line is set to give a pixel intensity of ~75% of the PMT saturation. A range indicator LUT is used to verify that no pixels are reading zero intensity or saturating intensity gray levels.
- A lambda stack of images is collected using these settings.

Data Analysis
- The image intensity is measured as a function of wavelength. Each intensity peak should match the laser line wavelength and the FWHM should match the spectral resolution of the CLSM.

7.5.6 PROTOCOL 6: SPECTRAL UNMIXING ALGORITHM ACCURACY

The algorithms and separation routines that perform the mathematical differentiation are often poorly understood and not corroborated (Garini et al., 2006). The selection of the specific routine and the setting of their associated parameters are critical to produce aberrant-free high-quality separation. The protocol in the succeeding text abrogates the need for additional complex hardware and should facilitate the implementation of such tests in core facilities.

Slide
- Double-orange 6 μm fluorescent microspheres (FocalCheck™, Cat# F-36906, Life Technologies, Grand Island, NY) were used. These microspheres are composed of two fluorescent materials, an outer shell (0.5 μm thick) excitation/emission of 532/552 nm, and an inner core (5.5 μm diameter) excitation/emission of 545/565 nm. Although they appeared to be the same color by eye, they can be resolved and separated by spectral linear unmixing techniques but not by standard optical techniques.

Depending on the microscope design, it may be possible to perform one or both of the methods in the following text.

7.5.6.1 Channel (Multi-PMT) method
This method works best when the dyes are spatially separated:

- Turn on the microscope and ideally allow the laser to warm up for 1 h.
- Configure as many PMTs as possible to cover the spectral range from 520 to 595 nm.
- Collect the spectra of both fluorophores, that is, shell and core.
- Hold the gain and offset constant for all PMTs.
- Image the microspheres using the 514 nm or equivalent laser.

- Set a pixel size of ~13 nm.
- With a $\geq 20\times$ objective, focus to the center of a microsphere. The maximum diameter can be used as a metric for the center of the bead.
- Collect images with a pixel intensity of ~75% of saturation. Line or frame averaging should be used to achieve high S/N images.

7.5.6.2 Separation (Unmixing)

The Channel Dye Separation method uses reference regions from within the image to identify the distribution coefficients of the fluorochromes based on different channels (PMTs). These regions need to be defined in the specimen in areas where only a single dye is present, that is, the core and shell. The algorithm then deconstructs the image, pixel-by-pixel, into the corresponding "separated" channels. In our experience, it was difficult to get "pure" spectra directly from these samples, and artifacts were seen in the data following the unmixing process. It is most ideal to have independent samples each containing a single dye in order to measure the individual spectra precisely.

7.5.6.3 Spectral detection method

This method works well when reference spectra from all the fluorophores/dyes being imaged were known and spectra could be entered into the instrument's software:

- Use a single PMT and slit detector to capture the emission spectra from both the core and shell. "Alternatively, certain microscopes have a dedicated detector array specifically designed for this purpose."
- Set a pixel size of ~13 nm.
- Set the lambda step size as small as possible (3–10 nm).
- Focus to the approximate center of the microsphere, using the maximum diameter as a metric.
- Collect images with a pixel intensity of ~75% of saturation. Line or frame averaging can be used to achieve high S/N images.
- Collect a lambda stack series from 520 to 595 nm in order to collect both shell and core fluorophore spectra.

The spectral data for the core and the shell can be found at http://www.abrf.org/ResearchGroups/LightMicroscopyResearchGroup/Protocols/orangebeadcenteremission.txt and http://www.abrf.org/ResearchGroups/LightMicroscopyResearchGroup/Protocols/orangebeadringemission.txt. If it is not possible to import the provided spectral data and an "automatic" unmixing algorithm exists, then it should be used. The algorithms deconstructed the images pixel-by-pixel into the corresponding "separated" channels by assigning a percentage of the intensity of each dye to each pixel. The accuracy of the unmixing results can be assessed by comparing the ratio of the core FWHM to the ring FWHM with the expected ratio being $5.5/0.5 = 11$.

CONCLUSIONS

While the confocal microscope is a powerful quantitative tool, it should not be viewed as a "black box." Instead, both the microscope and the sample need to be approached with a stepwise analytic approach. Starting with, is the CLSM the appropriate microscope to use based on the sample and the hypothesis being tested? Next, is the microscope operating as designed, that is, are the objective lens, illumination system, and detection system within specification? On the majority of nonimaging analytic instruments, running standards before experiments is the norm, why not on imaging systems? It is probably due to the slow evolution from a microscope composed of a simple lens and light source, combined with the mistaken belief held by some microscopists that simply looking at the image from today's imaging systems is an adequate test of the microscope's performance and the fact that systems were traditionally designed to take a pretty picture.

Sample preparation and control samples are equally important when performing quantitative imaging and analysis. This starts with the choice of fluorophore, which again should be based on the question(s) being asked. There is an ever-increasing selection of both antibody and transgenics allowing for increased multiplexing. The BrainBow project (Card et al., 2011) is an example of extreme multiplexing to track axons and dendrites over long distances. However, with the increased number of fluorophores within the sample comes an increased need for controls to check for cross-reactions. In addition to those controls, the standard ones also need to be performed.

Finally, collecting quantitative images (e.g., offset and avoiding saturation) and performing image processing and analysis (e.g., background and flat-field corrections) in a way that maintains the quantitative nature of the data are imperative.

We now have the tools within our toolbox to ask and answer the "big" picture questions and truly bring the benchtop side mantra to reality. The microscopes are now producing large volumes of data at higher resolutions than ever before. The key is to maintain the validity of that data.

REFERENCES

Bordeaux, J., Welsh, A., Agarwal, S., Killiam, E., Baquero, M., Hanna, J., et al. (2010). Antibody validation. *Biotechniques*, *48*, 197–209.

Broussard, J. A., Rappaz, B., Webb, D. J., & Brown, C. M. (2013). Fluorescence resonance energy transfer microscopy as demonstrated by measuring the activation of the serine/threonine kinase Akt. *Nature Protocols*, *8*, 265–281.

Card, J. P., Kobiler, O., McCambridge, J., Ebdlahad, S., Shan, Z., Raizada, M. K., et al. (2011). Microdissection of neural networks by conditional reporter expression from a Brainbow herpesvirus. *Proceedings of the National Academy of Sciences of the United States of America*, *108*, 3377–3382.

Cole, R. W., Jinadasa, T., & Brown, C. M. (2011). Measuring and interpreting point spread functions to determine confocal microscope resolution and ensure quality control. *Nature Protocols*, *6*, 1929–1941.

Cole, R. W., Thibault, M., Bayles, C. J., Eason, B., Girard, A.-M., Jinadasa, T., et al. (2013). International test results for objective lens Quality, Resolution, spectral accuracy and spectral separation for confocal laser scanning microscopes. *Microscopy and Microanalysis*, *19*, 1653–1668.

Frigault, M. M., Lacoste, J., Swift, J. L., & Brown, C. M. (2009). Live-cell microscopy—Tips and tools. *Journal of Cell Science*, *122*, 753–767.

Garini, Y., Young, I. T., & McNamara, G. (2006). Spectral imaging: Principles and applications. *Cytometry. Part A : The Journal of the International Society for Analytical Cytology*, *69*, 735–747.

Kredel, S., Oswald, F., Nienhaus, K., Deuschle, K., Rocker, C., Wolff, M., et al. (2009). mRuby, a bright monomeric red fluorescent protein for labeling of subcellular structures. *PLoS One*, *4*, e4391.

Lacoste, J., Young, K., & Brown, C. M. (2013). Live-cell migration and adhesion turnover assays. *Methods in Molecular Biology*, *931*, 61–84.

Pawley, J. (2000). The 39 steps: A cautionary tale of quantitative 3-D fluorescence microscopy. *Biotechniques*, *28*(884–886), 888.

Shaner, N. C., Campbell, R. E., Steinbach, P. A., Giepmans, B. N., Palmer, A. E., & Tsien, R. Y. (2004). Improved monomeric red, orange and yellow fluorescent proteins derived from Discosoma sp. red fluorescent protein. *Nature Biotechnology*, *22*, 1567–1572.

Shaner, N. C., Steinbach, P. A., & Tsien, R. Y. (2005). A guide to choosing fluorescent proteins. *Nature Methods*, *2*, 905–909.

Stack, R. F., Bayles, C. J., Girard, A.-M., Martin, K., Opansky, C., Schulz, K., et al. (2011). Quality assurance testing for modern optical imaging systems. *Microscopy and Microanalysis*, *17*, 598–606.

Zucker, R. M. (2006). Quality assessment of confocal microscopy slide-based systems: Instability. *Cytometry. Part A*, *69*, 677–690.

Zucker, R. M., Rigby, P., Clements, I., Salmon, W., & Chua, M. (2007). Reliability of confocal microscopy spectral imaging systems: Use of multispectral beads. *Cytometry. Part A: The Journal of the International Society for Analytical Cytology*, *71*, 174–189.

Zucker, R. M., & Price, O. (2001). Evaluation of confocal microscopy system performance. *Cytometry*, *44*, 273–294.

CHAPTER

Assessing and benchmarking multiphoton microscopes for biologists

8

Kaitlin Corbin*, Henry Pinkard*, Sebastian Peck*,[1], Peter Beemiller[†], Matthew F. Krummel*

*Biological Imaging Development Center and Department of Pathology, University of California, San Francisco, California, USA
[†]Department of Pathology, University of California, San Francisco, California, USA

CHAPTER OUTLINE

Introduction: Practical Quantitative 2P Benchmarking ... 136
8.1 Part I: Benchmarking Inputs ... 136
 8.1.1 Laser Power at the Sample ... 137
 8.1.2 Photomultiplier Settings ... 138
 8.1.2.1 Method 1—Fixed PMT Voltage 139
 8.1.2.2 Method 2—PMT Voltage Range 140
 8.1.3 Standard Samples ... 140
 8.1.3.1 A Standard Three-Dimensional Sample Set with Variable Dispersive Properties .. 141
 8.1.3.2 Standard Biological Samples .. 143
 8.1.4 Sample-Driven Parameters: How Fast/How Long 143
8.2 Part II: Benchmarking Outputs ... 144
 8.2.1 The Point Spread Function .. 144
 8.2.2 SNR and Total Intensity ... 146
 8.2.3 Maximal Depth of Acquisition .. 148
8.3 Troubleshooting/Optimizing ... 150
8.4 A Recipe for Purchasing Decisions ... 150
Conclusion .. 151
Acknowledgments .. 151
References .. 151

[1]Present address: Nikon Instruments, Inc., 1300 Walt Whitman Road, Melville, New York, USA.

Abstract

Multiphoton microscopy has become staple tool for tracking cells within tissues and organs due to superior depth of penetration, low excitation volumes, and reduced phototoxicity. Many factors, ranging from laser pulse width to relay optics to detectors and electronics, contribute to the overall ability of these microscopes to excite and detect fluorescence deep within tissues. However, we have found that there are few standard ways already described in the literature to distinguish between microscopes or to benchmark existing microscopes to measure the overall quality and efficiency of these instruments. Here, we discuss some simple parameters and methods that can either be used within a multiphoton facility or by a prospective purchaser to benchmark performance. This can both assist in identifying decay in microscope performance and in choosing features of a scope that are suited to experimental needs.

INTRODUCTION: PRACTICAL QUANTITATIVE 2P BENCHMARKING

Benchmarking and comparison of multiphoton microscopes have traditionally had little rhyme or reason. It is not uncommon for a biologist to make claims of depth of penetration such as his or her microscope "is sensitive to 500 µm" as an attempted method of comparison. However, such a metric clearly depends on many factors, not the least of which is the nature of the sample. Specifically, intensity of the fluorophore, intrinsic autofluorescence and particularly dispersion and scatter within a tissue of interest all contribute extensively to such a metric. It is also possible to illuminate a biological sample with sufficient power to make a single observation at significant depth, but which effectively destroys the sample in the process. Multiphoton illumination does produce photodamage, of course, only less than equivalent single-photon illumination that would be required to illuminate a fluorophore when dispersion and scatter are present.

We have found that the lack of routine quantitative measurements of key components of microscope systems makes rational purchasing decisions difficult and troubleshooting/maintenance uncertain. The former is important when one wishes to independently assess the claims of commercial scopes. The latter is important for keeping microscopes in optimal order and in evaluating the source of poor imaging quality from users of a given microscope. In this review, we discuss some of the methods that we have come to use that allow us to keep track of the quality of microscopes within a lab or shared facility. We have also used these methods for purchasing decisions and we discuss both applications.

8.1 PART I: BENCHMARKING INPUTS

Benchmarking a microscope is similar to conducting a controlled experiment; the most important aspect is to keep key parameters constant. One crucial example is laser power at the sample; every microscope can produce brighter images with lower noise using higher laser power, but such power increase comes with a predictable and

fairly routine increase in photodamage and photobleaching. Below, we introduce three parameters that we keep constant when benchmarking or testing scopes. The values of the parameters that we keep constant are similar but not identical to conditions used in everyday biological experiments. For example, since the increase in power per unit area within an illumination pixel in a scanning system is likely to produce fairly uniform increases across microscopes, we start by choosing a value for this parameter and holding it constant across all measurements. Below, we define three key parameters that are either maintained identically between benchmarking sessions or that can be used routinely between microscopes to allow comparison.

8.1.1 LASER POWER AT THE SAMPLE

Laser power at the sample is a measure of photon flux to the sample and produces the largest impact on sample viability of all the parameters we discuss here. It is therefore the most important parameter to keep constant when comparing instrument performance. It also represents a quick check of laser excitation alignment. Decay in the amount of excitation light reaching the sample may occur slowly on a day-to-day basis, but over long periods of time will have a negative effect on the system's overall efficiency unless the system is routinely measured for misalignment or reduction of the light reaching the sample. This measure can be a quick diagnosis for some of the most common problems on a multiphoton microscope. The long path length in multiphoton microscopes as the beam is routed on the bench top creates a number of opportunities for misalignment such as: temperature variations, accidental knocks of beam steering mirrors, or malfunctions in the laser excitation pathway.

To obtain a baseline for the performance of the laser, a power meter is placed just after the power modulator, in our case an electro-optical modulator (EOM), and the maximum output wattage is recorded. Because the maximum wattage will vary across the laser's tunable range, this is done using several commonly used wavelengths about 100 nm apart as benchmarks. Using the same wavelengths and a known amount of power after the EOM, it is expected that there will be a decrease in the laser power reaching the sample due to the objective transmission capability, overfilling the back aperture, and reflection or transmission efficiency of the primary dichroic. In our system, we have observed this decay can be as high as 40% depending upon the wavelength. Such a decrease in the amount of light reaching the sample without a corresponding drop in laser output at the EOM can be indicative of clipping in the excitation path or dirty or misaligned optics. To measure the output then at the objective for comparison, place the power meter below the objective (on an upright microscope; above on an inverted stand) at approximately its specified working distance and record the wattage delivered at maximum output. For this purpose, we use a Thor Labs brand power meter that integrates at 20 Hz. Whichever brand of power meter selected, the device should be calibrated over time and used similarly for each benchmark so as not to introduce this as an unknown variable in comparisons. It is also important that the power meter chosen is able to handle the very high peak powers of titanium sapphire lasers. Note that some power meters will produce readings

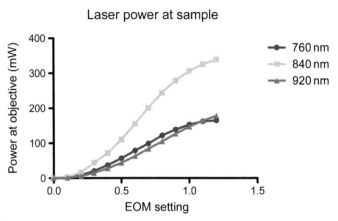

FIGURE 8.1

Change in laser power measured with corresponding EOM voltage change at the sample with varied wavelength. Measured from Spectra Physics MaiTai XF-1 (710–920 nm).

that vary slightly when used under a microscope objective so it is important to establish a routine. We have found that securing the detector to the microscope stage and moving the stage incrementally allows us to find the optimal position from which we record the highest stable value.

We note that it is important to consider the response of the modulator being used to adjust laser power. Commonly used power modulators such as EOMs and acousto-optic tunable filters often do not attenuate laser power linearly as voltage is applied, resulting in a response curve similar to Fig. 8.1. While not essential for comparing between microscopes, the generation of graphs such as Fig. 8.1 is helpful in selecting appropriate settings for biological samples when the wattage applied can adversely affect the life of the sample and fluorescence of interest. Set the modulator so that the same laser power is delivered to the sample on each microscope during a continuous scanning mode or when a single point is being continuously scanned. In our hands, 2 mW as measured at the objective is sufficient for the bead gel assay described below and is a value that we routinely use. The lymph node, our standard biological sample described, is routinely imaged using 12 mW for benchmarking.

8.1.2 PHOTOMULTIPLIER SETTINGS

Photomultiplier tubes (PMTs) are quite variable when implemented in a microscope setting, even comparing those of identical manufacturer "minimum specification," and so benchmarking and standardizing for them can be one of the most difficult aspects of this process. This is easier when comparing the performance of a microscope over time, and we recommend choosing a single applied voltage for benchmarking and keeping it constant. When comparing entire microscope rigs with different makes or models of PMTs with different gain voltages or characteristics, this can be a bit more difficult.

To consider the problem is to consider signal and noise features in detectors generally. PMTs, like other detectors, contribute two distinct types of noise to the images they form. Dark noise can be observed when images are captured while no light falls on the detectors. Dark noise generates low or zero intensity values for the vast majority of pixels but yields stochastic, high intensity pixels that do not coincide in position with the location of fluorescent objects. Frame averaging can be an excellent method of removing this high intensity speckling since these bright pixels rarely happen in the same place across multiple frames. Shot noise (Poisson noise; Chapters 1 and 3), on the other hand, is signal dependent. As voltage is increased in an effort to increase the signal intensity, noise also increases. The higher voltages applied in this scenario also produce higher gains for signal so some excellent images can be produced under these conditions. There are many excellent reviews (Yotter & Wilson, 2003), which are helpful in understanding the source and quantification of noise.

Although we will discuss frame averaging later, we have observed in practice that some users can mine very weak signals to detect and measure objects of interest (e.g., GFP-positive cells "identified" deep in tissue) when gains are used that produce speckles of high intensity. Thus, although the average or standard deviation of the noise may still be low, some pixels of very high intensity are found but can sometimes be accommodated. This is due to the higher gain in such a PMT giving rise to higher overall signals for the true luminescent objects and the ability to "average" out this noise at acquisition or remove single-pixel noise in postprocessing using a Gaussian kernel. But if very small objects are ultimately to be best spatially resolved it remains best to minimize this noise. Since frame averaging is essentially applied identically across all microscopes and should also never vary in how it functions (it is simply a mathematical average), for the purpose of this discussion, we will assume that a user will always do benchmarking with the same frame averaging used. We recommend single frame collection at the same frame rate in a resonant scanning system is used if testing the same microscope over time, or when comparing between scopes to determine efficiency of light detection/capture, identical criteria (notably pixel dwell time) are applied.

There are, however, the practical issues of simply obtaining the best, unambiguous detection of the objects of interest and of obtaining images that will yield quantitative and revealing data about the response of the PMTs and their role in the system as a whole. For this reason, we describe two approaches to benchmarking: the "fixed PMT voltage" method is faster and easier to perform, and the "variable PMT bias voltage" method which is more time consuming but yields a more complete characterization of the detectors, which can be useful for choosing parameters for imaging actual tissues. In general, benchmarks via the first method will mirror those in the second.

8.1.2.1 Method 1—Fixed PMT voltage
Often, end users raise PMT voltage to compensate for a poorly performing microscope in an effort to obtain adequate signal, which results in noisy images. Although having to apply high PMT voltage to detect signal may be indicative of PMT

insensitivity brought on by age or damage, the source of the problem may be found elsewhere. To differentiate a loss of PMT sensitivity from a change in actual signal generated or poor collection efficiency due to alignment, we have devised a simple test.

For the purposes of the bead gel assay that we describe below, we choose a target signal intensity for the most superficially detected beads that precludes pixel saturation and adjust the PMT gain to achieve the desired value, keeping the laser power constant. In an 8-bit system (intensity values 0–255), we typically set the PMT bias voltage so that the target intensity is 240. Once this parameter has been set, we collect Z-stacks of both the dispersive and nondispersive bead samples, at approximately the Nyquist rate (Chapter 1) for the given system, that extend from most superficial beads detected until signal can no longer be distinguished from noise. Our standard data sets extend 500 μm in Z at approximately 500 and 250 nm pixel lateral resolution using a 20× or 25× water-dipping lens with a long working distance.

Using this method, the signal-to-noise ratio (SNR; Chapter 1) at a given sample depth can be calculated, and changes in the instrument's ability to detect objects deep within a sample can be identified as discussed below. The large Z-stack collected here will also be used to evaluate the point spread function (PSF; Chapters 1 and 10) of the instrument as another measure of performance.

8.1.2.2 Method 2—PMT voltage range

The second method of detector benchmarking, which more fully characterizes the response of PMTs, allows more direct comparison and perhaps optimization of individual detectors. As with the previous method, the same laser power should be used across all tests, but in this method, we will use a range of PMT voltages. Note that we will be testing changes in SNR as a function of voltage change, it is therefore important to avoid saturation (e.g., values >255 for 8-bit images). If the bead intensities become saturated, there will be no gains in signal, while noise will continue to increase, changing the response profile. Begin by collecting a small (∼20 μm) representative Z-stack at maximum PMT voltage, sampling at approximately the Nyquist rate. Repeat the same Z-stack acquisition adjusting the PMT voltage by 10% through the PMT's entire range. Some users may choose to acquire the same series of images using a standard biological sample as well due to greater heterogeneity in fluorescence, as it will alter the amount of shot noise produced and give a more accurate picture of how the instrument behaves in experimental settings. In this case, it may be acceptable to allow some saturation in bright areas as it allows dimmer, biologically relevant features to be detected.

8.1.3 STANDARD SAMPLES

Perhaps, the most valuable part of benchmarking is the establishment of a standard sample that can be used over time or at different physical sites. The key features are reproducibility, and representative samples tailored to the types of challenges to

which multiphoton is best applied. To this end, while a standard 10-μm thick histology slide, a pollen grain slide, or immobilized bead standards can provide some insight, the best samples are thick specimens set into media that is dispersive to the same extent as biological specimens. We recommend that one establish two such samples. The first, which we have mentioned in passing above, is reproducible fluorophore-impregnated beads distributed in dispersive nonfluorescent beads, all embedded in a thick slab of hydrogel material. The fluorescent beads mimic fluorophores that might be present in a biological tissue and the second set of beads mimic the effects of biological tissues upon the mean-free path of light within tissues (Theer, Hasan, & Denk, 2003). The sample described below may roughly mimic tissue such as a lymph node. If the target tissue or organ for a study is vastly different, a modified sample (e.g., fewer dispersive beads) may be made to better mimic its properties. The second sample we will describe is a "standard biological sample," a tissue whose optical properties very faithfully represent samples to be used in final experiments but critically whose fluorescent intensity can be maintained to very close tolerances over time.

8.1.3.1 A standard three-dimensional sample set with variable dispersive properties

We recommend, in fact, that two formats of this sample should be made. A first "nondispersive" sample will allow the comparison of the PSF of a multiphoton system. Note that due to the lower numerical aperture (Chapter 2) typically used in multiphoton imaging, and due to the longer wavelength of light, this will typically be inferior to collection in any of the other typical modalities. By collecting a Z-stack of this sample, you will observe that, were tissues not complex (dispersive), imaging depths would be limited only by the working distance of the objective lens. The second variation of this sample, "dispersive," will demonstrate the degree to which the two-photon effect improves imaging at depths in complex tissues and, in comparison to the first version, will demonstrate the degree to which dispersive objects affect imaging deep within tissues.

8.1.3.1.1 Support protocol: Preparation of PSF beads in a dispersive or nondispersive support

Nondispersive gel:

1.5 ml	Polyacrylamide (40%, 19:1 acrylamide:bis-acrylamide)
4.25 ml	ddH$_2$0 (makes 10% polyacrylamide total)
10 μl	Red beads (Invitrogen F13083 1.0 μM 1 × 10^{10}/ml)
10 μl	Green beads (Invitrogen F13081 1.0 μM 1 × 10^{10}/ml)
250 μl	APS (10% solution of powder (kept frozen))
5 μl	TEMED to polymerize the gel

Dispersive gel:

1.5 ml	Polyacrylamide (40%, 19:1 acrylamide:bis-acrylamide)
2.25 ml	ddH$_2$O (makes 10% polyacrylamide total)
10 µl	Red beads (Invitrogen F13083 1.0 µM 1 × 10^{10}/ml)
10 µl	Green beads (Invitrogen F13081 1.0 µM 1 × 10^{10}/ml)
2 ml	Sulfate latex beads (Interfacial Dynamics/Invitrogen: 5 µm diameter. stock: 6.1 × 10^8)
250 µl	APS (10% solution of powder (kept frozen))
5 µl	TEMED to polymerize the gel

Mix all ingredients except TEMED into a six-well dish or mold of choice. Then add the TEMED and gently swirl. Allow to polymerize. Figure 8.2 shows samples ready for use.

Note that other beads may be used but should have standardized emission spectra, brightness, and shape. We have selected 1.0 µm beads, as they are small enough to serve as an approximation of the PSF given the magnification and pixel calibration of our systems, yet are large enough to evaluate SNR. Others may choose to prepare separate samples or include smaller (0.1 µm) and larger beads (10 µm) to more critically evaluate these two parameters. Absolute knowledge of the refractive and dispersive properties is important for the sulfate latex beads or equivalent, but the most important consideration for the purposes of your own benchmarking is that the QC of these beads is consistent. Consider purchasing a lot and maintaining it in the fridge over time.

Note also that the mean-free path for the dispersive sample described above is ~300 µm, calculated with a Mie scattering theorem. In our hands, this shows intensity drop-offs with depths that are similar to mouse lymph nodes. The full calculation

FIGURE 8.2

Nondispersive (left) and dispersive (right) bead gels in 35-mm dishes ready for use.

of this requires more extensive knowledge of the properties of beads, their precise geometry, etc. and is typically given by:

Mean-free path for scattering

$$s = 1/N\sigma_s = 4/NK_s\pi d^2$$

where N is the number of spheres per unit volume, σ_s is the scattering cross section, K_s is the scattering coefficient (the ratio of the scattering to the geometrical cross section), and d is the diameter of the spheres (Churchill, Clark, & Sliepcevich, 1960).

For the purposes of direct comparisons between microscopes, the important feature is that the sample remains the same. Ultimately, the most important test of a microscope will use the tissue of interest. Individual tissues obviously have their own characteristics (e.g., mean-free path) as well as additional features such as fluorescent absorption, which may further reduce detection efficiency but should contribute similarly between microscopes.

8.1.3.2 Standard biological samples

A standard biological sample is also extremely useful in multiphoton benchmarking, and the best choices are those identical or very similar to tissues of interest. It is important for such samples to have fluorescence intensities and tissue composition that remain roughly constant over many trials and potentially many years. Each investigator may choose their own but ours consists of a lymph node from a 6- to 12-week-old C57Bl/6 mouse, containing cells from an ActinCFP (Hadjantonakis, Macmaster, & Nagy, 2002) (or UbiquitinGFP; Schaefer, Schaefer, Kappler, Marrack, & Kedl, 2001) transgenic animal. These latter donor mice produce T cells and B cells with consistent fluorescence intensity, and the use of a standard strain and age of donor mice produces organs with consistent size and density and therefore similar optical properties. It is likely that a user can find similar strains of zebrafish or *C. elegans* systems with similarly consistent levels of fluorescent protein expression. As discussed in the next section, the choice of the system that best matches your "typical" experimental system may help to choose the last imaging parameters that you will want to hold constant in your benchmarking.

8.1.4 SAMPLE-DRIVEN PARAMETERS: HOW FAST/HOW LONG

Since the goals of tissue imaging can vary, there is one last factor to consider in determining how to benchmark your microscopes. This is the issue of how much light your sample can tolerate. Laser power is one aspect of this, but damage is a function of both power and time. Some fluorophores and tissues are resistant to long-term exposure, whereas others are very photosensitive. We will not treat this issue in great detail; microscope detection capability can be benchmarked identically. However, scanning details such as long pixel dwell times can be more destructive than rapid sweeps (e.g., resonant or fast galvanometer scans). Especially, when optimizing

imaging lengths, it may be useful to have prior knowledge of this feature when choosing laser power and scanning parameters for benchmarking.

As an example, for the lymph node samples, our biological standard, we collect timelapse sequences at 30-s intervals encompassing \sim100 μm of z-space at 5-μm intervals. T cells (approximately 5 μm in diameter) will be assessed within the lymph node. The goal of this collection is to assess both the detection depth but also, by collecting a timelapse, to assess whether imaging conditions being tested are compatible with the biology; T cells are typically motile within lymph nodes, and it is a good control that your standard benchmarking imaging conditions for this sample be chosen to be in the range of biological compatibility.

8.2 PART II: BENCHMARKING OUTPUTS

Once a set of standard samples is identified and working parameters are established, it remains to test the microscope for the quality of images that are produced. We chose four parameters to measure routinely. First is the PSF, which allows one to observe the transfer function of a microscope. In other words, for a small point source of fluorescence in a sample, how well the microscope will transfer the intensity to an ideally small region at the detector. Second are the intertwined parameters of total intensity of an object (bead, cell) and the SNR of detection. Lastly, since detection of fluorescence deep within a sample is a desirable feature in multiphoton microscopy, we describe the use of sensitivity as a function of depth as a measured parameter.

8.2.1 THE POINT SPREAD FUNCTION

Degradation of the PSF is often the clearest indication of misalignment and optical aberration in an imaging system that is performing at a suboptimal level (Chapter 7). Figure 8.3A shows the severely aberrated intensity profile of a bead in nondispersive media acquired while the primary dichroic was warped by an aberrant holder. Although the central *XY* plane is comparable to that shown in Fig. 8.3B, a near ideal PSF, it is clear in the *XZ* and *YZ* views that the light propagating axially from the bead is asymmetric, distorting the shape of any detected object (Fig. 8.3C). The cross shape of the PSF is characteristic of an astigmatism (Chapter 2) introduced by a skewed optic or bowing of a mirror. The direction of laser propagation, if it is at a slight angle rather than parallel to the objective as it enters the back aperture, and position of the beam also have a direct impact on the shape of the PSF (Fig. 8.3D). Aberrations may also result from an off-axis optic, for example, in a damaged objective.

Spherical aberration is another prevalent source of degradation of the PSF in tissues. Spherical aberration occurs when light rays that pass through the outside of the optical axis are focused to a different *Z* position than light rays that pass through the center of the optical axis (Chapter 2). For example, consider a simple curved lens that

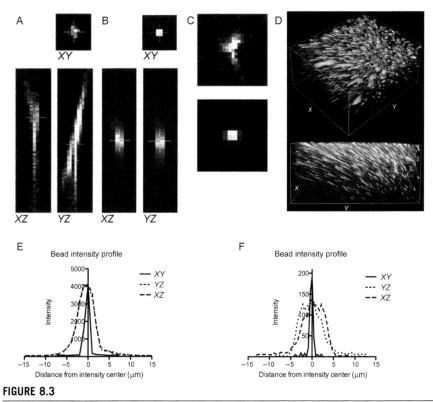

FIGURE 8.3

Acceptable and poor PSFs obtained during benchmarking. (A) Poor PSF suffering from astigmatism. Central XY plane, XZ and YZ views. (B) Acceptable PSF central XY plane, XZ and YZ views. (C) Maximum intensity Z-projections of a single bead (top A, bottom B). (D) XZ view of PSF when the laser beam enters the objective at an angle. (E) FWHM resolution of A. (F) FWHM resolution of B. (See the color plate.)

is ground spherically, the rays that pass through the lens near the outside will be focused differently than the rays that pass through the center. This causes a large spreading of the PSF in the Z axis, and decreases resolution and intensity considerably. Modern optics are corrected for spherical aberration with a specific optical path length, but in practice, this path length invariably changes when imaging through large samples. This is why it is very important to use an objective that has an immersion media matched to the sample, or use an objective that has a correction collar that allows you to correct for any spherical aberration. Especially, when considering the nonlinear dependence of multiphoton excitation, this can have a huge impact on the brightness and quality of your image.

Using the Z-stack acquired of beads in nondispersive media, we select a representative bead and calculate lateral and axial full-width half maximum (FWHM; Chapter 7) based on the centroid intensity (Fig. 8.3E and F). Although this method

may not be sensitive enough to be applied to other systems, particularly those designed for high precision localization, it allows direct comparison between the performance of instruments. Importantly, it provides a quick method of quantification for gains made through incremental tweaks in alignment and optimization and always will affect the other two measurements we will make.

8.2.2 SNR AND TOTAL INTENSITY

Because SNR is a ratio, it is a dimensionless parameter that does not have units; it provides an easy method of comparison of the quality of images. As a first measure of system performance and sensitivity we use the large Z-stack acquired using the dispersive bead gel (method 1) to evaluate the SNR of the most superficial beads. We use Imaris (Bitplane AG) spot detection to identify beads and calculate the average signal intensity in a selected plane. This can also be done in ImageJ using the TrackMate plug-in or creating masks, which cover the bead area (for our systems $\sim 2 \times 2$ pixel spots). Whichever method is preferred, it should be used identically for all measurements. There are several methods for calculating image noise (Paul, Kalamatianos, Duessman, & Huber, 2008; Yotter & Wilson, 2003) all of which have practical applications, but for our purposes in PMT detection where there can be high shot noise, the standard deviation of pixel intensity in areas without beads is most suitable. Two 140×140 pixel regions of interest (ROIs) in a single plane free of beads were selected and used to calculate the standard deviation of the noise (Fig. 8.4A). We consider that at a minimum standard, a scope should be able to deliver an SNR of no less than 10:1 for the fluorescent beads in dispersive media at superficial depths or in a nondispersive sample. That is, with a target signal intensity of 240, standard deviation of noise should be no greater than 24. In subsequent deeper planes, the SNR can be expected to decrease with scattering and absorption until beads can no longer be detected. SNR as a metric of maximal depth penetration will be discussed below.

While the performance of the PMTs will affect the total intensity and maximal depth of acquisition, any change in these metrics that can be traced back to other elements such as alignment should be corrected prior to evaluating the response of the detectors themselves.

The data set collected in method 2 can be used to generate the response profile of a detector under standardized conditions. We select a representative plane from the acquired Z-stack and repeat the same spot detection and noise calculation steps as described for method 1 for images acquired using each PMT voltage. Both signal (Fig. 8.4B) and noise (Fig. 8.4C and D) intensities increase as more voltage is applied.

As evident visually in Fig. 8.4E, as higher voltage is applied, PMTs generate high intensity noise at higher frequency. Because these high intensity pixels occur stochastically, they are not biased toward particular pixels across frames and their effect on noise standard deviation and maximum can be mitigated by frame averaging (Fig. 8.4C and D). The cost of this noise reduction is a reduction in frame rate,

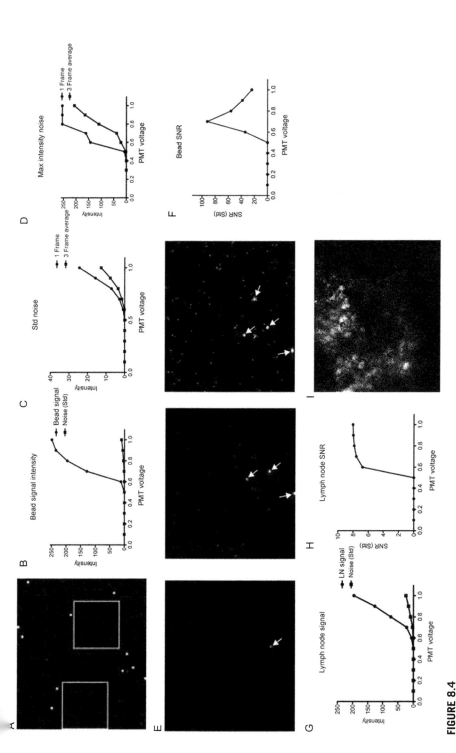

FIGURE 8.4

(A) Spots detected used to calculate signal average intensity and two 140 × 140 pixel square ROIs used to calculate noise standard deviation. (B) Average bead intensity signal with increased PMT voltage at a single Z-plane (15 μm depth). (C) Standard deviation of noise calculated from two 140 × 140 pixel ROIs with increased PMT voltage in a single image and from an average of three images at a single Z-plane (15 μm depth). (D) Maximum intensity of noise in two 140 × 140 pixel ROIs with increased PMT voltage from single image and from an average of three images at a single Z-plane (15 μm depth). (E) Bead images at the same Z-plane at 0.6 V (left), 0.8 V (center), 1.0 V (right) shown at ~2.5× for clarity. Arrows indicate position of fluorescent beads; intensity values at other pixels are the result of noise. Noise frequency and intensity increases with bias voltage. (F) Signal-to-noise ratio of beads with varied PMT voltage. (G) Average yellow channel signal intensity from a single Z-plane (20 μm depth) of actin-CFP CD11-c-YFP lymph node. (H) Signal-to-noise ratio of yellow channel from single plane of actin-CFP CD11-c-YFP lymph node image. (I) Image of single plane of actin-CFP, CD11-c-YFP lymph node.

for example, in Fig. 8.4 speed is reduced from 30 frames per second (video rate) to 10 frames per second. When acquisition speed and photodamage are not primary concerns, averaging of an extremely noisy detector can generate images with acceptable SNRs.

Ideally, as PMT voltage is increased, signal intensity will increase exponentially while noise increases only linearly, improving the SNR. Typically, each detector has a sample-dependent optimal setting for the signal gains beyond which increased voltage produces only marginal returns while continuing to produce noise. Figure 8.4F shows the SNR curve for beads detected at varying voltages. Although the highest SNR is achieved at 0.7 V, by visually inspecting the image, it is clear that several beads that are present are not detected at this setting. Although a higher voltage results in a decrease in SNR (to a level still well above our minimum detection threshold, $SNR > 4$), the gains in ability to identify objects of interest are more valuable. This trade-off is made in biological samples in an effort to image dimmer, smaller features of interest. We routinely perform the same benchmarking procedure using excised lymph nodes containing actin-CFP as well as CD11c-YFP cells, in addition to bead samples, as we have found the shot noise and signal gains generated are highly context dependent (Fig. 8.4G and I). That is, the beads alone do not give a full picture of how well the detector is truly doing when generating useful experimental images.

Ultimately, the goal of this exercise is to create a historical standard for the signal and noise generated by a PMT at a given voltage in response to a known sample, against which the microscope can be compared on a regular basis. We have found that even on the same instrument, the performance of PMTs of the same make and model varies. Figure 8.5A shows the difference between the SNR of the PMT used as our green channel, which is approximately 3-years old, and a newly replaced PMT used as our red channel. The change in a single PMT's response between years can also be characterized in this way using beads or a standard biological sample (Fig. 8.5B), which we have found more informative about the instrument's practical performance.

8.2.3 MAXIMAL DEPTH OF ACQUISITION

The choice to use two-photon imaging over other optical sectioning techniques is most often due to its ability to penetrate further into tissue, allowing the visualization of biological processes in context without physical disruption. Although the depth at which features will be able to be resolved ($SNR > 4$) will vary depending on the scattering properties of the tissue and brightness of the features themselves, the microscope should reliably be able to image to a consistent depth in the standard bead sample made of dispersive media. Figure 8.6A (right) shows the falloff of sample intensity with depth. To quantify this parameter, beads were identified in the data set described in PMT Settings, method 1 (500 μm Z-stack, 0.4 μm steps, dispersive sample) using Imaris (Bitplane AG) spot detection. SNR was calculated by dividing mean bead intensity at the intensity center by the standard deviation of the noise. Beads could not reliably be identified at depths beyond 350 μm with $SNR > 4$ at the chosen laser power and PMT voltages (Fig. 8.6B).

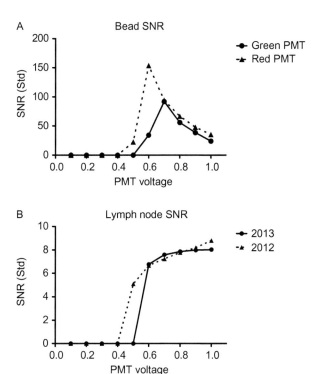

FIGURE 8.5

Comparison of SNR in beads and lymph nodes across years. (A) SNR from red and green (solid and dashed in print version) beads generated under identical conditions between two detectors on the same microscope. (B) SNR of images from the same detector of a CD11c-YFP lymph node under identical conditions taken 1 year apart. Gains in SNR with increased voltage are reduced between benchmarking experiments indicating decreased sensitivity.

Changes in depth of penetration between benchmarking experiments may be indicative of several independent factors. As PMTs age, they may see increased noise and decreased gains in signal, reducing overall sensitivity and making it more difficult to resolve features deep in the sample. Quantifying and diagnosing PMT changes are discussed in the following section.

Temporal dispersion of the femtosecond laser pulses used in multiphoton systems can decrease the effective power delivered to the focal plane, an affect that is worsened with scattering deep in tissue. Such dispersion results from differential wavelength-dependent refraction of excitation light caused by routing optics or the optical properties of tissues. Some multiphoton lasers include hardware and software packages that allow users to compensate for this dispersion by "chirping" pulses (predispersing laser pulses in the opposite direction to compensate for dispersion introduced by the system).

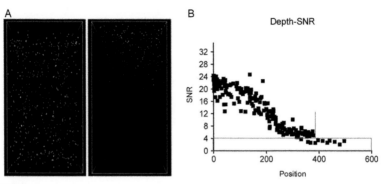

FIGURE 8.6

Z-projections of nondispersive bead, dispersive bead, and a standard biological sample. (A) YZ oriented 3D view of 500 μm thick Z-stack taken with 0.4 μm Z steps in nondispersive gel (left) and dispersive gel (right). The working distance of the objective typically limits Z collection in nondispersive samples. Dispersive media limits the depth at which images can be collected. (B) SNR of beads detected through spot detection algorithm versus depth in dispersive gel media. SNR decreases with imaging depth, and we see a corresponding drop in the number of detected spots. Box indicates beads with SNR < 4, and vertical line indicates "maximal depth" achieved by imaging system.

8.3 TROUBLESHOOTING/OPTIMIZING

Throughout this discussion, there is the presumption that certain parameters can be better in one scope as compared to another or can decay (or improve) in a given scope over time or with change in alignment, etc. A few key parameters to note are the alignment of the system (PSF and intensity), the quality and age of PMTs (intensity and maximal depth of acquisition) and the pulse width of the laser (maximal depth of acquisition) (Zucker & Price, 2001). Of course, many other factors play into the quality achieved by microscope and can be as mundane as the bandpass of detection filters or dust on various optical elements (Chapter 4). The benchmark we describe, however, can be performed and vigorously promoted with a service engineer (in the case of a commercially produced microscope) or with a local technician (in the course of a microscope built or serviced in-house). It is quite important and very helpful that "poor performance" be unambiguously tracked to the microscope itself and not simply a spate of bad samples.

8.4 A RECIPE FOR PURCHASING DECISIONS

Multiphoton microscopes require significant alignment to function optimally and when considering commercially produced microscopes, this is an important issue to understand. The proper perspective on this issue is that you want to have the very best system for your needs, regardless of whether it can be set up in your lab for a 1-week trial or if, conversely, a technician might hand-carry the samples to a distant

site. We suggest the latter will be the best way to see the best instrument that a vendor can offer. Based on our experiences, we recommend against having a vendor "demo" microscope on-site since invariably the scope will not function optimally in a short demonstration period, and even if it is functioning to its design optimum, you may wonder if "it might have done better" given stable and optimal conditions. Such is not a rational selection mechanism. A benchmark as used here can be best used during instrument selection to choose 'the best' for your uses and then a second time when a purchased instrument is installed to confirm that the instrument that is delivered operates to your required specification.

CONCLUSION

The process of benchmarking is important in the testing and acquisition of a system as well as throughout its life span. It is important to define key collection parameters and samples to use for benchmarking. A standard dispersive bead sample and a standard biological sample represent key steps in establishing a protocol for obtaining and maintaining a microscope with optimal function for biological applications. Ultimately, it helps to determine whether a biological experiment can or cannot be done, and whether the biology or the microscope might be improved to facilitate an experiment.

ACKNOWLEDGMENTS

The authors thank the Krummel lab for helpful discussions. The authors declare no competing financial interests.

REFERENCES

Churchill, S. W., Clark, G. C., & Sliepcevich, C. M. (1960). Light-scattering by very dense monodispersions of latex particles. *Discussions of the Faraday Society, 30*, 192–199.

Hadjantonakis, A. K., Macmaster, S., & Nagy, A. (2002). Embryonic stem cells and mice expressing different GFP variants for multiple non-invasive reporter usage within a single animal. *BMC Biotechnology, 2*, 11.

Paul, P., Kalamatianos, D., Duessman, H., & Huber, H. (2008). Automatic quality assessment for fluorescence microscopy images. In *8th IEEE international conference on BioInformatics and BioEngineering, BIBE 2008, 8–10, 2008* (pp. 1–6), pp. 1–6.

Schaefer, B. C., Schaefer, M. L., Kappler, J. W., Marrack, P., & Kedl, R. M. (2001). Observation of antigen-dependent CD8+ T-cell/dendritic cell interactions in vivo. *Cellular Immunology, 214*, 110–122.

Theer, P., Hasan, M. T., & Denk, W. (2003). Two-photon imaging to a depth of 1000 micron in living brains by use of a Ti:Al2O3 regenerative amplifier. *Optics Letters, 28*, 1022–1024.

Yotter, R. A., & Wilson, D. M. (2003). A review of photodetectors for sensing light-emitting reporters in biological systems. *IEEE Sensors Journal, 3*, 288–303.

Zucker, R. M., & Price, O. (2001). Evaluation of confocal microscopy system performance. *Cytometry, 44*, 273–294.

CHAPTER

Spinning-disk confocal microscopy: present technology and future trends

9

John Oreopoulos*, Richard Berman*, Mark Browne[†]

*Spectral Applied Research, Richmond Hill, Ontario, Canada
[†]Andor Technology, Belfast, United Kingdom

CHAPTER OUTLINE

9.1 Principle of Operation .. 153
9.2 Strengths and Weaknesses ... 155
9.3 Improvements in Light Sources .. 157
9.4 Improvements in Illumination ... 157
9.5 Improvements in Optical Sectioning and FOV ... 162
9.6 New Detectors ... 166
9.7 A Look Into the Future .. 167
References ... 171

Abstract

Live-cell imaging requires not only high temporal resolution but also illumination powers low enough to minimize photodamage. Traditional single-point laser scanning confocal microscopy (LSCM) is generally limited by both the relatively slow speed at which it can acquire optical sections by serial raster scanning (a few Hz) and the higher potential for phototoxicity. These limitations have driven the development of rapid, parallel forms of confocal microscopy, the most popular of which is the spinning-disk confocal microscope (SDCM). Here, we briefly introduce the SDCM technique, discuss its strengths and weaknesses against LSCM, and update the reader on some recent developments in SDCM technology that improve its performance and expand its utility for life science research now and in the future.

9.1 PRINCIPLE OF OPERATION

The central concept of spinning-disk confocal microscopy (SDCM), first conceived by Petrán (Petrán, Hadravsk, Egger, & Galambos, 1968), is that an array of illuminated pinholes positioned at one of the microscope's intermediate image planes will

create a demagnified array of tiny excitation focal volumes at the conjugate objective lens object plane. Light (generated by reflection, fluorescence, or otherwise) emanating from these focal volumes is collected by the objective lens and returned to a corresponding pinhole in the array, thus satisfying the confocal criterion. When the array of pinholes is repeatedly scanned across the sample in an appropriate fashion at a sufficiently high rate (video rates or faster), a real-time confocal image of the in-focus sample is generated, which can be viewed directly by eye or recorded with a camera. It is essential that the pinholes be disposed in a pattern that illuminates each point in the sample field of view (FOV) for an equal length of time during successive scans to produce a uniformly exposed image. Both of these conditions can be achieved with an array of regularly spaced pinholes arranged in an Archimedean spiral on a fast-rotating wheel with a constant velocity (Fuseler, Jerome, & Price, 2011)—a so-called Nipkow disk that has its origins in an abandoned electromechanical form of television created by the German engineer Paul Nipkow.

A major limitation of early single disk SDCM designs was their poor illumination efficiency (\sim4% transmission) (Xiao, Corle, & Kino, 1988). Li Chen and his colleagues at Wayne State University sought to address this problem by inventing the dual-disk SDCM, in which a pinhole disk containing \sim20,000 pinholes is combined with a second disk having a matching array of microlenses. Each pinhole is associated with a microlens at the same disk coordinate, and the disks are comounted onto a motor shaft with a separation equal to the focal length of the microlenses (Kuo, 1992). When illuminated with collimated light, each microlens creates a focused spot of light, of which approximately 40% can enter the associated pinhole. Chen also introduced a polarizing prism between the disks projecting the reflected light into an orthogonal detector path, thereby isolating the detector channel from the primary source of image background caused by stray illumination light.

This patented dual-disk technology was licensed to Yokogawa Electric Corporation in the early 1990s, and the Yokogawa Confocal Scanner Unit (CSU) was introduced to the market soon afterward (Fig. 9.1; Ichihara, Tanaami, Ishida, & Shimizu, 1999; Tanaami et al., 2002). During the unit's development, Yokogawa realized two important things: First, confocal fluorescence microscopy was quickly becoming the method of choice for live-cell imaging studies, fuelled by the discovery of green fluorescent protein (GFP) and its spectral variants (see Chapter 6). Second, to make the CSU suitable for this growing field, a plate dichroic mirror placed between the two disks was needed for fluorescence detection.

When combined with concurrent advances in camera and laser technology, the CSU provided a revolutionary tool for life sciences (Genka et al., 1999; Inoue & Inoue, 2002; Nakano, 2002; Stehbens, Pemble, Murrow, & Wittmann, 2012). Integrated SDCM systems like these have proven to be effective for following transitory electrophysiology processes such as calcium sparks (Enoki, Ono, Hasan, Honma, & Honma, 2012), observing and analyzing 3D intracellular fluorescent protein dynamics (Gierke & Wittmann, 2012), protein localization, endo- and exocytosis, embryo development (Abreu-Blanco, Verboon, & Parkhurst, 2011), *in vivo* immune responses (Wong, Jenne, Lee, Leger, & Kubes, 2011), and even the diffusion and

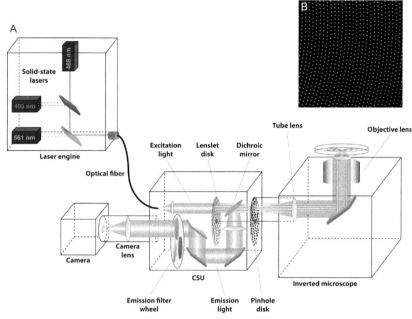

FIGURE 9.1

Schematic layout of a dual-disk SDCM (A) (not to scale) and real image of a stationary pinhole disk (B).

interactions of single molecules in living cells (Tadakuma, Ishihama, Toshiharu, Tani, & Funatsu, 2006).

9.2 STRENGTHS AND WEAKNESSES

There are three distinguishing aspects of SDCM that lend it a few advantages over traditional LSCM. First, charge-coupled device (CCD) cameras have significantly higher quantum efficiencies (QEs) (65–90%) than LSCM photomultiplier tubes (PMTs) (20%) or avalanche photodiodes (APDs) (40%), and therefore, the available emission photons are collected more efficiently (Toomre & Pawley, 2006). Second, this greater detection sensitivity reduces the required exposure times in SDCM experiments, permitting higher frame rates for equivalent image signal to noise ratios (SNRs). Because of these first two advantages, SDCM can deliver the same multidimensional image dataset at 10–100 times the rate of LSCM. Considering that a typical core facility charges an hourly rate for access, it is easy to understand why SDCMs are often the most heavily booked instruments. Third, SDCM has been shown to inflict markedly less photobleaching compared to LSCM, allowing live cells to be imaged for longer periods of time and with a lower risk of phototoxic degradation (Inoue & Inoue, 2002). This observation has been attributed to the

differences in the excitation light dosage rates and detection duty cycles between SDCM and LSCM (Graf, Rietdorf, & Zimmermann, 2005; Wang, Babbey, & Dunn, 2005). In LSCM, a high-intensity laser beam passes over every point in the sample once but only for a very short period of time during which the PMT detects emission light (the pixel dwell time, typically a few microseconds). On the other hand, in SDCM, the excitation light is spread over >1000 beams of correspondingly 1000-fold lower intensity that pass over the same point in the sample several tens of times over a longer period totaling the camera exposure time. Assuming an equal frame rate and excitation light flux entering the objective lens and matching detection pinhole size and detector sensitivity, the two situations would yield exactly the same fluorescence intensity in the image were it not for the fact that fluorescence can be saturated through ground state depletion (Wolf, 2007). LSCMs that accomplish high-speed serial scanning with resonant galvanometric mirrors necessitate increased power levels during the shorter pixel dwell time and hence the greater phototoxicity that attends fluorescence saturation conditions. Therefore, the superior live-cell imaging characteristics of SDCM derive from not only a more efficient mechanism of fluorescence detection but also a more efficient mechanism of fluorescence excitation (Murray, Appleton, Swedlow, & Waters, 2007).

Disadvantages of SDCM include the lack of a scan zoom function to alter the digital image sampling rate (Heintzmann, 2006) and the inability to adjust the pinhole size to alter the optical sectioning strength and imaging resolution. In addition, quantitative imaging techniques like colocalization, Förster resonance energy transfer (FRET), and image segmentation are often compromised by the nonuniform illumination profiles encountered in SDCM (Fig. 9.2A; Murray, 2007). Furthermore, acquiring registered multicolor images simultaneously (as opposed to sequentially)

FIGURE 9.2

A comparison of single-mode (A) and multimode (B) fiber SDCM illumination. 1 μm diameter TetraSpeck™ fluorescent microspheres (Invitrogen) were excited with a 642 nm laser and imaged with CSU-X1 scan head onto an EMCCD camera through a 700/75 nm emission bandpass filter. (See the color plate.)

is not trivial since this requires multiple cameras or image-splitting devices. SDCM also lacks the ability to scan arbitrary 3D shapes across the sample, which is convenient for applications where cross-sectional (x, z), line, or single-point region acquisitions are needed for logging very rapid (sub-ms) events in isolated cellular structures (e.g., axon action potentials).

The most substantial disadvantage of SDCM is the pinhole cross talk effect that creates a perceptible hazy background signal and impacts the image's axial resolution (Conchello & Lichtman, 1994, 2005). As the crosstalk effect also depends not only on pinhole size and objective magnification but on other non-constant parameters such as the labeling density and sample thickness in addition to the pinhole size, a specific equation for the actual axial resolution of SDCM cannot be easily formulated (Amos, McConnell, & Wilson, 2012). A balance must therefore be struck between the pinhole spacing and the intensity of the cross talk background. While closer spaced pinholes will increase the excitation and emission light that impinges on and radiates from the sample, respectively, it will concurrently raise the cross talk background signal (Murray et al., 2007).

The wider benefits of SDCM have not yet been fully exploited due to these existing disadvantages in current SDCM instrument designs. In the following sections, we review a number of the newer technological additions to SDCM that improve upon some of these limitations and that we predict will promote its utility in other fields such as intravital imaging or developmental biology and neurobiology.

9.3 IMPROVEMENTS IN LIGHT SOURCES

Lasers are the preferred light source for the CSU because they provide a powerful, monochromatic, and coherent beam of light that can be launched into an optical fiber. While gas lasers such as argon ion and krypton–argon are adequate laser sources for SDCM, they require gas recharging after around 2000 h, have a large footprint, and incur high electrical loads. Over the last decade, a migration towards directly modulated (shutter-free) solid-state lasers has taken place (Gratton & vandeVen, 2006). A wide range of wavelengths (375–785 nm), powers (20–500 mW), and lifetimes (\sim10,000 h) are now attainable in compact enclosures referred to as "laser engines." Moreover, laser engines can be purchased with multiple, fast-switching output fibers that allow the encased lasers to be shared for other modes of optical imaging such as total internal reflection fluorescence (TIRF) and fluorescence recovery after photobleaching (FRAP). Most laser engines now also allow for rapid gating of the lasers during the camera readout, to eliminate the streaking image artifacts due to exposure during the camera frame transfer cycle (Chong et al., 2004).

9.4 IMPROVEMENTS IN ILLUMINATION

All standard Yokogawa CSU models rely on single-mode optical fibers (SMFs) for illumination, which is partly driven by legacy from LSCM and partly for practical reasons. The output from an SMF is a nearly ideal diffraction-limited source of light

a few micrometers in size with a Gaussian intensity distribution. It works well when used as the confocal source for an LSCM since the tip of the fiber is imaged through the microscope to a diffraction-limited spot on the sample (~250 nm laterally and ~500 nm axially). A SMF is less ideal when implemented as a source for the CSU or other similar SDCMs, since the illumination light of this small source must be spread out over a relatively large FOV. The CSU illumination optics enlarge and collimate the beam exiting the SMF and cast it onto the microlens disk. Pinholes in the center of the FOV receive greater illumination intensities than those near the edges because of the light's Gaussian intensity distribution. The early CSU models (10–22) reduced the absolute variation in intensity by greatly overfilling the FOV, only utilizing light near the centre of the Gaussian profile. Although this reduces the variation in illumination intensity, it is an inefficient use of light with only 6–12% of the light exiting the fiber transmitted as useable light onto the sample, neglecting losses within the microscope.

A primary improvement in the Yokogawa CSU-X1 design was the introduction of an aspheric beam-shaping lens into the illumination path. The purpose of this lens was to redistribute light from the center of the SMF Gaussian distribution to the lower intensity wings of the distribution. This allowed the amount of FOV overfill to be reduced, resulting in not only a more uniform illumination profile but also a greater light efficiency. The improvement is significant, particularly at the blue wavelengths (450–500 nm). Green and red wavelengths (550–650 nm) continued to show characteristic hot spots with an overall nonuniformity of 30% or greater (Fig. 9.3). The reason for this is that different colors of light emerge from a SMF with different numerical aperture values, making the optimization of the aspheric lens across all wavelengths difficult.

More recently, a patented modification to the CSU illumination optics known as Borealis has been implemented by Spectral Applied Research and enables the application of larger core multimode optical fibers (MMFs) for light delivery in SDCM with compelling advantages (Berman, 2012; Cooper, 2013). The normally irregular speckled output of a MMF can be transformed into a nearly perfect flat light distribution using an in-line randomizer that scrambles the coherence of the laser light and averages out the irregularities (Fewer, Hewlett, & McCabe, 1998). The MMF can also be fabricated with any arbitrary shape, the ideal being a square or rectangular shape that matches the proportions of the camera. In the Borealis implementation, the tip of the fiber is imaged directly onto the microlens array (a form of critical illumination) culminating in an extremely uniform distribution of light in the FOV (Fig. 9.2B). Corner-to-corner "flatness of field" index values (Hibbs, MacDonald, & Garsha, 2006) below 10% are not uncommon and when the system is properly aligned to microscopes equipped with highly corrected low field curvature, plan-apochromatic objective lenses can approach 5% or less (Fig. 9.3).

Uniform illumination profiles are important since reliable and accurate quantitative comparisons of fluorescence intensities across an image are hindered without them (Waters, 2009; Wolf, Samarasekera, & Swedlow, 2007), especially when comparisons are made between images captured in different spectral channels that have different degrees of illumination uniformity (i.e., FRET, calcium ratio imaging, and

9.4 Improvements in illumination

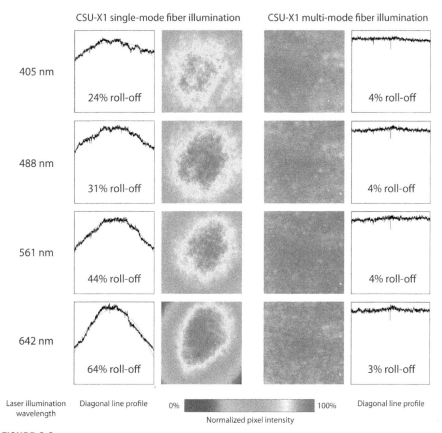

FIGURE 9.3

Directly viewed CSU-X1 single-mode and multimode fiber laser illumination profiles. A beam profiler camera focused onto the pinhole disk plane of CSU-X1 captured images of the laser output of the scan head at different excitation wavelengths and with different types of fiber illumination. The camera FOV was cropped to match the area viewed by an EMCCD camera with a 1.2× camera lens. For each laser wavelength, a diagonal line profile of pixel intensities is plotted beside each image and a second-order polynomial is fit to the data to determine the flatness of field index (expressed as a percent roll-off). In the case of single-mode fiber illumination, the flattest region of the illumination profile (less than 10% roll-off) corresponds to approximately only 20–40% of the usable EMCCD sensor-chip area. (See the color plate.)

colocalization) (see Chapters 18 and 24). Furthermore, most automated image analysis algorithms assume even illumination across the FOV (Michálek, Čapek, & Kubínová, 2011). In this regard, gradients in the illumination profile thwart proper thresholding, segmentation, object counting, 3D reconstruction, morphology, and intensity distribution evaluation. The detrimental effects of inhomogeneous illumination are even more striking when a mosaic composed of images from a number of adjacent fields of view is analyzed since automatic stitching algorithms may fail to recognize connecting structures (Fig. 9.4).

FIGURE 9.4

Image stitching with single-mode (A) and multimode (B) fiber illumination. A tiled image composed of 8 × 10 EMCCD image fields of a fluorescently labeled mouse embryo was acquired with no image overlap using both types of illumination. The uneven illumination profile caused by single-mode fiber illumination leads to a pincushion effect that makes it difficult to discern features and connections at the edges of tiled frames.

An additional advantage of the Borealis illumination scheme is that a greater fraction of the laser light is transferred through the scan head (up to $3\times$ more on older upgraded CSU models and wavelength-dependent) because only the camera FOV is illuminated with little overfill. This allows one either to reduce the camera exposure time (higher frame-rate) or achieve greater image SNR by applying more light to the specimen.

Implementation of larger-core-diameter MMFs grants a stable, long-term coupling of laser light from the laser engine into the CSU scan head that is less prone to mechanical, thermal, and optical drift. Often, these kinds of drift cause SMF-based laser couplings to go out of alignment. Proper matching between the illumination and the camera detection areas also minimizes sample photobleaching and the generation of phototoxic products in unobserved regions of the specimen beyond the FOV. This feature is helpful for sensitive and prolonged time-lapse imaging of living specimens.

MMFs can also propagate light across a wider range of wavelengths than SMFs, which presents the opportunity to illuminate specimens in SDCM with laser wavelengths that extend beyond the visible region and into the ultraviolet (UV) and near-infrared (NIR) regions of the electromagnetic spectrum. Together with the development of newer contrast agents or engineered proteins that absorb NIR light (730–800 nm) and emit NIR fluorescence (750–1000 nm), NIR-SDCM at longer wavelengths where tissue autofluorescence is essentially absent (Frangioni, 2003) is now a viable option for researchers. Many cellular tissues are also relatively transparent to infrared light, exhibiting lower absorbance and scattering by molecules like hemoglobin and skin melanin, and as a result, fluorescent proteins/probes that can be excited at these wavelengths are useful for deeper-tissue optical imaging. NIR-SDCM is demonstrated in Fig. 9.5 where the entire 90 μm thickness of an aged rat brain slice containing oligodendrocytes labeled with LI-COR® IRDye 800CW NHS Ester has been imaged in 3D with 730 nm excitation and >785 nm emission with a Borealis-modified CSU. Tissues like these accumulate autofluorescent lipofuscin pigments that create a high image background when excited and imaged at more common visible wavelengths. The quality of NIR-SDCM images is enhanced by the utilization of CCD cameras manufactured with silicon array sensors that reduce fixed pattern noise (fringes) caused by NIR etaloning (eXcelon™ technology available from E2V; Princeton Instruments, 2010).

MMF illumination does present a few constraints. SMFs can preserve polarization, whereas MMFs cannot. Experiments requiring polarized excitation light necessitate the MMF light to be repolarized using a polarizer at the tip of the fiber. In practice, other optics and mirrors in the illumination train tend to induce depolarization, and so, the best location for the polarizer is between the microlens and the pinhole disks (Ghosh, Saha, Goswami, Bilgrami, & Mayor, 2012). The randomizer imposes another restriction. Laser light randomization must occur on the timescale of a single pinhole traversing a distance equal to its diameter to avoid uneven, speckled illumination profiles. In the case of the Borealis modification, the flattest profiles are achieved at exposure times greater than 1 ms.

FIGURE 9.5

Maximum intensity z-projection (A) and 3D volume rendering (B) of an aged rat brain slice containing oligodendrocytes and blood vessels fluorescently labeled with Invitrogen Alexa Fluor 488 dye and LI-COR® IRDye 800. Tissues like these accumulate autofluorescent lipofuscin pigments that create a high image background when excited and imaged with visible wavelengths. The same z-projection (C) and volume rendering (D) of the brain slice when excited and imaged with infrared wavelengths show a greatly reduced autofluorescence background signal and a deeper imaging depth. Specimen kindly prepared by Dr. Claude Messier, University of Ottawa. (See the color plate.)

9.5 IMPROVEMENTS IN OPTICAL SECTIONING AND FOV

The CSU has been through five model changes since its initial debut. The CSU-10, CSU-21, CSU-22, and CSU-X1 models offer a FOV of approximately 10 × 7 mm at the intermediate image plane (Fig. 9.6) and utilize the same disk pattern—50 μm pinhole diameter with 250 μm pinhole spacing (Fig. 9.1B)—with 12 pattern repetitions per revolution, yielding 1000 fps at disk speeds of 5000 rpm. In terms of optical sectioning capability, the 50 μm pinhole size is optimized for a 100×, 1.4 NA objective lens (~1 airy unit in the visible region; see Table 9.1) and translates to 4% open area

9.5 Improvements in optical sectioning and FOV

FIGURE 9.6

Relative sizes of various camera sensor-chip areas compared to the image size-limiting CSU-X1 field aperture. (A) 21.8 mm diagonal sCMOS camera, 1× camera lens. (B) 18.8 mm diagonal sCMOS camera with 1× camera lens. (C) CSU-X1 field aperture. (D) 10.9 mm diagonal interline CCD camera, 1× camera lens. (E) 11.6 mm diagonal EMCCD camera, 1.2× camera lens. In (C), a measured CSU-X1 illumination profile spanning the entire field aperture is displayed. The flattest part of this profile (less than 10% roll-off) corresponds to only 19% of the usable EMCCD sensor-chip area.

ratio of the pinhole disk. In this configuration, about 1000 beamlets sweep the specimen in a full FOV. The stock CSU-X1 model point spread function (PSF) has a full width at half maximum (FWHM) of approximately 1 μm using a 60×, 1.4NA objective lens. Pinhole separation sets a limit to specimen thickness before the cross talk between pinholes becomes a significant source of background. In a "fluorescence sea experiment" (Egner, Andresen, & Hell, 2002), the limit was found to be around 10 μm, but in specimens with specific labeling and where efforts are made to minimize immersion and mounting medium refractive index mismatches, it is quite possible to achieve high-contrast imaging at more than 100 μm deep.

The most recent model, CSU-W1, has made substantial changes to the disk pattern and now offers a 17 × 16 mm FOV at the intermediate image plane. With an option for two separate disks and bypass mode as standard, the CSU-W1 provides selection of 50 or 25 μm diameter pinholes. The microlens diameter is 500 μm, and the larger spacing pinhole arrangement achieves three pattern repetitions per revolution, resulting in 200 fps at a disk speed of 4000 rpm. As before, the 50 μm pinhole is optimized for a 100×, 1.4 NA objective lens, while the 25 μm pinhole is ideal for either a 40×, 1.0 NA objective lens or a 25×, 0.6 NA objective lens (Table 9.1). This translates to either 1% or 0.25% open area ratio of the pinhole disk and taking into account the larger FOV results in ∼1000 beamlets focused onto the specimen in

Table 9.1 Yokogawa CSU system imaging parameters with a fluorescence emmision wavelength of $\lambda = 525$ nm

Configuration and camera type	Objective lens magnification	Objective lens NA	Rayleigh resolution (nm)	Intermediate image plane airy disc diameter (μm)	Pinhole size[a] (Airy Units)	Camera lens magnification	Digital sampling factor (pixels per airy disc radius)	Sample plane pixel size[b] (nm)	Sample plane field of view[c] (μm)
CSU-X1 with EMCCD[d]	25	0.6	534	27	1.9	1.2	1.0	533	386
	40	1.0	320	26	2.0	1.2	1.0	333	241
	60	1.4	229	27	1.8	1.2	1.0	222	161
	100	1.4	229	46	1.1	1.2	1.7	133	97
CSU-X1 with CCD[e]	25	0.6	534	27	1.9	1.0	2.1	258	436
	40	1.0	320	26	2.0	1.0	2.0	161	272
	60	1.4	229	27	1.8	1.0	2.1	108	182
	100	1.4	229	46	1.1	1.0	3.5	65	109
CSU-X1 with sCMOS[f]	25	0.6	534	27	1.9	1.0	2.1	260	489
	40	1.0	320	26	2.0	1.0	2.0	163	305
	60	1.4	229	27	1.8	1.0	2.1	108	204
	100	1.4	229	46	1.1	1.0	3.5	65	122
CSU-W1 with sCMOS[f] 50 μm diameter pinhole disk	25	0.6	534	27	1.9	1.0	2.1	260	753
	40	1.0	320	26	2.0	1.0	2.0	163	471
	60	1.4	229	27	1.8	1.0	2.1	108	314
	100	1.4	229	46	1.1	1.0	3.5	65	188
CSU-W1 with sCMOS[f] 25 μm diameter pinhole disk	25	0.6	534	27	1.3	1.0	2.1	260	753
	40	1.0	320	26	1.4	1.0	2.0	163	471
	60	1.4	229	27	1.3	1.0	2.1	108	314
	100	1.4	229	46	0.8	1.0	3.5	65	188

[a]The physical pinhole diameter in the CSU-X1 is 50 μm.
[b]The length of a single side of the pixel is reported.
[c]Field of view is reported as the length of the image diagonal.
[d]EMCCD refers to a camera having a sensor chip with 512 × 512 pixels, each pixel measuring 16 μm × 16 μm in physical size.
[e]CCD refers to a camera having a sensor chip with 1344 × 1024 pixels, each pixel measuring 6.45 μm × 6.45 μm in physical size.
[f]sCMOS refers to a camera having a sensor chip with 2048 × 2048 pixels, each pixel measuring 6.5 μm × 6.5 μm in physical size.

a full FOV. The open area ratio sets a limit of 20–30 μm on specimen thickness before cross talk between pinholes becomes apparent in a fluorescence sea experiment. In practice, the fluorescence sea response sets the worst-case scenario for SDCM cross talk background. In our experience, the CSUW1 operates with high contrast in zebra fish, chick embryos, and BABB (benzyl alcohol–benzyl benzoate)-cleared kidney specimens of several hundred micrometers of thickness (Fig. 9.7). The short focal length of the microlenses used in earlier CSU models required that the dichroic mirror be thin and small, thus limiting the FOV (Fig. 9.6C). The longer focal length

FIGURE 9.7

530 μm thick volume rendering of a fluorescently labeled chick embryo heart section. Data acquired with a SDCM (CSU-W1, 50 μm pinhole disk) equipped with a 40× water immersion, NA 1.15 objective lens and an sCMOS camera. Cell nuclei are shown in blue (DAPI), F-actin in green (Alexa 488), and alpha actinin anti-rabbit in red (Cy5). Volume dimensions are 416 μm × 351 μm × 530 μm. Specimen kindly prepared by Dr. Jay D. Potts, University of South Carolina. Volume rendered in Imaris data visualization software (Bitplane).

microlenses of the CSU-W1 eliminate this requirement, and therefore, the instrument offers a much larger FOV that is compatible with newer large-sensor-chip sCMOS cameras (see the succeeding text and Fig. 9.6A and B).

9.6 NEW DETECTORS

Initially, the best available detectors for SDCM were intensified video cameras, and to this day, the CSU continues to output a disk timing synchronization signal for a video rate at either 50 or 60 Hz. 50 Hz reflects the field rate of the interlaced European video standard CCIR, while 60 Hz reflects the same rate in the US and Japanese standard RS170. Intensified cameras are sensitive but have very limited dynamic range and can be damaged by exposure to room light, making them vulnerable for general use. The CSU design provides low background making this a satisfactory pairing, but many cellular processes happen at faster timescales and with wider dynamic range than these cameras can detect. By the time the CSU-21 came to the market, interline CCD cameras with 1.4 megapixels, 10–20 MHz readout, and >60% QE became the preferred cameras. However, the low light levels frequently experienced in SDCM ultimately limited the frame rate. Electron-multiplying CCD (EMCCD) cameras were later introduced by Andor Technology and shown not only to overcome the read noise using on-chip electron multiplication gain but also to provide the highest QE (>90%) at acquisition speeds of many hundred frames per second (Coates, Denvir, Conroy, et al., 2003; Coates, Denvir, McHale, Thornbury, & Hollywood, 2003; Toomre & Pawley, 2006). Deep-cooled EMCCDs rapidly became the camera of choice for SDCM thereafter and popularized SDCM into a tool for live-cell imaging.

In recent years, scientific complementary metal-oxide semiconductor (sCMOS) cameras were released for microscopic imaging (Coates, 2011a, 2011b and Chapter 3). The main benefit of sCMOS technology is that, unlike CCD and EMCCD technologies, it can exploit advances in high-density planar semiconductor processing, making possible the integration of complex circuitry onto the same chip as a photosensor array. The readout circuitry, amplifiers, and analog digital converters can all be embedded at such high density that each row of the sensor can have its own readout channel operating in parallel. Therefore, even the moderate pixel readout speeds used to achieve low readout noise, can result in very high frame rates when executed in parallel (hundreds of fps full chip and thousands of fps on cropped regions of interest). These same planar processing features enable sCMOS to be used for the creation of very large sensor arrays. For example, the current highest performing sensors in the sCMOS range provide, respectively, the following: 2560×2160, 6.5×6.5 μm pixels with peak QE \sim62%, delivering 100 fps with read noise of \sim1.2 electrons rms, and 2048×2048, 6.5×6.5 μm pixels with peak QE \sim70%, delivering 100 fps with read noise of \sim1.0 electrons rms.

Some predict that sCMOS cameras are likely to eclipse EMCCD cameras for scientific applications (Fullerton, Bennett, Toda, & Takahashi, 2011), but in practice,

the story is more complex and EMCCDs still have much to offer to live-cell SDCM. To establish their relative performance, a direct head-to-head comparison was made between the two camera types (Oreopoulos, 2012). The purpose was to empirically quantify the SNR crossover point between EMCCD and sCMOS cameras. To this end, a dual-camera SDCM test apparatus with two identical emission filters and a 50/50 beam splitter configuration was assembled to observe the same specimen simultaneously (Fig. 9.8). Great care was taken to ensure an unbiased result by matching effective pixel size, alignment, and so forth. These experiments demonstrated that even in a direct camera comparison with nearly equal light intensities presented to both cameras (<2% difference, no pixel binning), when compared with sCMOS cameras, EMCCD cameras were still able to produce superior, quantifiable images of fluorescent samples with intensities of 50 photoelectrons per pixel or less. These represent quite typical light levels seen in much of confocal microscopy and are especially relevant to live-cell imaging where low light levels are essential to minimize phototoxicity and reflect endogenous levels of protein expression in model organisms (Anonymous, 2013; Pawley, 2006;).

9.7 A LOOK INTO THE FUTURE

Can SDCM technology be advanced any further? Even though other alternative optical sectioning techniques such as light-sheet microscopy (LSM) and structured illumination microscopy (SIM) are becoming mainstream (see Chapters 11, 16, and 17), we anticipate that the SDCM will grow in popularity because of its simplicity, accessibility, and ability to probe biological phenomena with relatively high spatial and temporal resolution. Indeed, there are a number of important developments exemplified in the literature that we foresee could further bolster the application of this imaging method in the biological sciences and perhaps even cause the technique to supplant the more traditional LSCM.

As we have seen in the preceding text, modern SDCMs are no longer limited to a single pinhole size optimized for certain objective magnification and numerical aperture. The ability to manufacture disks with smaller pinhole sizes permits the proper application of SDCM at lower magnifications and numerical apertures for the purpose of imaging larger specimens over bigger fields of view (in combination with large format camera detectors) with some degree of confocality. This feature is important for discerning complex or dynamic biochemical signaling relationships and interconnections between cells spread throughout a tissue with a clear view in 3D. More often than not, living biological samples are weakly fluorescent or photobleach easily, and the optimal pinhole size for confocal imaging with a given objective lens cannot be used. In these cases, some amount of spatial resolution must be sacrificed for image contrast by opening up the pinhole above one airy unit (Hibbs, 2004). In this regard, LSCM had an advantage over SDCM with an adjustable pinhole, but the advent of exchangeable-disk SDCMs possessing larger pinhole disks as well will allow confocal microscopists to correspondingly deal with difficult imaging situations

FIGURE 9.8

Experimental setup for digital camera comparison. (A) Schematic diagram of the SDCM modified for dual-camera imaging with equal photon fluxes projected onto both sCMOS and EMCCD camera sensors (fluorescence emission pathway depicted only). (B) An exposure image series of two adjacent rat thoracic aorta myoblast cells captured with the sCMOS (cropped region of interest) and EMCCD (full-chip) digital cameras through the CSU. F-actin filaments inside the cells were fluorescently labeled with Bodipy FL phallacidin. Each image in the series has been autocontrasted. Below each image appears a histogram depicting the photoelectron pixel count distribution. Image dimensions: 512 × 512 pixels, scale bar = 10 μm.

like these. In a similar vein, depending on the choice of fluorescent probe, labeling density, and spatial arrangements of the structure of interest, some specimens may be more or less tolerant of the background caused by pinhole cross talk. We therefore envision a library of exchangeable-disk types with different permutations of pinhole size, pinhole spacings, and spiral layouts designed to provide the best

possible balance between pinhole cross talk and 3D sectioning capability for certain fluorescently labeled cellular structures, tissues, or organisms.

Another distinct advantage that LSCM currently holds over SDCM is the ability to flexibly change the area over which the focused point of light is scanned onto the sample (scan zoom). With the scan zoom, an LSCM can increase the image magnification to achieve a digital sampling frequency that matches the Nyquist criterion for any objective lens. Alternatively, the scan zoom can purposefully be left at a low level to undersample the image and make gains in image signal strength and FOV. An analogous operation could be achieved in SDCM with an adjustable focal length field lens situated between the pinhole disk and the microscope. Another way to shrink or enlarge the illumination and observation areas in SDCM to attain different sampling frequencies would be to have a means of altering the size of the distal end of the MMF projected onto the pinhole disk while concurrently increasing or decreasing the camera lens magnification with an adjustable zoom lens. Such devices may be released in the future, but it will be challenging to implement such optics without incurring significant light losses or degrading the achromatic, diffraction-limited imaging performance of the system.

LSCMs are often installed with 4–5 PMTs for simultaneous multichannel imaging. Simultaneous two-channel detection is now common with SDCMs having two camera ports. We also anticipate that SDCM will be extended to three or four simultaneous multichannel imaging with optical attachments that split the fluorescence emission light between three to four different optical paths and cameras.

Modern, high-end LSCMs are equipped with dispersive prisms or diffraction gratings in the detection pathway that enable hyperspectral fluorescence imaging of the sample with approximately 1–5 nm spectral resolution (Zucker, Rigby, Clements, Salmon, & Chua, 2007). Spectrally resolved image stacks (λ-stacks) are useful for classifying image features based on color (karyotyping), inferring changes in the local chemical environment surrounding the fluorescent probe, or computationally removing autofluorescent signals via linear unmixing (Garini, Young, & McNamara, 2006). SDCM would also benefit from the addition of a spectrally resolved imaging dimension. The technology to implement hyperspectral detection in SDCM would differ from that in LSCM, however, since it is a wide-field mode of imaging. Here, acousto-optic and liquid-crystal filtering devices offer fast, tunable wavelength- and bandwidth-adjustable selection that rivals the speed of spectral detection strategies presently used in LSCM. Such devices are currently available (Lerner, Gat, & Wachman, 2010), but they incur significant light losses (50% or more, mainly due to polarization-dependent transmission properties) that make them less suitable for the low-light fluorescence imaging common in biological SDCM. Various manufacturers are currently investigating strategies and designs to improve the light throughput of these devices.

Confocal imaging and computational deconvolution imaging (Chapter 10) are often seen as competing methods aimed at the same goal of producing 3D images of fluorophore distributions, but they are in fact not mutually exclusive. Deconvolution will increase contrast, reduce noise, and even improve resolution of a confocal image

stack (Cannell, McMorland, & Soeller, 2006). Many confocalists opt to ignore the gains that can be made by deconvolution of confocal images, however, because of the computational costs and wait times associated with the process (especially when dealing with vast multidimensional image datasets). Open-source, real-time 3D deconvolution using low-cost graphics processing units (GPUs; Bruce & Butte, 2013) may make the computational enhancement of confocal images more practical and, when joined with SDCM using large (>1–4 airy units) pinhole disks, might prove very useful for high-content screening applications that require 3D object discrimination in multiple spectral channels.

What other optical techniques might benefit from unification with SDCM and find widespread use in the future? There have been several pioneering studies in this area already. One such study showed that the SDCM can be modified to include polarization optics in the excitation and emission pathways of the spinning-disk scan head to permit confocal detection of molecular-scale interactions of membrane proteins labeled with the same fluorescent protein via homogenous Förster resonance energy transfer (homo-FRET) and thus provide strong evidence for the existence of the so-called lipid rafts (Ghosh et al., 2012; Gowrishankar et al., 2012). The homo-FRET method holds several advantages over its more traditional counterpart of heterogenous Förster resonance energy transfer (hetero-FRET), which uses spectrally distinct fluorescent proteins (such as CFP and YFP) attached to the donor and acceptor molecules (Piston & Rizzo, 2008).

Fluorescence lifetime imaging microscopy (FLIM) maps the spatial distribution of the excited state lifetimes of extrinsic fluorescent labels or endogenously autofluorescent materials in cells and generates a new mode of image contrast based on the local chemical environment of the fluorescent molecule (such as pH). FLIM is also an excellent tool for detecting hetero-FRET and is superior to steady-state fluorescence microscopy hetero-FRET measurements (Hink, Bisseling, & Visser, 2002). Unfortunately, out-of-focus light in FLIM images not only degrades the spatial resolution but also reduces the lifetime contrast and accuracy. A few research groups have shown that FLIM can be combined with SDCM to yield 3D FLIM image stacks with short (several Hz to video rate) acquisition times that overcome out-of-focus light issues (Grant et al., 2007).

Alternative approaches to quantify protein aggregation states or the stoichiometry of biomolecular complexes in cells include a family of fluorescence fluctuation correlation techniques such as fluorescence correlation spectroscopy (FCS), image correlation spectroscopy (ICS), and number and brightness (N&B) analysis (Digman & Gratton, 2011; Digman, Wiseman, Choi, Horwitz, & Gratton, 2009; Kolin & Wiseman, 2007). These fluctuation approaches can be integrated with SDCM, thus providing a means to rapidly carry out these types of measurements in any 2D plane within a sample (Needleman, Xu, & Mitchison, 2009).

SDCM can also be merged with other nonoptical forms of microscopy that generate image contrast through some other physical or chemical means. These so-called correlated or combinatorial microscopy platforms generate registered micrographs of the same FOV that provide complementary pieces of information about the sample

under investigation, which would otherwise remain hidden from the observer if the two microscopy techniques were applied independently (Axelrod & Omann, 2006). For example, the Trache group has shown that correlated SDCM and atomic force microscopy (AFM) enable real-time tracking and a fundamental understanding of the response of subcellular structures and tissues to mechanical stimulus—an important determinant of many muscle cell functions including contraction, proliferation, migration, and cell adhesion (Trache & Lim, 2009). We expect that combinatorial microscopy platforms that incorporate SDCM will become commonplace as science moves closer towards more interdisciplinary research.

Multiphoton LSCM excitation through nonlinear absorption of near-infrared (NIR) light allows deep imaging (hundreds of micrometers to millimeters) into dense, scattering living specimens (Chapter 8). High-frame-rate multiphoton SDCM would be a noteworthy advancement for intravital imaging of small animal tissues and organs and has been demonstrated recently (Shimozawa et al., 2013). A major challenge facing multiphoton SDCM, however, is the currently available output power of expensive pulsed infrared lasers to trigger 2-photon absorption when spread out over many tens of pinholes, which in turn limits the illumination area (\sim10% of usable CCD area when using a $60\times$ objective lens) and the maximum imaging depth.

Perhaps, the most important and exciting development in SDCM will be the application of optical "superresolution" approaches with this technique (see Chapters 14 and 15), offering images of cellular structures at spatial resolutions exceeding the diffraction limit (\sim250 nm laterally and \sim500 nm axially) and acquired at appreciable depths that are difficult to achieve with nonconfocal versions of these approaches. A few research groups have proven that both structured illumination and localization microscopy strategies are adaptable with mostly standard SDCM hardware (Gao, Garcia-Uribe, Liu, Li, & Wang, 2014; Hosny et al., 2013; Schulz et al., 2013).

REFERENCES

Abreu-Blanco, M. T., Verboon, J. M., & Parkhurst, S. M. (2011). Cell wound repair in drosophila occurs through three distinct phases of membrane and cytoskeletal remodeling. *The Journal of Cell Biology*, *193*, 455–464.

Amos, B., McConnell, G., & Wilson, T. (2012). Confocal microscopy. In E. H. Egelman (Ed.), *Comprehensive biophysics* (pp. 3–23). Amsterdam: Elsevier.

Anonymous. (2013). Artifacts of light. *Nature Methods*, *10*, 1135.

Axelrod, D., & Omann, G. M. (2006). Combinatorial microscopy. *Nature Reviews. Molecular Cell Biology*, *7*, 944–952.

Berman, R. (2012). United States of America Patent No. 8,275,226.

Bruce, M. A., & Butte, M. J. (2013). Real-time GPU-based 3D deconvolution. *Optics Express*, *21*, 4766–4773.

Cannell, M., McMorland, A., & Soeller, C. (2006). Image enhancement by deconvolution. In J. B. Pawley (Ed.), *Handbook of biological confocal microscopy* (pp. 488–500). New York, NY: Springer.

Chong, F. K., Coates, C. G., Denvir, D. J., McHale, N., Thornbury, K., & Hollywood, M. (2004). Optimization of spinning disk confocal microscopy: Synchronization with the ultra-sensitive EMCCD. In J. A. Conchello, C. H. Cogswell, & T. Wilson (Eds.), *Three-dimensional and multidimensional microscopy: Image acquisition and processing xi: Vol. 5*. (pp. 65–76). Bellingham, WA: SPIE—Int. Soc. Optical Engineering.

Coates, C. (2011a). EMCCD vs. sCMOS. *Photonics Spectra, 45*, 14.

Coates, C. (2011b). New sCMOS vs. current microscopy cameras. *Biophotonics International*, 24–27.

Coates, C. G., Denvir, D. J., Conroy, E., McHale, N., Thornbury, K., & Hollywood, M. (2003). Back-illuminated electron multiplying technology: The world's most sensitive CCD for ultra low-light microscopy. In D. V. Nicolau, J. Enderlein, R. C. Leif, & D. L. Farkas (Eds.), *Manipulation and analysis of biomolecules, cells and tissues: Vol. 4962*. (pp. 319–328). Bellingham, WA: SPIE—Int. Soc. Optical Engineering.

Coates, C. G., Denvir, D. J., McHale, N. G., Thornbury, K. D., & Hollywood, M. A. (2003). Ultra-sensitivity, speed and resolution: Optimizing low-fight microscopy with the back-illuminated electron multiplying CCD. In T. Wilson (Ed.), *Confocal, multiphoton, and nonlinear microscopic imaging: Vol. 5139*. (pp. 56–66). Bellingham, WA: SPIE—Int. Soc. Optical Engineering.

Conchello, J. A., & Lichtman, J. W. (1994). Theoretical analysis of a rotating-disk partially confocal scanning microscope. *Applied Optics, 33*, 585–596.

Conchello, J. A., & Lichtman, J. W. (2005). Optical sectioning microscopy. *Nature Methods, 2*, 920–931.

Cooper, D. J. F. (2013). Canada Patent No. 2,779,146.

Digman, M. A., & Gratton, E. (2011). Lessons in fluctuation correlation spectroscopy. In S. R. Leone, P. S. Cremer, J. T. Groves, & M. A. Johnson (Eds.), *Annual review of physical chemistry: Vol. 62*. (pp. 645–668). Palo Alto, CA: Annual Reviews.

Digman, M. A., Wiseman, P. W., Choi, C., Horwitz, A. R., & Gratton, E. (2009). Stoichiometry of molecular complexes at adhesions in living cells. *Proceedings of the National Academy of Sciences of the United States of America, 106*, 2170–2175.

Egner, A., Andresen, V., & Hell, S. W. (2002). Comparison of the axial resolution of practical Nipkow-disk confocal fluorescence microscopy with that of multifocal multiphoton microscopy: Theory and experiment. *Journal of Microscopy, 206*, 24–32.

Enoki, R., Ono, D., Hasan, M. T., Honma, S., & Honma, K. (2012). Single-cell resolution fluorescence imaging of circadian rhythms detected with a Nipkow spinning disk confocal system. *Journal of Neuroscience Methods, 207*, 72–79.

Fewer, D. T., Hewlett, S. J., & McCabe, E. M. (1998). Laser sources in direct-view-scanning, tandem-scanning, or Nipkow-disk-scanning confocal microscopy. *Applied Optics, 37*, 380–385.

Frangioni, J. V. (2003). In vivo near-infrared fluorescence imaging. *Current Opinion in Chemical Biology, 7*, 626–634.

Fullerton, S., Bennett, K., Toda, E., & Takahashi, T. (2011). ORCA-Flash4.0: Changing the game. Unpublished technical white paper. Hamamatsu Photonics.

Fuseler, J., Jerome, W. G., & Price, R. (2011). Types of confocal instruments: Basic principles and advantages and disadvantages. In R. L. Price & W. G. Jerome (Eds.), *Basic confocal microscopy* (pp. 157–179). New York, NY: Springer.

Gao, L., Garcia-Uribe, A., Liu, Y., Li, C. Y., & Wang, L. H. V. (2014). Photobleaching imprinting microscopy: Seeing clearer and deeper. *Journal of Cell Science, 127*, 288–294.

Garini, Y., Young, I. T., & McNamara, G. (2006). Spectral imaging: Principles and applications. *Cytometry. Part A, 69*, 735–747.

Genka, C., Ishida, H., Ichimori, K., Hirota, Y., Tanaami, T., & Nakazawa, H. (1999). Visualization of biphasic Ca2+ diffusion from cytosol to nucleus in contracting adult rat cardiac myocytes with an ultra-fast confocal imaging system. *Cell Calcium, 25*, 199–208.

Ghosh, S., Saha, S., Goswami, D., Bilgrami, S., & Mayor, S. (2012). Dynamic imaging of homo-FRET in live cells by fluorescence anisotropy microscopy. In P. M. Conn (Ed.), *Methods in Enzymology: Vol. 505.* (pp. 291–327). San Diego, CA: Academic Press.

Gierke, S., & Wittmann, T. (2012). EB1-recruited microtubule plus tip complexes coordinate protrusion dynamics during 3D epithelial remodeling. *Current Biology, 22*, 753–762.

Gowrishankar, K., Ghosh, S., Saha, S., Rumamol, C., Mayor, S., & Rao, M. (2012). Active remodeling of cortical actin regulates spatiotemporal organization of cell surface molecules. *Cell, 149*, 1353–1367.

Graf, R., Rietdorf, J., & Zimmermann, T. (2005). Live cell spinning disk microscopy. In J. Rietdorf (Ed.), *Advances in biochemical engineering/biotechnology: Vol. 95.* (pp. 57–75). Berlin: Springer-Verlag.

Grant, D. M., McGinty, J., McGhee, E. J., Bunney, T. D., Owen, D. M., Talbot, C. B., et al. (2007). High speed optically sectioned fluorescence lifetime imaging permits study of live cell signaling events. *Optics Express, 15*, 15656–15673.

Gratton, E., & vandeVen, M. (2006). Laser sources for confocal microscopy. In J. B. Pawley (Ed.), *Handbook of biological confocal microscopy* (pp. 80–125). New York, NY: Springer.

Heintzmann, R. (2006). Band limit and appropriate sampling in microscopy. In J. E. Celis (Ed.), *Cell biology* (pp. 29–36) (3rd ed.). Burlington, MA: Academic Press.

Hibbs, A. R. (2004). *Confocal microscopy for biologists* (1st ed.). New York, NY: Springer.

Hibbs, A., MacDonald, G., & Garsha, K. (2006). Practical confocal microscopy. In J. B. Pawley (Ed.), *Handbook of biological confocal microscopy* (pp. 650–671). Springer US.

Hink, M. A., Bisseling, T., & Visser, A. (2002). Imaging protein-protein interactions in living cells. *Plant Molecular Biology, 50*, 871–883.

Hosny, N. A., Song, M. Y., Connelly, J. T., Ameer-Beg, S., Knight, M. M., & Wheeler, A. P. (2013). Super-resolution imaging strategies for cell biologists using a spinning disk microscope. *PLoS One, 8*(10), 1–9.

Ichihara, A., Tanaami, T., Ishida, H., & Shimizu, M. (1999). Confocal fluorescent microscopy using a Nipkow scanner. In W. T. Mason (Ed.), *Fluorescent and luminescent probes for biological activity* (pp. 344–349) (2nd ed.). London: Academic Press.

Inoue, S., & Inoue, T. (2002). *Direct-view high-speed confocal scanner: The CSU-10 cell biological applications of confocal microscopy: Vol. 70* (2nd ed.). (pp. 87–127). San Diego, CA: Academic Press Inc.

Kolin, D. L., & Wiseman, P. W. (2007). Advances in image correlation spectroscopy: Measuring number densities, aggregation states, and dynamics of fluorescently labeled macromolecules in cells. *Cell Biochemistry and Biophysics, 49*, 141–164.

Kuo, P. K. (1992). United States of America Patent No. 5,351,152.

Lerner, J. M., Gat, N., & Wachman, E. (2010). Approaches to spectral imaging hardware. *Current Protocols in Cytometry, 53*, 12.20.1–12.20.40, John Wiley & Sons, Inc.

Michálek, J., Čapek, M., & Kubínová, L. (2011). Compensation of inhomogeneous fluorescence signal distribution in 2D images acquired by confocal microscopy. *Microscopy Research and Technique, 74*, 831–838.

Murray, J. M. (2007). Practical aspects of quantitative confocal microscopy. In G. Sluder & D. E. Wolf (Eds.), *Digital microscopy: Vol. 81.* (pp. 467–478) (3rd ed.). San Diego, CA: Elsevier Academic Press Inc.

Murray, J. M., Appleton, P. L., Swedlow, J. R., & Waters, J. C. (2007). Evaluating performance in three-dimensional fluorescence microscopy. *Journal of Microscopy, 228*, 390–405.

Nakano, A. (2002). Spinning-disk confocal microscopy—A cutting-edge tool for imaging of membrane traffic. *Cell Structure and Function, 27*, 349–355.

Needleman, D. J., Xu, Y. Q., & Mitchison, T. J. (2009). Pin-hole array correlation imaging: Highly parallel fluorescence correlation spectroscopy. *Biophysical Journal, 96*, 5050–5059.

Oreopoulos, J. (2012). A comparison of sCMOS and EMCCD digital camera technologies for spinning disk confocal microscopy. Unpublished technical white paper. Spectral Applied Research.

Pawley, J. (2006). Fundamental limits in confocal microscopy. In J. B. Pawley (Ed.), *Handbook of biological confocal microscopy* (pp. 20–42). New York, NY: Springer.

Petrán, M., Hadravsk, M., Egger, M. D., & Galambos, R. (1968). Tandem-scanning reflected-light microscope. *Journal of the Optical Society of America, 58*, 661–664.

Piston, D. W., & Rizzo, M. A. (2008). FRET by fluorescence polarization microscopy. In K. F. Sullivan (Ed.), *Fluorescent proteins: Vol. 85.* (pp. 415–430) (2nd ed.). San Diego, CA: Elsevier Academic Press Inc.

Princeton Instruments. (2010). New-generation CCD/EMCCD technology: A primer on eXcelon™ technology. Unpublished technical white paper. Princeton Instruments.

Schulz, O., Pieper, C., Clever, M., Pfaff, J., Ruhlandt, A., Kehlenbach, R. H., et al. (2013). Resolution doubling in fluorescence microscopy with confocal spinning-disk image scanning microscopy. *Proceedings of the National Academy of Sciences of the United States of America, 110*, 21000–21005.

Shimozawa, T., Yamagata, K., Kondo, T., Hayashi, S., Shitamukai, A., Konno, D., et al. (2013). Improving spinning disk confocal microscopy by preventing pinhole cross-talk for intravital imaging. *Proceedings of the National Academy of Sciences of the United States of America, 110*, 3399–3404.

Stehbens, S., Pemble, H., Murrow, L., & Wittmann, T. (2012). Imaging intracellular protein dynamics by spinning disk confocal microscopy. In P. M. Conn (Ed.), *Method enzymol: Vol. 504.* (pp. 293–313). San Diego, CA: Academic Press.

Tadakuma, H., Ishihama, Y., Toshiharu, S., Tani, T., & Funatsu, T. (2006). Imaging of single mRNA molecules moving within a living cell nucleus. *Biochemical and Biophysical Research Communications, 344*, 772–779.

Tanaami, T., Otsuki, S., Tomosada, N., Kosugi, Y., Shimizu, M., & Ishida, H. (2002). High-speed 1-frame/ms scanning confocal microscope with a microlens and Nipkow disks. *Applied Optics, 41*, 4704–4708.

Toomre, D., & Pawley, J. (2006). Disk-scanning confocal microscopy. In J. B. Pawley (Ed.), *Handbook of biological confocal microscopy* (pp. 221–238). New York, NY: Springer.

Trache, A., & Lim, S. M. (2009). Integrated microscopy for real-time imaging of mechanotransduction studies in live cells. *Journal of Biomedical Optics, 14*, 034024.

Wang, E., Babbey, C. M., & Dunn, K. W. (2005). Performance comparison between the high-speed yokogawa spinning disc confocal system and single-point scanning confocal systems. *Journal of Microscopy, 218*, 148–159.

Waters, J. C. (2009). Accuracy and precision in quantitative fluorescence microscopy. *The Journal of Cell Biology, 185*, 1135–1148.

Wolf, D. E. (2007). Fundamentals of fluorescence and fluorescence microscopy. In G. Sluder & D. E. Wolf (Eds.), *Digital microscopy: Vol. 81.* (pp. 63–91) (3rd ed.). San Diego, CA: Elsevier Academic Press Inc.

Wolf, D. E., Samarasekera, C., & Swedlow, J. R. (2007). Quantitative analysis of digital microscope images. In G. Sluder & D. E. Wolf (Eds.), *Digital microscopy: Vol. 81.* (pp. 365–396) (3rd ed.). San Diego, CA: Elsevier Academic Press Inc.

Wong, C. H. Y., Jenne, C. N., Lee, W. Y., Leger, C., & Kubes, P. (2011). Functional innervation of hepatic inkt cells is immunosuppressive following stroke. *Science, 333*, 101–105.

Xiao, G. Q., Corle, T. R., & Kino, G. S. (1988). Real-time confocal scanning optical microscope. *Applied Physics Letters, 53*, 716–718.

Zucker, R. M., Rigby, P., Clements, I., Salmon, W., & Chua, M. (2007). Reliability of confocal microscopy spectral imaging systems: Use of multispectral beads. *Cytometry. Part A, 71*, 174–189.

CHAPTER

Quantitative deconvolution microscopy

10

Paul C. Goodwin[*,†]

[*]GE Healthcare, Issaquah, Washington, USA
[†]Department of Comparative Medicine, University of Washington, Seattle, Washington, USA

CHAPTER OUTLINE

Introduction	178
10.1 The Point-spread Function	180
10.2 Deconvolution Microscopy	182
10.2.1 Deblurring	183
10.2.2 Image Restoration	184
10.2.3 Fourier Transforms	184
10.2.4 Iterative Methods	185
10.2.5 The Importance of Image Quality	186
10.2.5.1 Factors That Affect Image Restoration	186
10.3 Results	187
10.3.1 Assessing Linearity	189
10.3.2 Applications of Deconvolution Microscopy	190
Conclusion	191
References	191

Abstract

The light microscope is an essential tool for the study of cells, organelles, biomolecules, and subcellular dynamics. A paradox exists in microscopy whereby the higher the needed lateral resolution, the more the image is degraded by out-of-focus information. This creates a significant need to generate axial contrast whenever high lateral resolution is required. One strategy for generating contrast is to measure or model the optical properties of the microscope and to use that model to algorithmically reverse some of the consequences of high-resolution imaging. Deconvolution microscopy implements model-based methods to enable the full diffraction-limited resolution of the microscope to be exploited even in complex and living specimens.

INTRODUCTION

Microscopes are some of the most ubiquitous tools in the biological laboratory, yet most scientists use them without knowing much about them or the fundamental physics necessary to get the most from them. Our look at quantitative deconvolution microscopy will begin with a look at the microscope itself. In order for a microscope to be useful, it must fulfill three functions: magnification, resolution, and contrast. A microscope that delivers one or two of these attributes but not all three is of little value. We start by looking at each of these attributes and how they affect the image from the microscope. The process of looking at these attributes elucidates the limitations of the microscope and motivates this chapter.

Magnification, for the sake of this chapter, will be defined as the portion of the field of view that is projected onto the detector. Compared to the field of view of a human eye, five times ($5\times$) magnification would project one-fifth of the lateral dimensions onto the eye. Since magnification takes place in both lateral dimensions, the area reduction is the magnification squared or 1/25 in the case of the $5\times$ objective. The general formula is

$$\text{FOV} = \frac{1}{M^2} \quad (10.1)$$

This has a profound effect on the amount of signal that can be collected with increasing magnification. For a fixed light collection efficiency (to be discussed later), the amount of signal from a sample also falls according to this relationship:

$$\text{Brightness} = \frac{1}{M^2} \quad (10.2)$$

If we start with a given field of view that generates a total of one million photons per second and view that area with a $5\times$ objective, the number of photons drops to 40,000. For a $100\times$ objective, the number of photons drops to only 100 photons. This has a significant impact on the contrast of the image. The statistical noise (Poisson noise) in the image is

$$\text{Noise}_{\text{Poisson}} = \sqrt{\text{Events}} \quad (10.3)$$

The consequences of magnification on the signal-to-noise ratio (SNR) can be seen in Table 10.1.

Table 10.1 Effect of increased magnification on SNR

Magnification	Photons	Noise	SNR
$1\times$	1,000,000	1000	1000:1
$5\times$	40,000	200	200:1
$100\times$	100	10	10:1

Introduction

The SNR drops from 1000:1 to 10:1 purely as a consequence of the magnification change from $1\times$ to $100\times$. So, how do we overcome this loss? The answer is in the numerical aperture (NA) of the objective lens. NA is defined as

$$NA = n * \sin(\Theta) \qquad (10.4)$$

where n is the lowest index of refraction between the sample and the front of the objective lens and theta (Θ) is the half angle that describes the cone of light that can be effectively captured by a given lens. The consequence of a larger cone (higher NA) is that many more photons can be collected. Overall, the relative brightness is proportional to the NA to the fourth power divided by the magnification squared:

$$\text{Brightness} \propto \frac{NA^4}{M^2} \qquad (10.5)$$

Some examples of brightness for known lenses are given in Table 10.2.

As you can see, the loss of brightness as a consequence of magnification is more than compensated for by a concomitant increase in NA. On the surface, this is beneficial because the resolution also increases with NA. In fact, Z resolution increases with NA^2 so this would seem to be advantageous for microscopy. The problem is demonstrated in Fig. 10.1.

Table 10.2 Relative brightness of common objective lenses

Magnification	NA	FOV	Brightness
1	0.157	1.00000	1.000
5	0.15	0.04000	0.033
10	0.40	0.01000	0.421
20	0.85	0.00250	2.148
40	1.30	0.00063	2.938
60	1.42	0.00028	1.859
100	1.40	0.00010	0.632

FIGURE 10.1

Lateral and axial contrast as a function of spatial detail. Lateral ($k_{x,y}$) and axial (k_z) contrast as a function of spatial detail in a microscope. Notice that the lateral detail (resolution) is well supported by significant contrast, while the axial detail is poorly supported; consequently, with increasing NA, a thinner image plane is in focus, while the out-of-focus contribution from adjacent planes is still present. The overall effect is higher axial blur in images as a function of higher NA.

As you can see, while the resolution along the Z-axis increases, there is no gain in the axial contrast with NA. In other words, as NA increases, the contribution of blurred (out-of-focus) information actually increases. So, the dimmer and smaller something is, the more problem there is with blur in the image. This is referred to as "the missing cone," and it has led microscopists to seek ways of generating axial contrast in order to be able to increase the sensitivity and in-focus information. Some of those methods include mechanical sectioning, deconvolution microscopy, confocal microscopy, multiphoton microscopy, and selective plane illumination. This chapter focuses on deconvolution microscopy. With the exception of mechanical sectioning, all of these methods are reserved for fluorescence and do not apply to transmissive imaging. In a transmissive image such as the absorption of light by a chromogen or stain, the intensity at each point is the sum of the absorptions along a ray from the light source to the sample. While the absorption of light along that ray is linearly related to mass (per Beer's law), the exact location of each chromogen is difficult to assess. In fluorescence, the measured light originates at the fluorochrome. This greatly simplifies the mathematical model of the microscope and enables advanced optical methods such as confocal microscopy.

10.1 THE POINT-SPREAD FUNCTION

The resolution of the microscope is finite. In fluorescence microscopy (where the condenser and the objective lens are the same lens), the resolution (D) is given as

$$D = \frac{0.61 * \lambda}{\text{NA}} \text{(Rayleigh criterion)} \qquad (10.6)$$

So, for green fluorescence emitted from eGFP (em=510 nm) and an ideal 1.4 NA objective, the resolution could be as good as 222 nm (per Rayleigh). The consequence is that any object that is smaller than 222 nm will project to a minimum of 222 nm. But it is actually more complicated in three dimensions. If one were to measure how a single point of light spreads through space, he or she would visually describe the blurring that occurs in the microscope. Such a measurement is called the point-spread function (PSF).

One can view the PSF by collecting a set of images of a fluorescent bead sitting on a cover glass. Starting away from the plane of best focus, one can collect a series of images approaching the plane of best focus and moving beyond that plane of focus. Figure 10.2 shows two views of the image series. Panel (A) shows a through-focus series of the PSF enhanced to show the low intensity values by expressing the displayed intensities as the third power of the actual values, that is, $D = I^3$. Panel (B) shows the image series as an orthogonal view through the same PSF.

As you can see in panel (A), the out-of-focus bead generates a series of rings that narrow as they become the closer to the optimum focus and that then spread out again in a symmetrical fashion as the focus is passed. The symmetry of the spread of the rings laterally and through the focus is indicative of the optical conditions and the

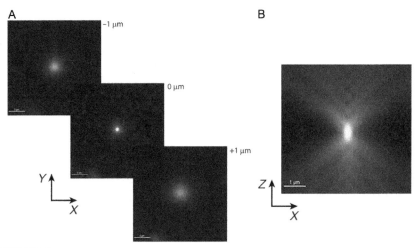

FIGURE 10.2

Lateral and axial views of the point-spread function (PSF). The point-spread function (PSF) of a good-quality lens is marked by lateral and axial symmetry. Panel (A) shows how the PSF of a good lens is symmetrical about the center of the image as the microscope is focused one micrometer below (−1 μm), in the middle of (0 μm), and 1 μm above (+1 μm) the plane of best focus. Panel (B) is a representation of an X–Z section through the same bead in panel (A). To generate the X–Z section, a series of X–Y images were collected at 0.2 μm spacing through the focus of a single fluorescent latex bead (0.1 μm diameter). A software is then used to properly scale and orthogonally section the stack of X–Y images into the single X–Z section presented. For both panels, the intensities are displayed and raised to the third power (display = I^3) as discussed in the text.

quality of the objective lens and can be used to evaluate optical systems (Goodwin, 2007). Even in the best case, these images are not simple to collect and interpret and in the case of optical aberrations become quite complex. Importantly, the PSF demonstrates how each point source of light in the object is spread. So, any image acquired in the microscope is actually the summation of all of the overlapping PSFs from each subresolution point in space. This is expressed as the imaging formula

$$I_{\text{Image}} = I_{\text{Actual}} \otimes \text{PSF} \qquad (10.7)$$

The frustration of every microscopist is that they never see the actual object (I_{Actual}). All they can ever see is a projection of the object blurred by the PSF (I_{Image}). This is illustrated in Fig. 10.3.

The term convolution (\otimes) is a specific mathematical description of the physical phenomenon of the overlap of the PSFs. One analogy is that of a paint brush that dabs a pattern (the PSF) on every point in the object. Deconvolution is a mathematical process that seeks to reverse this process and restore an image that more closely approximates the image of the original object.

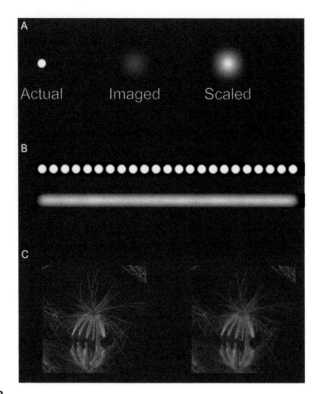

FIGURE 10.3

The effect of inherent blur in microscopy. Since the NA of the objective lens is limited, complete knowledge of the actual object is not obtained in the light microscope (see Eq. 10.7). The image that is obtained (I_{Image}) is the actual object (I_{Actual}) convolved with the PSF. Panel (A) shows the effect of this blurring on a single point of fluorescence. The actual object is blurred resulting in a spreading and reduction of the intensity of the object (Imaged). If the image is scaled (Scaled), one can see the significant spreading that occurs. If one were to then take a series of points in a row (panel B) and blur those, they would appear as a continuous line. The effect that this has on real object, in this case a PTK1 cell labeled with a fluorescent antibody against b-tubulin, is evident in panel (C, right). While considerably more detail can be seen in a superresolution image of the cell (panel C, left), the resolution of the object is substantially decreased when imaged with diffraction-limited optics.

Fluorescent sample kindly provided by Dr. Keith DeLuca, University of Colorado.

10.2 DECONVOLUTION MICROSCOPY

Deconvolution microscopy is an image-processing method that seeks to computationally reverse the effects of the blurring in the microscope. There are generally two types of deconvolution: deblurring and image restoration.

10.2.1 DEBLURRING

Deblurring (also called nearest-neighbor deconvolution, multineighbor deconvolution, etc.) is a fast algorithm for reducing blur in an image. It has the advantage that it is quickly calculated but has the disadvantage that it tends to be noisy and that the results produced are not generally linear (Fig. 10.4):

$$\text{Deconvolved}(n_j) = n_j - \left(n_{j-1} \otimes \text{PSF}_{\text{Est}}\right) - \left(n_{j+1} \otimes \text{PSF}_{\text{Est}}\right) \quad (10.8)$$

The image taken in a given focal plane is the object at that plane blurred by the in-focus PSF and the out-of-focus contribution from the objects above and below that plane. Deblurring attempts to estimate the contribution attributable to the out-of-focus image planes and subtract them from the in-focus image plane. To estimate the contribution of the out-of-focus planes, the images taken at the adjacent image planes $n(j-1)$ and $n(j+1)$ are each blurred by an estimate of the PSF (based on NA). In multineighbor deblurring, the contribution for further adjacent planes such as $n(j-2)$ and $n(j-2)$ is also blurred and subtracted from the image plane. As mentioned, these calculations are fast but they are prone to two problems. First, since it is a subtractive process, the SNR of the resulting image is reduced. The signal is lost from subtraction and the noise is increased by the propagation of error. Second, the intensity of a given location is significantly influenced by the imprecision in the estimation of the contribution of out-of-focus objects, such that linearity is lost. The contribution from neighboring objects can only be estimated since their intensity is also not known (along with the in-focus object). The estimation of blurring the out-of-focus planes before subtraction does not adequately describe their contribution. As a consequence, deblurring should never be used when intensity is intended to represent actual mass of fluorochromes in a location.

Deblurring becomes less relevant as computational power increases. In the 1990s, when these methods were made popular, the computational power necessary for proper image restoration was too expensive. Advances in computational speed have rendered these deblurring algorithms as unnecessary, but they still persist in some software applications.

FIGURE 10.4

Nearest-neighbor deconvolution. In this figure, a cell is imaged by taking five images (n_1, n_2, n_3, n_4, and n_5) at successive focal planes through the object. The images in adjacent images can be used to subtract their contribution. See text for details.

10.2.2 IMAGE RESTORATION

Image restoration turns back to the imaging equation in Eq. (10.7). By making a careful measure of I_{Image} and the PSF, one can use mathematics to derive the best estimate of the actual object (I_{Object}) that when blurred by the PSF generates the measured I_{Image}. But how is this accomplished?

10.2.3 FOURIER TRANSFORMS

Jean Baptiste Joseph Fourier (1768–1830) was a French polymath. Among many of his activities, he was attempting to model how heat transfers through metals. This ended up being critical to making improvements to the steam engine that had been introduced earlier by James Watt. As Fourier worked on the model, he realized that he had insufficient mathematical tools to solve the problem, so he created new tools. These tools were built around his realization that any waveform could be expressed in terms of a series of cosine waves with different amplitudes and phase (now referred to as a Fourier series). By converting complex waveforms into a Fourier series, certain types of functions that were very difficult or impossible to solve without the tool became solvable. The complex form could be converted into frequency space (cosine functions with different amplitudes and phases), simple algebra could be used to solve the equations, and the results could be converted back into real space to provide the solution. The process is analogous to using logarithms to solve complex multiplications, convert the numbers to logs, add the numbers, and then convert the results back into decimal values. For a thorough description of Fourier methods, the reader is referred to Goodman (2005).

In the case of image restoration as described in the preceding text, we need to work around the term "blurred with the PSF." In real space, this is a very difficult concept, and it is mathematically difficult to solve for this notion of blurring with the PSF. The process is called convolution (symbolized as \otimes) and it is a bit complex to solve for 3D space. In the frequency space, convolution simply becomes multiplication. Taking the imaging formula (Eq. 10.7), we can transform it to frequency space as

$$F'(I_{\text{Image}}) = F'(I_{\text{Actual}}) \times F'(\text{PSF}) \quad (10.9)$$

where F' represents the Fourier transform. The terms of the equation can be rearranged to

$$F'(I_{\text{Actual}}) = \frac{F'(I_{\text{Image}})}{F'(\text{PSF})} \quad (10.10)$$

By now taking the reverse Fourier transform of this ratio, we can now solve for the I_{Actual}. This method is referred to as the inversion solution. While relatively simple, the problem with this method is noise. Whenever a measurement is made, there is uncertainty. At the limit of resolution for the I_{Image} and the PSF, the values approach zero and the noise dominates the measures, resulting in significant errors

caused by dividing by zero. To avoid these problems, more elegant solutions are normally deployed. While space limitations preclude an exhaustive review of all published methods, the following sections describe a few of the more common methods.

10.2.4 ITERATIVE METHODS

Iteration is a method of solving equations that overcomes the problems of dividing by values close to zero. In the case of image restoration, the steps are as follows:

1. I_{Actual} is estimated ($I_{Estimate}$).
2. $I_{Estimate}$ is then blurred with the PSF (I_{Blur}).
3. I_{Blur} is compared to I_{Image} resulting in $I_{Residual}$.
4. Refine $I_{Estimate}$ based on $I_{Residual}$.
5. Repeat 2–4 minimizing $I_{Residual}$.

This represents the simplest form of iterative deconvolution algorithm. In practice, as was discussed in the preceding text, every measurement contains noise. This noise leads to instabilities in this simplest form. A number of modifications have been made to this simplest form to incorporate a priori constraints. These constraints stabilize the algorithm, reduce the number of iterations necessary to obtain an acceptable outcome, and can somewhat extend the resolution of the image (Mertz, 2010). One form of constraint is to limit the noise by periodically introducing a smoothing operation, such that $I_{Estimate}$ is periodically blurred. Another form of constraint sets any negative values to zero when updating $I_{Estimate}$, based on the observation that negative intensity is nonsensical (Goodman, 2005; Mertz, 2010; Wallace, Schaefer, & Swedlow, 2001). This method was first introduced by Gold and refined by Agard (Agard, 1984; Gold, 1964; Swedlow et al., 1997) based on modifications to the original methods of Jansson (Jansson, 1997) and Van Cittert (Frieden, 1975). The treatment of noise is generally referred to as "noise regularization." A full treatment of these methods is beyond the reach of this chapter, and the user is instead referred to Wallace et al. (2001), Mertz (2010), Conchello (1998), Holmes (1992), McNally, Karpova, Cooper, and Conchello (1999), Shaw (1993), and Shaw and Rawlins (1991).

In some cases, the PSF is not known. Estimating the PSF through first principles (Goodman, 2005, Shaw, 1993, Shaw & Rawlins, 1991) can be used, but in our experience, these methods do not fully account for the resolution empirically observed (Hiraoka, Sedat, & Agard, 1990). In addition, in some samples, the PSF is highly variable throughout the volume of the sample. To overcome these limitations, a class of algorithms have been developed that solve for both the object (I_{Actual}) and the PSF. This class of algorithms are referred to as "blind deconvolution" (Holmes, 1992) and in some cases have proved to be quite effective, especially when the performance of the entire optical system (including the sample) is difficult to assess. For an approachable discussion of these and other methods, the reader is referred to Wallace et al. (2001).

10.2.5 THE IMPORTANCE OF IMAGE QUALITY

The age-old axiom of "garbage in, garbage out" certainly applies to all image-processing methods and deconvolution in particular. Like many methods, deconvolution microscopy assumes a model for the microscope and optics and uses that model to extract more information from the data. The degree to which the actual microscope matches the model used will determine the quality of the restored image. If the microscope is well matched to the model, then the restored image will closely approximate the actual object. If the microscope is poorly matched to the model, then the restored image will have little in common with the actual object. In the latter case, the model needs to be adapted to accommodate the unexpected behavior. For poorly behaved systems, these adaptations will adversely affect the quality and quantitative nature of the restored images.

10.2.5.1 Factors that affect image restoration

1. Geometry—As we have explored earlier, restorations generally rely on 3D data sets. The microscope model assumes that the geometry of the data accurately reflects the geometry of sample. For example, many algorithms perform the deconvolution in spatial coordinates and not pixel coordinates. This is a more precise way of estimating the object but it requires that the pixel geometry is known. Importantly, it requires that the Z-step size is precise (consistent) and uncoupled to the X-axis and Y-axis. If the Z-step size is variable, then the geometry of the data does not match the geometry of the sample, and deconvolution will struggle. Likewise, a common problem in microscope stages is cross coupling of the axes. In cross coupling, movements in one axis, say Z, induce changes in an orthogonal axis (X and/or Y). This results in misalignment of the image data and poor agreement between the sample and the data.

2. Intensity—Image restoration assumes that differences in pixel intensities reflect differences in the mass of material at each position in space. If the relationship between mass and intensity is variable, then the restoration will poorly reflect the sample. Factors that affect the mass–intensity relationship include variable illumination, photobleaching, and nonlinear fluorescence. The intensity of a given volume pixel (voxel) is a function of the input light (illumination), the detection efficiency, and the mass of available fluorescent molecules. Changes in each of these parameters will affect the mass–intensity relationship. Illumination intensity at each point in the sample starts with spatial and temporal stability of the light source (Chapter 1). Light uniformity can be maximized by assuring that the microscope is properly aligned for Koehler illumination. Temporal fluctuations in lamp intensity can be normalized using the integrated intensity of each Z-plane. Since there is little expected change in integrated intensity between planes with wide-field microscopy and Koehler illumination, then this model can be effective. With other illumination schemes, these methods may or may not work. Illumination stability is also affected by debris and defects in the light path including the excitation filter and dichromatic

beam splitter. These should be clean and free of these defects (Chapter 4). Likewise, changes in detection efficiency (emission filter defects, camera gain noise, etc.) can also affect how well the restored image reflects the sample. Finally, there are changes in fluorochrome that can affect the model. If the mass of available fluorochrome changes through the experiment (e.g., photobleaching), then the intensity–mass relationship is perturbed. Also, changes in quantum yield due to fluorochrome saturation, quenching, and the local environment (solvent effects) can all lead to artifacts that will affect the appropriateness of the model and thus the quality of the deconvolution process. Some of these can be mitigated by experimental condition (choice of fluorochrome, illumination intensity, etc.) or corrected using a suitable model (photobleaching), but the user should be aware of the limitations of this or any other method.

3. Optics—The best resolution that an optical system can achieve is when the system is free of aberrations. Any deviations from the ideal can only degrade the resolution and contrast in the system. Optical aberrations can be caused by defects in the microscope itself (objective lenses, tube lens, etc.), and the microscope should be tested for these defects (Goodwin, 2007). However, most users are unaware of the effects of the sample on optical quality. Even if the microscope is free of defects and aberrations, the optical properties between the specimen and the front lens of the objective significantly contribute to the overall optical system. Some of these defects are difficult to avoid, for example, imaging through a cell wall (in plants and some microbes), a cuticle (such as a drosophila embryo), or high-refractive-index surfaces (like neural tissue). However, in many cases, the sample effects are avoidable. For example, dirt and smudges on the cover glass, mixing different immersion oils, improper mounting of the media, tilted cover glass, and uncorrected spherical aberration all significantly degrade the reconstruction because they are not included in the model. While one could construct a much more complex imaging model, it is more generally applicable to fix the problems that can be fixed (the smudges and such) and reserve improvements in the model for those attributes that are not easily fixed (e.g., the diffraction limit).

10.3 RESULTS

One way to assess the effects of deconvolution is to visually inspect the outcome, but this is a qualitative measure that lacks exactness. Another way is to take the Fourier spectrum of images pre- and postdeconvolution. In the case of Fig. 10.5B and D, the spectrum represents the Fourier spectrum of the images pre- and postdeconvolution (A and C, respectively). In this representation, the Fourier spectrum is plotted such that the low-frequency components (those values that are spatially variant over large distances) are plotted toward the center. As one expands radially from the center, higher-frequency components (the intensity fluctuations that are spatially variant

FIGURE 10.5

Resolution enhancement with deconvolution. Panel (A) represents the image of a single field of view of fluorescently labeled 0.10-μm beads dried onto a coverslip. Panel (B) represents the Fourier spectrum of the image in panel (A) scaled to illustrate the weak values in the image. In this representation of the Fourier spectrum, the contrast of low spatial detail is plotted in the center of the image and spatial detail increases toward the perimeter. The white circle illustrates the spatial frequency at which the contrast falls to background levels. Panel (C) represents the data in panel (A) after deconvolution was applied, and similarly, panel (D) represents the Fourier spectrum of that image. The outer circle illustrates the resolution limits after deconvolution as compared with the resolution limit prior to deconvolution (inner circle). See text for details.

over short distances) are plotted. The intensity of the Fourier spectrum (in this case squared) represents the contrast observed at that particular spatial frequency. The extent to which the spectrum spreads laterally is a measure of the lateral resolution. This spectrum also extends axially but is not displayed here. If the Fourier spectrum of one image extends further radially than another, it indicates that the spatial frequencies are higher than those in the other image.

In the case of Fig. 10.5B and D, the circles are approximations of the extent of the Fourier spectrum and are presented merely for clarity. In panel (D), the inner circle

represents the extent of the spectrum in the image predeconvolution. The outer circle represents the extent of the spectrum postdeconvolution. As can be seen, in this example, the deconvolution process extended the resolution approximately 20%. In reality, the resolution improvement is even less. Most of the apparent improvement is the result of an increase in contrast (signal-to-background) due to deconvolution. All of the resolution in the postdeconvolution image (panel C) was present in the predeconvolved image (panel A); however, the resolution was not accessible due to a lack of contrast. In the predeconvolution image, blur throughout the volume of the image increases the background of the image. After deconvolution, the background intensities contributed by blur are assigned to their proper locations in space, resulting in not only a decrease in background but also a substantial increase in integrated intensities in the objects. This contrast (signal-to-background) improvement ranges from 10- to 100-fold depending on the extent of out-of-focus objects.

10.3.1 ASSESSING LINEARITY

The wide-field fluorescence microscope is generally considered to be a linear instrument. That is, over the majority of the dynamic range of the instrument, there exists a linear relationship between the mass of fluorochrome in the original sample and the observed fluorescence intensity. This is especially true for instruments that conform to the ideal model of the microscope discussed in the preceding text. This linearity allows for intensity measurements to be made and compared and for these comparisons to be correlated to mass changes in the actual object. Is this linearity maintained with deconvolution? Does the integrated intensity of an object postdeconvolution bear a mass relationship with fluorochrome in the actual objects? In short, it depends. Some systems and methods maintain the mass relationship, while others do not. No comprehensive assessment of the linearity of all imaging systems exists but one method of assessing linearity was published (Swedlow, Hu, Andrews, Roos, & Murray, 2002; Swedlow, 2007). In their method, Swedlow et al. obtained 2.5-µm latex beads with six different relative concentrations of fluorochrome over 3.5 orders of magnitude. The intensities of the beads were measured using fluorescence-activated cell sorting (FACS) including the means and coefficients of variation. Beads were then mixed and dried onto coverslips, and image stacks were collected with a wide-field microscope. The volumetric integrated intensity of the beads with pre- and postdeconvolution was compared to the distributions measured by FACS with comparable results over three orders of magnitude. The weakest intensity beads were shifted in mean and coefficient of variability. It should be noted that, in this paper and the test samples used, both wide-field and deconvolution methods fared better than confocal systems. In the presence of optical aberrations, such as spherical aberration, the confocal system would be expected to fair even worse (White, Errington, Fricker, & Wood, 1995). For this study, Swedlow et al. used the Agard constrained iterative method mentioned previously.

10.3.2 APPLICATIONS OF DECONVOLUTION MICROSCOPY

The contrast and resolution improvements afforded by deconvolution microscopy can be exceptionally useful for certain specimens and of little value in others. This has been the topic of countless investigations and "shoot-outs" at microscopy workshops and demonstrations. Needless to say, as with all techniques, there are some samples that are more appropriate than others (Murray, Appleton, Swedlow, & Waters, 2007). Deconvolution microscopy in general works in applications where the biological targets are small and where the density of labeling is relatively low. For example, deconvolution microscopy is ideally suited for studying cells and tissues in the range of 1–15 µm. Of course, there are some samples of tremendous depth (100 µm or so) where deconvolution has worked spectacularly, and there are some samples of shallow depth (<1 µm) that are impossible to image. Highly scattering and absorptive samples are extremely hard to optically image without mechanical sectioning.

One application where deconvolution often excels is in live-cell imaging up to a few cell layers deep. Live-cell imaging poses unique challenges to microscopy and especially fluorescence microscopy. Fluorescence is inherently an inefficient methodology. A tremendous number of excitation photons must be created in order to obtain even a modest number of emission photons. By some estimates, the most efficient microscopy systems yield approximately one detected photon for every 10^5 excitation photons (at the light source). As optical methods are deployed that eliminate emission photons (such as confocal) or that rely on rare nonlinear excitation (like multiphoton microscopy), the efficiencies decrease dramatically. Murray et al. estimate that spinning disk confocal microscopes are approximately 5% as efficient as wide-field systems and point-scanning confocal systems can be as little as 0.5% as efficient as wide-field systems. This often has tremendous implications for live-cell imaging. Many cells are poorly equipped for handling large photon doses. If one considers a cardiomyocytes in an intact human, that cell would rarely if ever be exposed to a photon with a wavelength of less than 1000 nm; consequently, it has few mechanisms for dealing with more energetic photons at shorter wavelengths. A wide-field microscope with a high-NA objective lens typically exposes a cell to roughly the same photon flux as sitting out in direct daylight. A point-scanning confocal may be 10,000 times higher, and a two-photon microscopy system can easily be 10,000 times higher than that. Some calculate the density of photons in a two-photon system to be higher than the photon density on the surface of the sun. Anything that can be done to reduce the photon flux on cells will help to minimize photodamage to the cell (Chapter 5).

Since we have established that deconvolving microscope images generally increases the contrast 10- to 100-fold, we can design experiments where this improvement is relied on. With deconvolution, we can often collect images with lower than desired contrast and count on the improvement that the algorithm affords. Lower contrast for the same hardware system translates into a combination of lower and shorter illumination onto the cell. This can lead to dramatic improvements in cell viability.

Deconvolution microscopy is not always effective. First of all, it is typically more effective with high-NA optics than it is with low-NA optics. Below an NA of 0.75, there is little axial resolution and contrast such that the algorithm has little information to work with. Very dense labeling can be problematic, again due to poor lateral and axial contrast. Samples that are highly scattering are difficult for all imaging systems, but the method of image formation in point-scanning systems can yield superior results over wide-field systems. Deconvolution microscopy works best with 3D data sets, while a confocal microscope system does not require 3D acquisition. This can yield faster results than deconvolution. This can be critical in attempting to image very rapidly moving objects, although new fast imaging modalities and brighter fluorescent probes (Chapter 6) mitigate much of this problem.

CONCLUSION

Deconvolution microscopy can be a highly effective method of enhancing the resolution and contrast of the optical microscope while enabling reduced photon load on the specimen. For many biological specimens, this improvement offers equivalent or better resolution than confocal or multiphoton systems while producing significant improvements in cell viability. Deconvolution can be linear and can maintain mass–intensity relationships in samples if properly deployed.

A general rule of thumb is to use only as much technology as the sample demands. If wide-field microscopy is sufficient, then there is no need for deconvolution. If deconvolution is necessary and sufficient, then there is no need for a confocal system. If the sample can tolerate higher photon flux and demands more contrast than deconvolution can deliver, then a confocal or even multiphoton system may be required.

As with all instrumentation, there is no single technology that can address all of the needs of a scientist; however, deconvolution has a proved history of being an important tool for microscopists and cell biologists.

REFERENCES

Agard, D. A. (1984). Optical sectioning microscopy: Cellular architecture in three dimensions. *Annual Review of Biophysics and Bioengineering*, *13*, 191–219.

Conchello, J. A. (1998). Superresolution and convergence properties of the expectation-maximization algorithm for maximum-likelihood deconvolution of incoherent images. *Journal of the Optical Society of America*, *15*, 2609–2619.

Frieden, B. R. (1975). Image enhancement and restoration. In T. S. Huang (Ed.), *Topics in applied physics: Picture processing and digital filtering: Vol. 6.* (pp. 177–248). New York, NY: Springer-Verlag.

Gold, R. (1964). *An iterative unfolding method for response matrices: Report No. ANL-6984.* Chicago, IL: Argonne National Laboratory.

Goodman, J. W. (2005). *Introduction to Fourier optics* (3rd ed.). Englewood, CO: Roberts and Company.

Goodwin, P. C. (2007). Evaluating optical aberrations using fluorescent microspheres: Methods, analysis, and corrective actions. In L. Wilson & P. Matsudura (Series Eds.) & G. Sluder & D. E. Wolf (Vol. Eds.), *Methods in cell biology: Vol. 81*. (pp. 397–413). London: Elsevier.

Hiraoka, Y., Sedat, J. W., & Agard, D. A. (1990). Determination of three-dimensional imaging properties of a light microscope system. Partial confocal behavior in epifluorescence microscopy. *Biophysical Journal, 57*(2), 325–333.

Holmes, T. J. (1992). Blind deconvolution of quantum-limited imagery: Maximum-likelihood approach. *Journal of the Optical Society of America, 9*, 1052–1061.

Jansson, P. A. (Ed.), (1997). *Deconvolution of images and spectra* (2nd ed.). New York, NY: Academic Press.

McNally, J. G., Karpova, J. G., Cooper, J., & Conchello, J. A. (1999). Three-dimensional imaging by deconvolution microscopy. *Microscopy Methods, 19*, 373–385.

Mertz, J. (2010). *Introduction to optical microscopy.* Greenwood Village, CO: Roberts and Co.

Murray, J. M., Appleton, P. L., Swedlow, J. R., & Waters, J. C. (2007). Evaluating performance in three-dimensional fluorescence microscopy. *Journal of Microscopy, 228*, 390–405.

Shaw, P. J. (1993). Computer reconstruction in three-dimensional fluorescence microscopy. In D. Shotton (Ed.), *Electronic light microscopy.* New York, NY: Wiley-Liss.

Shaw, P. J., & Rawlins, D. J. (1991). Three-dimensional fluorescence microscopy. *Progress in Biophysics and Molecular Biology, 56*, 187–213.

Swedlow, J. R. (2007). Quantitative fluorescence microscopy and image deconvolution. In L. Wilson & P. Matsudura (Series Eds.) & G. Sluder & D. E. Wolf (Vol. Eds.), *Digital microscopy. Methods in cell biology: Vol. 81*. (pp. 447–465). London: Elsevier.

Swedlow, J. R., Hu, K., Andrews, P. D., Roos, D. S., & Murray, J. M. (2002). Measuring tubulin content in *Toxoplasma gondii*: A comparison of laser-scanning confocal and wide-field fluorescence microscopy. *Proceedings of the National Academy of Sciences of the United States of America, 99*(4), 2014–2019.

Swedlow, J. R., Sedat, J. W., & Agard, D. A. (1997). Deconvolution in optical microscopy. In P. A. Jansson (Ed.), *Deconvolution of images and spectra* (2nd ed.). New York, NY: Academic Press.

Wallace, W., Schaefer, L. H., & Swedlow, J. R. (2001). A workingperson's guide to deconvolution in light microscopy. *BioTechniques, 31*, 1076–1097.

White, N. S., Errington, R. J., Fricker, M. D., & Wood, J. L. (1995). Aberration control in quantitative imaging of botanical specimens by multidimensional fluorescence microscopy. *Journal of Microscopy, 181*(2), 99–116.

CHAPTER

Light sheet microscopy 11

Michael Weber, Michaela Mickoleit, Jan Huisken
Max Planck Institute of Molecular Cell Biology and Genetics (MPI-CBG), Dresden, Germany

CHAPTER OUTLINE

Introduction	194
11.1 Principle of Light Sheet Microscopy	195
11.1.1 Light Sheet Illumination	195
11.1.2 Wide-Field Detection	196
11.1.3 Large Samples	198
11.2 Implementations of Light Sheet Microscopy	198
11.2.1 Light Sheet Properties	198
11.2.2 How to Generate a Light Sheet	199
11.2.3 Vertical Versus Horizontal Arrangements	201
11.2.4 Microscope Built Around the Sample	201
11.2.5 Objective Lenses	203
11.3 Mounting a Specimen for Light Sheet Microscopy	203
11.3.1 Solid Gel Cylinder	203
11.3.2 Tube Embedding	205
11.4 Acquiring Data	205
11.4.1 Orienting the Specimen	207
11.4.2 Light Sheet Alignment	207
11.4.2.1 Adjusting the Light Sheet Height	207
11.4.2.2 Adjusting the Light Sheet Thickness	208
11.4.2.3 Correct Position of the Beam Waist	208
11.4.2.4 Moving the Sheet in Focus	209
11.4.2.5 Eliminating Tilt	209
11.4.3 Choosing the Right Imaging Parameters	209
11.5 Handling of Light Sheet Microscopy Data	210
11.5.1 Coping with High-Speed and Large Data	210
11.5.2 Image Enhancements	211
11.5.3 Multiview Fusion	211
11.5.4 Image Analysis	212
References	212

Abstract

This chapter introduces the concept of light sheet microscopy along with practical advice on how to design and build such an instrument. Selective plane illumination microscopy is presented as an alternative to confocal microscopy due to several superior features such as high-speed full-frame acquisition, minimal phototoxicity, and multiview sample rotation. Based on our experience over the last 10 years, we summarize the key concepts in light sheet microscopy, typical implementations, and successful applications. In particular, sample mounting for long time-lapse imaging and the resulting challenges in data processing are discussed in detail.

INTRODUCTION

Selective plane illumination microscopy (SPIM) was introduced to the life sciences in 2004 (Huisken, Swoger, Del Bene, Wittbrodt, & Stelzer, 2004) although the idea of using a light sheet to achieve optical sectioning had already been around for a century (Siedentopf & Zsigmondy, 1902). SPIM turned out to be a very powerful tool especially for the community of biologists interested in imaging developmental processes in 3D. With the invention of genetically encoded fluorescent proteins in the early 1990s (Prasher, Eckenrode, Ward, Prendergast, & Cormier, 1992), scientist started to label different cell types in a living organism with a variety of colors (Tsien, 2010), but conventional microscopes were not able to provide sufficient penetration and acquisition speed to capture all the details in a live embryo. The size and opacity of whole organisms (often a few millimeters in size) made it difficult to achieve single-cell resolution deep inside the tissue. SPIM has filled this niche and quickly proofed useful for a variety of applications.

Nowadays, the user can choose from a number of different instrumental designs classified as light sheet microscopes, but they all still share the basic features: instantaneous optical sectioning is achieved by illuminating the sample with a sheet of light and generating fluorescence in a thin slice, which is then imaged with a fast camera (Huisken & Stainier, 2007). In SPIM, millimeter-sized specimens can be reconstructed by rotating and imaging them from different sides (multiview imaging) (Preibisch, Saalfeld, Schindelin, & Tomancak, 2010; Swoger, Verveer, Greger, Huisken, & Stelzer, 2007). SPIM has been widely used for various biological applications, mainly zebrafish (Keller, Schmidt, Wittbrodt, & Stelzer, 2008; Scherz, Huisken, Sahai-Hernandez, & Stainier, 2008; Swoger, Muzzopappa, López-Schier, & Sharpe, 2011) and fly embryos (Huisken et al., 2004; Krzic, Gunther, Saunders, Streichan, & Hufnagel, 2012; Tomer, Khairy, Amat, & Keller, 2012) as well as single cells and spheroids (Lorenzo et al., 2011; Planchon et al., 2011; Ritter, Veith, Veenendaal, Siebrasse, & Kubitscheck, 2010; Siedentopf & Zsigmondy, 1902), *Caenorhabditis elegans* (Fickentscher, Struntz, & Weiss, 2013; Prasher et al., 1992; Wu et al., 2011) and fixed mouse embryos or organs (Ermolayev et al., 2009; Jährling et al., 2009; Silvestri, Bria, Sacconi, Iannello, & Pavone, 2012; Tsien, 2010). Recently, also plants have been

imaged successfully with SPIM (Huisken et al., 2004; Maizel, Wangenheim, Federici, Haseloff, & Stelzer, 2011; Sena, Frentz, Birnbaum, & Leibler, 2011).

Phototoxicity in SPIM has been shown to be very low even at high acquisition rates (Preibisch et al., 2010; Reynaud, Krzic, Greger, & Stelzer, 2008). As a result, the imaging speed is less dictated by how much light the sample tolerates; rather, it is more determined by the speed of the camera. Therefore, SPIM instruments have become the tool of choice for recording fast-changing, weakly expressing tissues in sensitive embryos, where phototoxicity needs to be avoided at all costs (Ahrens, Orger, Robson, Li, & Keller, 2013; Ichikawa et al., 2013; Jemielita, Taormina, DeLaurier, Kimmel, & Parthasarathy, 2012; Keller et al., 2008; Scherz et al., 2008; Swoger et al., 2011; Tomer et al., 2012; Wu et al., 2011). Developmental biologists can now benefit from the ability to watch cellular and morphogenetic events occur in real time in an entire embryo, advancing our understanding on how cells form tissues and organs. At the same time, SPIM challenges existing data and image processing tools, which need to be adapted to extract the desired answers to our biological questions from the large amounts of data (Ahrens et al., 2013; Krzic et al., 2012; Schmid et al., 2013). In SPIM, besides the actual imaging, it is equally important to mount the sample under ideal physiological conditions and have the proper infrastructure to deal with the enormous datasets.

In this chapter, we take a close look at the principles of light sheet microscopy and the possible implementations. We also present mounting strategies for specimens and discuss data acquisition and handling.

11.1 PRINCIPLE OF LIGHT SHEET MICROSCOPY

Light sheet microscopy combines two distinct optical paths, one for fast wide-field detection and one for illumination with a thin sheet of light, orthogonally to the detection path (Fig. 11.1A; Huisken et al., 2004). The light sheet is aligned with the focal plane of the detection path, and the waist of the sheet is positioned in the center of the field of view (Fig. 11.1B).

11.1.1 LIGHT SHEET ILLUMINATION

SPIM's unique configuration addresses two fundamental limitations of single-lens setups, which are as follows:

1. Obtaining thin optical sections is very difficult with low-NA (numerical aperture) objectives.
2. The whole sample volume is illuminated when imaging a single section, multiplying the risk of fluorophore bleaching and phototoxicity (Fig. 11.2A). This effect accumulates quickly: when recording a stack of N planes, each plane is exposed N times.

By contrast, in SPIM, only the focal plane of the detection objective is selectively illuminated (Fig. 11.2B), which leads to an efficient decrease in energy input

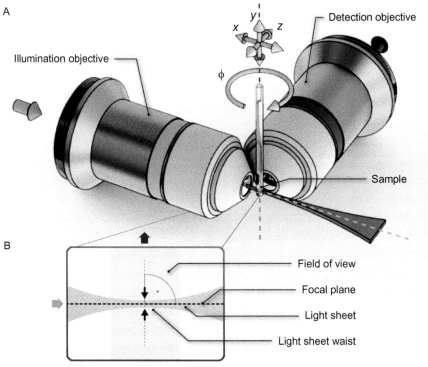

FIGURE 11.1

The principle of light sheet microscopy. (A) The illumination and the detection objectives are oriented orthogonally. The sample is placed at the intersection of their focal planes. A single slice of the sample is illuminated with a thin sheet of laser light. (B) Viewed from top, the light sheet has a waist in the center of the field of view and overlaps perfectly with the focal plane of the detection objective.

(Reynaud et al., 2008). Each plane is only exposed once during a stack. The thickness of the light sheet—usually a few micrometers—defines the axial extent of the optical section and is much thinner than the depth of field of the detection objective in common microscopy techniques. With light sheet microscopy, one can therefore acquire thin optical sections across large fields of view in big specimens.

11.1.2 WIDE-FIELD DETECTION

The unique optical arrangement in light sheet microscopy provides yet another advantage. While in confocal microscopy, time-consuming scanning and discrimination with pinholes is required (Fig. 11.2C); in SPIM, optical sectioning is achieved directly across the entire plane and the image is recorded in a single exposure (Fig. 11.2D). Each pixel collects photons for the entire duration of the exposure time—usually a few milliseconds. In contrast, in the confocal, the scanner needs to

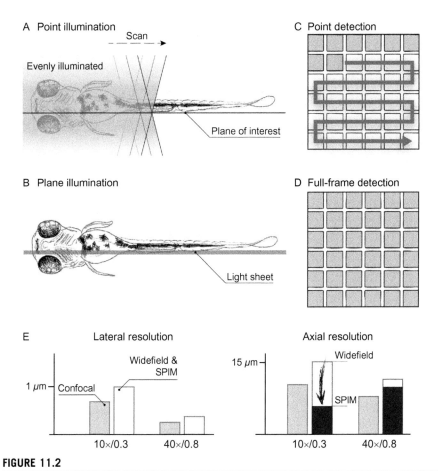

FIGURE 11.2

Light sheet microscopy has several benefits over confocal laser scanning microscopy. (A) In confocal laser scanning microscopy, the entire sample is evenly illuminated, even when imaging only a single plane. (B) In light sheet microscopy, only the plane of interest is selectively illuminated. (C) In the confocal, a laser spot needs to be scanned across the sample to create one image. (D) In light sheet microscopy, the entire field of view is imaged at once. (E) While the lateral resolution of a light sheet microscope is equal to that of a wide-field system, the axial resolution improves strongly due to the light sheet illumination (by factors of 2 and 2.5 over confocal laser scanning and wide-field microscopy, respectively, for a 10×/0.3 lens).

rush from one pixel to the next and can only rest for microseconds. Hence, the parallel recording of all pixels in light sheet microscopy is much more efficient, and the local excitation intensity can be kept very low. In addition, in combination with fast and sensitive cameras, large image datasets are acquired much faster than with any other technique while still offering a superior signal-to-noise ratio and minimal

phototoxicity. This makes light sheet microscopy the ideal technique to follow fast and dynamic developmental processes in sensitive living specimens in a minimally invasive manner (Weber & Huisken, 2011).

11.1.3 LARGE SAMPLES

Light sheet illumination is especially beneficial in microscopes with low-NA, low-magnification, and long-working-distance objectives as used for large samples. While the lateral resolution of a light sheet microscope is the same as in a wide-field microscope, the axial resolution is primarily given by the light sheet thickness. As a result, a light sheet microscope equipped with, for example, a 10×/0.3 lens exhibits a twofold better axial resolution than a confocal microscope (Fig. 11.2E; Engelbrecht & Stelzer, 2006).

11.2 IMPLEMENTATIONS OF LIGHT SHEET MICROSCOPY

The optical arrangement of a basic light sheet microscope is quite different from conventional microscopes, yet it is comparatively straightforward. The detection path is generally identical to a wide-field fluorescence microscope: A detection objective collects light from its focal plane and passes it through a fluorescence filter, and a tube lens projects the light onto a camera chip. No dichroic mirror is needed, since no excitation light needs to be introduced through the detection path. The distinct illumination path is oriented orthogonally to the detection path and consists mainly of a coherent light source and optics to form the light sheet and project it through an illumination lens onto the sample.

In the same way that compound microscopes are built in different configurations such as upright or inverted, light sheet microscopy also comes in a variety of implementations. Ideally, the microscope is built around the specimen, providing the best possible image quality and the necessary spatial and temporal resolution while maintaining the sample under ideal conditions for the duration of the experiment. Therefore, depending on the sample of interest, light sheet microscopes may look very different although they still share the same fundamental principle.

11.2.1 LIGHT SHEET PROPERTIES

Of crucial importance for the performance of the microscope are the properties of the light sheet such as thickness, uniformity, and ability to penetrate scattering tissue. The ideal scenario, a perfectly thin optical section, would be obtained if a sheet of light illuminated only the focal plane of the detection objective. Preferably, this sheet should be as thin as possible and uniform across the field of view. However, the laws of diffraction govern the dimensions of the light sheet and the thickness of the sheet changes across the field of view (Fig. 11.3). The NA of the illumination needs to be chosen carefully, to generate a light sheet that is sufficiently thin across the

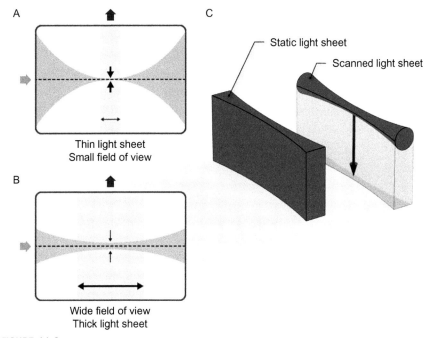

FIGURE 11.3

Light sheet characteristics and ways to generate a light sheet. (A) A thin light sheet yields even illumination only in a small field of view. (B) In contrast, a wide field of view is achieved only with a thicker light sheet. (C) A light sheet can be generated either by a cylindrical lens focusing a laser beam in one dimension (static light sheet) or by rapidly scanning a laser beam across the field of view (scanned light sheet).

entire field of view. Due to the diffraction-limited shape of the light sheet, one can generally choose between a thin light sheet (ca. 1 μm) for small fields of view (ca. 60 μm) (Fig. 11.3A) and thicker light sheets (ca. 6 μm) for large fields of view (ca. 600 μm) (Fig. 11.3B; Engelbrecht & Stelzer, 2006).

11.2.2 HOW TO GENERATE A LIGHT SHEET

Fundamentally, we distinguish between two classes of light sheet microscopes (Fig. 11.4C):

- The ones with a static light sheet, usually generated with cylindrical optics (Huisken et al., 2004)
- Microscopes with light sheets generated by rapidly scanning a beam up and down (Keller et al., 2008)

When compared to a cylindrical lens, a scanning mirror offers more flexibility. The height of the light sheet can easily be adapted by changing the scanning amplitude,

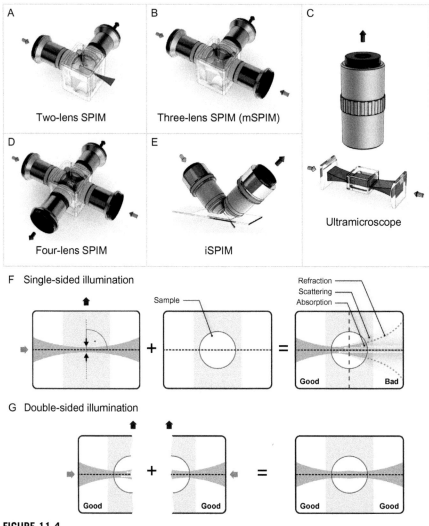

FIGURE 11.4

Implementations of light sheet microscopy and benefits of multilens setups. Light sheet microscopy is built around the sample and thus comes in numerous implementations. (A) A basic SPIM setup with one objective for illumination and one for detection. The sample is oriented vertically in the medium-filled chamber. (B) In this three-lens configuration, a second illumination objective is added. (C) An ultramicroscope with two illumination arms in an upright configuration with a low-magnification objective. The imaging chamber is typically isolated from the optical components to hold large, fixed samples in clearing agents. (D) A configuration with a second detection objective can be used to acquire images from two sides simultaneously. (E) A special 45° objective configuration (iSPIM) for using slide-mounted samples with light sheet microscopy. (F) Light sheet image data acquired with single-sided illumination can suffer from image distortions caused by refraction, scattering, and absorption. (G) Double-sided illumination (like in B, C, and D) can circumvent such distortions by combining two well-illuminated halves of an image into one.

and changing the diameter of the incoming beam can alter the light sheet thickness. Additionally, the light sheet intensity is homogeneous, and special techniques such as Bessel beams (Planchon et al., 2011), structured illumination (Breuninger, Greger, & Stelzer, 2007; Keller et al., 2010), two-photon excitation (Truong, Supatto, Koos, Choi, & Fraser, 2011), and confocal line detection (Baumgart & Kubitscheck, 2012; Fahrbach, Gurchenkov, Alessandri, Nassoy, & Rohrbach, 2013) can be integrated. The cylindrical lens on the other hand is easy to integrate and does not require moving parts. The entire field can be illuminated at once, resulting in much less power per line and higher acquisition speeds, which are not limited by the speed of a scanning mirror but only by the speed of the camera.

11.2.3 VERTICAL VERSUS HORIZONTAL ARRANGEMENTS

To accomplish the orthogonal optical arrangement of the two beam paths, light sheet microscopes are often set up in the horizontal plane, with the sample hanging from above at the intersection of illumination and detection paths (Fig. 11.1A). A unique advantage of this vertical sample mounting is the ability to rotate the sample without deformations to quickly and precisely orient it and to image it from multiple angles (multiview acquisition; Swoger et al., 2007). A combination of linear and rotational stages is used to position the specimen and record z-stack, multiposition, and multiview datasets.

11.2.4 MICROSCOPE BUILT AROUND THE SAMPLE

While light sheet microscopy can also be used to image fixed, cleared samples faster and more efficiently than with other techniques, light sheet microscopy excels in the imaging of living samples: Dramatically reduced phototoxicity, combined with fast acquisition and flexible sample orientation, is ideal for imaging rapid developmental processes in cell colonies, tissue samples, or entire animals. In order to provide the best environmental conditions for such imaging tasks, many light sheet microscopes are equipped with a medium-filled sample chamber and water-corrected illumination and detection objective lenses (Fig. 11.4A). Combined with water-based sample mounting, a refractive index-matched beam path can be achieved. The medium-filled imaging chambers also provide incubation systems for environmental control or drug supply.

Unfavorable optical properties of the sample can cause absorption, scattering, and refraction, which limit the penetration depth of the light sheet, broaden it, and alter its location (Fig. 11.4F). The resulting images may appear blurry, out of focus, and stripy. In this case, a second illumination arm (three-lens configuration) can improve image quality (Fig. 11.4B; Huisken & Stainier, 2007). Its optical configuration is typically identical to the first illumination arm and illuminates the sample from the opposite direction through an additional illumination lens. The light sheets generated by both illumination arms are aligned to the very same plane, the focal plane of the detection objective. The illumination arms can typically be

switched on separately, in an alternating fashion, or both simultaneously. The well-illuminated parts of the images from each illumination side can then be stitched resulting in a final image of evenly good quality (Fig. 11.4G). In addition, both illumination arms may feature additional optics to pivot the light sheet around the center of the field of view to generate a more even illumination and to efficiently eliminate shadows (multidirectional, mSPIM) (Huisken & Stainier, 2007).

Double-sided illumination can also improve overall fluorescence excitation in fixed and cleared specimens (Dodt et al., 2007; Ermolayev et al., 2009; Jährling et al., 2009). For such samples, mostly upright detection paths are chosen with the sample enclosed in a cuvette (ultramicroscopy; Fig. 11.4C). Living embryos, however, are relatively opaque and impossible to penetrate from a single side. The images become deteriorated when imaging deeper into the tissue. One potential way of solving these issues is multiview acquisition, in which the specimen is rotated to acquire datasets from multiple angles and fuse them subsequently (Fig. 11.5A). Multiview acquisition holds two advantages: On the one hand, the overall image quality is improved as additional data are acquired from more favorable angles; on the other hand, overlapping datasets can be processed to yield more isotropic resolution (Swoger et al., 2007).

To facilitate multiview imaging further, a second detection arm can be added (-four-lens configuration; Fig. 11.4D and B). Now, the specimen is imaged from two sides simultaneously and both halves—the front and the back of the sample—are imaged in one continuous z-stack. Besides a minor gain in speed, the main advantage is

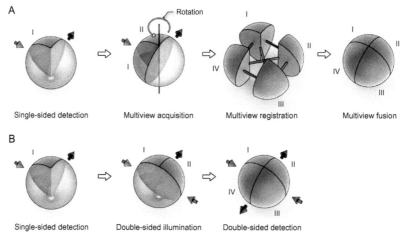

FIGURE 11.5

Multiview image acquisition. Scattering samples such as living embryos cannot be imaged with even resolution from a single side only. Multiview acquisition combines image data from different views into a single dataset to capture the entire specimen. (A) The sample is rotated and subsequently imaged from multiple angles. The individual datasets are then registered and fused. (B) Alternatively, the specimen may be illuminated from two sides and imaged from two sides in a continuous z-stack using double-sided detection.

that the views from the two cameras are aligned and no further registration is necessary. The fusion can therefore be performed in real time (Krzic et al., 2012; Schmid et al., 2013). If rotation is not required, or the specimen itself demands a horizontal orientation, light sheet illumination can also be implemented in different arrangements (e.g., iSPIM, Wu et al., 2011; Fig. 11.4E).

11.2.5 OBJECTIVE LENSES

Of crucial importance for the optical performance of a light sheet microscope is the choice of objective lenses for illumination and detection. For imaging living specimens, water-corrected objective lenses are the first choice. In case of a horizontal arrangement and the use of a medium-filled chamber, either water-dipping or air objectives can be used. Optically ideal is the use of water-dipping lenses: the minimized amount of interfaces with varying refractive indexes helps to get the best possible light sheet across the entire excitation spectrum. But often, the orthogonal orientation of the illumination and detection paths restricts the selection of suitable objectives. A high-numerical-aperture detection objective is typically too big to be combined with another, orthogonally placed water-dipping objective. Therefore, in many cases, an air illumination objective needs to be used. Fortunately, no high NA is required on the illumination side, and a simple $10\times/0.3$ lens is sufficient to generate a light sheet with a thickness of only a couple of micrometers.

11.3 MOUNTING A SPECIMEN FOR LIGHT SHEET MICROSCOPY

No matter how powerful a certain microscopy technique is, it will only be useful when it is compatible with biological samples; hence, the mounting of the sample is crucial. In light sheet microscopy, sample preparation is radically different from the dish or slide mounting used for conventional microscopy, since usually, the sample is oriented vertically. Further, the mounted sample needs to be cylindrical to observe the specimen from all sides without distortions and exploit the unique sample rotation in light sheet microscopy. Therefore, new mounting strategies have been established dedicated for light sheet microscopy imaging as well as for particular samples and biological questions (Kaufmann, Mickoleit, Weber, & Huisken, 2012). Living samples are most often immersed in an aqueous medium appropriate for the particular organism. For ultramicroscopy, the fixed sample is immersed in a clearing solution and illuminated and imaged from outside the chamber (Dodt et al., 2007). Since light sheet microscopy has a unique potential in imaging living samples, we primarily discuss mounting strategies for *in vivo* imaging in the succeeding text.

11.3.1 SOLID GEL CYLINDER

One of the first, broadly used mounting protocols involves low-melting agarose in a glass capillary (Fig. 11.6A; Reynaud et al., 2008). Here, the specimen is embedded in a solid cylinder of agarose, which is extruded into the medium-filled chamber. The

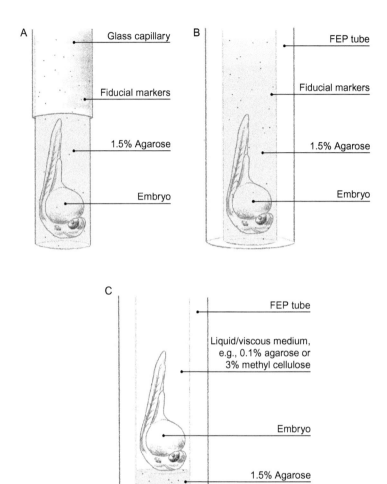

FIGURE 11.6

Sample mounting. The *zebrafish* embryo is shown here as an example for a living and growing sample. (A) For short experiments, the sample is embedded in a solid agarose cylinder inside a capillary. For imaging, the cylinder is extruded into the medium-filled sample chamber. (B) Alternatively, FEP tubes can be used to enclose the agarose cylinder and increase the overall stability of the sample mounting. (C) For time-lapse experiments, the sample is mounted in FEP tubes filled with liquid or viscous medium.

transparent agarose matches the refractive index of water (1.33) and biological tissue, and concentrations of 1.0–1.5% provide enough mechanical stability to reproducibly move the sample. The glass capillaries are reusable and easy to handle. Fiducial markers like beads for multiview reconstruction can be added and dispersed

easily in liquid agarose yielding an even distribution within the solid agarose cylinder (Fig. 11.6A). Capillaries with different sizes are available, such that the right size can be chosen for the particular model system. This method works well for medium to large specimens like zebrafish and drosophila embryos. Single cells and cysts are generally embedded in hollow agarose cylinders or Matrigel enclosed in a small bag of transparent foil (Keller, Pampaloni, & Stelzer, 2006). Mounting in an agarose cylinder is ideal for snapshots, since the sample is immobilized very well.

11.3.2 TUBE EMBEDDING

If the experimental design requires fast movements or rotations of the sample, the agarose cylinder might shake resulting in a blurred image. Therefore, plastic tubes made of fluorinated ethylene propylene (FEP) can be used to surround the agarose cylinder (Fig. 11.6B). These tubes were chosen for their refractive index (1.34), which is close to the one of water (1.33) allowing to image through the tube without extruding the wobbly agarose cylinder. It was shown that the image quality with tubes is as good as with pure agarose cylinders (Kaufmann et al., 2012). The tubes are commercially available in different sizes, and the appropriate size for the particular experiment can be chosen, for example, zebrafish embryos of various stages inside or outside the chorion. The tubes need to be cleaned prior to mounting by rinsing with NaOH, EtOH, and water and ultrasonication (Kaufmann et al., 2012).

The mounting protocols in FEP tubes can also be adapted for long-term experiments. Imaging developing organisms over many hours or a few days requires careful optimization of the mounting technique, since the organism may grow and change its outer shape significantly over the course of the experiment. For example, the size of zebrafish embryos increases by a factor of 4 within 3 days (Kimmel, Ballard, Kimmel, Ullmann, & Schilling, 1995). Time-lapse imaging of embryos embedded in a rigid scaffold, such as agarose, leads to severe growth restrictions and developmental defects (Kaufmann et al., 2012). The optimal mounting for imaging developmental processes should provide enough space for the sample to grow while keeping it in a fixed position. To ensure the sample's normal growth and development during long-term experiments, the FEP tube can be filled with liquid or viscous media, for example, methylcellulose or low-concentrated agarose (Fig. 11.6C). Sedative drugs can also be used to immobilize the organism but should be kept to a minimum since prolonged exposure might interfere with development (Kaufmann et al., 2012). The tube is closed with a plug made of 1–3% low-melting agarose. This slightly more laborious mounting method ensures normal development of a rapidly growing organism like the zebrafish embryo (Fig. 11.7).

11.4 ACQUIRING DATA

Every microscope is different and so are the user's experiences. SPIM may feel particularly different from a conventional microscope since most setups are fully digital; no eyepiece is available to quickly check the location and orientation of the sample

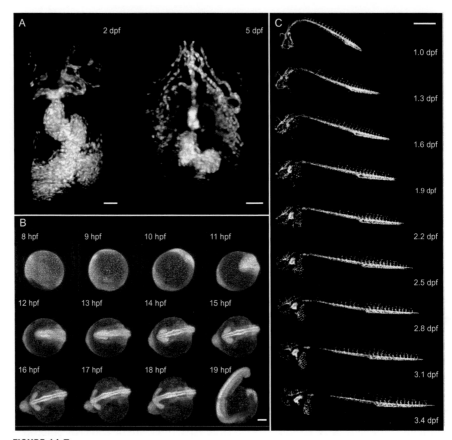

FIGURE 11.7

Zebrafish development with SPIM. The *zebrafish* embryo as one of the pioneering model organisms in modern light sheet microscopy demonstrates the power of the technique. (A) A complex network of blood vessels around the beating heart of a living transgenic *Tg(myl7:dsRed, kdrl:GFP, gata1a:DsRed) zebrafish* embryo at 2 and 5 days post fertilization (dpf). Scale bars: 50 μm. (B) A transgenic *Tg(H2A:GFP) zebrafish* imaged through the chorion during early embryogenesis. Scale bar: 150 μm. (C) A transgenic *Tg(kdrl:GFP) zebrafish* develops inside a medium-filled FEP tube while being imaged every 10 min for more than 2 days. Scale bar: 500 μm.

by eye. Moreover, the specimen is often oriented vertically rather than horizontally, and stage controls may be very different from classical microscope interfaces. The ability to quickly scan through the entire depth of the sample without the need to wait for a scan to finish like on a confocal microscope makes the SPIM workflow very fast and straightforward. Similarly, data acquisition is very fast and experiments can be performed in rapid succession. However, a large amount of data can accumulate

quickly, and long recordings should be done only under cautious consideration of storage and processing capacity.

11.4.1 ORIENTING THE SPECIMEN

In a normal compound fluorescence microscope, the mounted sample is placed on the microscope stage, and both illumination and detection are performed from either above or below (upright or inverted microscope). This constellation fixes the viewing angle and the sample can only be translated in x, y, and z. Light sheet microscopy adds another degree of freedom with sample rotation and thus allows the user to precisely orient the sample. This additional freedom alleviates mounting when it comes to accurately position the sample, since final adjustments in sample orientation can be performed in the microscope while evaluating the resulting images in real time. Additionally, multiple datasets can be acquired from different views and fused to image samples that would otherwise exceed the microscope's penetration depth.

At the same time, in SPIM, the orientation of the sample is also more important than in a classical single-lens microscope. The user needs to ensure that the sample is properly oriented with respect to both the illumination axis and the detection axis: The light sheet needs to reach the region of interest without passing highly refractive or absorbing structures of the sample, and the fluorescence should leave the sample unhindered. The ability to rotate the sample can be crucial for finding the optimal angle.

11.4.2 LIGHT SHEET ALIGNMENT

The first crucial step during the process of image acquisition that differs distinctly from traditional fluorescence microscopy techniques is the alignment of the light sheet. Here, we distinguish between adjusting the basic parameters of the light sheet, namely, height and thickness, and correctly positioning the light sheet in the focal plane of the detection lens. All three steps are essential for achieving the best possible optical sectioning performance as well as reliable, consistent performance. Furthermore, the alignment of the light sheet and the knowledge of its parameters can be a crucial prerequisite for defining further experimental strategies, for example, the spacing of a z-stack and subsequent analysis steps.

Indispensable tools for setting up and aligning the light sheet are three test specimens: a fully reflective mirror, a reflective grid, and (multicolor) beads in agarose. They help to control the thickness of the light sheet at various positions, the homogeneity of illumination, the precise positioning in the focal plane of the detection objective, and (for multicolor experiments) the proper alignment of different excitation sources.

11.4.2.1 Adjusting the light sheet height

The light sheet needs to cover the entire height of the field of view. In the case of a scanned light sheet, this property can simply be adjusted by setting the scanning amplitude. In the case of a static light sheet, the illumination beam has to be expanded.

The intensity profile of the incoming beam typically follows a Gaussian pattern, and only the central part of the beam is considered more or less uniform. A slit aperture limits the height of the light sheet and avoids unnecessary energy input outside the field of view.

11.4.2.2 Adjusting the light sheet thickness

As mentioned earlier, the thickness of the light sheet defines the extent of the optical section in axial direction. The thinner the light sheet, the smaller the extent of the waist along the beam propagation axis and, consequently, the smaller the useable field of view (Fig. 11.3A and B). These light sheet properties are generally determined by the optics and are often chosen during the design of the instrument. The user then only needs to confirm the proper alignment of the light sheet before an experiment (Fig. 11.8A).

11.4.2.3 Correct position of the beam waist

Once the NA of the illumination has been chosen to give the ideal light sheet for the desired field of view, the light sheet needs to be aligned with respect to the focal plane of the detection arm. The first step is to translate the light sheet along its direction until it is centered in the field of view (Fig. 11.8B). To verify this position, the excitation beam is attenuated and the emission filter removed. A reflective mirror is placed in the focal plane and tilted by 45° into the direction of the light sheet. By

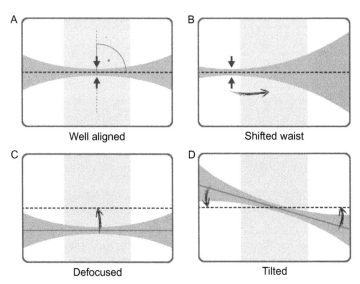

FIGURE 11.8

Light sheet alignment. (A) A well-aligned light sheet from top. (B) The waist of the light sheet needs to be centered in the field of view. (C) The light sheet needs to be precisely placed in the focal plane of the detection objective. (D) The illumination axis needs to be orthogonal to the detection axis.

moving the mirror along the illumination axis, one can sample the light sheet and find the waist, which needs to be in the center of the field of view. In addition, the homogeneity of the illumination in the center of the light sheet can be checked at this point.

11.4.2.4 Moving the sheet in focus
The light sheet needs to illuminate the focal plane of the detection unit (Fig. 11.8C). A semireflective grid is the ideal tool to perform this adjustment. Turned by 45°, the focal plane can be clearly identified in transmission and the light sheet is visible on the reflective gridlines. Using an adjustable mirror in the illumination path (Huisken & Stainier, 2007), the light sheet is moved along the detection axis until it overlaps with the focal plane. Additionally, mounted fluorescent beads can be used to adjust the light sheet until the point-spread function appears symmetric. If the system features multiple excitation laser lines, all light sheets need to overlap, which can be checked easily with multicolor fluorescent beads.

11.4.2.5 Eliminating tilt
To confirm that the light sheet is overlapping with the focal plane across the entire field of view (Fig. 11.8D), the grid can be moved along the illumination axis. Residual tilt needs to be eliminated.

11.4.3 CHOOSING THE RIGHT IMAGING PARAMETERS
Light sheet microscopes feature both high speed and low phototoxicity, so that many planes and many time points can be imaged without any impact on the specimen. Although one may aim for highest spatial and temporal resolution, the resulting data volumes are enormous; thus, data storage and strong computation power need to be available to process and archive the data. More than for other microscopy techniques, in SPIM, the user has to think about the necessary amount of information before the experiment.

Acquisition parameters to be considered are

- light sheet thickness,
- z-spacing for stacks,
- exposure time and region of interest of the camera,
- laser illumination power and duration,
- movie frame rate and duration,
- time-lapse interval and duration,
- number of angles for multiview acquisition.

The user needs to find the right balance between image quality and data size. A thinner light sheet gives a better axial resolution, but more planes are required to reconstruct the sample. A shorter exposure and illumination time results in less motion blur in moving specimens and higher temporal resolution, but it requires more energy per frame for the same signal-to-noise ratio. Increasing the frame rate

not only gains temporal resolution but also increases the amount of data. Here, the necessary speed depends very much on the actual speed of events in the specimen. The same holds true for the interval for time-lapse recordings.

An exceptional feature of light sheet microscopes is the ability to rotate the specimen. This is advantageous when imaging samples that are too big to be imaged from a single side. Multiview reconstruction also improves the axial resolution by adding high-resolution information from an overlapping acquisition taken under a different angle (Preibisch et al., 2010). Prior to any multiview acquisition, it is crucial to set the right number of angles to achieve full coverage of the sample with sufficient overlap.

11.5 HANDLING OF LIGHT SHEET MICROSCOPY DATA
11.5.1 COPING WITH HIGH-SPEED AND LARGE DATA

One of the striking advantages of SPIM is its ability to image large specimen with high spatial and temporal resolution over several hours or even days (Kaufmann et al., 2012). The resulting amounts of image data are enormous, easily several terabytes. The speed at which the samples can be imaged is not limited anymore by the acquisition but rather by the processing computers, the storage capacity, and data transfer rates.

When imaging at moderate frame rates, the data from the camera can simply be transferred to the storage drive of the acquisition computer by means of standard consumer-level connections such as USB or FireWire or even to a remotely located storage computer using network connections. With faster cameras, data transfer rates become limiting. Some cameras allow streaming image data to internal storage, which needs to be read out after acquisition. Other cameras use faster data connections, which partly require additional hardware (frame grabber) to be installed in the computer. The data are then streamed either to the main memory that needs to be sufficiently large or to a data storage device that must then be equally fast to avoid loss of data.

One way to reduce the data rate is image compression. Image data can be compressed either in the camera, in the frame grabber card, by the processor (CPU), or the graphics card (GPU). This relieves pressure from the data transmission and storage system but increases the demand of processing power for compression and subsequent decompression.

A more powerful option to cope with the amount of data is to predefine regions of interest and store only data from those regions, as it was done with the endoderm during zebrafish gastrulation (Schmid et al., 2013). This kind of real-time processing is custom-made for a certain specimen and a scientific question, but the image data are inherently reduced. At the same time, the data are already nicely visualized to facilitate further analysis. Ideally, the microscope (or the camera) should directly deliver preprocessed and compressed data or, if possible already, the final results (Fig. 11.9).

11.5 Handling of light sheet microscopy data

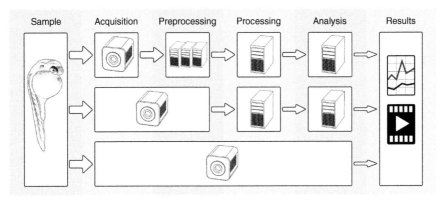

FIGURE 11.9

Handling large SPIM datasets. The large amounts of data generated by light sheet microscopy require a powerful processing infrastructure. Traditional strategies for an imaging experiment (top row) start with the acquisition of image data from the sample using a camera. After preprocessing (e.g., conversion and cropping), the data are processed (e.g., filtering, registration, and segmentation) and analyzed (e.g., cell tracking and intensity measurements), before results can be obtained. Custom routines (middle row) can handle the preprocessing during specific imaging experiments in real time and reduce the load on subsequent processing and analysis steps. Ideally, the microscope or even the camera itself delivers the results without any storing, transferring, and processing of raw data (last row).

The third possibility is intelligent microscopy, going one step further and not predefining regions of interest, but rather letting the microscope decide which areas to image at which resolution. This decision could even be based on existing, previously recorded data from similar specimen.

11.5.2 IMAGE ENHANCEMENTS

Image data from light sheet microscopes do typically not require excessive enhancement, denoising, or restoration steps, thanks to its superior signal-to-noise ratio and overall image quality. If necessary, various filters used for confocal or wide-field microscopy data can be used for SPIM data as well.

11.5.3 MULTIVIEW FUSION

A necessary processing step after acquiring multiview image data (see acquisition) is multiview fusion. The first step is to register the individual views to each other in space, which can be facilitated by fiducial markers (e.g., fluorescent beads, see mounting; Preibisch et al., 2010), structures within the specimen (e.g., fluorescent nuclei), or precise knowledge of the relative motor positions during the acquisition (Krzic et al., 2012; Schmid et al., 2013). Once registered, image data can be fused by

averaging the image intensities or in a content-based manner. The result of multiview fusion is a single dataset that inherits the best features of the individual views. Ultimately, one would want to perform this multiview fusion in real time so that only the fusion is saved and none of the raw data.

11.5.4 IMAGE ANALYSIS

Methods for image analysis do not differ much between SPIM and conventional, for example, confocal microscopes. Datasets may need to be reconstructed in 3D, objects may need to be segmented and tracked, intensities may need to be measured over space and time, and correlations between multiple channels may need to be analyzed. For colocalization studies and fluorescence quantification, one has to keep in mind that the light sheet dimensions and intensities change towards the edges of the field of view, influencing illumination and fluorescence. Therefore, the user should carefully check the light sheet parameters (see acquisition) and use beads to verify the overlay of individual channels in x, y, and z.

The main difference, however, to common light microscopy data is typically the sheer amount of data. Light sheet microscopy data acquired with high spatial and temporal resolution require significantly more computing power. This especially applies for the analysis of time-lapse data, for which common analysis tools often require the entire dataset to be loaded in the memory, which is often impossible with SPIM data. More than for common light microscopy experiments, the user must think about the required resolution: The highest possible speed, largest field of view, and highest resolution may be nice to have but can render subsequent analysis a lot more difficult.

REFERENCES

Ahrens, M. B., Orger, M. B., Robson, D. N., Li, J. M., & Keller, P. J. (2013). Whole-brain functional imaging at cellular resolution using light-sheet microscopy. *Nature Methods*, *10*(5), 413–420. http://dx.doi.org/10.1038/nmeth.2434.

Baumgart, E., & Kubitscheck, U. (2012). Scanned light sheet microscopy with confocal slit detection. *Optics Express*, *20*(19), 21805–21814.

Breuninger, T., Greger, K., & Stelzer, E. H. K. (2007). Lateral modulation boosts image quality in single plane illumination fluorescence microscopy. *Optics Letters*, *32*(13), 1938–1940.

Dodt, H.-U., Leischner, U., Schierloh, A., Jährling, N., Mauch, C. P., Deininger, K., et al. (2007). Ultramicroscopy: Three-dimensional visualization of neuronal networks in the whole mouse brain. *Nature Methods*, *4*(4), 331–336. http://dx.doi.org/10.1038/nmeth1036.

Engelbrecht, C. J., & Stelzer, E. H. (2006). Resolution enhancement in a light-sheet-based microscope (SPIM). *Optics Letters*, *31*(10), 1477–1479.

Ermolayev, V., Friedrich, M., Nozadze, R., Cathomen, T., Klein, M. A., Harms, G. S., et al. (2009). Ultramicroscopy reveals axonal transport impairments in cortical motor neurons

at prion disease. *Biophysical Journal, 96*(8), 3390–3398. http://dx.doi.org/10.1016/j.bpj.2009.01.032.

Fahrbach, F. O., Gurchenkov, V., Alessandri, K., Nassoy, P., & Rohrbach, A. (2013). Self-reconstructing sectioned Bessel beams offer submicron optical sectioning for large fields of view in light-sheet microscopy. *Optics Express, 21*(9), 11425. http://dx.doi.org/10.1364/OE.21.011425.

Fickentscher, R., Struntz, P., & Weiss, M. (2013). Mechanical cues in the early embryogenesis of Caenorhabditis elegans. *Biophysical Journal, 105*(8), 1805–1811. http://dx.doi.org/10.1016/j.bpj.2013.09.005.

Huisken, J., & Stainier, D. Y. R. (2007). Even fluorescence excitation by multidirectional selective plane illumination microscopy (mSPIM). *Optics Letters, 32*(17), 2608–2610.

Huisken, J., Swoger, J., Del Bene, F., Wittbrodt, J., & Stelzer, E. H. K. (2004). Optical sectioning deep inside live embryos by selective plane illumination microscopy. *Science, 305*(5686), 1007–1009. http://dx.doi.org/10.1126/science.1100035.

Ichikawa, T., Nakazato, K., Keller, P. J., Kajiura-Kobayashi, H., Stelzer, E. H. K., Mochizuki, A., et al. (2013). Live imaging of whole mouse embryos during gastrulation: Migration analyses of epiblast and mesodermal cells. *PLoS One, 8*(7), e64506. http://dx.doi.org/10.1371/journal.pone.0064506.

Jährling, N., Becker, K., & Dodt, H.-U. (2009). 3D-reconstruction of blood vessels by ultramicroscopy. *Organogenesis, 5*(4), 227–230.

Jemielita, M., Taormina, M. J., DeLaurier, A., Kimmel, C. B., & Parthasarathy, R. (2012). Comparing phototoxicity during the development of a zebrafish craniofacial bone using confocal and light sheet fluorescence microscopy techniques. *Journal of Biophotonics, 6*(11–12), 920–928. http://dx.doi.org/10.1002/jbio.201200144.

Kaufmann, A., Mickoleit, M., Weber, M., & Huisken, J. (2012). Multilayer mounting enables long-term imaging of zebrafish development in a light sheet microscope. *Development, 139*(17), 3242–3247. http://dx.doi.org/10.1242/dev.082586.

Keller, P. J., Pampaloni, F., & Stelzer, E. H. (2006). Life sciences require the third dimension. *Current Opinion in Cell Biology, 18*(1), 117–124. http://dx.doi.org/10.1016/j.ceb.2005.12.012.

Keller, P. J., Schmidt, A. D., Santella, A., Khairy, K., Bao, Z., Wittbrodt, J., et al. (2010). Fast, high-contrast imaging of animal development with scanned light sheet-based structured-illumination microscopy. *Nature Methods, 7*(8), 637–642. http://dx.doi.org/10.1038/nmeth.1476.

Keller, P. J., Schmidt, A. D., Wittbrodt, J., & Stelzer, E. H. K. (2008). Reconstruction of zebrafish early embryonic development by scanned light sheet microscopy. *Science, 322*(5904), 1065–1069. http://dx.doi.org/10.1126/science.1162493.

Kimmel, C. B., Ballard, W. W., Kimmel, S. R., Ullmann, B., & Schilling, T. F. (1995). Stages of embryonic development of the zebrafish. *Developmental Dynamics, 203*(3), 253–310. http://dx.doi.org/10.1002/aja.1002030302.

Krzic, U., Gunther, S., Saunders, T. E., Streichan, S. J., & Hufnagel, L. (2012). Multiview light-sheet microscope for rapid in toto imaging. *Nature Methods, 9*(7), 730–733. http://dx.doi.org/10.1038/nmeth.2064.

Lorenzo, C., Frongia, C., Jorand, R., Fehrenbach, J., Weiss, P., Maandhui, A., et al. (2011). Live cell division dynamics monitoring in 3D large spheroid tumor models using light sheet microscopy. *Cell Division, 6*, 22. http://dx.doi.org/10.1186/1747-1028-6-22.

Maizel, A., Wangenheim, von D., Federici, F., Haseloff, J., & Stelzer, E. H. K. (2011). High-resolution live imaging of plant growth in near physiological bright conditions using light

sheet fluorescence microscopy. *The Plant Journal, 68*(2), 377–385. http://dx.doi.org/10.1111/j.1365-313X.2011.04692.x.

Planchon, T. A., Gao, L., Milkie, D. E., Davidson, M. W., Galbraith, J. A., Galbraith, C. G., et al. (2011). Rapid three-dimensional isotropic imaging of living cells using Bessel beam plane illumination. *Nature Methods, 8*(5), 417–423. http://dx.doi.org/10.1038/nmeth.1586.

Prasher, D. C., Eckenrode, V. K., Ward, W. W., Prendergast, F. G., & Cormier, M. J. (1992). Primary structure of the Aequorea victoria green-fluorescent protein. *Gene, 111*(2), 229–233.

Preibisch, S., Saalfeld, S., Schindelin, J., & Tomancak, P. (2010). Software for bead-based registration of selective plane illumination microscopy data. *Nature Methods, 7*(6), 418–419. http://dx.doi.org/10.1038/nmeth0610-418.

Reynaud, E. G., Krzic, U., Greger, K., & Stelzer, E. H. K. (2008). Light sheet-based fluorescence microscopy: More dimensions, more photons, and less photodamage. *HFSP Journal, 2*(5), 266–275. http://dx.doi.org/10.2976/1.2974980.

Ritter, J. G., Veith, R., Veenendaal, A., Siebrasse, J.-P., & Kubitscheck, U. (2010). Light sheet microscopy for single molecule tracking in living tissue. *PLoS ONE, 5*(7), e11639. http://dx.doi.org/10.1371/journal.pone.0011639.

Scherz, P. J., Huisken, J., Sahai-Hernandez, P., & Stainier, D. Y. R. (2008). High-speed imaging of developing heart valves reveals interplay of morphogenesis and function. *Development, 135*(6), 1179–1187. http://dx.doi.org/10.1242/dev.010694.

Schmid, B., Shah, G., Scherf, N., Weber, M., Thierbach, K., Campos, C. P., et al. (2013). High-speed panoramic light-sheet microscopy reveals global endodermal cell dynamics. *Nature Communications, 4*, 2207. http://dx.doi.org/10.1038/ncomms3207.

Sena, G., Frentz, Z., Birnbaum, K. D., & Leibler, S. (2011). Quantitation of cellular dynamics in growing Arabidopsis roots with light sheet microscopy. *PLoS ONE, 6*(6), e21303. http://dx.doi.org/10.1371/journal.pone.0021303.

Siedentopf, H., & Zsigmondy, R. (1902). Uber Sichtbarmachung und Größenbestimmung ultramikoskopischer Teilchen, mit besonderer Anwendung auf Goldrubingläser. *Annalen der Physik, 315*(1), 1–39. http://dx.doi.org/10.1002/andp.19023150102.

Silvestri, L., Bria, A., Sacconi, L., Iannello, G., & Pavone, F. S. (2012). Confocal light sheet microscopy: Micron-scale neuroanatomy of the entire mouse brain. *Optics Express, 20*(18), 20582–20598. http://dx.doi.org/10.1364/OE.20.020582.

Swoger, J., Muzzopappa, M., López-Schier, H., & Sharpe, J. (2011). 4D retrospective lineage tracing using SPIM for zebrafish organogenesis studies. *Journal of Biophotonics, 4*(1–2), 122–134. http://dx.doi.org/10.1002/jbio.201000087.

Swoger, J., Verveer, P., Greger, K., Huisken, J., & Stelzer, E. H. K. (2007). Multi-view image fusion improves resolution in three-dimensional microscopy. *Optics Express, 15*(13), 8029–8042.

Tomer, R., Khairy, K., Amat, F., & Keller, P. J. (2012). Quantitative high-speed imaging of entire developing embryos with simultaneous multiview light-sheet microscopy. *Nature Methods, 9*(7), 755–763. http://dx.doi.org/10.1038/nmeth.2062.

Truong, T. V., Supatto, W., Koos, D. S., Choi, J. M., & Fraser, S. E. (2011). Deep and fast live imaging with two-photon scanned light-sheet microscopy. *Nature Methods, 8*(9), 757–760. http://dx.doi.org/10.1038/nmeth.1652.

Tsien, R. Y. (2010). Nobel lecture: Constructing and exploiting the fluorescent protein paintbox. *Integrative Biology, 2*(2–3), 77–93. http://dx.doi.org/10.1039/b926500g.

Weber, M., & Huisken, J. (2011). Light sheet microscopy for real-time developmental biology. *Current Opinion in Genetics & Development*, *21*(5), 566–572. http://dx.doi.org/10.1016/j.gde.2011.09.009.

Wu, Y., Ghitani, A., Christensen, R., Santella, A., Du, Z., Rondeau, G., et al. (2011). Inverted selective plane illumination microscopy (iSPIM) enables coupled cell identity lineaging and neurodevelopmental imaging in Caenorhabditis elegans. *Proceedings of the National Academy of Sciences*, *108*(43), 17708–17713. http://dx.doi.org/10.1073/pnas.1108494108.

CHAPTER

DNA curtains: Novel tools for imaging protein–nucleic acid interactions at the single-molecule level

12

Bridget E. Collins[*,1], **Ling F. Ye**[*,1], **Daniel Duzdevich**[*], **Eric C. Greene**[†,‡]

[*]*Department of Biological Sciences, Columbia University, New York, USA*
[†]*Department of Biochemistry and Molecular Biophysics, Columbia University, New York, USA*
[‡]*Howard Hughes Medical Institute, Columbia University, New York, USA*

CHAPTER OUTLINE

Introduction	218
12.1 Overview of TIRFM	219
12.2 Flow Cell Assembly	220
12.3 Importance of the Lipid Bilayer	221
12.4 Barriers to Lipid Diffusion	222
12.5 Different Types of DNA Curtains	223
12.5.1 Single-Tethered Curtains	223
12.5.2 Double-Tethered DNA Curtains	223
12.5.3 Parallel Array of Double-Tethered Isolated Patterns and Crisscrossed DNA Curtains	225
12.5.4 ssDNA Curtains	225
12.6 Using DNA Curtains to Visualize Protein–DNA Interactions	226
12.6.1 Binding Site Preferences	226
12.6.2 Target Search Mechanisms	227
12.6.3 Protein–Protein Colocalization	231
12.6.4 ATP Hydrolysis-Driven DNA Translocation	231
12.6.5 Beyond Nucleic Acids	231
12.7 Future Perspectives	232
Acknowledgments	232
References	232

[1]Equal contribution.

Abstract

Interactions between proteins and nucleic acids are at the molecular foundations of most key biological processes, including DNA replication, genome maintenance, the regulation of gene expression, and chromosome segregation. A complete understanding of these types of biological processes requires tackling questions with a range of different techniques, such as genetics, cell biology, molecular biology, biochemistry, and structural biology. Here, we describe a novel experimental approach called "DNA curtains" that can be used to complement and extend these more traditional techniques by providing real-time information about protein–nucleic acid interactions at the level of single molecules. We describe general features of the DNA curtain technology and its application to the study of protein–nucleic acid interactions *in vitro*. We also discuss some future developments that will help address crucial challenges to the field of single-molecule biology.

INTRODUCTION

Technologies that enable the visualization of single biological macromolecules are revolutionizing scientific inquiry into molecular mechanisms (Sarkar, Bumb, Mills, & Neuman, 2013; Spies, 2013; van Oijen, 2011). These unique tools have been especially powerful for probing the interactions between proteins and nucleic acids. However, most single-molecule techniques involve surface-based detection platforms that require the use of biological molecules linked to a solid support. The potential for nonspecific interactions between the molecules under investigation and the support to which they are anchored can render a biological system experimentally inaccessible or lead to erroneous results. A large part of our research has been devoted to developing technologies that overcome these technical issues and can be used to study a wide range of biological interactions. We refer to this technology as "DNA curtains," which use a combination of nanofabricated surface patterns, fluid lipid bilayers, and hydrodynamic force to align thousands of DNA molecules into defined patterns on a flow cell surface for single-molecule visualization.

A key feature of DNA curtains is that the supporting surface is passivated with a lipid bilayer that mimics the phospholipid membranes of living cells. DNA molecules are anchored by one end to the bilayer and then pushed by hydrodynamic force toward the leading edges of the nanofabricated chromium barriers, which act as barriers to lipid diffusion (Fazio, Visnapuu, Wind, & Greene, 2008; Gorman, Fazio, Wang, Wind, & Greene, 2010; Greene, Wind, Fazio, Gorman, & Visnapuu, 2010; Visnapuu, Fazio, Wind, & Greene, 2008). The molecules align along these barriers, enabling the visualization of hundreds or even thousands of individual DNAs in real time using total internal reflection fluorescence microscopy (TIRFM; Axelrod, 1989). Different barrier patterns allow the DNA to be anchored in various configurations, as necessary for specific experiments (Greene et al., 2010). Here, we describe what DNA curtains are, how they are made, and what they can be used for. We also provide sufficient information for our experimental platform to be replicated, given moderate experience in general single-molecule techniques.

12.1 OVERVIEW OF TIRFM

TIRFM uses spatially selective illumination to minimize background signal and enable detection of single molecules (Fig. 12.1; Axelrod, 1989). TIRFM illumination produces an evanescent field with an excitation volume of just a few femtoliters. TIRF illumination is achieved by directing a laser beam through either a microscope slide (prism-type TIRFM) or a coverslip (objective-type TIRFM) and reflecting the beam off of the interface between the slide or coverslip surface and an aqueous media. When light is reflected from an interface between media of differing refractive indexes, the incident energy penetrates a few hundred nanometers into the medium of lower refractive index before being reflected away from the surface. For further discussion of TIRFM, we refer the reader to an outstanding review (Axelrod, 1989).

Our laboratory uses an inverted Nikon microscope setup for prism-type TIRF illumination (Greene et al., 2010). Our choice of prism-type illumination is dictated by its overall simplicity and because this configuration allows us to put nanofabricated patterns on the thicker slide glass rather than the thinner coverslip, which makes barrier fabrication easier and yields a more robust device (see text later). Illumination is provided by a diode-pumped solid-state laser (DPSSL: 488 nm, 200 mW laser; Coherent, Inc.: 561 nm, 200 mW laser; or CrystaLaser: 532 nm, 75 mW laser), which is passed through the face of a fused silica prism onto the surface of a microfluidic flow cell to generate an evanescent wave within the sample chamber. Laser alignment is controlled by a remotely operated mirror (New Focus, Inc.), which guides the beam to the prism face. Photons are collected with a microscope objective ($100\times$, 1.4 NA, oil immersion Plan Apo, Nikon; $60\times$, 1.2 NA, water immersion Plan Apo, Nikon); passed through a notch filter (Semrock), which is essential to block scattered laser light; and detected using a back-illuminated electron-multiplying CCD (EMCCD; Cascade II, Photometrics; or iXon, Andor Technology).

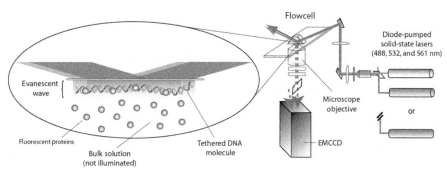

FIGURE 12.1

Total internal reflection fluorescence microscope. Schematic of custom-designed TIRF microscope consisting of three independent lasers, which provide illumination and are reflected off the surface of a microfluidic sample chamber to generate an evanescent field.

A dual-view beam splitting device (Roper Bioscience) that separates the optical paths based on wavelength using a dichroic mirror is used for simultaneous two-color detection.

12.2 FLOW CELL ASSEMBLY

DNA curtains are assembled within flow cells made from fused silica microscope slides (G. Finkenbeiner, Inc.), double-sided tape, and borosilicate glass coverslips (Fig. 12.2A; Greene et al., 2010). The slide surface is first patterned by electron-beam lithography (described in the succeeding text). Inlet and outlet holes are then bored into the slide using a diamond-coated 1.4 mm drill bit (Kassoy) mounted on a high-precision drill press (Servo Products Company). The slide is submerged in water during drilling, which cools the bit and removes fused silica dust. Slides are then cleaned by sequential submersion in 2% Hellmanex™, 1 M NaOH (for 30 min each), and Milli-Q™ water (3 × 15 min) and rinsed under running

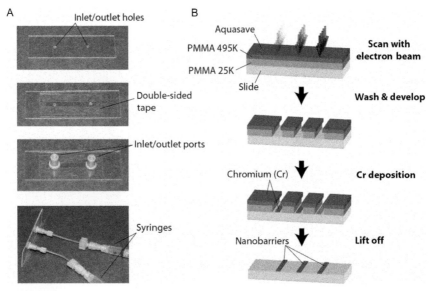

FIGURE 12.2

Nanofabrication and flow cell construction. (A) Key stages of flow cell preparation showing a fused silica slide glass with drilled inlet and outlet holes, a sample chamber made using double-sided tape, inlet and outlet ports glued to the slide, and attached syringes used for manual delivery of components necessary for bilayer deposition. (B) Outline of the barrier fabrication procedure. Patterns are generated by scanning the sample with an electron beam, followed by deposition of metal (chromium) over the entire surface. Removal (liftoff) of the remaining PMMA leaves behind the desired pattern on the fused silica slide.

Adapted with permission from Greene et al. (2010).

Milli-Q™ water between each step. The slide is then rinsed with absolute methanol and dried at 120°°C under vacuum for ∼1 h. The sample chamber is prepared using a precut piece of double-sided tape (3 M) and sealed with a borosilicate glass coverslip (Fisher Scientific). The flow cell is clamped between two borosilicate slides to evenly distribute pressure and then placed in a 120 °C vacuum oven for 2 h to ensure a good seal. Inlet and outlet ports (Upchurch Scientific) are then glued over the drilled holes, and syringes are connected to the ports to allow for bilayer deposition (see the succeeding text). Prior to use, the flow cells are connected to a syringe pump (KD Scientific) and an HPLC six-way injection valve (Scivex), which are used to regulate buffer flow through the chamber and enable sample delivery.

12.3 IMPORTANCE OF THE LIPID BILAYER

The lipid bilayer coats the surface of the microfluidic sample chamber, rendering it inert, and provides a mobile attachment for the DNA (Greene et al., 2010). The bilayer coats the entire surface but is disrupted at strategic locations on the surface by metallic barriers. The bilayers are prepared by first generating liposomes, which are typically comprised of a mixture of 1,2-dioleoyl-*sn*-glycero-phosphocholine, 0.5% biotinylated DPPE (1,2-dipalmitoyl-*sn*-glycero-3-phosphoethanolamine-*N*-(cap biotinyl)), and 8% mPEG 2000-DOPE (1,2-dioleoyl-*sn*-glycero-3-phosphoethanolamine-*N*-[methoxy(polyethylene glycol)-2000]) (Avanti Polar Lipids). Inclusion of the PEGylated lipids helps to ensure complete surface passivation, and the biotinylated lipids provide attachment points for DNA to the bilayer (see the succeeding text). Lipids arrive from the manufacturer as lyophilized powder. The dry components are mixed in the appropriate proportions before resuspension in chloroform to ensure uniform mixing and for storage. This stock can be stored at $-20\,°C$ for several months. For liposome preparation, the chloroform must be evaporated under a stream of nitrogen and the lipid film resuspended into buffer containing 100 mM NaCl and 10 mM Tris (pH 7.8) to a final concentration of ∼10 mg/ml. The lipid suspensions are then sonicated to form liposomes, which can be stored at 4 °C. Liposomes should be used within several weeks of preparation or resonicated to disperse vesicles that spontaneously fuse during storage.

The liposomes are injected into a flow cell and incubated for a period of ∼30 min. During this time, the liposomes deposit on the surface and begin to spontaneously rupture and fuse with one another until the entire surface is eventually covered with a single bilayer. Excess liposomes are rinsed away with buffer containing 40 mM Tris–HCl (pH 7.8), 1 mM DTT, 1 mM $MgCl_2$, and 0.2 mg/ml BSA and incubated for an additional 15 min. Buffer containing streptavidin (0.02 mg/ml) is then injected into the sample chamber. Streptavidin has four biotin binding sites, so streptavidin coupled to the biotinylated DPPE can be linked to the biotinylated DNA. For our experiments, we typically use the ∼48.5 kilobase (kb) genome of the bacteriophage lambda, which is commercially available and harbors convenient 12-nucleotide

single-stranded DNA (ssDNA) overhangs. These overhangs can be easily tagged with biotin or digoxigenin (DIG) by annealing complementary oligonucleotides, functionalized as desired (Greene et al., 2010). Once the DNA is tethered to the bilayer, the molecules can be aligned along the diffusion barriers by applying buffer flow and then visualized with the fluorescent intercalating dye YOYO1 (Invitrogen).

The preparation of the bilayer is perhaps the most important part of making DNA curtains. If the bilayer isn't present or fluid, then the DNA will not align along the barrier edges. If the liposome preparation and bilayer deposition steps are suspect, then one can conduct a simple control by spiking the liposomes with a small fraction (~0.1%) of fluorescently tagged lipids (e.g., 1,2-dimyristoyl-*sn*-glycero-3-phosphoethanolamine-*N*-[lissamine rhodamine B sulfonyl], Avanti Polar Lipids, or Lissamine™ rhodamine B 1,2-dihexadecanoyl-*sn*-glycero-3-phosphoethanolamine, Life Technologies). The deposition of the fluorescent bilayer can then be confirmed by visual inspection, and the fluidity of the bilayer can be measured by fluorescence recovery after photobleaching (FRAP).

12.4 BARRIERS TO LIPID DIFFUSION

DNA curtains require that the lipid bilayer coating the surface of the sample chamber be disrupted at defined locations. This is accomplished by deposition of metallic patterns in the slide surface, which form a physical barrier to lipid diffusion (Fazio et al., 2008; Gorman, Fazio, et al., 2010; Visnapuu et al., 2008). Our favored approach is to make barriers by electron-beam (e-beam) lithography (Fig. 12.2B) (Greene et al., 2010).

Slides are first cleaned in piranha solution (two parts sulfuric acid and one part hydrogen peroxide) for 30 min, then rinsed with acetone and isopropanol, and dried with N_2 (Fazio et al., 2008; Greene et al., 2010). The slides are then sequentially spin-coated with a layer of 25 K polymethylmethacrylate resist (PMMA, molecular weight 25K, 3% in anisole; MicroChem, Newton, MA), a layer of 495K PMMA resist (1.5% in anisole; MicroChem, Newton, MA), and a final layer of conducting polymer (aquaSAVE; Mitsubishi Rayon). An FEI Sirion scanning electron microscope equipped with a pattern generator and lithography control system is then used for generating the barrier patterns on the coated slide (J.C. Nabity, Inc., Bozeman, MT). The aquaSAVE is then removed with a deionized water rinse, and the resist is developed using a 3:1 solution of isopropanol to methyl isobutyl ketone for 1 min with ultrasonic agitation at 5 °C, and the slide is quickly rinsed with isopropanol and dried with nitrogen. Barriers are typically made of a 15–20 nm layer of chromium (Cr), which is deposited over the surface using a Semicore electron-beam evaporator. Liftoff is effected by submerging the slide in a 65 °C acetone bath for ~30 min, followed by gentle sonication. Following liftoff, samples are rinsed with acetone, dried again with a stream of nitrogen, and then assembled into flow cells as described earlier (see Section 12.1).

12.5 DIFFERENT TYPES OF DNA CURTAINS

DNA curtains can be made in several different configurations, each of which can be used to meet specific experimental requirements (Fig. 12.3). Here, we describe the different types of DNA curtains utilized in our laboratory and briefly highlight why the different types of curtains are necessary or beneficial for addressing specific experimental questions.

12.5.1 SINGLE-TETHERED CURTAINS

The DNA substrates used for single-tethered curtains are anchored by only one end to the lipid bilayer (Fig. 12.3A; Fazio et al., 2008). The molecules can only be visualized by TIRFM when they are extended parallel to the sample chamber surface by continuous buffer flow, thereby confined within the detection volume defined by the penetration depth of the evanescent field. This configuration allows transient pauses in buffer flow to be used as a standard control for verifying that the DNA and any proteins bound to the DNA are not simply stuck to the sample chamber surface: molecules nonspecifically adsorbed to the surface will remain visible without flow, whereas molecules that are on DNA will diffuse out of the evanescent field and disappear from view until flow is reapplied (Gorman et al., 2007; Visnapuu & Greene, 2009).

Single-tethered curtains can be made using linear barriers or barriers shaped in a "zigzag" pattern. Linear barriers are simple (Fig. 12.3A), but they provide no control over the lateral distribution of the DNA molecules within the curtains, which can result in overlapping DNA molecules. The presence of overlapping DNA molecules is fine for many types of experiments, but in some situations, it is critical that the DNA molecules be spatially separated from their nearest neighbors. This is achieved using barriers that are shaped in a zigzag pattern as opposed to straight lines (Fig. 12.3B) (Visnapuu et al., 2008). When the DNA molecules are subjected to buffer flow and pushed into the zigzag barriers, they are funneled to the apex of a single zigzag. As such, each zigzag acts as an individual "nanowell" that can hold one or more DNA molecules. The peak-to-peak distance between the adjacent nanowells dictates the minimal lateral separation of the DNA molecules within the curtain, and the number of DNA molecules loaded per nanowell can be controlled by adjusting the total amount of DNA injected into the sample chamber.

12.5.2 DOUBLE-TETHERED DNA CURTAINS

The DNA curtains described earlier require continuous buffer flow, and if flow is turned off, the DNA disappears from view. For some experiments, it is desirable to visualize the DNA without buffer flow. For example, if the experiment requires the use of expensive reagents, then a small volume of sample can be injected into the flow cell and then buffer flow turned off. Similarly, some protein–DNA interactions can be perturbed by hydrodynamic force, making it essential to perform reactions

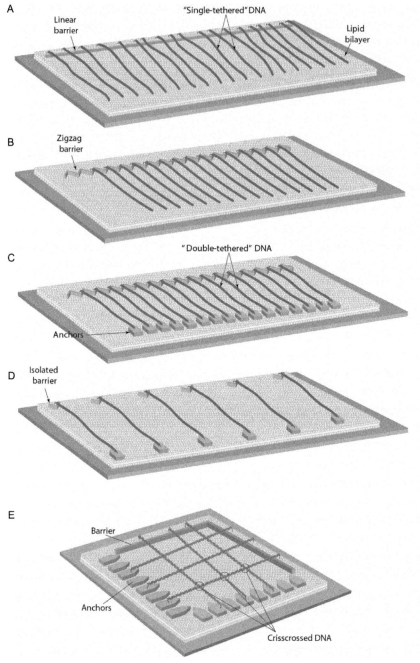

FIGURE 12.3

Different types of DNA curtains. (A) Single-tethered DNA curtain made with a linear barrier. (B) Single-tethered DNA curtain made with zigzag barrier; the distance between adjacent DNA molecules is dictated by the zigzag pattern. (C) Double-tethered DNA curtain where the downstream DNA ends are tethered to antibody-coated anchor points that project up above the lipid bilayer. (D) Double-tethered DNA curtains made using PARDI patterns, where the molecules are maintained at very low local concentrations. (E) Crisscrossed DNA curtains, where intersections between the crisscrossed molecules (circled) represent regions of locally high DNA concentration.

without constant buffer flow. Double-tethered DNA curtains are designed to allow the DNA to be imaged across its full contour length in the absence of buffer flow by anchoring both ends of the DNA to the surface (Fig. 12.3B; Gorman, Fazio, et al., 2010). This is accomplished through the use of two pattern elements: linear or zigzag barriers for aligning the DNA and downstream pedestals for anchoring the second end of the DNA. The first end of the DNA is anchored by a biotin–streptavidin linkage, as described earlier for single-tethered curtains. Buffer flow pushes the DNA into the linear or zigzag barriers, and then, the strands stretch out parallel to the sample chamber surface. The second end of the DNA is labeled with a different tag, typically DIG, and the pedestals are coated with anti-DIG antibodies. The DIG-tagged DNA ends are then anchored to the antibody-coated pedestals, allowing the DNA molecules to remain stretched out parallel to the sample chamber surface even when buffer flow is terminated.

12.5.3 PARALLEL ARRAY OF DOUBLE-TETHERED ISOLATED PATTERNS AND CRISSCROSSED DNA CURTAINS

We have also developed two distinct variations of the double-tethered DNA curtains for use in more specialized experiments. PARDI (parallel array of double-tethered isolated) molecules patterns are used to make sparsely populated DNA curtains where the distance between adjacent molecules is sufficiently large so as to avoid any potential for the presence of one DNA molecule to influence protein association kinetics with the nearest neighboring DNA molecules (Fig. 12.3D; Wang et al., 2013). These PARDI pattern curtains were developed specifically to look at protein binding kinetics under conditions where the DNA is maintained at a very low local concentration (Wang et al., 2013). Another variation of the double-tethered DNA curtains is crisscrossed curtains, in which lapping DNA molecules are organized at 90° angles relative to another, such that the intersections between DNA molecules represent regions of local high DNA concentration (Fig. 12.3E; Gorman et al., 2012). We have used the crisscrossed curtains to studying the ability of proteins to move back and forth between two close DNA molecules (Gorman et al., 2012).

12.5.4 ssDNA CURTAINS

ssDNA is a key intermediate in nearly all biochemical reactions involving DNA replication and DNA repair, but there has been a marked absence of techniques for visualizing long ssDNA molecules (Ha, Kozlov, & Lohman, 2012). There are several challenges when trying to work with ssDNA. For example, fluorescence-based microscopy experiments often require intercalating dyes such as YOYO1 to view dsDNA, but YOYO1 can also damage DNA upon laser illumination. This is problematic with ssDNA because even a single nick in the phosphate backbone will cause ssDNA to break away from its attachment to the surface. In addition, dsDNA is stiff and readily stretched by the application of buffer flow, whereas ssDNA has a much shorter persistence length and can also form extensive secondary structure.

The much greater force required to stretch out ssDNA is typically inaccessible with the laminar flow systems used for single-molecule imaging.

To prepare ssDNA curtains, long ssDNA molecules are first synthesized by rolling circle DNA replication using phi29 DNA polymerase, and a circular ssDNA template annealed to a biotinylated DNA primer (Gibb, Silverstein, Finkelstein, & Greene, 2012). The ssDNA products of the rolling circle replication assays are then anchored to the bilayer through a biotin–streptavidin linkage and aligned along the leading edges of nanofabricated barriers using buffer flow. The ssDNA cannot be visualized because it is highly compacted and cannot be labeled with intercalating dyes without breaking the ssDNA. To visualize the ssDNA, we use a GFP (green fluorescent protein)-tagged version of a single-stranded eukaryotic DNA-binding protein called replication protein A (RPA), which is itself a key protein that participates in most biochemical reactions involving ssDNA intermediates. RPA binds ssDNA and removes secondary structure, and the RPA-ssDNA filaments are much stiffer than naked ssDNA, allowing the RPA-bound ssDNA to be stretched by buffer flow. The resulting ssDNA curtains are fluorescently labeled with the GFP-tag on RPA. This newest addition to the different types of DNA curtain techniques offers outstanding potential for studying DNA repair reactions such as homologous recombination, where the first intermediate in the physiological pathway is in fact an ssDNA molecule coated with RPA.

12.6 USING DNA CURTAINS TO VISUALIZE PROTEIN–DNA INTERACTIONS

The primary motivation for developing DNA curtains is to image protein–DNA interactions. In the succeeding text, we provide a very brief description of different examples of protein–DNA interactions that we have begun exploring using our DNA curtain approach. For more specific details regarding these experiments or data analysis, we refer the reader to the original publications.

12.6.1 BINDING SITE PREFERENCES

Nearly, all biological processes that happen on DNA require the specific binding of protein with an associated target sequence. These processes, which notably include DNA replication and repair, permit the proteins involved to extract information from a local DNA sequence and to communicate that information to other proteins in solution by conformational and/or chemical changes. We have begun to address these types of problems using DNA curtains in relation to two very different systems—postreplicative mismatch repair (MMR) and transcription initiation by RNA polymerase (RNAP)—by determining DNA-binding landscapes, protein lifetimes, and real-time protein–DNA dynamics.

We used the *Saccharomyces cerevisiae* proteins MutSα and MutLα to study the early stages of MMR (Gorman et al., 2007; Gorman, Plys, Visnapuu,

Alani, & Greene, 2010; Gorman et al., 2012). Initially, MutSα searches for and binds DNA lesions, forming a nucleic acid–protein complex that serves as a binding substrate for MutLα, the endonuclease responsible for initiating lesion repair. Using DNA curtains, we showed that MutSα can bind base pair mismatches engineered into lambda DNA and that MutLα is targeted to those lesion-bound complexes (Gorman et al., 2012). For these experiments, three tandem G–T mismatches were localized 38 base pairs apart in DNA lambda, and these substrates were used to verify that MutSα was in fact targeted to these DNA lesions (Fig. 12.4A, upper panel). One major advantage of the DNA curtain approach is that each DNA molecule aligns in the same orientation—this often allows the general outcomes of experiments to be immediately interpreted based just on initial visual inspection. For example, a hypothetical line drawn across a DNA curtain will intersect the same sequence site on each DNA. Similarly, a fluorescent site-specific DNA-binding protein is expected to appear as a line spanning the field of view and demarking the location of the protein's binding site. In the case of MutSα, we observed lines of quantum dot (QDot; Life Technologies)-labeled protein along the mismatch-containing DNA curtains, immediately revealing that MutSα preferentially bound the mismatches. Quantitative plots of the MutSα binding distribution confirmed a pronounced correlation between the MutSα binding site and the mismatch location.

These techniques have also been applied to promoter binding by *Escherichia coli* RNAP (Wang et al., 2013). RNAP binds to promoter sequences, composed of hexameric consensus sequences at the -10 and -35 positions relative to the transcription start site. Binding site distribution histograms built from images of RNAP bound to the lambda genome indicated low RNAP occupancy at nonpromoter sites and high occupancy at the native promoter sites (Fig. 12.4B). Moreover, data collected in real time revealed that each RNAP–DNA binding event conformed to one of the three observed lifetimes consistent with the three known stages of RNAP promoter engagement: nonspecific DNA binding, open complex formation at promoter sites, and promoter-dependent closed complex formation, respectively.

12.6.2 TARGET SEARCH MECHANISMS

A recurrent challenge in biology is to understand how DNA-binding proteins rapidly and selectively find their targets amid a large pool of nonspecific sequences. Because DNA curtains permit the direct visualization of protein binding and translocation along individual duplexes, they provide a platform for observing and differentiating among target search mechanisms. There are four possible diffusion-based mechanisms that could be used by DNA-binding proteins to find their targets: (1) one-dimensional (1D) "hopping," by which a protein scans a DNA molecule through related submicroscopic dissociation and reassociation events; (2) 1D sliding, by which a protein conducts a random walk along DNA without dissociating; (3) intersegmental transfer, by which a protein is transferred from one segment of DNA to another via a looped intermediate; and (4) three-dimensional (3D) diffusion, by which a protein, fully equilibrated in solution, physically collides with a target site

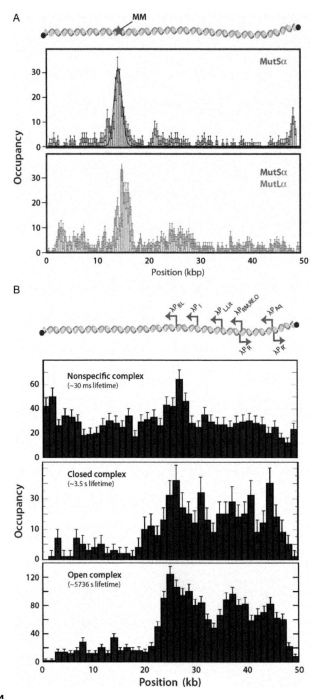

FIGURE 12.4

Measuring binding site preferences with DNA curtains. (A) The upper panel shows an example of a binding site distribution histogram for MutSα bound to lambda phage DNA bearing three mismatched base pairs as a defined location (MM). The lower panel shows an overlay of the binding distributions for MutSα and MutLα on the same lesion-bearing DNA substrate. (B) Examples of the binding distribution histograms for bacterial RNA polymerase (RNAP). Separate histograms are shown for each of the binding intermediated, including the nonspecifically bound complex, the closed complex, and the open complex (as indicated).

Adapted with permission from Gorman et al. (2012) and Wang et al. (2013).

on the DNA (von Hippel & Berg, 1989). The first three mechanisms, collectively referred to as "facilitated diffusion," can potentially confer a faster target-association rate than 3D diffusion alone. These mechanisms are not mutually exclusive, and proteins can potentially use two or more search modes while looking for binding sites.

To determine the target search mechanisms of MutSα and MutLα, we constructed a double-tethered curtain experiment to directly observe the proteins in real time as they searched for lesions on double-tethered DNA curtains (Fig. 12.5A; Gorman et al., 2012). These experiments revealed that 1D sliding contributed to 42.5% of MutSα-DNA binding events, while the remaining 57.5% were the result of apparent 3D diffusion (submicroscopic 1D sliding events were counted as the latter); this ratio of 1D to 3D events is most likely dictated by protein concentration (see the succeeding text). We also showed that, upon ATP-induced release of MutSα from bound DNA complexes, MutSα continued to search the surrounding DNA primarily via 1D diffusion but did not reengage the target sequence (Fig. 12.5B). This ATP-triggered release illustrates an important aspect of MutSα activity: MutSα must engage its target, dissociate in an ATP-dependent manner, and successfully elude its own target site to allow for downstream protein-mediated repair. Reengagement of the mismatch would preclude MMR by inhibiting the downstream steps in the repair reaction.

We have also used DNA curtains to analyze the physical basis for the diffusion of both MutSα and MutLα along DNA. These studies indicated that MutSα slides along DNA while maintaining constant contact with the phosphate backbone (Gorman et al., 2007), whereas MutLα can hop on DNA and can also undergo intersite transfer (Gorman et al., 2012). Work from our laboratory has demonstrated that MutLα can bypass stationary nucleosomes during 1D diffusion along DNA, whereas MutSα cannot (Gorman, Plys, et al., 2010). Based on these results, we hypothesized that the different behaviors of MutLα and MutSα in response to collisions with nucleosomes may reflect general mechanistic attributes of their respective modes of 1D diffusion: proteins such as MutSα that track the phosphate backbone while sliding along DNA will experience a barrier upon encountering obstacles, where proteins like MutLα that do not track the backbone can traverse obstacles on DNA (Gorman, Plys, et al., 2010).

Similar real-time experiments were used to study the promoter search mechanism of RNAP (Wang et al., 2013). These experiments supported the 3D diffusion model for the promoter search mechanism. Based on careful promoter binding kinetics measurements made possible through the use of PARDI patterns, we were also able to develop a new theoretical basis for understanding the process that contributes to target search even at the submicroscopic scale. These calculations revealed that RNAP can indeed undergo some search facilitation, but only at a submicroscopic scale corresponding to just ∼6 base pairs. More importantly, these calculations revealed that the ability of proteins to utilize facilitated diffusion as a mechanism for enhancing search rates is extremely dependent upon protein concentrations: higher protein concentrations will always favor target site binding through 3D diffusion regardless of whether or not the protein in question is capable of sliding or hopping along DNA.

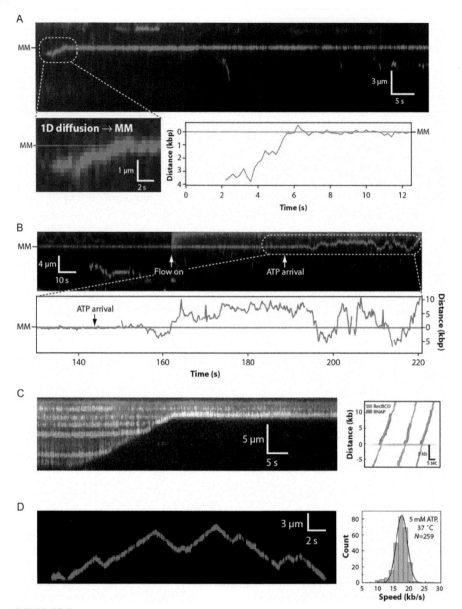

FIGURE 12.5

Visualizing protein movement on DNA with double-tethered curtains. (A) Kymograph and corresponding particle tracking data illustrating the 1D diffusive movement of MutSα (magenta) along a single DNA molecule (unlabeled) as it searches for mismatched based. (B) Kymograph and particle tracking data highlighting the response of mismatch-bound MutSα upon injection of buffer containing ATP into the sample chamber. (C) Kymograph (left panel) and particle tracking data (right panel) illustrating the movement of the DNA translocase/exonuclease RecBCD (unlabeled) along a single DNA molecule (shown in green) as it collides with DNA-bound molecules of RNA polymerase (magenta). (D) Kymograph (left panel) and velocity distribution histogram (right panel) highlighting the ATP-dependent translocation of the hexameric DNA translocase FtsK (magenta) as it translocates along a single DNA molecule (unlabeled). (See the color plate.)

Adapted with permission from references Gorman et al. (2012), Wang et al. (2013), and Lee, Finkelstein, Crozat, Sherratt, and Greene (2012).

12.6.3 PROTEIN–PROTEIN COLOCALIZATION

Biological reactions often involve large macromolecular assemblies of proteins on DNA, and DNA curtain experiments are amenable to colocalization experiments involving multiple tagged components. We have successfully carried out such experiments using MutSα and MutLα labeled with differently colored QDots (Gorman et al., 2012). As illustrated by the binding site distributions, MutSα could bind engineered mismatch with a DNA substrate, and MutLα could then bind to the lesion-bound MutSα. We anticipate the use of DNA curtains for a wider variety of colocalization experiments as experiments increase in complexity.

12.6.4 ATP HYDROLYSIS-DRIVEN DNA TRANSLOCATION

DNA translocases are motor proteins that convert the chemical energy of ATP hydrolysis into directional movement along DNA. We have used DNA curtains to study the movement of the motor proteins RecBCD and FtsK. RecBCD participates in the repair of potentially lethal double-stranded DNA breaks (Bianco et al., 2001; Dillingham & Kowalczykowski, 2008). When visualized using single-tethered DNA curtains, RecBCD translocates rapidly along DNA (Finkelstein, Visnapuu, & Greene, 2010), in agreement with previous single-molecule studies (Bianco et al., 2001). This process is revealed by the disappearance of YOYO1 (Fig. 12.5C), which is released as the DNA is degraded by the nucleolytic activity of RecBCD. Using RecBCD as a model system, we sought to determine how DNA translocase respond during collisions with stationary proteins on DNA, as well as the fate of the protein when they were rammed by an oncoming translocase. These experiments showed that RecBCD could readily remove other proteins from DNA (Fig. 12.5C; Finkelstein et al., 2010), leading to a model for protein eviction by RecBCD wherein the "roadblock" protein was rapidly pushed from one nonspecific binding site to the next and dissociation occurred as the protein was forced to "step" along the DNA by RecBCD.

We have also used DNA curtains to study FtsK, which is a DNA translocase that assists in chromosome segregation during cytokinesis in bacteria (Aussel et al., 2002; Barre, 2007). FtsK does not degrade DNA like RecBCD and was instead visualized on double-tethered DNA curtains by labeling the protein with a QDot (Fig. 12.5D; Lee et al., 2012). One remarkable finding from these experiments was that FtsK could travel along DNA at speeds approaching 18,000 base pairs per second at 37 °C (Lee et al., 2012). By comparison, the Lockheed SR-71 Blackbird is \sim32 m long and can go as fast as \sim2200 miles per hour, corresponding to a velocity of \sim30 body lengths per second. While FtsK is just \sim6 nm in length, it can travel at velocities approaching \sim1000 body lengths per second, making it 30 times faster than the world's fastest aircraft!

12.6.5 BEYOND NUCLEIC ACIDS

The applicability of the DNA curtains technology has also been extended to investigate biological problems that do not include DNA molecules. We have recently adapted the DNA curtain approach to study the formation of actin filaments

(Courtemanche, Lee, Pollard, & Greene, 2013). Formin proteins bind the barbed, fast-growing end of actin filaments and promote actin polymerization. To make "actin curtains," *S. cerevisiae* formin was biotinylated and coupled to the lipid bilayer. Upon injection of fluorescent actin monomers into the chamber and application of buffer flow, the bound formin molecules promoted polymerization of actin filaments, forming "actin curtains" along the diffusion barriers. We anticipate that the "actin curtain" methodology will continue to be a valuable new approach for studying actin filaments and proteins that interact with these filaments.

12.7 FUTURE PERSPECTIVES

DNA curtains offer a powerful experimental platform that can be implemented in most laboratories familiar with single-molecule techniques and can be readily adapted for the study of different biological problems. Challenges nevertheless remain, some of which are specific to DNA curtain applications, and others of which encompass all techniques being applied to the study of single biological molecules. For example, our work has relied primarily of the use of lambda DNA, but this substrate cannot be extensively manipulated because it is limited to specific DNA sequences that are necessary for phage propagation and packaging. Cosmids and bacmids are large plasmid-like DNAs, which can be propagated in bacteria, and may offer many advantages for DNA curtains. An even broader challenge is to develop assays that more closely mimic biological reactions while still gaining important biochemical insights into the processes under investigation. Moving forward, these considerations will serve as a guide to develop increasingly complex single-molecule experiments, which may require the engagement of multiple biologically active components or involve changes in component structure and composition.

ACKNOWLEDGMENTS

We thank Sy Redding for the insightful comments. Research in the Greene laboratory is funded by NIH grants GM074739 and GM082848 and NSF Award MCB1154511 (to E. C. G.). Dr. Greene is an HHMI early career scientist.

REFERENCES

Aussel, L., Barre, F., Aroyo, M., Stasiak, A., Stasiak, A., & Sherratt, D. (2002). FtsK Is a DNA motor protein that activates chromosome dimer resolution by switching the catalytic state of the XerC and XerD recombinases. *Cell*, *108*, 195–205.

Axelrod, D. (1989). Total internal reflection fluorescence microscopy. *Methods in Cell Biology*, *30*, 245–270.

Barre, F. (2007). FtsK and SpoIIIE: The tale of the conserved tails. *Molecular Microbiology*, *66*, 1051–1055.

Bianco, P. R., Brewer, L. R., Corzett, M., Balhorn, R., Yeh, Y., Kowalczykowski, S. C., et al. (2001). Processive translocation and DNA unwinding by individual RecBCD enzyme molecules. *Nature, 409*, 374–378.

Courtemanche, N., Lee, J. Y., Pollard, T. D., & Greene, E. C. (2013). Tension modulates actin filament polymerization mediated by formin and profilin. *Proceedings of the National Academy of Sciences of the United States of America, 110*, 9752–9757.

Dillingham, M. S., & Kowalczykowski, S. C. (2008). RecBCD enzyme and the repair of double-stranded DNA breaks. *Microbiology and Molecular Biology Reviews, 72*, 642–671, Table of Contents.

Fazio, T., Visnapuu, M. L., Wind, S., & Greene, E. C. (2008). DNA curtains and nanoscale curtain rods: High-throughput tools for single molecule imaging. *Langmuir, 24*, 10524–10531.

Finkelstein, I., Visnapuu, M.-L., & Greene, E. (2010). Single-molecule imaging reveals mechanisms of protein disruption by a DNA translocase. *Nature, 468*, 983–987.

Gibb, B., Silverstein, T. D., Finkelstein, I. J., & Greene, E. C. (2012). Single-stranded DNA curtains for real-time single-molecule visualization of protein-nucleic acid interactions. *Analytical Chemistry, 84*, 7607–7612.

Gorman, J., Chowdhury, A., Surtees, J. A., Shimada, J., Reichman, D. R., Alani, E., et al. (2007). Dynamic basis for one-dimensional DNA scanning by the mismatch repair complex Msh2-Msh6. *Molecular Cell, 28*, 359–370.

Gorman, J., Fazio, T., Wang, F., Wind, S., & Greene, E. (2010). Nanofabricated racks of aligned and anchored DNA substrates for single-molecule imaging. *Langmuir, 26*, 1372–1379.

Gorman, J., Plys, A., Visnapuu, M., Alani, E., & Greene, E. (2010). Visualizing one-dimensional diffusion of eukaryotic DNA repair factors along a chromatin lattice. *Nature Structural and Molecular Biology, 17*, 932–938.

Gorman, J., Wang, F., Redding, S., Plys, A. J., Fazio, T., Wind, S., et al. (2012). Single-molecule imaging reveals target-search mechanisms during DNA mismatch repair. *Proceedings of the National Academy of Sciences of the United States of America, 109*, E3074–E3083.

Greene, E., Wind, S., Fazio, T., Gorman, J., & Visnapuu, M.-L. (2010). DNA curtains for high-throughput single-molecule optical imaging. *Methods in Enzymology, 472*, 293–315.

Ha, T., Kozlov, A., & Lohman, T. (2012). Single-molecule views of protein movement on single-stranded DNA. *Annual Review of Biophysics, 41*, 295–319.

Lee, J. Y., Finkelstein, I. J., Crozat, E., Sherratt, D. J., & Greene, E. C. (2012). Single-molecule imaging of DNA curtains reveals mechanisms of KOPS sequence targeting by the DNA translocase FtsK. *Proceedings of the National Academy of Sciences of the United States of America, 109*, 6531–6536.

Sarkar, S. K., Bumb, A., Mills, M., & Neuman, K. C. (2013). SnapShot: Single-molecule fluorescence. *Cell, 153*, 1408–1408.e1.

Spies, M. (2013). There and back again: New single-molecule insights in the motion of DNA repair proteins. *Current Opinion in Structural Biology, 23*, 154–160.

van Oijen, A. M. (2011). Single-molecule approaches to characterizing kinetics of biomolecular interactions. *Current Opinion in Biotechnology, 22*, 75–80.

Visnapuu, M. L., Fazio, T., Wind, S., & Greene, E. C. (2008). Parallel arrays of geometric nanowells for assembling curtains of DNA with controlled lateral dispersion. *Langmuir, 24*, 11293–11299.

Visnapuu, M.-L., & Greene, E. (2009). Single-molecule imaging of DNA curtains reveals intrinsic energy landscapes for nucleosome deposition. *Nature Structural and Molecular Biology, 16*, 1056–1062.

von Hippel, P., & Berg, O. (1989). Facilitated target location in biological systems. *The Journal of Biological Chemistry, 264*, 675–678.

Wang, F., Redding, S., Finkelstein, I. J., Gorman, J., Reichman, D. R., & Greene, E. C. (2013). The promoter-search mechanism of *Escherichia coli* RNA polymerase is dominated by three-dimensional diffusion. *Nature Structural and Molecular Biology, 20*, 174–181.

CHAPTER

Nanoscale cellular imaging with scanning angle interference microscopy

13

Christopher DuFort[*,†], Matthew Paszek[‡,§]

[*]*Department of Surgery, University of California, San Francisco, California, USA*
[†]*Department of Orthopaedic Surgery, University of California, San Francisco, California, USA*
[‡]*School of Chemical and Biomolecular Engineering, Cornell University, Ithaca, New York, USA*
[§]*Kavli Institute at Cornell for Nanoscale Science, Ithaca, New York, USA*

CHAPTER OUTLINE

Introduction	236
Superresolution Optical Imaging	236
Theory of SAIM	238
13.1 Experimental Methods and Instrumentation	241
13.1.1 Microscope and Instrumentation	241
13.1.2 Preparation of Reflective Substrates	242
13.1.3 Selection of Fluorescent Probes	242
13.1.4 Cell Culture and Transfection	243
13.1.5 Immunolabeling of Samples	244
13.1.6 Microscope Calibration and Configuration	246
13.1.7 Image Acquisition	247
13.2 Image Analysis and Reconstruction	250
Conclusion	250
Acknowledgments	251
References	251

Abstract

Fluorescence microscopy is among the most widely utilized tools in cell and molecular biology due to its ability to noninvasively obtain time-resolved images of live cells with molecule-specific contrast. In this chapter, we describe a simple high-resolution technique, scanning angle interference microscopy (SAIM), for the imaging and localization of fluorescent molecules with nanometer precision along the optical axis. In SAIM, samples above a reflective surface are sequentially scanned with an excitation laser at varying angles of incidence. Interference patterns generated between the incident and reflected lights result in an

emission intensity that depends on the height of a fluorophore above the silicon surface and the angle of the incident radiation. The measured fluorescence intensities are then fit to an optical model to localize the labeled molecules along the z-axis with 5–10 nm precision and diffraction-limited lateral resolution. SAIM is easily implemented on widely available commercial total internal reflection fluorescence microscopes, offering potential for widespread use in cell biology. Here, we describe the setup of SAIM and its application for imaging cellular structures near (<1 μm) the sample substrate.

INTRODUCTION
SUPERRESOLUTION OPTICAL IMAGING

Fluorescence microscopy has been among the most widely utilized techniques for the observation and characterization of subcellular interactions due to its molecular specificity and compatibility with live-cell imaging (Michalet et al., 2003). However, the spatial resolution of traditional fluorescence microscopes is limited by diffraction to approximately 200 nm in xy-dimensions and 500 nm along the optical axis. The ability to directly observe nanoscopic cellular structures and biomolecular spatial organization below this limit promises to greatly enhance our understanding of molecular processes and interactions in cells. Motivated by this promise, the past decade has seen the emergence of various superresolution fluorescence methods, namely, techniques that break the diffraction barrier and image samples at length scales considerably less than the wavelength of visible light.

Owing to its relative ease of sample preparation and operation of instrumentation, 3-D single-molecule localization microscopy (SMLM) has emerged as a popular choice among biologists for full three-dimensional superresolution imaging. In SMLM, specific implementations of which have been named photoactivated localization microscopy (PALM) (Betzig et al., 2006), stochastic optical reconstruction microscopy (STORM) (Rust, Bates, & Zhuang, 2006), and ground-state depletion (GSD) microscopy (Folling et al., 2008); the diffraction limit is overcome by taking advantage of photoswitchable molecules that can be stochastically switched on and off depending on the wavelength of incident light (Allen, Ross, & Davidson, 2013). By imaging only a small fraction of non-overlapping, stochastically activated fluorophores at a time and localizing their positions, subdiffraction images can be reconstructed with approximately 20 nm lateral and 50 nm axial resolution. Additional precision along the z-axis can be obtained with more complicated optical setups having two opposing objectives (Aquino et al., 2011; Shtengel et al., 2009), which permit self-interference among emitted photons. However, these interference-based methods suffer from instrument complexity and high maintenance requirements, because of the relatively low coherence of emitted photons, making them impractical for the nonspecialist. Furthermore, SMLM methods generally have poor temporal resolution and are typically performed on fixed cells due of the necessity of acquiring large image sequences in order to faithfully reconstruct the sample at high resolution.

Other popular superresolution approaches rely on structured illumination to break the diffraction barrier. In the wide-field approach called structured

illumination microscopy (SIM), a grid pattern of excitation light is superimposed on the sample while imaging (Frohn, Knapp, & Stemmer, 2000; Gustafsson, 2000; Heintzmann & Cremer, 1999). Through proper grid rotation and translation, high-frequency information can be extracted from the raw images, enabling super-resolution images to be reconstructed at approximately half of the diffraction limit. Additional improvements in resolution can be obtained if the fluorophore responds nonlinearly to the illumination intensity, such as has been achieved with photo-switchable fluorophores. An alternative scanning-based approach, stimulated emission depletion (STED) microscopy, uses a second laser to reduce the scanning spot size of the excitation laser, effectively increasing the resolution of the point-scanned image (Hell & Wichmann, 1994). While compatible with live-cell imaging, a major drawback of the structured illumination techniques is that they currently provide axial resolutions of at best 50–100 nm.

Due to the difficulty of imaging along the optical axis at high precision (10 nm or less) in living cells with other superresolution technologies, we recently developed scanning angle interference microscopy (SAIM). The theory and methodology behind SAIM are extensions of an interferometric technique called fluorescence interference contrast (FLIC) microscopy (Lambacher & Fromherz, 1996). In FLIC, a mirror is introduced behind the sample to create axially varying structured illumination, which is used to probe the vertical position of fluorescent objects with nanometer precision. In its original implementation, samples are prepared on a reflective silicon substrate with terraced oxide layers functioning as spacers between the sample and the reflective silicon. Terraces typically have micron-sized lateral dimensions, and generally, only samples that are large enough to span multiple terraces are effectively imaged with FLIC. This limitation is overcome in a technique called variable incidence angle FLIC (VIA-FLIC) (Ajo-Franklin, Ganesan, & Boxer, 2005) by using custom-fabricated annular filters to create hollow cones of excitation light that allow the sample to be probed without the necessity of terraced substrates.

SAIM is an easy to implement variant of VIA-FLIC that improves upon previous iterations in several key ways (Paszek et al., 2012). Foremost, the hardware setup and calibration for SAIM are relatively simple, and the sample preparation is straightforward. SAIM also does not require assumptions about fluorophore orientation, which is difficult to predict a priori, for image reconstruction. Furthermore, by eliminating periodic replication artifacts, SAIM extends the practical working range of interference contrast microscopy to ~1 μm or more.

The basic hardware requirements for SAIM are a fluorescence microscope, a coherent excitation source (i.e., a laser) with motorized optics to focus the source at defined locations on the back aperture of the microscope objective, and a camera detector. These requirements are satisfied by the current generation of motorized total internal reflection fluorescence (TIRF) microscope systems offered by major microscope manufacturers. Although conducted on a TIRF microscope, SAIM is not actually performed with laser incident angles that exceed the critical angle for total internal reflection. Rather, the TIRF illuminator provides a simple means for controlling the position of the excitation laser beam on the back aperture of the objective

and, hence, the incident angle of the excitation beam out of the front lens of the objective. With the motorized TIRF illuminator, a sample on a reflective substrate is sequentially scanned and imaged while varying the incident angle of the excitation laser. From this sequence of images, the positions of fluorescent objects are reconstructed with 10 nm or better precision.

It is important to note that SAIM is not a true superresolution technique in the sense that it cannot resolve the position of individual fluorophores within a diffraction-limited spot. Rather, SAIM compliments existing superresolution techniques in its capability to dynamically image the position or topography of discrete biological structures of nanometer thickness. Specifically, SAIM is ideal for imaging structures whose vertical thickness is approximately 100 nm or less, which includes the plasma membrane, cellular glycocalyx, cytoskeleton, membrane-incorporated signaling complexes, and intracellular vesicles. For these structures, SAIM reports the average vertical position of fluorophores within a diffraction-limited volume.

Given its unique capabilities and accessibility, SAIM has the potential to find widespread use in cell biology. For example, SAIM excels at imaging membrane topography, and potential applications include investigation of membrane organization, cytoskeletal coupling, inner–outer leaflet coupling, receptor-mediated interactions with the extracellular matrix (ECM), and trafficking through processes such as endocytosis. SAIM also holds promise for detailing the inner workings of cellular machines at the plasma membrane. For example, focal adhesion complexes are composed of structural and signaling components that are organized vertically into well-defined, stratified layers of nanoscale thickness, and this organization can be dynamically resolved by SAIM in living cells (Kanchanawong et al., 2010; Paszek et al., 2012). Thus, SAIM may be used to relate the biological functioning of these machines to their nanoscale organization and could similarly be applied to other multimolecular systems, including the adherens junctions (Hartsock & Nelson, 2008), immunologic synapse (Dustin & Groves, 2012), and Fc receptor complexes (Torres, Vasudevan, Holowka, & Baird, 2008).

Here, we describe the optical theory behind SAIM and provide an explanation of its practical implementation and execution. We show how SAIM can be used to measure cellular structures near the substrate, including the plasma membrane, adhesion complexes, and cytoskeleton.

THEORY OF SAIM

High-resolution image reconstructions in SAIM are generated by fitting raw interference images to an optical model that describes how intensity varies as a function of fluorophore height and the incident angle of the excitation laser. The complete theory describing the excitation of fluorophores and the detection of emitted light above a reflective surface is described in the pioneering work of Lambacher and Fromherz on FLIC (Lambacher & Fromherz, 1996, 2002). In this section, we present the key theory and equations that are applicable to SAIM.

As originally described by Lambacher and Fromherz (Lambacher & Fromherz, 1996), the intensity I of detected fluorescence above a reflective surface is proportional to the probabilities of fluorophore excitation (P_{ex}) and emission (P_{em}) per unit time that are given by

$$I \sim P_{ex} P_{em} \quad (13.1)$$

In SAIM, samples are prepared on a reflective silicon substrate with a layer of oxide that is carefully selected, such that the variation in P_{em} with fluorophore height is relatively small. Moreover, P_{em} is not a function of the angle of incidence of the excitation laser, θ, and thus, the expression for detected fluorophore intensity in SAIM can be rewritten as a height-dependent function of P_{ex} only:

$$I(\theta) \sim P_{ex}(\theta, h) \quad (13.2)$$

The probability of fluorophore excitation is related to the intensity of the excitation field:

$$P_{ex} \sim |F_{ex} \cdot e_{ex}|^2 \quad (13.3)$$

where F_{ex} is the amplitude of the excitation field and e_{ex} is the orientation of the fluorophore excitation dipole. For a monochromatic, coherent light source of defined incident angle, θ, and polarization angle with respect to the plane of incidence, α, the amplitude of the field is given by

$$F_{ex} \sim \sin\alpha \begin{bmatrix} 0 \\ 1 + r^{TE}e^{i\phi} \\ 0 \end{bmatrix} + \cos\alpha \begin{bmatrix} \cos\theta(1 - r^{TM}e^{i\phi}) \\ 0 \\ \sin\theta(1 + r^{TM}e^{i\phi}) \end{bmatrix} \quad (13.4)$$

where r^{TE} and r^{TM} are the transverse electric and transverse magnetic Fresnel equations, respectively, which describe the reflections and refractions of light when moving through media of differing refractive indices, and ϕ is the phase shift between direct light and reflected light of wavelength, λ, at a height, H, above the oxide substrate:

$$\phi = \frac{4\pi}{\lambda}(nH\cos\theta) \quad (13.5)$$

In SAIM, the excitation light is linearly polarized orthogonal to the plane of incidence ($\alpha = 90°$). Therefore, the $\cos\alpha$ terms in Eq. (13.4) are equal to zero and Eq. (13.1) can be simplified as

$$I(\theta) \sim |1 + r^{TE}e^{i\phi}|^2 \quad (13.6)$$

To formulate an expression for r^{TE} in Eq. (13.6), we must consider reflections and refractions as light travels through a multilayered media, consisting of the buffer and cell, the silicon oxide, and the silicon (see Table 13.1). The cell membrane and internal organelles, such as the nucleus, will also reflect and refract light, but we find that the structure of the field is largely dominated by the silicon oxide and silicon interface. Therefore, the membrane and internal organelles can be neglected without significant loss of accuracy for imaging cellular structures near the substrate surface.

Table 13.1 Typical Experimental Parameters in SAIM

Parameter	Definition	Value
θ	Angle of incidence of the excitation laser through the sample	User-defined
λ	Wavelength of the excitation laser	User-defined
α	Polarization of excitation laser (s-polarized)	90°
n	Refractive index of the sample and buffer	1.36
n_{ox}	Refractive index of the silicon oxide	1.46
n_{Si}	Refractive index of the silicon (complex)	4.293+0.05i
d_{ox}	Thickness of the silicon oxide layer	Custom (~1 μm)

For the three-layered cell/buffer, silicon oxide, and silicon system, r^{TE} is formulated using transfer matrices and is given by

$$r^{TE} = \frac{(m_{11}^{TE} + m_{12}^{TE}p_o)p_2 - (m_{21}^{TE} + m_{22}^{TE}p_o)}{(m_{11}^{TE} + m_{12}^{TE}p_o)p_2 + (m_{21}^{TE} + m_{22}^{TE}p_o)} \quad (13.7)$$

$$M^{TE} = \begin{bmatrix} m_{11}^{TE} & m_{12}^{TE} \\ m_{21}^{TE} & m_{22}^{TE} \end{bmatrix} = \begin{bmatrix} \cos(k_{ox}d_{ox}\cos\theta_{ox}) & -\frac{i}{p_1}\sin(k_{ox}d_{ox}\cos\theta_{ox}) \\ -ip_1\sin(k_{ox}d_{ox}\cos\theta_{ox}) & \cos(k_{ox}d_{ox}\cos\theta_{ox}) \end{bmatrix} \quad (13.8)$$

$$p_o = n_{Si}\cos\theta_{Si}, \quad p_1 = n_{ox}\cos\theta_{ox}, \quad p_2 = n\cos\theta \quad (13.9)$$

$$k_{ox} = \frac{2\pi n_{ox}}{\lambda}, \quad k_{si} = \frac{2\pi n_{si}}{\lambda} \quad (13.10)$$

$$\theta_{ox} = \sin^{-1}\frac{n\sin\theta}{n_{ox}}, \quad \theta_{si} = \sin^{-1}\frac{n_{ox}\sin\theta_{ox}}{n_{si}} \quad (13.11)$$

where k_{ox} and k_{si} are the wave numbers for the excitation light in the silicon oxide and silicon, respectively; n_{Si}, n_{ox}, and n are the refractive index of the silicon, silicon oxide, and sample, respectively; θ_{Si}, θ_{ox}, and θ are the incident angles of the excitation laser through the silicon, silicon oxide, and sample, respectively; d_{ox} is the thickness of the silicon oxide layer; and λ is the wavelength of the excitation light.

The structure of the interference pattern in SAIM is thus a function of the experimental parameters and variables, including the wavelength and polarization of the excitation laser; the refractive indexes of the reflective silicon substrate and oxide layer, the sample, and the sample buffer; and the angle of incidence of the excitation source relative to the reflective substrate. Given the values for these parameters and variables, the height-dependent interference profile given by Eq. (13.6) can be calculated using Eqs. (13.5) and (13.7–13.11).

13.1 EXPERIMENTAL METHODS AND INSTRUMENTATION
13.1.1 MICROSCOPE AND INSTRUMENTATION

SAIM is readily implemented on a commercial TIRF microscope system with minimal modification (Fig. 13.1). Various designs of motorized TIRF illuminators are sold commercially and, in general, should be compatible with SAIM. The excitation source should be linearly polarized orthogonal to the plane of incidence across which the laser is scanned out of the objective front lens. A linear polarizer is typically the only additional hardware that must be installed on a motorized TIRF system for SAIM and can be easily mounted in the filter cube housing the dichroic mirror. We found that the small ellipticity in polarization that is introduced by optics downstream of the polarizer does not significantly influence imaging with SAIM.

For the best overall performance, careful consideration should be given to the selection of the microscope objective and camera. Since SAIM requires imaging through a relatively thick aqueous buffer, optimal performance and maximum resolution are achieved with a high numerical aperture water immersion objective

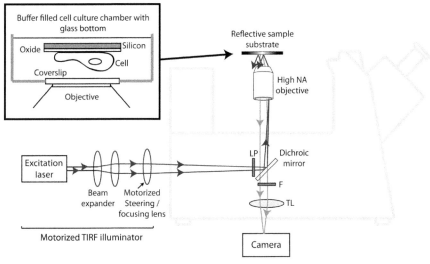

FIGURE 13.1

Schematic of scanning angle interference microscopy (SAIM). A typical optical setup and excitation path for SAIM consist of a coherent excitation source (laser), a motorized illuminator for focusing and steering the beam on the back aperture of the microscope objective, a linear polarizer (LP) to maintain s-polarization, a dichroic, a high numerical aperture objective, and a reflective substrate above the sample. The emission path incorporates the dichroic, an emission filter (EM), the microscope tube lens (TL), and a low-noise scientific camera. The hardware configuration is satisfied by motorized total internal reflection microscope systems with installation of the linear polarizer, which can be conveniently placed in the microscope filter cube housing the dichroic.

coupled with a detector that has appropriate pixel sizes to satisfy the Nyquist criterion. We found that an ideal pairing is a 60× water immersion objective with a low-noise, scientific complementary metal oxide semiconductor (sCMOS) camera with small pixel sizes (6.5 μm × 6.5 μm) and a global shutter mode. However, other objective and camera configurations can provide suitable performance, depending on the imaging criteria.

Since the sample is imaged with a coherent light source in SAIM, the microscope optics should be as clean as possible to minimize uneven illumination due to laser fringing. Dust on filters, dichroics, and lenses should be periodically cleaned with a jet of air or more stringent methods, if necessary.

13.1.2 PREPARATION OF REFLECTIVE SUBSTRATES

Silicon wafers with a thin layer of oxide serve as cheap, commercially available reflective substrates for samples in SAIM. We recommend wafers (N-type [100] orientation) with an oxide thickness of 1 μm, which provides the ideal spacing between the sample and the reflective surface. The use of wafers with oxide layers thinner than 500 nm risks having suboptimal contrast of interference patterns. Several vendors of semiconductor materials, such as Addison Engineering, supply inexpensive wafers with user-defined silicon oxide layers. A diamond-tip pen is used to cut larger wafers into square pieces of ~ 1 cm^2 to serve as sample substrates.

The silicon oxide layer can be functionalized with proteins and other biomolecules using protocols similar to those for glass slides. Here, we provide one example. The wafers are cleaned by sonicating in acetone for 20 min and followed by three rinses with water. Further cleaning is done by sonicating the wafers for 20 min in 1 M potassium hydroxide and followed by extensive rinsing in water. It is important that the wafers are not left in hydroxide for longer than 20 min, as significant etching of the oxide layer will occur. For functionalization, the wafers are incubated while rocking in 0.5% 3-aminopropyltrimethoxysilane in water at room temperature for 1 h. They are next washed with five exchanges of water with 5 min of sonication per wash to remove excess silane. The wafers are then immersed in 0.5% glutaraldehyde in PBS, pH 7.4, and placed on a rocker for 1 h. Afterward, the wafers are rinsed 5× with water for 5 min with sonication. The wafers are then dried under inert gas and sterilized under a UV lamp.

For conjugation of proteins, including cell adhesion molecules, the wafers are incubated overnight at 4 °C in a 20 μg ml^{-1} protein solution in PBS. The wafers are then rinsed with PBS and incubated for 30 min in PBS + 20 mM glycine to quench unreacted aldehydes. The wafers are then rinsed twice with PBS and stored.

13.1.3 SELECTION OF FLUORESCENT PROBES

When designing an experiment for SAIM, it is important to note that special fluorophores are not required and that the technique is compatible with both fluorescent proteins and synthetic dyes. As in most fluorescence microscopy applications,

fluorophores for SAIM should be bright with high quantum yields to provide good signal-to-noise ratios. Fluorophores should also have high photostability. A common imaging sequence in SAIM requires 20–90 individual images across a full angle sweep, and photobleaching during this scan should be minimized.

Genetically encoded fluorescent proteins have the principal advantage of being compatible with live-cell imaging when dynamics or real-time cellular responses are under investigation. Fluorescent proteins are also capable of achieving maximal labeling specificity, removing any possible problems associated with nonspecific labeling. They also do not require fixation or permeabilization procedures that could perturb cellular nanostructure. Some fluorescent proteins successfully used in SAIM include cyan fluorescent proteins (e.g., mTurq2), green fluorescent proteins (e.g., EGFP and mEmerald), and the red fluorescent protein mCherry (Day & Davidson, 2009). Some of the newer fluorescent proteins with excellent brightness and photostability, such as mNeonGreen (Shaner et al., 2013) and mRuby2 (Lam et al., 2012), should also perform well in SAIM and merit consideration.

Immunofluorescence or bioorthogonal chemical labeling (e.g., SNAP-tag) approaches can also be used to prepare samples for SAIM with organic dyes. Compared to fluorescent proteins, organic dyes are smaller, brighter, and more photostable and have a wider accessible spectral range. However, they can also suffer from decreased labeling specificity and incompatibility with live-cell imaging. Dyes that have performed well for us in fixed samples include AlexaFluor 488, AlexaFluor 568, AlexaFluor 647, and Cy5.

13.1.4 CELL CULTURE AND TRANSFECTION

1. Dulbecco's Modified Eagle Medium F-12 (DMEM/F-12; Invitrogen #11330-032)
2. 5 % donor horse serum (Invitrogen #16050-122)
3. 20 ng ml^{-1} epidermal growth factor (EGF) (Peprotech #315-09)
4. 10 μg ml^{-1} insulin (Sigma #I6634)
5. 0.5 μg ml^{-1} hydrocortisone (Sigma #H0888)
6. 0.1 μg ml^{-1} cholera toxin (Sigma #C8052)
7. 100 U ml^{-1} penicillin/streptomycin (Invitrogen #15070-063)
8. Nucleofector™ Kit V (Lonza)

In this section, we describe a protocol for transient transfection and plating of an example cell line—MCF10A mammary epithelial cells—for imaging with SAIM. Similar protocols should apply to other adherent cell lines.

We find nucleofection to be one of the more reliable techniques for transient transfection and expression of genetically encoded tagged proteins. For nucleofection, MCF10A cells are cultured in normal growth media (reagents 1–7) until they reach 70–80% confluency. Attempting nucleofection at higher confluencies or at low densities could result in inconsistent transfection efficiency and an increase in cell death. When ready, cells are washed once with calcium- and magnesium-free balanced salt

solution (DPBS) and then incubated with 0.05% trypsin–EDTA at 37 °C until cells are detached. The trypsin is neutralized by adding fresh media, and cells are counted with a hemacytometer. Approximately 1 million cells are added to centrifuge tube and spun down at a low speed; $220 \times g$ for 5 min at room temperature. Higher centrifugation speeds can reduce transfection efficiency. Cell pellets are gently resuspended in 100 µL of Nucleofector™ Kit V (Lonza) solution and mixed with 2 µg of DNA. This solution is toxic to the cells, so care should be taken to proceed with the subsequent steps quickly. The cell/DNA solution is then transferred to the nucleofection cuvette while being cautious to avoid any bubbles. For MCF10A cells, program T-024 yields an efficiency of ~70% with cell survival of ~80%. When the program is done running, 500 µL of warm media is added to the cuvette and the cells are gently transferred directly to a cell culture dish with prewarmed media and placed in an incubator overnight. Cells should be undisturbed for 24 h and left to recover.

The next day, cells are screened for gene expression and, if viable and expressing, replated directly onto silicon wafers functionalized with cell adhesion proteins. After replating on the silicon substrates, cells are given another 18–24 h to adhere before fixation or live imaging, at which time they are typically fully recovered from transfection and expressing the transgene at near maximal levels. Figure 13.2A shows an example of SAIM reconstructions of MCF10A cells expressing the focal adhesion proteins mCherry-vinculin and paxillin-mEmerald.

13.1.5 IMMUNOLABELING OF SAMPLES

1. 0.25% glutaraldehyde
2. Solution containing 0.25% glutaraldehyde with 0.1% Triton X-100 in PBS
3. PBS
4. 0.2% sodium borohydride in PBS
5. Solution containing 2% BSA and 0.1% Triton X-100 in PBS
6. 2 µg ml^{-1} of clone YL1/2 rat monoclonal tubulin-specific antibody (Serotec)
7. 5 µg ml^{-1} of AlexaFluor 488-conjugated rat-specific secondary antibody (Invitrogen)

Cells can be prepared with standard immunofluorescence protocols for imaging with SAIM. Special attention should be given to ensure that the fixation protocol preserves the cellular nanostructure. Although freshly prepared 2–4% paraformaldehyde has yielded adequate results in many tested applications, the preservation of membrane structure and cytoskeletal architecture benefits from more stringent fixatives, such as glutaraldehyde. Here, we present an example protocol for fixation and labeling of microtubules in epithelial cells.

For immunofluorescence applications, MCF10A cells are plated directly onto fibronectin-coated silicon wafers and allowed to adhere overnight in an incubator at 37 °C. The next day, wafers are fixed in a solution of 0.25% glutaraldehyde for 30 s and then permeabilized in 0.25% glutaraldehyde with 0.1% Triton X-100 in PBS for 10 min. Note that not all antibodies are compatible with glutaraldehyde

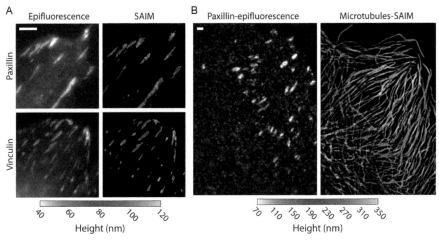

FIGURE 13.2

Imaging cellular nanostructure with SAIM. SAIM has a number of potential applications in the study of cell biology that are difficult to achieve with other imaging techniques. One example is the characterization of stratified hierarchical structures such as focal adhesions, which have proteins at discrete heights in individual adhesion complexes. To demonstrate the ability of SAIM to resolve these proteins along the optical axis, MCF10A cells were transfected with mCherry- and mEmerald-labeled constructs of the focal adhesion proteins paxillin and vinculin. From epifluorescence images, the focal adhesion proteins paxillin and vinculin look indistinguishable from one another (A). However, when imaged with SAIM, it becomes clear that the proteins are actually localized at distinct positions vertically: ~60 nm for paxillin and ~95 nm for vinculin. Future experiments with this technique should be capable of observing complex protein–protein interactions in similar structures in real time in response to stimuli. SAIM is also capable of resolving structures on the order of 100s of nanometers above the fluorescent substrate, such as microtubules, shown in B. In this example, MCF10A cells were fixed and labeled by immunofluorescence. The SAIM three-dimensional reconstruction of the labeled microtubules shows a variation in height from ~70 to 350 nm, well outside the range of TIRF-based approaches. (See the color plate.)

fixation, and in these cases, 2–4% paraformaldehyde can be considered as an alternative. Nonreduced glutaraldehyde is autofluorescent and, when used as a fixative, can greatly enhance background. To reduce this background, wafers are rinsed with PBS and then covered with a drop of 0.2% sodium borohydride in PBS with three exchanges over 30 min to reduce nonreacted aldehydes. Cells are then washed 2× with PBS and blocked by incubation in 2% BSA with 0.1% Triton X-100 for 10 min. To label the microtubules, rat monoclonal tubulin-specific antibody (Serotec) is diluted to 2 µg ml^{-1} in 2% BSA and 0.1% Triton X-100 in PBS overnight at 4 °C. The next day, the wafers are washed 5× with PBS and incubated with AlexaFluor 488-conjugated rat-specific secondary antibody (Invitrogen) diluted in 2% BSA and 0.1% Triton X-100 in PBS for 1 h at room temperature while being

protected from light. Finally, wafers are rinsed generously 3× with PBS. A representative reconstruction of labeled microtubules imaged with SAIM is shown in Fig. 13.2B.

13.1.6 MICROSCOPE CALIBRATION AND CONFIGURATION

Prior to imaging with SAIM, the TIRF illuminator must be calibrated to ensue appropriate scanning of the excitation angle. This is accomplished by manually adjusting the motor units of the TIRF illuminator turret and measuring the subsequent laser angle out of the microscope objective. A clean #1.5 glass coverslip is first placed in the stage holder and the objective focused on the top surface of the coverslip. To assist with the calibration, a grid with demarcations in millimeter increments can be used to precisely calculate the angle out of the objective. The calibration grid is printed and adhered to a flat support, which is set on the microscope stage (Fig. 13.3). The grid is positioned, such that it lies parallel to the plane of incidence carved by the laser beam as the TIRF illuminator motor position is varied.

The calibration is performed in air, and later, the corresponding angles in buffer are calculated using Snell's law. To begin calibration, the laser angle is adjusted

FIGURE 13.3

Angle calibration of a motorized TIRF microscope system. Demonstration of the calibration process at one angle. The calibration grid is placed on the stage above an oil/water immersion objective with #1.5 coverslip. Two vertical and two horizontal points on the grid are recorded and used to calculate the angle of the laser out of the objective.

manually to project perpendicular vertically from the objective front lens and coverslip, the position of which corresponds to 0°. The motor units of the motorized TIRF illuminator are then varied and the positions where the laser falls on uppermost and lower horizontal lines of the measuring grid are recorded. The ruled positions on the grid enable the angle of the laser out of the front lens to be calculated with basic trigonometric relations. Taking the difference between the two vertical and the two horizontal points yields distances that correspond to the vertical and horizontal ends of a right triangle that can then be used to calculate the angle of the laser out of the objective. To ensure an accurate calibration, we typically measure the angle, and corresponding motor unit, for ~30 data points, 15 to the right of 0° and 15 to the left of 0°. The angle corresponds to the angle in air and must be corrected for imaging in an aqueous sample. This is done using Snell's law by first calculating the angle through the glass coverslip, θ_{glass}, and then calculating the angle through an aqueous buffer above the coverslip θ_{water}:

$$\theta_{glass} = \sin^{-1}\left[\frac{\sin\theta_{air}}{n_{glass}}\right], \quad \theta_{water} = \sin^{-1}\left[\frac{n_{glass}\sin\theta_{glass}}{n_{water}}\right] \quad (13.12)$$

where n_{glass} and n_{water} are the refractive indexes of glass ($n_{glass} = 1.515$) and water ($n_{water} = 1.33$), respectively. Here, θ_{air} is the angle measured on the grid, which is used to calculate θ_{water} for cases when imaging in aqueous media.

To complete the calibration, the calculated angles in water are plotted against the corresponding motor units. A linear fit to these points yields an equation that can be used to calculate the calibrated motor unit for any arbitrary angle.

13.1.7 IMAGE ACQUISITION

SAIM requires the acquisition of a sequence of images each captured at a calibrated laser angle of incidence. The optimal range of angles and the angle step size depend on the expected height of the sample above the substrate. Structures that are positioned higher above the substrate undergo more frequent inversions in fluorescence intensity across a given range of angle compared to lower structures (Fig. 13.4). It is important that a fine enough angle sampling rate is selected to fully sample the periodic intensity profile. For example, using too course of an angle sampling rate would result in missed inversions in intensity and poor reconstructions. Although a finer sampling rate and a wider sampling range will typically result in more accurate reconstructions, there is a trade-off with acquisition time, which negatively impacts dynamic performance and results in longer exposure of cells to excitation radiation.

An automated acquisition sequence for varying angles can be programmed in typical microscope control programs, including NIS-Elements (Nikon), MetaMorph, and μ-Manager (Open Source), in a manner similar to how the more familiar multidimensional acquisitions are set up. For a wafer with 1 μm of oxide, we typically scan from 40° in 2° increments to the left and the right of 0° for a total of 41 data

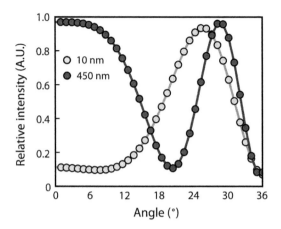

FIGURE 13.4

SAIM intensity profiles. Theoretical intensity of observed fluorescence of a structure 10 nm or 450 nm above a reflective silicon substrate with a 1 μm thick layer of oxide and imaged with an excitation laser at the indicated angle of incidence. Fluorophores positioned higher above the substrate surface undergo more periodic intensity inversions and should be imaged with a finer angle sampling rate.

points, corresponding to 41 total images. To program this acquisition sequence, we set up a "multidimensional acquisition" with 41 sequential optical configurations, each of which having a unique TIRF motor position corresponding to the different scan angles. Typically, we start from the left (−40°), scan up to 0°, and then to the right (+40°). Redundancy in scanned angles allows averaging of images to reduce artifacts due to laser fringing. Once the acquisition series has been input into the software, a "blank" image sequence is run to confirm the laser is scanning correctly across desired angles.

After calibration and configuration of the microscope, samples on the reflective substrates are imaged inverted in a glass-bottom petri dish (MatTek Corp. #1.5 coverslips, 35 mm dish) containing either phenol red-free growth medium for live cells or PBS for fixed samples. The wafers should be immobilized and kept close to the coverslip. Although specialized samples chambers could be constructed, we find it is sufficient to add a small weight of ∼1.75 g on top of the wafers to immobilize them in the dishes. For live-cell imaging, the microscope chamber is warmed to 37 °C and CO_2 is maintained with a feedback controller for long-term imaging or by supplementing the media with 25 mM Hepes (pH 7.4) for short-term imaging.

Once mounted, the sample is allowed to equilibrate on the microscope stage for 20 min to reduce sample drift during image acquisition. After equilibration, the laser is adjusted to 0° and the desired sample is located. After adjusting the laser intensity, exposure time, and focus, the multidimensional acquisition program is executed. As the sequence is running, the intensity of the sample should vary as a function of incident angle. With these settings, one full imaging sequence takes

on the order of 10–60 s depending on the number of angles, exposure time, and speed of the hardware. At the completion of the imaging sequence, the acquired set of 41 raw images is ready for processing, analysis, and reconstruction. An example of raw images of the cell membrane and the reconstructed topography is presented in Fig. 13.5.

To ensure the correct configuration of the interference microscope, it is recommended that a test sample be run to verify the accuracy of measurement. We typically image 100 nm fluorescent spheres (FluoSpheres; Invitrogen) absorbed on the silicon substrates to test our setup. The beaded substrates are prepared by dropping a 2% w/v solution of beads, diluted $1:10^6$ in ethanol, onto the surface of a cleaned silicon substrate and allowing to air-dry. The test sample is rinsed in PBS and imaged with the programmed angle acquisition sequence. If properly configured, SAIM will report the centroid height of the beads, ~50–60 nm, above the oxide surface.

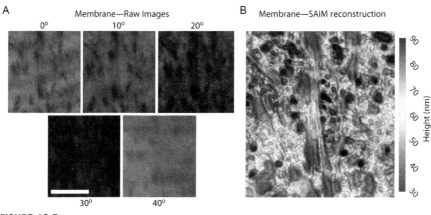

FIGURE 13.5

Raw interference and height reconstruction of the plasma membrane. MCF10A epithelial cells were grown on fibronectin-coated silicon wafers and labeled with the green fluorescent membrane dye Vybrant DiO (3,3′-dioctadecyloxacarbocyanine perchlorate; Life Technologies). To reduce background signal for this illustrative example, cells had their dorsal membrane and nucleus removed by swelling with a hypotonic buffer and short sonication burst as described previously (Paszek et al., 2012). The remaining ventral cell membranes were then imaged with a scanning angle imaging sequence with 488 nm laser excitation. Representative images at 0°, 10°, 20°, 30°, and 40° incident angles are shown in A. Scanning from 0° to 40°, the intensity of the images go from a region of high intensity at 0°, through a minimum at 30°, and back to a region of high intensity at 40° going through a full inversion cycle. For the highest-quality fitting, it is necessary for the images to go through at least one such cycle. A three-dimensional reconstruction of the raw images in A is shown in B. The height mapping corresponds to the absolute distance from the top of the silicon oxide surface to the cell membrane. (See the color plate.)

13.2 IMAGE ANALYSIS AND RECONSTRUCTION

Images with nanoscale height information are reconstructed from the stack of raw images by analyzing intensity profiles on a pixel by pixel basis across the image stack. The expected variation in intensity as a function of height and laser incident angle is given by Eq. (13.6). In practice, the intensity variation with angle at each pixel is fit to the three-parameter model:

$$I = A\left|1 + r^{\text{TE}} e^{i\phi(H)}\right|^2 + B \qquad (13.13)$$

The scaling parameter A accounts for variation in intensity due to factors, such as excitation laser power, fluorophore density, fluorophore brightness, interference of emitted photons, and efficiency of emitted photon detection. The offset parameter B accounts for background fluorescence in the sample images. For cellular samples with high autofluorescence or background due to nonspecific labeling, it can be useful to use the alternative model:

$$I = A\left|1 + r^{\text{TE}} e^{i\phi(H)}\right|^2 + B\theta \qquad (13.14)$$

This model accounts for the increased detected background with larger angles that can result from the wider node spacing of the excitation patterns at larger angles.

For fitting, a manual or automatic threshold is set based on the average pixel intensity across the entire stack of images. The intensity profiles at pixels above the threshold are fit for A, B, and H to Eq. (13.13) or Eq. (13.14) using nonlinear least squares optimization. Since Eqs. (13.13) and (13.14) are periodic, care must be taken to ensure that convergence is to the global minimum versus a local minimum. The global minimum in our software, which is available upon request, is calculated using multistart methods coupled with trust region algorithms for least squares optimization.

CONCLUSION

In summary, we present a microscopy technique that is capable of dynamically imaging living cells with 5–10 nm precision along the optical axis. Due to the simple nature of the experimental setup and the computational ease with which images are processed, we expect this technique will find wide use in a number of applications. While SAIM can be readily implemented on commercial TIRF microscope systems, additional improvements in speed and performance could be realized with custom microscope setups. For example, synchronized triggering of the camera and scanner could significantly improve acquisition time. Useful future developments in SAIM include the addition of optical sectioning and finer angle control, which would permit deeper imaging into the cell. The current combination of nanometer precision and live-cell capability distinguishes SAIM from existing superresolution techniques.

ACKNOWLEDGMENTS

We thank Kurt Thorn and Valerie Weaver for their contributions to the original development of SAIM. We thank Mike Davidson for plasmids encoding fluorescent protein tagged paxillin and vinculin. Imaging was performed at the Nikon Imaging Center at the University of California, San Francisco. We acknowledge the financial support from the Bay Area Physical Sciences-Oncology Center (NIH/NCIU54CA143836-01) and the Kavli Institute at Cornell for Nanoscale Science.

REFERENCES

Ajo-Franklin, C. M., Ganesan, P. V., & Boxer, S. G. (2005). Variable incidence angle fluorescence interference contrast microscopy for z-imaging single objects. *Biophysical Journal*, *89*(4), 2759–2769.

Allen, J. R., Ross, S. T., & Davidson, M. W. (2013). Single molecule localization microscopy for superresolution. *Journal of Optics*, *15*(9), 094001.

Aquino, D., Schoenle, A., Geisler, C., von Middendorff, C., Wurm, C. A., Okamura, Y., et al. (2011). Two-color nanoscopy of three-dimensional volumes by 4pi detection of stochastically switched fluorophores. *Nature Methods*, *8*(4), 353–359.

Betzig, E., Patterson, G. H., Sougrat, R., Lindwasser, O. W., Olenych, S., Bonifacino, J. S., et al. (2006). Imaging intracellular fluorescent proteins at nanometer resolution. *Science*, *313*(5793), 1642–1645.

Day, R. N., & Davidson, M. W. (2009). The fluorescent protein palette: Tools for cellular imaging. *Chemical Society Reviews*, *38*(10), 2887–2921.

Dustin, M. L., & Groves, J. T. (2012). Receptor signaling clusters in the immune synapse. *Annual Review of Biophysics*, *41*, 543–556.

Folling, J., Bossi, M., Bock, H., Medda, R., Wurm, C. A., Hein, B., et al. (2008). Fluorescence nanoscopy by ground-state depletion and single-molecule return. *Nature Methods*, *5*(11), 943–945.

Frohn, J. T., Knapp, H. F., & Stemmer, A. (2000). True optical resolution beyond the Rayleigh limit achieved by standing wave illumination. *Proceedings of the National Academy of Sciences of the United States of America*, *97*(13), 7232–7236.

Gustafsson, M. G. L. (2000). Surpassing the lateral resolution limit by a factor of two using structured illumination microscopy. *Journal of Microscopy*, *198*(Pt. 2), 82–87.

Hartsock, A., & Nelson, W. J. (2008). Adherens and tight junctions: Structure, function and connections to the actin cytoskeleton. *Biochimica Et Biophysica Acta*, *1778*(3), 660–669.

Heintzmann, R., & Cremer, C. (1999). Laterally modulated excitation microscopy: Improvement of resolution by using a diffraction grating. *Proceedings of the SPIE*, *3568*, 185–196.

Hell, S. W., & Wichmann, J. (1994). Breaking the diffraction resolution limit by stimulated-emission - stimulated-emission-depletion fluorescence microscopy. *Optics Letters*, *19*(11), 780–782.

Kanchanawong, P., Shtengel, G., Pasapera, A. M., Ramko, E. B., Davidson, M. W., Hess, H. F., et al. (2010). Nanoscale architecture of integrin-based cell adhesions. *Nature*, *468*(7323), 580–584.

Lam, A. J., St-Pierre, F., Gong, Y., Marshall, J. D., Cranfill, P. J., Baird, M. A., et al. (2012). Improving fret dynamic range with bright green and red fluorescent proteins. *Nature Methods*, *9*(10), 1005–1012.

Lambacher, A., & Fromherz, P. (1996). Fluorescence interference-contrast microscopy on oxidized silicon using a monomolecular dye layer. *Applied Physics A*, *63*(3), 207–216.

Lambacher, A., & Fromherz, P. (2002). Luminescence of dye molecules on oxidized silicon and fluorescence interference contrast microscopy of biomembranes. *Journal of the Optical Society of America B*, *19*(6), 1435–1453.

Michalet, X., Kapanidis, A. N., Laurence, T., Pinaud, F., Doose, S., Pflughoefft, M., et al. (2003). The power and prospects of fluorescence microscopies and spectroscopies. *Annual Review of Biophysics and Biomolecular Structure*, *32*, 161–182.

Paszek, M. J., DuFort, C. C., Rubashkin, M. G., Davidson, M. W., Thorn, K. S., Liphardt, J. T., et al. (2012). Scanning angle interference microscopy reveals cell dynamics at the nanoscale. *Nature Methods*, *9*(8), 825–827.

Rust, M. J., Bates, M., & Zhuang, X. W. (2006). Sub-diffraction-limit imaging by stochastic optical reconstruction microscopy (storm). *Nature Methods*, *3*(10), 793–795.

Shaner, N. C., Lambert, G. G., Chammas, A., Ni, Y., Cranfill, P. J., Baird, M. A., et al. (2013). A bright monomeric green fluorescent protein derived from branchiostoma lanceolatum. *Nature Methods*, *10*(5), 407–409.

Shtengel, G., Galbraith, J. A., Galbraith, C. G., Lippincott-Schwartz, J., Gillette, J. M., Manley, S., et al. (2009). Interferometric fluorescent super-resolution microscopy resolves 3d cellular ultrastructure. *Proceedings of the National Academy of Sciences of the United States of America*, *106*(9), 3125–3130.

Torres, A. J., Vasudevan, L., Holowka, D., & Baird, B. A. (2008). Focal adhesion proteins connect ige receptors to the cytoskeleton as revealed by micropatterned ligand arrays. *Proceedings of the National Academy of Sciences of the United States of America*, *105*(45), 17238–17244.

CHAPTER 14

Localization microscopy in yeast

Markus Mund*, Charlotte Kaplan[†], Jonas Ries*

**European Molecular Biology Laboratory, Cell Biology and Biophysics Unit, Heidelberg, Germany*
[†]Institute of Biochemistry, ETH Zurich, Switzerland

CHAPTER OUTLINE

Introduction	254
14.1 Preparing the Yeast Strain	256
14.2 Considerations for the Choice of a Labeling Strategy	257
14.3 Preparing the Sample	260
14.3.1 Immobilizing and Fixing the Yeast Cells on Coverslips	260
14.3.1.1 Materials and Reagents	260
14.3.1.2 Procedure	261
14.3.2 Labeling with Organic Dyes	262
14.3.2.1 Materials and Reagents	262
14.3.2.2 Procedure: Nanobody or SNAP-tag Staining	264
14.3.2.3 Procedure: ConA Staining	264
14.4 Image Acquisition	264
14.4.1 Materials	264
14.5 Results	265
Summary	267
Acknowledgments	269
References	269

Abstract

Conventional light and fluorescence microscopy techniques have offered tremendous insight into cellular processes and structures. Their resolution is however intrinsically limited by diffraction. Superresolution techniques achieve an order of magnitude higher resolution. Among these, localization microscopy relies on the position determination of single emitters with nanometer accuracy, which allows the subsequent reconstruction of an image of the target structure.

In this chapter, we provide general guidelines for localization microscopy with a focus on *Saccharomyces cerevisiae*. Its different cellular architecture complicates efforts to directly transfer protocols established in mammalian cells to yeast. We compare different methodologies to label structures of interest and provide protocols for the respective sample preparation, which are not limited to yeast.

Using these guidelines, nanoscopic subcellular structures in yeast can be investigated by localization microscopy, which perfectly complements live-cell fluorescence and electron microscopy.

INTRODUCTION

For decades, fluorescence microscopy techniques have provided tremendous insight into cellular processes. While they offer molecular specificity and excellent signal-to-noise ratios, the resolution of light microscopy is intrinsically limited by the diffraction limit to ~250 nm (Abbe, 1873). This is much above the relevant size range for many cellular structures. Recently developed superresolution techniques offer the means to overcome this barrier and achieve an order of magnitude higher resolution. Among these are single-molecule localization-based methods (PALM, Betzig et al., 2006; STORM, Rust, Bates, & Zhuang, 2006), named "localization microscopy" in this chapter, that share a common principle. Due to the optical properties of any light microscope, a fluorescent point source is imaged not as point, but as diffraction-limited spot. The size of this so-called point spread function (PSF) depends on the wavelength of the emitted light and is much larger than the fluorophore itself. However, the position of the point source is at the center of the spot and can be estimated with a precision much higher than the optical resolution limit by centroid calculation or fitting with a PSF model. This procedure can however not be trivially extended to multiple overlapping PSFs and is thus restricted to isolated emitters—a requirement that is typically unmet in biological samples.

Localization microscopy relies on separating emitters over time (Fig. 14.1). When only a small subset of all molecules is fluorescent at a time, single PSFs can be observed and the corresponding emitter positions can be localized with high precision. Subsequently, the active emitters are bleached or converted to a dark state; another set of fluorophores becomes bright and gets imaged. By repeating this cycle many times, eventually all fluorescent molecules in the sample are localized and a superresolution image can be reconstructed in a two- or three dimensional superresolution image can be reconstructed (Huang, Wang, Bates, & Zhuang, 2008).

The only general requirement is that emitting molecules be switchable between generic on and off states. Thus, a variety of fluorophores can be used for localization microscopy. Photoactivatable/photoswitchable fluorescent proteins (Betzig et al., 2006) can be switched either from a nonfluorescent to a fluorescent state or from one to another fluorescence color. Organic dyes can be switched under special buffer conditions (Heilemann et al., 2008; Rust et al., 2006) and paired with activator dyes (Rust et al., 2006). Furthermore, signal accumulation

Introduction

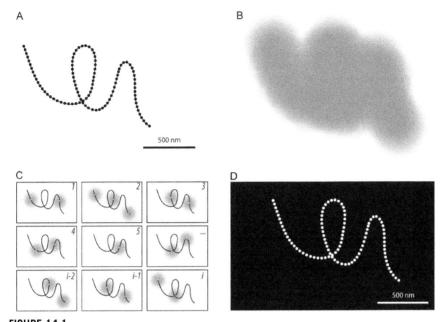

FIGURE 14.1

Principle of localization microscopy. Using conventional light microscopy, an object with closely spaced emitters (A) will give rise to a diffraction-limited image (B) with a maximum resolution of approximately half the wavelength of the emitted light. With only a small subset of the emitters active, individual PSFs can be observed and the respective molecules can be precisely localized. By repeating this process many times (C), all molecules are localized and a superresolution image (D) can be reconstructed.

(Sharonov & Hochstrasser, 2006) or fluorescence enhancement upon binding to target structures (Schoen, Ries, Klotzsch, Ewers, & Vogel, 2011) has been exploited in localization microscopy.

For localization microscopy, the target structures have to be labeled specifically and densely with a switchable fluorophore. Genetic tagging and immunocytochemistry are standard experimental approaches to label specific proteins, organelles, and cellular components. Existing sample preparation protocols can in principle be transferred to superresolution microscopy. Due to the increased resolution, however, perturbations in the structural integrity and low labeling efficiencies become obvious that were previously concealed by the diffraction limit. Consequently, optimized sample preparation for superresolution microscopy has been critical for recent insights, for example, into cytoskeletal structures (Xu, Zhong, & Zhuang, 2013) and multiprotein complexes such as the nuclear pore complex (NPC) (Szymborska et al., 2013).

In contrast to mammalian cells, sample preparation protocols for superresolution microscopy of yeast are not as numerous (see, e.g., Lubeck & Cai, 2012; Puchner,

Walter, Kasper, Huang, & Lim, 2013; Stagge, Mitronova, Belov, Wurm, & Jakobs, 2013). In this chapter, we provide an overview of protocols that serve as starting point to prepare superresolution samples of the widely used model organism *Saccharomyces cerevisiae*.

S. cerevisiae offers easy and versatile genetics that can straightforwardly be extended to high throughput. Genetic tagging at the endogenous locus helps to avoid the artifacts from exogenous protein (over-)expression that can often be observed in nongenome-edited mammalian cells. The yeast genome contains approximately 6000 open reading frames (ORFs), which have been modified in many ways giving rise to a variety of yeast strain libraries, including a GFP collection, a knockout library, and a Tet-off promoter library. Yeast is thus a very powerful eukaryotic model organism to study complex cellular processes.

For superresolution imaging of yeast cells, four general experimental aspects are different from mammalian cells and will be addressed in this chapter. First, long-term rigid cell immobilization is not as straightforward as for tissue culture cells, which typically adhere to cover glass by secreting extracellular matrix components (Fig. 14.3). Second, the thick yeast cell wall cannot be penetrated by antibodies and thus prohibits classical immunofluorescence approaches. Third, due to the spherical cell shape, it is usually not possible to use total internal reflection fluorescence imaging, which is often used for mammalian cells to increase signal-to-noise ratios. Lastly, as yeast cells are grown at lower temperatures than mammalian cells, fluorescent proteins optimized for maturation at 37 °C will not necessarily perform optimally under these different conditions.

Conventional fluorescence microscopy and electron microscopy have been used to study cellular processes and structures in yeast with great detail. Localization microscopy combines high resolution with molecular specificity and thus offers a third, complementary toolkit, which is envisioned to bridge the gap between these existing techniques and allows exciting insight into cellular structures in yeast.

14.1 PREPARING THE YEAST STRAIN

In *S. cerevisiae*, ORFs can be genetically tagged at their endogenous locus in a straightforward manner, exploiting the high efficiency of homologous recombination in yeast. While a detailed description of the procedure is beyond the scope of this chapter and can be found elsewhere in the literature (e.g., Janke et al., 2004; Khmelinskii, Meurer, Duishoev, Delhomme, & Knop, 2011), the key steps shall be reiterated here for completeness.

A DNA cassette comprising the sequence to be introduced into the genome, flanked by sequences homologous to the desired integration site, is amplified and transformed into yeast. Typically, a marker is part of the cassette that enables direct positive selection of transformants. This procedure allows for easy C-terminal and N-terminal tagging of ORFs under their endogenous promoter.

In summary, a strain can be created as follows in less than a week:

1. Primers with homologous regions to the ORF of interest are designed appropriately so they can be used with the PCR toolbox (Janke et al., 2004) and for seamless N-terminal tagging (Khmelinskii et al., 2011).
2. The respective plasmids, for example, pFA6a or pMaM173, are modified to substitute the GFP sequence for the desired localization microscopy tag, for example, the fast SNAP-tag (Sun et al., 2011) or PAFPs.
3. The cassette is amplified from the plasmid template. The DNA is transformed into competent haploid yeast cells (Knop et al., 1999).
4. Positive clones are selected using appropriate selection plates and validated by colony PCR amplification of a fragment spanning the integration site.
5. The tagged sequence is amplified by PCR using extracted yeast DNA as template and sequenced to exclude mutations in the introduced DNA sequence.

14.2 CONSIDERATIONS FOR THE CHOICE OF A LABELING STRATEGY

A number of chemical and photophysical properties are required for localization microscopy probes (Dempsey, 2013). Among them, fluorophore brightness and labeling density are key determinants of the achievable spatial resolution. The uncertainty of single-molecule localization by fitting a Gaussian $\sigma_{x,y}$ has an inverse square root dependence on the number of emitted photons N (Thompson, Larson, & Webb, 2002) (Eq. 14.1, where σ_{PSF} is the standard deviation of the microscope PSF), indicating that brighter individual fluorophores can be localized more precisely:

$$\sigma_{x,y} \sim \frac{\sigma_{PSF}}{\sqrt{N}} \qquad (14.1)$$

The spatial resolution is furthermore limited by the labeling density, which according to the Nyquist theorem implies that in order to resolve a 10-nm feature, there has to be a label at least every 5 nm (Shroff, Galbraith, Galbraith, & Betzig, 2008).

Localization microscopy is most commonly performed using either photoactivatable/photoswitchable fluorescent proteins (PAFPs) or organic dyes. PAFPs are genetically encoded and thus offer in principle a zero-background quantitative labeling scheme. A wide variety of PAFPs have already been employed in localization microscopy (see, e.g., Allen, Ross, & Davidson, 2013), many of which have just recently been developed. Choosing a PAFP of a certain color is based on finding an optimum of four criteria: its quaternary structure, brightness, switching kinetics, and maturation efficiency. Oligomerization into dimers or tetramers can potentially introduce mislocalization and aggregation artifacts. Sufficient brightness and appropriate switching kinetics allow for high resolution. The efficiency of chromophore maturation determines the quantitativeness of labeling, in principle a major advantage of PAFPs over organic dyes. However, one should note that recent PAFPs are usually optimized to work in mammalian cells, that is, at incubation temperatures of 37 °C. These PAFPs potentially mature less efficiently in yeast, with its incubation

temperature typically being no higher than 30 °C and its protein folding kinetics differing from mammalian cells. This needs to be considered when choosing a PAFP. An empirical screen might be worth the effort to determine the optimal PAFP for a specific target. In this chapter, we present a comparison between the PAFPs mEOS3.2 and mMaple, with the latter performing considerably better in yeast.

Organic dyes offer higher brightness, photostability, and a greater number of switching cycles. Many of these require special buffer additives to get favorable blinking kinetics. Much experimental effort has gone into determining optimal conditions to perform localization microscopy with a variety of organic dyes (Dempsey, Vaughan, Chen, Bates, & Zhuang, 2011). This is owed to the fact that even chemically related dyes exhibit different photophysical behavior (Dempsey et al., 2011). Furthermore, the properties of the dye are influenced by its immediate nanoenvironment. The performance is potentially dependent on the molecular conjugation partner (i.e., antibody, nanobody, and benzylguanine for SNAP-tag), the labeled structure, and to some extent the cellular compartment. Cy5 and its analog Alexa Fluor 647 are to date the best-performing and most widely used dyes. Dual-color experiments with organic dyes can be performed using another dye of a different color, using different activator dyes (Bates, Huang, Dempsey, & Zhuang, 2007), or unmixing of overlapping emission spectra (Bossi et al., 2008). Careful optimization of the experimental conditions is essential to obtain satisfactory resolution in every color.

Organic dyes cannot be genetically encoded and have to be delivered to the protein of interest. Their brightness and photostability therefore offer higher localization precision at the cost of more laborious sample preparation procedures and possibly lower labeling densities.

The widely used immunofluorescence techniques rely on labeling with dye-conjugated antibodies. Membrane permeabilization is required to allow these large molecules to enter the cells. In contrast to mammalian cells, however, yeast cells are surrounded by a cell wall that serves as mechanical support to maintain cell shape and cellular osmotic conditions and scaffolding structure for specific proteins. Classical antibody-based immunocytochemistry protocols require the enzymatic removal of the cell wall, called spheroplasting, allowing the big immunoglobulin molecules to penetrate into the cytosol. Naturally, the overall cellular architecture is perturbed considerably in the resulting fragile spheroplasts. This step is thus best avoided, if possible. Also owing to their size, antibodies do not readily bind epitopes in dense structures.

The cell wall is however permeable for molecules below a certain size. Labeling schemes using smaller molecules are thus generally preferable. Small single-chain antibodies from camelids, referred to as nanobodies (Rothbauer et al., 2006), have been shown to penetrate the cell wall (Ries, Kaplan, Platonova, Eghlidi, & Ewers, 2012) and are thus better suited for yeast immunocytochemistry than classical antibodies. A selection of nanobodies is commercially available, including anti-GFP and anti-RFP. GFP (as well as its derivatives CFP and YFP that are also recognized by the anti-GFP nanobody) and RFP are widely used as protein fusion partners in biological imaging. The nanobodies can thus directly make a wide variety of existing strains

and cell lines with fluorescent protein constructs available for superresolution microscopy. For *S. cerevisiae*, this includes the entire GFP collection in which more than two-thirds of its ORFs were reported to give an above-background fluorescence signal (Huh et al., 2003). Nanobodies can be coupled to fluorescent dyes that have been derivatized as *N*-hydroxysuccinimide (NHS) esters. They form covalent amide bonds with amino groups of nanobody molecules, preferably their N-termini. Reaction conditions need to be optimized for different dyes to obtain a degree of labeling (DOL) of ~1. In the following protocol, coupling of anti-GFP nanobodies to Alexa Fluor 647 is described. An average DOL slightly higher than 1 is desirable, as overlabeling potentially decreases the affinity of the nanobody to GFP and a lower labeling ratio will increase the fraction of nanobodies bearing no label at all.

SNAP-tag technology offers another labeling scheme that can be applied to yeast cells without removal of the cell wall. It is based on an engineered version of human DNA repair protein O^6-alkylguanine–DNA alkyltransferase (Keppler, 2004). This enzyme forms a covalent bond with the substrate O^6-benzylguanine, which can be coupled to organic dyes. A variety of dye-coupled substrates are commercially available, as well as the reactive substrate alone that can then be coupled to the fluorophore of choice. Improved versions of SNAP-tag with faster reaction rates have been developed in recent years (Sun et al., 2011). By modifying the SNAP-tag enzyme, the orthogonal CLIP-tag system (Gautier et al., 2008) was developed that uses benzylcytosine substrates, of which a variety are commercially available as well.

Compared to traditional immunolabeling, the use of small labeling schemes offers the additional advantage of lower linkage errors (Fig. 14.2). Primary and secondary

FIGURE 14.2

Linkage error in labeling schemes. Classical indirect immunofluorescence using primary and secondary antibodies (B) displaces the label by more than 10 nm from the detected epitope. Labeling schemes based on nanobodies, here depicted as anti-GFP (A), PAFPs (C), or SNAP-tag (D), induce considerably lower linkage errors. P: protein of interest. Star: fluorophore. (See the color plate.)

antibodies readily position the fluorescent label more than 10 nm away from the protein of interest. This error is in the same order of magnitude as the localization precision and can potentially lead to misinterpretation. Nanobody- and SNAP-tag-based and direct small-molecule labeling schemes like phalloidin are thus preferable.

In this chapter, we compare nanobody and SNAP-tag labeling with PAFPs using the NPC, a mitochondrial and an ER protein as example structures. Furthermore, we use fluorescently labeled concanavalin A (ConA) to image the yeast cell wall, which provides a superresolution reference in a second color. The obtained cell outlines can also be used for automated segmentation of the cell and to determine the cell cycle state and the position of the focal plane relative to the cell.

14.3 PREPARING THE SAMPLE
14.3.1 IMMOBILIZING AND FIXING THE YEAST CELLS ON COVERSLIPS

Rigid and potentially long-term immobilization of the sample on the coverslip is crucial for localization microscopy. The movement of the sample during image acquisition will lead to motion blur in the reconstructed image.

Typically, yeast cells are immobilized on ConA-coated cover glass. ConA is a lectin that binds to carbohydrate residues on the cell surface. This method is suitable for samples, which are imaged directly after sample preparation and for a rather short time only. After that, a substantial fraction of the cells will start trembling and eventually detaching from the cover glass. Due to the simplicity of the procedure, we still include it in this chapter. Furthermore, we also present a second, slightly more complex protocol modified from Maeder et al. (2007) during which ConA is covalently linked to the cover glass (Fig. 14.3), leading to considerably higher stability of the sample over extended periods of time.

Fixation of the yeast cells is performed using formaldehyde. It is crucial to fix the cells when they already adhered to ConA, as fixation prior to binding to coverslip would impair rigid immobilization.

14.3.1.1 Materials and reagents
- HCl, MeOH, PBS
- ConA solution: 2 mg/mL Concanavalin A (Sigma, C7275) in H_2O
- Bio-Conext (amchro, PSX1055)
- Fixation solution: 4% PFA, 2% sucrose, PBS
- Quenching solution: 50 mM NH_4Cl, PBS

14.3.1.1.1 ConA-coated coverslips
1. Clean coverslips in HCl/MeOH (1:1) for 12 h. Rinse with water until the pH remains neutral and let dry.
2. Add 20 µL of ConA solution on the coverslip and spread with a pipette tip. Incubate for 30 min at room temperature in a moisturized atmosphere to avoid evaporation.

FIGURE 14.3

Immobilization of yeast cells. Mammalian cells typically adhere to the coverslip in a spread-out fashion (A). Yeast cells are conventionally immobilized by coating the coverslip with ConA (B), which is suitable for relatively short times. As an experimental session in localization microscopy easily consumes many hours, covalent cross-linking of ConA (C) can be used for rigid, long-term immobilization.

3. Remove excess liquid and let the coverslip dry at 37 °C for at least 1 h, and then store until needed.

14.3.1.1.2 ConA-cross-linked coverslips
1. Clean coverslips in HCl/MeOH for at least 12 h. Rinse with water until the pH remains neutral and let dry.
2. Spread out 20 μL of Bio-Conext and incubate for 30 min at room temperature in a moisturized atmosphere to avoid evaporation.
3. Wash twice with ethanol, then twice with water, and dry at 65 °C for 30 min.
4. Spread out 20 μL of ConA solution on the coverslip, and incubate for 60 min at room temperature.
5. Rinse 3 × with water, air-dry, and store until needed.

14.3.1.2 Procedure
1. Spin down 2 mL of an OD 0.8 log phase yeast culture in a tabletop centrifuge for 2 min at 2500 rpm.
2. Remove the supernatant, resuspend the pellet in 100 μL H_2O, and spread on the coverslip. Let the cells attach for 15 min.

FIGURE 14.4

Comparison of mEOS3.2 and mMaple in fixed yeast cells. With Pho86 in the endoplasmic reticulum, Ilv6 in the mitochondria, and Nic96 in the nuclear envelope, three compartmental markers (Huh et al., 2003) have been imaged using localization microscopy. The mMaple fusions (A–C) show good contrast and reveal subdiffraction details, while fusion to mEOS3.2 (D–F) leads to low contrast and sparse signal. Diffraction-limited reconstructions are shown as insets for comparison. Scale bar 1 μM.

3. Remove excess liquid and transfer coverslip in fixation solution containing 4% PFA. Remove loosely bound cell layers by gently pipetting up and down the solution. Incubate on an orbital shaker for 15 min.
4. Transfer the coverslip to quenching solution and incubate on an orbital shaker for 15 min. Repeat this step once.
5. Briefly wash the coverslip in PBS.

If the protein of interest is tagged with a PAFP, the sample can be imaged now (Fig. 14.4), while labeling with organic dyes requires additional steps.

14.3.2 LABELING WITH ORGANIC DYES

14.3.2.1 Materials and reagents
- PBS, DMSO, NaN_3, BSA, $NaCO_3$, Triton X-100
- Concanavalin A (Sigma, C7275)
- Alexa Fluor 647 NHS ester (Life Technologies, A37573)
- CF™ 680 SE (Biotium, 92139)
- GFP-Trap nanobodies (ChromoTek, gt-250)
- Zeba spin desalting columns (Thermo Scientific, 89882)
- Image-iT FX (Life Technologies, I36933)

- SNAP-Surface Alexa Fluor 647 (New England Biolabs, S9136S)
- Blocking solution: 0.25% Triton X-100, PBS, 50% Image-iT FX
- SNAP-tag staining solution: 1 µM SNAP-Surface Alexa Fluor 647, 0.25% Triton X-100, 1% BSA, 0.005% NaN$_3$, PBS
- Nanobody staining solution: 0.25 µM Alexa Fluor 647-conjugated anti-GFP nanobodies, 0.25% Triton X-100, 1% BSA, 0.005% NaN$_3$, PBS
- ConA staining solution: 50 nM CF™680-conjugated ConA, PBS

14.3.2.1.1 Labeling of anti-GFP nanobodies with Alexa Fluor 647

Mix 50 µL of the nanobody solution with 14 µL 0.2 M NaCO$_3$, pH 8.2. This will adjust the pH to ~8.2 and dilute the nanobodies to a concentration of ~60 µM:

1. Add 2.6 µL Alexa Fluor 647 NHS stock solution. This will dilute Alexa Fluor 647 NHS to ~300 µM, resulting in a fivefold excess over nanobodies.
2. Incubate at 25 °C for 2 h.
3. Clean up the reaction using a Zeba spin desalting column according to the manufacturer's instructions. The column is washed 3× with PBS/0.005% sodium azide before the reaction mixture is applied.
4. The DOL is calculated by Eq. (14.2) from the absorption $A(280\,\text{nm})$ measured at 280 nm and $A(647\,\text{nm})$ measured at 647 nm with spectrophotometry.
 $0.03 \times A(647\,\text{nm})$ is the contribution of the dye to the absorption at 280 nm:

$$\text{DOL} = \frac{n(\text{dye})}{n(\text{protein})} = \frac{\dfrac{A(647\,\text{nm})}{239\,\text{mM}\,\text{cm}^{-1}}}{\dfrac{A(280\,\text{nm}) - 0.03 \cdot A(647\,\text{nm})}{27\,\text{mM}\,\text{cm}^{-1}}} \tag{14.2}$$

14.3.2.1.2 Labeling of ConA with CF™680

1. Mix 50 µL 2mg/mL ConA (PBS) with 14 µL 0.2M NaCO$_3$ pH 8.2. Add 0.65 µL of CF680-SE stock solution (10 mM in DMSO). This results in a 5-fold excess of the dye over ConA tetramers.
2. Incubate at 25 °C for 1 h.
3. Clean up the reaction using a Zeba spin desalting column according to the manufacturer's instructions. The column is washed 3× with PBS/N3 before the reaction mixture is applied.
4. The DOL is calculated by

$$\text{DOL} = \frac{n(\text{dye})}{n(\text{protein})} = \frac{\dfrac{A(682\,\text{nm})}{210\,\text{mM/cm}}}{\dfrac{A(280\,\text{nm}) - 0.09 \cdot A(682\,\text{nm})}{136\,\text{mM/cm}}} \tag{14.3}$$

14.3.2.2 Procedure: Nanobody or SNAP-tag staining
Following fixation, the cells are processed as follows:

1. Pipette 100 µL of blocking solution on parafilm and put the coverslip face down on the solution, avoiding air bubbles. Cover to minimize evaporation and incubate for 60 min.
2. Briefly wash the coverslip 3× with PBS.
3. Pipette 100 µL of nanobody/SNAP-tag staining solution on parafilm and put the coverslip face down on the solution. Cover and incubate for 120 min.
4. Wash coverslips 3× with PBS for at least 5 min.

The incubation times given here should be seen as the starting point of optimization rather than as precise instructions. Depending on the structure of interest, shorter or longer staining times can yield better balances between specific and unspecific binding and a higher portion of labeled over unlabeled cells.

14.3.2.3 Procedure: ConA staining
ConA staining is performed at the end of the sample preparation:

1. Pipette 100 µL of ConA staining solution on parafilm, and stain the cells for 30 min.
2. Wash out excess ConA with PBS 3× for 5 min.

14.4 IMAGE ACQUISITION
14.4.1 MATERIALS
- Imaging buffer for Alexa Fluor 647 and CF™ 680: 150 mM Tris–Cl pH 8, 10% glucose, 35 mM cysteamine, 0.5 mg/mL glucose oxidase, and 40 µg/mL catalase

A detailed description of the necessary instrumentation and experimental steps to perform localization microscopy is beyond the scope of this chapter and can be found in the literature (e.g., Dempsey, 2013). Some key aspects shall be reiterated here to provide a brief overview.

There are several commercial microscopes available specifically designed for localization microscopy. Many users who do not have access to these setups might however find themselves wanting to perform localization microscopy experiments. It is thus worth noting that other commercial microscopes can in principle also offer the possibility to run localization microscopy experiments if they meet certain key requirements. These include high-power laser excitation, detection using a highly sensitive camera (e.g., EMCCD), and high stability. At a resolution of tens of nanometers, the confounding effect of sample drift becomes much more apparent than in diffraction-limited imaging. Stable microscope bodies and temperature stabilization can help to minimize that problem. Drift can be detected and corrected using fiducial markers (Dempsey, 2013) or image correlation (Bates et al., 2007). However, axial drift can be more challenging to detect and correct post-image acquisition. It is thus

best corrected by a focus stabilization system that is active during the experiment. Image acquisition in principle involves little more than recording movies with tens of thousands of frames containing single-molecule blinking events. To optimize acquisition time, the switching kinetics can be tuned by adjusting the power of the 405-nm laser to have the highest possible number of nonoverlapping single molecules in each frame. Integrated software control of activation laser power is thus desirable.

Data analysis and image reconstruction can be performed using software bundled with the commercial setups, freely available (e.g., Henriques et al., 2010; Wolter et al., 2010), and custom written software.

14.5 RESULTS

First, we performed localization microscopy using PAFPs. Illustrative of the need to test different PAFPs in yeast that have been shown to perform excellently in mammalian cells, we compared mEOS3.2 (Zhang et al., 2012) and mMaple (McEvoy et al., 2012) here. The three proteins Nic96, Ilv6, and Pho86 (Fig. 14.4) represent a selection of three compartmental markers for the nuclear envelope, mitochondria, and the endoplasmic reticulum (Huh et al., 2003).

Various superresolution images of NPC components have been reported in the literature. Due to their symmetry and homogeneity, they have been used as standard samples for localization microscopy (Löschberger et al., 2012). Averaging of localization microscopy data has been used to determine the position of individual nucleoporins with nanometer accuracy (Szymborska et al., 2013). The yeast NPC is a 66-MDa macromolecular complex with an overall diameter of ~100 nm and a central pore of ~40 nm. Nic96 is the essential yeast homologue of human Nup93 and has been suggested to play a role in NPC assembly and homeostasis (Aitchison & Rout, 2012).

Pho86 is an ER resident protein that has been shown to be required for the ER exit of Pho84, a high-affinity phosphate transporter (Lau, Howson, Malkus, Schekman, & O'Shea, 2000). Ilv6 is part of acetolactate synthase, which is involved in branched-chain amino acid synthesis and localized to the mitochondria (Cullin, Baudin-Baillieu, Guillemet, & Ozier-Kalogeropoulos, 1998).

With the mEOS3.2 fusion, the overall signal is low. Intact ring structures are not observed for Nic96 and partial ring structures are rare (Figs. 14.4 and 14.5). This can potentially be attributed to poor chromophore maturation or fluorescence loss upon fixation. However, when Nic96 is tagged with mMaple, ring structures are readily observed, with a great overall signal-to-noise ratio. Both PAFPs give specific signal and are comparably bright, leading to comparable localization precisions. The observation is similar when imaging Pho86 and Ilv6. mMaple fusions give rise to high-contrast images, while the overall mEOS3.2 signal is low.

In order to compare PAFP and organic dye labeling, we have furthermore imaged Nic96 as Nic96-GFP stained with Alexa Fluor 647-coupled anti-GFP nanobodies and Nic96-SNAP stained with benzylguanine-Alexa Fluor 647.

FIGURE 14.5

Localization microscopy reveals ring structure of nuclear pore complex. Nic96 fused to mMaple (A–C) and mEOS3.2 (D–F), SNAP-tag imaged with BG-Alexa Fluor 647 (G–I), and GFP imaged with Alexa Fluor 647-coupled anti-GFP nanobodies (J–L). mMaple (C), SNAP-tag (I), and nanobody labeling (L) show the ring structure of the nuclear pore complex (indicated by dashed white line). As seen by many ring structures in the cell overview images, mMaple (B) and SNAP-tag (H) have a high labeling ratio. Nanobody staining leads to many incompletely stained rings (K), and the mEOS3.2 signal is very sparse overall (E). Diffraction-limited reconstructions are shown for comparison (A, D, G, J). Scale bar 100 nm (C, F, I, L) and 1 μM (all other panels).

As seen in Fig. 14.5, comparing SNAP-tag and nanobody labeling allows a qualitative comparison of the labeling efficiencies. Complete ring structures can be found for both labeling schemes; however, their fraction and thus the labeling efficiency are higher for SNAP-tag-labeled proteins. It is important to note that the choice of labeling scheme should be optimized for each protein of interest, since there is no unique set of conditions that will suit all targets.

The labeling ratio can potentially be determined quantitatively by counting the number of molecules and comparing them with known numbers. It should be noted that molecular counting using superresolution imaging is not trivial due to the photophysical behavior of organic dyes and PAFPs (Annibale, Vanni, Scarselli, Rothlisberger, & Radenovic, 2011; Veatch et al., 2012). Imaging standard structures like NPCs thus provides a straightforward option to obtain a rough estimate of labeling quality.

Dual-color superresolution imaging can provide an extra dimension of information, for instance, by providing structural reference. As an example, we imaged Cdc11, which is one of the five mitotic yeast septins (Oh & Bi, 2011). Septins are recruited early to the presumptive bud site, where they form a ring structure that further assembles into an hourglass-like arrangement during bud growth (Fig. 14.6, upper panel). Prior to cytokinesis, these structures split up into two rings with the septum being formed between them. One septin ring is retained in the mother cell, the other one passed on to the daughter cell. At the mother bud neck, septins have been shown to serve as protein scaffolds and to establish a membrane diffusion barrier.

By means of the cell wall labeling, we can sort the observed Cdc11 structures by cell cycle stage. Imaging the cell wall in superresolution furthermore provides information on the focal plane's position relative to the cell. If the cell wall is depicted as crisp line, the focal plane is at or close to the cell's equator. If however the cell wall is depicted as broad line, it is rather curved with respect to the focal plane. When imaging 3D structures with nonrandom orientation like the Cdc11 ring, this information can support careful analysis or classification of the structures. Here, we stained Cdc11-SNAP with BG-Alexa Fluor 647 and the cell wall with CFTM680-labeled ConA (Fig. 14.6).

SUMMARY

In this chapter, we presented general guidelines along which localization microscopy experiments in yeast can be planned. A large part of superresolution imaging is being performed in and optimized for mammalian cells. Therefore, the protocols for newly developed dyes and labeling schemes cannot always be directly applied to yeast. In our experience, it can be well worth the effort to compare labeling using photoswitchable proteins and organic dyes and to try different delivery methods for the label. Quick sample preparation without the need for detergents and in principle quantitative labeling are clear advantages of photoswitchable proteins. Organic dyes

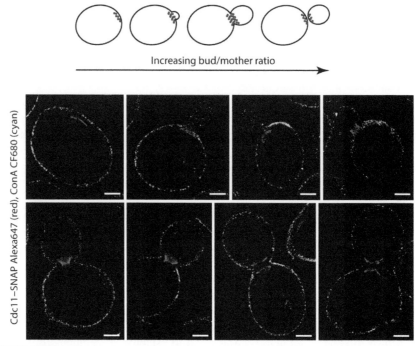

FIGURE 14.6

Dual-color localization microscopy of yeast septin Cdc11–SNAP-tag labeled with BG-Alexa Fluor 647 (red; intracellular structure) and the cell wall labeled with CF™680-conjugated ConA (cyan; surrounding the cells). The structural organization changes over the course of the yeast cell cycle (upper panel and see text). Here, dual-color superresolution imaging allows using the cell wall as a reference structure, for example, to align multiple sites for averaging or to precisely measure the distance of the structure from the cell outlines. Furthermore, the cell wall channel can be used to determine the cell cycle state and the position of the focal plane with respect to the cell. Alexa Fluor 647 and CF™680 were imaged at pH 8, 35 mM MEA using an enzymatic oxygen scavenging system. The fluorescence signal was split in two channels and analyzed using spectral unmixing. Upper panel: red small circles refer to septins. Scale bar 1 µM. (See the color plate.)

on the other hand are brighter labels and thus preferable to achieve the maximum possible resolution. This can be especially critical to successful dual-color experiments using spectral unmixing or 3D imaging.

Many complex cellular processes have been studied in yeast using a plethora of methods. Until recently, the potential to achieve nanometer resolution in imaging was reserved for electron microscopy. With superresolution imaging, almost comparable structural information can now be combined with molecular specificity. This offers the opportunity to elucidate exciting questions also in yeast, which were previously inaccessible by fluorescence microscopy.

ACKNOWLEDGMENTS
We thank Rohit Prakash and Sunil Kumar Dogga for their support of this work.

REFERENCES
Abbe, E. (1873). Beiträge zur Theorie des Mikroskops und der mikroskopischen Wahrnehmung. *Archiv für Mikroskopische Anatomie*, 9(1), 413–418.
Aitchison, J. D., & Rout, M. P. (2012). The yeast nuclear pore complex and transport through it. *Genetics*, 190(3), 855–883. http://dx.doi.org/10.1534/genetics.111.127803.
Allen, J. R., Ross, S. T., & Davidson, M. W. (2013). Sample preparation for single molecule localization microscopy. *Physical Chemistry Chemical Physics*, 15(43), 18771–18783. http://dx.doi.org/10.1039/c3cp53719f.
Annibale, P., Vanni, S., Scarselli, M., Rothlisberger, U., & Radenovic, A. (2011). Quantitative photo activated localization microscopy: Unraveling the effects of photoblinking. *PLoS One*, 6(7), e22678. http://dx.doi.org/10.1371/journal.pone.0022678.
Bates, M., Huang, B., Dempsey, G. T., & Zhuang, X. (2007). Multicolor super-resolution imaging with photo-switchable fluorescent probes. *Science*, 317(5845), 1749–1753. http://dx.doi.org/10.1126/science.1146598.
Betzig, E., Patterson, G. H., Sougrat, R., Lindwasser, O. W., Olenych, S., Bonifacino, J. S., et al. (2006). Imaging intracellular fluorescent proteins at nanometer resolution. *Science*, 313(5793), 1642–1645. http://dx.doi.org/10.1126/science.1127344.
Bossi, M., Fölling, J., Belov, V. N., Boyarskiy, V. P., Medda, R., Egner, A., et al. (2008). Multicolor far-field fluorescence nanoscopy through isolated detection of distinct molecular species. *Nano Letters*, 8(8), 2463–2468. http://dx.doi.org/10.1021/nl801471d.
Cullin, C., Baudin-Baillieu, A., Guillemet, E., & Ozier-Kalogeropoulos, O. (1998). Functional analysis of YCL09C: Evidence for a role as the regulatory subunit of acetolactate synthase. *Yeast*, 12(15), 1511–1518. http://dx.doi.org/10.1002/(SICI)1097-0061(199612)12:15<1511::AID-YEA41>3.0.CO;2-B.
Dempsey, G. T. (2013). A user's guide to localization-based super-resolution fluorescence imaging. *Methods in Cell Biology*, 114, 561–592. http://dx.doi.org/10.1016/B978-0-12-407761-4.00024-5.
Dempsey, G. T., Vaughan, J. C., Chen, K. H., Bates, M., & Zhuang, X. (2011). Evaluation of fluorophores for optimal performance in localization-based super-resolution imaging. *Nature Methods*, 8(12), 1027–1036. http://dx.doi.org/10.1038/nmeth.1768.
Gautier, A., Juillerat, A., Heinis, C., Corrêa, I. R., Jr., Kindermann, M., Beaufils, F., et al. (2008). An engineered protein tag for multiprotein labeling in living cells. *Chemistry & Biology*, 15(2), 128–136. http://dx.doi.org/10.1016/j.chembiol.2008.01.007.
Heilemann, M., van de Linde, S., Schüttpelz, M., Kasper, R., Seefeldt, B., Mukherjee, A., et al. (2008). Subdiffraction-resolution fluorescence imaging with conventional fluorescent probes. *Angewandte Chemie, International Edition*, 47(33), 6172–6176. http://dx.doi.org/10.1002/anie.200802376.
Henriques, R., Lelek, M., Fornasiero, E. F., Valtorta, F., Zimmer, C., & Mhlanga, M. M. (2010). QuickPALM: 3D real-time photoactivation nanoscopy image processing in ImageJ. *Nature Methods*, 7(5), 339–340. http://dx.doi.org/10.1038/nmeth0510-339.

Huang, B., Wang, W., Bates, M., & Zhuang, X. (2008). Three-dimensional super-resolution imaging by stochastic optical reconstruction microscopy. *Science*, *319*(5864), 810–813. http://dx.doi.org/10.1126/science.1153529.

Huh, W.-K., Falvo, J. V., Gerke, L. C., Carroll, A. S., Howson, R. W., Weissman, J. S., et al. (2003). Global analysis of protein localization in budding yeast. *Nature*, *425*(6959), 686–691. http://dx.doi.org/10.1038/nature02026.

Janke, C., Magiera, M. M., Rathfelder, N., Taxis, C., Reber, S., Maekawa, H., et al. (2004). A versatile toolbox for PCR-based tagging of yeast genes: New fluorescent proteins, more markers and promoter substitution cassettes. *Yeast*, *21*(11), 947–962. http://dx.doi.org/10.1002/yea.1142.

Keppler, A. (2004). Labeling of fusion proteins with synthetic fluorophores in live cells. *Proceedings of the National Academy of Sciences of the United States of America*, *101*(27), 9955–9959. http://dx.doi.org/10.1073/pnas.0401923101.

Khmelinskii, A., Meurer, M., Duishoev, N., Delhomme, N., & Knop, M. (2011). Seamless gene tagging by endonuclease-driven homologous recombination. *PLoS One*, *6*(8), e23794. http://dx.doi.org/10.1371/journal.pone.0023794.

Knop, M., Siegers, K., Pereira, G., Zachariae, W., Winsor, B., Nasmyth, K., et al. (1999). Epitope tagging of yeast genes using a PCR-based strategy: More tags and improved practical routines. *Yeast*, *15*(10B), 963–972. http://dx.doi.org/10.1002/(SICI)1097-0061(199907) 15:10B<963::AID-YEA399>3.0.CO;2-W.

Lau, W. T., Howson, R. W., Malkus, P., Schekman, R., & O'Shea, E. K. (2000). Pho86p, an endoplasmic reticulum (ER) resident protein in Saccharomyces cerevisiae, is required for ER exit of the high-affinity phosphate transporter Pho84p. *Proceedings of the National Academy of Sciences of the United States of America*, *97*(3), 1107–1112.

Löschberger, A., van de Linde, S., Dabauvalle, M.-C., Rieger, B., Heilemann, M., Krohne, G., et al. (2012). Super-resolution imaging visualizes the eightfold symmetry of gp210 proteins around the nuclear pore complex and resolves the central channel with nanometer resolution. *Journal of Cell Science*, *125*(Pt 3), 570–575. http://dx.doi.org/10.1242/jcs.098822.

Lubeck, E., & Cai, L. (2012). Single-cell systems biology by super-resolution imaging and combinatorial labeling. *Nature Methods*, *9*(7), 743–748. http://dx.doi.org/10.1038/nmeth.2069.

Maeder, C. I., Hink, M. A., Kinkhabwala, A., Mayr, R., Bastiaens, P. I. H., & Knop, M. (2007). Spatial regulation of Fus3 MAP kinase activity through a reaction–diffusion mechanism in yeast pheromone signalling. *Nature Cell Biology*, *9*(11), 1319–1326. http://dx.doi.org/10.1038/ncb1652.

McEvoy, A. L., Hoi, H., Bates, M., Platonova, E., Cranfill, P. J., Baird, M. A., et al. (2012). mMaple: A photoconvertible fluorescent protein for use in multiple imaging modalities. *PLoS One*, *7*(12), e51314. http://dx.doi.org/10.1371/journal.pone.0051314.

Oh, Y., & Bi, E. (2011). Septin structure and function in yeast and beyond. *Trends in Cell Biology*, *21*(3), 141–148. http://dx.doi.org/10.1016/j.tcb.2010.11.006.

Puchner, E. M., Walter, J. M., Kasper, R., Huang, B., & Lim, W. A. (2013). Counting molecules in single organelles with superresolution microscopy allows tracking of the endosome maturation trajectory. *Proceedings of the National Academy of Sciences of the United States of America*. http://dx.doi.org/10.1073/pnas.1309676110.

Ries, J., Kaplan, C., Platonova, E., Eghlidi, H., & Ewers, H. (2012). A simple, versatile method for GFP-based super-resolution microscopy via nanobodies. *Nature Methods*, *9*(6), 582–584. http://dx.doi.org/10.1038/nmeth.1991.

Rothbauer, U., Zolghadr, K., Tillib, S., Nowak, D., Schermelleh, L., Gahl, A., et al. (2006). Targeting and tracing antigens in live cells with fluorescent nanobodies. *Nature Methods*, *3*(11), 887–889. http://dx.doi.org/10.1038/nmeth953.

Rust, M. J., Bates, M., & Zhuang, X. (2006). Sub-diffraction-limit imaging by stochastic optical reconstruction microscopy (STORM). *Nature Methods*, *3*(10), 793–796. http://dx.doi.org/10.1038/nmeth929.

Schoen, I., Ries, J., Klotzsch, E., Ewers, H., & Vogel, V. (2011). Binding-activated localization microscopy of DNA structures. *Nano Letters*, *11*(9), 4008–4011. http://dx.doi.org/10.1021/nl2025954.

Sharonov, A., & Hochstrasser, R. M. (2006). Wide-field subdiffraction imaging by accumulated binding of diffusing probes. *Proceedings of the National Academy of Sciences of the United States of America*, *103*(50), 18911–18916. http://dx.doi.org/10.1073/pnas.0609643104.

Shroff, H., Galbraith, C. G., Galbraith, J. A., & Betzig, E. (2008). Live-cell photoactivated localization microscopy of nanoscale adhesion dynamics. *Nature Methods*, *5*(5), 417–423. http://dx.doi.org/10.1038/nmeth.1202.

Stagge, F., Mitronova, G. Y., Belov, V. N., Wurm, C. A., & Jakobs, S. (2013). Snap-, CLIP- and halo-tag labelling of budding yeast cells. *PLoS One*, *8*(10), e78745. http://dx.doi.org/10.1371/journal.pone.0078745.

Sun, X., Zhang, A., Baker, B., Sun, L., Howard, A., Buswell, J., et al. (2011). Development of SNAP-tag fluorogenic probes for wash-free fluorescence imaging. *Chembiochem: A European Journal of Chemical Biology*, *12*(14), 2217–2226. http://dx.doi.org/10.1002/cbic.201100173.

Szymborska, A., de Marco, A., Daigle, N., Cordes, V. C., Briggs, J. A. G., & Ellenberg, J. (2013). Nuclear pore scaffold structure analyzed by super-resolution microscopy and particle averaging. *Science*, *341*(6146), 655–658. http://dx.doi.org/10.1126/science.1240672.

Thompson, R. E., Larson, D. R., & Webb, W. W. (2002). Precise nanometer localization analysis for individual fluorescent probes. *Biophysical Journal*, *82*(5), 2775–2783. http://dx.doi.org/10.1016/S0006-3495(02)75618-X.

Veatch, S. L., Machta, B. B., Shelby, S. A., Chiang, E. N., Holowka, D. A., & Baird, B. A. (2012). Correlation functions quantify super-resolution images and estimate apparent clustering due to over-counting. *PLoS One*, *7*(2), e31457. http://dx.doi.org/10.1371/journal.pone.0031457.

Wolter, S., Schüttpelz, M., Tscherepanow, M., van de Linde, S., Heilemann, M., & Sauer, M. (2010). Real-time computation of subdiffraction-resolution fluorescence images. *Journal of Microscopy*, *237*(1), 12–22. http://dx.doi.org/10.1111/j.1365-2818.2009.03287.x.

Xu, K., Zhong, G., & Zhuang, X. (2013). Actin, spectrin, and associated proteins form a periodic cytoskeletal structure in axons. *Science*, *339*(6118), 452–456. http://dx.doi.org/10.1126/science.1232251.

Zhang, M., Chang, H., Zhang, Y., Yu, J., Wu, L., Ji, W., et al. (2012). Rational design of true monomeric and bright photoactivatable fluorescent proteins. *Nature Methods*, *9*(7), 727–729. http://dx.doi.org/10.1038/nmeth.2021.

CHAPTER

Imaging cellular ultrastructure by PALM, iPALM, and correlative iPALM-EM

15

Gleb Shtengel[*], Yilin Wang[†], Zhen Zhang[†], Wah Ing Goh[†], Harald F. Hess[*], Pakorn Kanchanawong[†,‡]

[*]*Howard Hughes Medical Institute, Janelia Farm Research Campus, Ashburn, Virginia, USA*
[†]*Mechanobiology Institute, National University of Singapore, Singapore*
[‡]*Department of Biomedical Engineering, National University of Singapore, Singapore*

CHAPTER OUTLINE

Introduction	274
15.1 Principles	275
15.1.1 2D Superresolution Microscopy by Photoactivated Localization Microscopy (PALM)	275
15.1.2 3D Superresolution by iPALM	275
15.2 Methods	277
15.2.1 Instrumentation for PALM	277
15.2.2 Fluorophore Choice and Sample Preparation for PALM and iPALM	279
15.2.3 Fiducial-Based Alignment: Drift Correction and Multichannel Registration	283
15.2.4 Implementation of iPALM	286
15.2.5 Extending iPALM Imaging Depth with Astigmatic Defocusing	290
15.3 Future Directions	290
Acknowledgments	291
References	292

Abstract

Many biomolecules in cells can be visualized with high sensitivity and specificity by fluorescence microscopy. However, the resolution of conventional light microscopy is limited by diffraction to ~200–250 nm laterally and >500 nm axially. Here, we describe superresolution methods based on single-molecule localization analysis of photoswitchable fluorophores

(PALM: photoactivated localization microscopy) as well as our recent three-dimensional (3D) method (iPALM: interferometric PALM) that allows imaging with a resolution better than 20 nm in all three dimensions. Considerations for their implementations, applications to multicolor imaging, and a recent development that extend the imaging depth of iPALM to ~750 nm are discussed. As the spatial resolution of superresolution fluorescence microscopy converges with that of electron microscopy (EM), direct imaging of the same specimen using both approaches becomes feasible. This could be particularly useful for cross validation of experiments, and thus, we also describe recent methods that were developed for correlative superresolution fluorescence and EM.

INTRODUCTION

Cells possess a complex and heterogeneous interior and thus biologists have long relied on imaging methods to probe cellular structures and functions. With a broad repertoire of high molecular specificity labeling techniques and minimal invasiveness, fluorescence microscopy has gained wide usage. As a light-based technique, however, fluorescence microscopy is limited in spatial resolution by diffraction; a fluorescent point source is imaged as a spread-out peak of finite size. This is typically referred to as the point spread function (PSF), whose dimension determines the resolving power of conventional light microscopy (LM)—the best resolution that high numerical aperture (NA) objectives can achieve is ~200 nm in the image plane (xy or lateral) and >500 nm along the optical axis (z or axial). To circumvent this limit, novel imaging methodologies have been developed over the past decade, collectively termed superresolution microscopy. In this chapter, we focus on a superresolution approach based on single-molecule localization. This family of techniques is known by acronyms such as (F)PALM (Betzig et al., 2006; Hess, Girirajan, & Mason, 2006) and STORM (Rust, Bates, & Zhuang, 2006), to name a few, and can achieve resolution of 10 nm or better under proper conditions, approaching the molecular length scale.

In the following section, we cover the principles of single-molecule localization microscopy (called PALM henceforth for short) and our 3D superresolution method (iPALM) (Shtengel et al., 2009). Our focus is on applying PALM and iPALM for ultrahigh-resolution imaging, and thus, the methods described herein are geared toward fixed specimens, though PALM has also been applied to live cells, albeit with a trade-off in spatial and temporal resolution (Shroff, Galbraith, Galbraith, & Betzig, 2008). Practical issues common to PALM and iPALM imaging such as fluorophore photoswitching, labeling strategy, sample preparation, and instrumentation for single-molecule imaging are described in Section 15.2, along with aspects specific to iPALM. As the resolving power of light-based techniques converges with that of electron microscopy (EM), a direct comparison between the two approaches becomes possible, providing a significant improvement over conventional correlative light-electron microscopy (CLEM). We conclude by describing the recent methods for integrating PALM or iPALM with EM for ultrastructural imaging.

15.1 PRINCIPLES
15.1.1 2D SUPERRESOLUTION MICROSCOPY BY PHOTOACTIVATED LOCALIZATION MICROSCOPY (PALM)

A key notion behind PALM and similar techniques is that the coordinate of a single fluorescence emitter can be determined with high precision by "localization analysis" of its diffraction-limited image, which can readily be recorded using a sufficiently high-intensity excitation (i.e., lasers), adequate light gathering power (i.e., a high NA objective), a sensitive detector (i.e., EMCCD camera), a relatively low noise background (total internal reflection fluorescence (TIRF) illumination and appropriate filters and dichroic mirrors), and sufficient sparsity such that there are few overlapping emitters within the PSF length scale (Betzig et al., 2006). In localization analysis, the observed intensity of each single molecule is fitted with an approximated model of the PSF. The uncertainty of the localized coordinates can be estimated by $\sigma = \sqrt{(s^2 + a^2/12)/N \cdot \left[(16/9) + \left(8\pi b^2(s^2 + a^2/12)/Na^2\right)\right]}$, where σ denotes the localization uncertainty, s the standard deviation of the PSF, N the number of photons detected, a the pixel size, and b the background noise (Mortensen, Churchman, Spudich, & Flyvbjerg, 2010). Multiple methods for precise estimation of the PSF center have been developed, such as by using nonlinear two-dimensional (2D) Gaussian fitting (Thompson, Larson, & Webb, 2002) or maximum likelihood estimator algorithms (Mortensen et al., 2010). Note that under certain situations such as when emitters are non-isotropically averaged, refinements of both the algorithms and error estimates may be necessary (Mortensen et al., 2010).

In addition to high localization precision, if structural details need to be resolved, PALM also requires a high density of single-molecule coordinates to satisfy the Nyquist–Shannon sampling criterion (Shannon, 1949). Since such high-labeling density means that neighboring fluorescent molecules will overlap, special classes of "blinking" fluorophores are called for. These are photoactivatable fluorescent proteins (PAFPs) or certain synthetic fluorophores that can be switched between bright ("ON") and dark ("OFF") states via photochemical or photophysical mechanisms (Patterson, Davidson, Manley, & Lippincott-Schwartz, 2010). With judicious control of photoswitching rates, the density of single fluorescent events can be tuned such that on average each observed peak corresponds to a single molecule. By accumulating and processing a large number of such raw image frames, a high density of high-precision coordinates can be gathered to reconstruct a superresolution image, whereby each peak is conventionally represented by a normalized 2D Gaussian peak, centered at the localized coordinate and whose width reflects the localization uncertainty σ (Betzig et al., 2006).

15.1.2 3D SUPERRESOLUTION BY iPALM

While single-molecule localization analysis provides robust resolution enhancement in the image plane, a different approach is required for axial (z) resolution enhancement. Several schemes have been implemented with localization microscopy such as

by the detection of the PSF at two focal planes, by shaping the PSF into an axially rotating double helix, or by astigmatic defocusing such that the PSF ellipticity corresponds to the z-coordinate (Kanchanawong & Waterman, 2012). One of the main challenges of superresolution in z, however, is that the PSF is far more extended along the optical axis (z) and thus the axial resolving power is generally a few times worse than the lateral. Typical demonstrated localization precision for defocus-based approaches is on the order of ~60 nm (Huang, Wang, Bates, & Zhuang, 2008), but these were obtained using very bright synthetic fluorophores. The performance with dimmer PAFPs is correspondingly poorer (Fig. 15.1).

To address this, we have combined a multiphase interferometry technique that enables high-precision z-coordinate measurement simultaneous with PALM. This method, called iPALM (interferometric photoactivated localization microscopy) (Shtengel et al., 2009), makes use of 4pi dual-opposed objective geometry (Hell & Stelzer, 1992), wherein each emitted photon can be considered to propagate

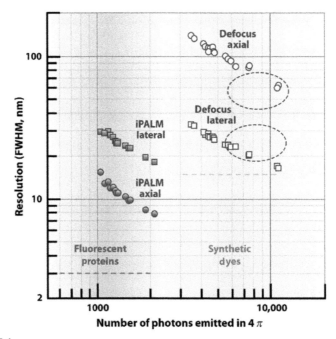

FIGURE 15.1

Comparison of resolution between iPALM and defocus-based superresolution methods. Localization accuracy (full-width half-maximum) as a function of fluorophore brightness: iPALM axial (solid circles), iPALM lateral (solid squares), defocus-based axial (open circles), and defocus-based lateral (open squares). Shade gradients indicate typical photon output of PAFPs and synthetic fluorophores. Dashed vertical lines indicate uncertainties due to probe sizes. Ovals outline the range of results from Huang et al. (2008).

Reproduced with permission from Shtengel et al. (2009).

through two optical paths and then self-interfere in a custom-designed three-way beam splitter. The z-coordinate information is contained in the phase of the self-interfered photon that is directly proportional to the path length differences between the two beams. The output beams of the three-way beam splitter have mutual phase differences of $\sim 120°$; therefore, the images of each single molecule on the three cameras occur at the same x–y coordinate (hence, PALM for x–y superresolution) but with differing intensity. This allows the z-coordinate to be extracted by comparing the observed intensity ratio to a calibration curve. Due to the sensitivity of the interferometric scheme, iPALM achieves z resolution almost $2\times$ better than x–y resolution, with overall resolution for PAFPs of <20 nm in 3D (Fig. 15.1), highlighting the unique axial resolution advantage of this approach (Kanchanawong et al., 2010; Shtengel et al., 2009).

However, the z-coordinate extracted using the original iPALM method is periodic, and the imaging depth is thus limited to a z range of ~ 250 nm (for the emission wavelength of ~ 600 nm). Beyond this range, peaks belonging to adjacent interferometric fringes cannot be distinguished, even though high localization accuracy is maintained. This can be addressed by combining iPALM with an astigmatic-defocusing scheme, which provides nonperiodic information on the z-coordinate, extending the imaging z depth to ~ 750 nm (Brown et al., 2011).

15.2 METHODS
15.2.1 INSTRUMENTATION FOR PALM

The recommended laser lines for PALM imaging are 488, 561, 640, and 750 nm, with 405 nm for photoactivation. Since 2D PALM can be performed on a commercial microscope equipped for TIRF microscopy, a prealigned fiber-coupled laser launch and an appropriate TIRF illuminator can be used, which will greatly simplify the instrumentation. However, with fiber-coupling efficiency loss, we found that a minimum laser power of ~ 50–100 mW is necessary, especially for imaging synthetic fluorophores that require high initial power density to suppress most molecules into dark state. On the other hand, an open-beam configuration allows for higher efficiency, ease of access, and customization but requires more setting up effort. For our iPALM system, we use an open-beam configuration with the lasers and appropriate filters as listed in Table 15.1. The intensity is modulated either via an AOTF (A-A Optoelectronic, France) or by on-head TTL modulation when available (see Table 15.1 for typical intensity for select fluorophores). The laser beam is expanded to ~ 5 mm in width and then focused onto the objective back focal plane by a convex lens ($f = 300$ mm). To allow for the adjustment of the incidence angle for TIRF, the illumination beam is propagated through a pair of mirrors mounted on a glass plate beam deflector.

For detection, we used deep-cooled back-illuminated EMCCD cameras (Andor, United Kingdom) whose high quantum efficiency and low read noise allow for high signal-to-noise imaging of single molecules. More recently, sCMOS cameras have

Table 15.1 Excitation and Photoactivation Parameters and Examples of Filters for PALM and iPALM Imaging of Select Fluorophores

Parameters	Photoactivation	Excitation: PSCFP2	Excitation: mEos2	Excitation: Alexa Fluor 647	Excitation: Alexa Fluor 750
Wavelength (nm)	405	488	561	637	750
Power density (W/cm^2)	~2–10	~400	~1000	~3000	~2000
Exposure time (ms)	0.5–50	50	50	20–30	40–50
Laser combining dichroic/excitation filter	LM01-427-25 (Semrock, Rochester, NY)	LM01-503-25 (Semrock)	LM01-613-25 (Semrock)	LM01-658-25 (Semrock)	HQ740/35x (Chroma, Bellow Falls, VT)
Emission filter	–	FF01-520/35 (Semrock)	FF01-593/40 (Semrock)	LP02-647RU and FF01-720/SP (Semrock)	HQ795/50m (Chroma)
Notch filter	NF01-405/488/561/635 (Semrock)				

also become available that offer much higher readout rates and have been shown to be suitable for PALM. However, the current generation of sCMOS cameras requires explicit correction for pixel-to-pixel variation; thus, additional downstream processing steps are necessary (Huang et al., 2013). To allow through-objective TIRF illumination and to gather as much emission light as possible, we use oil-immersion high NA objective lenses. Note that the dimension of the PSF in the image plane should be well matched to the pixel size of the camera (Thompson et al., 2002). For 2D PALM, we use a $100\times$ NA 1.49 objective on a Nikon inverted microscope with $1\times$ or $1.5\times$ tube lens, which (for cameras with 16×16 μm^2 pixel size) yields an effective pixel size of ~160 or ~107 nm, respectively, whereas for iPALM, we use a pair of Nikon $60\times$ NA 1.49 objective lenses and a $2\times$ (400 mm) tube lens for an effective pixel size of ~133 nm. For the rejection of excitation light in 2D PALM, we used a multiband dichroic mirror and emission filters mounted in a filter wheel, whereas for iPALM, a custom slotted mirror and emission and notch filters are used instead (see Table 15.1).

To acquire raw image sets, we operate the cameras in frame transfer mode with images streaming to the hard drives at ~20–50 fps (20–50 ms exposure time). The number of frames acquired ranges from 25,000 to 75,000 or more. For 2D PALM, commercial or open-source software packages can be easily configured for acquiring such raw data. On the other hand, specialized calibration and alignment steps for iPALM require additional scripting and processing, and thus, we use software custom-written in LabVIEW (National Instruments, Austin, TX). The processing of raw data involves peak detection, localization by nonlinear least-square fitting to 2D Gaussians, rejection of poorly fitted peaks, and reconstruction of the superresolved images, for which several open-source software packages have become available recently (El Beheiry & Dahan, 2013; Henriques et al., 2010; Wolter et al., 2012). We implemented our processing algorithm in IDL (Exelis VIS, Boulder, CO), which offers decent performance that can be scaled on distributed computing clusters as needed for large datasets. PALM analysis routines are also used in iPALM data processing but with additional steps described further in Section 15.2.4.

15.2.2 FLUOROPHORE CHOICE AND SAMPLE PREPARATION FOR PALM AND iPALM

In our experience, choosing the proper fluorophores and labeling methodologies is one of the most important factors for successful imaging. PAFPs and photoswitchable synthetic fluorophores differ in many aspects and can be used to complement each other. In Table 15.2, we briefly summarize labeling methods that have been employed for superresolution microscopy. The most important parameters in choosing the optimal labeling strategy are fluorophore brightness, linker length, specificity, ability to label with high density, and low background. Closely related to the low background is the ON–OFF ratio—the brightness ratio between the activated and nonactivated state (the so-called OFF state is rarely completely dark, but rather has lower emission relative to the ON state) (Shroff et al., 2007). The higher the desired labeling density, the higher

Table 15.2 A Brief Summary of Fluorescent Labeling Strategies and their Advantages and Limitations in Superresolution Microscopy

Labeling method	Advantages	Limitations
Fusion with genetically encoded fluorophores (PAFPs) (Patterson et al., 2010)	– Genetic encoding – Superior molecular specificity – Live cell compatible – Relatively small size of probe and linker (<5 nm) – Relatively economical to develop probes for new targets	– Lower photostability and brightness – Largely limited to protein-based targets – Limited choice of spectral ranges
Fluorophore-conjugated antibodies (Allen, Ross, & Davidson, 2013)	– Higher photostability and brightness – Commercial availability – Specificity to many biomolecules, posttranslational modifications, or other chemical modifications	– Probe size is large (>10 nm) in standard protocol – Limited commercial availability of smaller probe option (Fab or nanobodies) – Density and penetration limitation – Relatively costly to create new probes – Not live-cell permeable
Fluorophore-conjugated small molecules or oligonucleotides (Shim et al., 2012)	– Higher photostability and brightness – Commercial availability – Small probe size – Labeling of chromosomes (oligonucleotides)	– Types of structures that can be labeled limited
Direct fluorophore labeling of proteins (Vaughan, Jia, & Zhuang, 2012)	– Higher photostability and brightness – Smallest probe size	– Requires protein purification, fluorophore ligation, and microinjection into cells
Genetically encoded tags with synthetic fluorophores (Wombacher et al., 2010)	– Higher photostability and brightness – Relatively small size of probe and linker (<5 nm) – High specificity – Live-cell compatible	– Largely limited to protein-based target

the ON–OFF ratio is required, since any residual OFF state fluorescence will degrade the localization precision. Also, OFF time should be $>1000\times$ greater than ON time to enable good isolation in densely labeled samples.

PAFPs are commonly fused to the protein of interest via molecular cloning techniques. We observed that the position and the length of the linker of the PAFP tag can

have a significant impact on proper targeting of the fusion protein. Too short a linker of a few amino acids could hinder proper folding or block important binding sites; a linker of sufficient length (~10 or more amino acids) is generally more reliable. Vectors expressing the fusion proteins are introduced into cells via standard transfection methods; the fusion proteins could be expressed and targeted to structures of interest within 6 h or so. We recommend that the level and duration of expression of each PAFP fusion construct be empirically tested, since overexpression could lead to localization artifacts, aberrant cellular behaviors, and high fluorescent background. The presence of endogenous proteins could reduce the labeling density in the structures of interest. This could be addressed by coexpressing RNAi that targets endogenous proteins but not the fusion proteins or more comprehensively by genome-editing methods (Ran et al., 2013). In case of routine usage, stable cell lines expressing the fusion proteins can also be generated. PAFPs that we have found most reliable are the Eos family (tdEos, mEos2) (McKinney, Murphy, Hazelwood, Davidson, & Looger, 2009; Wiedenmann et al., 2004) that photoconvert from green-emitting (~520 nm) to red-emitting (~590 nm) upon 405 nm illumination; mEos3.2 and Dendra2 are other widely used FPs in this spectral class (Allen et al., 2013). PSCFP2, which photoconverts from cyan-emitting to green-emitting, and Dronpa, which photoswitches between dark state and green-emitting, have also been used successfully as a second label in multichannel imaging (Shroff et al., 2007). In terms of performance, single-molecule fluorescent events of PAFPs are generally less bright and shorter lived than synthetic fluorophores; this is reflected in their typical localization precision of ~20 nm for PALM and ~10–15 nm for iPALM (Betzig et al., 2006; Kanchanawong et al., 2010). We caution that many PAFPs (as well as most synthetic fluorophores) exhibit complicated photophysics, such as reversible switching that depends on imaging conditions, and thus, additional analysis is required for extracting stoichiometric information from localization data sets (Sengupta et al., 2011).

Several synthetic fluorophores have been shown to perform remarkably well for localization microscopy (typically called (d)STORM when these fluorophores are used) (Heilemann et al., 2008; Rust et al., 2006). In terms of operation, synthetic fluorophores usually require an initially strong excitation to turn "OFF" the majority of molecules before single-molecule blinking can be observed. Furthermore, their optimal photon output depends strongly on the formulation of the imaging buffer (van de Linde et al., 2011). Key parameters include pH, oxygen level, redox potential, and excitation intensity, and these should be empirically optimized for each fluorophore (Allen et al., 2013). One of the main strengths of these probes is their high brightness relative to PAFPs—a few times more photons under normal conditions and reportedly a few orders of magnitude under specialized conditions (Vaughan et al., 2012). For targeting these fluorophores to specific cellular structure, they are required to be covalently linked to either small molecules or antibodies that confer molecular specificity (Table 15.2). Many proteins can be readily detected using conventional immunofluorescence microscopy protocols, involving labeling with a primary antibody followed by a fluorophore-conjugated

secondary antibody. The steric exclusion effect due to the size of the antibodies (>10 nm), however, will reduce effective spatial resolution and labeling density. Smaller probe size could be achieved via several strategies such as by using only Fab or (Fab)$_2$ fragments for the secondary antibody, by using only fluorophore-tagged primary antibody, by using fluorophore-tagged Fab fragment of the primary antibody, by using fluorophore-tagged camelid antibody (nanobody) (Ries, Kaplan, Platonova, Eghlidi, & Ewers, 2012), or by direct labeling of the purified target protein itself (Vaughan et al., 2012). Certain specific structures like actin filaments can also be labeled with high density by fluorophores conjugated to phalloidin, a small peptide that binds filamentous actin. Since the cell membrane is not permeable to many of these probes, unless targeting the cell surface, their use requires either cell fixation and permeabilization or microinjection into living cells, with the exception of certain membrane-bound organelles such as mitochondria, endoplasmic reticulum, or lysosomes for which live-cell permeable fluorophores are commercially available (Shim et al., 2012). In recent years, a hybrid approach that makes use of small protein domains with binding sites for fluorophore-conjugated small molecules as fusion tags akin to PAFPs has emerged, thus endowing synthetic fluorophores with genetic encoding ability (Wombacher et al., 2010). Among the synthetic fluorophores used for localization microscopy, in our experience, Alexa Fluor 647 offers one of the best and most consistent performances. Additional probes that work well in our experience include ATTO 488, ATTO 520, Alexa Fluor 568, and Alexa Fluor 750.

For multichannel imaging, care must be taken to make sure that not only the fluorophores are "blinking" optimally but also their activation, excitation, and emission spectra are not conflicting and there is minimal cross talk between the different channels. Due to these considerations, we often perform multichannel imaging in a sequential manner. In Table 15.3, we summarize select combinations of fluorescent labels found to work reliably for multicolor PALM and iPALM imaging.

Another important factor in sample preparation is the fixation of cells. Generally, cross-linking reagents such as paraformaldehyde and glutaraldehyde are used as fixatives. While glutaraldehyde preserves the cytoskeleton and membrane very well, it could interfere with antibody recognition. Paraformaldehyde reacts faster and tends to better preserve antibody recognition sites, but may not preserve ultrastructure as well. Since the rate of the cross-linking reaction depends on many parameters including concentration, temperature, pH, cell permeability, and buffer condition, it is generally the case that different structures will be optimally preserved under different conditions and these should be determined empirically. We refer readers to a recent review for examples and specific guidance on sample preparation for different types of cellular structures (Allen et al., 2013). Finally, these fixatives tend to generate background autofluorescence, and thus, postfixation quenching is useful for paraformaldehyde and necessary for glutaraldehyde. For the former, we incubate with 50 mM NH$_4$Cl for 10 min and the latter, 0.1–0.5% NaBH$_4$ for 7–10 min.

Table 15.3 Examples of Fluorophore Combinations for Multicolor PALM and iPALM Imaging

Fluorophores and imaging conditions			
Channel 1	**Channel 2**	**Channel 3**	**Notes**
PSCFP2 $\lambda_{excitation} = 488$ nm No photoactivation	mEos2 or tdEos $\lambda_{excitation} = 561$ nm $\lambda_{activation} = 405$ nm	–	Two-color, all PAFP system: No antibody labeling required. Very reliable. Image channel 2 first
PSCFP2 $\lambda_{excitation} = 488$ nm No photoactivation	Alexa Fluor 647 $\lambda_{excitation} = 640$ nm No photoactivation	–	Two-color system: Alexa Fluor 647 is one of the best photoswitching fluorophores
ATTO 488 $\lambda_{excitation} = 488$ nm No photoactivation	Alexa Fluor 647 $\lambda_{excitation} = 640$ nm No photoactivation	–	Two-color system: For cases where PSCFP2 cannot be used
PSCFP2 $\lambda_{excitation} = 488$ nm No photoactivation	Alexa Fluor 647 $\lambda_{excitation} = 640$ nm No photoactivation	Alexa Fluor 750 $\lambda_{excitation} = 750$ nm No photoactivation	Three-color system: the performance of Alexa Fluor 750 is similar to Eos

15.2.3 FIDUCIAL-BASED ALIGNMENT: DRIFT CORRECTION AND MULTICHANNEL REGISTRATION

In addition to high localization precision and high-labeling density, optimal PALM and iPALM resolutions also require low sample drift and/or good drift correction over the acquisition time of several minutes or more; ideally, the uncorrected drift itself should be on the order of a few tens of nm. In cases of multichannel imaging, whether multicolor PALM/iPALM or CLEM, the ability to register these channels with equally high precision is crucial. The most reliable results are obtained when stable emitters are included in each imaging field as fiducial marks. Although it is possible to correct for drift using autocorrelation (Huang et al., 2008), in our experience, the residual localization uncertainty remains higher compared to the fiducial approach. Also, it is difficult to assess the quality of the autocorrelation-based registration without known fixed points in the sample, whereas with fiducials, this can readily be examined by comparing multiple fiducials.

Au nanoparticles have unique fluorescent properties suitable for drift correction (Betzig et al., 2006), image registration (Shroff et al., 2007), and iPALM calibration. Like many metal and hybrid nanoparticles, their photoluminescence is greatly enhanced by localized surface plasmon resonance (LSPR) (Boyd, Yu, & Shen, 1986; Mohamed, Volkov, Link, & El-Sayed, 2000). When illuminated, each

nanoparticle acts as a bright and stable radiating dipole. The LSPR emission of Au peaks at 520 nm and is wide enough that 80 nm bare Au nanoballs can be used in the 480–620 nm range (Shroff et al., 2007). Au nanorods have two LSPR modes—lateral and axial. The wavelength of the lateral LSPR is similar to that of bulk Au, while the wavelength of the axial LSPR mode can be tuned from 520 to 1000 nm depending on the nanorod aspect ratio (Murphy et al., 2005). As shown in Fig. 15.2, the 25 nm × 100 nm Au nanorods can be used in the 480–800 nm range, generally with 5–10 nm localization accuracy. While fluorescent beads have also been used as fiducial marks (Dempsey, Vaughan, Chen, Bates, & Zhuang, 2011), we note that they are limited by their relatively large (100 nm or more) diameter and that they are not true single-dipole emitters. Moreover, multicolor beads rely on multiple types of fluorophores, and thus, the centers of each channel could have inherent random displacement on the order of tens of nanometers, depending on their specific manufacturing processes. Au nanoparticles do not suffer from this limitation, thus allowing for greater registration accuracy.

For regular usage, we deposit the Au nanoparticles with a density of 2000–20,000 mm^{-2} on precleaned glass coverslips and then sputter-coated with a thin (~20 nm) layer of SiO_2 or indium tin oxide (ITO) for CLEM. This ensures the nanoparticles are stably immobilized to serve as fiducial markers. For drift correction, the localized fiducial coordinates report frame-to-frame positional

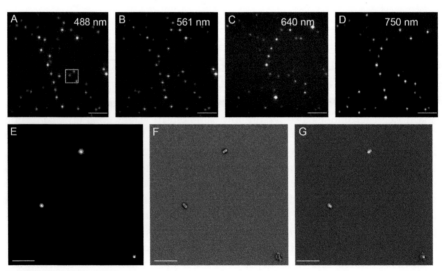

FIGURE 15.2

Au nanoparticles as fluorescent fiducial marks. (A–D) Fluorescence images of 25 × 100 nm bare Au nanorods under a typical PALM imaging condition for 488, 561, 640, and 750 nm channels. Scale bars, 5 μm. (E) Single-molecule localizations (PALM image) in all four channels from boxed area (A), with SEM micrograph and PALM-SEM overlay in (F) and (G), respectively. Scale bar, 500 nm.

variation, which, typically after moving-average smoothing or polynomial fitting, can be subtracted from the coordinates of all detected molecules. With bright fiducials, one can almost completely eliminate the adverse effects of sample drift.

The registration of different channels is essential for multichannel PALM, iPALM, and CLEM. Particularly in case where different channels have different emission wavelengths, the data in two channels are typically not aligned "as acquired"; they could be shifted and tilted due to different filter sets and/or slight wavelength-dependent magnification differences. Their registration can be performed using the localized coordinates of fiducials that are detectable in both channels. The uncertainties due to uncorrected drift and imperfect image registration must also be accounted for when estimating compound localization accuracy; usually, these are treated as independent and are added in quadratures (Pertsinidis, Zhang, & Chu, 2010): $\sigma = \sqrt{\sigma_{loc1}^2 + \sigma_{loc2}^2 + \sigma_{reg}^2}$ where σ_{loc1} and σ_{loc2} are the localization accuracies in each channel and σ_{reg} the accuracy of interchannel registration. Assuming the simplest case with no chromatic aberrations, the images collected in the two channels should be related by a similarity transformation (Brown et al., 2011):

$$\begin{pmatrix} X' \\ Y' \end{pmatrix} = M \begin{pmatrix} \cos\alpha & -\sin\alpha \\ \sin\alpha & \cos\alpha \end{pmatrix} \begin{pmatrix} X \\ Y \end{pmatrix} + \begin{pmatrix} \Delta_x \\ \Delta_y \end{pmatrix}$$

where (X, Y) and (X', Y') are the original and transformed coordinates, respectively, M is the relative magnification, α is the degree of rotation, and $\Delta_{x,x}$ is the shift. If aberrations are present, nonlinear transformation is required. We found that first-order polynomial spatial warping (POLYWARP function in IDL) works very well for both multichannel PALM and CLEM registration:

$$X' = Kx_{00} + Kx_{01} \cdot X + Kx_{10} \cdot Y + Kx_{11} \cdot X \cdot Y$$
$$Y' = Ky_{00} + Ky_{01} \cdot X + Ky_{10} \cdot Y + Ky_{11} \cdot X \cdot Y$$

where (X, Y) and (X', Y') are as in the preceding text, while Kx_{ij} terms are the transformation coefficients (Kopek, Shtengel, Grimm, Clayton, & Hess, 2013). The nonlinear terms Kx_{11} and Ky_{11} are usually very small. For a ~30 μm field of view, the average registration error is typically below 10 nm. In choosing imaging sites, we recommend selecting areas that contain at least a few fiducials (more for iPALM or multicolor imaging), so as to provide multiple constraints for alignment and also because Au nanoparticles occasionally form clusters (Fig. 15.2F–G, lower right), which tend to exhibit wavelength-dependent, higher-order multipole radiation patterns, resulting in erroneous localization results. It is usually relatively easy to identify and exclude these fiducials during processing. It should also be noted that large Au nanoparticles (>150 nm) should be avoided for the same reason—their spectral range is extended by higher-order multipole radiation, which may result in high registration error.

15.2.4 IMPLEMENTATION OF iPALM

As shown in Fig. 15.3A, the optics of iPALM is based on a dual-opposed objective configuration. To implement this, we find it simpler to build a system using a mix of custom-machined and commercially available optomechanical parts instead of modifying an existing microscope. As a chassis, we use a thick baseplate with pre-drilled holes and optical ports, which helps to simplify many alignment steps. To minimize thermal drift, the baseplates and several custom-machined parts are fabricated from Invar, an alloy with very low thermal expansion, though stainless steel may probably be sufficient

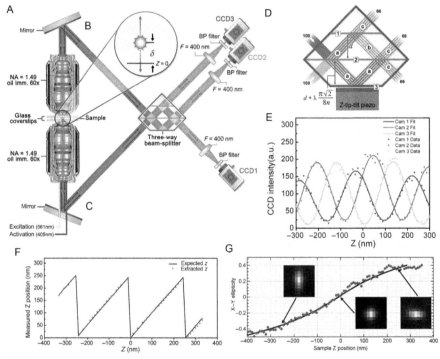

FIGURE 15.3

Principles of iPALM. (A–C) Schematic diagram of the iPALM system. (D) Three-way beam splitter for multiphase interferometry. (E) iPALM calibration curve relating the intensities in three cameras to z-coordinate. (F) Extracted z positions of an Au fiducial from (E) versus piezo-z positions (expected values: solid line), showing a period of ~250 nm (for 600 nm emission). (G) The x–y ellipticity of an Au fiducial (red diamonds, polynomial fit: black line) versus piezo-z position used to extract z position with no periodicity. Au fiducial images at different z are shown in insets. The comparison of the interferometric (F) and astigmatic (G) z-coordinates allows "unwrapping" of interferometric z, allowing the z range to be extended by 3× to around ~750 nm. (See the color plate.)

(A–F) Reproduced with permission from Kanchanawong et al. (2010). (G) Reproduced with permission from Brown et al. (2011).

with a tightly controlled ambient temperature. Two infinity-corrected Nikon $60 \times$ NA 1.49 objective lenses are mounted on spring-loaded translation stages equipped with piezoelectric actuators to allow for focusing, with the stages in turn mounted onto the baseplate. The mounting bracket for each objective is equipped with 2-axis spring-loaded fine-threaded adjusters to allow for x–y centration.

The sample holder assembly for iPALM is an essential part of the system, as it is equipped with piezoelectric actuators to allow nm precision translation in z, essential during the alignment and calibration of the system. In our design, the sample holder rests on a smooth pedestal and can be translated by servo actuators to select imaging areas. The sample for iPALM needs to be thin as optical access is required from both sides. We assemble the sample chamber by carefully placing a clean coverslip (#1.5, \varnothing 18 mm) on top of the cell-containing cover glass (#1.5, \varnothing 25 mm). By using a small volume of imaging buffer and gentle pressure, sample chamber as thin as <15 μm can be achieved, which will be apparent from the Newton's rings pattern. The sample is sealed with small drops of fast-curing epoxy, followed by melted vaseline, and held firmly on the sample holder by small magnets.

Fluorescence emission collected by each objective lens is directed toward the beam splitter via turning mirrors oriented at $22.5°$ (Fig. 15.3B and C). These mirrors are custom-fabricated with a central reflective surface and small clear slots on the edge and are placed on a 2-axis piezoelectric mirror mounts. In the case of extended z range iPALM (Section 15.2.5), these turning mirrors can be strained to achieve a mild hyperbolic saddle shape. To illuminate the sample, excitation light from the laser assembly is directed through a port in the baseplate and through a slot in the turning mirror. The return beam due to TIR then exits through another slot. In this way, the turning mirrors also function to reject excitation light akin to a dichroic mirror but with a broad spectral bandwidth. Additional stray excitation light is rejected by multiband notch filters mounted close to the cameras. Each optical path is equipped with a mechanical shutter between the turning mirrors and the beam splitter to allow imaging through either or both objectives.

The three-way beam splitter essential for multiphase interferometry is custom-manufactured (Rocky Mountain Instruments, Lafayette, CO) to contain three main reflective interfaces. The top interface (#1 in Fig. 15.3D) reflects 33% of the beam incident at $45°$ (i.e., 66% of the incident beam is transmitted through), the middle interface is a 50:50 beam splitter (#2 in Fig. 15.3D), while the bottom interface is 100% reflective. It is essential that both amplitude and phase of the reflection at each surface inside the beam splitter are as uniform as possible across the relevant emission spectral range and that these are polarization-independent. In order to allow adjustable path length d within the beam splitter (Fig. 15.3D), the beam splitter is made with a clear bottom, which rests above a flat dielectric mirror over a thin gap filled with index-matching oil. The beam splitter is held stationary within its housing, while the bottom mirror is mounted on a 3-axis piezoelectric stage that allows for the adjustment of the gap and the tilt of the mirror to optimize the interference between beam a and beam b in Fig. 15.3D. The whole beam splitter assembly is then mounted onto a 5-axis piezoelectric stage on the baseplate.

Following the beam splitter, each of the three exit beams is focused by an achromatic doublet lens ($f=400$ mm) through motorized filter wheels mounted with the appropriate emission and notch filters and onto the EMCCD cameras. Each camera is mounted with 45° rotation to correspond with the translation axis of the sample. We use custom-fabricated brackets on rail stages for camera mounting for ease of focusing during the alignment.

The iPALM system can be brought to alignment in a stepwise manner. Briefly, after the initial coarse placement of the optics, the bottom objective together with camera #3 can be used to image a bright sample. Once proper focus for camera #3 is achieved, other cameras can likewise be brought into focus. The bottom objective is then held constant, while the top objective is adjusted for proper centration. This and other alignment steps are aided by a custom LabVIEW program that allows real-time subpixel localization of a fiducial. Since the emission is incoherent, in order for interference to occur, the optical path lengths through the top and bottom objectives to the beam splitter must be matched to within a few microns. This is achieved via the following: The sample holder is first continuously oscillated along the z-axis over a range of 400 nm while a fiducial is imaged continuously; the beam splitter assembly is then translated up or down until the intensity of the fiducial oscillates due to the interferometric effect. With proper path length matching, the peak-to-valley ratio of >10 can be expected (Fig. 15.3E). Next, fine alignment of the beam splitter is carried out by optimizing the calibration curve. This involves translating the sample in discrete z steps of 8 nm over a range of 800 nm; as seen in Fig. 15.3E, the intensity of a fiducial will oscillate with a similar period but with different phases between cameras #1–3. The position and tilt of the bottom mirror can then be adjusted so that camera #1 and camera #2 phase difference is maximized, ideally at 120°.

Once aligned, iPALM imaging at each site also requires the measurement of a calibration curve, both for optimizing the alignment and for subsequent z-coordinate extraction. Once calibrated, the acquisition of raw image sets can proceed. To facilitate synchronized and fast streaming, each camera is set to a trigger-driven exposure mode, with the trigger generated by a master computer, whereas each camera streams to a dedicated computer. For processing, we first perform localization analysis on the raw images similar to 2D PALM. The localized coordinates from the three cameras are then aligned using the fiducial-based method described earlier. For each detected single molecule, a summed image is constructed from registered three-camera data, which allows for the extraction of the normalized amplitude ratio between the three cameras. To extract the z-coordinate, the calibration data are first fitted by nonlinear least-square fitting to the equations: $I_k = A_k \sin(\omega z + \varphi_k) + B_k/(1+(z/D)^2)$, where k denotes each camera channel (1–3), I_k the corresponding peak intensity, and D the parameter of the focal envelope function (Fig. 15.3E). For each molecule, the I_k parameters are used to solve for z given A_k and B_k using Newton's method. Following z extraction, 3D drift is corrected based on fiducials as described earlier. Multicolor iPALM imaging is performed by sequentially imaging each channel in the appropriate order (Table 15.3), as the calibration curves differ somewhat for each spectral range. An example of a single-channel iPALM image of the actin cytoskeleton in C2C12 cells is shown in Fig. 15.4A, with the z-coordinates represented by a

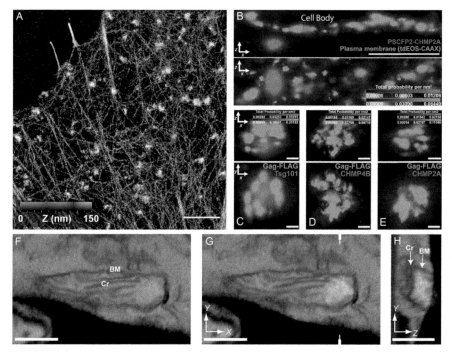

FIGURE 15.4

Imaging of cellular ultrastructure by iPALM and correlative iPALM-EM. (A) iPALM image of the actin cytoskeleton of a C2C12 mouse myoblast cell, labeled with Alexa Fluor 647 phalloidin. Color represents the z-coordinate relative to the cover glass. Color scale, 0–150 nm. Scale bar, 2 μm. (B) Two-color iPALM images of a budding HIV Gag particles (green: ESCRT-III subunit, PSCFP2-CHMP2A) relative to the plasma membrane (red: tdEos-farnesyl). The HIV particles can be seen to be clearly separated from the plasma membrane (top panel, x–z axial view; bottom panel, x–y lateral view). Scale bar, 500 nm. (C–E) Two-color iPALM images of single clusters of HIV Gag particles (red: Alexa Fluor 647 Gag FLAG) and ESCRT-I and ESCRT-III subunits (green: PSCFP2-Tsg101, PSCFP2-CHMP4B, and PSCFP2-CHMP2A, respectively). Top panels, x–z axial view. Bottom panels, x–y lateral view. Scale bars, 50 nm. (F) 5 nm thick x–y cross-sectional FIB-SEM image of a Swiss 3T3 cell expressing mitochondrial DNA binding protein (TFAM-mEos2) prepared by a modified Tokuyasu method. Good preservation of the ultrastructure is observed; BM, mitochondrial boundary membrane; Cr, cristae. (G) Correlative iPALM-FIB-SEM image for the same x–y slice in (F), iPALM image of TFAM-Eos2 shown in red. (H) 5 nm z–y slice perpendicular to the image in (G); white marks in (G) indicates the intersection of x–y and z–y cross sections. Scale bars (F–H), 500 nm. (See the color plate.)

(C–E) Reproduced with permission from van Engelenburg et al. (2014); (F–H) reproduced with permission from Kopek et al. (2013).

hue scale, while Fig. 15.4B–E shows two-color iPALM images of Gag and ESCRT machinery proteins in HIV viral buds, visualized by either PAFP fusion or antibody labeling.

15.2.5 EXTENDING iPALM IMAGING DEPTH WITH ASTIGMATIC DEFOCUSING

The periodic nature of the iPALM interferometric z-coordinate can readily be seen from the period of the calibration curve (Fig. 15.3F). Thus, while high localization accuracy is maintained, one cannot discriminate between adjacent interference fringes, resulting in an ambiguity of $\pm\sim 250$ nm (for 600 nm emission). To address this, we modified the flat 22.5° mirrors (Fig. 15.3B and C) into mildly hyperbolic mirrors that adds a saddle-shaped phase shift across the pupil plane (Brown et al., 2011). As a result, the PSF became elliptical (Fig. 15.3G insets), with the ellipticity varying relatively slowly with the z-coordinate (Kao & Verkman, 1994), which can then be used to discriminate adjacent interferometric fringes. It is important that the hyperbolic shapes of the turning mirrors are matched so that the phase differences between the two beams remain constant across the pupil plane, preserving the multi-phase interferometry critical for iPALM. The astigmatic PSF can be approximated by 2D Gaussians with different x- and y-widths. The x–y ellipticity can be defined as $\epsilon = (\sigma_x - \sigma_y)/(\sigma_x + \sigma_y)$, where σ_x and σ_y are the Gaussian widths along the x- and y-axes. For extended z range iPALM imaging, a calibration curve can be measured similarly to in Section 15.2.4, with additional analysis steps where the ϵ versus z dependence is characterized (Fig. 15.3G) and used to extract the z-coordinate. While the astigmatic defocusing method has much lower accuracy than the interferometric technique, it is not limited to a single interferometric fringe and therefore can be used to determine the fringe order. In combination, this allows for accurate determination of the z-coordinate over a range of ~ 750 nm, that is, close to the focal depth of high NA objective lenses. There is a small fraction of molecules for which the interferometric fringe is determined incorrectly. This "ghosting error" can be estimated using the ellipticity and interferometry data, and for reasonably bright PAFP labels, such as EosFP, it is generally between 1% and 5% (Brown et al., 2011). For example, iPALM data presented in Fig. 15.4B–H were taken on samples 300–750 nm thick and show no significant ghosting errors.

15.3 FUTURE DIRECTIONS

With axial localization accuracy equal to or exceeding the lateral, iPALM provides nearly isotropic, ultrahigh 3D resolution. Combined with the high molecular specificity of fluorescent labeling methods, this unique capability has been applied to visualize molecular scale organization of a number of subcellular structures. Recent examples include scaffolding of ESCRT complexes in HIV viral particles (van Engelenburg et al., 2014), mitochondrial nucleoids (Brown et al., 2011),

clathrin-coated endocytic vesicles (Sochacki et al., 2012), and focal adhesions (Kanchanawong et al., 2010). At the same time, it is also recognized that such high resolution and high molecular specificity naturally complement EM imaging (Betzig et al., 2006), and thus, superresolution CLEM has been an area of active ongoing development; we anticipate that this approach will increasingly be used to cross validate findings from superresolution microscopy.

Among the most serious challenges of superresolution CLEM remains the incompatibility of the fixation and staining protocols necessary for each modality (Watanabe et al., 2010). Moreover, optimal methods may vary significantly depending on the types of structures being investigated. For instance, while metal-replica EM is suitable for structures close to the plasma membrane (Sochacki, Shtengel, van Engelenburg, Hess, & Taraska, 2014), organelles deeper into the cells require a different method (Kopek, Shtengel, Xu, Clayton, & Hess, 2012). As an example, for correlative iPALM-EM imaging of the mitochondria, a slightly modified Tokuyasu protocol was chosen, as this tends to preserve the PAFPs signals relatively well while offering higher quality EM image. Cells are first fixed with 2% glutaraldehyde and 5% sucrose and then frozen and sectioned with a thickness of 500 or 750 nm for iPALM imaging. These cryosections are placed on coverslips precoated with Au nanoparticles and ITO (Section 15.2.3), treated with $NaBH_4$ to reduce autofluorescence, and then assembled into an imaging chamber (Section 15.2.4). Once mounted on the iPALM setup, intact cryosections and appropriate imaging areas are located using the differential interference contrast (DIC) mode, followed by the standard iPALM imaging sequences of alignment, calibration, acquisition, and processing. Subsequent 3D EM imaging of these thick cryosections is performed using FIB-SEM (focused ion beam-scanning EM) approach. Here, the cryosections are retrieved; stained in a solution of 2% osmium tetroxide, 0.6% uranyl acetate, and 0.0075% Sato's lead; and then spin-dried (Kopek et al., 2013). To smooth the specimen for more uniform ion milling, a ~1–5 μm layer of cyanoacrylate could be added over the dried sections. The EM images from FIB-SEM are then registered with the iPALM images based on the Au nanorods fiducials, easily visible in both EM and iPALM channels (Section 15.2.3). An example image of the protein TFAM relative to the mitochondrial membranes acquired using this iPALM–FIB-SEM protocol is shown in Fig. 15.4F–H. Note that while relatively thick (500–750 nm) cryosections such as this require 3D superresolution CLEM, much simpler 2D PALM and SEM can be employed in cases where thin (50–100 nm) cryosectioning is feasible (Kopek et al., 2013).

ACKNOWLEDGMENTS

P. K., Y. L. W., Z. Z., and W. I. G. acknowledges the funding support from the Singapore National Research Foundation under the NRF Fellowship Scheme to P. K. (NRF-NRFF-2011-4) and core facilities support from the Mechanobiology Institute. G. S. and H. F. H. are supported by the Howard Hughes Medical Institute. We thank Xiaoduo Dong for preparing the sample for Fig. 15.4A.

REFERENCES

Allen, J. R., Ross, S. T., & Davidson, M. W. (2013). Sample preparation for single molecule localization microscopy. *Physical Chemistry Chemical Physics, 15*(43), 18771–18783.

Betzig, E., Patterson, G. H., Sougrat, R., Lindwasser, O. W., Olenych, S., Bonifacino, J. S., et al. (2006). Imaging intracellular fluorescent proteins at nanometer resolution. *Science, 313*(5793), 1642–1645.

Boyd, G. T., Yu, Z. H., & Shen, Y. R. (1986). Photoinduced luminescence from the noble metals and its enhancement on roughened surfaces. *Physical Review B, 33*(12), 7923–7936.

Brown, T. A., Tkachuk, A. N., Shtengel, G., Kopek, B. G., Bogenhagen, D. F., Hess, H. F., et al. (2011). Superresolution fluorescence imaging of mitochondrial nucleoids reveals their spatial range, limits, and membrane interaction. *Molecular and Cellular Biology, 31*(24), 4994–5010.

Dempsey, G. T., Vaughan, J. C., Chen, K. H., Bates, M., & Zhuang, X. (2011). Evaluation of fluorophores for optimal performance in localization-based super-resolution imaging. *Nature Methods, 8*(12), 1027–1036.

El Beheiry, M., & Dahan, M. (2013). ViSP: Representing single-particle localizations in three dimensions. *Nature Methods, 10*(8), 689–690.

Heilemann, M., van de Linde, S., Schuttpelz, M., Kasper, R., Seefeldt, B., Mukherjee, A., et al. (2008). Subdiffraction-resolution fluorescence imaging with conventional fluorescent probes. *Angewandte Chemie (International Ed. in English), 47*(33), 6172–6176.

Hell, S., & Stelzer, E. H. K. (1992). Properties of a 4Pi confocal fluorescence microscope. *Journal of the Optical Society of America. A, 9*(12), 2159–2166.

Henriques, R., Lelek, M., Fornasiero, E. F., Valtorta, F., Zimmer, C., & Mhlanga, M. M. (2010). QuickPALM: 3D real-time photoactivation nanoscopy image processing in ImageJ. *Nature Methods, 7*(5), 339–340.

Hess, S. T., Girirajan, T. P., & Mason, M. D. (2006). Ultra-high resolution imaging by fluorescence photoactivation localization microscopy. *Biophysical Journal, 91*(11), 4258–4272.

Huang, F., Hartwich, T. M., Rivera-Molina, F. E., Lin, Y., Duim, W. C., Long, J. J., et al. (2013). Video-rate nanoscopy using sCMOS camera-specific single-molecule localization algorithms. *Nature Methods, 10*(7), 653–658.

Huang, B., Wang, W., Bates, M., & Zhuang, X. (2008). Three-dimensional super-resolution imaging by stochastic optical reconstruction microscopy. *Science, 319*(5864), 810–813.

Kanchanawong, P., Shtengel, G., Pasapera, A. M., Ramko, E. B., Davidson, M. W., Hess, H. F., et al. (2010). Nanoscale architecture of integrin-based cell adhesions. *Nature, 468*(7323), 580–584.

Kanchanawong, P., & Waterman, C. M. (2012). Advances in light-based imaging of three-dimensional cellular ultrastructure. *Current Opinion in Cell Biology, 24*(1), 125–133.

Kao, H. P., & Verkman, A. S. (1994). Tracking of single fluorescent particles in three dimensions: Use of cylindrical optics to encode particle position. *Biophysical Journal, 67*(3), 1291–1300.

Kopek, B. G., Shtengel, G., Grimm, J. B., Clayton, D. A., & Hess, H. F. (2013). Correlative photoactivated localization and scanning electron microscopy. *PLoS One, 8*(10), e77209.

Kopek, B. G., Shtengel, G., Xu, C. S., Clayton, D. A., & Hess, H. F. (2012). Correlative 3D superresolution fluorescence and electron microscopy reveal the relationship of

mitochondrial nucleoids to membranes. *Proceedings of the National Academy of Sciences of the United States of America*, *109*(16), 6136–6141.

McKinney, S. A., Murphy, C. S., Hazelwood, K. L., Davidson, M. W., & Looger, L. L. (2009). A bright and photostable photoconvertible fluorescent protein. *Nature Methods*, *6*(2), 131–133.

Mohamed, M. B., Volkov, V., Link, S., & El-Sayed, M. A. (2000). The 'lightning' gold nanorods: Fluorescence enhancement of over a million compared to the gold metal. *Chemical Physics Letters*, *317*(6), 517–523.

Mortensen, K. I., Churchman, L. S., Spudich, J. A., & Flyvbjerg, H. (2010). Optimized localization analysis for single-molecule tracking and super-resolution microscopy. *Nature Methods*, *7*(5), 377–381.

Murphy, C. J., Sau, T. K., Gole, A. M., Orendorff, C. J., Gao, J., Gou, L., et al. (2005). Anisotropic metal nanoparticles: Synthesis, assembly, and optical applications. *The Journal of Physical Chemistry. B*, *109*(29), 13857–13870.

Patterson, G., Davidson, M., Manley, S., & Lippincott-Schwartz, J. (2010). Superresolution imaging using single-molecule localization. *Annual Review of Physical Chemistry*, *61*, 345–367.

Pertsinidis, A., Zhang, Y., & Chu, S. (2010). Subnanometre single-molecule localization, registration and distance measurements. *Nature*, *466*(7306), 647–651.

Ran, F. A., Hsu, P. D., Wright, J., Agarwala, V., Scott, D. A., & Zhang, F. (2013). Genome engineering using the CRISPR-Cas9 system. *Nature Protocols*, *8*(11), 2281–2308.

Ries, J., Kaplan, C., Platonova, E., Eghlidi, H., & Ewers, H. (2012). A simple, versatile method for GFP-based super-resolution microscopy via nanobodies. *Nature Methods*, *9*(6), 582–584.

Rust, M. J., Bates, M., & Zhuang, X. (2006). Sub-diffraction-limit imaging by stochastic optical reconstruction microscopy (STORM). *Nature Methods*, *3*(10), 793–795.

Sengupta, P., Jovanovic-Talisman, T., Skoko, D., Renz, M., Veatch, S. L., & Lippincott-Schwartz, J. (2011). Probing protein heterogeneity in the plasma membrane using PALM and pair correlation analysis. *Nature Methods*, *8*(11), 969–975.

Shannon, C. (1949). Communication in the presence of noise. *Proceedings of the IRE*, *37*, 10–21.

Shim, S. H., Xia, C., Zhong, G., Babcock, H. P., Vaughan, J. C., Huang, B., et al. (2012). Super-resolution fluorescence imaging of organelles in live cells with photoswitchable membrane probes. *Proceedings of the National Academy of Sciences of the United States of America*, *109*(35), 13978–13983.

Shroff, H., Galbraith, C. G., Galbraith, J. A., & Betzig, E. (2008). Live-cell photoactivated localization microscopy of nanoscale adhesion dynamics. *Nature Methods*, *5*(5), 417–423.

Shroff, H., Galbraith, C. G., Galbraith, J. A., White, H., Gillette, J., Olenych, S., et al. (2007). Dual-color superresolution imaging of genetically expressed probes within individual adhesion complexes. *Proceedings of the National Academy of Sciences of the United States of America*, *104*(51), 20308–20313.

Shtengel, G., Galbraith, J. A., Galbraith, C. G., Lippincott-Schwartz, J., Gillette, J. M., Manley, S., et al. (2009). Interferometric fluorescent super-resolution microscopy resolves 3D cellular ultrastructure. *Proceedings of the National Academy of Sciences of the United States of America*, *106*(9), 3125–3130.

Sochacki, K. A., Larson, B. T., Sengupta, D. C., Daniels, M. P., Shtengel, G., Hess, H. F., et al. (2012). Imaging the post-fusion release and capture of a vesicle membrane protein. *Nature Communications*, *3*, 1154.

Sochacki, K. A., Shtengel, G., van Engelenburg, S. B., Hess, H. F., & Taraska, J. W. (2014). Correlative super-resolution fluorescence and metal-replica transmission electron microscopy. *Nature Methods*, *11*(3), 305–308.

Thompson, R. E., Larson, D. R., & Webb, W. W. (2002). Precise nanometer localization analysis for individual fluorescent probes. *Biophysical Journal*, *82*(5), 2775–2783.

van de Linde, S., Loschberger, A., Klein, T., Heidbreder, M., Wolter, S., Heilemann, M., et al. (2011). Direct stochastic optical reconstruction microscopy with standard fluorescent probes. *Nature Protocols*, *6*(7), 991–1009.

van Engelenburg, S. B., Shtengel, G., Sengupta, P., Waki, K., Jarnik, M., Ablan, S. D., et al. (2014). Distribution of ESCRT Machinery at HIV Assembly Sites Reveals Virus Scaffolding of ESCRT Subunits. *Science*, *343*(6171), 653–656.

Vaughan, J. C., Jia, S., & Zhuang, X. (2012). Ultrabright photoactivatable fluorophores created by reductive caging. *Nature Methods*, *9*(12), 1181–1184.

Watanabe, S., Punge, A., Hollopeter, G., Willig, K. I., Hobson, R. J., Davis, M. W., et al. (2010). Protein localization in electron micrographs using fluorescence nanoscopy. *Nature Methods*, *8*(1), 80–84.

Wiedenmann, J., Ivanchenko, S., Oswald, F., Schmitt, F., Rocker, C., Salih, A., et al. (2004). EosFP, a fluorescent marker protein with UV-inducible green-to-red fluorescence conversion. *Proceedings of the National Academy of Sciences of the United States of America*, *101*(45), 15905–15910.

Wolter, S., Loschberger, A., Holm, T., Aufmkolk, S., Dabauvalle, M. C., van de Linde, S., et al. (2012). rapidSTORM: Accurate, fast open-source software for localization microscopy. *Nature Methods*, *9*(11), 1040–1041.

Wombacher, R., Heidbreder, M., van de Linde, S., Sheetz, M. P., Heilemann, M., Cornish, V. W., et al. (2010). Live-cell super-resolution imaging with trimethoprim conjugates. *Nature Methods*, *7*(9), 717–719.

CHAPTER

Seeing more with structured illumination microscopy

16

Reto Fiolka

Department of Cell Biology, UT Southwestern Medical Center, Dallas, Texas, USA

CHAPTER OUTLINE

Introduction	296
16.1 Theory of Structured Illumination	297
16.1.1 2D Image Formation	297
16.1.2 Structured Illumination	298
16.1.3 SIM Combined with Total Internal Reflection Fluorescence Microscopy	301
16.2 3D SIM	302
16.2.1 3D Image Formation	302
16.2.2 3D SIM Theory	303
16.2.3 Practical Implementations of 3D SIM	305
16.3 SIM Imaging Examples	307
16.3.1 TIRF SIM Application	307
16.3.2 3D SIM Applications	307
16.4 Practical Considerations and Potential Pitfalls	310
16.5 Discussion	311
References	312

Abstract

Optical microscopy enables minimally invasive imaging of cellular structures and processes with high specificity via fluorescent labeling, but its spatial resolution is fundamentally limited to approximately half the wavelength of light. Structured illumination microscopy (SIM) can improve this limit by a factor of two while keeping all advantages of light microscopy. Most importantly, SIM is compatible with live-cell imaging, as it only requires low illumination intensities and can rapidly acquire large field of views. It can also take advantage of essentially all fluorophores that are available for fluorescence microscopy and it does not require any specialized sample preparation.

INTRODUCTION

Light microscopy is an indispensable tool in biological research as it allows minimally invasive, three-dimensional imaging of the interior of cells and organisms with molecular sensitivity through fluorescent labeling. Its most obvious drawback is its modest spatial resolution, which is limited by diffraction to approximately half the wavelength of light (Abbe, 1873). Another shortcoming of conventional widefield light microscopy is its even further limited axial resolving power and the lack of any optical sectioning capability. A slice in a three-dimensional image stack contains not only the information from the corresponding focal plane but also out-of-focus blur stemming from all other planes.

The confocal microscope, the workhorse in cell biology, drastically improves the 3D imaging performance by blocking out-of-focus light with a pinhole and thus enabling optical sectioning (Pawley, 2006). In principle, the use of a very small pinhole can also slightly improve the spatial resolution but at the cost of valuable in-focus light that is discarded as well. Therefore, confocal microscopes are commonly operated with wider pinholes that still enable optical sectioning but result in spatial resolution similar to widefield microscopy. Being a point-scanning technique, confocal microscopy is also limited in acquisition speed, which can become prohibitive when large field of views or three-dimensional volumes are imaged.

In contrast, structured illumination microscopy (SIM) doubles the resolution in all three dimensions and provides optical sectioning without discarding any light by a pinhole or other masks (Gustafsson et al., 2008). SIM employs fine interference patterns for illumination to encode otherwise undetectable sample information via frequency mixing. As it is a widefield technique, SIM is highly light-efficient and large field of views can be acquired in parallel.

In the last two decades, a large number of techniques have been introduced that can drastically extend the spatial resolution in fluorescence microscopy beyond the diffraction limit (Betzig et al., 2006; Klar, Jakobs, Dyba, Egner, & Hell, 2000; Rust, Bates, & Zhuang, 2006). Among them, STED and localization microscopy have been shown to achieve spatial resolution down to single-digit nanometer levels (Rittweger, Han, Irvine, Eggeling, & Hell, 2009; Vaughan, Jia, & Zhuang, 2012). In contrast, SIM achieves only resolution levels of around 100 nm laterally. There are nonlinear forms of SIM (Gustafsson, 2005; Rego et al., 2012) that can further extend its resolution, but in this chapter, we will only focus on linear SIM, a technique that is mature, and multiple commercial systems are readily available. The main advantage of SIM compared to the aforementioned "superresolution" techniques is that it is readily compatible with live-cell imaging, that is, its frame rate is fast enough to capture rapid cell dynamics, and it can be operated at low light levels that limit phototoxic effects (Fiolka, Shao, Rego, Davidson, & Gustafsson, 2012; Shao, Kner, Rego, & Gustafsson, 2011). Thus, SIM achieves a good balance between spatial and temporal resolution and is one of the most "biocompatible" high-resolution microscopy techniques currently available.

In this chapter, the theory behind SIM and how it can be realized in a practical setup will be presented. The theory is explained with the least amount of math possible but with the goal of providing the reader an intuitive understanding of how it works. Examples of SIM imaging applied to living cells are given, and potential pitfalls and practical recommendations for SIM are discussed as well.

16.1 THEORY OF STRUCTURED ILLUMINATION
16.1.1 2D IMAGE FORMATION

In order to understand the concept of structured illumination, some basic principles of image formation in a light microscope need to be introduced. In a shift-invariant imaging system, an image is formed by convolution of the object with the point spread function (PSF) of the system. The PSF can be imagined as a brush to paint an image, with the size of the brush determining the finest structures that can be painted. Shift invariance means that each point in space is treated the same way; thus, the same brush is applied throughout the painting. In microscopy, it means that every point is imaged the same way. Figure 16.1 illustrates the 2D image formation process with Fig. 16.1A showing a simulated fluorescent object and Fig. 16.1C its image as observed with an idealized microscope system. In this example, some of the structures of the object are too fine to be resolved by this particular imaging system.

It is convenient to look at the image formation in Fourier space, since a convolution in real space becomes a multiplication in reciprocal space. Figure 16.1B shows the spatial spectrum of the object. In the image formation, the object's spectrum is multiplied with the Fourier transform of the PSF, the optical transfer function (OTF). Due to diffraction, a light microscope can only detect sample information up to a maximum spatial frequency. In an incoherent system, this cutoff frequency amounts to $2NA/\lambda$, which is also known as the Abbe diffraction limit. NA denotes the numerical aperture (Chapter 2) and λ is the wavelength of the emission light. In 2D imaging, the Abbe diffraction limit leaves us with a circular low-pass filter that cuts off all frequencies outside of its passband (white circle in Fig. 16.1D). An inverse Fourier transform of the low-pass-filtered object spectrum yields the real space image of the object. By reciprocity, a small PSF in real space (high spatial resolution) corresponds to a large passband of the OTF. Thus, in order to obtain high spatial resolution, the goal is to shrink the PSF and to enlarge the passband of the OTF.

The Abbe diffraction limit is a hard physical boundary and has not been fundamentally broken in far-field imaging. However, Abbe did not consider fluorescence imaging, which allows one to circumvent the limit and to extend resolution. Here, it is important to note that in fluorescence imaging, we do not directly look at the object (i.e., the fluorophore distribution), but its fluorescence emission, which can be modified. In the linear regime, the fluorescence emission is the product of the object's fluorophore distribution and the illumination intensity. The Abbe diffraction limit applies to fluorescence widefield imaging when uniform, "flood light" illumination

FIGURE 16.1

2D image formation. (A) Fluorophore distribution. (B) Fourier transform of (A). (C) Simulated microscope image of the fluorophore distribution in (A). (D) Fourier transform of the simulated microscope image. The white circle represents the Abbe diffraction limit.

is used. However, the illumination light can be made nonuniform (varying in space) to modify the fluorescence emission. As we will see in the Section 16.1.2, this can be used to bypass the Abbe diffraction limit.

16.1.2 STRUCTURED ILLUMINATION

SIM extends the resolution of a widefield fluorescence microscope by frequency mixing of the sample information with a spatially varying illumination pattern. Thereby, otherwise undetectable Fourier components of the sample are downconverted and brought into the passband of the microscope. Different illumination patterns can achieve this and a prominent example is confocal microscopy where the sample is illuminated with a focused laser spot. However, the simplest and yet most powerful pattern in terms of resolution enhancement is a sinusoidal intensity distribution.

To understand what happens when we excite a fluorescent sample with a sinusoidal light pattern, we again switch our analysis to Fourier space. Figure 16.2A shows a fine stripe pattern of the form $1 + m*\sin(\underline{u}*\underline{x})$. The factor m is called the

FIGURE 16.2

Working principle of 2D SIM. (A) Illumination intensity (sinusoidal pattern). (B) Low-pass filtered Fourier transform of the product of the illumination pattern with the fluorophore distribution in Fig. 16.1A. The three white dots represent the Fourier components of the illumination pattern in (A). Convolution with these Fourier components superimposes three copies of the object spectrum into the passband of the microscope (white arrows). (C) Reconstructed passband with enhanced support in the direction of pattern (A). (D) Reconstructed passband using three different orientations of the illumination pattern.

modulation contrast of the pattern, the magnitude of vector \underline{u} is the spatial frequency of the pattern, and \underline{x} is the position vector. If we take the Fourier transform of this pattern (white dots in Fig. 16.2B), we obtain three peaks (delta functions), one centered at the origin of reciprocal space and a peak at $+\underline{u}$ and one at $-\underline{u}$.

If we multiply in real space the stripe pattern with the fluorophore distribution of the sample, we obtain a modified fluorescence emission. The Fourier transform of this product becomes a convolution of the two functions in reciprocal space. The result can be visualized rather easily, as a convolution of a function with a delta function is trivial: it is the same function, however, centered at the position of the delta

function. The convolution with three delta functions becomes the superposition of three copies of the said function with each copy being centered at the peak of one of the delta functions.

This can be seen in Fig. 16.2B that shows the low-pass-filtered Fourier transform of the modified emission function. One can identify three copies of the original object spectrum, one centered at the origin (henceforth called the DC component), one at $+\underline{u}$, and one at $-\underline{u}$ (henceforth called sidebands). It is important to note that the frequency mixing occurs *before* the imaging process. Thus, the same rules as outlined in the previous section apply when imaging the modified fluorescence emission. Hence, only the information within a circle given by the Abbe diffraction limit is being transmitted by the microscope (Fig. 16.2B). Owing to the frequency mixing, the two additional sidebands have transferred some previously undetectable Fourier components into the passband of the OTF.

The remaining problem is that the two sidebands are superimposed with the DC component and that they are misplaced (shifted) in Fourier space. Separating the three information components can be achieved by phase stepping the illumination pattern and thereby changing the fluorescence emission. In Fourier space, the phase stepping changes the complex weight of the sidebands. Acquiring three images at different phase steps allows for the separation of the two sidebands from the DC component in a post-processing step, which is schematically shown in Fig. 16.2B (white arrows point to the separated bands). The two sidebands are then mathematically shifted to their proper position in frequency space and are combined with the DC component to yield a reconstruction of the sample spectrum with extended support (Fig. 16.2C). The resolution enhancement scales linearly with the magnitude of \underline{u}, that is, finer illumination patterns result in a larger extension of the passband, which in turn means higher resolution in real space. If the illumination pattern is projected onto the sample using the same objective that is used for image detection, then the illumination pattern is diffraction-limited to a similar value as the detection is. In frequency space, this means that the two spots responsible for the sidebands can at best lie on the circle that limits the passband of the microscope. In that scenario, one can effectively extend the passband twofold, which in turn results in doubling the spatial resolution in real space.

Obviously, the resolution enhancement only occurs in the direction of the pattern vector \underline{u}. In order to achieve isotropic resolution, the process is typically repeated twice, employing an illumination pattern that is rotated by steps of 60°. This yields an almost circular extended passband as shown in Fig. 16.2D.

It has to be noted that the presented SIM theory is not limited to one-dimensional stripe patterns that are applied sequentially. More complicated two- and three-dimensional patterns can be employed as well. As an example, Frohn and colleagues used a 2D pattern, formed by the incoherent superposition of two interference patterns that are normal to each other (Frohn, Knapp, & Stemmer, 2000). In Fourier space, the resulting illumination pattern consists of five peaks, which yield five copies of the object's spectrum, one DC component and four sidebands. The individual Fourier components can be unmixed by phase stepping of the illumination pattern.

Since there are five unknowns involved, at least five images at different phase steps need to be acquired. The advantage of such a scheme is that the amount of raw data is nearly cut in half (five images compared to nine images in the sequential scheme with three-pattern orientations), however, at the price of slightly anisotropic resolution (Stemmer, Beck, & Fiolka, 2008).

16.1.3 SIM COMBINED WITH TOTAL INTERNAL REFLECTION FLUORESCENCE MICROSCOPY

2D-structured illumination, as outlined in Section 16.1.2, is limited to very thin samples or to applications that can provide sectioning by other means. For thicker samples, out-of-focus blur will generate strong artifacts, as the 2D SIM theory only applies for in-focus information. There is a slightly different form of structured illumination that aims at optical sectioning only, which will not be discussed in this chapter (Neil, Juskaitis, & Wilson, 1997).

As a consequence, the most widespread application of 2D SIM is its combination with total internal reflection fluorescence (TIRF) microscopy that readily provides optical sectioning (Fiolka, Beck, & Stemmer, 2008; Kner, Chhun, Griffis, Winoto, & Gustafsson, 2009). This is schematically shown in Fig. 16.3: two mutually coherent laser beams are incident on the coverslip above the critical angle for total internal reflection. They create two counterpropagating evanescent fields that interfere with each other. The resulting intensity distribution is a fine lateral interference pattern that decays exponentially in the axial direction. With penetration depths below 100 nm, only a very thin slice in the proximity to the coverslip is illuminated, resulting in very crisp images that are almost free of any blur.

As a further advantage, the evanescent interference pattern can have a much finer line spacing than any interference pattern in the far field can have (for a given refractive index). This enables TIRF SIM to improve the resolution up to 2.5-fold into the range of 80–90 nm for green emission (Beck, Aschwanden, & Stemmer, 2008; Fiolka et al., 2008). An obvious drawback is that the evanescent field is bound to the coverslip and cannot be moved axially to image the interior of a cell.

FIGURE 16.3

Schematic illustration of SIM combined with total internal reflection fluorescence (TIRF). d, penetration depth of the evanescent field; n_1, refractive index of glass; n_2, refractive index of the sample.

16.2 3D SIM

Most cellular structures and processes are three-dimensional, and thus, they should be best studied with a microscope that has true 3D imaging capability. The classical widefield fluorescence microscope, however, is very limited in resolving any details in the axial direction and cannot reject out-of-focus fluorescence. The lack of any optical sectioning capability can turn any imaging attempts futile when out-of-focus blur dominates over the in-focus signal. The extension of structured illumination to 3D imaging, from now on referred to as 3D SIM, solves both of these shortcomings, as it doubles resolution in all three dimensions and also removes most of the out-of-focus light. In the field of structured illumination, 3D SIM has so far proved to be the most versatile and most widespread technique, as it can be applied to a wide range of samples, and it is also surprisingly robust and user-friendly. In the following sections, the theory and practical implementations of 3D SIM are presented.

16.2.1 3D IMAGE FORMATION

Before going into the theory behind 3D SIM, the very basics about three-dimensional image formation in a widefield microscope are introduced. In order to get a better understanding on how a microscope can gather 3D information of a sample, we first ask what information an electromagnetic field (from now on denoted as e-field) can transfer. In reciprocal space, all information that can be carried with a monochromatic wave lies on a sphere with radius n/λ (which we define here as the wavenumber K), as shown in Fig. 16.4A. Each point on this sphere corresponds to a plane wave traveling in a particular direction and has a phase and amplitude value. A microscope objective has only a limited acceptance angle, determined by its numerical aperture. Therefore, it can only collect a subset of this sphere, a spherical cap as shown in Fig. 16.4A.

When we acquire image data, we however do not measure the instantaneous e-field but its intensity, which is given as the e-field times its complex conjugate. In Fourier space, this operation can be visualized graphically: the result consists of all difference vectors than can be formed between all the points on the spherical cap. In Fig. 16.4B, this is shown in a 2D cross section for one point. If this procedure is repeated for all points on the spherical cap, one obtains the 3D OTF of a widefield microscope, as shown in Fig. 16.4C. If we Fourier transform the 3D OTF into real space, we obtain the 3D PSF, which is shown in Fig. 16.4D.

The image formation process in 3D works the same way as in 2D: in reciprocal space, the OTF is a three-dimensional low-pass filter that only transmits sample information that falls into its passband. In real space, the PSF blurs the information that is contained in a 3D data set. The 3D PSF is elongated in the axial direction, which causes the poor resolution in this direction (i.e., image data appear more blurry axially). Furthermore, one can also appreciate hourglass-shaped sidelobes that extend above and below the main lobe of the PSF. These structures are generating the out-of-focus blur. In reciprocal space, the same characteristics may be seen by analyzing the

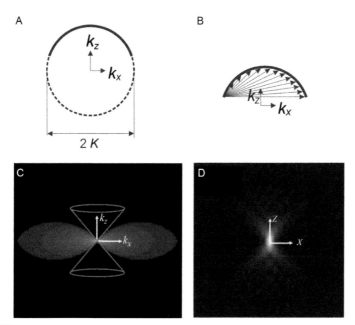

FIGURE 16.4

3D image formation in a widefield microscope. (A) Possible amplitudes of a monochromatic electromagnetic field (dotted line) and the spherical cap that can be accessed with a microscope objective. K is the wavenumber of light. (B) Difference vectors (arrows) for one point on the spherical cap in (A). Cross section through the 3D optical transfer function (OTF) of a widefield microscope. (D) Cross section through the 3D PSF of a widefield microscope.

OTF. It features a missing cone region as illustrated in Fig. 16.4C. In the axial direction, the OTF support is very limited to almost nonexistent on the optical axis itself. In order to gain axial resolution, this region of frequency space needs to be filled with sample information, which, as it turns out, will also give the microscope the capability of optical sectioning.

16.2.2 3D SIM THEORY

How does 3D SIM work? In principle, the same way as its two-dimensional version: an illumination pattern that varies in 3D space is used to enlarge the 3D OTF using sample information that becomes accessible via frequency mixing. Figure 16.5A illustrates the generation of one possible pattern that is tilted in 3D space. Two illumination beams are employed, one traveling along the optical axis and one among a marginal ray (a ray that travels at the highest incidence angle allowed by the objective). The Fourier components can be readily determined by taking the difference vectors between the two waves (white dots in Fig. 16.5B). Using this illumination

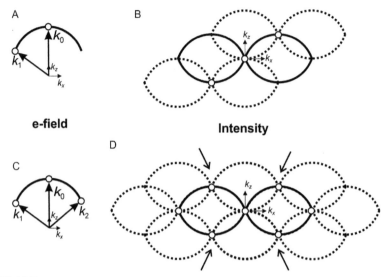

FIGURE 16.5

Schematic illustration of the resolution enhancement in 3D SIM. (A) Pattern generation using two illumination beams, one along the optical axis (wavevector k_0) and one along a marginal ray (wavevector k_1). (B) Fourier components of the illumination pattern of (A) (white dots) and Fourier components of the sample that become accessible (within solid line and dotted line). (C) Pattern generation using three-beam illumination, one beam along the optical axis (wavevector k_0) and two beams along marginal rays (wavevectors k_1 and k_2). (D) Fourier components of the illumination pattern corresponding to (C) (white dots) and Fourier components of the sample that become accessible (within solid and dotted lines). Arrows indicate new missing cone regions.

pattern, two additional sidebands (dotted line in Fig. 16.5B) are encoded that readily fill the missing cone, which in turn enables optical sectioning.

Surprisingly, with the addition of only one more illumination beam (Fig. 16.5C), the resulting illumination pattern contains seven Fourier components (white dots in Fig. 16.5D) that can double the OTF support both laterally and axially (Fig. 16.5D). One can see that the extended passband features new "missing cones" (arrows in Fig. 16.5D), since the copies have the same shape as the widefield OTF. However, these "dimples" do not exhibit the same detrimental effects as the missing cone in the conventional widefield OTF. Furthermore, upon lateral rotation of the illumination pattern and repeating the reconstruction procedure, a more isotropically enlarged OTF can be obtained that effectively removes the dimples.

There is however a subtle difference between the 3D and the 2D case. This difference lies in how we acquire the raw image data. A 2D image can be formed in parallel on a camera, but a 3D image data set needs to be acquired by scanning the sample axially. This is typically done by acquiring a focal series of images while

incrementally moving the sample stage or the objective. To keep the analogy between 2D and 3D SIM, we would need to keep the illumination pattern stationary in respect to the reference frame of the sample while we acquire our 3D image stack by z-stepping. If we do so, image formation and frequency mixing of new information are conceptually the same as in the 2D case: Two shifted copies of the sample spectrum are created and the superimposed information (DC band plus two sidebands) is transmitted by the conventional widefield OTF. The two sidebands can be recovered using phase stepping of the illumination pattern and need to be shifted to their true origin in 3D reciprocal space, as it was outlined for 2D SIM.

However, due to the serial (and not parallel) scanning of the axial direction, one can alternatively keep the illumination pattern fixed to the focal plane while acquiring a focal series. In this case, the sample is being scanned with the focal plane *and* the pattern. The outcome is that the two sidebands will already appear separated in the axial direction in a Fourier transform of the raw data. In other words, the passband of the OTF has been physically extended. This process is henceforth called self-demodulation. To intuitively understand this process, the reader might replace the sinusoidal illumination pattern with a very thin light sheet, that is, a Gaussian function centered on the focal plane. If one imagines a very thin light sheet, it becomes obvious that the resulting "optical sections" will already exhibit a greatly improved axial resolution. As this increased axial resolution is already present in the raw data, its Fourier transform needs to feature an extended support to afford for the increased axial resolution. The same argument applies when a sinusoidal function is used. While a sinusoidal function features a different Fourier transform than a Gaussian one, the mechanism remains the same.

Most 3D SIM implementations use the outlined self-demodulation scheme for the axial components of the illumination pattern (Gustafsson et al., 2008). However, any lateral frequency components of the illumination still require active demodulation, that is, separation of the sidebands via phase stepping and shifting them to their true origin in frequency space.

16.2.3 PRACTICAL IMPLEMENTATIONS OF 3D SIM

In this section, the technical implementation of 3D SIM is discussed. Most commonly, a phase grating is imaged into the sample plane by using the zero and ± 1 diffraction orders (Fig. 16.6). As we have seen in Section 16.2.2, such a three-beam illumination scheme generates the necessary axial components in the interference pattern. A schematic representation of the resulting 3D interference pattern is shown in the circular inset in Fig. 16.6. The popularity of this "image"-based approach to generate the illumination pattern stems from the fact that such an implementation is very stable, as all the beams travel through the same optics (also referred to as *common path*). For phase stepping and orientation of the illumination pattern, the grating needs to be translated and rotated. This can be done by mechanical means (a combination of a translation and rotation stage) (Gustafsson et al., 2008) or by using a spatial light modulator as a programmable diffraction grating. The latter

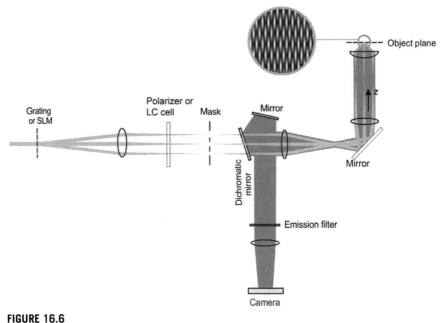

FIGURE 16.6

Schematic representation of a 3D SIM setup. The round inset shows a simulation of a three-beam illumination interference pattern. SLM, spatial light modulator; LC, liquid crystal.

approach offers pattern switching times below 1 ms (Fiolka et al., 2012; Kner et al., 2009; Shao et al., 2011), which makes the camera integration time the rate-determining step in the image acquisition.

For every pattern orientation, s-polarization of the laser beams in the sample plane needs to be maintained to achieve the highest possible modulation contrast. This can be achieved by rotating a polarizer with the phase grating or by using a dedicated liquid crystal cell. In any case, great care needs to be taken that no depolarization is introduced by the optical components in the setup. Mirrors, especially dichroic ones, can introduce a large phase shift between the s- and p-polarization components, which can significantly alter the polarization state of the laser beams in the sample plane. Failure to prevent this can result in a drastic loss of modulation contrast for certain pattern orientations, which in turn can prevent successful SIM reconstructions. Therefore, often custom-made dichroic mirrors are employed that were engineered to have as little as possible depolarization effects around the laser lines that are used in the microscope. It is easier to achieve this design goal in a dichroic mirror in transmission at a shallow angle, which can lead to a mirror arrangement as shown in Fig. 16.6.

To acquire a 3D stack, either the sample or the objective is moved in fine steps along the optical axis to acquire a focal series. By doing so, the illumination pattern

remains fixed to the focal plane. This results in self-demodulation of the axial sidebands and the minimal number of phase steps per orientation amounts to five in 3D SIM. Accounting for the three orientations of the illumination pattern, a total of 15 images need to be acquired per focal plane. Due to the effectively enlarged z-resolution in the raw data, however, an axial sampling twice as fine as in conventional microscopy needs to be applied.

If in contrast the pattern remains fixed to the sample, no self-demodulation in any spatial direction occurs, as described in Section 16.2.2. Therefore, seven components per orientation would need to be unmixed. This requires at least seven phase steps, which results in a total of 21 raw images per focal plane. However, the number of z-slices in a 3D image stack is reduced by a factor of 2, as the raw data are transferred within the classical widefield OTF (hence, coarser sampling is sufficient). This corresponds to a reduction of raw images by a factor of \sim1.4 compared to the self-demodulation case. Although such a scheme would be interesting in terms of acquisition rate, in practice, it proved to be too complex: in order to keep the interference pattern fixed to the sample while it is being scanned in the z-direction, the grating would need to move along the optical axis accordingly (or alternatively, a suitable phase shift would need to be introduced between the zero and ± 1 diffraction orders). To date, all successful 3D SIM systems keep the axial illumination component fixed to the focal plane, as it proved to be much simpler and reliable than trying to keep the pattern fixed in respect to the sample.

16.3 SIM IMAGING EXAMPLES
16.3.1 TIRF SIM APPLICATION

Figure 16.7 shows an example of live-cell imaging of HeLa cells expressing alpha-tubulin EGFP using TIRF and TIRF SIM. A Zeiss NA 1.45/100× objective was employed, the excitation wavelength was 488 nm, the penetration depth (calculated) amounted to 217 nm, and the line spacing of the SIM pattern was 181 nm in the sample plane. TIRF SIM reveals the tubulin network with much greater detail than widefield microscopy (insets in Fig. 16.7). Using fluorescent microspheres, a resolution of around 90 nm was measured with comparable experimental conditions (Beck et al., 2008; Fiolka et al., 2008).

16.3.2 3D SIM APPLICATIONS

Live HeLa cells labeled with MitoTracker green were imaged using a 3D SIM setup suitable for fast image acquisition (maximum volume rate of 1 Hz per 1 μm thickness). Figure 16.8 shows mitochondria in a HeLa cell as imaged by standard widefield microscopy (A and C) and 3D SIM (B and D). Notably, 3D SIM removes almost all out-of-focus blur, which becomes very obvious in a Y–Z cross section (Fig. 16.8C and D). In addition, the twofold increase in resolution clearly resolves individual

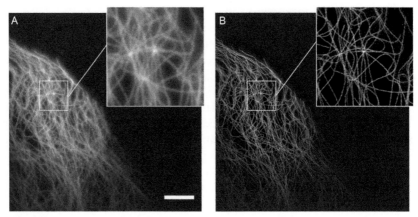

FIGURE 16.7

Microtubular network in a live HeLa cell, as imaged with TIRF microscopy (A) and TIRF SIM (B). Scale bar 10 μm.

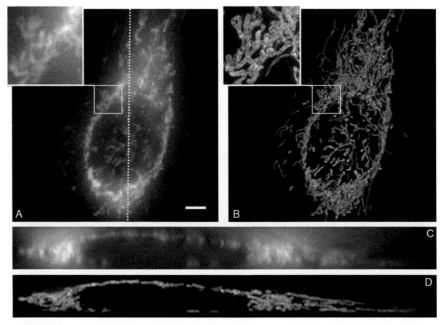

FIGURE 16.8

Mitochondria in a live HeLa cell, as imaged with widefield and 3D SIM microscopy. (A) Maximum intensity projection of a 3D data set acquired with widefield microscopy. (B) Maximum intensity projection of a 3D data set acquired with 3D SIM. (C and D) Y–Z cross section along the dotted line in (A) acquired with widefield microscopy (C) and 3D SIM (D). Scale bar 10 μm.

mitochondria in the axial direction (Fig. 16.8D), which are unresolvable in the widefield image (Fig. 16.8C). In a lateral view, 3D SIM reveals internal structures in the mitochondria that resemble cristae, as shown in the inset in Fig. 16.8B.

To illustrate the potential of 3D SIM for time-lapse imaging, HeLa cells labeled with TD tomato LifeAct were imaged using 3D SIM. The acquisition of one time point (one complete 3D data set) took 21 s and a wait time of an additional 21 s was inserted before the next stack was acquired.

Figure 16.9A shows a cropped maximum intensity projection of a widefield image at the first time point. Figure 16.9B–F shows maximum intensity projections of all odd time points of the time-lapse series acquired with 3D SIM. 3D SIM reveals dramatically more details of the actin structures within filopodia. In addition, the acquisition frame rate was fast enough to follow the dynamics of the actin structures throughout the whole cell without any noticeable motion blur or related artifacts.

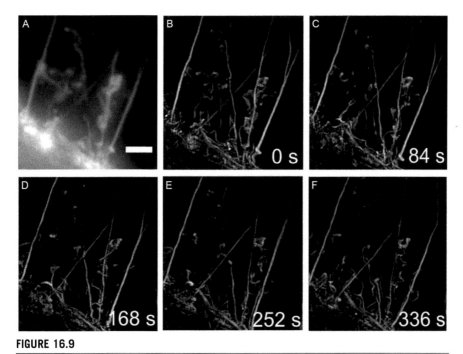

FIGURE 16.9

Time-lapse imaging of a HeLa cell labeled with TD tomato LifeAct. (A) Maximum intensity projection at the first time point of a 3D data set acquired with widefield microscopy. (B–F) Maximum intensity projection through time points 1, 3, 5, 7, and 9 using 3D SIM. Scale bar 5 μm.

16.4 PRACTICAL CONSIDERATIONS AND POTENTIAL PITFALLS

In SIM, it is recommended to put in a great effort to achieve high image quality in the raw data—in other words, to minimize aberrations in the microscope system and to maintain a decent signal-to-noise ratio (SNR; Chapter 1). 3D SIM can tolerate shift-invariant aberrations to a certain degree (provided that the OTF is not too severely deteriorated), as long as the PSF is accurately measured and does not change from the calibration to the actual biological imaging. As an example, mild spherical aberrations do not cause a problem as long as they are accounted for with a measured PSF. To achieve the same PSF in each experiment, the thickness of the coverslip should be comparable (within $\pm 5\ \mu m$) and the settings of the objective correction collar (Chapter 2) should not be altered between experiments.

What cannot be tolerated are aberrations that vary throughout imaging space, as SIM builds on the principle of shift-invariant imaging. While most microscopes are very good at providing shift-invariant lateral imaging, refractive index mismatch will inevitably cause the PSF to vary in the axial direction. It is therefore mandatory to match the refractive index closely to the design refractive index of the immersion objective (e.g., water, glycerol, and oil). Live 3D cell imaging (watery medium) has to be performed exclusively with water immersion objectives and not with high-NA oil-immersion objectives.

TIRF SIM relies more strongly on a sharp lateral PSF as the overlap region of the sidebands with the DC band in Fourier space is narrower than in 3D SIM. A poor, aberrated PSF results in an OTF with a smaller passband, which in turn makes SIM reconstructions more difficult. One can improve the PSF in a high-NA TIRF objective by empirically varying the refractive index of the immersion oil (Rego et al., 2012). In addition, great care should be taken to perfectly focus onto the sample. If the evanescent field layer is slightly out-of-focus, the image will be less sharp and will be transferred with a weaker OTF. A perfect focusing system, which has recently become commercially available, can help to consistently find and maintain the optimal position of the focal plane.

Another critical aspect in TIRF SIM is the alignment of the illumination beams. Their incident angles need to be tightly matched such that all beams generate an evanescent field of equal penetration depth. If one beam happens to fall slightly out of TIR, it will generate undue amounts of blur. As mentioned earlier, blur is not accounted for in the 2D SIM theory and will cause artifacts. But even with perfect beam alignment, some out-of-focus blur is unavoidable in TIRF as the evanescent field is scattered by cellular structures (Mattheyses, Shaw, & Axelrod, 2006). Depending on the labeling density, the scattered light will cause fluorescence excitation outside of the evanescent field.

Reconstruction artifacts in SIM (3D and TIRF) can occur due to insufficient knowledge of the imaging parameters (such as pattern orientation, phase, and line spacing), from insufficient modulation contrast of the illumination pattern or poor SNR of the raw data. The fidelity of a SIM reconstruction can be estimated by

the correlation coefficient of the Fourier components within the overlap region between the sidebands and the DC band. A perfect reconstruction should yield a perfect match of the overlapping components and hence a high correlation coefficient. If the separation of the components fails due to phase shift errors or the different components are "stitched" together wrongly due to errors in estimating the line spacing or orientation of the pattern, the correlation coefficient drops drastically.

A great effort has been dedicated to reliably estimate all illumination parameters from the raw data itself (Wicker, 2013; Wicker, Mandula, Best, Fiolka, & Heintzmann, 2013). The involved algorithms have improved so far that phase step errors can be compensated and the line spacing and orientation of the pattern do not need to be known *a priori*. However, the only parameter that cannot be fixed computationally is the modulation contrast. If it is too low, the sidebands will be transferred with very limited strength and their associated SNR will become too low to yield a reasonable reconstruction. The modulation contrast can be retrieved from the reconstruction algorithm and should be comparable for all orientations of the illumination pattern. If it varies from pattern to pattern, then some detective work is needed on the microscope system. To do so, the laser power first needs to be reduced and the operator should wear laser safety glasses. A polarizer can be placed on the nose piece of the microscope after removing the objective. For every pattern orientation, one should be able to almost completely extinct the laser beams by turning the polarizer. If this is not the case, then either the polarization rotation mechanism is defective or some components, like the dichroic mirror, introduce an unacceptable amount of depolarization and need to be replaced.

16.5 DISCUSSION

SIM has become an attractive choice for live-cell imaging at extended resolution. It is a very "biocompatible" technique as it can be operated at low light levels and does not require specialized fluorophores or sample preparation. With the advent of commercial systems, it is expected that SIM will challenge the current workhorse in cell biology, the confocal microscope. In contrast to confocal microscopy, SIM offers increased spatial resolution and a parallelized and light-efficient image acquisition.

Since SIM does not have a physical mechanism to reject out-of-focus light, its penetration depth is limited. For large and densely labeled samples, the SIM raw data will contain mostly out-of-focus light. As soon as the associated shot noise (Chapters 1 and 3) exceeds the in-focus signal, SIM reconstructions are expected to fail. Thus, there is a crossover point where a confocal microscope will start to perform better due to its physical blur rejection mechanism. As an example, SIM imaging performance was found to deteriorate when imaging early *C. elegans* embryos consisting of multiple cells (Gao et al., 2012). However, applied to single cells up to depths of around 10–15 μm, SIM routinely achieves its nominal resolution and outperforms a confocal microscope (Schermelleh et al., 2008).

Other superresolution techniques can achieve much greater spatial resolution, however, at the cost of temporal resolution, and often, drastically higher light intensities are needed. Therefore, most of these techniques are limited to fixed samples. There are nonlinear versions of SIM that are not fundamentally limited in resolving power and spatial resolution in the range of 50 nm has been reported (Gustafsson, 2005; Rego et al., 2012). In contrast to localization-based microscopy techniques, nonlinear SIM does not rely on sparse emission, which in turn reduces the amount of raw images needed to reconstruct one superresolution image. Therefore, it is expected that nonlinear SIM can be applied to live-cell superresolution imaging at moderate frame rates.

In summary, SIM can double the resolution in all three spatial dimensions in a widefield fluorescence microscope. It does so without discarding any fluorescence light or requiring excessive excitation intensities. Therefore, it is very well suited for live-cell imaging and is expected to play an important role in the life sciences.

REFERENCES

Abbe, E. (1873). Beiträge zur theorie des mikroskops und der mikroskopischen wahrnehmung. *Archiv für mikroskopische Anatomie, 9*(1), 413–418.

Beck, M., Aschwanden, M., & Stemmer, A. (2008). Sub-100-nanometre resolution in total internal reflection fluorescence microscopy. *Journal of Microscopy, 232*(1), 99–105.

Betzig, E., Patterson, G. H., Sougrat, R., Lindwasser, O. Wolf, Olenych, S., Bonifacino, J. S., et al. (2006). Imaging intracellular fluorescent proteins at nanometer resolution. *Science, 313*(5793), 1642–1645.

Fiolka, R., Beck, M., & Stemmer, A. (2008). Structured illumination in total internal reflection fluorescence microscopy using a spatial light modulator. *Optics Letters, 33*(14), 1629–1631.

Fiolka, R., Shao, L., Rego, E. H., Davidson, M. W., & Gustafsson, M. G. L. (2012). Time-lapse two-color 3D imaging of live cells with doubled resolution using structured illumination. *Proceedings of the National Academy of Sciences of the United States of America, 109*(14), 5311–5315.

Frohn, J. T., Knapp, H. F., & Stemmer, A. (2000). True optical resolution beyond the Rayleigh limit achieved by standing wave illumination. *Proceedings of the National Academy of Sciences of the United States of America, 97*(13), 7232–7236.

Gao, L., Shao, L., Higgins, C. D., Poulton, J. S., Peifer, M., Davidson, M. W., et al. (2012). Noninvasive imaging beyond the diffraction limit of 3D dynamics in thickly fluorescent specimens. *Cell, 151*(6), 1370–1385.

Gustafsson, M. G. L. (2005). Nonlinear structured-illumination microscopy: Wide-field fluorescence imaging with theoretically unlimited resolution. *Proceedings of the National Academy of Sciences of the United States of America, 102*(37), 13081–13086.

Gustafsson, M. G. L., Shao, L., Carlton, P. M., Wang, C. J. R., Golubovskaya, I. N., Cande, W. Z., et al. (2008). Three-dimensional resolution doubling in wide-field fluorescence microscopy by structured illumination. *Biophysical Journal, 94*(12), 4957–4970.

Klar, T. A., Jakobs, S., Dyba, M., Egner, A., & Hell, S. W. (2000). Fluorescence microscopy with diffraction resolution barrier broken by stimulated emission. *Proceedings of the National Academy of Sciences of the United States of America*, *97*(15), 8206–8210.

Kner, P., Chhun, B. B., Griffis, E. R., Winoto, L., & Gustafsson, M. G. L. (2009). Super-resolution video microscopy of live cells by structured illumination. *Nature Methods*, *6*(5), 339–342.

Mattheyses, A. L., Shaw, K., & Axelrod, D. (2006). Effective elimination of laser interference fringing in fluorescence microscopy by spinning azimuthal incidence angle. *Microscopy Research and Technique*, *69*(8), 642–647.

Neil, M. A. A., Juskaitis, R., & Wilson, T. (1997). Method of obtaining optical sectioning by using structured light in a conventional microscope. *Optics Letters*, *22*(24), 1905–1907.

Pawley, J. B. (2006). *Handbook of biological confocal microscopy*. New York: Plenum Press.

Rego, E. H., Shao, L., Macklin, J. J., Winoto, L., Johansson, G. A., Kamps-Hughes, N., et al. (2012). Nonlinear structured-illumination microscopy with a photoswitchable protein reveals cellular structures at 50-nm resolution. *Proceedings of the National Academy of Sciences of the United States of America*, *109*(3), E135–E143.

Rittweger, E., Han, K. Y., Irvine, S. E., Eggeling, C., & Hell, S. W. (2009). STED microscopy reveals crystal colour centres with nanometric resolution. *Nature Photonics*, *3*(3), 144–147.

Rust, M. J., Bates, M., & Zhuang, X. (2006). Sub-diffraction-limit imaging by stochastic optical reconstruction microscopy (STORM). *Nature Methods*, *3*(10), 793–796.

Schermelleh, L., Carlton, P. M., Haase, S., Shao, L., Winoto, L., Kner, P., et al. (2008). Sub-diffraction multicolor imaging of the nuclear periphery with 3D structured illumination microscopy. *Science*, *320*(5881), 1332–1336.

Shao, L., Kner, P., Rego, E. H., & Gustafsson, M. G. L. (2011). Super-resolution 3D microscopy of live whole cells using structured illumination. *Nature Methods*, *8*(12), 1044–1046, advance online publication.

Stemmer, A., Beck, M., & Fiolka, R. (2008). Widefield fluorescence microscopy with extended resolution. *Histochemistry and Cell Biology*, *130*(5), 807–817.

Vaughan, J. C., Jia, S., & Zhuang, X. (2012). Ultrabright photoactivatable fluorophores created by reductive caging. *Nature Methods*, *9*(12), 1181–1184.

Wicker, K. (2013). Non-iterative determination of pattern phase in structured illumination microscopy using auto-correlations in Fourier space. *Optics Express*, *21*(21), 24692–24701.

Wicker, K., Mandula, O., Best, G., Fiolka, R., & Heintzmann, R. (2013). Phase optimisation for structured illumination microscopy. *Optics Express*, *21*(2), 2032–2049.

CHAPTER

Structured illumination superresolution imaging of the cytoskeleton

17

Ulrike Engel

Center for Organismal Studies and Nikon Imaging Center, Bioquant, University of Heidelberg, Heidelberg, Germany

CHAPTER OUTLINE

Introduction	316
Superresolution Microscopy	316
SIM for Imaging of the Cytoskeleton	316
17.1 Instrumentation for SIM Imaging	316
17.1.1 Illumination Pattern	317
17.1.2 Objective and Camera	317
17.1.3 Reconstruction and Judging of SIM Images	321
17.2 Sample Preparation	322
17.2.1 Materials	322
17.2.2 Choice of Fluorophore and Staining	322
17.2.3 Fixation	323
17.2.4 Index Matching and Embedding of Sample	323
17.3 Minimizing Spherical Aberration	324
17.3.1 What is Spherical Aberration and When Does It Occur	324
17.3.2 Steps to Minimize Spherical Aberration on the Microscope	325
17.4 Multichannel SIM	327
17.4.1 Setting Up Multicolor SIM	327
17.4.2 Correction for Chromatic Shift	328
17.4.3 Colocalization	328
17.4.4 Notes on Quantitative Analysis of Intensity Distribution	328
17.5 Live Imaging with SIM	330
Acknowledgments	331
References	331

Abstract

Structured illumination microscopy (SIM) with a 3-dimensional illumination pattern allows to double image resolution laterally and axially. For cell biologists, SIM may become an attractive tool for refined colocalization studies and to investigate the assembly of components at higher resolution. In this chapter, we focus on the use of a commercial available SIM setup and provide guidance on sample preparation and image acquisition. We present superresolution images of the cytoskeleton in fixed cells and discuss the potential and limitations for SIM in live imaging.

INTRODUCTION
SUPERRESOLUTION MICROSCOPY

The resolution limit in light microscopy as imposed by diffraction is around 200 nm, structures spaced less than that cannot be discerned from each other. Several techniques surpassing this resolution limit are summarized as superresolution techniques (Huang, Bates, & Zhuang, 2009; Schermelleh, Heintzmann, & Leonhardt, 2010), although they differ in approach (Han, Li, Fan, & Jiang, 2013). Structured illumination microscopy (SIM) achieves a resolution doubling by combining widefield imaging with an illumination pattern that allows to transport frequencies that are otherwise unresolved into the detection range of the microscope (Gustafsson, 2000a). In three-dimensional structured illumination microscopy (3D-SIM), also the axial resolution can be doubled (Gustafsson et al., 2008). Further resolution increase can be achieved by nonlinear SIM using photoactivatable proteins (Rego et al., 2012).

SIM FOR IMAGING OF THE CYTOSKELETON

In comparison with superresolution methods based on single-molecule detection (e.g., PALM and STORM), the resolution gain with SIM is modest, but since it applies laterally and axially, the localization volume is 1/8th (Schermelleh et al., 2010). Since 3D-SIM can work in intact cells and provides a large field of view, it captures structures within their cellular context.

3D-SIM provided new insight into the organization of actin networks at the leading edge or neuronal growth cones (Marx et al., 2013) and CAD cells (Vitriol, Wise, Berginski, Bamburg, & Zheng, 2013). Thanks to its ease in multichannel imaging, 3D-SIM has been successfully used to study centrosome organization (Mennella et al., 2012; Sonnen, Schermelleh, Leonhardt, & Nigg, 2012) and demonstrate colocalization of flotillin and N-cadherin at the cell periphery (Guillaume et al., 2013). SIM can be used for time-lapse imaging (see Section 17.5), but in our hands, time-lapse imaging requires far more from sample and operator, than fixed specimen.

17.1 INSTRUMENTATION FOR SIM IMAGING

We use a Nikon SIM (N-SIM) setup on an inverted microscope equipped with four lasers, but for experiments presented here, a 488 and a 561 nm laser would be sufficient. A schematic overview of the setup shows that the system can be operated as

either 2D-SIM or 3D-SIM setup. A phase grating moved by a piezo and illuminated by a multimode laser fiber generates the pattern. The 2D illumination and 3D illumination use the same grating; however, in the 3D pattern, three beams corresponding to +1, 0, and −1 diffraction orders of the phase grating interfere to produce a coarse, but 3D pattern (Fig. 17.1B′; Gustafsson et al., 2008), whereas only +1 and −1 diffraction orders contribute to the 2D pattern (Fig. 17.1B).

17.1.1 ILLUMINATION PATTERN

The phase grating generates a sinusoidal stripe pattern in the focus plane. The 2D pattern has a fine pitch (Fig. 17.1C), but does not extend axially (Fig. 17.1B). In our hands, it only produces good results for very thin specimens, such as chromosome spreads. All experiments described here use the 3D-SIM pattern, which also provides an increase of resolution in the axial direction (Gustafsson et al., 2008).

The illumination pattern is often well visible in raw images (Fig. 17.2A–C). To produce one superresolution image, the 3D pattern is projected in three orientations and shifted five times for each of these orientations, resulting in 15 images (Fig. 17.2A). Adding all 15 images results in an image that is evenly illuminated (Fig. 17.2D). This widefield image can be used as a reference for comparison. Indeed, it is a good reference, as it results from the same amount of photons as the superresolution image.

17.1.2 OBJECTIVE AND CAMERA

The obvious choice for the objective is one with a high numerical aperture (NA). The NA of the objective (Chapter 2) defines the resolution that can be achieved in widefield fluorescence, which is then doubled in SIM. The N-SIM makes use of a TIRF objective with a NA of 1.49 (Fig. 17.3C).

For simplicity, we concentrate here on the objective as an image forming device and the camera, to show how optical resolution and pixel resolution have to be matched. In commercial systems, either EM-CCD or sCMOS cameras (Chapter 3) are used. The N-SIM uses an EM-CCD with a back-illuminated chip, which provides the highest quantum efficiency (greater than 95% at 600 nm). In EM-CCDs, the generated photoelectrons are amplified on chip by an electron multiplier (EM) prior to readout to elevate the signal over the read noise. sCMOS cameras do not use an EM, because their read noise is very low already. The advantage is that they have much more pixels of relatively small size compared to the EM-CCDs. A drawback is that the quantum efficiency is generally below 60%.

Objective and camera play together to generate resolution in a digital image:

- The optical resolution can be calculated by the Rayleigh criterion: $d_{min} = 0.61 \times \lambda/\text{NA}$ objective. For the Nikon TIRF objective and green emission, this equals 210 nm. To faithfully display this in a digital image, 2–3 pixels have to be used per 210 nm to make sure that no information is lost (Pawley, 2006).

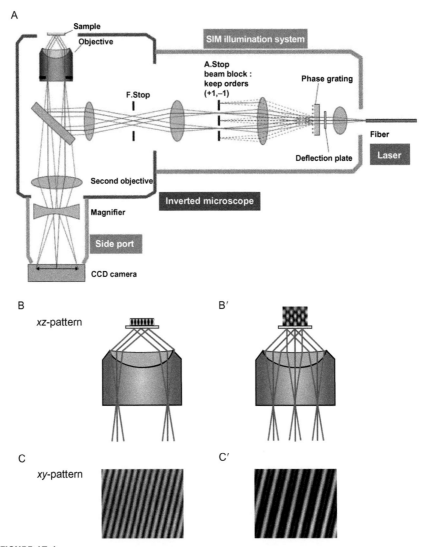

FIGURE 17.1

SIM for superresolution. (A) Schematic overview of SIM microscope setup as described by Gustafsson, Agard, and Sedat (2000b). In 2D-SIM illumination, interference of two beams at the focus plane (B) results in a fine sinusoidal pattern (C), whereas in 3D-SIM illumination, three beams interfere to result in a modulated intensity along the z-axis (B′) and a coarser pattern in xy (C′).

Panels A–B′ with kind permission from Nikon Inc.

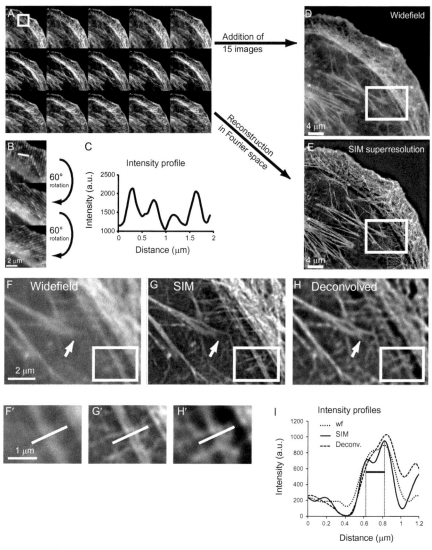

FIGURE 17.2

3D-SIM raw images and reconstructed superresolution images. The example shows an epithelial cell stained with phalloidin Atto 565. For 3D-SIM reconstruction, 15 raw images (A) are acquired, including three rotations (B). The sinusoidal illumination pattern (C) is often visible. The raw images can be added to result in a widefield image (D) or be used to calculate a superresolution image (E). A detail of the image shows how actin bundles are anchored to the substrate (arrow). The SIM image (G) shows fine fibers, which are not visible in the widefield image (F). Deconvolution of widefield images improves contrast, but fails to reveal equally fine structures. An inset (F′, G′, and H′) shows two parallel running actin bundles in all modes. Evaluation of a line profile (I) demonstrates that SIM clearly resolves the bundles spaced by 165 nm, whereas in widefield and deconvolved images, they cannot be resolved.

Panels A–E adapted from Engel (2012).

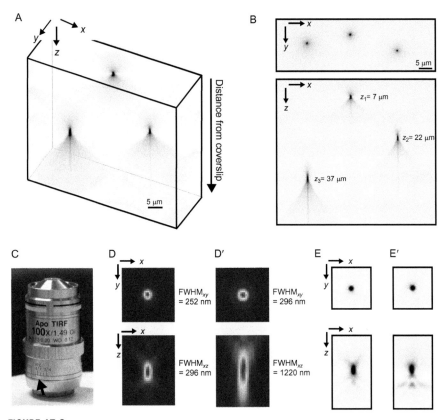

FIGURE 17.3

Distortion of PFS due to spherical aberration. (A and B) Fluorescent microbeads (100 nm diameter) embedded in agar imaged with a NA 1.4 oil objective. Depth-dependent spherical aberration introduced by mismatch between RI of immersion (oil = 1.51) and the aqueous medium (agar, close to water = 1.3) leads to an elongation of the PSF in the axial direction. A three-dimensional rendering (A) illustrates the difference in shape of the PSF at different distances from the objective. In (B), an xy maximal projection and an xz maximal projection are shown with the z-position of the beads indicated. (C) Nikon Apo TIRF objective used for SIM with coverslip correction collar. The correction collar (arrow) includes a temperature correction from 23 to 37 °C. (D and D′) Influence of correction collar on PSF illustrated by slices in xy and xz for correct (D) and wrong position (D′). The full width at half maximum (FWHM) measurements show the dramatic effect on the axial spread. (E) Mounting of specimen affects PSF shape. (E) Shows specimen mounted with level coverslip, (E′) with a slight deviation from horizontal.

- On the Andor iXon EM-CCD camera, pixels are 16 μm in size. The 210 nm in the sample is magnified by the 100× TIRF objective to 21 μm, obviously not enough to fit 2–3 pixels into them. Therefore, the N-SIM uses an additional magnification lens of 2.5× mounted in front of the camera. This results in a small field of view (32 μm length) but is necessary to sample all the resolution in the raw image. In comparison, sCMOS with more and smaller pixels will provide a much bigger field of view.
- As in the reconstructed image, the resolution limit is halved, and the number of pixels (512 × 512) is doubled (1024 × 1024) by interpolation to accommodate the newly gained resolution. In the case of the N-SIM, the pixel size in the raw image is 64 nm and decreased to 32 nm after reconstruction.

Tip: In EM-CCDs, it is important to understand that a high pixel count (gray level) does not necessarily mean a good signal. In an image with a peak gray level of 3000, less bright features are maybe only 300 gray levels. With a gain of 300×, these 300 counts might reflect as little as 38 photoelectrons (3 MHz, 14-bit readout). Because of the stochastic nature of photons, the signal-to-noise ratio will be around 6:1 and the noise will make it difficult to extract superresolution information. Therefore, when signal is abundant, the gain should only be used at moderate levels (e.g., <100×). High gain also cuts into the dynamic range, and (even with 14 or 16 bits) at high amplifications, part of the image may be saturated, making the image useless for reconstruction.

17.1.3 RECONSTRUCTION AND JUDGING OF SIM IMAGES

Commercial systems integrate data acquisition and reconstruction into the same software. The superresolution image is assembled from the raw images in Fourier space, using the algorithm published by Gustafsson et al. (2008). This reconstruction works on 3D image data; therefore, a 3D image stack needs to be acquired with a defined z-distance (120 nm). Nikon also offers a reconstruction that works on single slices. This has the advantage of speed (see Section 17.5), but sometimes out of focus signal is not completely suppressed.

A common way to judge resolution is to plot a line intensity profile across a fine structure. The full width at half maximum (FWHM) of the intensity distribution can be used as absolute measure for resolution if the size of the object is known (e.g., 100 nm beads; Fig. 17.3D; Hibbs, McDonald, & Garsha, 2006). Alternatively, the distance between two peaks can be used. In Fig. 17.2, the peak distance between two adjacent actin bundles is used to demonstrate that SIM can resolve structures spaced 165 nm, while in widefield, this is not possible (compare Fig. 17.2F′ and G′; profile in I). We also compared the SIM image with a deconvolved image. Deconvolution is a computational way to enhance localization accuracy (Cannel, McMorland, & Soeller, 2006), and we used a method based on a calculated point spread function (PSF) to deconvolve the widefield image stack (Huygens 4.2 software, SVI, Hilversum, The Netherlands). In the deconvolved widefield images, the blur is successfully removed; however, the fine bundles are less clear and show artificial thickenings at crossing points (compare Fig. 17.2G′ and H′).

17.2 SAMPLE PREPARATION
17.2.1 MATERIALS

Coverslip dishes
 MatTek glass bottom dishes, 35 mm diameter, P35G-1.5-14C (MatTek Corporation, Ashland, MA, USA)
 Alternatively, chambered cover glass (Lab-Tek II, Thermo Fisher Scientific)

Fixative
 4% Paraformaldehyde (EM grade) in phosphate-buffered saline (PBS) with 30% sucrose

Primary antibodies
 Anti-α-tubulin clone DM1A, #T6199, Sigma
 Anti-paxillin, clone 349, #610051, BD Biosciences

Secondary antibodies
 Here, IgG, H+L chain preparations are used at 1:400
 Alexa Fluor 488 goat anti-mouse, A-11001, Life Technologies
 Alexa Fluor 568 goat anti-mouse, A-11004, Life Technologies

Fluorescent dyes
 Phalloidin coupled to ATTO-565 (AD 565-81, ATTO-TEC GmbH, Siegen, Germany), use 40 nM
 Phalloidin coupled to Alexa Fluor 488 (Life Technologies), use 100–200 nM

Mounting and index matching
 ProLong Gold (Life Technologies)
 TDE (2,2′-thiodiethanol) (Abberior GmbH, Göttingen, Germany)

Bead samples
 Microbeads: FluoSpheres 0.1 μm, red fluorescent F-8801 or yellow-green fluorescent, F-8803, Life Technologies
 Multicolor beads: TetraSpeck 0.2 μm, T7280, Life Technologies
 Poly-D-lysine, P6407, Sigma

17.2.2 CHOICE OF FLUOROPHORE AND STAINING

A good SIM specimen is one with bright fluorescence and little background, as low photon counts are associated with noise, which will make reconstruction difficult. Fluorophore brightness can be characterized by the amount of photons absorbed by the molecule (molar extinction coefficient) and the relative amount of fluorescence photons emitted (quantum yield). The obvious choices are fluorophores with high absorption and high yield. However, bleaching is another criterion and that is why FITC should not be used, but replaced by more stable fluorophores such as Alexa Fluor 488.

 Brightness is also achieved by high density of fluorophore. DAPI and phalloidin are powerful stains, as the small molecules have many binding sites. With antibodies,

high fluorophore density can be achieved by indirect immunofluorescence, as the primary antibody is amplified by several fluorophore-coupled secondary antibodies. In the succeeding text, different strategies for sample labeling are discussed.

Indirect immunofluorescence
- Advantages
 - Signal amplification by secondary antibody.
 - Stable organic fluorophores available.
- Disadvantages
 - Primary antibody needs to be specific to avoid nonspecific staining.
 - Immunoglobulins are large and the apparent diameter of the detected structure increases by each antibody around 10 nm.
 - Directly labeled antibodies are a compromise between enhancement and size, but not always available.

Genetically encoded fluorescence (fusion proteins with fluorescent proteins)
- Advantages
 - Specific localization if expressed at physiological level.
 - Fluorescent proteins are smaller than immunoglobulins.
 - Live imaging capability.
- Disadvantages
 - Expression needs to be controlled for as not to result in aberrant function and localization.
 - One fluorophore per molecule of interest. Physiological expression might not provide enough signal density.
 - Bleaching, in some color variants.
 - Cytoplasmic (unbound) pool might be high, if overexpressed on top of endogenous protein.

For fixed specimen staining expressing GFP, staining with anti-GFP antibodies is worth trying. Very popular for superresolution are the so-called nanobodies, camel antibodies that are composed of a single chain only (Ries, Kaplan, Platonova, Eghlidi, & Ewers, 2012). Commercially available nanobodies to fluorescent proteins are available as nanoboosters (Chromotek, Planegg-Martinsried, Germany).

17.2.3 FIXATION

Generally, the fixation that best works for your antibody should be used. For GFP-labeled specimens, fixation will generally lower fluorescence, but in most cases, 4% PFA in PBS will work well. Methanol-fixed GFP samples will be much reduced in intensity after fixation.

17.2.4 INDEX MATCHING AND EMBEDDING OF SAMPLE

After finishing staining procedures, samples can be directly imaged by SIM if they are mounted such that the coverslip is the interface to the objective. For adherent cell cultures, we have found it easiest to perform both immunostaining and, if required,

clearing protocols on cultures grown in coverslip dishes (see Section 17.2.1). This way, no hardening mounting media is required. Alternatively, cells that have been growing on coverslips can be mounted on slides with a (hardening) embedding media. There is a great choice of embedding media, which cannot be covered in detail here. Several properties are important for SIM. Antifade reagents are valuable in preserving fluorescence and should be included if possible. The refractive index (RI) of the embedding media should match the immersion. For fixed specimen, the obvious choice is a RI close to that of the immersion oil ($RI=1.51$). We have had good experience with ProLong Gold (Life Technologies), which is described to have a RI of 1.45 after 2 days of curing.

However, embedding cells in mounting media does not mean that the RI inside the cells is also matched. Often, the mounting media only poorly penetrates single cells and multicellular objects not at all. To achieve this, optical clearing is required, which aims at matching all components to a similar RI. As every boundary between a lipid-containing membrane and the aqueous surrounding represents a change in RI, these clearing procedures can enhance image quality greatly by ensuring that the illumination pattern is preserved several μm deep into the specimen and that emitted photons make it back to the objective.

Clearing protocols attempt to substitute the aqueous parts of the tissue with a higher RI, ideally similar to that of membranes and/or to that of the oil immersion ($RI=1.51$ at 25 °C) or glycerol ($RI=1.47$ at 25 °C). These techniques can be applied to fixed specimens only and involve dehydration in alcohol, followed by incubation in the clearing medium of high RI. A classical procedure is dehydration in ethanol followed by clearing in Murray's clear (also called BABB, a 2:1 benzyl alcohol:benzyl benzoate mixture) as described in Dodt et al. (2007). Dehydration and clearing chemicals may affect fluorescence of GFP (ethanol and Murray's; see Becker, Jahrling, Saghafi, Weiler, & Dodt, 2012). A dehydration series in increasing percentage of TDE combines dehydration and clearing in one step and has been tested for superresolution microscopy (Staudt, Lang, Medda, Engelhardt, & Hell, 2007). Fluorescence of many fluorophores is preserved; however, phalloidin binding is abolished (Staudt et al., 2007). In our hands, DAPI staining is also significantly reduced after index matching of TDE. It is now available commercially as ready to use mounting kit (see Section 17.2.1), already adjusted to neutral pH.

Note: Matching of indices in the sample results in a drastic loss of contrast when using differential interference contrast or phase contrast to visualize cells.

17.3 MINIMIZING SPHERICAL ABERRATION

17.3.1 WHAT IS SPHERICAL ABERRATION AND WHEN DOES IT OCCUR

Spherical aberration (SA) can be a classical lens aberration, where the oblique rays entering the objective are not focused to the same plane as the central rays (Chapter 2). Such a lens would not produce a well-focused image at any plane. In the high-quality objectives designed for superresolution imaging, these SAs have been eliminated by design. However, SA still haunts almost all applications in microscopy (Cannel et al., 2006; Hibbs et al., 2006), as they can be introduced by

(1) mismatch of RIs of immersion and embedding media,
(2) unintended change of immersion RI by temperature,
(3) wrong thickness of coverslip,
(4) RI mismatch in the sample (see Section 17.2.4).

(1) RIs of immersion and sample can be matched, and in SIM, this is worthwhile when imaging 5 µm or more into the sample as the SA increases with distance from the coverslip (Fig. 17.3A–B′).
(2) The change of RI of immersion oil is just a special case of RI mismatch. However, it is often forgotten that the RI of the immersion oil changes dramatically with temperature. The Nikon TIRF objective has a correction collar where temperature correction is combined with coverslip thickness correction (see Fig. 17.3C; Chapter 2). While the correction for coverslip thickness from 150 µm (No. 1.0 coverslip thickness) to 170 µm (standard thickness, No. 1.5 coverslip thickness) is relatively small, a change from room temperature to 37 °C requires a drastic correction. Any temperature in between 23 and 37 °C requires experimental adjustment (see succeeding text).
(3) For objectives with no correction collar, coverslips should be chosen that match the ones specified on the objective, which is 170 µm (coverslip thickness No. 1.5, usually 160–190 µm) or precision cover glasses with less tolerance (Marienfeld thickness No. 1.5H, 170 ± 5 µm, Paul Marienfeld GmbH, 97922 Lauda Königshofen, Germany).

17.3.2 STEPS TO MINIMIZE SPHERICAL ABERRATION ON THE MICROSCOPE

Even if great care has been taken to match the mounting medium to the RI of immersion oil and choose the appropriate coverslips, it is best to check whether SA is present. For this, an experimental PSF is acquired, that is, a 3D image of a subresolution bead (Cannel et al., 2006, Hibbs et al., 2006). The SA can then be corrected for by readjusting the correction collar. In the succeeding text, the procedure is outlined for an objective with correction collar that can accommodate temperature changes from 23 to 37 °C (Fig. 17.3C). If coverslip correction is not available or is limited to a small range, the correction needs to be done by choosing an immersion oil with appropriate RI (described for the OMX 3D-SIM system by Hubner, Cremer, & Neumann, 2013). In both cases, the quality of the PSF has to be evaluated after readjusting the correction collar or changing the oil immersion, respectively.

Figure 17.3D and E illustrates how the PSF should look if the correction ring is set to minimize SA. A very asymmetrical and elongated PFS in Fig. 17.3D′ results from setting the collar far from the correct position.

Prepare bead sample
- Use 100 nm fluorescent beads excitable by 488 or 561 nm laser (see Section 17.2.1), and prepare a solution in water containing one or both of them at 1:10,000 dilution.

- Coat coverslip dishes or coverslips used to plate cells with 0.5 mg/ml poly-D-lysine for 30 min, by placing a drop on the surface to be covered.
- Rinse coverslips with distilled water, remove all water (if necessary by blotting with filter paper), and dry. If not used immediately, coverslips can be stored for several weeks.
- Add a drop of bead suspension and leave for 15 min. Remove bead suspension and replace by embedding medium or PBS. In case of lose coverslips, mount them with hardening mounting media such as ProLong Gold.

Measure point spread function
- Mount slide or coverslip dish on microscope stage. Take great care that the sample is level on the stage. Otherwise, the PSF will be distorted, even if the correction collar is set correctly (Fig. 17.3E′ compare to E).
- Use appropriate epifluorescence setting to find focus.
- To acquire the PSF, switch to widefield laser illumination. This laser illumination is provided by the 0 order of the laser. Otherwise, use epifluorescence.
- Adjust camera and laser settings. As the beads are very bright, low EM gain on the EMCCD (e.g., around $50 \times$ for the Andor iXon) can be used. Adjust laser intensity or exposure time while looking at the bead with a saturation indicator on. Make sure that the maximal intensity is around 50% of saturation. Use laser intensities that result in an exposure time <100 ms to speed up acquisition.
- In z-acquisition, define a 4 μm stack with 150–200 nm spacing around the current position (-2 to $+2$ μm). Use piezo for speed and precision.
- Display an xz-view of the data to look at the bead image along the z-axis (see succeeding text). If the quality of the PSF is not good, change the coverslip correction slightly and repeat the process.
- Be aware that changing the coverslip correction changes the focus.

Qualitative assessment of PSF
- Use slice view (also called orthogonal view) to display the xz- and yz-views to display the PSF along z.
- At the correct setting, the angle of expansion of the PSF is high and the intensity spreads over few z-slices.
- Strong rings above or below the bead center indicate SA.

Quantitative assessment
- In the correct setting, the peak intensity is highest, as the intensity of the bead image is concentrated to a smaller volume than with suboptimal settings. So the peak intensity in the 3D histogram can be used to quantify the quality of the PSF. If the stack histogram is not easily accessible, one needs to find the center slice of the bead and read the maximum value from the histogram of this slice.
- With the right coverslip correction, the intensity along the z-axis spreads a minimal distance. This value is determined as the FWHM and is the distance in the z-profile where the intensity drops to half of the peak. In the Nikon software

NIS-Elements, an *xz*-view from the slice view can be generated. Using the profile tool, the FWHM can be interactively determined. Use 0 neighbor integration (1 pixel) for the line profile.

Note: In the bead samples, the beads are adsorbed directly on the coverslip (at 0 μm distance). The embedding medium has little influence on the PSF and we may even overlay them with PBS instead of a medium of RI, which matches the immersion. However, the correction collar setting or the oil immersion would be entirely different for a bead at 5 μm from the coverslip embedded in agar and then change again at 10 μm. To keep it constant, RIs of immersion and embedding need to be matched.

Tip: The PSF is the readout of the entire system. If it looks odd, this could be because the objective has been damaged or because the sample is not mounted level (Fig. 17.3E′).

Tip: The correction is only valid for this particular coverslip thickness and temperature of the system. Wait for the system to warm up (in our case, 2 h with all the components on). Make sure that the cells are grown on the same kind of coverslips and that these have a narrow tolerance (less than ±10 μm).

17.4 MULTICHANNEL SIM

SIM multicolor imaging is relatively easily possible, and all commercial systems are set up to do multichannel SIM. In the N-SIM, the blue, green, red, and far-red channel can be imaged using the same phase grating block. If the far-red is not included in the experiment, a different block for three channels that offers better resolution should be used.

17.4.1 SETTING UP MULTICOLOR SIM

For multichannel imaging, fluorophores must be chosen for minimal cross talk between channels, as is true for every microscope used for colocalization. For 488 and 561 nm excitation, possible pairs are as follows:

- Alexa Fluor 488 and Alexa Fluor 568
- Alexa Fluor 488 and Atto 565
- EGFP/TagGFP and mCherry
- EGFP/TagGFP and Alexa 568
- Alexa Fluor 488 and mCherry

For the 640 nm laser line (far-red channel), a series of good dyes exist, such as Atto 647N and Alexa Fluor 647. However, when using them in combination with the red channel, it has to be considered that they are also excitable with 561 nm and might show in the red channel.

For 405 nm excitation, fluorescent dyes are not very bright, and many bleach rapidly. Despite the inefficient excitation at 405 nm, DAPI works well for SIM, as it has almost unlimited binding sites on DNA and can be used at high concentrations with little background staining.

17.4.2 CORRECTION FOR CHROMATIC SHIFT

Chromatic shifts can be introduced by different optical parts, the ones introduced by filters (dichroic and emission filters) being most prominent and relatively easy to correct for after acquisition. SIM objectives are chromatically corrected (Apo correction), but within the specification of this correction, small shifts along the z-axis are apparent using SIM, which need to be corrected for computationally.

The first step to channel alignment is to measure the chromatic shift. For this, a sample of multicolor beads (see Section 17.2.1) is imaged in the channels of interest, ideally with many beads over the field of view. In a color overlay of the channels (Figure 17.4A, shown in black and white here), it becomes clear that the red channel is systematically shifted to the lower right relative to the green. An xz-view illustrates the axial shift. Since the shift is more or less the same for all beads in the view, a linear shift correction is enough, but only subpixel shift corrections (interpolation) provide satisfactory results. Many tools are available for linear shift correction (rigid transformations, rotations, and translations) for 2D data, but alignment should be done in 3D if axial shift is present. We have used the Chromatic Shift Corrector in the Huygens software (4.2, SVI) where the shift vector is measured in an image volume of TetraSpeck beads by cross correlation and can then be applied to sample images (Fig. 17.4B).

Note: In the case of N-SIM, the same light path is used for all channels; only the filter cubes are changed. Therefore, systematic shifts in xy by the dichroic filter and emission filter are predominant, and a linear method provides satisfactory results (Fig. 17.4B). Multicamera systems have more complex shifts, like difference in magnification and nonlinear warps of the image. In this case, a method that creates a map of pixel assignment over the field of view is required.

17.4.3 COLOCALIZATION

Because of the higher localization accuracy, SIM is an attractive tool to determine colocalization of two or more markers (Mennella et al., 2012; Sonnen et al., 2012). Many markers that seem to have substantial overlap in confocal or widefield will have less overlap or lower colocalization coefficients if they occupy adjacent but distinct domains. If comparing different samples for degree of colocalization, it is important to keep SIM filter settings in the reconstruction constant as they might influence intensity distribution in the image and background.

17.4.4 NOTES ON QUANTITATIVE ANALYSIS OF INTENSITY DISTRIBUTION

In diffraction-limited microscopy, the image contrast declines as structures become smaller. At the resolution limit, as defined by the Rayleigh criterion, the contrast is only 20%. Structures near the resolution limit are blurred out in the image and a

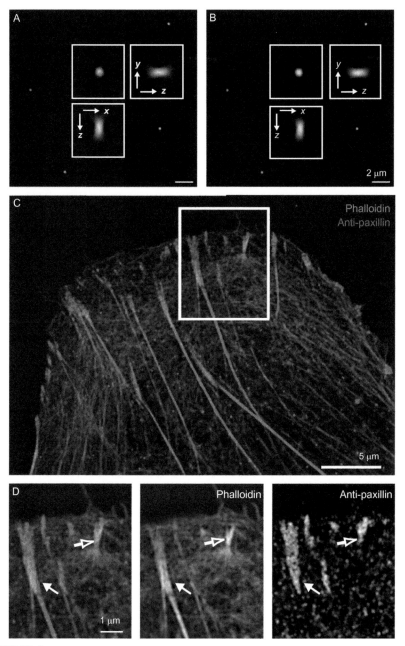

FIGURE 17.4

Multichannel SIM imaging. (A–B) SIM multichannel data need to be corrected for chromatic shift in *xyz*. The shift can be measured with multicolor beads (A) and the shift can then be corrected for by subpixel alignment (B), here the green channel was shifted by the shift vector ($x = -30$ nm, $y = -40$ nm, $z = 50$ nm) to increase the overlap of the two channels. One out of four beads across the field of view is magnified to show the effect (inset length = 2 μm). (C–E) A U2OS cell stained with phalloidin Alexa 488 and anti-mouse paxillin detected by anti-mouse Alexa Fluor 568. The channels were aligned using the shift vector obtained from (A). A projection of 10 slices (1.25 μm) is shown in (C), where actin stress fibers are anchored in adhesions in the periphery. The inset (D) shows a single slice near the substrate where actin stress fibers (arrow) and thinner actin bundles (open arrow) connect to adhesions. (See the color plate.)

substantial part is dispersed, such that it gets subtracted as background. Therefore, when measuring small objects, their intensity is underestimated relative to structures >1 μm. However, this is different in SIM images, where small structures are resolved and weighted stronger, and the intensity distribution within an image looks very different (compare Fig. 17.2F and G). This means that when quantifying intensities, different results are to be expected for SIM as compared to widefield or even confocal imaging.

17.5 LIVE IMAGING WITH SIM

Light microscopy can provide direct information on dynamics by time-lapse imaging. However, in 3D-SIM, several technical issues restrict time-lapse imaging. One is the speed of the pattern formation; the other is the time to acquire a z-stack with 15 images per slice, where exposure time adds up. In the commercial systems that use gratings for illumination that have to be physically shifted, acquisition speed is limited. There is beautiful work done with an experimental system equipped with fast spatial light modulators, such as imaging of fast microtubule movement by Kner, Chhun, Griffis, Winoto, and Gustafsson (2009) where a resolution of 3 fps was achieved.

The N-SIM and the newer OMX system with the Blaze SIM module (Applied Precision Instruments) are specified for live imaging, while the original OMX and the Zeiss Elyra are restricted to fixed specimen. However, because of the earlier-mentioned technical constraints and the often poorer labeling, time-lapse imaging using the N-SIM is difficult and is currently only applicable to a limited set of specimens. This selection is linked to the use of the slice reconstruction provided by Nikon, which performs well on thin specimens with little out of focus signal. Figure 17.5A shows a neuronal growth cone, where microtubule dynamics were imaged every 10 s, enough to see major changes from microtubule growth to depolymerization. Neuronal growth cones are very prone to the effects of phototoxicity, and the maximum frame rate (every 2 s) was not exploited in order to image over several minutes.

Significant movement of structures in the time needed to acquire 15 frames (here 2 s) will result in artifacts in the superresolution image. In another imaged growth cone, microtubules were pushed and the microtubules appear to be splayed in structure (Fig. 17.5B and arrow in B′).

Pursuing live imaging with 3D-SIM is rewarding, as superresolution dynamics can be made visible. In our case of the growth cone, single microtubules in the dense arrays inside the growth cones can be observed. However, compared to fixed and immunostained samples, the live imaging provides poorer contrast and resolution (compare Fig. 17.5A′ and C′).

Note: We used the oil immersion objective, as images where taken <1 μm from the coverslip. Deeper inside the cells, the water immersion objective might be a better choice (Plan Apo, NA 1.27) to limit SA.

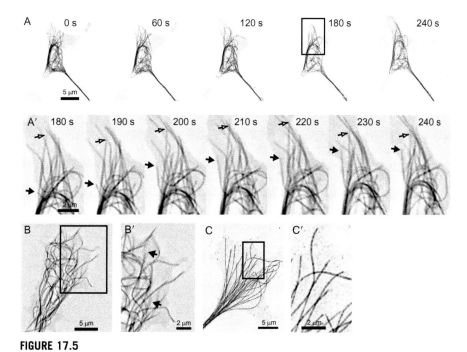

FIGURE 17.5

SIM time-lapse microscopy. (A and B) *Xenopus* spinal cord neurons expressing GFP–tubulin were imaged every 10 s for 4 min. In (A), the growth cone is shown every minute, to show forward movement of the growth cone. A detail is shown in (A′) at 10-s intervals; arrows point out growth and shrinkage of individual microtubules. (B) Rapid translocation of microtubules leads to movement artifacts in reconstructed images, highlighted by arrows in (B′). (C and C′) SIM image of a fixed growth cone, where microtubules have been stained by anti-tubulin and secondary antibody anti-mouse Alexa 488, shows higher contrast compared to GFP–tubulin.

ACKNOWLEDGMENTS

The N-SIM was purchased by the CellNetworks Cluster, University of Heidelberg. I would like to thank Kees van der Oord at Nikon Europe for helpful discussions and Christian Ackermann (Heidelberg University) and Laure Plantard (Copenhagen University) for comments on the chapter.

REFERENCES

Becker, K., Jahrling, N., Saghafi, S., Weiler, R., & Dodt, H. U. (2012). Chemical clearing and dehydration of GFP expressing mouse brains. *PLoS One, 7*, e33916.

Cannel, M. B., McMorland, A., & Soeller, C. (2006). Image enhancement by deconvolution. In J. B. Pawley (Ed.), *Handbook of biological confocal microscopy* (pp. 488–500). New York: Springer.

Dodt, H. U., Leischner, U., Schierloh, A., Jahrling, N., Mauch, C. P., Deininger, K., et al. (2007). Ultramicroscopy: Three-dimensional visualization of neuronal networks in the whole mouse brain. *Nature Methods, 4,* 331–336.

Engel, U. (2012). Wie ein puzzle zusammengesetzt: Hochauflösung mit strukturierter beleuchtung. *BIOspektrum, 18,* 408–410.

Guillaume, E., Comunale, F., Do Khoa, N., Planchon, D., Bodin, S., & Gauthier-Rouviere, C. (2013). Flotillin microdomains stabilize cadherins at cell-cell junctions. *Journal of Cell Science, 126,* 5293–5304.

Gustafsson, M. G. (2000a). Surpassing the lateral resolution limit by a factor of two using structured illumination microscopy. *Journal of Microscopy, 198,* 82–87.

Gustafsson, M. G., Agard, D. A., & Sedat, J. W. (2000b). Doubling the lateral resolution of wide-field fluorescence microscopy using structured illumination. *Proc. SPIE, 3919,* Three-Dimensional and Multidimensional Microscopy: Image Acquisition Processing VII, *141,* http://dx.doi.org/10.1117/12.384189.

Gustafsson, M. G., Shao, L., Carlton, P. M., Wang, C. J., Golubovskaya, I. N., Cande, W. Z., et al. (2008). Three-dimensional resolution doubling in wide field fluorescence microscopy by structured illumination. *Biophysical Journal, 94,* 4957–4970.

Han, R., Li, Z., Fan, Y., & Jiang, Y. (2013). Recent advances in super-resolution fluorescence imaging and its applications in biology. *Journal of Genetics and Genomics, 40,* 583–595.

Hibbs, A. R., McDonald, G., & Garsha, K. (2006). In J. B. Pawley (Ed.), *Handbook of biological confocal microscopy* (pp. 488–500). New York: Springer.

Huang, B., Bates, M., & Zhuang, X. (2009). Super-resolution fluorescence microscopy. *Annual Review of Biochemistry, 78,* 993–1016.

Hubner, B., Cremer, T., & Neumann, J. (2013). Correlative microscopy of individual cells: Sequential application of microscopic systems with increasing resolution to study the nuclear landscape. *Methods in Molecular Biology, 1042,* 299–336.

Kner, P., Chhun, B. B., Griffis, E. R., Winoto, L., & Gustafsson, M. G. (2009). Super-resolution video microscopy of live cells by structured illumination. *Nature Methods, 6,* 339–342.

Marx, A., Godinez, W. J., Tsimashchuk, V., Bankhead, P., Rohr, K., & Engel, U. (2013). Xenopus cytoplasmic linker-associated protein 1 (XCLASP1) promotes axon elongation and advance of pioneer microtubules. *Molecular Biology of the Cell, 24,* 1544–1558.

Mennella, V., Keszthelyi, B., McDonald, K. L., Chhun, B., Kan, F., Rogers, et al. (2012). Subdiffraction-resolution fluorescence microscopy reveals a domain of the centrosome critical for pericentriolar material organization. *Nature Cell Biology, 14,* 1159–1168.

Pawley, J. B. (2006). Points, pixels, and grey levels: Digitizing image data. In J. B. Pawley (Ed.), *Handbook of biological confocal microscopy* (pp. 59–79). New York: Springer.

Rego, E. H., Shao, L., Macklin, J. J., Winoto, L., Johansson, G. A., Kamps-Hughes, et al. (2012). Nonlinear structured-illumination microscopy with a photoswitchable protein reveals cellular structures at 50-nm resolution. *Proceedings of the National Academy of Sciences of the United States of America, 109,* E135–E143.

Ries, J., Kaplan, C., Platonova, E., Eghlidi, H., & Ewers, H. (2012). A simple, versatile method for GFP-based super-resolution microscopy via nanobodies. *Nature Methods, 9,* 582–584.

Schermelleh, L., Heintzmann, R., & Leonhardt, H. (2010). A guide to super-resolution fluorescence microscopy. *The Journal of Cell Biology, 190,* 165–175.

Sonnen, K. F., Schermelleh, L., Leonhardt, H., & Nigg, E. A. (2012). 3D-structured illumination microscopy provides novel insight into architecture of human centrosomes. *Biology Open, 1*, 965–976.

Staudt, T., Lang, M. C., Medda, R., Engelhardt, J., & Hell, S. W. (2007). 2,2'-Thiodiethanol: A new water soluble mounting medium for high resolution optical microscopy. *Microscopy Research and Technique, 70*, 1–9.

Vitriol, E. A., Wise, A. L., Berginski, M. E., Bamburg, J. R., & Zheng, J. Q. (2013). Instantaneous inactivation of cofilin reveals its function of F-actin disassembly in lamellipodia. *Molecular Biology of the Cell, 24*, 2238–2247.

CHAPTER

Analysis of focal adhesion turnover: A quantitative live-cell imaging example 18

Samantha J. Stehbens*, Torsten Wittmann[†]

*Institute of Health Biomedical Innovation (IHBI), Queensland University of Technology Translational Research Institute, Brisbane, Queensland, Australia
[†]Department of Cell and Tissue Biology, University of California, San Francisco, USA

CHAPTER OUTLINE

Introduction to Focal Adhesion Dynamics ... 335
18.1 FA Turnover Analysis .. 337
 18.1.1 Sample Preparation .. 337
 18.1.2 Imaging ... 339
 18.1.3 Image Analysis .. 340
 18.1.4 Data Analysis .. 341
Acknowledgments .. 346
References ... 346

Abstract

Recent advances in optical and fluorescent protein technology have rapidly raised expectations in cell biology, allowing quantitative insights into dynamic intracellular processes like never before. However, quantitative live-cell imaging comes with many challenges including how best to translate dynamic microscopy data into numerical outputs that can be used to make meaningful comparisons rather than relying on representative data sets. Here, we use analysis of focal adhesion turnover dynamics as a straightforward specific example on how to image, measure, and analyze intracellular protein dynamics, but we believe this outlines a thought process and can provide guidance on how to understand dynamic microcopy data of other intracellular structures.

INTRODUCTION TO FOCAL ADHESION DYNAMICS

Cell migration is essential for tissue development, tissue remodeling, and wound healing and requires complex rearrangements of intracellular macromolecular structures. Quantitative analysis of the molecular processes that drive cell migration are

essential for our understanding of how cell migration is deregulated in pathological states, such as in cancer metastasis, for example. In addition to the coordination of signaling pathways to control polarity and cytoskeleton rearrangements, cell migration requires force generation that relies on the coordinated remodeling of interactions with the extracellular matrix (ECM). These interactions are mediated by integrin-based focal adhesions (FAs) that were first described in the 1970s by interference reflection microscopy (Heath & Dunn, 1978), and recent superresolution microscopy demonstrates the complex multilayered architecture of FA plaques (Kanchanawong et al., 2010). Despite recent controversy of FAs being a tissue culture artifact of cells growing on stiff, flat surfaces, cells clearly utilize FAs in physiological 3D environments during migration along ECM fibers (Gierke & Wittmann, 2012; Kubow & Horwitz, 2011) although FA-independent, amoeboid modes of cell migration exist. The FA life cycle involves the formation of integrin-mediated, nascent adhesions near the cell's leading edge, which either rapidly turn over or connect to the actin cytoskeleton (Parsons, Horwitz, & Schwartz, 2010; Stehbens & Wittmann, 2012). Actomyosin-mediated pulling forces allow a subset of these nascent FAs to grow and mature and provide forward traction forces. However, in order for cells to productively move forward, FAs also have to release and disassemble underneath the cell body and in the rear of the cell. Spatial and temporal control of turnover of these mature FAs is important as they provide a counterbalance to forward traction forces, and regulated FA disassembly is required for forward translocation of the cell body.

The FA binding kinetics of specific proteins can be analyzed by fluorescence recovery after photobleaching (FRAP) in which fluorescently tagged FA components are photobleached and the rate by which fluorescence returns to the bleached area is monitored (Lele et al., 2006; Pasapera, Schneider, Rericha, Schlaepfer, & Waterman, 2010). FRAP data contains information on how rapidly specific FA-associated proteins exchange with the soluble cytoplasmic pool. While this may influence FA turnover, it is not *a priori* directly related to turnover of the FA structure. For example, typical FA lifetimes are in the order of tens of minutes, while turnover of most FA-bound proteins is in the order of seconds. Thus, during the life of an individual adhesion site, FA components dissociate and reassociate many times. This is also the case for many other intracellular assembly and disassembly processes, and it is crucial to not confuse these two types of dynamics: the lifetime of the underlying structure versus the binding kinetics of individual molecules. A macroscopic analogy is, for example, the lifetime of an ants' colony compared with the time an individual ant spends in the colony, which obviously cannot be used to make any conclusions about the growth or stability of the colony.

In contrast, analysis of intensity changes of fluorescently tagged FA components over time can be used to determine assembly and disassembly rates of the FA structure and thus to quantitatively test how FA dynamics and therefore cell migration are controlled. A landmark paper by Webb et al. first utilized this method by linear regression of a semilogarithmic plot of fluorescence intensity as a function of time (Webb et al., 2004). This approach assumes that both assembly and disassembly

follow exponential kinetics, which is likely not a good model for the assembly phase (see the succeeding text). In contrast, we find that the direct curve fitting of the fluorescence intensity profiles with appropriate functions provides more robust results and more completely describes FA turnover dynamics (Meenderink et al., 2010). However, further improvements in live-cell imaging technology show that FA dynamics can be complicated, and more complex FA dynamics such as sliding, splitting, and merging will require different analysis approaches. In this chapter, we describe a step-by-step procedure of how we image, measure, and analyze FA turnover in migrating cells, which can also be used as a general guideline of important points to consider when attempting dynamics analysis of any fluorescent structure.

18.1 FA TURNOVER ANALYSIS
18.1.1 SAMPLE PREPARATION

In the example discussed here, we analyze FA turnover dynamics at the edge of a migrating HaCaT keratinocyte epithelial cell sheet. We grow these cells on fibronectin-coated coverslips and generate an experimental cell sheet edge by removing half of the cell monolayer (Stehbens, Pemble, Murrow, & Wittmann, 2012). Coverslips are then mounted in sealed aluminum slide chambers (see Chapter 5) and returned to the tissue culture incubator overnight to allow cells to recover and to polarize. Because polarity is largely determined by cell–cell contacts in the cell monolayer, epithelial sheet migration is highly directional. Depending on the experimental question, different cell types and/or different imaging chambers can be used, and the method adapted accordingly. For example, mesenchymal cell types such as fibroblasts and melanocytes tend to migrate as individual cells and may require less time to recover after wounding, and FA shape, dynamics, and morphology are cell type-dependent.

In general, reproducibility of the results will depend to a large extent on reproducible cell culture conditions, and care should be taken at every step to ensure sample preparation of the highest quality. Cells should be at low passage and not cultured for too long. Different matrices such as fibronectin, laminin, and collagen can influence cell migration and FA morphology because different integrins have different ECM specificities. It is also recommended that surfaces for migration are clean, and we routinely acid-wash or detergent-sonicate coverslips before ECM coating and plating cells.

A large number of FA-associated proteins including talin, vinculin, paxillin, and zyxin have been tagged with fluorescent proteins (FPs) and used to image FA dynamics. Although transient transfection of FP-tagged constructs can be used, we believe it is well worth the initial investment of time to generate stable cell lines expressing the FP-tagged protein of interest to be able to reproducibly image large numbers of cells within one sample. For this reason, we routinely use lentivirus-mediated gene

transduction to produce stable cell lines. Sorting the population for the desired FP-expression level by FACS reduces the variability between cells, which becomes important when the sample size is reduced to cells along a wound edge, ensuring adequate cell numbers within each experiment. Care needs to be taken when expressing FP-tagged proteins as overexpression can introduce artifacts affecting the dynamics of the process under investigation. For example, overexpression of many FA proteins results in FA stabilization. In our hands, lentivirus expression is the method of choice as FP-tagged FA proteins express evenly at close to endogenous levels, which in a stable cell line can be verified by immunoblotting, in addition to comparing FA morphology to endogenous protein immunofluorescence. Of note, lentiviral packaging limitations need to be taken into consideration when designing an experiment, and some FA proteins, such as α-actinin, are quite large and approach the upper limitations of lentiviral packaging capacity.

In our system, we find that stable, low-level expression of paxillin–mCherry is a reliable reporter of FA dynamics (Fig. 18.1) (Hu, Ji, Applegate, Danuser, & Waterman-Storer, 2007). However, it is important to note that different FA markers

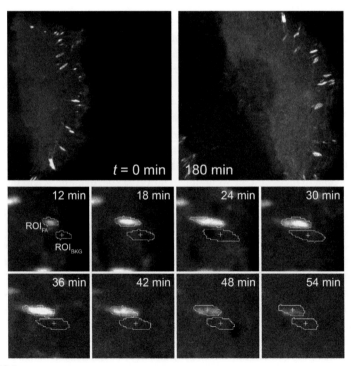

FIGURE 18.1

Images from a 3-h spinning-disk confocal time-lapse sequence of paxillin–mCherry expressing, migrating HaCaT keratinocytes. The bottom panels show example FA and background ROIs used for the analysis of FA turnover.

may report different phases of the FA turnover cycle and choice will be determined by cell system and experimental question. For example, paxillin is recruited to both nascent and mature adhesions, while other components such as vinculin or zyxin are thought to associate with FAs only at later maturation stages.

18.1.2 IMAGING

As with any live-cell imaging experiment, care should be taken to ensure a physiological environment for the observed cells. Light exposure and associated photobleaching and photodamage that will inhibit cell migration should be limited as much as possible (see Chapter 5). Because FA turnover is a comparably slow process and requires time-lapse recordings of several hours at high magnification, this imaging benefits significantly from a high-precision, linear-encoded motorized stage for imaging multiple fields of view and an autofocus system in order to allow for parallel acquisition of many cells in a single experiment (Chapter 5).

We routinely acquire 3-h time-lapse sequences at 90–180 s intervals of typically 10–20 different stage positions. While these time-lapse settings work well for relatively slow FA turnover in our experimental system, it is important to determine the right compromise of time-lapse intervals and duration with respect to the process under investigation (Chapter 1). For example, too long intervals between images may not provide sufficient data points for reliable analysis, and dynamics are missed. In contrast, too short intervals will limit the total duration of imaging at useful signal-to-noise ratio due to photobleaching and in our case greatly reduce the number of FAs for which both assembly and disassembly can be observed. We image paxillin–mCherry-expressing cells by spinning-disk confocal microscopy using a Nikon 60× 1.49 NA CFI Apochromat TIRF objective and a cooled interline CCD camera with 6.45 µm × 6.45 µm pixels (see Stehbens et al., 2012 for a more detailed description of our spinning-disk microscope setup). 60× magnification is recommended because it provides sufficient resolution to image FA dynamics and allows more light collection per pixel compared with a higher magnification. Typical exposure settings using a 100 mW 561 nm solid-state excitation laser are 4–8 mW light power at the objective front lens and exposure times of 200–400 ms. We use a 568-nm longpass emission filter to collect as much of the mCherry emission spectrum as possible. Although this is certainly a subjective criterion and depends on the type of light source used for epifluorescence, to limit paxillin–mCherry overexpression effects, we aim to image cells that are barely visible through the eyepiece. It is also important to note that paxillin–mCherry and many other FA-associated proteins have a quite substantial soluble cytoplasmic pool, which makes it near impossible to discern FAs at low expression levels by epifluorescence illumination by eye, and cells will appear mostly as a faint fluorescent glow. Thus, in setting up the multipoint experiment, we minimize direct viewing and instead take quick snapshots at reduced excitation light intensity to select and focus appropriate cells to minimize light exposure and photobleaching before starting time-lapse acquisition. Never use any "live view" function on a sample that is to be used for quantitative imaging purposes.

Finally, all microscope settings should be recorded for later reference (ideally, this is automatically saved in the imaging software metadata), and most importantly, all settings that alter image intensities (i.e., camera gain, exposure time, and light power) or spatial and temporal sampling (i.e., camera binning, magnification, and time-lapse intervals) must be kept constant to ensure reproducibility in comparing different conditions.

18.1.3 IMAGE ANALYSIS

Fully computerized image analysis methods are becoming more commonly used within the cell biology community. For example, a MATLAB-based software package that segments FAs and extracts dynamics from TIRF image sequences has recently been published (Berginski, Vitriol, Hahn, & Gomez, 2011). While the continued development of such tools is advantageous, users should be aware of the potential pitfalls associated with such software. To the end user, computational image analysis tools often carry the risk of being a black box, and the systematic and random error introduced by high-throughput image analysis essentially remains unknown. It can be extremely difficult to validate computational image analysis in specific experimental conditions and to assess how exactly a software algorithm has generated a set of numbers. This is especially true for commercial solutions for which the underlying code is not available. We would argue that image analysis tools should not be used for scientific purposes if they cannot be fully understood by the user. In addition, one should remain aware that human-written software inevitably contains coding errors that may affect analysis outcome. It is also important to remember that any analysis can only be as good as the input data and that results obtained from noisy, out-of-focus, and unevenly illuminated images can be essentially meaningless. Finally, free parameters of the software, such as segmentation thresholds, often are not robust and may have to be optimized for specific sets of input images, which may not be trivial.

Here, we describe how we analyze FA dynamics using readily available image analysis software and subsequent data analysis in Microsoft Excel. While this is certainly not the most high-throughput method, it stays close to the data and can also be used as a guideline on how to analyze the dynamics of other intracellular structures. Most importantly, quantification of fluorescence intensity should only be done on original microscope data that have not been altered by nonlinear intensity transformations. Image data must not be compressed or downsampled, and the original bit depth should be used, ensuring that data are not lost at any point during analysis.

We use image analysis tools in Nikon NIS-Elements AR (v4.2) software to measure the FA-associated intensity of paxillin–mCherry as a function of time although other microscopy software suites such as MetaMorph, ImageJ, and Fiji can certainly be used. A region of interest (ROI) is drawn around an FA to determine the average FA-associated paxillin–mCherry fluorescence, $I_{FA}(t)$ (Fig. 18.1). In order to fully capture the FA turnover dynamics and obtain meaningful lifetime measurements,

it is important that the entire FA turnover cycle can be observed in the data set, that is, FAs selected for analysis should be absent both in the beginning and at the end of the time-lapse sequence. However, if only assembly or disassembly rates are being measured, for example, as a result of pharmacological treatment, this may not be necessary. The ROI defining $I_{FA}(t)$ should be drawn closely around the FA at its maximum size to minimize the background correction error. If the number of background pixels is large compared with the number of pixels encompassing the signal of interest, the average intensity will decrease substantially and noise becomes dominant. FAs will often significantly change their size and location during the image sequence, and it may thus be necessary to adjust size and position of the ROI during the time-lapse series to obtain accurate FA intensity measurements. For example, especially under conditions that inhibit FA disassembly, we have observed significant sliding of FAs and splitting and merging of FAs, which complicates the analysis. Not all software packages will support ROI editing in a time-lapse sequence, but in NIS-Elements, this can be done using the function "Edit ROIs in time," which generates a trajectory of changing ROIs through the time-lapse sequence, effectively expanding or shrinking the ROI over time with the focal adhesion. We then duplicate the FA-associated ROI and place it next to the FA for background correction, and measure the average fluorescence intensity in each frame. Measurements in this region, $I_{BKG}(t)$, include both cytoplasmic background fluorescence and the camera offset (Fig. 18.1). In NIS-Elements, this is done in the "Time Measurements" dialog. It is important to determine $I_{BKG}(t)$ in each time frame (not only the first) as the local background over time will fluctuate due to cell migration across the adhesion site and associated cell thickness changes. In addition, one should verify that no other fluorescent structure (i.e., another FA) wanders into the background region, which would result in artificially high background values. This generates two fluorescence intensity profiles, one of the FA and one of the background ROI over time, which allows for background correction at each point within the adhesion lifecycle. Data are then exported to Microsoft Excel for further analysis.

18.1.4 DATA ANALYSIS

FA turnover can be separated into three different phases: assembly, during which the FA increases in size and intensity; disassembly, during which FA intensity decreases; and the time in between, during which FA intensity may fluctuate, but on average, the FA neither assembles nor disassembles. We use this simple model to describe FA turnover and determine assembly and disassembly rate constants by curve fitting of the different phases. Before curve fitting, a background-corrected intensity profile is calculated, and a three-frame running average can be used to smoothen frame-to-frame intensity variations to better determine the transition points between FA turnover phases:

$$I(t) = \frac{1}{3} \sum_{n=t-1}^{t+1} (I_{FA}(n) - I_{BKG}(n))$$

Even though photobleaching occurs at the same rate throughout the image, it is important to remember that background subtraction does not accurately correct for photobleaching. The absolute amount of photobleaching depends on fluorescence intensity (i.e., 10% of a 100 gray level background value is not the same as 10% of a 500 gray level signal), and photobleaching correction thus requires normalization of the total image fluorescence to a reference value (i.e., intensity in the first frame; see Chapter 1). However, generating a good photobleaching curve from long time-lapse experiments is difficult as cells will migrate in and out of the field of view making it impossible to accurately measure fluorescence intensity in the whole image as a function of time. We are not measuring absolute fluorescence, and the degree of photobleaching is small compared with fluorescence intensity changes associated with FA turnover. Thus, photobleaching introduces only a small error into FA turnover measurements, and we therefore do not typically correct for signal decrease due to photobleaching.

Once FA disassembly is initiated, it is reasonable to assume that dissociation of paxillin–mCherry molecules from the FA mostly depends on the amount of paxillin–mCherry still bound to the FAs. Thus, like radioactive decay, FA disassembly is expected to follow a single exponential decay with the rate constant k_d in which a is the offset of the exponential function along the time axis and f_0 the intensity at $t=a$:

$$I_{\text{disassembly}}(t) = f_0 e^{-k_d(t-a)}$$

The assembly phase is more complicated, and without precise knowledge of the underlying molecular mechanism, it is difficult to design an accurate mathematical model. However, for descriptive purposes, as previously described, we found that a sigmoid, logistic function as a model for self-limiting growth fits the FA assembly phase well (Meenderink et al., 2010) in which k_a is the rate constant, f_{\max} is the maximum fluorescence intensity, and $t_{1/2}$ is the time at half maximum:

$$I_{\text{assembly}}(t) = \frac{f_{\max}}{1 + e^{-k_a(t-t_{1/2})}}$$

In both equations, the rate constants k describe the steepness of the curve, that is, smaller k corresponds to slower assembly or disassembly. This relatively simple model has worked well for us to describe FA dynamics in migrating epithelial cell sheets during which FAs assemble and disassemble in a very coordinated manner. However, depending on the conditions and cell type, FA turnover can be more complex, that is, incomplete disassembly and reassembly or FA merging and splitting that are not described well by this model. Curve fitting can be done in many software packages. However, Microsoft Excel, a program that is commonly installed on most computers, includes a "Solver" add-in that is a powerful optimization engine that can be used to calculate a least-square curve fit of virtually any function. The "Solver" add-in is not automatically installed, but can be found in the Microsoft Excel options tab and easily added. The basic outline of how to set up an excel worksheet to run a

18.1 FA turnover analysis

curve fit is shown in Fig. 18.2. Briefly, three columns are set up that contain the data (D10:D35 for the assembly phase in Fig. 18.2), a calculated fit (E10:E35) based on initial values of the free parameters (E3:E5) and the independent variable (in this case, time in column A), and the residual, that is, the difference between the observed value and calculated fit for each time point (F10:F35). A dedicated cell (F4) contains the sum of squares of the residuals:

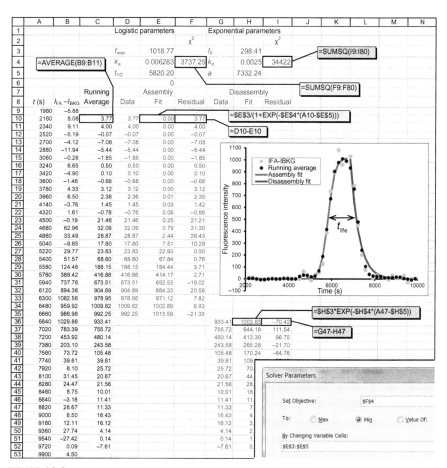

FIGURE 18.2

Sample spreadsheet layout to use the Microsoft Excel "Solver" for least-square curve fitting of FA turnover dynamics, which can be adapted to fit any nonlinear function. Columns D–F contain the data for the assembly, logistic fit and G–I for the disassembly, exponential fit. Boxes indicate spreadsheet formulas. The transitions between phases at which curve fits should begin or end are visually determined from a plot of the running average of the intensity data.

$$\chi^2 = \sum_{t=1}^{n} (I(t) - I_{\text{fit}}(t))^2$$

Minimization of χ^2 by altering the free parameters of the fitting function will determine the best fit of the data. This is done by running the "Solver" with the "objective" cell set to F4 "By Changing Variable Cells" E3:E5 using the "GRG Nonlinear" engine. Whether the fit has worked can be easily determined graphically (Fig. 18.2). If the fit fails, it likely indicates conversion of the optimization algorithm to a local minimum, a common problem in nonlinear curve fitting. This can usually be corrected by adjusting the initial parameters closer to the expected values before rerunning the "Solver."

Finally, based on $t_{1/2}$ of the logistic curve fit, we can define an FA lifetime, t_{life} (Fig. 18.2), as the time during which paxillin–mCherry fluorescence intensity remains above the half maximum, which can be calculated from the parameters determined in the assembly and disassembly curve fits:

$$t_{\text{life}} = a - \frac{\ln\left(\frac{f_{\max}}{2f_0}\right)}{k_d} - t_{1/2}$$

It is important to note that the values for disassembly rate constant and lifetime are interrelated and depend on how well the FA disassembly phase is fitted. A steeper disassembly fit will result in increased apparent lifetime. Thus, in case of a disassembly defect, both values are affected in opposite ways, which makes the method quite robust in detecting differences between conditions even if it is difficult to accurately determine the start of the disassembly phase.

Figure 18.3 shows the outcome of FA turnover analysis of a moderately large number of FAs in paxillin–mCherry expressing, migrating HaCaT keratinocytes. As expected, the results for all three calculated FA turnover parameters are relatively broadly distributed demonstrating the variability of stochastic intracellular dynamics. Further analysis of the distributions shows that only the FA assembly rate is normally distributed; disassembly rates and lifetimes are not. This illustrates that many parameters derived from intracellular dynamic processes are not normally distributed, and thus, statistic testing for differences should not be done by using t-tests or ANOVA that assumes normal distribution of the underlying data. Instead, nonparametric statistics such as Kruskal–Wallis analysis of variance should be used. For the same reason, it is best practice to show nonparametric representations of data such as box-and-whisker plots in figures rather than bar graphs indicating only mean and standard error (Spitzer, Wildenhain, Rappsilber, & Tyers, 2014). Finally, it is important to remember that a statistically significant difference does not necessarily imply a biologically meaningful effect.

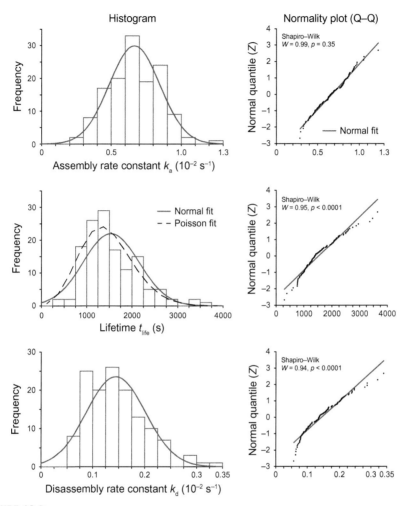

FIGURE 18.3

Statistical analysis of FA assembly and disassembly rates and lifetimes from $n=135$ FA intensity profiles in ~20 migrating HaCaT keratinocytes. Normality plots on the right show the results of Shapiro–Wilk tests indicating a normal data distribution only for FA assembly rates.

ACKNOWLEDGMENTS

This work was supported by National Institutes of Health Grants R01 GM079139 and R01 GM094819 and Shared Equipment Grant S10 RR26758.

REFERENCES

Berginski, M. E., Vitriol, E. A., Hahn, K. M., & Gomez, S. M. (2011). High-resolution quantification of focal adhesion spatiotemporal dynamics in living cells. *PLoS One*, *6*, e22025.

Gierke, S., & Wittmann, T. (2012). EB1-recruited microtubule +TIP complexes coordinate protrusion dynamics during 3D epithelial remodeling. *Current Biology*, *22*, 753–762.

Heath, J. P., & Dunn, G. A. (1978). Cell to substratum contacts of chick fibroblasts and their relation to the microfilament system. A correlated interference-reflexion and high-voltage electron-microscope study. *Journal of Cell Science*, *29*, 197–212.

Hu, K., Ji, L., Applegate, K. T., Danuser, G., & Waterman-Storer, C. M. (2007). Differential transmission of actin motion within focal adhesions. *Science*, *315*, 111–115.

Kanchanawong, P., Shtengel, G., Pasapera, A. M., Ramko, E. B., Davidson, M. W., Hess, H. F., et al. (2010). Nanoscale architecture of integrin-based cell adhesions. *Nature*, *468*, 580–584.

Kubow, K. E., & Horwitz, A. R. (2011). Reducing background fluorescence reveals adhesions in 3D matrices. *Nature Cell Biology*, *13*, 3–5.

Lele, T. P., Pendse, J., Kumar, S., Salanga, M., Karavitis, J., & Ingber, D. E. (2006). Mechanical forces alter zyxin unbinding kinetics within focal adhesions of living cells. *Journal of Cellular Physiology*, *207*, 187–194.

Meenderink, L. M., Ryzhova, L. M., Donato, D. M., Gochberg, D. F., Kaverina, I., & Hanks, S. K. (2010). P130Cas Src-binding and substrate domains have distinct roles in sustaining focal adhesion disassembly and promoting cell migration. *PLoS One*, *5*, e13412.

Parsons, J. T., Horwitz, A. R., & Schwartz, M. A. (2010). Cell adhesion: Integrating cytoskeletal dynamics and cellular tension. *Nature Reviews Molecular Cell Biology*, *11*, 633–643.

Pasapera, A. M., Schneider, I. C., Rericha, E., Schlaepfer, D. D., & Waterman, C. M. (2010). Myosin II activity regulates vinculin recruitment to focal adhesions through FAK-mediated paxillin phosphorylation. *The Journal of Cell Biology*, *188*, 877–890.

Spitzer, M., Wildenhain, J., Rappsilber, J., & Tyers, M. (2014). BoxPlotR: A web tool for generation of box plots. *Nature Methods*, *11*, 121–122.

Stehbens, S., Pemble, H., Murrow, L., & Wittmann, T. (2012). Imaging intracellular protein dynamics by spinning disk confocal microscopy. *Methods in Enzymology*, *504*, 293–313.

Stehbens, S., & Wittmann, T. (2012). Targeting and transport: How microtubules control focal adhesion dynamics. *The Journal of Cell Biology*, *198*, 481–489.

Webb, D. J., Donais, K., Whitmore, L. A., Thomas, S. M., Turner, C. E., Parsons, J. T., et al. (2004). FAK-Src signalling through paxillin. ERK and MLCK regulates adhesion disassembly. *Nature Cell Biology*, *6*, 154–161.

CHAPTER

Determining absolute protein numbers by quantitative fluorescence microscopy

19

Jolien Suzanne Verdaasdonk, Josh Lawrimore, Kerry Bloom

Department of Biology, University of North Carolina at Chapel Hill, Chapel Hill, North Carolina, USA

CHAPTER OUTLINE

Introduction	348
19.1 Methods for Counting Molecules	348
19.1.1 Imaging and Measurement Considerations	348
19.1.2 Fluorescence Correlation Spectroscopy	349
19.1.3 Stepwise Photobleaching	351
19.1.4 Ratiometric Comparison of Fluorescence Intensity to known Standards	352
19.1.5 Fluorescence Standards	354
19.2 Protocol for Counting Molecules by Ratiometric Comparison of Fluorescence Intensity	356
19.2.1 Minimizing Instrument Error	356
19.2.2 Measuring Instrument Variation	357
19.2.3 Budding Yeast Imaging Protocol	358
19.2.4 Measuring Background-Subtracted, Integrated Intensity	358
19.2.5 Depth Correction	359
19.2.6 Calculating Photobleaching Correction Factor	360
19.2.7 Gaussian Fitting and Ratiometric Comparison to Determine Protein Count	360
Conclusions	361
References	361

Abstract

Biological questions are increasingly being addressed using a wide range of quantitative analytical tools to examine protein complex composition. Knowledge of the absolute number of proteins present provides insights into organization, function, and maintenance and is used in mathematical modeling of complex cellular dynamics. In this chapter, we outline and describe three microscopy-based methods for determining absolute protein numbers—fluorescence correlation spectroscopy, stepwise photobleaching, and ratiometric comparison of fluorescence intensity to known standards. In addition, we discuss the various fluorescently labeled proteins that have been used as standards for both stepwise photobleaching and ratiometric comparison analysis. A detailed procedure for determining absolute protein number by ratiometric comparison is outlined in the second half of this chapter. Counting proteins by quantitative microscopy is a relatively simple yet very powerful analytical tool that will increase our understanding of protein complex composition.

INTRODUCTION

The intersection of physics and computational, molecular, and cellular biology reflects major changes in our approach to basic cell biological questions in the post-genome era. New strategies to beat the resolution limit in live cells, examine dynamic processes with speed and accuracy, and perform these genome-wide challenge cell biologists to make quantitatively accurate measurements. Determining the protein composition of complex dynamic structures is needed for a complete understanding of cellular function. Quantitative analysis of fluorescence microscopy images can provide absolute protein numbers and information regarding stoichiometry of protein complexes. Knowledge of the number of proteins present in a given complex is crucial for the development of structural and dynamic models of cellular processes. Here, we discuss three methods for determining absolute protein numbers using quantitative fluorescence microscopy and provide a step-by-step protocol for counting molecules by ratiometric comparison of fluorescence intensity.

19.1 METHODS FOR COUNTING MOLECULES
19.1.1 IMAGING AND MEASUREMENT CONSIDERATIONS

In order to obtain reliable and quantifiable images for analysis, some general considerations should be kept in mind. General microscope alignment and sample preparation concerns are discussed in greater detail elsewhere (Rottenfusser, 2013; Salmon et al., 2013; Waters, 2013). In order to accurately measure fluorescence intensity, it is essential to maximize the signal-to-noise ratio while also minimizing photobleaching. Microscope alignment, the objective lens, and the sample preparation contribute in large part to image quality. Proper alignment ensures even illumination across the field of view. The objective lens should have a high numerical aperture (NA) and be corrected for optical aberrations at a magnification level appropriate for the sample to obtain the greatest image intensity. For quantitative image

acquisition in budding yeast, we acquire images on a widefield microscope with a 100× objective with an NA of at least 1.4. For proteins of interest in thicker specimens, it may be preferable to use a confocal microscope or total internal reflection (TIRF) microscopy to reduce out-of-focus light (Hallworth & Nichols, 2012; Joglekar, Bouck, et al., 2008; Ulbrich & Isacoff, 2007). The sample should be fluorescently labeled in a manner that ensures a consistent ratiometric relationship between fluorescent signal intensity and number of proteins of interest. This can be most easily achieved using a genetically encoded fluorophore that is both bright and stable (Douglass & Vale, 2008; Johnson & Straight, 2013; Xia, Li, & Fang, 2013). Imaging parameters should minimize sample photobleaching, and all methods discussed are very sensitive to loss of signal intensity due to unintended photobleaching during image acquisition (Coffman & Wu, 2012; Johnson & Straight, 2013). The detailed protocol that follows includes specific guidelines for optimization of image acquisition.

The details of postacquisition image analysis vary by method, but proper quantification of image intensity is universally important. The fluorescence intensity of a two-dimensional image can be measured from either the peak intensity of the spot (brightest pixel intensity) or the integrated intensity of the whole spot. We use integrated intensity for intensity quantification since this method does not assume a constant volume. When comparing multiple structures that differ in size and/or shape, measurement by integrated intensity will more accurately describe the intensity independent of fluorophore density (Fig. 19.1). Brightest pixel measurements will show a reduced signal intensity if a structure increases in size (reducing fluorophore density) and can result in misleading analysis of the number of fluorophores. It may also be necessary to sum intensity values of multiple z-planes if the structure of interest is larger than the resolution limit in z. For relatively small structures, such as yeast kinetochore spots, we acquire sufficiently closely spaced z-planes (with respect to the objective) to capture the in-focus image plane for analysis (Joglekar, Salmon, & Bloom, 2008). For larger structures, it may be necessary to use the sum intensity of multiple z-planes to fully capture the intensity (Coffman & Wu, 2012; Wu & Pollard, 2005). In addition to using integrated intensity measurements, it is important to correct for background fluorescence (Hoffman et al., 2001). This is done by measuring total integrated intensity of the region of interest and that of a slightly larger region and obtaining the background intensity value (Fig. 19.1D). This value is then subtracted to calculate the intensity of the spot of interest.

19.1.2 FLUORESCENCE CORRELATION SPECTROSCOPY

Fluorescence correlation spectroscopy (FCS) is a microscopy method in which the fluorescence intensity arising from molecules within a small volume is collected over time and correlated to obtain information regarding dynamics and concentrations. This method can be applied *in vivo* and, like other fluorescence microscopy techniques, is nondestructive. FCS measurements are highly sensitive and can be done at the single-molecule level (Chen, Muller, Ruan, & Gratton, 2002). In principle, FCS measures the small changes in fluorescence intensity arising when a

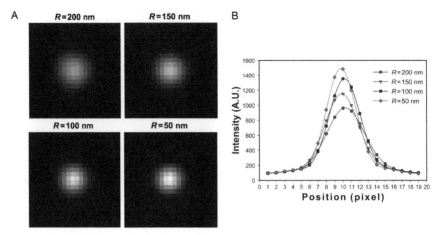

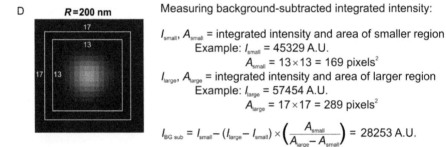

FIGURE 19.1

Methods for measuring fluorescence intensity. (A) Simulated and convolved spheres of known subresolution diameters populated with a constant number of fluorophores ($N=50$) shown on the same intensity scale (generated using FluoroSim; Quammen et al., 2008). (B) Linescans through the brightest pixel of the simulated sphere images. The maximum intensity decreases as the size of the sphere is increased. (C) Comparison of maximum intensity and integrated intensity measurements. Integrated intensity values show a 4% difference between values measured for the largest and smallest spheres. For comparison, the maximum intensity values show an almost 40% difference. (D) The procedure for measuring background-corrected integrated intensity. Briefly, two square regions are drawn around the signal of interest and the integrated intensity values of these are recorded. Using the areas and integrated intensities of these squares, the final background-corrected integrated intensity can be calculated (Example shown is for the $R=200$ nm simulated sphere image from (A).).

(D) Adapted from Hoffman, Pearson, Yen, Howell, and Salmon (2001).

molecule enters the observation volume and the corresponding drop when it leaves (Braeckmans, Deschout, Demeester, & De Smedt, 2011; Bulseco & Wolf, 2013; Gosch & Rigler, 2005; Levin & Carson, 2004). Correlation analysis of the measured fluorescence intensity over time should reveal the concentration and diffusion rate of particles through the observation volume.

FCS experiments require a more specialized optical setup than stepwise photobleaching or ratiometric comparison of fluorescence intensity (Bacia & Schwille, 2003; Bulseco & Wolf, 2013; Haustein & Schwille, 2007). Recent advances in microscope detector sensitivity (photomultiplier tube or avalanche photodiode (APD)) have allowed for greater sensitivity and analysis in FCS experiments (Ries & Schwille, 2012; Tian, Martinez, & Pappas, 2011; Vukojevic et al., 2005). In contrast to a standard laser scanning confocal microscope, for FCS experiments, the laser beam position remains constant and the fluorescence intensity within the observation volume is measured over time. The confocal FCS observation volume is defined by the focusing of laser excitation light, and, as with typical confocal microscopes, apertures are used to reduce out-of-focus light (Bulseco & Wolf, 2013). For aligned and optimized confocal FCS microscope systems, the observation volume is approximately 0.5 fL and 600 nm in diameter (Bulseco & Wolf, 2013; Slaughter & Li, 2010).

FCS relies on the dynamic diffusion of particles through the observation volume, and this method is limited to measuring diffusion rates and molecule numbers for mobile samples. The length of observation is determined by the speed of particle diffusion and, as with the other techniques described here, it is important to consider and minimize photobleaching effects when choosing fluorophores and during image acquisition (Bacia & Schwille, 2003; Ries & Schwille, 2012). In addition to being limited to measuring mobile samples, FCS is best applied to certain concentration ranges (\sim1 fluorescent particle per observation volume), and concentrations that are too low or too high require very long observation times for reliable analysis (Enderlein, Gregor, Patra, & Fitter, 2004; Levin & Carson, 2004; Slaughter & Li, 2010).

Photon counting histogram (PCH) analysis (and fluorescence intensity distribution analysis) can be applied to the data to measure the absolute number of particles (Thompson, Lieto, & Allen, 2002). PCH analysis utilizes the fluorescence measurements observed within the observation volume and mathematically relates this intensity distribution to the number of molecules present (Chen, Muller, Berland, & Gratton, 1999; Chen, Muller, So, & Gratton, 1999; Kask, Palo, Ullmann, & Gall, 1999). FCS imaging within a small observation volume and PCH analysis have been used to generate a calibration curve relating brightness and absolute number of particles and compare these to experimental structures *in vivo* (Shivaraju et al., 2012; Slaughter, Huff, Wiegraebe, Schwartz, & Li, 2008).

19.1.3 STEPWISE PHOTOBLEACHING

The measurement of protein counts by observation of photobleaching dynamics has been applied to a wide range of biological systems to determine number and stoichiometry of protein subunits. This method captures the irreversible photobleaching of

fluorophores fused to the protein of interest at single-molecule resolution. In addition to imaging considerations previously discussed, the experimental setup should be optimized to minimize photobleaching multiple fluorophores in the same event (Coffman & Wu, 2012; Hallworth & Nichols, 2012). This includes those considerations discussed in the preceding text and the incorporation of well-characterized control structures. A range of structures have been used as controls to assess the reliability of detection and analysis, including various membrane-bound channels and receptors, cytosolic fluorophores, or the bacterial flagellar motor MotB (Coffman, Wu, Parthun, & Wu, 2011; Leake et al., 2006; Padeganeh et al., 2013; Ulbrich & Isacoff, 2007).

There are two general approaches for the measurement of the number of proteins present in a given structure or complex by stepwise photobleaching—direct counting of photobleaching steps and the determination of the step size of a single photobleaching event to extrapolate the total number of fluorophores. The direct counting of photobleaching steps is most relatable for low protein numbers. The maximum number of steps that can be measured without additional mathematical extrapolation ranges from 5–7 to 15 steps (Das, Darshi, Cheley, Wallace, & Bayley, 2007; Ulbrich & Isacoff, 2007). The raw data can be further processed to enable detection of a larger number of photobleaching steps using a Chung–Kennedy filter or methods to detect changes in intensity state such as hidden Markov modeling (Chung & Kennedy, 1991; Engel, Ludington, & Marshall, 2009; McKinney, Joo, & Ha, 2006; Watkins & Yang, 2005). Alternatively, it is possible to measure the intensity drop corresponding to the photobleaching of one fluorophore and compare this value to the unbleached spot intensity to extrapolate the number of fluorophores in the structure. This approach has been used to determine the composition of various complexes including the bacterial flagellar motor and yeast centromeres (Coffman et al., 2011; Leake et al., 2006). A combination of photobleaching and brightness analysis has been used to measure the subunit composition of mammalian membrane proteins (Madl et al., 2010).

19.1.4 RATIOMETRIC COMPARISON OF FLUORESCENCE INTENSITY TO KNOWN STANDARDS

The stepwise photobleaching method can thus be applied in a manner that compares the fluorescence drop upon bleaching a single fluorophore to the total fluorescence of the sample. This is, in principle, similar to the ratiometric comparison of fluorescence intensity to determine the absolute protein number and allows for the measurement of a greater number of protein counts than direct stepwise photobleaching experiments. This method works by building a standard curve relating fluorescence intensity to number of molecules through careful and consistent measurement of fluorescence intensity of one or more fluorescence standards (Fig. 19.2). Alternatively, one can measure the ratio of bulk to single-molecule intensity of a standard and compare this to the bulk intensity of the labeled protein of interest to determine the intensity of a single fluorescent protein of interest (Graham, Johnson, & Marko, 2011).

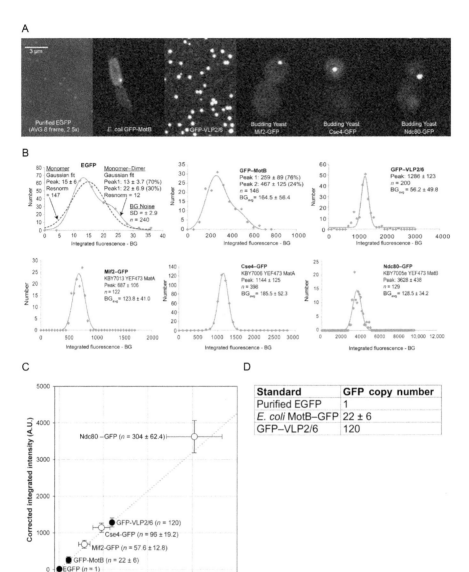

FIGURE 19.2

Generating a standard curve. (A) Representative images of standards used in Lawrimore, Bloom, and Salmon (2011) and yeast strains in which anaphase copy numbers were measured. Purified EGFP (top left panel) was imaged with 2.5-fold longer exposure time (1500 vs. 600 ms) than other specimens and image shown is an average of eight images. (B) Gaussian fits of depth- and photobleaching-corrected integrated fluorescence intensity for standards and anaphase GFP spots in yeast strains. Peak intensities of each Gaussian fit are provided with standard deviation. EGFP and GFP–MotB can be fitted with two Gaussian curves (peak 1 and peak 2). BG noise is the average background intensity corrected for in each sample. (C) Standard curve generated from EGFP-, GFP-MotB-, and GFP–VLP2/6-corrected integrated fluorescence intensity versus protein number (black circles) with GFP spots from yeast strains (white circles). The dotted line represents a linear regression of the three standards (black circles). Values ± standard deviation. (D) Table of GFP copy numbers for three fluorescence standards used to generate the standard curve in (C).

Panels (A) and (B): Adapted from Lawrimore et al. (2011).

Fluorescence standards are discussed in greater detail later in the text and should be characterized using biochemical or electron microscopy assays to confirm their composition. The fluorescence of an experimental spot can then be measured under identical conditions and compared to the standard curve to determine protein count (Fig. 19.2C).

Ratiometric comparison of fluorescence intensities can be applied to a range of biological questions, including measurements of the budding yeast kinetochore to examine transcription dynamics in *Escherichia coli* (Taniguchi et al., 2010; Yu, Xiao, Ren, Lao, & Xie, 2006) and the organization of the kinetochore–microtubule attachment in budding yeast (Joglekar, Bouck, et al., 2008; Joglekar, Bouck, Molk, Bloom, & Salmon, 2006; Joglekar, Salmon, et al., 2008). More recently, ratiometric comparison of fluorescence intensity has been applied to understand the γ-tubulin microtubule nucleation structure (Erlemann et al., 2012). Fission yeast cytokinetic contractile ring proteins have been measured by comparing fluorescence intensity to a quantitative immunoblotting standard curve (McCormick, Akamatsu, Ti, & Pollard, 2013; Wu & Pollard, 2005). Overall, ratiometric comparison of fluorescence intensities is a powerful method of determining protein counts in a variety of systems that does not require highly specialized equipment. This method, like the FCS-based counting and stepwise photobleaching, requires rigorous quantification of known fluorescence standards to validate and calibrate the experiment.

19.1.5 FLUORESCENCE STANDARDS

For all the methods discussed, it is essential to validate the acquisition and analysis methodology using a range of known fluorescence standards to determine the relationship between fluorescence intensity and number of molecules (Fig. 19.2). The protein composition and stoichiometry of these fluorescence standards have been characterized using a range of different procedures. The most straightforward standard, though technically challenging to image, is soluble GFP either *in vitro* or cytosolic (Lawrimore et al., 2011; Padeganeh et al., 2013). The typical *E. coli* flagellar motor is composed of 11 stators, and each contains two copies of the MotB protein, as determined by electron microscopy and biochemical analysis (Khan, Dapice, & Reese, 1988; Kojima & Blair, 2004). Fluorescence imaging and stepwise photobleaching analysis have shown that GFP–MotB clusters contain approximately 22 times the intensity of a single GFP molecule (Leake et al., 2006). Subsequent studies have confirmed the composition of this structure by stepwise photobleaching and ratiometric comparison of fluorescence intensity (Coffman et al., 2011; Lawrimore et al., 2011). The virus-like particles (VLP), formed by proteins GFP–VP2/6, contains 120 GFPs as determined by electron tomography and an extinction coefficient predicted for 120 GFPs per virus capsid and has been used as a fluorescence standard for ratiometric comparison (Charpilienne et al., 2001; Lawrimore et al., 2011).

The centromere-specific histone H3 variant in budding yeast, Cse4p, has been used as a fluorescence standard, and recent studies have further clarified the composition of Cse4p clusters *in vivo*. Given the sequence-specific nature of the budding

yeast centromere, it was thought that each chromosome contained only one Cse4p-containing nucleosome, making this an attractive fluorescent standard (Joglekar, Bouck, et al., 2008; Joglekar et al., 2006; Johnston et al., 2010). The 16 budding yeast kinetochores are clustered together into two close to diffraction-limited spots during M phase. These clusters have been shown to appear anisotropic during metaphase and more compact during anaphase (Haase, Stephens, Verdaasdonk, Yeh, & Bloom, 2012). The peak intensity value of these clusters is increased during anaphase as the spots are more compacted, but there is no change in integrated intensity between metaphase and anaphase (Fig. 19.1).

The single nucleosome concept was derived from chromatin immunoprecipitation demonstrating that Cse4p was concentrated at the centromere DNA (Furuyama & Biggins, 2007; Verdaasdonk & Bloom, 2011). However, the single Cse4p nucleosome standard failed to match protein numbers estimated from biochemistry. Various groups have measured the number of Cse4p proteins in each kinetochore cluster. Coffman et al. and Lawrimore et al. each generated a standard curve of fluorescence intensity versus number of molecules using some of the fluorescence standards described in the preceding text by stepwise photobleaching or ratiometric comparison of fluorescence intensity, respectively (Coffman et al., 2011; Lawrimore et al., 2011). Lawrimore et al. reported ~5 Cse4p per chromosome for a total of 80 per haploid cluster and Coffman et al. found ~7–8 Cse4p per chromosome for a total of 122 per cluster (Coffman et al., 2011; Lawrimore et al., 2011). These studies show that there are extra Cse4p molecules incorporated at random positions over 20–50 kb of DNA flanking the centromere. This anisotropy of Cse4p clusters is abolished in the mRNA processing *pat1Δ* or *xrn1Δ* mutants, and the number of Cse4p molecules associated with chromatin is also reduced (Haase et al., 2013; Maresca, 2013). These findings support the presence of extra Cse4p molecules per chromosome and show that these are not essential for chromosome segregation.

Using FCS of soluble GFP to calibrate APD confocal imaging, Shivaraju et al. found 1–2 Cse4p per chromosome (depending on cell cycle stage) (Shivaraju et al., 2012). The FCS imaging methodology used in this study examines fluorescence in a defined volume that may be excluding fluorescence resulting from the extra Cse4p incorporated away from the centromere in anisotropic fluorescence clusters. Previous work has shown that Cse4p clusters change size/shape throughout the cell cycle (Haase et al., 2012), and thus, the use of maximum intensity instead of integrated intensity measurements could account for the variation in Cse4p intensity between metaphase and anaphase observed by Shivaraju et al. (2012). Therefore, it is possible that Shivaraju et al. had very accurately measured the Cse4p content at the centromere (~2 Cse4p per chromosome) while excluding the fluorescence intensity from the extra Cse4p molecules observed by Coffman et al. (2011), Lawrimore et al. (2011), and Shivaraju et al. (2012). The result that the centromere nucleosome contains 2 Cse4p proteins is consistent with TIRF stepwise photobleaching of single nucleosomes in mammalian cells (Padeganeh et al., 2013) and BiFC complementation experiments (Aravamudhan, Felzer-Kim, & Joglekar, 2013).

Analysis of whole fluorescent clusters of Cse4p yields a number of 5–6 Cse4p per chromosome (80–96 molecules per cluster). Using these values, the ratiometric comparison of fluorescence intensity approach is consistent with independent protein measurements for cytokinesis (McCormick et al., 2013; Wu & Pollard, 2005), γ-tubulin small complex (Erlemann et al., 2012), and Cnp1 in fission yeast (Lando et al., 2012).

19.2 PROTOCOL FOR COUNTING MOLECULES BY RATIOMETRIC COMPARISON OF FLUORESCENCE INTENSITY

This protocol uses the protein copy number of Cse4–GFP (anaphase) published in Lawrimore et al. (2011) to calculate protein copy numbers of other GFP-fused proteins. As discussed earlier in the text, Cse4–GFP intensity has been compared to a range of other fluorescence standards of known composition to validate its use as a standard. Either GFP(S65T) or EGFP(S65T, F64L) can be used as they have similar emission spectra and other properties (Patterson, Knobel, Sharif, Kain, & Piston, 1997). In addition to yeast, this protocol has been used to count the number of molecules in DT40 cells (Johnston et al., 2010). The protocol in the succeeding text is primarily designed for imaging punctate spots in budding yeast cells; however, these methods can be adapted for imaging larger GFP signals or in other cell types. Since this method is based on comparing the intensity of a known standard (Cse4–GFP) to other samples, consistency during the experiment is crucial.

19.2.1 MINIMIZING INSTRUMENT ERROR

Before undertaking any quantitative fluorescence measurements, it is essential to understand how the specifications and setup of an imaging system will affect the precision of the measurements. The following steps will help minimize any potential systematic errors:

- *Camera*: Ensure that the camera you are using has high quantum efficiency for the EGFP emission spectrum (Tsien, 1998). The lower the quantum efficiency, the more variation will occur in all of the fluorescence intensity measurements. In addition, use a camera with the smallest possible pixel size. Images can be binned to increase signal if needed. Suggested pixel size of the images is 130 nm.
- *Objective*: Only use the highest NA and magnification objectives. An NA of 1.4 or higher and a magnification of $100\times$ are required.
- *Stage*: Since fluorescence intensity reduces as a function of sample depth, a stage that allows accurate and consistent Z-steps should be used.
- *Light source*: The consistency of the light used in quantitative measurements is essential. No matter the light source used, the intensity of the light should be

checked regularly. Measure the intensity of the light every 20 min after allowing 30 min of warm-up to ensure the light source is stable. Arc lamps are less stable than laser and LED-based lighting systems and thus should be used with caution. However, frequent light intensity readings and allowing proper warm-up time will mitigate variation in light intensity.
- *Imaging environment*: Any ambient light will cause increased variation in fluorescence intensity measurements. All imaging should be performed in the darkest and most consistent conditions possible.

19.2.2 MEASURING INSTRUMENT VARIATION

The steps in the succeeding text directly measure the precision of an imaging system and are intended to quantify the amount of variation resulting from different imaging components that will influence fluorescence intensity measurements. Note that the sources of variation are additive in the order they are given. It is strongly suggested that the following steps be performed in the order given:

1. *Dark noise*
 - Turn on the imaging system and allow for proper warm-up of all components.
 - Take five, full-chip images with the camera shutter closed.
 - Measure the mean intensity of several regions across the full-chip image. Note any intensity variations present in the dark images and take it into account when selecting a region of interest for imaging.
 - Measure the mean intensity and standard deviation of your region of interest to be used during imaging.
 - Average the five mean intensity and standard deviation measurements together to calculate the noise due to electronic noise.
2. *Light leakage*
 - Repeat the steps earlier in the text but with the camera shutter open but with no light from the light source allowed in the camera path to test for any possible light leakage.
3. *Light noise*
 - Repeat the steps in the first section but allow excitation light through the objective. The light coming from the light source should be measured by carefully removing the objective or rotating the microscope turret to an empty slot and using a light meter to measure the intensity of the light. Suggested light intensity is 0.5 mW of 488 nm light. Any increase in the standard deviation will reflect the variation from the light source.
4. *Sample buffer noise*
 - Repeat the steps in the first section with a slide filled with imaging buffer/media. For yeast, use a synthetic media. Autoclaved rich yeast media containing sugar is highly autofluorescent and should not be used.

19.2.3 BUDDING YEAST IMAGING PROTOCOL

This section outlines the procedure for growth and imaging of the yeast strain expressing Cse4–GFP (KBY7006). To minimize protein count variation due to different health conditions of yeast, all yeast should be grown to an optical density ($\lambda = 660$ nm) of at least 0.4 twice before starting an imaging culture. Image each strain until a sample size of 100 is obtained. Do not analyze any images where the GFP spot is moving:

1. Grow yeast in YPD media at 24 °C in 50 mL or greater flasks until reaching mid-logarithmic phase ($OD_{660} = 0.4$–0.8).
2. Thirty minutes prior to imaging, turn on all imaging components.
3. Spin down 1 mL yeast culture for 1 min at 4000 rpm.
4. Aspirate supernatant and resuspend in 1 mL synthetic media.
5. Spin down 1 mL yeast culture for 1 min at 4000 rpm.
6. Aspirate supernatant and resuspend in 20–100 µL synthetic media depending on the size of the pellet.
7. Pipet yeast resuspension on a concanavalin A-coated coverslip, place coverslip on slide, and seal edges with VALAP (1:1:1 mix of vaseline/lanolin/paraffin).
8. Immediately prior to imaging, measure the light intensity by removing the objective or moving turret to blank slot. Place light meter where slide will rest during imaging. Set light intensity to 0.5 mW.
9. Obtain Z-series image stacks with 40, 200 nm step sizes of yeast in anaphase. Anaphase yeast will have large buds and the GFP spots will be separated by 4–5 µm. The objective should be focused above/below the coverslip so that the Z-series will pass through the coverslip before focusing on yeast. If the pixel size of the image is near 65 nm, use 2×2 binning.
10. Note the frame where the coverslip is in focus. There will be an autofluorescent residue on the coverslip surface to indicate when the coverslip is in focus.
11. Note the frame where the GFP spot is in focus.
12. After 20 min of imaging, remove the slide and check the image intensity. If the intensity has drifted, do not analyze the z-stacks acquired. Do not image a slide for longer than 20 min as the yeast viability will deteriorate over time.

19.2.4 MEASURING BACKGROUND-SUBTRACTED, INTEGRATED INTENSITY

The image analysis described here entails measuring the integrated intensity (summing of all pixel values in a region of interest) of a larger and a smaller region of interest around the in-focus GFP spot and subtracting the integrated intensity of the surrounding background. Different imaging systems and specimens will require different regions of interest sizes. Ensure that region size and shape selected are large enough to capture the entire signal of the GFP spot. For most punctate GFP spots, a 5×5 pixel square (where 1 pixel = 135 nm) is sufficient to encompass the GFP spot. For GFP signals that are not punctate, draw a region large enough to encompass the whole signal.

In order to measure the background of a GFP spot, draw a second region of interest centered on the region encompassing the GFP spot. For the punctate spots within a 5×5 pixel region, a larger 7×7 (where 1 pixel = 135 nm) pixel square was used. The following equation describes how to calculate the background-subtracted, integrated intensity from the two concentric regions (adapted from Hoffman et al., 2001):

$$I_{BG\,sub} = I_{small} - (I_{large} - I_{small}) \times \left(\frac{A_{small}}{A_{large} - A_{small}} \right)$$

where I_{small} is the integrated intensity of the smaller region, I_{large} is the integrated intensity of the larger region, A_{small} is the area in pixels of the smaller region, and A_{large} is the area in pixels of the larger region (Fig. 19.1D). To minimize error, the area of the larger region should be close to twice the size of the smaller region. However, regions of any size and shape can be used. In yeast, the nucleus is present during mitosis and has a slightly higher background than the cytoplasm. In cases where the GFP spot is against the nuclear envelope, the larger region can be shifted to capture more of the nuclear background. However, the larger region must fully encompass the smaller region.

For specimens where the GFP signal background cannot be measured as described in the preceding text, regions distal to the GFP signal can be used if the background intensity is similar to the region proximal to the GFP signal. Alternatively, specimens lacking the GFP signal can be measured to calculate an average background. However, this method will introduce measurement error if the background intensities of the specimen lacking GFP differ or are highly variable. For these methods, use the same region sizes for the sample and the background and directly subtract the background-subtracted, integrated intensity from the sample's integrated intensity.

19.2.5 DEPTH CORRECTION

The further away a GFP spot is from the coverslip surface, the lower the integrated intensity will be. To calculate the depth of a GFP spot, subtract the frame number of the coverslip from the frame number of the in-focus GFP spot. Plot the background-subtracted, integrated intensity against the depth. Perform a linear regression on the data and calculate the slope of the line. For each background-subtracted, integrated intensity, use the following equation to correct for depth variation:

$$I_{depth} = \left(f_{spot} - f_{cs} \right) \times (|m|) + I_{BG\,sub,PC}$$

where I_{depth} is the background-subtracted, depth-corrected, integrated intensity; f_{spot} is the frame number of the in-focus GFP spot; f_{cs} is the frame number of the coverslip; m is the slope of the linear regression; and $I_{BGsub,PC}$ is the background-subtracted, photobleach-corrected, integrated intensity. Plot the depth-corrected data against the depth and perform another linear regression. Ensure the slope of the depth-corrected intensities is now zero.

19.2.6 CALCULATING PHOTOBLEACHING CORRECTION FACTOR

As a consequence of taking multiple pictures per Z-series, a small amount of photobleaching will occur. In order to minimize the variation that results from differing rates of photobleaching, each experimental strain should have a photobleaching curve constructed. Take five consecutive Z-series with the same settings used for normal image acquisition. A sample size of at least 10 GFP spots should be obtained. Measure the background-subtracted, integrated intensity of each in-focus GFP spot as described previously in the text. Use the slope of the background-subtracted, integrated intensity versus depth plot to correct for depth variation.

To calculate the photobleaching correction factor, calculate the four percent differences for each of the five timelapses taken. Then, average all of the percent difference together and divided by two. This step is summarized in the following equation:

$$CF = \frac{\langle (I_{depth_x} - I_{depth_{x+1}})/I_{depth_x} \rangle}{2}$$

where CF is the photobleaching correction factor; I_{depth_x} is the background-subtracted, depth-corrected, integrated intensity of a particular timelapse; and $I_{depth_{x+1}}$ is the background-subtracted, depth-corrected, integrated intensity of the next sequential timelapse.

Multiply each background-subtracted, depth-corrected, integrated intensity by this factor to calculate the amount of integrated intensity lost due to photobleaching during image acquisition. Add this amount to the background-subtracted, depth-corrected, integrated intensity to correct for photobleaching. This step is summarized in the following equation:

$$I_{depth,photo} = (I_{depth} \times CF) + I_{depth}$$

where $I_{depth,photo}$ is the background-subtracted, depth- and photobleach-corrected, integrated intensity; I_{depth} is the background-subtracted, depth-corrected, integrated intensity of a spot; and CF is the photobleaching correction factor.

19.2.7 GAUSSIAN FITTING AND RATIOMETRIC COMPARISON TO DETERMINE PROTEIN COUNT

Perform a least-squares fit to a Gaussian curve on the background-subtracted, depth- and photobleach-corrected, integrated intensities to calculate the mean and standard deviation of each data set. To determine the intensity to copy number conversion factor, divide the mean and standard deviation of the experimental data set by the number of Cse4–GFP molecules/cluster($=96 \pm 19.2$, anaphase) (Fig. 19.2C; Lawrimore et al., 2011). This conversion factor can be used to calculate the copy number of other proteins tagged with GFP.

CONCLUSIONS

The methods discussed in this chapter provide a starting point for researchers wishing to determine the absolute number of their protein of interest. A broad range of biological questions can benefit from knowledge of protein numbers, such as examining protein complex organization throughout the cell cycle, how protein composition is maintained, or allowing for mathematical modeling of protein complex architecture and behavior. The ratiometric comparison of fluorescence intensity to known standards allows for measurement of a broad range of protein numbers using standard high-end microscopy equipment. We encourage scientists to consider protein counting as another tool to address their research questions.

REFERENCES

Aravamudhan, P., Felzer-Kim, I., & Joglekar, A. P. (2013). The budding yeast point centromere associates with two Cse4 molecules during mitosis. *Current Biology, 23*(9), 770–774. http://dx.doi.org/10.1016/j.cub.2013.03.042.

Bacia, K., & Schwille, P. (2003). A dynamic view of cellular processes by in vivo fluorescence auto- and cross-correlation spectroscopy. *Methods, 29*(1), 74–85.

Braeckmans, K., Deschout, H., Demeester, J., & De Smedt, S. C. (2011). Measuring molecular dynamics by FRAP, FCS, and SPT. *Optical fluorescence microscopy: From the spectral to the nano dimension.* (pp. 153–163). Berlin, Heidelberg: Springer-Verlag.

Bulseco, D. A., & Wolf, D. E. (2013). Fluorescence correlation spectroscopy: Molecular complexing in solution and in living cells. *Methods in Cell Biology, 114*, 489–524. http://dx.doi.org/10.1016/B978-0-12-407761-4.00021-X.

Charpilienne, A., Nejmeddine, M., Berois, M., Parez, N., Neumann, E., Hewat, E., et al. (2001). Individual rotavirus-like particles containing 120 molecules of fluorescent protein are visible in living cells. *The Journal of Biological Chemistry, 276*(31), 29361–29367. http://dx.doi.org/10.1074/jbc.M101935200.

Chen, Y., Muller, J. D., Berland, K. M., & Gratton, E. (1999). Fluorescence fluctuation spectroscopy. *Methods, 19*(2), 234–252. http://dx.doi.org/10.1006/meth.1999.0854.

Chen, Y., Muller, J. D., Ruan, Q., & Gratton, E. (2002). Molecular brightness characterization of EGFP in vivo by fluorescence fluctuation spectroscopy. *Biophysical Journal, 82*(1 Pt 1), 133–144. http://dx.doi.org/10.1016/S0006-3495(02)75380-0.

Chen, Y., Muller, J. D., So, P. T., & Gratton, E. (1999). The photon counting histogram in fluorescence fluctuation spectroscopy. *Biophysical Journal, 77*(1), 553–567. http://dx.doi.org/10.1016/S0006-3495(99)76912-2.

Chung, S. H., & Kennedy, R. A. (1991). Forward-backward non-linear filtering technique for extracting small biological signals from noise. *Journal of Neuroscience Methods, 40*(1), 71–86.

Coffman, V. C., & Wu, J. Q. (2012). Counting protein molecules using quantitative fluorescence microscopy. *Trends in Biochemical Sciences, 37*(11), 499–506. http://dx.doi.org/10.1016/j.tibs.2012.08.002.

Coffman, V. C., Wu, P., Parthun, M. R., & Wu, J. Q. (2011). CENP-A exceeds microtubule attachment sites in centromere clusters of both budding and fission yeast. *The Journal of Cell Biology, 195*(4), 563–572. http://dx.doi.org/10.1083/jcb.201106078.

Das, S. K., Darshi, M., Cheley, S., Wallace, M. I., & Bayley, H. (2007). Membrane protein stoichiometry determined from the step-wise photobleaching of dye-labelled subunits. *Chembiochem: A European Journal of Chemical Biology, 8*(9), 994–999. http://dx.doi.org/10.1002/cbic.200600474.

Douglass, A. D., & Vale, R. D. (2008). Single-molecule imaging of fluorescent proteins. *Methods in Cell Biology, 85*, 113–125. http://dx.doi.org/10.1016/S0091-679X(08)85006-6.

Enderlein, J., Gregor, I., Patra, D., & Fitter, J. (2004). Art and artefacts of fluorescence correlation spectroscopy. *Current Pharmaceutical Biotechnology, 5*(2), 155–161. http://dx.doi.org/10.2174/1389201043377020.

Engel, B. D., Ludington, W. B., & Marshall, W. F. (2009). Intraflagellar transport particle size scales inversely with flagellar length: Revisiting the balance-point length control model. *The Journal of Cell Biology, 187*(1), 81–89. http://dx.doi.org/10.1083/jcb.200812084.

Erlemann, S., Neuner, A., Gombos, L., Gibeaux, R., Antony, C., & Schiebel, E. (2012). An extended gamma-tubulin ring functions as a stable platform in microtubule nucleation. *The Journal of Cell Biology, 197*(1), 59–74. http://dx.doi.org/10.1083/jcb.201111123.

Furuyama, S., & Biggins, S. (2007). Centromere identity is specified by a single centromeric nucleosome in budding yeast. *Proceedings of the National Academy of Sciences of the United States of America, 104*(37), 14706–14711.

Gosch, M., & Rigler, R. (2005). Fluorescence correlation spectroscopy of molecular motions and kinetics. *Advanced Drug Delivery Reviews, 57*(1), 169–190. http://dx.doi.org/10.1016/j.addr.2004.07.016.

Graham, J. S., Johnson, R. C., & Marko, J. F. (2011). Counting proteins bound to a single DNA molecule. *Biochemical and Biophysical Research Communications, 415*(1), 131–134. http://dx.doi.org/10.1016/j.bbrc.2011.10.029.

Haase, J., Mishra, P. K., Stephens, A., Haggerty, R., Quammen, C., Taylor, R. M., 2nd., et al. (2013). A 3D map of the yeast kinetochore reveals the presence of core and accessory centromere-specific histone. *Current Biology, 23*(19), 1939–1944. http://dx.doi.org/10.1016/j.cub.2013.07.083.

Haase, J., Stephens, A., Verdaasdonk, J., Yeh, E., & Bloom, K. (2012). Bub1 kinase and Sgo1 modulate pericentric chromatin in response to altered microtubule dynamics. *Current Biology, 22*(6), 471–481. http://dx.doi.org/10.1016/j.cub.2012.02.006.

Hallworth, R., & Nichols, M. G. (2012). Single molecule imaging approach to membrane protein stoichiometry. *Microscopy and Microanalysis: The Official Journal of Microscopy Society of America, Microbeam Analysis Society, Microscopical Society of Canada, 18*(4), 771–780. http://dx.doi.org/10.1017/S1431927612001195.

Haustein, E., & Schwille, P. (2007). Fluorescence correlation spectroscopy: Novel variations of an established technique. *Annual Review of Biophysics and Biomolecular Structure, 36*, 151–169. http://dx.doi.org/10.1146/annurev.biophys.36.040306.132612.

Hoffman, D. B., Pearson, C. G., Yen, T. J., Howell, B. J., & Salmon, E. D. (2001). Microtubule-dependent changes in assembly of microtubule motor proteins and mitotic spindle checkpoint proteins at PtK1 kinetochores. *Molecular Biology of the Cell, 12*(7), 1995–2009.

Joglekar, A. P., Bouck, D., Finley, K., Liu, X. K., Wan, Y. K., Berman, J., et al. (2008). Molecular architecture of the kinetochore-microtubule attachment site is conserved between point and regional centromeres. *Journal of Cell Biology, 181*(4), 587–594. http://dx.doi.org/10.1083/jcb.200803027.

Joglekar, A. P., Bouck, D. C., Molk, J. N., Bloom, K. S., & Salmon, E. D. (2006). Molecular architecture of a kinetochore-microtubule attachment site. *Nature Cell Biology, 8*(6), 581–585. http://dx.doi.org/10.1038/Ncb1414.

Joglekar, A. P., Salmon, E. D., & Bloom, K. S. (2008). Counting kinetochore protein numbers in budding yeast using genetically encoded fluorescent proteins. *Methods in Cell Biology*, *85*, 127–151. http://dx.doi.org/10.1016/S0091-679X(08)85007-8.

Johnson, W. L., & Straight, A. F. (2013). Fluorescent protein applications in microscopy. *Methods in Cell Biology*, *114*, 99–123. http://dx.doi.org/10.1016/B978-0-12-407761-4.00005-1.

Johnston, K., Joglekar, A., Hori, T., Suzuki, A., Fukagawa, T., & Salmon, E. D. (2010). Vertebrate kinetochore protein architecture: Protein copy number. *The Journal of Cell Biology*, *189*(6), 937–943. http://dx.doi.org/10.1083/jcb.200912022.

Kask, P., Palo, K., Ullmann, D., & Gall, K. (1999). Fluorescence-intensity distribution analysis and its application in biomolecular detection technology. *Proceedings of the National Academy of Sciences of the United States of America*, *96*(24), 13756–13761.

Khan, S., Dapice, M., & Reese, T. S. (1988). Effects of mot gene expression on the structure of the flagellar motor. *Journal of Molecular Biology*, *202*(3), 575–584.

Kojima, S., & Blair, D. F. (2004). Solubilization and purification of the MotA/MotB complex of Escherichia coli. *Biochemistry*, *43*(1), 26–34. http://dx.doi.org/10.1021/bi035405l.

Lando, D., Endesfelder, U., Berger, H., Subramanian, L., Dunne, P. D., McColl, J., et al. (2012). Quantitative single-molecule microscopy reveals that CENP-A(Cnp1) deposition occurs during G2 in fission yeast. *Open Biology*, *2*(7), 120078. http://dx.doi.org/10.1098/rsob.120078.

Lawrimore, J., Bloom, K. S., & Salmon, E. D. (2011). Point centromeres contain more than a single centromere-specific Cse4 (CENP-A) nucleosome. *Journal of Cell Biology*, *195*(4), 573–582. http://dx.doi.org/10.1083/jcb.201106036.

Leake, M. C., Chandler, J. H., Wadhams, G. H., Bai, F., Berry, R. M., & Armitage, J. P. (2006). Stoichiometry and turnover in single, functioning membrane protein complexes. *Nature*, *443*(7109), 355–358. http://dx.doi.org/10.1038/nature05135.

Levin, M. K., & Carson, J. H. (2004). Fluorescence correlation spectroscopy and quantitative cell biology. *Differentiation; Research in Biological Diversity*, *72*(1), 1–10. http://dx.doi.org/10.1111/j.1432-0436.2004.07201002.x.

Madl, J., Weghuber, J., Fritsch, R., Derler, I., Fahrner, M., Frischauf, I., et al. (2010). Resting state Orai1 diffuses as homotetramer in the plasma membrane of live mammalian cells. *The Journal of Biological Chemistry*, *285*(52), 41135–41142. http://dx.doi.org/10.1074/jbc.M110.177881.

Maresca, T. J. (2013). Chromosome segregation: Not to put too fine a point (centromere) on it. *Current Biology*, *23*(19), R875–R878. http://dx.doi.org/10.1016/j.cub.2013.08.049.

McCormick, C. D., Akamatsu, M. S., Ti, S. C., & Pollard, T. D. (2013). Measuring affinities of fission yeast spindle pole body proteins in live cells across the cell cycle. *Biophysical Journal*, *105*(6), 1324–1335. http://dx.doi.org/10.1016/j.bpj.2013.08.017.

McKinney, S. A., Joo, C., & Ha, T. (2006). Analysis of single-molecule FRET trajectories using hidden Markov modeling. *Biophysical Journal*, *91*(5), 1941–1951. http://dx.doi.org/10.1529/biophysj.106.082487.

Padeganeh, A., Ryan, J., Boisvert, J., Ladouceur, A. M., Dorn, J. F., & Maddox, P. S. (2013). Octameric CENP-A nucleosomes are present at human centromeres throughout the cell cycle. *Current Biology*, *23*(9), 764–769. http://dx.doi.org/10.1016/j.cub.2013.03.037.

Patterson, G. H., Knobel, S. M., Sharif, W. D., Kain, S. R., & Piston, D. W. (1997). Use of the green fluorescent protein and its mutants in quantitative fluorescence microscopy. *Biophysical Journal*, *73*(5), 2782–2790. http://dx.doi.org/10.1016/S0006-3495(97)78307-3.

Quammen, C. W., Richardson, A. C., Haase, J., Harrison, B. D., Taylor, R. M., 2nd., & Bloom, K. S. (2008). FluoroSim: A visual problem-solving environment for fluorescence microscopy. *Eurographics Workshop on Visual Computing for Biomedicine, 2008*, 151–158. http://dx.doi.org/10.2312/VCBM/VCBM08/151-158.

Ries, J., & Schwille, P. (2012). Fluorescence correlation spectroscopy. *BioEssays: News and Reviews in Molecular, Cellular and Developmental Biology, 34*(5), 361–368. http://dx.doi.org/10.1002/bies.201100111.

Rottenfusser, R. (2013). Proper alignment of the microscope. *Methods in Cell Biology, 114*, 43–67. http://dx.doi.org/10.1016/B978-0-12-407761-4.00003-8.

Salmon, E. D., Shaw, S. L., Waters, J. C., Waterman-Storer, C. M., Maddox, P. S., Yeh, E., et al. (2013). A high-resolution multimode digital microscope system. *Methods in Cell Biology, 114*, 179–210. http://dx.doi.org/10.1016/B978-0-12-407761-4.00009-9.

Shivaraju, M., Unruh, J. R., Slaughter, B. D., Mattingly, M., Berman, J., & Gerton, J. L. (2012). Cell-cycle-coupled structural oscillation of centromeric nucleosomes in yeast. *Cell, 150*(2), 304–316. http://dx.doi.org/10.1016/j.cell.2012.05.034.

Slaughter, B. D., Huff, J. M., Wiegraebe, W., Schwartz, J. W., & Li, R. (2008). SAM domain-based protein oligomerization observed by live-cell fluorescence fluctuation spectroscopy. *PLoS One, 3*(4). http://dx.doi.org/10.1371/Journal.Pone.0001931.

Slaughter, B. D., & Li, R. (2010). Toward quantitative "in vivo biochemistry" with fluorescence fluctuation spectroscopy. *Molecular Biology of the Cell, 21*(24), 4306–4311. http://dx.doi.org/10.1091/mbc.E10-05-0451.

Taniguchi, Y., Choi, P. J., Li, G. W., Chen, H., Babu, M., Hearn, J., et al. (2010). Quantifying E. coli proteome and transcriptome with single-molecule sensitivity in single cells. *Science, 329*(5991), 533–538. http://dx.doi.org/10.1126/science.1188308.

Thompson, N. L., Lieto, A. M., & Allen, N. W. (2002). Recent advances in fluorescence correlation spectroscopy. *Current Opinion in Structural Biology, 12*(5), 634–641.

Tian, Y., Martinez, M. M., & Pappas, D. (2011). Fluorescence correlation spectroscopy: A review of biochemical and microfluidic applications. *Applied Spectroscopy, 65*(4), 115A–124A. http://dx.doi.org/10.1366/10-06224.

Tsien, R. Y. (1998). The green fluorescent protein. *Annual Review of Biochemistry, 67*, 509–544. http://dx.doi.org/10.1146/annurev.biochem.67.1.509.

Ulbrich, M. H., & Isacoff, E. Y. (2007). Subunit counting in membrane-bound proteins. *Nature Methods, 4*(4), 319–321. http://dx.doi.org/10.1038/nmeth1024.

Verdaasdonk, J. S., & Bloom, K. (2011). Centromeres: Unique chromatin structures that drive chromosome segregation. *Nature Reviews. Molecular Cell Biology, 12*(5), 320–332. http://dx.doi.org/10.1038/nrm3107.

Vukojevic, V., Pramanik, A., Yakovleva, T., Rigler, R., Terenius, L., & Bakalkin, G. (2005). Study of molecular events in cells by fluorescence correlation spectroscopy. *Cellular and Molecular Life Sciences, 62*(5), 535–550. http://dx.doi.org/10.1007/s00018-004-4305-7.

Waters, J. C. (2013). Live-cell fluorescence imaging. *Methods in Cell Biology, 114*, 125–150. http://dx.doi.org/10.1016/B978-0-12-407761-4.00006-3.

Watkins, L. P., & Yang, H. (2005). Detection of intensity change points in time-resolved single-molecule measurements. *The Journal of Physical Chemistry B, 109*(1), 617–628. http://dx.doi.org/10.1021/jp0467548.

Wu, J. Q., & Pollard, T. D. (2005). Counting cytokinesis proteins globally and locally in fission yeast. *Science, 310*(5746), 310–314. http://dx.doi.org/10.1126/science.1113230.

Xia, T., Li, N., & Fang, X. (2013). Single-molecule fluorescence imaging in living cells. *Annual Review of Physical Chemistry*, *64*, 459–480. http://dx.doi.org/10.1146/annurev-physchem-040412-110127.

Yu, J., Xiao, J., Ren, X., Lao, K., & Xie, X. S. (2006). Probing gene expression in live cells, one protein molecule at a time. *Science*, *311*(5767), 1600–1603. http://dx.doi.org/10.1126/science.1119623.

CHAPTER

High-Resolution Traction Force Microscopy

20

Sergey V. Plotnikov*,[1], Benedikt Sabass[†,1], Ulrich S. Schwarz[†]
Clare M. Waterman*

*National Heart, Lung, and Blood Institute, National Institutes of Health, Bethesda, Maryland, USA
[†]Institute for Theoretical Physics and BioQuant, Heidelberg University, Heidelberg, Germany

CHAPTER OUTLINE

Introduction	368
Basic Principle of High-Resolution Traction Force Microscopy (TFM)	370
Principles of Traction Reconstruction	372
Overview of Methods for Reconstruction of Traction Forces	373
High Resolution and Regularization	374
20.1 Materials	**374**
20.1.1 Instrumentation for High-Resolution TFM	375
20.1.2 Polyacrylamide Substrates with Two Colors of Fiducial Markers	377
20.1.2.1 Suggested Equipment and Materials	377
20.1.2.2 Protocol	378
20.1.3 Functionalization of Polyacrylamide Substrates with ECM Proteins	380
20.1.3.1 Suggested Equipment and Materials	380
20.1.3.2 Protocol	381
20.2 Methods	**381**
20.2.1 Cell Culture and Preparation of Samples for High-Resolution TFM	381
20.2.1.1 Suggested Equipment and Materials	382
20.2.1.2 Protocol	382
20.2.2 Setting Up a Perfusion Chamber for TFM and Acquiring TFM Images	383
20.2.2.1 Suggested Equipment and Materials	383
20.2.2.2 Protocol	383
20.2.3 Quantifying Deformation of the Elastic Substrate	385

[1]These authors contributed equally.

20.2.4 Calculation of Traction Forces with Regularized Fourier–Transform
 Traction Cytometry .. 387
 20.2.4.1 Computational Procedure .. 387
 20.2.4.2 Choice of the Regularization Parameter........................... 388
 20.2.4.3 Alleviating Spectral Leakage Due to the FFT..................... 390
20.2.5 Representing and Processing TFM Data... 390
 20.2.5.1 Spatial Maps of Traction Magnitude................................. 390
 20.2.5.2 Whole-Cell Traction ... 390
 20.2.5.3 Traction Along a Predefined Line 392
References .. 392

Abstract

Cellular forces generated by the actomyosin cytoskeleton and transmitted to the extracellular matrix (ECM) through discrete, integrin-based protein assemblies, that is, focal adhesions, are critical to developmental morphogenesis and tissue homeostasis, as well as disease progression in cancer. However, quantitative mapping of these forces has been difficult since there has been no experimental technique to visualize nanonewton forces at submicrometer spatial resolution. Here, we provide detailed protocols for measuring cellular forces exerted on two-dimensional elastic substrates with a high-resolution traction force microscopy (TFM) method. We describe fabrication of polyacrylamide substrates labeled with multiple colors of fiducial markers, functionalization of the substrates with ECM proteins, setting up the experiment, and imaging procedures. In addition, we provide the theoretical background of traction reconstruction and experimental considerations important to design a high-resolution TFM experiment. We describe the implementation of a new algorithm for processing of images of fiducial markers that are taken below the surface of the substrate, which significantly improves data quality. We demonstrate the application of the algorithm and explain how to choose a regularization parameter for suppression of the measurement error. A brief discussion of different ways to visualize and analyze the results serves to illustrate possible uses of high-resolution TFM in biomedical research.

INTRODUCTION

Cell contractile forces generated by the actomyosin cytoskeleton and transmitted to the extracellular matrix (ECM) through integrin-based focal adhesions drive cell adhesion, spreading, and migration. These forces allow cells to perform vital physiological tasks during embryo morphogenesis, wound healing, and the immune response (DuFort, Paszek, & Weaver, 2011). Cellular traction forces are also critical for pathological processes, such as cancer metastasis (Wirtz, Konstantopoulos, & Searson, 2011). Therefore, the ability to measure cellular traction forces is critical to better understand the cellular and molecular mechanisms behind many basic biological processes at both the cell and tissue levels.

Various experimental techniques for quantitative traction force mapping at spatial scales ranging from multicellular sheets to single molecules have been developed over the last 30 years. Traction force microscopy (TFM) was pioneered by Harris, Wild, and Stopak (1980), who showed that fibroblasts wrinkle an elastic silicone rubber substrate, indicating the mechanical activity. By applying known forces, Harris et al. were able to calibrate this technique and to assess the magnitude of traction forces. However, limitations of this approach include difficulty in force quantification due to the nonlinearity of the silicone rubber deformation and low spatial resolution (Beningo & Wang, 2002; Kraning-Rush, Carey, Califano, & Reinhart-King, 2012). Further development of this approach, which combined high-resolution optical imaging and extensive computational procedures, dramatically improved the resolution, accuracy, and reproducibility of traction force measurements and transformed TFM into a technique with relatively wide use in many biomedical research laboratories (Aratyn-Schaus & Gardel, 2010; Dembo & Wang, 1999; Gardel et al., 2008; Lee, Leonard, Oliver, Ishihara, & Jacobson, 1994; Ng, Besser, Danuser, & Brugge, 2012).

These days, plating cells on continuous, linearly elastic hydrogels labeled with fluorescent fiducial markers is the method of choice to visualize and to measure traction force exerted by an adherent cell. As a cell attaches to the surface of the substrate, it deforms the substrate in direct proportion to the applied mechanical force. These elastic deformations can be described quantitatively with high precision by continuum mechanics. Since the first introduction of this technique (Dembo, Oliver, Ishihara, & Jacobson, 1996), a variety of elastic materials and labeling strategies have been explored in order to improve measurement accuracy and to extend the number of biological applications where TFM can be applied (Balaban et al., 2001; Beningo, Dembo, Kaverina, Small, & Wang, 2001; Dembo & Wang, 1999).

Due to superior optical and mechanical properties, polyacrylamide hydrogels (PAAG) have become the most widely used substrates for continuous traction force measurements. PAAG are optically transparent, allowing a combination of TFM with either wide-field or confocal fluorescence microscopy to complement traction force measurements with the analysis of cytoskeletal or focal adhesion dynamics (Gardel et al., 2008; Oakes, Beckham, Stricker, & Gardel, 2012). The mechanical properties of polyacrylamide are also ideal for TFM since the gels are linearly elastic over a wide range of deformations and their elasticity can be tuned to mimic the rigidity of most biological tissues (Discher, Janmey, & Wang, 2005; Flanagan, Ju, Marg, Osterfield, & Janmey, 2002). Moreover, covalent cross-linking of PAAG with specific ECM proteins allows control of biochemical interactions between the cell and the substrate to activate distinct classes of adhesion receptors and, ultimately, to mimic the physiological microenvironment for various cell types.

Concurrent with development of TFM-optimized elastic materials, much effort was undertaken to improve the accuracy and spatial resolution at which the cell-induced substrate deformation is measured (Balaban et al., 2001; Beningo et al., 2001). Recently, TFM substrates labeled with a high density of fluorescent

microspheres of two different colors have been developed (Sabass, Gardel, Waterman, & Schwarz, 2008), allowing analysis of the distribution and dynamics of traction forces within individual focal adhesions (Plotnikov, Pasapera, Sabass, & Waterman, 2012).

The protocols described in this chapter are geared toward setting up and performing high-resolution TFM to quantify cell-generated traction forces at the scale of individual focal adhesions. We discuss the fundamentals and experimental considerations important for designing a high-resolution TFM experiment. This background is particularly important for new users since high-resolution TFM is a highly interdisciplinary technique borrowing some of its key concepts from optical microscopy, polymer chemistry, soft matter physics, and computer sciences. Here, we target an advanced audience and assume high-level knowledge in cell biological lab procedures (including mammalian cell culture and transfection), light microscopy-based live-cell imaging (including DIC, epifluorescence, spinning-disk confocal imaging, and digital imaging), image processing, and mathematics (including differential calculus and programming in a high-level computer language, e.g., MATLAB). The chapter is designed to provide such readers with specific protocols that will allow them to perform high-resolution TFM.

BASIC PRINCIPLE OF HIGH-RESOLUTION TRACTION FORCE MICROSCOPY (TFM)

High-resolution TFM is an experimental technique that utilizes computational analysis of the direction and the magnitude of elastic substrate deformations to reconstruct cell-generated traction forces with submicrometer spatial resolution (Fig. 20.1). These deformations are detected by capturing the lateral displacement of fiducial markers, that is, fluorescent beads embedded in the substrate, due to mechanical stress applied by an adherent cell. Experimentally, the displacements are measured by comparing images of fluorescent beads in the strained gel, that is, when the cell exerts force on the substrate, with the unstrained state after the cell has been detached from the substrate either enzymatically or mechanically. Tracking displacement of individual beads followed by numerical modeling of the substrate displacement field based on elastic mechanics yields detailed two-dimensional vector maps of traction forces beneath the adherent cell.

The spatial resolution of TFM is determined by the spatial sampling of the displacement field (Sabass et al., 2008), which is limited by the density of fiducial markers and the optical resolution of the microscope. Thus, labeling the elastic substrate with fiducial markers at the highest possible density is essential for high-resolution measurements. However, the necessity for resolving individual beads by the microscope to track their movement limits the density of fiducial markers and restricts spatial resolution of the displacement field. This holds true only if all fiducial markers are observed simultaneously. While this is applied for conventional TFM, recent studies have demonstrated that separation of fiducial markers in the wavelength domain by labeling the substrate with fluorescent beads of two different

Introduction

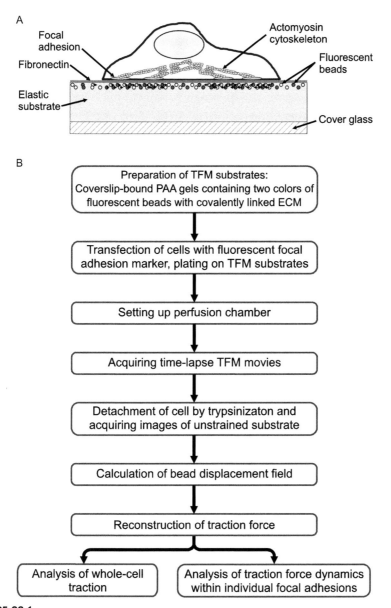

FIGURE 20.1

Schematic diagram of the procedure for performing high-resolution traction force microscopy (TFM) on a compliant PAA substrate. (A) Schematic of a TFM experiment depicting elastic substrate deformed by an adherent cell. (B) Flowchart for high-resolution TFM.

FIGURE 20.2

Two colors of fluorescent beads in polyacrylamide (PAA) TFM substrates increase the effective bead density. Confocal images of the uppermost surface of a PAA gel containing red and far-red fluorescent nanobeads visualized by red (left panel, also shown in red on color overlay) and far-red (middle panel, also shown in green on color overlay) fluorescence imaging. Scale bar = 5 μm. (See the color plate.)

colors overcomes this limitation (Fig. 20.2), doubles the spatial resolution of the displacement field, and allows analysis of traction forces at the submicrometer scale (Plotnikov et al., 2012; Sabass et al., 2008). Using multiple colors of fiducial markers also improves accuracy and reliability of traction force measurements by decreasing the noise and irregularities in bead tracking. These improvements can only be achieved if the displacement fields for both channels are quantified with similar precision, which requires an integrated and automated workflow of cell experiments and image processing.

PRINCIPLES OF TRACTION RECONSTRUCTION

Almost all procedures for traction reconstruction are based on the theory of linear elastostatics (Landau & Lifshitz, 1959), providing a convenient and tractable mathematical framework. We employ a Cartesian coordinate system where the coordinates (x_1, x_2) lie in a plane parallel to the relaxed surface of the TFM hydrogel. The third, normal coordinate x_3 is positive above the gel. Deformations along the coordinate i are denoted by u_i. Variation of u_i in space causes strain, which is the relevant physics concept here because only relative deformations generate elastic restoring forces. In undeformed coordinates x_i, the strain tensor is given by

$$\varepsilon_{ij} = \frac{1}{2}\left(\frac{\partial u_j}{\partial x_i} + \frac{\partial u_i}{\partial x_j} + \sum_{k=1}^{3} \frac{\partial u_k}{\partial x_i}\frac{\partial u_k}{\partial x_j}\right) \approx \frac{1}{2}\left(\frac{\partial u_j}{\partial x_i} + \frac{\partial u_i}{\partial x_j}\right) \quad (20.1)$$

The approximate equality in the last term is necessary to make the theory linear since the quadratic term represents geometric nonlinearities. This approximation implies that the length scale x_A over which the displacement varies is larger than the scale u_i of the displacements. For TFM, x_A is determined by the typical size of a focal adhesion and is usually on the order of 1 μm. Therefore, for high-resolution TFM, the displacements of the gel should satisfy $u_i < 1$ μm.

Introduction

For linearly elastic materials, the stress σ_{ij} is proportional to ε_{ij} (Hooke's law). On further assuming a stress-free reference state and homogeneous, isotropic, memoryless gels,

$$\sigma_{ij} = \frac{E}{1+s}\left(\varepsilon_{ij} + \frac{s}{1-2s}\delta_{ij}\sum_{k=1}^{3}\varepsilon_{kk}\right), \tag{20.2}$$

where E is Young's modulus, the determinant of the material rigidity, measured in pascal (N/m^2). The dimensionless quantity s is Poisson's ratio, a measure of the compressibility of the material. Incompressible materials are characterized by $s=0.5$. Other quantities used to describe elastic behavior, such as the shear modulus or the Lamé coefficients, can be converted to the pair (E, s).

Adherent cells apply forces only to the surface of the elastic gel where $x_3=0$. Since spatial variations of the stress σ_{ij} inside the bulk of the gel would require forces where none are applied, we have $0 = \partial \sigma_{ij}/\partial x_j$ for $x_3 < 0$. On the surface, the cell exerts a force per area, "traction," denoted by f_k. The traction is balanced by the surface stress resulting in the deformations $u_{1,2}$ at $x_3 = \mathrm{const.} \leq 0$. Mostly, the vertical forces are negligible; thus, $0 = \sigma_{zz}(x_3=0)$. It is assumed frequently that the gel is infinitely extended in the (x_1, x_2) plane and extends from $x_3 = 0$ to $x_3 = -\infty$, which determines the remaining boundary conditions. Due to the linearity of the problem, the solution can be generally written as

$$u_i(x_1, x_2, x_3) = \int \sum_{j=1}^{2} G_{ij}(x_1 - x'_1, x_2 - x'_2, x_3) f_j(x'_1, x'_2) \, dx'_1 dx'_2, \tag{20.3}$$

where Green's function G_{ij} depends on the gel properties and on the boundary conditions discussed earlier. For an elastic half-space, the solution is well known (*Boussinesq solution*) (Landau & Lifshitz, 1959) and can be readily used for TFM.

OVERVIEW OF METHODS FOR RECONSTRUCTION OF TRACTION FORCES

Historically, the first approach to calculate traction from the measured displacement field was an inversion of the integral Eq. (20.3) in real space (Dembo & Wang, 1999). While being quite flexible, constructing the matrices and inverting them is computationally demanding (Herant & Dembo, 2010; Sabass et al., 2008). Considerable simplification can be achieved if the location and extension of the adhesion sites are known. Traction reconstruction with point forces (Schwarz et al., 2002) avoids numerical integration by assuming that the force in Eq. (20.3) is localized to small regions. This approach is particularly appropriate if the location of adhesion sites is prescribed by patterns of surface-coupled ligands.

Alternatively, the differential equations can be solved with a finite element method (FEM) (Yang, Lin, Chen, & Wang, 2006). FEM has the advantage that almost arbitrary geometries and nonlinear gel responses can be studied. However, the

need to discretize the whole bulk inside the gel makes FEM computationally demanding. FEM approaches are especially suited for three-dimensional systems and recently have been used for traction force reconstruction for cells encapsulated in PEG hydrogels (Legant et al., 2010).

With Fourier transform traction cytometry (FTTC), Eq. (20.3) is solved in Fourier space, where the convolution integral becomes a matrix multiplication (Butler, Tolić-Nørrelykke, Fabry, & Fredberg, 2002). This method is efficient and reliable and has found wide popularity. Therefore, our method is also based on the idea of solving the pertinent equations in Fourier space (Sabass et al., 2008).

HIGH RESOLUTION AND REGULARIZATION

The resolution of TFM is strongly affected by errors in displacement measurements caused by inhomogeneity in substrate mechanics, optical aberrations, and lack of accuracy in the tracking routines. Errors can also result from violations of the assumption underlying the reconstruction. Since these error sources are all more or less local, the higher spatial frequency components of the reconstructed surface forces are most strongly affected. Obtaining good spatial resolution in TFM therefore requires a finely tunable and robust method for removing noise. For this purpose, we employ Tikhonov regularization of the traction field in Fourier space (Sabass et al., 2008). Here, $f_i(x_1,x_2)$ is required to minimize the functional

$$\sum_{\{x_1 x_2\}} \left(\|u_i - u_i(f_1, f_2)\|^2 + \lambda^2 \|f_i\|^2 \right), \tag{20.4}$$

where u_i are the measured displacements and $u_i(f_1,f_2)$ are the displacements that result from the traction f_i. The 2-norm is written as $\|\ldots\|$ and the sum over $\{x_1,x_2\}$ covers all positions on a spatial grid.

In Eq. (20.4), the difference between measurement and reconstruction is penalized by the first term. The second term constrains the magnitude of reconstructed forces and can be thought of as representing prior information about the uncertainty of the measurement. Increasing the regularization parameter λ leads to a "smoother" appearance of the traction field.

20.1 MATERIALS

The technique of high-resolution TFM relies on quantitative analysis of substrate deformation in response to cell-generated mechanical force. Depending on the substrate stiffness and cell contractility, the magnitude of the deformation varies from tens of nanometers to a micrometer. The necessity to capture such small deformations makes the imaging system the key component of the TFM setup and imposes several critical requirements on its optical performance. First, the imaging system should be equipped with a confocal scanner allowing for visualization of

fluorescent beads located in the uppermost layer of the elastic substrate. This increases the signal-to-background ratio of the fluorescent beads and thus greatly improves the accuracy with which they can be tracked. Second, the system should be equipped with a highly corrected water-immersion objective lens with high numerical aperture. This decreases imaging artifacts, including severe spherical aberration, resulting from imaging through a thick layer of PAAG, which has a refractive index close to water. Using an objective with high numerical aperture also improves the sensitivity of the imaging setup, increases the signal-to-noise ratio, and eventually leads to more accurate measurement of the displacement field. Third, the spatial sampling rate, that is, pixel frequency, of the imaging system should conform to the Nyquist criterion (Pawley, 2006) to allow accurate location of subresolution fiducial markers with subpixel accuracy. This requirement is especially important if the TFM setup is based on a spinning-disk confocal microscope, as for any given objective lens, the pixel frequency of such a system is determined by the pixel size of the CCD camera and cannot be adjusted. Finally, since traction force measurements require imaging of live cells, a stage-top incubator or another device to maintain cells at physiological conditions while acquiring images is also required.

20.1.1 INSTRUMENTATION FOR HIGH-RESOLUTION TFM

A computer-controlled research-grade inverted epifluorescence microscope is required. It is critical for high-resolution TFM that the imaging system is fully integrated allowing to control transmitted and epifluorescent illumination and image acquisition settings for multiple fluorescence channels. For our experiments, we use a Nikon Eclipse Ti microscope system, and comparable systems from other major manufacturers would be suitable. We utilize the MetaMorph software package for controlling the microscope functions. However, other commercial (e.g., Nikon Elements) or freely available (e.g., Micro-Manager) software packages should be considered if cost is an important consideration. If time-lapse TFM is required, the microscope needs to be equipped with a focus drift correction system (e.g., Nikon Perfect Focus) to maintain focus at the substrate–cell interface. It is critical that the microscope is equipped with an intermediate magnification-changer module (the sliding insert type) so that the Nyquist sampling criterion can be satisfied with the objective lens and camera recommended in the succeeding text. To allow imaging of the cell position, the microscope should be equipped with differential interference contrast (DIC) imaging components. The following equipment is recommended:

1. Highly corrected, high-magnification water-immersion objective lens. We use a Nikon $60\times$ Plan Apo NA 1.2 WI objective and DIC prisms. Using a water-immersion objective minimizes optical aberrations caused by imaging through a thick layer of PAA gel.
2. Spinning-disk confocal scanner (Yokogawa, CSU-X1-A3) equipped with quad-edge laser-grade dichroic beam splitter (Semrock, Di01-T405/488/568/647-$13 \times 15 \times 0.5$) and a set of emission filters (Chroma Technology, green,

et525/50 m; red, et605/52 m; Semrock, far-red, LP02-647RU) in an electronic filter wheel. Spinning-disk confocal scanner is highly recommended for high-resolution TFM, as it allows visualization of fiducial markers located in the uppermost layer of the elastic substrate while rejecting fluorescence emitted by out-of-focus beads and, also allows use of a low-noise CCD camera as an imaging detector. Using a spinning-disk confocal scanner also minimizes cell photodamage and improves TFM temporal resolution. A laser-scanning microscope system could be utilized, although these systems tend to elicit greater photobleaching of fluorophores in living cells and the noise level of the photomultiplier tube detectors is detrimental to accurate localization of fluorescent fiducials by subpixel fitting.
3. Multiwavelength laser combiner allowing control of laser illumination wavelength and intensity modulation. Since high-resolution TFM requires imaging of three fluorescent channels in rapid succession, the laser combiner should provide at least three laser lines (two bead colors and a fluorescent-tagged protein expressed in the cell). For our experiments, we use the LMM5 laser combiner (Spectral Applied Research) equipped with solid-state lasers with the following wavelength and power: 488 nm (Coherent, 100 mW), 560 nm (MPB Communications, 100 mW), and 655 nm (CrystaLaser, 100 mW). Note that substantial saving on equipment cost can be achieved by replacing solid-state lasers with a moderate-power ion laser (e.g., Coherent Innova series).
4. Scientific-grade CCD camera with 6.45 μm pixel size (Roper Scientific, Photometrics CoolSNAP HQ2). Using a high-end digital camera with low noise and small pixels is critically important for high-resolution TFM. High quantum yield and low noise of the camera increase image signal-to-noise ratio and improve accuracy of bead tracking. However, the necessity to conform pixel frequency to the Nyquist criterion when using a $60\times$ objective lens dictates that pixel size of the camera should not exceed 6.5 μm. Thus, EM-CCD cameras, which all have pixels over 10 μm, are not recommended for high-resolution TFM. Using a scientific CMOS camera is also not recommended, as these cameras can generate random "hot pixels" or periodic noise patterns that interfere with bead tracking software.
5. Airstream incubator (Nevtek, ASI 400). Many stage-top incubators and microscope enclosures are available on the market and can be purchased from major microscope manufacturers. However, for most of our TFM experiments, we prefer using a simple and inexpensive airstream incubator to maintain stable temperature on an unenclosed microscope stage.
6. Closed-loop XY-automated microscope stage with linear encoders (e.g., Applied Scientific Instrumentation, MS-2000). Using an automated microscope stage is optional but highly recommended as it substantially improves the efficiency of TFM data collection and allows imaging the cells and the substrate at multiple stage positions before and after trypsinization of the cells.

20.1.2 POLYACRYLAMIDE SUBSTRATES WITH TWO COLORS OF FIDUCIAL MARKERS

Since the mechanical properties of PAAG are easily tunable, these gels are the most commonly used substrates for traction force measurements. By changing the concentration of acrylamide and N,N'-methylenebisacrylamide, the building blocks of PAAG, the stiffness of PAAG can be adjusted to mimic the rigidity of most biological tissues (100 Pa to 100 kPa) without losing the elastic properties of the gel (Yeung et al., 2005). For most of our experiments, we use PAAG with a stiffness ranging from 4 to 50 kPa; gels softer than 4 kPa tend to inhibit cell spreading, while gels stiffer than 50 kPa usually cannot be deformed by most cell types. Different formulations of acrylamide/bisacrylamide can be used to produce PAAG with similar stiffnesses. The formulations described in this chapter have been adapted from Yeung et al. (2005) and their shear moduli have been confirmed by the Gardel group (Aratyn-Schaus, Oakes, Stricker, Winter, & Gardel, 2010). The volumes described herein will create a gel that has a thickness of ≈ 30 μm on 22×40 mm coverslips. Since the extent of polymer swelling varies with the PAAG formulation (Kraning-Rush et al., 2012) and cannot be easily predicted based on shear modulus alone, it is important to measure the height of the resulting TFM substrate. The gel must be sufficiently thick such that the gel can freely deform due to cellular forces without the influence of the underlying glass (Sen, Engler, & Discher, 2009). In the protocol in the succeeding text, we describe a method for preparing four coverslip-bound elastic PAAG that are labeled with fluorescent nanobeads of two different colors that serve to double the spatial resolution of traction force measurements.

20.1.2.1 Suggested equipment and materials
- Fume hood.
- Coverslip spinner. This is a custom-built device designed to remove the bulk of the water from the surface of the gel attached to the coverslip. Detailed description of the coverslip spinner has been published (Inoué & Spring, 1997) and is available online (http://www.proweb.org/kinesin/Methods/SpinnerBox.html).
- Vacuum chamber.
- Ultrasonic cleaning bath (e.g., Fisher Scientific FS140). An ultrasonic bath is required to prepare "squeaky clean" coverslips.
- Coverslips (#1.5, 22×40 mm). We use borosilicate coverslips supplied by Corning Inc. (#2940-224) due to their cleanliness, reliable optical properties, and low thermal expansion. It is strongly recommended not to buy low-grade coverslips as they can be variable in their amenability to surface chemistry and optical properties.
- (3-Aminopropyl) trimethoxysilane (APTMS, e.g., Sigma-Aldrich, #281778)
- 25% Glutaraldehyde solution. We use EM grade glutaraldehyde free of polymers packaged in 10 mL glass ampoules (Electron Microscopy Sciences, #16200).

- 40% Acrylamide solution (e.g., Bio-Rad, #161-0140).
- 2% Bisacrylamide solution (e.g., Bio-Rad, #161-0142).
- Ammonium persulfate (APS) (e.g., Sigma-Aldrich, #A3678).
- N,N,N',N'-tetramethylethylenediamine (e.g., TEMED, Bio-Rad, #161-0800).
- Fluorescently labeled latex microspheres of two colors. We use red-orange (565/580 nm, #F8794) and dark-red (660/680 nm, #F8789) fluorescent microspheres (FluoSpheres, carboxylate-modified microspheres, 0.04 µm) supplied by Life Technologies due to their brightness and resistance to photodamage.
- Microscope slides. We use 3×1" Gold Seal precleaned microslides, as their superior cleanliness contributes to consistent results.
- Rain-X (ITW Global Brands, available at automotive parts suppliers).
- Molecular biology-grade water (ddH_2O).

20.1.2.2 Protocol

1. Prepare "squeaky clean" coverslips: For the measurements of traction force to be reliable, stringent cleaning of coverslips, which ensures tight attachment of the PAAG to the glass surface, is required. For our experiments, we use "squeaky clean" coverslips prepared as described in Waterman-Storer (2001). Briefly, sonicate coverslips for 30 min in hot water containing VersaClean detergent. Rinse the coverslips several times, and then sonicate for 30 min in each of the following solutions in the following order: tap water, distilled water, 1 mM EDTA, 70% ethanol, and 100% ethanol. Transfer coverslips to a 500-mL screw cap jar, cover them with 100% ethanol, and store at room temperature until use.
2. Prepare master mix of acrylamide/bisacrylamide: Mix up 40% acrylamide and 2% bisacrylamide stock solutions following Table 20.1. We maintain several stock solutions that are optimized for PAAG of different stiffness. Stock solutions can be kept for at least a year at 4 °C.
3. Prepare 50% (3-aminopropyl)trimethoxysilane (APTMS) solution: Transfer 2 mL of APTMS into 15 mL conical tube containing 2 mL ddH_2O and mix up by pipetting up and down. Be aware that dissolving APTMS in water is exothermic and produces a lot of heat—the solution may start boiling. Preparing fresh APTMS solution on the day of coverslip activation is recommended to ensure reliable binding of the PAAG to the glass surface.
4. Prepare 0.5% solution of glutaraldehyde: add 1 mL of 25% glutaraldehyde stock solution into 49 mL of ddH_2O.
5. Prepare 10% solution of APS: dissolve 10 mg APS in 100 µL ddH_2O by vortexing. Prepare fresh APS solution on the day of the experiment. Alternatively, APS solution can be stored at -20 °C for up to a month.
6. Activate coverslips: Place four "squeaky clean" coverslips (#1.5, 22×40 mm) into a 15-cm glass Petri dish and apply 0.5 mL of 50% APTMS on top of each coverslip. Incubate at room temperature for 10 min, add ddH_2O into the Petri dish to immerse the coverslips (≈ 30 mL ddH_2O), and incubate on an orbital shaker for another 30 min. Rinse the coverslips with ddH_2O multiple times, transfer to a Petri dish with 50 mL of 0.5% glutaraldehyde, and incubate 30 min

Table 20.1 Composition of Acrylamide/Bisacrylamide Stock and Working Solutions Required for Preparation of Polyacrylamide Traction Force Microscopy (TFM) Substrates of Stiffness 2.3–55 kPa

	Polyacrylamide gel stiffness (G)					
	2.3 kPa	4.1 kPa	8.6 kPa	16.3 kPa	30 kPa	55 kPa
Stock solution (can be stored up to a year at +4 °C)						
40% Acrylamide (mL)	3.75	2.34	2.34	3.00	3.00	2.25
2% Bisacrylamide (mL)	0.75	0.94	1.88	0.75	1.40	2.25
dH_2O (mL)	0.5	1.72	0.78	1.25	0.60	0.50
Total volume (mL)	5	5	5	5	5	5
Working solution (use immediately)						
Stock solution (μL)	125	200	200	250	250	333
Red fluorescent beads (μL)	7.5	7.5	7.5	7.5	7.5	7.5
Far-red fluorescent beads (μL)	7.5	7.5	7.5	7.5	7.5	7.5
10% Ammonium persulfate (μL)	2.5	2.5	2.5	2.5	2.5	2.5
TEMED (μL)	0.75	0.75	0.75	0.75	0.75	0.75
ddH_2O (mL)	357	282	282	232	232	163

Use indicated volumes of stock solution (upper half of table) to make the working solution (lower half of table) for preparing TFM substrates of the desired stiffness. Note that working solutions should be used immediately after adding ammonium persulfate and N,N,N′,N′-tetramethylethylenediamine (TEMED) as these chemicals induce rapid polymerization of acrylamide. In contrast, after preparation, the stock solutions can be kept for at least a year as long as maintained at +4 °C.
Note that shear modulus (G) is shown in the table as a measure of gel stiffness. The conversion between the shear modulus (G) and Young's modulus (E) is given by the following formula:

$$G = \frac{E}{2(1+s)}$$

where s is Poisson's ratio.
Data in this table were obtained from Yeung et al. (2005) and confirmed by Aratyn-Schaus et al. (2010).

with agitation. Rinse activated coverslips with ddH$_2$O several times, arrange them on a coverslip rack, and dry in the desiccator. Activated coverslips can be stored in vacuum desiccator for at least 2 weeks. Note that only the top surface of each coverslip is activated and is able to bind PAAG covalently. Make sure that you keep track of the top surface.

7. Prepare microscope slides with a hydrophobic surface: Use clean KimWipe tissue to coat one microscope slide for each 22 × 40 mm activated coverslip with Rain-X (ITW Global Brands). Allow the slides to dry for 5–10 min, remove excess of Rain-X with a KimWipe tissue, wash extensively with deionized water, and then rinse several times with ethanol. Make sure to remove all debris from the slides, since

any remaining particles will be transferred to the polyacrylamide gel, interfering with polymerization and imaging. We usually prepare slides with hydrophobic surfaces in bulk and store them in the vacuum desiccator for several months.
8. Prepare polyacrylamide gel for TFM imaging: Prepare an acrylamide/bisacrylamide working solution by mixing the desired volume of stock solution, water, and fluorescent microspheres of two colors as listed in Table 20.1. To avoid bead agglomeration, sonicate the suspension of fluorescent microspheres in an ultrasonic bath for 30 s prior adding the beads to the working solution. Degas the working solution in a vacuum chamber for 30 min to remove oxygen, which prevents even polymerization of acrylamide. Remove the working solution from the vacuum chamber; add 0.75 µL of TEMED and 2.5 µL of 10% APS to initiate polymerization. Mix the solution by pipetting up and down several times. Avoid introducing air bubbles. Do not vortex. Apply 17 µL of acrylamide/bisacrylamide working solution on a hydrophobic microscope slide and cover with an activated coverslip. Make sure that activated surface is facing down (toward the solution). Let the gel polymerize for 20–30 min. After polymerization, lift the corner of the coverslip with a razor blade to detach the gel from the hydrophobic microscope slide, and immerse the gel attached to the coverslip in ddH$_2$O. Hydrated PAAG can be stored in ddH$_2$O at 4 °C for up to 2 weeks.

20.1.3 FUNCTIONALIZATION OF POLYACRYLAMIDE SUBSTRATES WITH ECM PROTEINS

Since mammalian cells do not adhere to polyacrylamide, ECM proteins have to be covalently cross-linked to the surface of the TFM substrates. We routinely functionalize the gels with human plasma fibronectin, although other ECM proteins, such as collagen I, collagen IV, laminin, or vitronectin, can also be used. In the protocol in the succeeding text, we describe a method for chemical conjugation of fibronectin to the surface of PAAG by using the photoactivatable heterobifunctional cross-linker, Sulfo-SANPAH.

20.1.3.1 Suggested equipment and materials
- Orbital shaker (e.g., Thermo Scientific Lab Rotator).
- Coverslip spinner (see preceding text).
- Ultraviolet cross-linker (e.g., UVP CL-1000) equipped with long-wave (365 nm) tubes. Using a cross-linker with a built-in UV sensor is recommended to ensure consistent fibronectin cross-linking to the surface of PAAG.
- N-sulfosuccinimidyl-6-(4'-azido-2'-nitrophenylamino)hexanoate (Sulfo-SANPAH, Thermo Fisher Scientific, #22589). Although ordering Sulfo-SANPAH in bulk may seem efficient, we recommend purchasing 50 mg vials of this chemical to prevent its degradation due to hydrolysis.
- Dimethyl sulfoxide (DMSO, e.g., Sigma-Aldrich, #41647).

- Native fibronectin purified from human plasma (EMD Millipore, 1 mg/mL fibronectin dissolved in phosphate-buffered saline, #341635). Note that fibronectin dissolved in Tris-buffered saline has to be dialyzed prior cross-linking to the TFM substrate since the amine groups of Tris will react with the cross-linker.
- Dulbecco's phosphate-buffered saline without calcium and magnesium (DPBS, e.g., Life Technologies, #14190-144).

20.1.3.2 Protocol

1. Prepare solution of Sulfo-SANPAH: Note that Sulfo-SANPAH undergoes rapid hydrolysis when dissolved in water. Prepare stock solution of Sulfo-SANPAH by dissolving 50 mg of Sulfo-SANPAH powder in 2 mL of anhydrous DMSO, aliquot in Eppendorf tubes (40 μL per tube), and freeze by immersing the tubes into liquid nitrogen. We store such stock solutions of Sulfo-SANPAH at $-80\ °C$ for several months.
2. Take an aliquot (40 μL) of Sulfo-SANPAH stock solution out of $-80\ °C$ freezer and thaw at room temperature for several minutes. One aliquot of Sulfo-SANPAH is sufficient to functionalize two 22×40 mm polyacrylamide gels.
3. Tape a piece of Parafilm in a square Petri dish (10×10 cm) and pipet one 50 μL drop of fibronectin solution (1 mg/mL) on the Parafilm for each cover glass.
4. While thawing Sulfo-SANPAH, spin two PAAGs quickly to remove excess of water. If coverslip spinner is not available, use KIMTECH Wipers (Kimberly-Clark) to remove excess water. Be careful not to touch gel surface in the center of the coverslip. Make sure that gels do not dry. Add 0.96 mL ddH_2O to the Sulfo-SANPAH aliquot, mix by pipetting, and apply 0.5 mL on top of each PAAG. Activate Sulfo-SANPAH by exposing gels to long-wavelength UV light (365 nm). To avoid decrease in Sulfo-SANPAH activation due to decline of UV lamp efficiency, we keep the expose energy constant ($750\ mJ/cm^2$), while the exposure time can change. During activation, the color of Sulfo-SANPAH solution will change from orange to brown.
5. Quickly wash PAAGs with ddH_2O, spin-dry, invert, and place the gel surface on the drop of fibronectin solution. Incubate at room temperature for 4 h, and then wash gels multiple times with DPBS with agitation on the shaker. Polyacrylamide substrates coated with ECM protein can be stored at $4\ °C$ for up to a week.

20.2 METHODS

20.2.1 CELL CULTURE AND PREPARATION OF SAMPLES FOR HIGH-RESOLUTION TFM

Preparation of mammalian cells for TFM requires basic equipment for sterile tissue culture. For the purpose of this chapter, it will be assumed that the reader is familiar with sterile tissue culture techniques and has access to a tissue culture room. For choice of cell lines, it should be noted that the computational algorithm

of traction force reconstruction discussed in this chapter relies on the assumption that deformation of the elastic substrate within the analyzed region is induced by a single cell and, thus, should be applied only to cell types which can be maintained in sparse culture conditions. Many different cell lines, including immortalized mouse embryo fibroblasts (MEFs), human foreskin fibroblasts, osteosarcoma cells U2OS, and mammary tumor epithelial cells MDA-MB-231, satisfy this requirement and have been previously used by us and others for TFM (Aratyn-Schaus & Gardel, 2010; Gardel et al., 2008; Kraning-Rush et al., 2012; Ng et al., 2012; Plotnikov et al., 2012; Sabass et al., 2008). In addition, for visualizing the location of focal adhesions, cells should be transfected with a cDNA expression construct that encodes a GFP fusion of a common focal adhesion protein.

20.2.1.1 Suggested equipment and materials
- Transfection reagents and apparatus. We perform electroporation with a Lonza Nucleofector 2b system and Nucleofector Kit V (#AAB-1001 and #VCA-1003, respectively). However, lipid-based transfection reagents such as Lipofectamine or FuGENE can also be used.
- cDNA expression construct(s) to visualize focal adhesions in live cells. For most experiments, we use a C-terminal fusion of eGFP to paxillin, since this construct labels focal adhesions in all stages of maturation (nascent adhesion, focal complexes, and focal adhesions) and has no significant effect on focal adhesion dynamics (Webb et al., 2004). The cDNA should be purified and should not contain endotoxins.
- Cells. We use immortalized MEFs (ATCC # CRL-1658).

20.2.1.2 Protocol
1. Culture the desired cell line in the appropriate medium and environmental condition. For example, we culture MEFs in DMEM media supplemented with 15% fetal bovine serum, 2 mM L-glutamine, 100 U/mL penicillin/streptomycin, and nonessential amino acids in a humid atmosphere of 95% air and 5% CO_2 at 37 °C.
2. Prepare media for live-cell imaging by adding fetal bovine serum (final concentration 15%) and L-glutamine (final concentration 2 mM) to DMEM lacking phenol red.
3. One day prior to measuring traction forces, transfect cells with the cDNA expression construct for visualizing focal adhesions in live cells.
4. The next day after cell transfection, preincubate polyacrylamide substrates for 30 min with media for live-cell imaging to equilibrate ion/nutrient concentration. Harvest transfected MEFs by trypsinization, resuspend in media for live-cell imaging, and plate on TFM substrates for 1–3 h. Plating time may vary substantially for different cell types: epithelial cells usually adhere and spread slower than fibroblasts. For most of the experiments, we plate the cells for just enough time to fully spread and polarize. This decreases ECM deposition and matrix remodeling by the cells and improves reproducibility of TFM measurements.

20.2.2 SETTING UP A PERFUSION CHAMBER FOR TFM AND ACQUIRING TFM IMAGES

In TFM experiments, images are acquired before and after detachment of the cell from the TFM substrate by perfusion of trypsin in order to allow visualization of the strained and unstrained substrate. This necessitates a very stable and reliable perfusion system that allows high-magnification, high-resolution imaging with an immersed objective lens, liquid perfusion of the cells while maintaining temperature, and reimaging the same position without loss of focus or movement of stage position.

20.2.2.1 Suggested equipment and materials
- Perfusion chamber for live-cell imaging with an appropriate microscope stage adapter. Using a commercial microscope perfusion chamber is required for high-resolution TFM, as it dramatically decreases the drift of the sample and improves the reliability of bead tracking. We suggest using an RC30 closed chamber system from Warner Instruments, as this perfusion chamber has been specifically designed for oil- or water-immersed objective lenses in confocal imaging applications and has the ability to use standard-size coverslips, providing high-quality images acquired in both epifluorescent and transmitted modes. The large viewing area of this chamber also increases the efficiency of TFM data collection, as several different cells per experiment can be imaged. Warner Instruments provides adapters to fit the stages of major microscope manufacturers, although if using an automated stage, custom-machined adapters may be needed. We utilize an automated stage made by Applied Scientific Instruments.
- Coverslips (#1.5, 22×30 mm, Corning, #2940-224).
- 12 mL disposable Luer-lock syringes and Luer-lock 3-way disposable stopcock (available from medical suppliers).
- Media for live-cell imaging prepared as described in previous section.
- Trypsin–EDTA, no phenol red (0.5%, Life Technologies, #15400-054).
- Vacuum grease.

20.2.2.2 Protocol
1. Prior to the experiment, warm up 10 mL aliquots of trypsin–EDTA and media for live-cell imaging and load them into 12 mL disposable syringes.
2. Assemble the perfusion chamber according the manufacture manual (http://www.warneronline.com/Documents/uploader/RC-30%20%20(2001.03.01).pdf). Connect the syringes loaded with trypsin–EDTA and media to the inlet line of the perfusion chamber via the three-way stopcock and fill the camber with media. Make sure that all air bubbles are removed from the chamber. Once the chamber is filled, use ddH_2O and ethanol to clean both top and bottom coverslips of the chamber. Make sure that the chamber is watertight and then mount it on the microscope, taking care to make sure that it is seated firmly in the stage. Immerse the $60 \times$ objective lens with water, and center the specimen over the lens.
3. Focus the $60 \times$ lens on the cells attached to the top surface of the PAAG by transmitted light mode, and then locate a candidate cell expressing moderate

levels of the GFP-tagged focal adhesion marker for TFM by using epifluorescent imaging. Use transmitted light imaging to make sure that the candidate cell is isolated with no other untransfected cells within 10–20 μm from the cell edge. Since the distance of force propagation through the substrate scales linearly as substrate stiffness decreases, additional care should be taken when performing TFM on substrates softer than 4 kPa.

4. Insert the intermediate magnification module (1.5×) into the microscope optical path to increase spatial sampling frequency of the imaging system. When the 1.5× magnification is included, digital images acquired by a Nikon Ti microscope equipped with a 60× NA 1.2 water-immersed objective and CoolSNAP HQ2 CCD camera will satisfy the Nyquist criterion and are suitable for localizing positions of the fiduciary markers with subpixel accuracy.

5. Insert DIC components into the light path, and acquire a cell image by DIC mode for reference. This image is not required for TFM, but it can be used later to quantify the area of the cell.

6. Remove the DIC prism from the objective lens side of the optical path to improve images of fluorescent microspheres and increase spatial resolution of the substrate displacement field.

7. Focus the microscope on focal adhesions by epifluorescent mode. In the case of GFP-tagged focal adhesion marker, the focal adhesions can be observed in the green fluorescence channel.

8. Switch to laser illumination and spinning-disk confocal imaging mode, and obtain images in the GFP and bead channels (red and far-red). Adjust illumination intensity and camera exposure time settings to obtain images in all three channels with similar maximal fluorescence intensity of ∼5 times higher than the background area that does not contain cells. This may take several images and testing several settings in each channel to get the settings right. During this procedure, minimize light exposure to the specimen, as this will contribute to bleaching and photodamage. Make sure to keep the specimen in precise focus (using the GFP-adhesion channel) because even very slight changes in focus with the high-NA lens will strongly affect the intensity in the image.

9. Acquire time-lapse TFM movies by capturing image triplets of fluorescently labeled focal adhesions and red and far-red fluorescent microspheres. It is important to acquire the images of fluorescent beads of different colors immediately after each other, as the deformation of the substrate changes rapidly due to focal adhesion turnover. If you have automated focus control, you may image the focal adhesions at their precise focal plane and image the beads at 0.4–1 μm deeper into the substrate, which will give higher contrast images of the beads. Furthermore, it allows bead tracking without the disturbance of cellular autofluorescence at the surface of the gel. However, the vertical position x_3 of the imaging plane must then be considered for the traction reconstruction as described in the succeeding text. If the imaging system is equipped with an

automated microscope stage, memorize X and Y coordinates and repeat measurements for several cells. For time-lapse TFM, we acquire image triplets at \sim15–60 s intervals.
10. Remove cells from the TFM substrate: Following imaging of the cells and the strained substrate, perfuse the cells with 5 mL 0.5% trypsin–EDTA solution and incubate it on the microscope stage for 10 min to detach the cells and to allow the substrate to relax from its cell-induced strained state. After incubation, remove the detached cells by perfusing the chamber with an additional 3–5 mL of trypsin–EDTA.
11. Image beads in the unstrained TFM substrate: Focus on the uppermost layer of the PAA gel and acquire z-stacks of bead images in the unstrained state with 100 nm increment. Later, one of these image planes will be selected in an automated and unbiased fashion as a reference (unstrained) image to quantify substrate deformation.
12. Move the stage to every memorized position, focus on the uppermost layer of PAA gel, and acquire z-stacks of bead images in the unstrained state as described.

20.2.3 QUANTIFYING DEFORMATION OF THE ELASTIC SUBSTRATE

Imaging multiple colors of fluorescent fiducials dramatically improves the accuracy and reliability of traction force measurement, since (1) it increases the density of the fiducial markers, which leads to better sampling of the substrate deformation, and (2) it decreases the noise and irregularities in bead tracking through averaging the displacement fields for the independent channels. In the protocol in the preceding text, we provide a step-by-step description of an algorithm that selects the reference (unstrained) images for each frame of a TFM image sequence, identifies fluorescent beads in the reference images, and tracks displacement of individual beads with subpixel accuracy. Although the initial image processing, for example, filtering, alignment, and image subtraction can be performed with a variety of software (e.g., ImageJ and MetaMorph), subsequent steps require the use of a high-level programming environment, for example, MATLAB:

1. Find reference images in a z-stack of images from the unstrained gel. The drift of the microscope stage makes it necessary to find a best-matching reference for each image of the TFM sequence and register the image and the reference. This can be done in an automated fashion by calculating the correlation coefficient between the images from deformed and shifted reference state. Correlation coefficients for whole images can be calculated efficiently by making use of the fast Fourier transform (FFT). MATLAB offers the "fft2()" function for this purpose.
2. Remove out-of-focus fluorescence and smooth each reference image by subtracting a median-filtered image from the original as $I'_{ref} = I_{ref} - \text{medfilt}(I_{ref})$.

The best results are mostly obtained with a filter window size larger than 2 µm^2. Subsequently, adjust the brightness of the new image as $I''_{\text{ref}} = I'_{\text{ref}} - \min(I'_{\text{ref}})$.

3. Find local maxima in reference images by locating pixels that are brighter than their neighbors and also brighter by a factor t than the average intensity of the whole image. When numbering the pixels in the (x_1, x_2) plane by (m_1, m_2), maxima at location (m_1^*, m_2^*) are found from the conditions $I''_{\text{ref}}(m_1^*, m_2^*) > I''_{\text{ref}}(m_1^* \pm 1, m_2^* \pm 1)$ and $I''_{\text{ref}}(m_1^*, m_2^*) > t \text{ mean}(I''_{\text{ref}})$. The factor t should typically be set between 0.5 and 2.

4. Remove maxima that are too close to each other to avoid tracking similar features more than once. We exclude brightness peaks that are less than a pixels away from other peaks. Typically, we chose $a = 4 \ldots 10$ pixels, depending on the bead density.

5. Improve quality of bead recognition. Fitting a two-dimensional parabola to an environment of a^2 pixels around (m_1^*, m_2^*) helps to determine whether the local intensity maximum belongs to a fluorescent bead. This procedure is not essential, but highly improves the bead recognition. The target function $\|I''_{\text{ref}}(m_1, m_2) - A_0 - A_1(m_1 - m_1^{**})^2 - A_2(m_2 - m_2^{**})^2\|$ can be minimized analytically to quickly yield the center of the parabola (m_1^{**}, m_2^{**}). Individual brightness peaks are rejected if (m_1^{**}, m_2^{**}) lies outside the region of a^2 pixels or if the fit fails. The results (A_1, A_2) also yield statistics about the width of the point-spread function.

6. Track displacement of fiducial markers: Use the unfiltered images (I_{ref}, I) for tracking. Place windows $W_{\text{ref},ci}(m_1, m_2)$ on top of each recognized bead in the reference images from the microscope channels $c1$ and $c2$. The size of the windows is usually on the order of 15×15 pixels or ≈ 1 µm^2. All windows are normalized individually as
$\widetilde{W}_{ci}(m_1, m_2) = (W_{ci}(m_1, m_2) - \text{mean}(W_{ci})) / \|W_{ci}(m'_1, m'_2) - \text{mean}(W_{ci})\|$.
Calculate the cross correlation between all reference windows $W_{\text{ref},ci}(m_1, m_2)$ and corresponding shifted windows $W_{ci}(m_1 + b_1, m_2 + b_2)$ with

$$cc(b_1, b_2) = \frac{1}{2} \sum_{i=1,2} \sum_{m_1, m_2} \widetilde{W}_{ci}(m_1 + b_1, m_2 + b_2) \widetilde{W}_{\text{ref},ci}(m_1, m_2), \quad (20.5)$$

where the sum over m_1, m_2 only covers the indices inside the windows. The location (b_1^*, b_2^*) of the maximum in $cc(b_1, b_2)$ is the average displacement in each window in units of pixels. The summation over the two channels leads to a significantly more robust tracking of substrate deformation. By averaging the correlation coefficients and not the windows themselves, we avoid mixing terms $\sim W_{c1} W_{c2}$ in the cross correlation.

7. Calculate subpixel displacements: Fitting a two-dimensional Gaussian to the maximum of the correlation matrix $cc(b_1, b_2)$ yields a subpixel estimate of the position of the maximum. This position is taken as the displacement of the bead. The formulas for fitting two-dimensional Gaussians can be found elsewhere (Nobach & Honkanen, 2005).

20.2.4 CALCULATION OF TRACTION FORCES WITH REGULARIZED FOURIER–TRANSFORM TRACTION CYTOMETRY

The most common methods for traction reconstruction rely on the validity of several assumptions. While these assumptions are not *a priori* necessary, they render the computational procedure tractable. Experiments should be conducted with keeping the following points in mind:

1. The TFM substrate is infinitely thick and its lateral deformation is negligible compared to the gel thickness. In practice, this means that 30 μm or thicker PAA gels should be used for traction force measurements (Boudou, Ohayon, Picart, Pettigrew, & Tracqui, 2009; Merkel, Kirchgessner, Cesa, & Hoffmann, 2007). Bead displacement on the surface of the gel should not exceed 1 μm. Geometric and material nonlinearities, as well as the finite depth of the gel, may otherwise influence the result.
2. Forces normal to the surface of the substrate are very small. Although the vertical component of traction force is measurable (Delanoë-Ayari, Rieu, & Sano, 2010; Koch, Rosoff, Jiang, Geller, & Urbach, 2012; Legant et al., 2013), this assumption is valid for the majority of adherent cell types. However, since these forces are neglected, care should be taken that only well-spread and flat cells are analyzed.
3. The displacement field in the image is assumed to result only from the cell in the field of view. Disturbances out of the field of view should be negligible. To reconstruct traction forces exerted by a sheet of cells, other algorithms can be employed (Liu et al., 2010; Maruthamuthu, Sabass, Schwarz, & Gardel, 2011; Ng et al., 2012; Tambe et al., 2013).

20.2.4.1 Computational procedure

In the following, we explain step-by-step how to proceed to reconstruct traction with regularized Fourier–transform traction cytometry (Reg-FTTC). We encourage readers who are experiencing difficulties with the implementation to contact the authors:

1. The displacement field determined in the previous steps (Section 20.2.3) will consist of irregularly spaced bead locations and displacements of these beads. For subsequent use with FFT, the irregular field must be interpolated on to a rectangular, regular grid that covers the whole image. Use, for example, the function "griddata()" in MATLAB. The grid nodes at position (x_1, x_2) are numbered by a pair (n_1, n_2) of integers $n_i \in [-(N_i/2 - 1) \ldots N_i/2]$ where N_i is an even number of nodes.
2. Construct discrete wave vectors for the Fourier transform as $k_i = 2\pi n_i/(dN_i)$. Here, d is the nodal distance of the grid in units of pixels.
3. Employ an FFT to obtain the discrete Fourier transform $\tilde{u}_i(k_1, k_2)$ of the displacement field $u_i(n_1, n_2)$. All the data and results are real numbers. Since a discrete Fourier transform of any real quantity satisfies $\tilde{g}(k) = \tilde{g}^*(-k)$, we only have $N_i/2+1$ independent Fourier modes in each of the two coordinates of the plane.

4. Construct a matrix of the Fourier-transformed Green's function

$$\widetilde{G}_{ij}(k_1,k_2,x_3) = \frac{2(1+s)e^{x_3\sqrt{k_1^2+k_2^2}}}{E(k_1^2+k_2^2)^{3/2}}\left((k_1^2+k_2^2)\delta_{ij} - k_i k_j \left(s - \frac{x_3\sqrt{k_1^2+k_2^2}}{2}\right)\right). \quad (20.6)$$

An overall displacement of the whole gel in the image corresponds to the mode ($k_1=0$, $k_2=0$). The assumption that all the sources of traction are in the field of view allows to avoid divergence of Green's function by setting $\widetilde{G}_{ij}(0,0,x_3)=0$. This Green's function also depends on the vertical position x_3 of the imaging plane where the displacements were measured.

Next, construct a matrix $\widetilde{M}_{ij}(k_1,k_2)$ for any chosen regularization parameter λ as

$$\widetilde{M}_{ij}(k_1,k_2) = \sum_l \left(\sum_m \widetilde{G}_{ml}(k_1,k_2)\widetilde{G}_{mi}(k_1,k_2) + \lambda^2 \delta_{il}\right)^{-1} \widetilde{G}_{jl}(k_1,k_2). \quad (20.7)$$

5. Calculate traction in Fourier space as $\widetilde{f}_i(k_1,k_2) = \sum_j \widetilde{M}_{ij}(k_1,k_2)\widetilde{u}_j(k_1,k_2)$.
A simple matrix multiplication determines the Fourier components of the traction.
6. Transform the result into real space with inverse FFT. In MATLAB, the command "ifft2(..., 'symmetric')" can be used here. The result, $f_i(n_1,n_2)$, is a discrete field of traction values that extends over the whole image.

20.2.4.2 Choice of the regularization parameter

The Tikhonov regularization parameter λ in Reg-FTTC can be determined in the framework of Bayes theory (Gelman, Carlin, Stern, & Rubin, 2003) by comparison with a maximum a posteriori (MAP) estimator of the traction. The prior probability distribution for f_i, as well as the probability distribution for the noise in u_i, is a convex function that can be approximated by Gaussians with variances α^2 and ξ^2, respectively. The posterior probability distribution can be calculated with Bayes law as

$$P(\{f\}|\{u\}) = \frac{P(\{u\}|\{f\})P(\{f\})}{P(\{u\})}$$

$$\sim e^{-\sum_{\{x_1,x_2\}}\left(\|u_i - u_i(\{f\})\|^2\right)/\zeta^2} e^{-\sum_{\{x_1,x_2\}}\|f_i\|^2/\alpha^2}. \quad (20.8)$$

Minimization of Eq. (20.4) corresponds to maximizing the posterior probability, Eq. (20.8); when

$$\lambda = \frac{\xi}{\alpha}, \quad (20.9)$$

the MAP estimation of f_i therefore yields an estimate for the optimal regularization parameter λ. With a measurement standard deviation of $\xi \cong 0.17$ pixels, a 90× effective magnification (60× objective and 1.5× intermediate magnification, pixel size is 70 nm), and typical traction magnitudes of $\alpha \cong 130$ Pa (Fig. 20.3A and B),

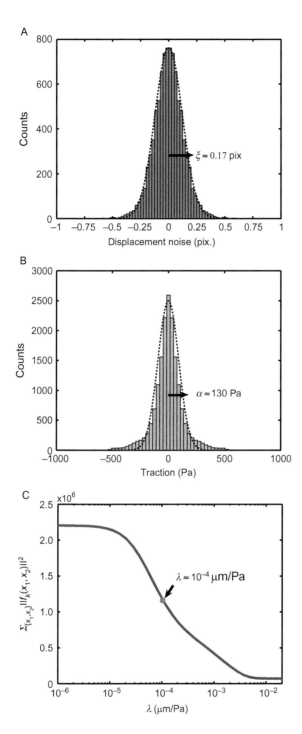

FIGURE 20.3

Choice of the regularization parameter. (A) Histogram of the displacement error obtained by tracking beads in a region where no gel deformation occurs. Dotted line is a Gaussian fit. (B) Histogram of symmetrized traction in x_1 and x_2 directions. Data were collected from adhesion sites and their immediate proximity in one cell. A Gaussian fit (dotted line) allows to estimate the prior distribution of traction. (C) Example for the dependence of the overall traction magnitude on the regularization parameter.

we find $\lambda \cong 10^{-4}$ μm/Pa. Regularization parameters estimated with Eq. (20.9) usually yield a fairly smooth traction field with high resolution.

Figure 20.3C demonstrates that the norm of the overall traction decreases sharply when the regularization parameter is ramped up. Heuristically, λ should be chosen as low as possible but from a range of parameters where the overall traction magnitude starts to become independent of the regularization parameter (L-curve criterion) (Schwarz et al., 2002). Alternatively, one can use advanced techniques that provide a value for λ from given assumptions about the underlying noise, such as the unbiased predictive risk estimator method (Mallows, 1973). It is advised to choose one value of λ and keep this value fixed when comparing different cells under similar conditions.

20.2.4.3 Alleviating spectral leakage due to the FFT
A frequently observed artifact is the formation of "aliases" at the edge of the image. Such artifacts result from spectral leakage, which occurs in discrete Fourier transformations when the data are nonperiodic. The problem can be effectively remedied by appending columns and rows of zeros around the measured two-dimensional field in (x_1, x_2) space. Such an artificial extension of the measurement window is called zero padding. However, we found that zero padding should not be used when $x_3 \neq 0$.

20.2.5 REPRESENTING AND PROCESSING TFM DATA
20.2.5.1 Spatial maps of traction magnitude
Usually, the data sets are represented as a heat map of traction magnitude (Fig. 20.4). Here, the norm is plotted in varying colors. Alternatively, the traction norm can also be mapped linearly on the brightness of one color. This approach allows to directly plot fluorescence signal of cellular components together with the traction.

20.2.5.2 Whole-cell traction
The average of the whole traction is always zero by construction. However, the force dipole moment and higher force moments can be extracted from the traction field (Butler et al., 2002). The evolution of these moments can yield information about the dynamics of migrating cells.

The overall strength of a cell can be quantified through the median of the traction magnitude. Bar graphs of traction magnitude yield clear visual criteria for the strength of cells. An alternative measure for the overall strength of the cell is the total strain energy that is given by

$$U = \frac{l^2}{2} \sum_{n_1, n_2} \sum_{i=1}^{2} f_i(n_1, n_2) u_i(n_1, n_2), \qquad (20.10)$$

where l^2 is the square of the nodal distance in the rectangular grid in μm^2. Strain energy also incorporates information on how much the cell is able to deform the substrate. Therefore, U can be useful if cell behavior on substrates with different

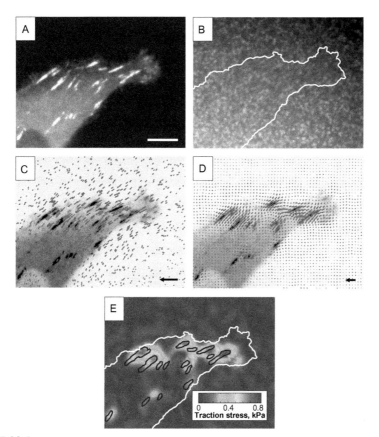

FIGURE 20.4

Quantification of traction forces exerted by individual focal adhesions on a TFM substrate. Human breast adenocarcinoma cells (MDA-MB-231) were transfected with N-terminus-tagged eGFP–paxillin and seeded onto an 8.6 kPa TFM substrate labeled with red and far-red fluorescent nanobeads. (A) Confocal images of focal adhesions labeled with eGFP–paxillin. Scale bar = 5 μm. (B) Positions of far-red fluorescent nanobeads embedded in PAA gel in the strained (red) and unstrained (green) states. Cell edge is outlined in white. (C) Bead displacement field displayed as color coded vector plot overlaid on inverted-contrast image of eGFP–paxillin. Red and green vectors indicate lateral displacement of red and far-red fluorescent nanobeads from the unstrained position, respectively. Scale vector is 1 μm. (D) Traction stress vector field overlaid on inverted-contrast image of eGFP–paxillin. Scale vector is 1 pN. (E) Color-coded heat map of reconstructed traction stress on the ECM with focal adhesions outlined in black. Cell edge is outlined in white. (See the color plate.)

stiffness is to be compared. However, in spite of being an integrated quantity, the quadratic dependence of U on the measurement data makes this quantity prone to measurement errors. This drawback can be somewhat mitigated by restricting the sum over n_1, n_2 to the area of the adherent cell and its immediate surroundings.

20.2.5.3 Traction along a predefined line

In analogy to the common kymograph, traction variation along prescribed one-dimensional coordinates can be plotted over time to quantify motion of the position of peak traction within individual adhesions (Plotnikov et al., 2012). These plots can be produced as follows: First, draw the lines along which traction is to be recorded by using MATLAB command "getline()." Next, partition the lines into segments of length d' pixels. d' can be chosen to be equal to the mesh size d. Finally, record the average traction and fluorescence in a region with area d'^2 at each segment.

REFERENCES

Aratyn-Schaus, Y., & Gardel, M. L. (2010). Transient frictional slip between integrin and the ECM in focal adhesions under myosin II tension. *Current Biology*, 20, 1145–1153.

Aratyn-Schaus, Y., Oakes, P. W., Stricker, J., Winter, S. P., & Gardel, M. L. (2010). Preparation of complaint matrices for quantifying cellular contraction. *Journal of Visualized Experiments*, 14, 2173.

Balaban, N. Q., Schwarz, U. S., Riveline, D., Goichberg, P., Tzur, G., Sabanay, I., et al. (2001). Force and focal adhesion assembly: A close relationship studied using elastic micropatterned substrates. *Nature Cell Biology*, 3, 466–472.

Beningo, K. A., Dembo, M., Kaverina, I., Small, J. V., & Wang, Y. L. (2001). Nascent focal adhesions are responsible for the generation of strong propulsive forces in migrating fibroblasts. *Journal of Cell Biology*, 153, 881–888.

Beningo, K. A., & Wang, Y. L. (2002). Flexible substrata for the detection of cellular traction forces. *Trends in Cell Biology*, 12, 79–84.

Boudou, T., Ohayon, J., Picart, C., Pettigrew, R. I., & Tracqui, P. (2009). Nonlinear elastic properties of polyacrylamide gels: Implications for quantification of cellular forces. *Biorheology*, 46, 191–205.

Butler, J. P., Tolić-Nørrelykke, I. M., Fabry, B., & Fredberg, J. J. (2002). Traction fields, moments, and strain energy that cells exert on their surroundings. *American Journal of Physiology. Cell Physiology*, 282, C595–C605.

Delanoë-Ayari, H., Rieu, J. P., & Sano, M. (2010). 4D traction force microscopy reveals asymmetric cortical forces in migrating dictyostelium cells. *Physical Review Letters*, 105, 248103.

Dembo, M., Oliver, T., Ishihara, A., & Jacobson, K. (1996). Imaging the traction stresses exerted by locomoting cells with the elastic substratum method. *Biophysical Journal*, 70, 2008–2022.

Dembo, M., & Wang, Y. L. (1999). Stresses at the cell-to-substrate interface during locomotion of fibroblasts. *Biophysical Journal*, 76, 2307–2316.

Discher, D. E., Janmey, P. A., & Wang, Y. L. (2005). Tissue cells feel and respond to the stiffness of their substrate. *Science*, 310, 1139–1143.

DuFort, C. C., Paszek, M. J., & Weaver, V. M. (2011). Balancing forces: Architectural control of mechanotransduction. *Nature Reviews Molecular Cell Biology, 12*, 308–319.

Flanagan, L. A., Ju, Y. E., Marg, B., Osterfield, M., & Janmey, P. A. (2002). Neurite branching on deformable substrates. *Neuroreport, 13*, 2411–2415.

Gardel, M. L., Sabass, B., Ji, L., Danuser, G., Schwarz, U. S., & Waterman, C. M. (2008). Traction stress in focal adhesions correlates biphasically with actin retrograde flow speed. *Journal of Cell Biology, 183*, 999–1005.

Gelman, A., Carlin, J. B., Stern, H. S., & Rubin, D. B. (2003). *Bayesian data analysis* (2nd ed.). Chapman and Hall/CRC.

Harris, A. K., Wild, P., & Stopak, D. (1980). Silicone rubber substrata: A new wrinkle in the study of cell locomotion. *Science, 208*, 177–179.

Herant, M., & Dembo, M. (2010). Cytopede: A three-dimensional tool for modeling cell motility on a flat surface. *Journal of Computational Biology, 17*, 1639–1677.

Inoué, S., & Spring, K. (1997). *Video microscopy: The fundamentals (The language of science)* (2nd ed.). New York: Springer.

Koch, D., Rosoff, W. J., Jiang, J., Geller, H. M., & Urbach, J. S. (2012). Strength in the periphery: Growth cone biomechanics and substrate rigidity response in peripheral and central nervous system neurons. *Biophysical Journal, 102*, 452–460.

Kraning-Rush, C. M., Carey, S. P., Califano, J. P., & Reinhart-King, C. A. (2012). Quantifying traction stresses in adherent cells. *Methods in Cell Biology, 110*, 139–178.

Landau, L. D., & Lifshitz, E. M. (1959). *Theory of elasticity: Vol. 7 of course on theoretical physics*. London: Pergamon.

Lee, J., Leonard, M., Oliver, T., Ishihara, A., & Jacobson, K. (1994). Traction forces generated by locomoting keratocytes. *Journal of Cell Biology, 127*, 1957–1964.

Legant, W. R., Choi, C. K., Miller, J. S., Shao, L., Gao, L., Betzig, E., et al. (2013). Multidimensional traction force microscopy reveals out-of-plane rotational moments about focal adhesions. *Proceedings of the National Academy of Sciences of the United States of America, 110*, 881–886.

Legant, W. R., Miller, J. S., Blakely, B. L., Cohen, D. M., Genin, G. M., & Chen, C. S. (2010). Measurement of mechanical tractions exerted by cells in three-dimensional matrices. *Nature Methods, 7*, 969–971.

Liu, Z., Tan, J. L., Cohen, D. M., Yang, M. T., Sniadecki, N. J., Ruiz, S. A., et al. (2010). Mechanical tugging force regulates the size of cell–cell junctions. *Proceedings of the National Academy of Sciences of the United States of America, 107*, 9944–9949.

Mallows, C. (1973). Some comments on Cp. *Technometrics, 15*, 661–675.

Maruthamuthu, V., Sabass, B., Schwarz, U. S., & Gardel, M. L. (2011). Cell-ECM traction force modulates endogenous tension at cell–cell contacts. *Proceedings of the National Academy of Sciences of the United States of America, 108*, 4708–4713.

Merkel, R., Kirchgessner, N., Cesa, C. M., & Hoffmann, B. (2007). Cell force microscopy on elastic layers of finite thickness. *Biophysical Journal, 93*, 3314–3323.

Ng, M. R., Besser, A., Danuser, G., & Brugge, J. S. (2012). Substrate stiffness regulates cadherin-dependent collective migration through myosin-II contractility. *Journal of Cell Biology, 199*, 545–563.

Nobach, H., & Honkanen, M. (2005). Two-dimensional Gaussian regression for sub-pixel displacement estimation in particle image velocimetry or particle position estimation in particle tracking velocimetry. *Experiments in Fluids, 38*, 511–515.

Oakes, P. W., Beckham, Y., Stricker, J., & Gardel, M. L. (2012). Tension is required but not sufficient for focal adhesion maturation without a stress fiber template. *Journal of Cell Biology, 196*, 363–374.

Pawley, J. (2006). *Handbook of biological confocal microscopy* (3rd ed.). Springer.
Plotnikov, S. V., Pasapera, A. M., Sabass, B., & Waterman, C. M. (2012). Force fluctuations within focal adhesions mediate ECM-rigidity sensing to guide directed cell migration. *Cell, 151*, 1513–1527.
Sabass, B., Gardel, M. L., Waterman, C. M., & Schwarz, U. S. (2008). High resolution traction force microscopy based on experimental and computational advances. *Biophysical Journal, 94*, 207–220.
Schwarz, U. S., Balaban, N. Q., Riveline, D., Bershadsky, A. D., Geiger, B., & Safran, S. A. (2002). Calculation of forces at focal adhesions from elastic substrate data: The effect of localized force and the need for regularization. *Biophysical Journal, 83*, 1380–1394.
Sen, S., Engler, A. J., & Discher, D. E. (2009). Matrix strains induced by cells: Computing how far cells can feel. *Cellular and Molecular Bioengineering, 2*, 39–48.
Tambe, D. T., Croutelle, U., Trepat, X., Park, C. Y., Kim, J. H., Millet, E., et al. (2013). Monolayer stress microscopy: Limitations, artifacts, and accuracy of recovered intercellular stresses. *PLoS One, 8*, e55172.
Waterman-Storer, C. M. (2001). Microtubule-organelle motility assays. In J. S. Bonifacino, M. Dasso, J. B. Harford, J. Lippincott-Schwartz, & K. M. Yamada (Eds.), *Current Protocols in Cell Biology*. John Wiley & Sons.
Webb, D. J., Donais, K., Whitmore, L. A., Thomas, S. M., Turner, C. E., Parsons, J. T., et al. (2004). FAK-Src signalling through paxillin, ERK and MLCK regulates adhesion disassembly. *Nature Cell Biology, 6*, 154–161.
Wirtz, D., Konstantopoulos, K., & Searson, P. C. (2011). The physics of cancer: The role of physical interactions and mechanical forces in metastasis. *Nature Reviews Cancer, 11*, 512–522.
Yang, Z., Lin, J. S., Chen, J., & Wang, J. H. (2006). Determining substrate displacement and cell traction fields—A new approach. *Journal of Theoretical Biology, 242*, 607–616.
Yeung, T., Georges, P. C., Flanagan, L. A., Marg, B., Ortiz, M., Funaki, M., et al. (2005). Effects of substrate stiffness on cell morphology, cytoskeletal structure, and adhesion. *Cell Motility and the Cytoskeleton, 60*, 24–34.

CHAPTER

Experimenters' guide to colocalization studies: finding a way through indicators and quantifiers, in practice

21

Fabrice P. Cordelières*, Susanne Bolte[†]

Bordeaux Imaging Center, UMS 3420 CNRS—Université Bordeaux Segalen—US4 INSERM, Pôle d'imagerie photonique, Institut François Magendie, Bordeaux Cedex, France
[†]*Sorbonne Universités—UPMC Univ Paris 06, Institut de Biologie Paris-Seine—CNRS FR 3631, Cellular Imaging Facility, Paris Cedex, France*

CHAPTER OUTLINE

Introduction .. 396
21.1 An Overview of Colocalization Approaches ... 397
 21.1.1 Two Types of Numerical Values to Extract: Colocalization Indicators and Colocalization Quantifiers 397
 21.1.2 Two Ways to Work on Colocalization Evaluation: Taking the Image as a Whole and Splitting It Into Objects 397
 21.1.2.1 Working on Image Intensities .. 397
 21.1.2.2 Working on Objects .. 403
Conclusion ... 406
References ... 407

Abstract

Multicolor fluorescence microscopy helps to define the local interplay of subcellular components in cell biological experiments. The analysis of spatial coincidence of two or more markers is a first step in investigating the potential interactions of molecular actors. Colocalization studies rely on image preprocessing and further analysis; however, they are limited by optical resolution. Once those limitations are taken into account, characterization might be performed. In this review, we discuss two types of parameters that are aimed at evaluating colocalization, which are indicators and quantifiers. Indicators evaluate signal coincidence

over a predefined scale, while quantifiers provide an absolute measurement. As the image is both a collection of intensities and a collection of objects, both approaches are applicable. Most of the available image processing software include various colocalization options; however, guidance for the choice of the appropriate method is rarely proposed. In this review, we provide the reader with a basic description of the available colocalization approaches, proposing a guideline for their use, either alone or in combination.

INTRODUCTION

In cell biology, colocalization studies are performed to infer the coincidence of two or more signals within the volume of a sample. This event might occur in two ways: Proteins of interest are locally present on a structure; their concentrations are locally linked. The diagnosis of coincidence is based on a representation of the biological sample by a set of images. The latter is formed through a microscope and its attached numerization device (detector). Since the resolution of an optical system is diffraction-limited, colocalization studies may also be impaired by this limited optical resolution. Thus, optical resolution is a referential that should always be clearly stated. In cell biology, the conclusion of colocalization analysis is usually formulated as "two markers are at the same location." But the real conclusion of a colocalization analysis should rather be stated as "knowing the current resolution, it cannot be excluded that the two markers are at the same location." The term "colocalization" is used abusively, as only a diagnosis of close vicinity can be stated with certitude.

The image formation process being the key point for setting the colocalization referential, care should be taken in both, sample preparation and image acquisition. The former implies preserving the spatial distribution of the components to analyze and using appropriate markers, usually fluorescent, that are devoid of cross talk and bleedthrough (for review, refer to Bolte & Cordelières, 2006). Sample mounting is also a critical parameter. When dealing with 3D samples, the use of setting mounting media may alter the thickness of cells and impair further analysis. As resolution depends on both the composite refractive index (RI) of the crossed media and the angular properties of the objective (numerical aperture, NA), oil and objectives should be chosen with care. For instance, when working on subcellular structures, the use of high-NA objectives is recommended, with immersion media that match mounting medium RI. Finally, the imaging process is also crucial. As stated by the Shannon–Nyquist–Whittaker theorem (Shannon, 1998), an element of resolution should always be sampled at least twice, which means in practice that a subdiffraction object should be represented by $3 \times 3(\times 3)$ pixels (voxels).

Several strategies might be used to unravel colocalization occurrence in a set of images. One may want to have a global diagnosis, taking the image as a whole or increasing the level of granularity and rather work on objects. In the former case, two types of colocalization evaluation might be performed, extracting either indicators or quantifiers. When working on objects, only quantifiers have yet been proposed as colocalization evaluators. Two choices appear when working on a set of

images: the experimenter might analyze intensities, expecting some links between their distributions, or investigate signal coincidence. There is a whole set of parameters one has to choose from. In this review, we present the most commonly used colocalization approaches, giving insight in their domains of application, while guiding the user in the choices and combinations that are offered.

21.1 AN OVERVIEW OF COLOCALIZATION APPROACHES

21.1.1 TWO TYPES OF NUMERICAL VALUES TO EXTRACT: COLOCALIZATION INDICATORS AND COLOCALIZATION QUANTIFIERS

Colocalization analysis should always start by a close visual inspection of the image couple and a simple channel overlay might be the starting point. However, the experimenter should stay critical as the typical yellowish colocalization pattern might be achieved through an exaggerated image processing. This first step might be a final step in conditions where evident colocalization is present in the sample. However, care should be taken about cross talk and bleedthrough.

In the following lines, colocalization evaluation will be used as a generic term encompassing the use of both colocalization indicators and colocalization quantifiers. *Colocalization indicators* are numerical values that evaluate a degree of signal coincidence over a predefined scale, but are not suitable to calculate a precise amount of overlap. They are suitable for relative comparisons, without being usable for direct quantitative studies. *Colocalization quantifiers* provide the experimenter with an absolute value, quantifying the overlap of signals by using physical descriptors such as area or volume or by measuring distances between defined coordinates within the structures.

21.1.2 TWO WAYS TO WORK ON COLOCALIZATION EVALUATION: TAKING THE IMAGE AS A WHOLE AND SPLITTING IT INTO OBJECTS

21.1.2.1 Working on image intensities

21.1.2.1.1 Legacy colocalization indicators and visualization methods
How should one evaluate the dependency between signals acquired for colocalization evaluation? Most basically, a linear relationship among the intensities of both channels can be assumed. Manders, Stap, Brakenhoff, van Driel, and Aten (1992) transposed a classical visualization of flow cytometry data by a scatter plot to confocal images: The intensity of a given pixel in the green image is used as the x-coordinate of the scatter plot and the intensity of the corresponding pixel in the red image as the y-coordinate. The composed figure takes the shape of a dot cloud, its form unraveling the colocalization state. In case of unambiguous colocalization, the shape might be approximated as a line centered over the cloud. The scatter plot might also display two separated populations of dots, close to each axis. In this case, two conclusions might be drawn: If these two clouds have a line shape, they might result from either cross excitation or cross detection of signals. Alternatively, less

structured clouds hint for nonlinked signals. Finally, the scatter plot might also display additional dot arrangements: combinations of the former, multiple linear dependencies, and/or single/multiple nonlinear dependencies. Those arrangements increase the difficulty of the interpretation process. Under such circumstances, one should remember that the scatter plot representation omits spatial information. Therefore, it is crucial to go back to the overlay image, trying to identify regions where each single dependency (linear/nonlinear) occurs and redo the analysis on identified regions of interest (ROI).

To characterize the linear dependency of two signals, Manders et al. introduced the use of the *Pearson correlation coefficient* (PC) (Pearson, 1901), as a *colocalization indicator* in 1992 (Manders et al., 1992) (see Table 21.1). The PC characterizes the linear relationship between two variables, providing a value of 1 in case of complete positive correlation (colocalization), −1 for negative correlation (exclusion), and zero when no correlation is found. Although this scale seems comfortable, the extent of each extreme value remains to be determined: which limit should be put between total positive correlation (PC=1) and no correlation (PC=0)? Midrange values will remain hard to interpret, when taken alone. Therefore, a scatter plot should always accompany PC. As previously shown (Bolte & Cordelières, 2006), a midrange value might correspond to either no correlation or correlation corrupted by noise. Depending on the shape of the dot clouds, the experimenter will be able to infer the former or the latter. In cases where several experimental conditions are to be compared, PC might be used to show a difference of colocalization. However, the PC remains an indicator and may not be used to express the amount of colocalization within a sample.

Table 21.1 Colocalization Evaluators

Method	Formula
Pearson coefficient (indicator)	$PC = \dfrac{\sum_i (A_i - a) \times (B_i - b)}{\sqrt{\sum_i (A_i - a)^2 \times \sum_i (B_i - b)^2}}$
Overlap coefficient (indicator)	$Overlap = \dfrac{\sum_i A_i \times B_i}{\sqrt{\sum_i (A_i)^2 \times \sum_i (B_i)^2}}$
k_1 and k_2 coefficients (indicators)	$k_1 = \dfrac{\sum_i A_i \times B_i}{\sqrt{\sum_i A_i^2}}, k_2 = \dfrac{\sum_i A_i \times B_i}{\sqrt{\sum_i B_i^2}}$
M_1 and M_2 coefficients (quantifiers)	$M_1 = \dfrac{\sum_i A_{i,coloc}}{\sum_i A_i}, M_2 = \dfrac{\sum_i B_{i,coloc}}{\sum_i B_i}$
M_1 and M_2 thresholded coefficients (quantifiers)	$tM_1 = \dfrac{\sum_i A_{i,thr_A}}{\sum_i A_i}, tM_2 = \dfrac{\sum_i B_{i,thr_B}}{\sum_i B_i}$

A_i and B_i: intensities of the pixel i on images A and B, respectively.
a and b: average intensities of images A and B, respectively.
A_{max} and B_{max}: maximum intensities of images A and B, respectively.
$A_{i,coloc}$, $B_{i,coloc}$: $A_{i,coloc}$ takes the value A_i if $B_i > 0$ and $B_{i,coloc}$ takes the value B_i if $A_i > 0$.
A_{i,thr_A}, B_{i,thr_B}: A_{i,thr_A} takes the value A_i if $B_i > thr_B$ and B_{i,thr_B} takes the value B_i if $A_i > thr_A$.

Attempts have been made to ease the interpretation of PC. The overlap coefficient (see Table 21.1) has been designed by taking the mean intensity values out of the equation (Manders, Verbeek, & Ate, 1993). This results in a numerical value in the 0–1 range, where 0 corresponds to negative correlation, 0.5 to no correlation, and 1 to full correlation. This shift brings confusion in the interpretation. The experimenter may abusively refer to this [0, 1] as a percentage of colocalization, which, of course, is not true.

Looking more closely to the overlap coefficient, one might distinguish two parts within the expression: one encountering for channel A, the other for channel B. Subsequently, two *colocalization indicators* were built, k_1 and k_2 (Manders et al., 1993, see Table 21.1). When a perfect correlation is present in the image couple, k_1 tends to a value close to the normalized stoichiometry (value in the 0–1 range) depending on the slope of the average line in the scatter plot, and k_2 to $1/k_1$. A noise- and/or background-corrupted channel will result in an increase in the denominator and therefore the k coefficient will decrease (Cordelières & Bolte, 2008). The evaluation of the distortion between the k coefficient and its expected value when considering plain correlation might be a trail to pursue, helping to infer colocalization diagnosis in the case of noisy signals.

Correlation-based methods require a certain degree of dependency between signal intensity. Colocalization might be a more subtle phenomenon: two proteins might appear in a spatially correlated manner, not implying specific stoichiometries. To assess the superimposition of distribution patterns, Manders et al. (1993) introduced M_1 and M_2 coefficients, nowadays named after the author (see Table 21.1). Calculating M_1 implies calculating the ratio of intensities, taking summed intensities of channel A that find a non-null counterpart in channel A, and dividing it by the total intensity of pixels in A. M_2 is obtained by calculating the other way round. M_1 and M_2 express the percentage of fluorescence having a counterpart in the other channel. Manders coefficients are therefore to be considered as *colocalization quantifiers*. Those coefficients were originally defined for use with confocal images, based on photomultiplier detectors, for which a detection offset has to be set. Technical innovations on detectors and imaging modalities have opened a wide range of applications where the minimum intensity on an image might not be null. As a consequence, the zero value is not always the appropriate value to distinguish non-pertinent from pertinent signal. Two new parameters have been derived from the Manders coefficient, the thresholded Manders coefficients (tM_1 and tM_2; see Table 21.1), belonging to the class of *colocalization quantifiers*. Thresholded Manders coefficients consider intensity values above a user-defined value.

21.1.2.1.2 Legacy colocalization indicators and visualization methods, revisited

Interpreting the scatter plot might seem easy when dealing with a well-defined colocalization phenomenon. The experimenter might find easily the contribution of background/noise as a shapeless cloud surrounding the scatter plot origin and cross talk/bleedthrough as a rather linearly shaped dot cloud located near the axes. It is however difficult to eliminate those unwanted contributions.

Simple thresholding of the images is one option when using Manders coefficients however, it is user-dependent. Costes et al. (2004) proposed an automated thresholding method. It consists in iteratively lowering the threshold, starting at highest intensity values for both channels, and calculating PC only taking into account values below these thresholds. When a null or negative value of PC is found, that is when the uncorrelated population has been delineated (background/noise), and the process is stopped. Pertinent coefficients are then calculated from the intensities lying above both thresholds. As background, cross talk, and bleedthrough are hardly present as a well-defined line parallel to the axis, this procedure will only remove them partially.

Gavrilovic and Wählby (2009) proposed an alternative to the scatter plot, in the form of a spectral angle representation. This histogram carries angles taken within the $0°$ to $90°$ range on the x-axis. Each couple of intensities (A_i, B_i) contributes to the histogram through the angle $\mathrm{atan}(B_i/A_i)$, assuming that channel A's intensities are plotted on the x-axis of the scatter plot, and a magnitude depending on the distance of the corresponding point to the origin. Corrections to the spectral angle histogram are made to account for the discrete nature of image intensities (please refer to the original paper for more details). From this representation, three populations of pixels might be extracted: two corresponding to cross talk/bleedthrough and the third to colocalization, from which legacy indicators and quantifiers might be calculated. This method has the advantage of defining populations in the scatter plot based on angles, rather than intensity thresholds. It is also a method of choice when several stoichiometries link channel intensities as multiple threshold angles might be extracted out of the spectral angle histogram.

An additional issue relies on the interpretation of indicator/quantifier values, especially when dealing with PC coefficient. Although this process is rather simple when comparing several experimental conditions, care should be taken if only one situation is to be evaluated. Two descriptive methods might be used to help interpreting data: Van Steensel's method and Costes' randomization.

Van Steensel et al. (1996) proposed the use of a cross correlation function in colocalization studies. It consists in calculating PC while operating a pixel shift to one of the two channels. As a consequence, colocalization contribution should disappear when the pixel shift is applied: the higher the pixel shift, the lower the PC. Plotting the PC as a function of the pixel shift results in a bell-like curve when colocalization occurs, a rather flat line when no colocalization is present, and a pit in case of signal exclusion. Van Steensel's method is a graphical way to assess colocalization for low PC values (close to zero). It also provides a mean to quantify and further correct for chromatic aberration, since in such case, the maximum of the bell-shaped curve will not fit the zero pixel shift.

Costes' randomization (Costes et al., 2004) is a process based on the comparison of the PC of original image couples and the PC between a randomized image of channel A and the original image of channel B. Randomization of the image of channel A is done by shuffling pixel positions. Repeating the process allows collecting a distribution of PCs that encounters for colocalization events due to hazard. Comparing

the original PC value, obtained from nonrandomized channels, to this distribution helps to position the current situation to a random colocalization event.

Finally, in spite of those methods, some experimental situations are simply not compatible with the use of PC. PC requires the two signals to be linearly linked, which may not always be the case. When a monotonic relation links intensities, either increasing or decreasing, an additional *colocalization indicator* might be used: Spearman's coefficient (SC) (French, Mills, Swarup, Bennett, & Pridmore, 2008; Spearman, 1904). Rather than working on raw intensities, a classification is first made. To exemplify, let's take a group of intensities: {0, 1, 2, 4, 8, and 16}. Grouping intensities into classes will convert the former array of values to the following: {0, 1, 2, 3, 4, and 5}. While the original data were unevenly distributed, the transformed data are well ordered, all classes being evenly spaced. This process results in a linearization of the nonlinear dataset. The PC calculated accordingly is called SC and its value is in the $[-1, 1]$ range, while its interpretation is similar to the PC.

21.1.2.1.3 Which strategy to adopt?

As we have seen, when dealing with pixel intensity-based colocalization methods, a plethora of tools exist. While most of the experimenters would usually only pick one tool, several of them can be combined to describe the signal interplay.

First, as a preliminary step, colocalization study should always start by overlaying channels. The resultant image gives a first insight on signal coincidence. It also helps defining ROI, to which analysis might be restricted later on. Chromatic aberration-free images being a prerequisite to proper colocalization evaluation, overlay is also a tool to detect such phenomenon. Van Steensel's cross correlation approach helps quantifying it, as its extremum's position (maximum in case of colocalization and minimum in case of exclusion) generally corresponds to chromatic shift.

Once images have been corrected for chromatic aberration, a scatter plot should be built. Its analysis will be useful in defining the contribution of cross talk/bleed-through and background/noise to pertinent signal. Two strategies are to be applied: The first consists in removing both contributions by applying thresholds to channels A and B. This step might be achieved either manually or using automated Costes' threshold. Another approach is to perform spectral angle representation and use the histogram segmentation method proposed by Gavrilovic and Wählby (2009).

Signals being now exempt of parasite contributions, the colocalization evaluation process can be performed. Two kinds of tests might be performed: retrieval of colocalization indicators and quantifiers. The former are to be used to prove a monotonic relationship between intensities of both channels and the later to quantify the amount of overlapping signals.

Being the oldest used indicator, the PC is usually the first to be calculated. This is only appropriate when a linear relationship links intensities of both channels. Alternatively, in case the connection is not linear but still monotonic, the use of SC should be preferred. In both cases, care should be taken with their interpretation. While low, null, and high values permit straightforward conclusions (exclusion, no correlation,

and colocalization, respectively), midrange values are ambiguous. Going back to the scatter plot helps, as the spread of cloud distribution is an indication of noise-corrupted signal. This can easily be assessed by calculating the two components of the overlap coefficient: k_1 and k_2. Both values should drift from the ideal $1/a$ and a values, a being the slope of the regression line describing best the dot cloud. Alternatively, one may identify more than one dot cloud on the scatter plot, which would lead to similar issues on PC/SP, k_1 and k_2. This situation might be circumvented by isolating individual dot populations and performing the former tests on individual groups of intensities.

Once those observations and partitioning have been performed, the experimenter may want to investigate *colocalization indicator* relevance in the current experimental situation. When comparing several conditions, PC/SP for each might be compared using regular statistical tests (see the recent review by McDonald & Dunn, 2013). When only one experimental situation is to be diagnosed for colocalization, the task might seem harder to pursue. Using Costes' randomization is then the best available choice, as a reference dataset is generated from the actual content of both input images, one of them being shuffled. When performing this approach, care should be taken for two parameters: the size of the ROI, relative to the extent of pertinent signal, and the number of randomizations to be performed. Performing the analysis on an ROI where the ratio between the number of pixels belonging to the objects is low, as compared to the number of nonobject pixels, will lead to a distribution of PC where values are expected to be centered around 0 and the full width at half maximum (FWHM) is rather low. In this situation, the PC calculated on the original couple of images is likely to be well outside this distribution. To the opposite, an ROI devoted to nonobject pixels will give a larger FWHM, intensities within objects likely being correlated. Under those circumstances, the original PC will fall into the distribution, and erroneous conclusion of "random" colocalization might be drawn. Therefore, it is advisable to consider an ROI where approximately 50% of the pixels belong to structures, when performing such an approach. The number of randomization rounds is also of main concern. A low number of randomization will end up in a sharp bell-shaped curve, centered on the most probable PC encountered in random colocalization situations, omitting the less occurring events, located on both extreme sides of the distribution. In their original paper, Costes et al. (2004) used 200 rounds of randomization of their tests. The final output of Costes' method is a P-value (to be differentiated from the statistical test output, p-value). It corresponds to the area under the distribution of PC from randomized images, starting from its minimum, until the intercept with the original PC value. Colocalization is considered true when the P-value is above 95%, meaning that for 200 rounds of randomization, the original PC value or higher is found in less than 10 cases.

Among legacy colocalization quantifiers lay the Manders coefficients. M_1 and M_2 should rather be used to estimate the amount of colocalization between two channels, meaning when proper quantitative values have to be extracted. The first step here is to correct for potential chromatic aberration using Van Steensel's method. To get rid of cross talk/bleedthrough and noise, either manual thresholding or Costes' method

might be applied, together with spectral angle histogram representation, as previously stated. Alternatively, image processing might be applied to isolate the pertinent objects from the image. Denoising, wavelet transformation, texture-based analysis, etc., might be performed to segment the image. Once information-containing regions have been extracted, the analysis is to be performed on the original image. Binary masks may be generated from the processed images and applied on the original images. Manders et al. had not proposed these kinds of processing steps in their original paper but rather applied a simple threshold before calculating tM_1 and tM_2 (M_1 and M_2 in their thresholded form). Once clean out has been performed on both images, both coefficients are calculated on remaining pixel intensities. While Manders coefficients give a direct readout of the amount of signal engaged in the colocalization process, this method requests a precocious determination of the thresholds, partitioning the intensities belonging to objects and the ones lying in the background. When comparing several sets of conditions, this process should be first applied to the images where colocalization is supposed to be the most present, assuming all sets of images have been acquired under the same conditions. Once determined, those parameters should be left untouched and applied to all remaining images within the dataset.

21.1.2.2 Working on objects

Manders coefficients are colocalization quantifiers calculated using only pixels belonging to objects. While this approach is object-based, the calculations are made using a different level of granularity, pixel-wise. Those quantifiers are therefore global, and more advanced diagnostic might be performed using a lower level of granularity, object-wise.

Two strategies might be used when dealing with problematic colocalization: considering the image couple as a container for intensity couples, which may or may not be spatially related, and, alternatively, as a container for a population of object couples. The latter opens the possibility to evaluate the interplay between signals locally. The methods that will be applied not only are restricted to colocalization evaluation but can also be used to investigate parameters such as proximity, apposition, and overlap in an object-to-object way.

21.1.2.2.1 Grouping pixels into objects: Image segmentation

Images are composed of discrete elements, resulting from the sampling of the original scene, namely, the biological sample, seen through a detector, and by the use of fluorescent molecules. Each pixel carries an intensity that corresponds to the local concentration of the probes. Fluorescence emission and its digitalization are noise-creating processes, and the experimenter has to deal with those parasite contributions to the signal. Generating an image through a microscope is also not a faithful process. The view of a biological sample presented by an image is dependent on the instrument response function that takes the form of a point-spread function (PSF). The image of a subresolution object will therefore be a 3D hourglass shape, whose minimum width is the actual resolution of the optical system. Performing a proper

isolation of the objects out of the image will imply taking into account all those contributions to the image formation process.

Two types of noise impair the image, Poisson and Gaussian noise, resulting from both the stochastic nature of the fluorescence process and the electronics used to collect photons and to digitize the signal. A good object delineation might be hard to achieve, when dealing with low signal-to-noise ratio (SNR) images, for instance, in video-microscopy experiments. Several denoising tools have been released that use both local and temporal estimations of noise to enhance the original signal (Boulanger et al., 2010; Luisier, Vonesch, Blu, & Unser, 2010). Additionally, image restoration algorithms may be applied to account for and revert the instrument function response. Deconvolution is a process aimed at bringing the signal spread out back to its origin, using the PSF. It will enhance the SNR and ease the object delineation process (for review, see Sibarita, 2005). Recent work by Paul, Cardinale, and Sbalzarini (2013) proposed to do both deconvolution and image segmentation concomitantly, a strategy that may also be applied to images before object-based colocalization.

Once image enhancement has been performed, easy object delineation steps might be achieved. Wavelet transformation, among other methods (for a comparative review, see Ruusuvuori et al., 2010), can be used to isolate objects of specific shape and size.

The final steps of object isolation are achieved through thresholding and connexity analysis of the resultant image. Pixels are therefore separated into two populations, based on their intensities, namely, the nonobject and the object pixels. Then, classification of spatially juxtaposed pixels is done to determine the objects.

Those preprocessing steps impair the original signal and thus have to be performed with care. However, they are crucial for faithful object delineation. Knowing the nature of analysis to be performed on object geometry or intensity, the resulting images will have to be used raw or as masks, through which original intensities will be observed, respectively.

21.1.2.2.2 Colocalization quantifiers based on object overlaps

Connexity analysis is a means to combine pixels carrying relevant intensities (i.e., which lie above the threshold) into objects and to retrieve pertinent information from them subsequently. This information may contain the measurement of the area in two dimensions, volume in three dimensions, perimeter, and centers. Centers can be considered either geometric, only taking into account positions of pixels belonging to objects, or intensity-based (center of mass or barycenter). Using those descriptors, new *colocalization quantifiers* might be built.

Objects larger than the optical resolution will always appear as covering a surface larger than the expected 3×3 pixel area, when optimal sampling has been performed. A straightforward analysis is to measure the overlap surface existing between the two channels for each object. In a way, this approach is similar to the Manders coefficient method but differs from it as it relies on physical overlap rather than on intensity overlap. A Manders coefficient can also be calculated, object per object, determining the proportion of signal involved in colocalization.

The proposed approaches rely on local analysis as well as global analysis. They allow investigating region per region coincidence of signals or, more generally, physical overlap.

However, when dealing with size heterogeneity of structures between two channels, physical or intensity-wise overlaps are hard to interpret. For instance, taking images presenting large objects in one channel and resolution-limited objects in the other, the measures will be low in the former and close to 100% in the latter. There are two ways to proceed: The first would consist in setting a threshold of overlap above which structures are considered as colocalized. Two ratios are then calculated, expressing the percentage of objects in channel A that overlap, physically or intensity-wise, with an object from channel B, and vice versa. In this matter, the thresholding step relies only on user input, which might be impaired by a priori knowledge of the expected results. A second option consists in plotting a histogram of the degrees of overlap, to help tuning the limit above which two objects are considered as colocalized.

Alternatively, resolution-limited objects from channel A might be reduced to their centers. In homogeneously labeled structures, both centers of mass and geometric centers should fall on the same pixel. Colocalization quantifiers are then calculated by counting the number of centers from channel A that fall onto the surface/volume of objects from channel B. This approach was proposed by Lachmanovich et al. (2003). The reduction of an object to its center is only allowed in cases where its dimensions are close to the optical resolution. This is also true for the barycenter, when intensities are evenly distributed within the object. Therefore, using one or the other parameter will depend on both the area of the object and the intensity distribution within the object.

21.1.2.2.3 Colocalization quantifiers based on object distances

Previously described methods were based on the search for an overlap between relevant object descriptors. However, due to the combination of the limit of resolution and the sampling performed by the imaging process, two point-shaped structures will appear on blocks of 3×3 pixels. In this situation, colocalizing objects may fall onto pixels as distant as 3 pixels. This imprecision of localization may result in underestimation of colocalization when only looking for a true, precise overlap. The alternative might be to work rather on distances than on coincidences (Cordelières & Bolte, 2008; Lachmanovich et al., 2003).

Knowing all parameters that can be extracted out of objects, several choices are offered to quantify colocalization. Distances might be calculated between the envelopes of objects from both channels, considering that colocalization occurs when two surfaces/volumes are distant from less than the optical resolution. The same rule may be applied to distances between centers of objects from both channels. Direct quantifications are achieved by counting the number of colocalization events and dividing it by the overall number of objects for one channel.

More subtle characterization may be performed: A histogram of all distances can be plotted. The analysis of this representation may help in distinguishing several populations. More than a binary analysis, distance histograms may help to reveal

colocalization (distances below the optical resolution), apposition (distances higher but close to optical resolution), or non-colocalization events. When considering an experimental situation where colocalization varies upon the addition of a drug, and/ or as a function of time, a comparison of the histogram helps directly to visualize the evolution of the three aforementioned populations.

21.1.2.2.4 Which strategy to adopt?

There are a plethora of parameters that can be extracted out of objects, after the segmentation process, and this might impede the choice of the appropriate colocalization method. It has to be made depending on three factors: the size of the structures, their shapes, and their relative distribution between channels A and B.

When the objects have a size close to the optical resolution, the easiest way to work is to use their centers. The small number of pixels makes the use of both types of centers (of mass and geometric) equivalent. Objects larger than the optical resolution have to be used as a whole: Their surface, if working in 2D, or volume, if working in 3D, has to be used. Colocalization methods will then depend on the parameters extracted from both channels. In the center–center case, evaluation has to be done on distances. In the center–area/volume case, the experimenter should rather investigate coincidence between the latter and the former. Finally, in the area/volume–area/volume, measure of the overlap may be performed. This measure might be performed either geometry-based or intensity-based. The choice should be performed in view of the phenomenon to study and the signal distribution within objects. When the intensity is homogeneous within the structure, both methods will end up with similar results. Combining measures of the overlap of surfaces/volumes and the coincidence of signal might be used to infer the nonhomogeneous distribution of the markers within the structures.

Additional analysis is accessible from those parameters. For instance, when two vesicular markers are to be analyzed, one being the content and the other an outer labeling, apposition of the two signals may be evaluated in a two-step process. First, using the center–center approach, the experimenter will measure distances close to the optical resolution. As a second step, the overlap measurements between areas/volumes will display a value close to zero. This is a typically expected result when working on round structures, surrounded by a donut-shaped signal. When the structures are rather elongated than round-shaped, for instance, when working on pre-/postsynaptic markers, apposition might be revealed by considering the minimum distances between envelopes of objects from both channels.

CONCLUSION

Colocalization studies are usually performed using the most widely available methods, namely, by calculating the PC or Manders coefficient. However, these are not generic methods, and both have domains of application that should be respected. Alternative methods should be investigated, as they either are more

appropriate or might give insights to the legacy indicator and quantifier interpretation. All the tools that were made available were designed to answer a specific biological problem. A more general approach should therefore consist in first verifying that published tools are applicable to the experimenter's problem and alternatively trying to design appropriate indicators/quantifiers relevant to the field of investigation.

The development of superresolution microscopy techniques is now breaking down the resolution limit. Previously published colocalization studies might soon have to be revisited in light of the improved performances of optical systems. The output of structured illumination and STED microscopies is still images, where legacy methods might be applied. However, pointillist techniques generate not only images but also localization information that is characterized by uncertainty of measure, making the data uneven resolution-wise. Using generic methods is the most straightforward strategy, which should be applied to images reconstructed from localization data. Raw data have to be analyzed as distance maps, taking into account the localization imprecision. In this matter, up to now, no real effort has been made in trying to find good indicators/quantifiers. This definitely opens new fields of investigation for colocalization specialist.

REFERENCES

Bolte, S., & Cordelières, F. P. (2006). A guided tour into subcellular colocalization analysis in light microscopy. *Journal of Microscopy*, *224*(3), 213–232.

Boulanger, J., Kervrann, C., Bouthemy, P., Elbau, P., Sibarita, J.-B., & Salamero, J. (2010). Patch-based nonlocal functional for denoising fluorescence microscopy image sequences. *IEEE Transactions on Medical Imaging*, *29*(2), 442–454.

Cordelières, F. P., & Bolte, S. (2008). JACoP v2.0 : Improving the user experience with co-localization studies. In *ImageJ User & Developer Conference* (pp. 174–181).

Costes, S. V., Daelemans, D., Cho, E. H., Dobbin, Z., Pavlakis, G., & Lockett, S. (2004). Automatic and quantitative measurement of protein–protein colocalization in live cells. *Biophysical Journal*, *86*(6), 3993–4003.

French, A. P., Mills, S., Swarup, R., Bennett, M. J., & Pridmore, T. P. (2008). Colocalization of fluorescent markers in confocal microscope images of plant cells. *Nature Protocols*, *3*(4), 619–628.

Gavrilovic, M., & Wählby, C. (2009). Quantification of colocalization and cross-talk based on spectral angles. *Journal of Microscopy*, *234*(3), 311–324.

Lachmanovich, E., Shvartsman, D. E., Malka, Y., Botvin, C., Henis, Y. I., & Weiss, A. M. (2003). Co-localization analysis of complex formation among membrane proteins by computerized fluorescence microscopy: Application to immunofluorescence co-patching studies. *Journal of Microscopy*, *212*(Pt. 2), 122–131.

Luisier, F., Vonesch, C., Blu, T., & Unser, M. (2010). Fast interscale wavelet denoising of Poisson-corrupted images. *Signal Processing*, *90*(2), 415–427.

Manders, E. M., Stap, J., Brakenhoff, G. J., van Driel, R., & Aten, J. A. (1992). Dynamics of three-dimensional replication patterns during the S-phase, analysed by double labelling of DNA and confocal microscopy. *Journal of Cell Science*, *103*, 857–862.

Manders, E. M. M., Verbeek, F. J., & Ate, J. A. (1993). Measurement of co-localisation of objects in dual-colour confocal images. *Journal of Microscopy, 169*(3), 375–382.

McDonald, J. H., & Dunn, K. W. (2013). Statistical tests for measures of colocalization in biological microscopy. *Journal of Microscopy, 252*(3), 295–302.

Paul, G., Cardinale, J., & Sbalzarini, I. F. (2013). Coupling image restoration and segmentation: A generalized linear model/Bregman perspective. *International Journal of Computer Vision, 104*(1), 69–93.

Pearson, K. (1901). On lines and planes of closest fit to systems of points in space. *Philosophical Magazine Series 6, 2*(11), 559–572.

Ruusuvuori, P., Aijö, T., Chowdhury, S., Garmendia-Torres, C., Selinummi, J., Birbaumer, M., et al. (2010). Evaluation of methods for detection of fluorescence labeled subcellular objects in microscope images. *BMC Bioinformatics, 11*, 248.

Shannon, C. E. (1998). Communication in the presence of noise. *Proceedings of the IEEE, 86*(2), 447–457.

Sibarita, J. (2005). Deconvolution microscopy. *Advances in Biochemical Engineering/Biotechnology, 95*, 201–243.

Spearman, C. (1904). The proof and measurement of association between two things. *The American Journal of Psychology, 15*(1), 72–101.

Van Steensel, B., van Binnendijk, E., Hornsby, C., van der Voort, H., Krozowski, Z., de Kloet, E., et al. (1996). Partial colocalization of glucocorticoid and mineralocorticoid receptors in discrete compartments in nuclei of rat hippocampus neurons. *Journal of Cell Science, 792*, 787–792.

CHAPTER

User-friendly tools for quantifying the dynamics of cellular morphology and intracellular protein clusters

22

Denis Tsygankov[*], Pei-Hsuan Chu[*], Hsin Chen[†], Timothy C. Elston[*], Klaus M. Hahn[*,#]

[*]Department of Pharmacology, University of North Carolina, Chapel Hill, North Carolina, USA
[†]Department of Pharmacology and Cancer Biology, Duke University, Durham, North Carolina, USA
[#]Lineberger Cancer Center, University of North Carolina, Chapel Hill, North Carolina, USA

CHAPTER OUTLINE

Introduction ... 410
22.1 Automated Classification of Cell Motion Types ... 411
22.2 GUI for Morphodynamics Classification and Ready Representation of Changes in Cell Behavior Over Time .. 415
22.3 Results of Morphodynamics Classification .. 417
22.4 Geometry-based Segmentation of Cells in Clusters ... 418
22.5 GUI for Cell Segmentation and Quantification of Protein Clusters 421
 22.5.1 GUI Module for 2D Analysis .. 421
 22.5.2 GUI Module for 3D Analysis .. 423
22.6 Results for Quantifying Protein Clusters ... 424
22.7 Discussion ... 424
Acknowledgments .. 426
References ... 426

Abstract

Understanding the heterogeneous dynamics of cellular processes requires not only tools to visualize molecular behavior but also versatile approaches to extract and analyze the information contained in live-cell movies of many cells. Automated identification and tracking of cellular features enable thorough and consistent comparative analyses in a high-throughput manner. Here, we present tools for two challenging problems in computational image analysis:

(1) classification of motion for cells with complex shapes and dynamics and (2) segmentation of clustered cells and quantification of intracellular protein distributions based on a *single* fluorescence channel. We describe these methods and user-friendly software[1] (MATLAB applications with graphical user interfaces) so these tools can be readily applied without an extensive knowledge of computational techniques.

INTRODUCTION

Quantitative image analysis not only provides rigor in the comparison of experimental observations but also enables the extraction of information that is not apparent to the naked eye (Danuser, 2011). This is particularly true for correlation analyses, given that biological data often exhibit high variability. Automated microscopes provide the capability to image large populations of cells on a cell by cell basis, enabling correlative studies despite heterogeneous responses across cell populations, but this capability also presents challenges for image analysis methods, as the heterogeneous responses must be imaged and characterized with minimal human intervention.

One example of such a challenge is the quantification of changes in the morphology of cells with complex geometries. Methods have been developed to characterize and classify static cell shapes (Loncaric, 1998; Sailem, Bousgouni, Cooper, & Bakal, 2014; Zhang & Lu, 2004), but modern live-cell microscopy requires us to address the quantitation and analysis of cell *dynamics*. Studying motility, immune synapse formation, tissue development, and a host of other processes requires understanding the evolution of complex shapes (Machacek et al., 2009). Here, we present a method for automated classification of cell motion types and a user-friendly tool based on this method. The method differentiates between six types of cellular motion and assigns one of the motion types to each time frame in a movie. The parameters of the method can be interactively adjusted in a graphical user interface (GUI) provided with the software. By applying this tool to many cells, one can establish the dominant modes of motion at different stages of transient cell dynamics and quantify the effects of drugs or mutations on cell morphology and motility.

Another image analysis challenge involves the segmentation of tightly packed cells, which is necessary for automated quantification of many cell behaviors. Previous studies addressed this challenge with the help of fluorescent nuclear or membrane markers (see Doncic, Eser, Atay, & Skotheim, 2013; Indhumathi, Cai, Guan, & Opas, 2011; Malpica et al., 1997; Nilsson & Heyden, 2005; Schmitt & Reetz, 2009; and references therein). However, cell behaviors of interest must frequently be detected at the same time using fluorescent probes (e.g., to track intracellular localization of proteins or movements of subcellular structures); and additional markers for segmentation may obscure the behavior of interest. In addition, fluorescence microscopy can induce significant phototoxicity (Carlton et al., 2010), and imaging larger numbers of

[1] https://dl.dropboxusercontent.com/u/7035514/GUIs_for_MCB.zip

fluorescence probes can limit either the duration of filming or the frequency with which images can be captured without undue harm to the cells. To circumvent these issues, we developed a method for *simultaneous* segmentation of tightly packed cells and quantification of protein clusters based on a *single* fluorescent marker. The method is ideal for cells with a simple geometry (such as yeast) and has the flexibility to address several questions about probe behavior. In particular, we have used the method to track the assembly, disassembly, and movements of polarity clusters in 2D or 3D. We also present the GUIs that implement this method in a user-friendly manner.

22.1 AUTOMATED CLASSIFICATION OF CELL MOTION TYPES

Cells that undergo a series of changes over time, or populations with changing proportions of cells undergoing different morphodynamics, cannot be fully characterized simply by comparing the initial and final states. Visual inspection of movies can be used to assess transient behaviors, but with such manual scoring, the transition points between different motion types are not strictly defined, results are subject to personal bias, and throughput is limited. Therefore, we have developed an automated quantification of transient cell dynamics for consistent statistical analysis of many cells. It characterizes cell dynamics at *every* time frame of movies, associating each frame with one of several possible motion types.

Here, we combine two measures of cell morphology, the rate of area change and a polarization parameter, which together can be used to characterize major types of cell dynamics. In the example here, we focus on differentiating six types of cell morphology changes typically seen in adherent cells undergoing random movement: uniform spreading, uniform shrinking, polarized spreading, polarized shrinking, polarized movement, and steady shape (nonsignificant change). The area change is used to classify motion as spreading, shrinking, or neither (constant area); and the polarization parameter is used to classify motion as uniform or polarized. Once the cell outline is determined, the first measure is simply the area difference between two time points. However, the polarization parameter can be defined in a number of different ways:

1. If the cell spreads or shrinks uniformly, its centroid does not move. Thus, the velocity of the shape centroid P_1 can serve as a measure for polarized movement. This approach works well for cells with simple shapes and significant centroid displacement from frame to frame.
2. Another way to introduce a polarization parameter, for cells with more complex geometries or with more subtle dynamics, is to identify boundary points at frame $T+dT$ that protruded (lay outside) or retracted (lay inside) the boundary at time T, where dT is the time lag parameter (Fig. 22.1A and B). The measure of how uniformly the protruding or retracting boundary points are distributed along the cell perimeter is the measure of cell polarization at a given time. The Kolmogorov–Smirnov test can be used to quantify deviation of the distribution of the protruding (or retracting) boundary points from a uniform distribution.

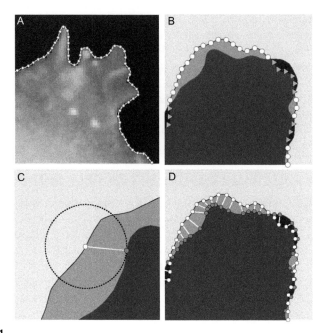

FIGURE 22.1

Boundary characterization. (A) Smooth cell boundary obtained by (1) applying a Gaussian filter to the cell binary mask, (2) building a contour (isoline) at the 0.5 level, and (3) equally distributing a specified number of points along the contour. (B) Two overlaid boundaries from time T (black) and $T+dT$ (grey). Protruding and retracting boundary points at $T+dT$ with respect to the boundary at T are marked as white circles and grey triangles, respectively. (C) The amount of protrusion is measured as a minimal distance (illustrated by dashed circle) from a boundary point at $T+dT$ to the boundary at T. (D) Displacement vectors for boundaries in B defined as illustrated in C.

We consider polarization parameters based on protruding boundary points, because our method was developed for studying proteins that are involved in regulating protrusions. However, all following definitions are directly applicable to retracting boundary points as well. Let $n=1, 2,\ldots, N$ be a numerical label of boundary points and $v(n)$ be 1 if the point n is protruding and 0 otherwise, so that $M=\sum_{n=1}^{N} v(n)$ is the total number of protruding points. Then, for the measure of uniformness, we can use

$$P_2(T) = \max_m \left| \frac{1}{N} \sum_{n=1}^{mN/M} v(n) - \frac{m}{M} \right|$$

where $m=1, 2,\ldots, M$.

3. Parameter P_2 does not take into account the amount of protrusion, but only the distribution of protruding points along the cell outline. As an alternative

approach, the polarization parameter can be defined as the length of the polarization vector formed by summation of displacement vectors of protruding boundary points, $\vec{D}(n) = [D_x(n), D_y(n)]$. However, there are two complications: (1) Simple summation of displacement vectors is dependent on cell geometry, and (2) in order to find displacement vectors, we need to establish an association between boundary points at times T and $T+dT$ (which is a nontrivial problem in general). The first problem can be resolved by mapping the arbitrary cell boundary onto a circle, so that the polarization vector is

$$\vec{P}_3(T) = \left[\sum_{n=1}^{N} |\vec{D}(n)| \cos\left(\frac{2\pi n}{N}\right) \Big/ \sum_{n=1}^{N} v(n), \sum_{n=1}^{N} |\vec{D}(n)| \sin\left(\frac{2\pi n}{N}\right) \Big/ \sum_{n=1}^{N} v(n) \right]$$

The simplest solution to the second problem is to measure the displacement as the minimal distance from the boundary points at time $T+dT$ to the boundary at time T (Fig. 22.1C and D). Alternatively, the displacement vectors could be determined, for example, by using a physical model with identical springs connecting points between the two boundaries and finding the spring distribution that minimizes the total energy (Allen, Tsygankov, Zawistowski, Elston, & Hahn, 2014; Machacek & Danuser, 2006). However, these approaches are still hard to apply to cells with highly dynamic protrusions such as filopodia. In such cases, a preprocessing step that extracts the underlying cell body might be required (Tsygankov et al., 2014).

4. Mapping the cell boundary onto a circle (Fig. 22.2), the uniformness also can be defined as the length of the vector

$$\vec{P}_4(T) = \left[\frac{\pi}{N} \sum_{n=1}^{N} v(n) \cos\left(\frac{2\pi n}{N}\right), \frac{\pi}{N} \sum_{n=1}^{N} v(n) \sin\left(\frac{2\pi n}{N}\right) \right]$$

This definition is significantly different from the definition in 2 because P_2 reaches its maximum value when there is a single protruding point on the boundary and $|\vec{P}_4|$ is largest when half of the boundary points protrude all on one side of the circle.

5. So far, we have not considered the directional persistence of the polarization. Indeed, if a polarization vector (such as \vec{P}_3 or \vec{P}_4) changes direction from one side to the opposite and back over several time frames, the cell would not move significantly even though the length of the polarization vector would remain large. Thus, the parameter for persistent polarization can be defined as the length of the vector:

$$\vec{P}_5(T) = \frac{1}{2w+1} \sum_{\tau=-w}^{w} \vec{P}_3(T+\tau) \text{ or } \vec{P}_6(T) = \frac{1}{2w+1} \sum_{\tau=-w}^{w} \vec{P}_4(T+\tau)$$

where w is the half width of the averaging window.

Using the rate of area change R_a and one of the polarization parameters above $|\vec{P}_i|$, the cell dynamics can be represented as a trajectory in the parameter

414 CHAPTER 22 Quantification of morphodynamics and protein clusters

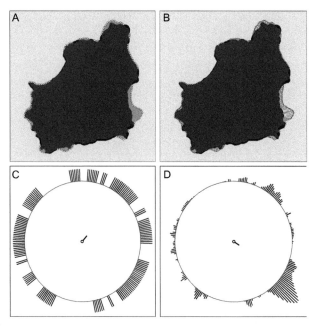

FIGURE 22.2

Illustration of polarization parameters: (A and B) two overlaid boundaries from time frame T (black) and $T+dT$ (grey). (A) Protruding boundary points are indicated by white circles. (B) Displacement vectors for protruding boundary points are shown as white lines. (C and D) Distribution of protruding boundary points from (A and B) mapped on a circle. (C) Each protruding boundary point contributes a radially directed unit vector. Polarization parameter P_4 is the length of the total vector (in the center) calculated as the sum of all radial vectors. Factor π/N scales the polarization vectors so that its maximum possible length is 1. (D) Each protruding boundary point contributes a radially directed vector with length equal to the length of the corresponding displacement vector. Polarization parameter P_3 is the length of the total vector (in the center) calculated as the sum of all radial vectors and normalized by the number of protruding points.

space $\left\{R_a, |\vec{P}_i|\right\}$. Then, choosing two critical values, R_{cr} and P_{cr}, we split the parameter space into six regimes (Fig. 22.3) corresponding to uniform spreading ($R_a \geq R_{cr}$, $|\vec{P}_i| < P_{cr}$), uniform shrinking ($R_a \leq -R_{cr}$, $|\vec{P}_i| < P_{cr}$), polarized spreading ($R_a \geq R_{cr}$, $|\vec{P}_i| \geq P_{cr}$), polarized shrinking ($R_a \leq -R_{cr}$, $|\vec{P}_i| \geq P_{cr}$), polarized movement ($-R_{cr} < R_a < R_{cr}$, $|\vec{P}_i| \geq P_{cr}$), and finally the steady shape ($-R_{cr} < R_a < R_{cr}$, $|\vec{P}| < P_{cr}$). Thus, at any time point, the cell dynamics are classified as one of the motion types according to the location in the parameter space (supplemental movie, http://dx.doi.org/10.1016/B978-0-12-420138-5.00022-7).

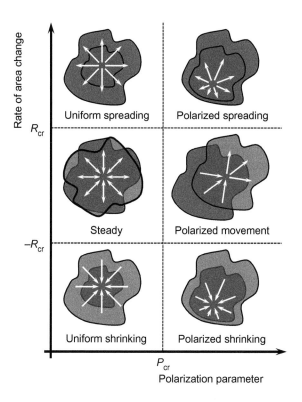

FIGURE 22.3

Illustration of different types of cell shape changes represented by different areas in the parameter space: Critical polarization parameter P_{cr} separates uniform and polarized shape changes; critical rate area change R_{cr} separates spreading, shrinking, and nonsignificant area changes. Thus, a two-parameter classification distinguishes uniform spreading, polarized spreading, uniform shrinking, polarized shrinking, polarized movement, and steady shape.

Basically, the movement of the cell is represented as a *trajectory* in parameter space, where each frame of a movie is represented as a different point in the parameter space shown in Figs. 22.3 and 22.4.

22.2 GUI FOR MORPHODYNAMICS CLASSIFICATION AND READY REPRESENTATION OF CHANGES IN CELL BEHAVIOR OVER TIME

To make our method easy to use, we built a graphical user interface, *SquigglyMorph*, which requires MATLAB, but does not require direct interaction with the code (Fig. 22.4). The GUI allows import of data as TIF stacks of cell masks. For the preprocessing step, segmenting cells and acquiring cell masks, any image processing

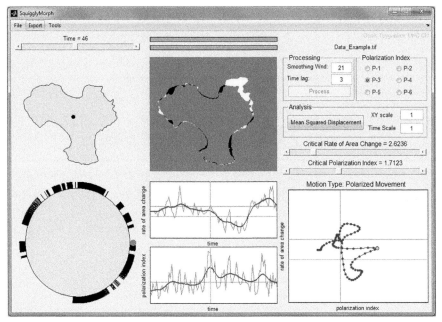

FIGURE 22.4

Screenshot of the graphical user interface, *SquigglyMorph*, for classification of cell motion types. The GUI displays cell boundary, protruding and retracting cell parts, distribution profile of protruding boundary points, rate of area change and polarization parameter as functions of time, and the morphodynamics trajectory in parameter space. The GUI also includes controls that adjust critical parameters for tuning the classification procedure.

software, such as ImageJ or MetaMorph, will work. However, for the sake of completeness, we included a simple segmentation module *MovThresh*, originally developed as a part of the *CellGeo* package for quantification of cellular protrusion dynamics (Tsygankov et al., 2014). Accurate delineation of the cell boundary is critical; the quality of our analysis is dependent on the quality of the original image and cell segmentation.

After importing a movie, *SquigglyMorph* displays the cell outline and its geometric centroid and allows for visual inspection of the cell dynamics using the time slider. Depending on the data, the user might want to adjust the time lag parameter dT and the smoothing window size W before the next processing step. The processing (initiated by the "Process" button) includes calculation of the rate of area change R_a and polarization indexes $|\vec{P}|$.

The processing activates five display windows. The first window displays protruding (white) and retracting (black) areas for every time point T with respect to time point $T+dT$. The second window shows the distribution of protruding and retracting boundary points along the boundary as being mapped onto a circle. The

red dot on the circle in window 2 corresponds to the red dot on the cell boundary in window 1. The third and fourth windows show the rate of area change and polarization index as a function of time (red) and the running average of these parameters (blue) with Gaussian smoothing window of the user-specified size W. Finally, the fifth window displays the parameter space (rate of area change vs. polarization index) and the cell dynamics represented as the trajectory through six possible parameter regimes and the corresponding motion types (as stated above the graph). The green dot (and green vertical lines in windows 3 and 4) indicates the current time point, so that users can move the time slider and visually assess the results of automated classification.

At this point, users can interactively adjust the values of the critical parameters, R_{cr} and P_{cr}, and switch between different polarization indexes, $|\vec{P}_i|$, to examine how these parameters affect results and to provide a better understanding of what factors influence the users' visual assessment of cell dynamics. Users can save the session (the current choice of parameters and the results) for later reloading if needed and also export the result to a text file.

The idea behind such a GUI design is to give users an opportunity to tune the parameters of the classification algorithm (i.e., manually train the algorithm) to a satisfactory level using several examples and then run the analysis for all cells consistently with a fixed set of parameters. This final step of batch processing is available in Tools → Batch_Processing of the main menu.

As an additional option, the "Analysis" panel allows the user to display the mean square displacement (MSD) of the cell centroid in a new figure. The default units for MSD calculation are pixel and time frame, but this can be changed by specifying the temporal and spatial scales on the right side of the panel.

Importantly, note that the blue line in the lower right-hand window represents the changing behavior of the cell over time, showing with a simple graphic representation how the cell transformed from one movement type to another during the course of the experiment. A complex behavior can be represented, stored, and analyzed based on this simple representation in 2D space.

22.3 RESULTS OF MORPHODYNAMICS CLASSIFICATION

Figure 22.5 illustrates the results of our classification method for a cell that undergoes a series of shape transformations (best seen in the supplemental movie, http://dx.doi.org/10.1016/B978-0-12-420138-5.00022-7). Every 12th frame of the movie is shown in Fig. 22.5A. The dynamic classifications are shown in Fig. 22.5B for two of the polarization measures ($|\vec{P}_5|$ and $|\vec{P}_6|$). In this figure, every time point is colored according to the type of the cell motion (cyan, uniform spreading; yellow, uniform shrinking; magenta, polarized spreading; green, polarized shrinking; blue, polarized movement; and red, no change in shape). The differences in the two measures are not surprising because the polarity measures $|\vec{P}_1|$, $|\vec{P}_3|$, and $|\vec{P}_5|$ take into account the magnitude of shape change along the boundary, while

CHAPTER 22 Quantification of morphodynamics and protein clusters

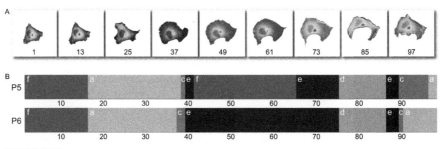

FIGURE 22.5
Analysis of cell motion types: (A) 9 time frames from a cell movie (supplemental materials, http://dx.doi.org/10.1016/B978-0-12-420138-5.00022-7). (B) Motion types as a function of time using two different polarizations parameters ($|\vec{P}_5|$ and $|\vec{P}_6|$). Motion types are labeled according to the following scheme: a (uniform spreading), b (uniform shrinking), c (polarized spreading), d (polarized shrinking), e (polarized movement), and f (steady/nonsignificant change). The differences in cell movement indicated by the classification are best seen in the movie.

polarity measures $|\vec{P}_2|$, $|\vec{P}_4|$, and $|\vec{P}_6|$ account only the distribution of the change along the boundary. Thus, when the cell spreads along the entire boundary (uniformly), but more on one side than the other, the first and the second groups classify the change as polarized and uniform spreading, respectively. Neither of these results is right or wrong, but depends on what information is most important for the study at hand. In the present case, it is our view that the classification given by parameter $|\vec{P}_6|$ corresponds most closely to visual inspection of the morphodynamics of this cell. Importantly, for any choice of $|\vec{P}_i|$, our method provides a consistent analysis of many cells using precise mathematical definitions.

22.4 GEOMETRY-BASED SEGMENTATION OF CELLS IN CLUSTERS

The human visual processing system is remarkably good at picking out cells even when they are tightly clustered, using a variety of different cues. Computational approaches to solving this "segmentation problem" also take advantage of such cues. For example, by imaging fluorescently labeled nuclei and membrane simultaneously, one can segment cells with an algorithm that uses the nucleus as a starting indicator of each individual cell and then fills the space between the nucleus and the membrane markers to recover cell shapes. Even if such labeling is not an option, segmentation can succeed by exploiting expectations about cell shape when cells have a simple geometry. For instance, Fig. 22.6A shows a cluster of cells of the budding yeast *Saccharomyces cerevisiae* expressing a fluorescent probe that concentrates at polarity sites and mother-bud necks. After thresholding, the corresponding binary

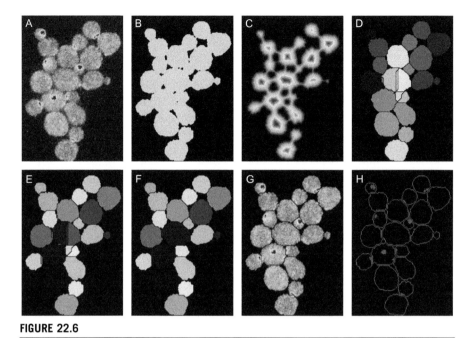

FIGURE 22.6

Segmentation of cells in clusters. (A). Original (unprocessed) image. (B) Thresholded (binary) image. (C) Distance map of the image in B. (D–F) Watershed segmentation of the distance map in (C) using the built-in MATLAB function (D), our algorithm without merging (E), and our algorithm with merging (F). Only the algorithm with merging (F) provides proper (visually expected) segmentation. (G) Original image overlaid with segmented cell masks. (H) Segmented cell outlines and internally thresholded protein clusters. (See the color plate.)

image in Fig. 22.6B lacks intensity cues for the location of cell borders, yet the human eye can readily identify the cells by relying purely on geometric cues.

The following geometry-based segmentation method enables automatic segmentation of cells in clusters that can then be tracked over time. The method includes three main steps: First, a binary image is obtained by thresholding to eliminate the extracellular background noise (Fig. 22.6B). Second, a distance map of the binary image is built so that each nonbackground pixel gets a value equal to the minimal distance from this pixel to the background. The fact that yeast cells are closed ovals (geometric cue) ensures that the distance map has local peaks at the centers of individual cells (Fig. 22.6C). Third, watershed segmentation is applied to the distance map (Fig. 22.6D–F). Because the built-in MATLAB function for watershed segmentation (*watershed*) produced unexpected cuts through some of the cells (Fig. 22.6D), we used our own implementation of the watershed algorithm. This oversegmentation problem is well known in watershed applications and typically addressed by postprocessing merging of segmented regions (Adiga & Chaudhuri, 2001; Long, Peng, & Myers, 2007; Najman & Schmitt, 1996). In contrast, in our algorithm, regions

incrementally grow starting from the local intensity maxima, so that when two regions meet, the algorithm either indicates the pixel between the regions as the border or merges the regions together, depending on whether the intensity range (max - min) in the neighboring region is larger or smaller than a given parameter, S_{cr}. For $S_{cr}=0$, the result has the same artifacts as the MATLAB's *watershed* (Fig. 22.6E); however, for $S_{cr}=1$, all the unwanted artifacts disappear and segmentation works as expected (Fig. 22.6F). In principle, the described approach does *not* require that the cells have circular or elliptical shapes as long as there are enough empty spaces (holes) in places where three or more cells come together. However, it is unlikely that cells that can assume an arbitrary shape (e.g., some mammalian cells) would systematically leave such spaces in their clusters. Thus, the method is most obviously applicable to clusters of units with simple definite shapes such as yeast cells, bacterial cells, red blood cells, or the nuclei of mammalian cells.

Because the results of the segmentation routine depend on the initial choice of the threshold value and we do not have a way to assess the quality of segmentation other than by visual inspection (Fig. 22.6A and G), our approach is to start by running segmentation for a number of threshold values within a manually specified range and then choose a threshold value H_{ref} for one of the time points T_{ref} as a reference for automatic tracking through the other frames. Let $L(T,H)$ be a numerical label of cells at time T as segmented with the threshold H. The tracking objective is to find a sequence of labels $\{L(1,H_1), L(2,H_2),\ldots, L(N,H_N)\}$ for each $L(T_{ref},H_{ref})$. In this way, two different cells at frame $T_{ref}+1$ that correspond to two different cells at (T_{ref},H_{ref}) might come from segmentation at two different threshold levels. In order to establish such correspondence, for a given cell n at (T,H), we minimize the mismatch

$$E_{n,m}^{H,H'}(T) = \sum_{x,y} |I_{n(T,H)} - I_{m(T+1,H')}|$$

over all cells m and all threshold values H' at time $T+1$, where $I_{n(T,H)}$ is the binary mask of the cell n at (T,H). The minimization procedure is repeated for every cell at the reference frame (T_{ref},H_{ref}) iteratively starting from the reference frame forward and backward in time.

Once segmentation and tracking are completed, we overlay cell masks with the original images (Fig. 22.6G) (by tracking, we mean identifying the same cell as it occurs in different frames of a movie, even when its size and position have changed over time). We can then employ internal thresholding to identify all protein clusters (connected objects) within the cells (Fig. 22.6H). Internal thresholds can be set manually or can be determined automatically as, for example, mean intensity plus 2 standard deviations from the mean. We keep track of the biggest and the second biggest spots to capture the situations when large protein clusters break up into smaller pieces. A variety of quantitative measures can then be used to describe the dynamics of protein localization. For the example of clusters of polarity factors, this can include tracking the size and integrated intensity of the cluster, the velocity or MSD of moving clusters (Dyer et al., 2013), and the coefficient of variation of total cell pixel intensity (indicative of the degree of clustering).

22.5 GUI FOR CELL SEGMENTATION AND QUANTIFICATION OF PROTEIN CLUSTERS

We implemented the aforementioned method in a two-part interface, *SegmentMe*, for cell segmentation and quantification of protein cluster dynamics in 2D projection and in 3D space for z-stack data. These GUIs are coded in MATLAB (with supplementary functions in Java) and require MATLAB installation. However, they are designed as an intuitive click-and-drag software interface.

22.5.1 GUI MODULE FOR 2D ANALYSIS

The controls in this module are separated in two blocks: a "Processing" panel and an "Analysis" panel (Fig. 22.7A). All the controls are deactivated until users import a movie as a TIF stack. If the original data exist as a collection of z-stack files for each time frame, users can use one of the available image processing tools, such as ImageJ, to create average or maximum projections from the z-stacks and then combine individual time frames into a single TIF stack.

Upon importing the movie, the processing controls become activated successively, starting with the noise reduction step that includes two types of smoothing: three-frame time averaging ("Dynamic Filter" button) and spatial averaging ("Gaussian Filter" button). For the Gaussian filter, users can specify the filter size and standard deviation. This step can be skipped if the signal-to-noise ratio is high enough. The next processing step (activated by the "Threshold" button) allows users to set the range and number of threshold values. The idea here is to choose a range, which is broad enough to ensure that there are optimal threshold values within the range for each part of the image and each frame of the movie. The tracking algorithm will scan through the different threshold values to find the best correspondence with each cell in the reference frame, as described in the previous section. Choosing a range that is too broad and/or a number of threshold values that are too large is counterproductive, because it will make the processing unnecessarily slow without any gain in the quality of segmentation. A good strategy is to use both the vertical threshold slider and the horizontal time slider to explore the thresholding effects at different time points before setting the range and the number of steps. The next step is to run segmentation ("Segment" button) and explore the results (as displayed in the bottom-right window, Fig. 22.7A) using the vertical threshold slider and the horizontal time slider to choose the reference frame ("Set Reference" button), that is, the time point and threshold value for which most of the cells are segmented accurately enough. After the reference image is set, the tracking can be initiated by clicking the "Track" button.

Upon completion of the tracking, the "Analysis" panel becomes activated. The top-left window now displays the original data before noise reduction (Fig. 22.7B). At this point, the results of segmentation and tracking can be saved either to reload later when needed or to be imported by the other module for 3D analysis. Individual cells can be accessed in two ways: A horizontal cell slider highlights cells in the order from the largest to the smallest; alternatively, activating "Cell Select" from the tool bar below the menu allows the user to drag the red target marker

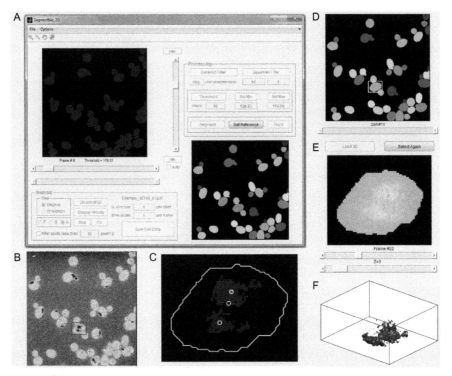

FIGURE 22.7

Screenshot of the graphical user interface, *SegmentMe*, for protein cluster quantification in 2D and 3D. A. Screenshot of the processing step in the graphical user interface, *SegmentMe*, for cell segmentation: bottom-right panel shows the result of segmentation of the binary image at the top-left panel. (B and C) Screenshots from the analysis step. (B) An interactively selected cell in the original image highlighted by a box. (C) The selected cell after segmentation, tracking, and internal thresholding. Light grey, dark grey, and black circles indicate centroids of the largest, the second largest, and all clusters, respectively. (D–F) Screenshots from the protein cluster quantification step in 3D. (D and E). An interactively selected cell (highlighted with a white box in D). (E) The transition between time frames and z-stack levels is controlled by two sliders under the cell image. (F) The panel that shows 3D spots (as isosurfaces) defined by internal thresholding (with automatically or manually chosen threshold value).

over any cell of interest; and deactivating "Cell Select" completes the selection. The highlighted cells are also displayed individually in the bottom-right corner for closer inspection (Fig. 22.7C).

To analyze the dynamics of protein clusters (intensity spots) in the selected cells, users need to switch to the "Threshold" view in the "View" panel and either activate "auto" thresholding or select a fixed threshold value using the vertical slider

(Fig. 22.7A). The automatic thresholds are calculated as the mean plus two standard deviations of the intensity values inside the cell. The size filter checkbox at the bottom of the "Analysis" panel filters out all spots smaller than the user-specified size in square pixels. Any of three different measures—the MSD of the centroid, velocity of the centroid, and spot size—can be displayed in a new figure by clicking the corresponding buttons. The GUI will display these measures for either the first (largest) spot "F," the second largest spot "S," or all the spots together "A" depending on the users' choice of corresponding radio buttons. In the bottom-right window for the individual cell view, the centroids of "F," "S," and "A" spots are marked by the red, blue, and black dots, respectively (Fig. 22.7C). The intensity coefficient of variation can be also displayed in a new figure ("CV" button). All measurements for the selected cell can be saved as a text file by clicking "Save Cell Data." It is important to specify the spatial and temporal scales before saving; otherwise, the measurements will be saved in pixel and frame units.

22.5.2 GUI MODULE FOR 3D ANALYSIS

This module requires two imports: The first is a MATLAB file (.mat) generated by the module for 2D analysis. This file contains the results of segmentation based on the 2D projection. For cells clustered on a substrate in a single-cell layer, it is sufficient to make a simple cylindrical extension of the 2D segments (i.e., apply the same masks to each z-slice) to segment cell data in 3D space. The second file that needs to be imported is a TIF file with the z-stack data for the first time frame. The other TIF files with the z-stack data for all other time frames will be imported automatically as long as they are in the same folder and named/numbered consistently.

The projected segments are displayed in the top-left window (Fig. 22.7D), and cell selection can be done with the cell slider or the "Cell Select" tool in the same manner as in the module for 2D analysis. The 3D data for the selected cell can be displayed in the top-right window by clicking the "Load 3D" button. Two sliders below the window then become active and allow the user to monitor each z-slice and time point (Fig. 22.7E). The bottom-right window is for the 3D visualization of protein clusters (intensity spots) inside the cell. The GUI generates isosurfaces for all 3D spots with intensity higher than a user-defined threshold value (Fig. 22.7F). The threshold can be specified either automatically (based on the mean plus two standard deviations intensity) using the "auto" checkbox or manually using the vertical threshold slider. Small spots can be taken out of consideration using the "Small Spot Filter" panel, where critical spot size is specified in cubic pixels.

All other controls in the GUI are analogous to the GUI for 2D analysis (Fig. 22.7A) and designed for visualization and saving various 3D measurements for dynamics of the first (largest) spot, the second largest spot, or all the spots together. To switch to another cell, the user needs to click the "Select Again" button, make a new selection, and click "Load 3D" again (Fig. 22.7E).

22.6 RESULTS FOR QUANTIFYING PROTEIN CLUSTERS

Figure 22.8 shows protein clusters identified in a cell that was segmented using our graphical user interface *SegmentMe*. In this figure, every fourth frame is shown. The top panels show the original fluorescence signal, and the bottom panels indicate the cell boundary and the detected protein clusters using an internal threshold of the mean+2 standard deviations (a 10-square-pixel filter is applied to eliminate small spots due to signal noise). In this example, the clusters are highly dynamic and undergo frequent splitting and merging events. The measurements successfully captured this behavior (Fig. 22.8B) as seen by the significant variations in the size of the largest (red lines) and the second largest (blue lines) clusters. Indeed, the ratio of the second largest cluster to the total size of all clusters fluctuates from 0 to ~0.5 throughout the movie (Fig. 22.8C). The MSD of the largest cluster (Fig. 22.8D) quickly reaches a plateau, which is characteristic for random motion within a confined area (the cell). Consistently with this behavior, the velocity of the largest spot (Fig. 22.8E) reaches values over half the cell size per frame (>25 pixel/frame).

22.7 DISCUSSION

Here, we presented quantitative methods for analysis of two very different types of cell biology problems involving cell morphology: dynamics of shape change for single cells with complex geometries and dynamics of protein clusters in tightly packed cells, taking advantage of their simple geometries to obviate the need for additional markers for segmentation.

The major issue in the first system was how to define measures of shape change that can be applied consistently across very diverse cell geometries. In general, there are a large number of geometric parameters that can be used to classify cell shapes. However, our focus here was on cell shape dynamics rather than on static shape. Therefore, for the classification of six major types of shape changes covering the typical morphodynamics of isolated motile cells, it was sufficient to use just two parameters: the rate of cell area change and polarization index, using different definitions of the polarization index as described in the preceding text. We developed a GUI that gives users an opportunity to try different polarization indexes, visualize, and assess the results with the click of a button. Interactive adjustment of critical parameters (border lines between motion types in parameter space) also provides the user with a way to examine the effects of parameter choice on analysis outcome. Importantly, once the parameter choices are made, the classification can be applied consistently to all the cells in the data set through the batch processing capabilities of the GUI.

In the second biological system, the major issue was how to correctly identify individual cells that are in contact with each other in an automated manner. Without additional segmentation probes, the solution is possible but must rely on geometric cues. Our method consists of a series of processing steps, including a modified

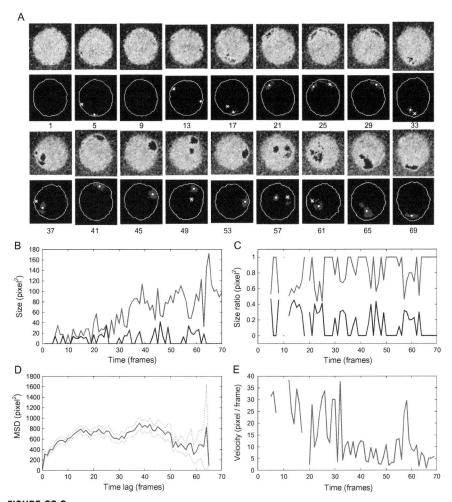

FIGURE 22.8

Analysis of protein cluster dynamics using *SegmentMe*: (A) 18 time frames of one of the cells in a movie after cell segmentation and tracking. Top panels show the original image cropped around the cell. The bottom panels show only the boundary of the cell (white) and bright spots (protein clusters). The threshold for cluster identification is found as mean intensity of all cell pixels plus two standard deviations. White dots and crosses indicate the centroids of the largest and the second largest spots, respectively. (B) The size of the largest (top curve) and the second largest (bottom curve) spots as a function of time. (C) The ratio of the largest (top curve) and the second largest (bottom curve) spots to the total size of all spots as a function of time. (D) The mean square displacement of the largest spot as function of time lag. Dotted lines indicate plus/minus standard error. (E) The velocity of the largest spot as a function of time. (See the color plate.)

watershed segmentation of the distance map. The modification that involves small region merging during watershed segmentation turned out to be critical because the traditional watershed method (e.g., as implemented in the MATLAB function *watershed*) produced unwanted cuts through some of the cells. Once again, we made the described method available as a GUI, which can be used for cell segmentation and also for quantification of protein cluster dynamics in both 2D and 3D.

Although the GUIs include a variety of quantitative measures, such as MSD or cluster size, this set might not cover all possible needs of a user. However, the output of the GUIs contains all the necessary information for further analysis that users can tailor to the specific needs of their project.

ACKNOWLEDGMENTS

We thank Michael Guarino and Ziyou Wu for their assistance in optimizing the code for faster performance. We are grateful for the funding from NIH (K. M. H.: NIGMS P01-GM103723-01; T. C. E.: NIH GM079271, NCI 200079604) and to the Army Research Office (T. C. E.) for supporting this work.

REFERENCES

Adiga, P. S. U., & Chaudhuri, B. B. (2001). An efficient method based on watershed and rule-based merging for segmentation of 3-D histo-pathological images. *Pattern Recognition*, *34*(7), 1449–1458.

Allen, R. J., Tsygankov, D., Zawistowski, J. S., Elston, T. C., & Hahn, K. M. (2014). Automated line scan analysis to quantify biosensor activity at the cell edge. *Methods*, *66*, 162–167.

Carlton, P. M., Boulanger, J., Kervrann, C., Sibarita, J. B., Salamero, J., Gordon-Messer, S., et al. (2010). Fast live simultaneous multiwavelength four-dimensional optical microscopy. *Proceedings of the National Academy of Sciences of the United States of America*, *107*(37), 16016–16022.

Danuser, G. (2011). Computer vision in cell biology. *Cell*, *147*(5), 973–978.

Doncic, A., Eser, U., Atay, O., & Skotheim, J. M. (2013). An algorithm to automate yeast segmentation and tracking. *PLoS ONE*, *8*(3).

Dyer, J. M., Savage, N. S., Jin, M., Zyla, T. R., Elston, T. C., & Lew, D. J. (2013). Tracking shallow chemical gradients by actin-driven wandering of the polarization site. *Current Biology*, *23*(1), 32–41.

Indhumathi, C., Cai, Y. Y., Guan, Y. Q., & Opas, M. (2011). An automatic segmentation algorithm for 3D cell cluster splitting using volumetric confocal images. *Journal of Microscopy*, *243*(1), 60–76.

Loncaric, S. (1998). A survey of shape analysis techniques. *Pattern Recognition*, *31*(8), 983–1001.

Long, F. H., Peng, H. C., & Myers, E. (2007). Automatic segmentation of nuclei in 3D microscopy images of C. elegans. In *2007 4th IEEE (Institute of Electrical and Electronics Engineers) international symposium on biomedical imaging: macro to nano* (Vols. 1–3, pp. 536–539). http://dx.doi.org/10.1109/ISBI.2007.356907.

Machacek, M., & Danuser, G. (2006). Morphodynamic profiling of protrusion phenotypes. *Biophysical Journal*, *90*(4), 1439–1452.

Machacek, M., Hodgson, L., Welch, C., Elliott, H., Pertz, O., Nalbant, P., et al. (2009). Coordination of Rho GTPase activities during cell protrusion. *Nature*, *461*(7260), 99–103.

Malpica, N., de Solorzano, C. O., Vaquero, J. J., Santos, A., Vallcorba, I., Garcia-Sagredo, J. M., et al. (1997). Applying watershed algorithms to the segmentation of clustered nuclei. *Cytometry*, *28*(4), 289–297.

Najman, L., & Schmitt, M. (1996). Geodesic saliency of watershed contours and hierarchical segmentation. *IEEE Transactions on Pattern Analysis and Machine Intelligence*, *18*(12), 1163–1173.

Nilsson, B., & Heyden, A. (2005). Segmentation of complex cell clusters in microscopic images: Application to bone marrow samples. *Cytometry. Part A*, *66*(1), 24–31.

Sailem, H., Bousgouni, V., Cooper, S., & Bakal, C. (2014). Cross-talk between Rho and Rac GTPases drives deterministic exploration of cellular shape space and morphological heterogeneity. *Open Biology*, *4*(1), 130132.

Schmitt, O., & Reetz, S. (2009). On the decomposition of cell clusters. *Journal of Mathematical Imaging and Vision*, *33*(1), 85–103.

Tsygankov, D., Bilancia, C. G., Vitriol, E. A., Hahn, K. M., Peifer, M., & Elston, T. C. (2014). Cell Geo: A computational platform for the analysis of shape changes in cells with complex geometries. *Journal of Cell Biology*, *204*(3), 443–460.

Zhang, D. S., & Lu, G. J. (2004). Review of shape representation and description techniques. *Pattern Recognition*, *37*(1), 1–19.

CHAPTER

Ratiometric Imaging of pH Probes

23

Bree K. Grillo-Hill, Bradley A. Webb, Diane L. Barber
Department of Cell and Tissue Biology, University of California, San Francisco, California, USA

CHAPTER OUTLINE

Introduction	430
23.1 Currently Used Ratiometric pH Probes	430
23.1.1 pH-Sensitive Ratiometric Dyes	431
23.1.1.1 Advantages, Limitations, and Caveats of Using Dyes	433
23.1.2 Genetically Encoded pH Sensors	433
23.1.2.1 Advantages, Limitations, and Caveats of Using Genetically Encoded pH Biosensors	434
23.2 Applications	435
23.2.1 Measuring pHi in Single Cells	435
23.2.1.1 General Considerations	435
23.2.1.2 Subcellular pH Measurements	436
23.2.2 Measuring pHi in Tissues	438
23.3 Protocols	438
23.3.1 Solutions	438
23.3.2 Preparation of Cultured Cells	440
23.3.2.1 Dye Loading in Cultured Cells	440
23.3.2.2 Expression of Genetically Encoded pH Biosensors in Cultured Cells	441
23.3.2.3 Dye Loading of Whole-Mount Tissue	442
23.3.2.4 Expression of Genetically Coded pH Biosensors in Genetically Tractable Organisms	442
23.3.3 Ratiometric Imaging	442
23.3.4 Generating Nigericin Calibration Curves	443
23.3.5 Ratiometric Analysis	444
Acknowledgments	445
References	445

Abstract

Measurement of intracellular pH can be readily accomplished using tools and methods described in this chapter. We present a discussion of technical considerations of various ratiometric pH-sensitive probes including dyes and genetically encoded sensors. These probes can be used to measure pH across physical scales from macroscopic whole-mount tissues down to organelles and subcellular domains. We describe protocols for loading pH-sensitive probes into single cells or tissues and discuss ratiometric image acquisition and analysis.

INTRODUCTION

Proton fluxes across cell membranes are regulated by extracellular and intracellular cues to drive many cell processes. Predominantly generated by ion exchangers, pumps, and channels, proton fluxes across the plasma membrane regulate dynamic changes in cytosolic or intracellular pH (pHi) that contribute to cell proliferation, cytoskeleton remodeling, and glycolytic metabolism (Casey, Grinstein, & Orlowski, 2010; Webb, Chimenti, Jacobson, & Barber, 2011). Proton fluxes across membranes of intracellular organelles generate pH gradients that drive vesicle trafficking and posttranslational modification and sorting of cargo proteins (Marshansky & Futai, 2008; Rivinoja, Kokkonen, Kellokumpu, & Kellokumpu, 2006; Vavassori et al., 2013). Although in normal conditions proton fluxes are homeostatically controlled to maintain pHi and organelle pH within narrow physiological ranges, dysregulated proton fluxes enable many diseases and pathologies, including cancer (Cardone, Casavola, & Reshkin, 2005; Stock & Schwab, 2009; Webb et al., 2011), neurodegenerative disorders (Harguindey, Reshkin, Orive, Arranz, & Anitua, 2007), and a number of myopathies and cardiovascular dysfunctions (Vaughan-Jones, Spitzer, & Swietach, 2009). Our current ability to measure dynamic and localized changes in pH within the cell is facilitated by new generations of pH-sensitive dyes and biosensors. In this chapter, we discuss commonly used fluorescence ratiometric probes, including their properties, uses, advantages, and limitations.

23.1 CURRENTLY USED RATIOMETRIC pH PROBES

Our ability to measure ion fluxes in real time was revolutionized in the 1980s by the development of high-affinity fluorescent Ca^{2+} dyes (Grynkiewicz, Poenie, & Tsien, 1985; Macdonald, Chen, & Mueller, 2012) and H^+ dyes (Paradiso, Tsien, & Machen, 1984; Shaner et al., 2004). The pH-sensitive polar fluorescein derivative 2′,7′-bis-(2-carboxyethyl)-5-(and-6)-carboxyfluorescein, acetoxymethyl ester (BCECF) remains the most widely used pHi indicator. However, experimental limitations imposed by pH-sensitive dyes have more recently led to the development of genetically encoded pH biosensors derived from the jellyfish *Aequorea victoria* green fluorescent

protein (GFP; Martinez et al., 2012; Miesenböck, De Angelis, & Rothman, 1998; Wilks & Slonczewski, 2007). Together, these pH-sensitive dyes and biosensors can be imaged using most standard fluorescence microscopes to measure steady-state and dynamic changes in pH within cells.

23.1.1 pH-SENSITIVE RATIOMETRIC DYES

The pH-sensitive ratiometric dyes BCECF and SNARF-5F 5-(and-6)-carboxylic acid, acetoxymethyl ester, acetate are routinely used to determine pHi in clonal cells and experimentally isolated tissues. The methyl ester moiety makes both dyes membrane-permeant but is cleaved by intracellular esterases, which trap the dyes within cells (Han & Burgess, 2010). The dual-excitation/single-emission dye BCECF has a pH-sensitive excitation at 490 nm (Em 535 nm). The pH-sensitive signal is standardized to dye abundance by pH-insensitive excitation at 440 nm. The dual-emission dye SNARF has pH-sensitive and pH-insensitive emission at 580 and 640 nm, respectively. The ratiometric measurement allows correction for dye leakage out of the cell, photobleaching, and differential dye loading between samples. The interval for optimal dye loading is dependent on cell type and ranges between 10 and 30 min at 37 °C. Of utmost importance is using the minimum dye concentration sufficient for obtaining a fluorescent signal because high dye concentrations can aberrantly sequester protons. In our experience with BCECF, loading 1 µM for 15 min is optimal, with the fluorescent signal lasting ~90 min. For SNARF, we generally use between 2 and 5 µM.

We routinely use SNARF to measure pHi in Chinese hamster lung fibroblasts (ATCC and CCL-39) (Fig. 23.1). In addition to measuring steady-state pH, we also measure the rates of proton efflux by using the NH_4^+ prepulse technique (Boron & De Weer, 1976). Cells incubated with 30 mM NH_4Cl buffer for 5 min have an initial increase in pHi as NH_3 enters the cells and complexes with protons (not shown) until a plateau pHi value is reached (Fig. 23.1, #1). Removing external NH_4Cl causes the pHi to rapidly decrease as NH_3 exits the cell, trapping the protons inside (Fig. 23.1, #2). This acid-loading approach allows measuring the rate of pHi recovery until a plateau is reached (Fig. 23.1, #3) as an index of the activity of ion transport proteins. With corrections for buffering capacity, the flux of proton equivalents can be calculated (Boron & De Weer, 1976). Changes in the rate of pHi recovery can be used to determine the regulation of ion transporter activity, including by growth factors, oncogenes, and extracellular osmolarity. For example, platelet-derived growth factor increases the activity of the plasma membrane Na^+/H^+ exchanger NHE1, as determined by increased pHi recoveries measured in a nominally HCO_3^--free HEPES buffer that prevents the activity of anion exchangers (Meima, Webb, Witkowska, & Barber, 2009). Fluorescence intensities are used to determine ratios that are converted to pH values using a nigericin calibration. Following pH measurement, cells are incubated in a Na^+-free, K^+ buffer containing the ionophore nigericin to equilibrate intracellular and extracellular pH (Thomas, Buchsbaum, Zimniak,

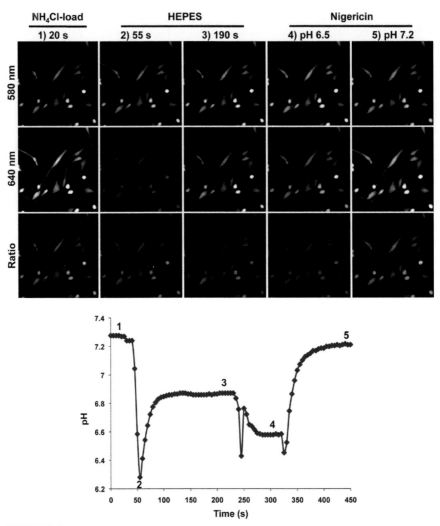

FIGURE 23.1

Using SNARF in CCL-39 fibroblasts to measure pHi recovery from an acid load. Top: Images of SNARF-loaded fibroblasts show the pH-sensitive (580 nm) and pH-insensitive (640 nm) channels and the 580 nm/640 nm ratio. Bottom: Plot of pH versus time calculated from the average 580 nm/640 nm ratio from 10 cells normalized to nigericin buffers of known pH values. See text for details.

& Racker, 1979). The fluorescence ratios obtained with sequential incubations in nigericin-containing buffer adjusted to known pH values are used to generate a calibration curve. Fluorescence ratios with nigericin are generally linear between pH 6.5 and 7.8; hence, we often use a two-point calibration (Fig. 23.1, #4 and #5).

23.1.1.1 Advantages, limitations, and caveats of using dyes

The BCECF and SNARF dyes are easy to use with clonal cells in culture because they do not require transfection or genetic modification to generate new cell lines. They have also been used successfully in some whole-mount tissues (Adams, Tseng, & Levin, 2013; Rossano, Chouhan, & Macleod, 2013). With a pK_a of ~7.0 for BCECF and ~7.5 for SNARF, these dyes are most suitable for measuring cytosolic pH and less effective for measuring pH of acidic intracellular organelles. As described in the preceding text, cleavage of the methyl ester of the AM forms of these dyes is dependent on the activity of intracellular esterases, which can lead to dye accumulation in organelles with high esterase activity. For example, BCECF–AM cannot be used to measure cytosolic pH in the yeast *Saccharomyces cerevisiae* because it accumulates in the yeast vacuole instead of the cytosol, in contrast to cytosolic accumulation in mammalian cells (Plant, Manolson, Grinstein, & Demaurex, 1999). For yeast cells, the genetically encoded pH sensor pHluorin, described in the succeeding text, is more effective for measuring pHi (Brett, Tukaye, Mukherjee, & Rao, 2005). One caveat in mammalian cells is heterogeneous dye uptake (Fig. 23.1). This underscores the importance of including nigericin calibrations with each experiment because dissimilar ratios can reflect variable dye levels rather than actual differences in pHi. Uneven dye loading is a significant problem in some whole-mount tissues, where genetically encoded pH biosensors may be a better approach (see Fig. 23.4). A minimum fluorescence intensity cutoff should be established before ratiometric analysis because ratios will vary significantly as the signal intensity decreases toward the threshold of detection. Metabolism of the dyes, leakage out of the cell, and photobleaching will all decrease the fluorescence intensity over time. Hence, dyes are optimally used for shorter-term measurements of <60 min.

23.1.2 GENETICALLY ENCODED pH SENSORS

Although GFP is pH-sensitive, its pK_a of <6.0 makes it unsuitable for measuring physiological pH in the cytosol and some subcellular compartments and organelles. Two different variants of GFP were first generated by the Rothman laboratory (Miesenböck et al., 1998). Ratiometric pHluorin has a pK_a of ~7.2. Like ratiometric dyes, pHluorin has pH-sensitive fluorescence (410 nm excitation, 510 nm emission) with increased intensity at higher pH and pH-insensitive fluorescence at the isosbestic excitation at 470 nm that can be used to normalize to biosensor abundance. Ecliptic pHluorin has a pK_a of ~7.1 and fluorescence also increases with increasing pH at 410 nm excitation; however, its emission spectrum does not have an isosbestic point to normalize intensity to protein abundance. In more recent studies, this limitation has been addressed by fusing ecliptic pHluorin and pH-insensitive mCherry (Koivusalo et al., 2010). This construct is easy to use with most fluorescence microscopes because ratiometric images can be obtained with GFP and mCherry filter sets, while filter sets for ratiometric pHluorin are distinct. pHluorin constructs have been used to measure pH in the cytosol, at the cell membrane, and in subcellular compartments, including neuronal synapses, the trans-Golgi network, and endosomes

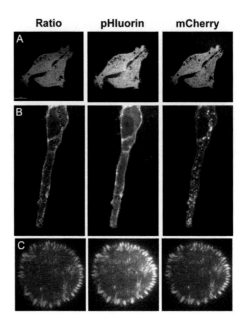

FIGURE 23.2

Targeting mCherry–pHluorin to different subcellular locations allows for the determination of spatially distinct pH. (A) Confocal micrograph of MTLn3 rat mammary adenocarcinoma cells expressing soluble mCherry–pHluorin measured the pH of the cytosol. (B) Confocal micrograph of Madin–Darby canine kidney (MDCK) cells grown in 3D cysts and induced with HGF to form extensions and expressing myristoylated mCherry–pHluorin, which targets the pH sensor to the plasma membrane. Puncta that show mCherry but not pHluorin fluorescence are visible, and these are seen in all cell and tissue samples expressing this pH biosensor. (C) Images of mouse embryonic fibroblast expressing focal adhesion targeting paxillin mCherry–pHluorin imaged by TIRF microscopy. (See the color plate.)

(Fig. 23.2). For additional information, several excellent reviews describe the use of genetically encoded fluorescent pH sensors (Ashby, Ibaraki, & Henley, 2004; Benčina, 2013; Han & Burgess, 2010; Pinton, Rimessi, Romagnoli, Prandini, & Rizzuto, 2007).

23.1.2.1 Advantages, limitations, and caveats of using genetically encoded pH biosensors

Genetically encoded biosensors have several major advantages. Expression is regulated and hence more homogenous compared with uneven loading of dyes within a cell population. Targeting to specific intracellular locations or subcellular compartments can be achieved, as we show with a paxillin–pHluorin–mCherry construct that localizes to cell-substrate focal adhesions (Fig. 23.2). Additionally, continuous expression of the biosensor allows for live-imaging experiments over a longer timescale than is possible using dyes. Although not currently exploited, whole-animal or tissue-specific expression could be used to image pHi dynamics during

development or disease progression. One caveat of ratiometric imaging is edge artifacts that can be caused by cell movement between taking the two images (Fig. 23.2A). In addition, uneven illumination that is different between the two channels will generate artificial gradients in the ratio image. Thus, ideally, a flat-field correction should be applied to normalize for uneven excitation. In addition to these microscopy-induced artifacts, fluorescent protein properties may also give rise to misinterpretation. For example, accumulations of mCherry-positive, pHluorin-negative punctae in the cytoplasm of cells and tissue (Fig. 23.2B) may be aggregates of misfolded protein or represent protein in endosomes or lysosomes where a lower pH would quench pHluorin fluorescence. For the mCherry–pHluorin fusion protein, maturation rates of mCherry (\sim155 min) are slower than pHluorin (GFP, \sim15 min) (Macdonald et al., 2012). Therefore, temporally regulated expression constructs may show increased ratio as a consequence of immature mCherry. Similarly, without appropriate correction, different rates of photobleaching will result in artificial ratio changes over time. For example, a total laser exposure time of 108 s results in significant photobleaching of a whole-mount *Drosophila* larval eye imaginal disk. This issue is further complicated when performing ratiometric imaging using mCherry–pHluorin, as the two fluorescent moieties show different rates of photobleaching resulting in an apparent change in pHi over time (Fig. 23.3). This underscores the importance of minimizing exposure of biological samples to light, especially epifluorescence. Several of these limitations can be corrected by calibrating fluorescence ratios to pH, as described earlier in the text with nigericin. Nigericin should equilibrate pH across the entire cell or tissue removing any biological pH gradients, while ratio differences attributable to imaging artifacts will remain. Different fluorescence ratios do not necessarily reflect different pH values and data should never be expressed as fluorescent signal intensity or uncalibrated ratios.

23.2 APPLICATIONS
23.2.1 MEASURING pHi IN SINGLE CELLS
23.2.1.1 General considerations
When selecting an appropriate pH indicator, several factors should be considered. What is the duration of the experiment? While dyes are easy to use, they are lost from the cell or degraded generally within an hour and are not suitable for long-term experiments. Is the objective to measure pH within the cytosol or within subcellular organelles? Dyes are most commonly used to determine pH of the cytoplasm and are difficult to compartmentalize. Genetically encoded sensors can be modified with targeting sequences to localize to distinct intracellular compartments. The pH of the region of interest (ROI) should be close to the pK_a of the fluorophore to ensure a maximum dynamic range. For example, the pH of the mitochondrial matrix is slightly basic (pH \sim7.8), whereas the pH of lysosomes is highly acidic (pH \sim4.8). Hence, pK_a values should be considered to choose an indicator that titrates within the pH range of the desired cellular compartment.

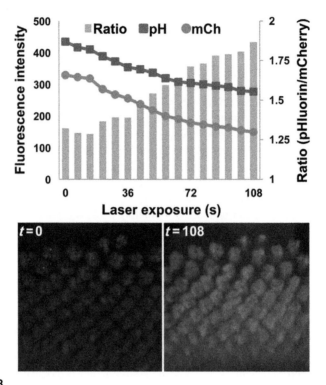

FIGURE 23.3

Increase of mCherry-pHluorin fluorescence ratio due to different photobleaching rates. Tissue was imaged every 5 s (300 ms exposure) over 30 min for a total laser exposure of 108 s. Following background subtraction, fluorescence intensity was measured at five regions and averaged. Absolute fluorescence intensity values (green squares for pHluorin and red circles for mCherry) after background subtraction decrease at different rates. Ratios are plotted on a secondary Y-axis were generated by dividing pHluorin by mCherry fluorescence values and appear to increase over time due to slower photobleaching of pHluorin compared with mCherry. This is consistent with reported photobleaching rates for GFP (t1/2 1/4115 s) and mCherry (t1/2 1/468 s) (Shaner et al., 2004). One important consequence of photobleaching is that the measured ratio in *Drosophila* eye imaginal disks appears to increase over time (bars and images).

23.2.1.2 Subcellular pH Measurements

As described earlier in the text, the pH of different organelles in the cell maintains distinct pH values, which is required to maintain specific biological processes. The intrinsic buffering capacity protects cellular compartments from rapid changes in pH while pH homeostasis is maintained by the coordinated activity of ion transporters, channels, and pumps. The narrow pH range of the cytosol allows for the optimal activity, stability, structure, and interactions of cytoplasmic macromolecules. The activity of select regulatory proteins, especially enzymes, is sensitive to small physiological changes in pH (Schönichen, Webb, Jacobson, & Barber, 2013), which

should be considered. In general, cytoplasmic pH in most organisms from bacteria (Martinez et al., 2012; Wilks & Slonczewski, 2007) to yeasts (Bagar, Altenbach, Read, & Bencina, 2009; Grynkiewicz et al., 1985) to mammalian cells (Fig. 23.1) is slightly basic (pH is ~7.0–7.8), with the exception of some acidophilic or basophilic bacteria (Paradiso et al., 1984; Slonczewski, Fujisawa, Dopson, & Krulwich, 2009). In contrast, the pH of lysosomes is acidic. Intraorganelle pH gradients are particularly important in the mitochondria. The mitochondria generate ATP by electron transport across the inner membrane coupled to chemiosmotic H^+ translocation from the inner membrane space to the matrix through the ATP synthase. The use of dyes to measure the pH of the mitochondrial matrix or inner membrane space in cells is limited by the inability to separate the mitochondria-specific signal from that of the cytoplasmic background (Chacon et al., 1994; Miesenböck et al., 1998; Porcelli et al., 2005). The development of genetically encoded pH-sensitive fluorescent proteins targeted to the mitochondrial matrix and inner membrane space allows determining mitochondrial pH gradients (Boron & De Weer, 1976; De Michele, Carimi, & Frommer, 2014; Pinton et al., 2007); the pH of the mitochondrial matrix is ~7.78 while the intermembrane space is ~6.88 (Porcelli et al., 2005; Thomas et al., 1979). Further, spontaneous, transient increases in pHi in the mitochondrial matrix, termed "flashes," have been recently observed and likely reflect changes in proton pump activity and the transmembrane H^+ gradient (Han & Burgess, 2010; Schwarzländer, Logan, Fricker, & Sweetlove, 2011; Schwarzländer et al., 2012).

The pH sensitivity of pHluorin has been widely used to determine real-time synaptic vesicle fusion events and endocytosis. When fused to vesicle-specific proteins such as synaptobrevin (Miesenböck et al., 1998), synaptophysin (Granseth, Odermatt, Royle, & Lagnado, 2006), and synaptotagmin (Diril, Wienisch, Jung, Klingauf, & Haucke, 2006), pHluorin localizes to the interior of synaptic vesicles and fluorescence is quenched by low pH (~5.5). With fusion of vesicle and plasma membranes, the pHluorin fluorescent signal rapidly increases. The pHluorin signal decreases again as endocytosis and vesicle acidification occur. This experimental strategy has revealed the kinetics and retrieval of vesicle dynamics (Granseth et al., 2006), vesicle fusion events in motor neurons in *Drosophila* larvae (Denker et al., 2011), and endocytosis *in situ* (Poskanzer, Marek, Sweeney, & Davis, 2003).

pH gradients within the same compartment have also been determined. For example, increased cytosolic pH and decreased extracellular pH at the leading edge of migrating cells are evolutionarily conserved signals necessary for directed cell migration. Experiments using BCECF and SNARF demonstrate that increased pHi promotes *de novo* actin polymerization in a variety of organisms including sea urchin eggs (Begg & Rebhun, 1979), the slime mold *Dictyostelium discoideum* (Patel & Barber, 2005; Plant et al., 1999; Van Duijn & Inouye, 1991), and mammalian cells (Denker & Barber, 2002). More recently, the use of TIRF microscopy using BCECF (Brett et al., 2005; Ludwig, Schwab, & Stock, 2013) and paxillin–mCherry–pHluorin (Fig. 23.2C; Choi, Webb, Chimenti, Jacobson, & Barber, 2013; Miesenböck et al., 1998) reveals an increase of focal adhesion pH during cell migration of mammalian cells. Further, targeting mCherry–pHluorin to the membrane by fusing the probe to

the membrane-targeting sequence of Lyn demonstrated that changes in pH during macropinocytic lamellipodia extension are more profound in the immediate vicinity of the membrane (Koivusalo et al., 2010).

23.2.2 MEASURING pHi IN TISSUES

Early techniques to measure pHi in whole-mount tissues used disruptive patch clamp techniques to monitor electric currents that result from ion exchange across biological membranes. More recently, PET imaging using radiolabeled probes has allowed for estimation of pHi; however, these measurements are imprecise because they rely on stable distribution of the probe that cannot be independently determined. Similar MRI-based techniques show low sensitivity (Miesenböck et al., 1998; Zhang, Lin, & Gillies, 2010). However, with the advent of fluorescent pH probes and quantitative confocal microscopy, it is now possible to accurately measure pHi in whole-mount tissues and *in situ*. Genetically encoded ratiometric pHluorin has been used to determine pHi in intestinal tissue of whole-mount *Caenorhabditis elegans*, where RNAi targeting the Na^+/H^+ exchanger *nhx-2* decreased pHi to ~7.23 compared with ~7.53 in control animals (Granseth et al., 2006; Nehrke, 2003). Also in *C. elegans*, genetically encoded pHluorin was used to measure pHi in the intestine (*nhx-2*, ~7.40), neurons (*cah-4a*, ~7.52), and body wall muscle (*myo-3*, ~7.49) (Diril et al., 2006; Johnson & Nehrke, 2010). BCECF and SNARF were used to measure pHi in *Xenopus* tadpoles (Adams et al., 2013). BCECF and both ratiometric and ecliptic pHluorins were used in *Drosophila* larvae to show that cytoplasmic pHi in motor nerve termini locally decreases with electric stimulation compared with resting conditions (Granseth et al., 2006; Rossano et al., 2013). We have measured pHi in dissected whole-mount tissue from *Drosophila*, including third larval instar imaginal disks and brain, pupal eyes, and wings and adult eyes (Fig. 23.4). We found uneven loading of pH-sensitive dyes, but using transgenic lines expressing UAS–mCherry–pHluorin under the ubiquitous tubulin–GAL4 driver, we obtained fairly homogeneous expression with robust signals amenable to calibration.

23.3 PROTOCOLS
23.3.1 SOLUTIONS

HEPES buffer
 25 mM HEPES
 140 mM NaCl
 5 mM KCl
 10 mM glucose
 1 mM $MgSO_4$
 2 mM $CaCl_2$

Note: pH to 7.4, adjust to volume and add $CaCl_2$ last after bringing almost to volume.

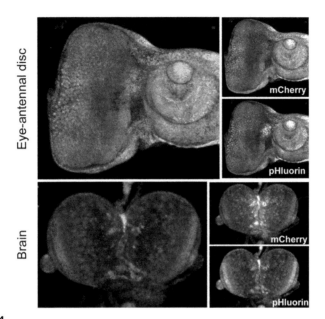

FIGURE 23.4

Determining pHi in whole-mount *Drosophila* tissues using genetically encoded mCherry–pHluorin biosensor. The ubiquitously expressed tubulin–GAL4 driver (Bloomington *Drosophila* Stock Center, # 5138) was used to drive the expression of UAS–mCherry–pHluorin. Tissues were dissected from third instar larvae into HCO_3 buffer and immediately imaged as described in the succeeding text. Ratio images were generated after background subtraction by dividing the fluorescence intensity of the pHluorin signal by the mCherry signal. Eye–antennal imaginal disk (top) and brain show differences in ratio across the tissues. (See the color plate.)

HCO_3 buffer
- 25 mM $NaHCO_3$
- 115 mM NaCl
- 5 mM KCl
- 10 mM glucose
- 1 mM KPO_4 pH 7.4
- 1 mM $MgSO_4$
- 2 mM $CaCl_2$

Note: pH to 7.4, adjust to volume and add $CaCl_2$ last after bringing almost to volume.

NH_4Cl buffer
- 30 mM HEPES
- 145 mM NaCl
- 30 mM NH_4Cl
- 5 mM KCl

10 mM glucose
1 mM KPO$_4$ pH 7.4
1 mM MgSO$_4$
2 mM CaCl$_2$

Note: pH to 7.4, adjust to volume and add CaCl$_2$ after bringing almost to volume.

Nigericin buffer
25 mM HEPES
105 mM KCl
1 mM MgCl$_2$
Add nigericin to 10 µM (stock is 10 mM in DMSO)
pH with KOH to desired pH points (6.5, 7.0, and 7.5)

Reconstitute 50 µg (one vial with special packaging) BCECF or SNARF (B-1170 and C-1272, Invitrogen) in DMSO to 1 mM. Dilute to working concentrations as indicated in protocols in the succeeding text.

For imaging cells and whole-mount tissues on inverted microscopes, we use 35 mm MatTek glass-bottomed dishes (uncoated, 1.5 mm cover glass; MatTek catalog number P35G-0.170-14-C).

23.3.2 PREPARATION OF CULTURED CELLS

Protocols will vary depending on the cell line being used and optimal conditions must be empirically determined. We describe later in the text a protocol we routinely use for CCL-39 fibroblasts (Fig. 23.1). Fibroblast stocks maintained in growth medium are trypsinized and replated into MatTek imaging dishes 48–72 h before pH measurements. To achieve quiescence, 24 h before use, cells are washed with PBS and maintained in medium with minimal FBS, generally 0.2%. For using dyes, we load cells with 1–5 µM dye for 15 min before use, followed by multiple washes with HCO$_3$ buffer used for measuring pH. It is important to note that to measure physiological pHi, HCO$_3$ and not HEPES buffer must be used. For experiments with genetically encoded biosensors, we transfect cells before or after plating in MatTek dishes.

23.3.2.1 Dye loading in cultured cells

Materials required
HEPES buffer
HCO$_3$ buffer
Nigericin buffers of at least 2 known pH values
NH$_4$Cl buffer
1 µM BCECF working solution in either tissue culture media without FBS or HCO$_3$ buffer
Warm solutions to 37 °C prior to the experiment:
(1) Remove culture media from cells.
(2) Wash cells twice with HEPES buffer.

(3) Add 1 ml 1 µM BCECF in HCO_3 buffer to cells. Incubate for 30 min in a 37 °C incubator with 5% CO_2/95% air.
(4) Wash cells twice with HCO_3 buffer. Incubate for 30 min in HCO_3 buffer in a 37 °C incubator to allow for the removal of nonhydrolyzed BCECF from the cells.
(5) After 30 min has elapsed, proceed to imaging the dish as described in the succeeding text.

23.3.2.2 Expression of genetically encoded pH biosensors in cultured cells

There are several methods to express genetically encoded pH biosensors in cells. The easiest method is to transfect the cells with plasmids expressing the biosensor using commercially available transfection reagents. We describe one such protocol later in the text using FuGENE HD to express mCherry–pHluorin in cells 48 h before imaging. Optimal conditions for each cell line and transfection reagent must be empirically determined. Cells that are highly proliferative, such as some cancer cell lines, may need to be transfected in a cell culture dish to drive biosensor expression and repassaged into imaging dishes prior to performing the experiment. For cell lines that are difficult to transfect, an alternative to transfection is to generate a virally encoded biosensor.

Materials required
- PBS solution
- Tissue culture media supplemented with Pen/Strep (basic media)
- Tissue culture media supplemented with FBS and Pen/Strep (complete media)
- FuGENE HD (Promega, catalog number E2311)
- Plasmid encoding a genetically encoded pH biosensor, such as mCherry–pHluorin (Denker et al., 2011; Koivusalo et al., 2010)
- Polypropylene round-bottom tube, 5 ml (Falcon, catalog number 352063)
- Warm media to 37 °C in a water bath before use.
- Warm FuGENE HD to room temperature and vortex before use.
- Cells plated on a MatTek dish, approximately 50–60% confluent at the time of transfection.
- The protocol is sufficient to transfect three 35 mm MatTek dishes:
 (1) For each transfection, add 300 µl of basic media a polypropylene tube.
 (2) Pipette 2 µg plasmid DNA and 8 µl FuGENE HD to the tube.
 (3) Incubate for 15 min at room temperature to complex the DNA.
 (4) Remove culture media from cells.
 (5) Wash twice with 2 ml PBS.
 (6) Add 2 ml fresh complete media and return to the 37 °C incubator.
 (7) After 15 min incubation, add 100 µl of FuGENE HD/DNA mixture to each MatTek dish. Mix by gently swirling the dish. Return cells to the incubator for 24–48 h.
 (8) After 24–48 h, proceed to imaging the dish as described in the succeeding text.

23.3.2.3 Dye loading of whole-mount tissue

We have had variable success dissecting whole tissues and incubating in pH-sensitive dyes. Some tissues showed uneven dye uptake, which made calibration or comparison between samples impossible. Other tissues showed poor dye uptake, such that there was insufficient signal for microscopic detection. Here, altering dye concentration between 5 and 50 μM and increasing incubation up to 60 min may improve signal strength; however, with increased incubation time, tissues will have a relatively shorter viability for imaging and pH calibration.

Materials required
- HCO_3 buffer
- Nigericin buffers of known pH values
- 10 μM BCECF working solution in HCO_3 buffer

Dissection tools
- MatTek dish

(1) Perform dissections of tissue into HCO_3 buffer.
(2) Incubate in 10 μM BCECF in HCO_3 buffer for 30 min in the dark.
(3) Wash tissue twice for 10 min each in HCO_3 buffer.
(4) Mount tissue in MatTek dishes for imaging in HCO_3 buffer. If tissue does not adhere well to the glass bottom, mount in a drop of HCO_3 buffer, and add a coverslip on top to minimize tissue movement after mounting. The coverslip may be secured with nail polish. However, do leave an area open to facilitate buffer exchange for pH calibration step.

23.3.2.4 Expression of genetically coded pH biosensors in genetically tractable organisms

Determination of tissue can be accomplished by using either genetically encoded pH biosensors, such as mCherry–pHluorin. These can be expressed using standard methods for the organism, such as the inducible bipartite GAL4–UAS system in *Drosophila* or as a direct promoter fusion in *C. elegans*:

(1) Perform dissections of tissue into HCO_3 buffer.
(2) Mount tissue in MatTek dishes for imaging in HCO_3 buffer. If tissue does not adhere well to the glass bottom, mount in a drop of HCO_3 buffer, and add a coverslip on top to minimize tissue movement after mounting. The coverslip may be secured with nail polish. However, do leave an area open to facilitate buffer exchange for pH calibration step.

23.3.3 RATIOMETRIC IMAGING

For our analyses, we used an inverted, spinning disk confocal microscope system that was built for live-cell imaging (Poskanzer et al., 2003; Stehbens, Pemble, Murrow, & Wittmann, 2012). For imaging mammalian cells, it is important to have temperature control and to have a constant CO_2 gas supply to support pH homeostasis for the

duration of the experiment. *Drosophila* and *C. elegans* tissue imaging should be performed at ambient temperature.

Acquisition settings should be empirically determined and with the following criteria in mind. First, exposure settings should be as low as possible to prevent photobleaching of samples. Single-fluor sensors (such as BCECF, SNARF, or ratiometric pHluorin) exhibit photobleaching over time, and extended imaging of pH homeostasis may preclude acquisition of accurate calibration curves. Dual-fluor pH sensors (e.g., mCherry–pHluorin) show differential rates of photobleaching (Fig. 23.4). Live-cell TIRF microscopy was performed as described previously (Rossano et al., 2013; Stehbens et al., 2012). Superecliptic pHluorin and mCherry signals were measured using 488 and 561 nm laser illumination, respectively. An initial experiment should be performed to ensure no photobleaching of the two channels occurs. In our hands, TIRF microscopy minimizes the amount of photobleaching observed and signals are stable for hours. At the end of the experiment, a nigericin calibration was performed to normalize pHi values as described later in the text.

23.3.4 GENERATING NIGERICIN CALIBRATION CURVES

Ratiometric pH data are achieved through calibration with a protonophore such as nigericin (Invitrogen, cat # N1495), which equilibrates pHi to buffer pH. By incubating the cell or tissue samples with a nigericin-containing buffer of predetermined pH, ratios can be calibrated to a known pH and a line generated to fit the data across two or three different pH points. It is important to use pH values for calibration that fall within the linear range of the pH sensor (Table 23.1).

Table 23.1 Ratiometric pH Probes for Determining Intracellular pH

Ratiometric pH-sensitive dyes	pH-sensitive wavelength (nm)		pH-insensitive wavelength (nm)		pH range (pK_a)
	Ex	Em	Ex	Em	
BCECF	490	535	440	535	6.4–7.8 (6.98)
SNARF	514	580	514	640	7.0–8.0 (7.5)

Genetically encoded pH biosensors	pH-sensitive wavelength (nm)		pH-insensitive wavelength (nm)		pH range (pK_a)
	Ex	Em	Ex	Em	
Ratiometric pHluorin	410	510	470	535	5.5–7.5 (7.2)
Ecliptic pHluorin	n/a	n/a	475	535	6.0–7.5 (7.1)
mCherry			587	610	(<4.5)

While some groups have used a standard curve to calculate pH data across experiments, we find that it is essential for accuracy and reproducibility to image controls, experimental conditions, and nigericin calibrations on the same day.

Tissues are more susceptible to death upon prolonged nigericin exposure, and severe morphological changes and tissues can disintegrate and make it difficult to generate calibration data for specific regions in tissue. Therefore, we recommend limiting the total time for nigericin incubations of tissues to 30 min.

Protocol
(1) Aspirate buffer and replace with nigericin buffer. Incubate cells for 10 min and tissue samples for 15–30 min.
(2) Image the samples using identical acquisition setting as determined earlier in the text.
(3) Aspirate and replace nigericin buffer. For subsequent buffers, an incubation time of 5 min is usually sufficient.
(4) Repeat as in the preceding text for the remaining calibration point.

23.3.5 RATIOMETRIC ANALYSIS

We perform our ratiometric analysis using the NIS-Elements software to subtract background and extract pixel intensity values and subsequently perform calculations in Microsoft Excel:

(1) Open images in image analysis program. If they are not already, put images from the same sample into a single file to facilitate ROI selection. Select a ROI encompassing only background, and perform background subtraction.
(2) Draw additional ROIs to select samples to calculate pixel intensities. Where appropriate, we often draw a circle and copy and paste to select multiple ROI. Alternately, tracing individual cell features (such as focal adhesions; Choi et al., 2013; Macdonald et al., 2012) may need to be accomplished by hand. When measuring individual cells, we typically select 20–30 cells using individual ROIs, while for tissue measurements, we select 3–5 ROIs per piece of tissue. It is also good to include a background ROI to confirm subtraction.
(3) Export average pixel intensities per ROI from both images into Excel or similar spreadsheet program.
(4) Calculate ratios by dividing the pixel intensity from the pH-sensitive wavelength (e.g., pHluorin) by the pixel intensity from the pH-insensitive wavelength (e.g., mCherry).
(5) Calculate standard curves from nigericin experiments to derive a standard line equation $y = mx + b$. Here, pH values of nigericin buffers will be the y-values, and ratios are the x-values. Solve for the slope and y-intercept.
(6) Take calculated ratios from experimental and control images, and solve the equation for pH value using values calculated previously in the text. Calculated pHi values can be analyzed using appropriate statistical tests.
(7) Images of pH-sensitive to pH-insensitive ratios are pseudocolored with appropriate lookup table (LUT). We use the Rainbow RGB LUT. The scale

should be calibrated using ratios calculated from the nigericin curve. A scale bar labeled with appropriate pH values should be included in the final image. The same scale should be used for all experiments to facilitate comparison across samples.
(8) It is also recommended to include single-channel black and white images for each channel. These images should have the same contrast settings to preserve the difference in signal that reflects different pHi across the sample.

ACKNOWLEDGMENTS
We thank S. Gierke and C. H. Choi for contributions to Fig. 23.2. This work was supported by NIH R01 GM047413, UCSF Academic Senate Grant and University of California Cancer Research Coordinating Committee Award.

REFERENCES
Adams, D. S., Tseng, A. S., & Levin, M. (2013). Light-activation of the Archaerhodopsin H^+-pump reverses age-dependent loss of vertebrate regeneration: Sparking system-level controls in vivo. *Biology Open*, *2*(3), 306–313. http://dx.doi.org/10.1242/bio.20133665.
Ashby, M. C., Ibaraki, K., & Henley, J. M. (2004). It's green outside: Tracking cell surface proteins with pH-sensitive GFP. *Trends in Neurosciences*, *27*(5), 257–261. http://dx.doi.org/10.1016/j.tins.2004.03.010.
Bagar, T., Altenbach, K., Read, N. D., & Bencina, M. (2009). Live-cell imaging and measurement of intracellular pH in filamentous fungi using a genetically encoded ratiometric probe. *Eukaryotic Cell*, *8*(5), 703–712. http://dx.doi.org/10.1128/EC.00333-08.
Begg, D. A., & Rebhun, L. I. (1979). pH regulates the polymerization of actin in the sea urchin egg cortex. *The Journal of Cell Biology*, *83*(1), 241–248.
Benčina, M. (2013). Illumination of the spatial order of intracellular pH by genetically encoded pH-sensitive sensors. *Sensors (Basel)*, *13*(12), 16736–16758. http://dx.doi.org/10.3390/s131216736.
Boron, W. F., & De Weer, P. (1976). Intracellular pH transients in squid giant axons caused by CO_2, NH_3, and metabolic inhibitors. *The Journal of General Physiology*, *67*(1), 91–112, Retrieved from: http://eutils.ncbi.nlm.nih.gov/entrez/eutils/elink.fcgi?dbfrom=pubmed&id=1460&retmode=ref&cmd=prlinks.
Brett, C. L., Tukaye, D. N., Mukherjee, S., & Rao, R. (2005). The yeast endosomal Na+K+/H+ exchanger Nhx1 regulates cellular pH to control vesicle trafficking. *Molecular Biology of the Cell*, *16*(3), 1396–1405. http://dx.doi.org/10.1091/mbc.E04-11-0999.
Cardone, R. A., Casavola, V., & Reshkin, S. J. (2005). The role of disturbed pH dynamics and the Na+/H+ exchanger in metastasis. *Nature Reviews. Cancer*, *5*(10), 786–795. http://dx.doi.org/10.1038/nrc1713.
Casey, J. R., Grinstein, S., & Orlowski, J. (2010). Sensors and regulators of intracellular pH. *Nature Reviews. Molecular Cell Biology*, *11*(1), 50–61. http://dx.doi.org/10.1038/nrm2820.
Chacon, E., Reece, J. M., Nieminen, A. L., Zahrebelski, G., Herman, B., & Lemasters, J. J. (1994). Distribution of electrical potential, pH, free $Ca2+$, and volume inside cultured adult rabbit cardiac myocytes during chemical hypoxia: A multiparameter digitized

confocal microscopic study. *Biophysical Journal*, *66*(4), 942–952. http://dx.doi.org/10.1016/S0006-3495(94)80904-X.

Choi, C.-H., Webb, B. A., Chimenti, M. S., Jacobson, M. P., & Barber, D. L. (2013). pH sensing by FAK-His58 regulates focal adhesion remodeling. *The Journal of Cell Biology*, *202*(6), 849–859. http://dx.doi.org/10.1083/jcb.201302131.

De Michele, R., Carimi, F., & Frommer, W. B. (2014). Mitochondrial biosensors. *The International Journal of Biochemistry & Cell Biology*, *48*, 39–44. http://dx.doi.org/10.1016/j.biocel.2013.12.014.

Denker, S. P., & Barber, D. L. (2002). Cell migration requires both ion translocation and cytoskeletal anchoring by the Na-H exchanger NHE1. *The Journal of Cell Biology*, *159*(6), 1087–1096. http://dx.doi.org/10.1083/jcb.200208050.

Denker, A., Bethani, I., Kröhnert, K., Körber, C., Horstmann, H., Wilhelm, B. G., et al. (2011). A small pool of vesicles maintains synaptic activity in vivo. *Proceedings of the National Academy of Sciences of the United States of America*, *108*(41), 17177–17182. http://dx.doi.org/10.1073/pnas.1112688108.

Diril, M. K., Wienisch, M., Jung, N., Klingauf, J., & Haucke, V. (2006). Stonin 2 is an AP-2-dependent endocytic sorting adaptor for synaptotagmin internalization and recycling. *Developmental Cell*, *10*(2), 233–244. http://dx.doi.org/10.1016/j.devcel.2005.12.011.

Granseth, B., Odermatt, B., Royle, S. J., & Lagnado, L. (2006). Clathrin-mediated endocytosis is the dominant mechanism of vesicle retrieval at hippocampal synapses. *Neuron*, *51*(6), 773–786. http://dx.doi.org/10.1016/j.neuron.2006.08.029.

Grynkiewicz, G., Poenie, M., & Tsien, R. Y. (1985). A new generation of Ca2+ indicators with greatly improved fluorescence properties. *The Journal of Biological Chemistry*, *260*(6), 3440–3450.

Han, J., & Burgess, K. (2010). Fluorescent indicators for intracellular pH. *Chemical Reviews*, *110*(5), 2709–2728. http://dx.doi.org/10.1021/cr900249z.

Harguindey, S., Reshkin, S. J., Orive, G., Arranz, J. L., & Anitua, E. (2007). Growth and trophic factors, pH and the Na+/H+ exchanger in Alzheimer's disease, other neurodegenerative diseases and cancer: New therapeutic possibilities and potential dangers. *Current Alzheimer Research*, *4*(1), 53–65.

Johnson, D., & Nehrke, K. (2010). Mitochondrial fragmentation leads to intracellular acidification in *Caenorhabditis elegans* and mammalian cells. *Molecular Biology of the Cell*, *21*(13), 2191–2201. http://dx.doi.org/10.1091/mbc.E09-10-0874.

Koivusalo, M., Welch, C., Hayashi, H., Scott, C. C., Kim, M., Alexander, T., et al. (2010). Amiloride inhibits macropinocytosis by lowering submembranous pH and preventing Rac1 and Cdc42 signaling. *The Journal of Cell Biology*, *188*(4), 547–563. http://dx.doi.org/10.1083/jcb.200908086.

Ludwig, F. T., Schwab, A., & Stock, C. (2013). The Na+/H+−exchanger (NHE1) generates pH nanodomains at focal adhesions. *Journal of Cellular Physiology*, *228*, 1351–1358. http://dx.doi.org/10.1002/jcp.24293.

Macdonald, P. J., Chen, Y., & Mueller, J. D. (2012). Chromophore maturation and fluorescence fluctuation spectroscopy of fluorescent proteins in a cell-free expression system. *Analytical Biochemistry*, *421*(1), 291–298. http://dx.doi.org/10.1016/j.ab.2011.10.040.

Marshansky, V., & Futai, M. (2008). The V-type H+-ATPase in vesicular trafficking: Targeting, regulation and function. *Current Opinion in Cell Biology*, *20*(4), 415–426. http://dx.doi.org/10.1016/j.ceb.2008.03.015.

Martinez, K. A., Kitko, R. D., Mershon, J. P., Adcox, H. E., Malek, K. A., Berkmen, M. B., et al. (2012). Cytoplasmic pH response to acid stress in individual cells of *escherichia coli* and bacillus subtilis observed by fluorescence ratio imaging microscopy. *Applied and Environmental Microbiology*, *78*(10), 3706–3714. http://dx.doi.org/10.1128/AEM.00354-12.

Meima, M. E., Webb, B. A., Witkowska, H. E., & Barber, D. L. (2009). The sodium-hydrogen exchanger NHE1 is an Akt substrate necessary for actin filament reorganization by growth factors. *The Journal of Biological Chemistry*, *284*(39), 26666–26675. http://dx.doi.org/10.1074/jbc.M109.019448.

Miesenböck, G., De Angelis, D. A., & Rothman, J. E. (1998). Visualizing secretion and synaptic transmission with pH-sensitive green fluorescent proteins. *Nature*, *394*(6689), 192–195. http://dx.doi.org/10.1038/28190.

Nehrke, K. (2003). A reduction in intestinal cell pHi due to loss of the *Caenorhabditis elegans* Na+/H+ exchanger NHX-2 increases life span. *The Journal of Biological Chemistry*, *278*(45), 44657–44666. http://dx.doi.org/10.1074/jbc.M307351200.

Paradiso, A. M., Tsien, R. Y., & Machen, T. E. (1984). Na+—H+ exchange in gastric glands as measured with a cytoplasmic-trapped, fluorescent pH indicator. *Proceedings of the National Academy of Sciences of the United States of America*, *81*(23), 7436–7440.

Patel, H., & Barber, D. L. (2005). A developmentally regulated Na-H exchanger in Dictyostelium discoideum is necessary for cell polarity during chemotaxis. *The Journal of Cell Biology*, *169*(2), 321–329. http://dx.doi.org/10.1083/jcb.200412145.

Pinton, P., Rimessi, A., Romagnoli, A., Prandini, A., & Rizzuto, R. (2007). Biosensors for the Detection of Calcium and pH. *Methods in Cell Biology*, *80*, 297–325. http://dx.doi.org/10.1016/S0091-679X(06)80015-4.

Plant, P. J., Manolson, M. F., Grinstein, S., & Demaurex, N. (1999). Alternative mechanisms of vacuolar acidification in H(+)-ATPase-deficient yeast. *The Journal of Biological Chemistry*, *274*(52), 37270–37279, Retrieved from: http://eutils.ncbi.nlm.nih.gov/entrez/eutils/elink.fcgi?dbfrom=pubmed&id=10601292&retmode=ref&cmd=prlinks.

Porcelli, A. M., Ghelli, A., Zanna, C., Pinton, P., Rizzuto, R., & Rugolo, M. (2005). pH difference across the outer mitochondrial membrane measured with a green fluorescent protein mutant. *Biochemical and Biophysical Research Communications*, *326*(4), 799–804. http://dx.doi.org/10.1016/j.bbrc.2004.11.105.

Poskanzer, K. E., Marek, K. W., Sweeney, S. T., & Davis, G. W. (2003). Synaptotagmin I is necessary for compensatory synaptic vesicle endocytosis in vivo. *Nature*, *426*(6966), 559–563. http://dx.doi.org/10.1038/nature02184.

Rivinoja, A., Kokkonen, N., Kellokumpu, I., & Kellokumpu, S. (2006). Elevated Golgi pH in breast and colorectal cancer cells correlates with the expression of oncofetal carbohydrate T-antigen. *Journal of Cellular Physiology*, *208*(1), 167–174. http://dx.doi.org/10.1002/jcp.20653.

Rossano, A. J., Chouhan, A. K., & Macleod, G. T. (2013). Genetically encoded pH-indicators reveal activity-dependent cytosolic acidification of Drosophila motor nerve termini in vivo. *The Journal of Physiology*, *591*(Pt 7), 1691–1706. http://dx.doi.org/10.1113/jphysiol.2012.248377.

Schönichen, A., Webb, B. A., Jacobson, M. P., & Barber, D. L. (2013). Considering protonation as a posttranslational modification regulating protein structure and function. *Annual Review of Biophysics*, *42*, 289–314. http://dx.doi.org/10.1146/annurev-biophys-050511-102349.

Schwarzländer, M., Logan, D. C., Fricker, M. D., & Sweetlove, L. J. (2011). The circularly permuted yellow fluorescent protein cpYFP that has been used as a superoxide probe is highly responsive to pH but not superoxide in mitochondria: Implications for the existence of superoxide 'flashes'. *Biochemical Journal*, *437*(3), 381–387. http://dx.doi.org/10.1042/BJ20110883.

Schwarzländer, M., Murphy, M. P., Duchen, M. R., Logan, D. C., Fricker, M. D., Halestrap, A. P., et al. (2012). Mitochondrial "flashes": A radical concept repHined. *Trends in Cell Biology*, *22*(10), 503–508. http://dx.doi.org/10.1016/j.tcb.2012.07.007.

Shaner, N. C., Campbell, R. E., Steinbach, P. A., Giepmans, B. N. G., Palmer, A. E., & Tsien, R. Y. (2004). Improved monomeric red, orange and yellow fluorescent proteins derived from Discosoma sp. red fluorescent protein. *Nature Biotechnology*, *22*(12), 1567–1572. http://dx.doi.org/10.1038/nbt1037.

Slonczewski, J. L., Fujisawa, M., Dopson, M., & Krulwich, T. A. (2009). Cytoplasmic pH measurement and homeostasis in bacteria and archaea. *Advances in Microbial Physiology*, *55*, 1–317. http://dx.doi.org/10.1016/S0065-2911(09)05501-5.

Stehbens, S., Pemble, H., Murrow, L., & Wittmann, T. (2012). Imaging intracellular protein dynamics by spinning disk confocal microscopy. *Methods in Enzymology*, *504*, 293–313. http://dx.doi.org/10.1016/B978-0-12-391857-4.00015-X.

Stock, C., & Schwab, A. (2009). Protons make tumor cells move like clockwork. *Pflügers Archiv/European Journal of Physiology*, *458*(5), 981–992. http://dx.doi.org/10.1007/s00424-009-0677-8.

Thomas, J. A., Buchsbaum, R. N., Zimniak, A., & Racker, E. (1979). Intracellular pH measurements in Ehrlich ascites tumor cells utilizing spectroscopic probes generated in situ. *Biochemistry*, *18*(11), 2210–2218, Retrieved from: http://eutils.ncbi.nlm.nih.gov/entrez/eutils/elink.fcgi?dbfrom=pubmed&id=36128&retmode=ref&cmd=prlinks.

Van Duijn, B., & Inouye, K. (1991). Regulation of movement speed by intracellular pH during Dictyostelium discoideum chemotaxis. *Proceedings of the National Academy of Sciences of the United States of America*, *88*(11), 4951–4955, Retrieved from: http://eutils.ncbi.nlm.nih.gov/entrez/eutils/elink.fcgi?dbfrom=pubmed&id=11607188&retmode=ref&cmd=prlinks.

Vaughan-Jones, R. D., Spitzer, K. W., & Swietach, P. (2009). Intracellular pH regulation in heart. *Journal of Molecular and Cellular Cardiology*, *46*(3), 318–331. http://dx.doi.org/10.1016/j.yjmcc.2008.10.024.

Vavassori, S., Cortini, M., Masui, S., Sannino, S., Anelli, T., Caserta, I. R., et al. (2013). A pH-regulated quality control Cycle for surveillance of secretory protein assembly. *Molecular Cell*, *50*(6), 783–792. http://dx.doi.org/10.1016/j.molcel.2013.04.016.

Webb, B. A., Chimenti, M., Jacobson, M. P., & Barber, D. L. (2011). Dysregulated pH: A perfect storm for cancer progression. *Nature Reviews. Cancer*, *11*(9), 671–677. http://dx.doi.org/10.1038/nrc3110.

Wilks, J. C., & Slonczewski, J. L. (2007). pH of the cytoplasm and periplasm of *Escherichia coli*: Rapid measurement by green fluorescent protein fluorimetry. *Journal of Bacteriology*, *189*(15), 5601–5607. http://dx.doi.org/10.1128/JB.00615-07.

Zhang, X., Lin, Y., & Gillies, R. J. (2010). Tumor pH and its measurement. *Journal of Nuclear Medicine*, *51*(8), 1167–1170. http://dx.doi.org/10.2967/jnumed.109.068981.

CHAPTER

Toward quantitative fluorescence microscopy with DNA origami nanorulers

24

Susanne Beater, Mario Raab, Philip Tinnefeld

Braunschweig University of Technology, Institute for Physical & Theoretical Chemistry and Braunschweig Integrated Centre of Systems Biology, Braunschweig, Germany

CHAPTER OUTLINE

Introduction	450
24.1 The Principle of DNA Origami	452
24.2 Functionalizing DNA Origami Structures	452
24.3 DNA Origami as Fluorescence Microscopy Nanorulers	455
24.4 Brightness References Based on DNA Origami	457
24.5 Applications of DNA Origami Nanorulers for Visualizing Resolution	458
24.5.1 Nanorulers with Defined Distances for Superresolution Microscopy	458
24.5.2 DNA-PAINT on the DNA Origami Nanoruler	459
24.6 How to Choose an Appropriate Nanoruler for a Given Application	461
References	463

Abstract

The dynamic development of fluorescence microscopy has created a large number of new techniques, many of which are able to overcome the diffraction limit. This chapter describes the use of DNA origami nanostructures as scaffold for quantifying microscope properties such as sensitivity and resolution. The DNA origami technique enables placing of a defined number of fluorescent dyes in programmed geometries. We present a variety of DNA origami nanorulers that include nanorulers with defined labeling density and defined distances between marks. The chapter summarizes the advantages such as practically free choice of dyes and labeling density and presents examples of nanorulers in use. New triangular DNA origami nanorulers that do not require photoinduced switching by imaging transient binding to DNA nanostructures are also reported. Finally, we simulate fluorescence images of DNA

origami nanorulers and reveal that the optimal DNA nanoruler for a specific application has an intermark distance that is roughly 1.3-fold the expected optical resolution.

INTRODUCTION

Light microscopy has been a powerful tool in biological applications since the invention of microscopes in the fifteenth and sixteenth centuries. The invention of fluorescence microscopy in the beginning of the twentieth century by August Köhler (Löwe, Rohr, Boegehold, & Eppenstein, 1927) allowed a more specific insight into biological samples as the region of interest could be labeled specifically. More recent developments allow single-molecule fluorescence microscopy (Moerner & Kador, 1989; Orrit & Bernard, 1990) and also overcome the diffraction barrier (Hell, 2007; Huang, Bates, & Zhuang, 2009; Rust, Bates, & Zhuang, 2006; van de Linde, Heilemann, & Sauer, 2012). As described by Ernst Abbe in 1873 (Abbe, 1873), any kind of light microscopy is limited by a naturally given diffraction barrier that does not allow the separation of two points that are closer together than approximately half of the wavelength of the light used. For visible light, this would be about 200–300 nm.

Starting in 1994 by the first description of stimulated emission depletion (STED) microscopy (Hell & Wichmann, 1994) and its realization in 2000 (Klar, Jakobs, Dyba, Egner, & Hell, 2000), various superresolution methods have by now overcome the diffraction limit, the most popular being stochastic optical reconstruction microscopy (STORM) (Rust et al., 2006) or direct STORM (dSTORM) (Heilemann et al., 2008), photoactivated localization microscopy (PALM) (Betzig et al., 2006) or fluorescence PALM (fPALM) (Hess, Girirajan, & Mason, 2006), and structured illumination microscopy (SIM) (Gustafsson, 2000) or rather saturated SIM (SSIM) (Gustafsson, 2005) and their extensions to three-dimensional superresolution (Huang, Wang, Bates, & Zhuang, 2008; Juette et al., 2008; Thompson, Casolari, Badieirostami, Brown, & Moerner, 2010). The methods increase the resolution down to molecular dimensions and provide new insight into biological structures and processes. Fluorescence superresolution methods complement the established method of electron microscopy, which is only possible for fixed and therefore dead material. As fluorescence superresolution microscopy can be accomplished in living cells (Hein, Willig, & Hell, 2008; Westphal et al., 2008), the development of fluorescence superresolution methods has been a milestone on the way to a better understanding of processes inside living cells.

These recent achievements in fluorescence superresolution microscopy require a mean to evaluate and compare these new methods quantitatively. To quantify, microtubule or actin filaments stained with fluorescent dyes have often been used (Chmyrov et al., 2013). The filaments illustrate the resulting resolution of a given instrument quite well but are not very reproducible and exact. Typically, either cross sections of individual filaments or two parallel filaments in close proximity are exemplarily shown. Their full width at half maximum (FWHM) or smallest distances between filaments were then identified as optical resolution. The growth of the filaments and the fluorescent dye staining can be controlled to some extent, but the subjective selection of picked examples induces a bias toward apparently better

resolution. This is because fluorescence images underlie noise and this noise brings about locations in images with apparently better than average resolution. Such sights are certainly picked by an experimenter who always aims at presenting the best results.

Techniques based on the successive localization of single molecules often identify the localization precision as resolution criterion. As exhaustively discussed in the literature, this is an oversimplification since many factors including labeling density, fraction of localized fluorophores, switching kinetics, and drift are not adequately taken into account (Cordes et al., 2010; Shroff, Galbraith, Galbraith, & Betzig, 2008; Steinhauer, Forthmann, Vogelsang, & Tinnefeld, 2008; Vogelsang et al., 2010).

Other than stained filaments, fluorescent beads are commonly used to demonstrate the resulting FWHM when applying a superresolution method (Meyer et al., 2008; Moneron et al., 2010). Fluorescent beads are usually filled with fluorescent dyes that have very broad absorption and emission spectra, making them very bright and stable. But as the resulting resolution of a system also depends on the fluorescent dye used (e.g., on the dye-specific saturation factor in STED microscopy; Westphal & Hell, 2005), the expected resolution for a dye-labeled specimen can only be roughly estimated.

To overcome these issues, DNA origami nanorulers have recently been introduced as a powerful tool (Schmied et al., 2013, 2012; Steinhauer, Jungmann, Sobey, Simmel, & Tinnefeld, 2009). DNA origamis are complex DNA nanostructures that are obtained by self-assembly in high yields (Rothemund, 2006). The main advantage of DNA origami to study the performance of fluorescence microscopes is the ability to place an exactly defined number of dyes in programmable geometries. DNA origamis offer an unprecedented versatility regarding the fluorescent dyes (both the kind of dye and number of dyes) and their arrangement on the DNA origami breadboard. A high number of dyes can be placed on the DNA origami without self-quenching so that the brightness directly relates to the number of fluorescent dyes. A large variety of arrangement of fluorescent marks ranging from 6 to 400 nm can be realized (Schmied et al., 2012) in different colors creating nanorulers for (superresolution) microscopy. Another advantage of using DNA origami to quantify the performance of a microscope is that all DNA origami structures are identical. This is the basis to easily achieve measurements from a large number of structures that are selected and analyzed automatically without bias induced by the experimenter.

This chapter briefly reviews the current state of DNA origami standards and rulers that can aid in making fluorescence microscopy more quantitative. We provide an introduction to DNA origami and present several examples of DNA origami nanorulers that are developed from four basic DNA origami structures. We then present triangular DNA origami nanorulers that are not limited by photobleaching and that do not require complex photophysics or photochemistry to be taken care of. We conclude by discussing the selection criteria of distances between marks on DNA origami nanorulers that are optimized for an anticipated resolving power of a microscope.

24.1 THE PRINCIPLE OF DNA ORIGAMI

The DNA origami technique was invented by Paul Rothemund in 2006 (Rothemund, 2006). As illustrated in Fig. 24.1, this technique uses a long (7000–9000 nucleotides (nt)) circular DNA strand—called "scaffold strand"—that stems from the bacteriophage M13mp18. By incubating the scaffold strand with about 200 short DNA strands (20–50 nt long, called "staples"), the scaffold strand can be "stapled" into almost every desired shape. Both two- and three-dimensional structures at the nanoscale have been realized (Douglas, Dietz, et al., 2009; Rothemund, 2006). The structures can be designed using the open-source software caDNAno (Douglas, Marblestone, et al., 2009). caDNAno provides tools to shape the scaffold strand and automatically calculates the required staple strand sequences.

As indicated in Fig. 24.1, the staple strands usually span three helices to ensure a comparably stiff and robust construct. Crossing-over between the helices is facilitated by the central motif of DNA nanotechnology, the Holliday junction (Seeman, 1982).

The folding process occurs at a temperature gradient in a buffer containing magnesium cations (typically 11–16 mM). By slowly cooling down the mixture of scaffold and staple strands from over 90 to 4 °C, quantitative folding occurs (Rothemund, 2006). Recently, fast-folding methods have been established, shortening the folding time from up to 3 days down to about 2 h (Sobczak, Martin, Gerling, & Dietz, 2012). To ensure a high yield of correctly folded structures, the staple strands are used in excess (5–20-fold). The folded structures are purified by gel electrophoresis or by filtering using an Amicon® filter system (100k).

24.2 FUNCTIONALIZING DNA ORIGAMI STRUCTURES

The DNA origami structures can be viewed as molecular breadboards. As each of the short staple strands can be extended and functionalized in many different ways, these constructs do allow not only specific binding on surfaces but also dye labeling in defined distances with nanometer accuracy (Stein, Schuller, Bohm,

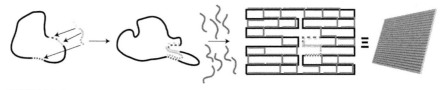

FIGURE 24.1

Illustration of DNA origami. A long circular DNA strand is incubated with ca. 200 short DNA strands to create a defined two- or three-dimensional shape. Each short staple strand finds its unique position in the construct that enables labeling at defined positions within the DNA origami. (See the color plate.)

Tinnefeld, & Liedl, 2011; Steinhauer et al., 2009). Above that, a high degree of control is maintained over the number of fluorescent dyes. In another variation, the binding of proteins and other nanoobjects can be realized by functionalizing them with DNA and binding them via the complementary sequence to the DNA origami (Andersen et al., 2009; Shen, Zhong, Neff, & Norton, 2009). Modified DNA origamis can be either used to study bioassays on the surface without changing their behavior compared to an ensemble experiment (Gietl, Holzmeister, Grohmann, & Tinnefeld, 2012) or used as fluorescence and superresolution standards (Schmied et al., 2013, 2012; Steinhauer et al., 2009).

Different methods of functionalizing or labeling the DNA origami constructs have been established. The most straightforward approach depicted in Fig. 24.2 is to functionalize one or more of the staple strands before the whole folding process. This leads to the so-called internal labeling of the structure. This method is very robust and gives very high yields of correctly labeled DNA origamis. Its obvious disadvantage is that only temperature-insensitive modifications can be folded with this method. As the folding process occurs at temperatures starting over 90 °C, the functionalization has to be stable enough to survive this process. The method of internal labeling is also not very cost-efficient especially when several identical modifications are intended: each of the staples that one wants to modify has a unique sequence that needs to be functionalized.

Another labeling approach is external labeling, which is illustrated in Fig. 24.3. For external labeling, the staple strands one wants to modify are not directly functionalized but prolonged by a specific DNA sequence of about 20 bases. This extended sequence then protrudes from the folded DNA origami and works as docking strand. This docking strand binds a complementary sequence with the desired modification. The external labeling can either be carried out in one step, which means that the whole construct (scaffold strand, unmodified and extended staple

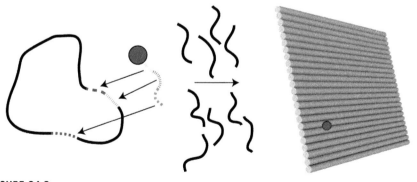

FIGURE 24.2

Labeling DNA origami. Internal labeling of DNA origami structures is accomplished by the substitution of a staple strand by its functionalized version, for example, a dye-labeled DNA strand.

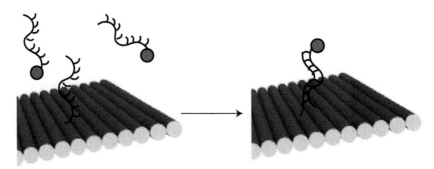

FIGURE 24.3

External labeling of DNA origami structures is realized by extending specific staple strands by about 20 bases that protrude from the folded structure and act as docking strands for the functionalized counter strand that can be added either before folding or after folding and purification. The modification of the counter strand can be pointing either toward the DNA origami or away from it. The latter causes less steric hindrance but is less accurate in terms of the exact position of the modification.

strands, and modified complementary sequence) is folded at once. Also, subsequent labeling is possible, which means that first, the DNA origami with the extended docking strands is folded and purified and then the functionalized counter strand is added, incubated for a short time (typically 2 h; Lin et al., 2012) and purified. The subsequent labeling can be done at milder conditions, especially at much lower temperatures (37 °C is common; Lin et al., 2012). Additionally, by using external labeling, a high number of identical modifications in one DNA origami become more cost-efficient. As the individual staple strands do not have to be expensively modified but only extended and not more than one modified counter strand is required, the costs decrease drastically. Using subsequent labeling, parallelization of the fabrication of differently labeled DNA origamis becomes easier as the basic construct remains unchanged and only the desired modified counter sequence has to be added after purification. Generally, however, external labeling goes along with lower yields compared to internal labeling.

One more way of modifying the DNA origami is the so-called enzymatic labeling (Jahn et al., 2011). This technique is practically a composition of external and internal labeling: The individual staple strands one wants to modify are enzymatically labeled with either a fluorophore or other groups, namely, biotin, amine, and digoxigenin groups. The modified staples are then simply mixed with the unmodified staple strands, scaffold, and buffer and annealed as usual.

The enzyme used in this reaction is DNA nucleotidylexotransferase that attaches dideoxynucleotide triphosphates to the 3′ end of the staple strands. By modifying the dideoxynucleotide triphosphates with a fluorophore or another modification as listed earlier in the text, the staple strand is extended by a labeled nucleotide. Dideoxynucleotides also ensure that only one single-labeled nucleotide is attached as the

reaction stops after the integration. This makes the labeling very controllable. As this enzymatic labeling can be done for several staple strands at once, it provides a cost-efficient way of labeling with certain functionalities.

Specific binding of DNA origamis to surfaces is mostly accomplished using biotin-modified DNA origami structures (about five biotin anchors per structure are common) and via an avidin derivate (NeutrAvidin or streptavidin) onto a BSA/biotin-coated surface. This method leads to very little unspecific background caused by excess staple strands or free dye. In contrast to electrostatic binding (which occurs on, e.g., poly-L-lysine surfaces), the DNA origami only binds in a predetermined orientation. This enables structures such as DNA origami nanopillars to stand upright (Schmied et al., 2013). Besides biotin and fluorescent dyes, also fluorescent proteins can be used to label DNA origamis as long as they can be functionalized with DNA (Shen et al., 2009).

The labeling density (which means the number of modifications per area) is mainly limited by steric constraints. In principal, each staple strand could be modified several folds, but at some point, the folding will be inhibited. Also, self-quenching of the fluorescent dyes can occur when the dyes get close enough to affect each other. It has been shown that modification of every staple at one end ($3'$ or $5'$) is possible without steric hindrance or self-quenching of the fluorescent dyes (Schmied et al., 2012). Especially, bundle-like structures are sufficiently rigid and offer a high labeling density. This can be exploited for quantitative analysis: Samples with different but defined numbers of fluorescent dyes can act as brightness references. Also, defined distances between two marks of fluorescent dyes can be used for quantifying the resolving power of a microscope. As for high-resolution methods like STED and SIM, a high density of dyes is beneficial, as DNA origamis qualify as STED or SIM rulers.

24.3 DNA ORIGAMI AS FLUORESCENCE MICROSCOPY NANORULERS

A single DNA origami scaffold strand involves roughly 8000 nt corresponding to about 2.7 µm of DNA. Common DNA origami structures have dimensions of up to 400 nm, for example, in a so-called six-helix bundle (6HB). With the ease of attaching two fluorescent marks on them, they are perfectly suited for rulers on the nanoscale that can directly visualize the resolving power of a microscope—simply by varying the distances between the two marks and checking whether a microscope is able to resolve the two marks. As every fluorescence microscopy method has its own properties and requirements, different kinds of fluorescence microscopy standards are needed. Rulers for SIM have a typical intermark distance of 120–180 nm and require high dye numbers. Especially for superresolution microscopy, the distances between the marks have to be smaller and well defined. STED microscopy (e.g., pulsed STED, continuous wave (cw) STED, and gated STED), for example, also requires high dye densities. Other methods that rely on the successive

localization of single blinking or switchable molecules require fewer dyes per mark, but the switching kinetics have to be well controlled. With DNA origami-based nanorulers, defined standards for each of the multitude of fluorescence techniques can be created.

Recently, a variety of different DNA nanorulers were presented (Schmied et al., 2013, 2012). All these DNA standards were made from one of four basic constructs: the 6HB, the 12-helix bundle (12HB), the rectangle (NRO), and the nanopillar. Sketches of the basic constructs are shown in Fig. 24.4.

The SHB is a construct of six DNA helices bundled together and has a length of about 400 nm. It can act as a ruler for confocal microscopy when modified with one or more fluorescent dyes on each end (Schmied et al., 2012). A contour length of 386 nm for the 6HB (see sketch in Fig. 24.4) yields two marks at a distance between the marks of ~357 nm because the 6HB is not perfectly stiff. This is far enough to be resolved with diffraction-limited optics, for example, in a confocal microscope.

The 12HB is similar to the 6HB but consists of 12 DNA helices. It has a length of about 200 nm and was, for example, used to create a nanoruler for SIM (Schmied et al., 2014). Therefore, the construct was externally labeled with two times 20 dyes at a distance of about 150 nm. Potentially, smaller distances can be accomplished and the 12HB could be used as a STED nanoruler with distances of 40–100 nm.

The rectangular DNA origami has a size of 70 nm × 100 nm. It is the simplest DNA origami used in our studies and provides multiple possibilities (Schmied et al., 2012; Steinhauer et al., 2009). A STED ruler was created by labeling the DNA origami with two lines of 20 fluorescent dyes each in a distance of 71 nm. Nanorulers for localization-based microscopy were created by labeling the rectangular structure in various distances and colors (Schmied et al., 2012; Steinhauer et al., 2009).

The DNA origami nanopillar is a 12HB with a broader base that is functionalized with biotin. By specific binding to a BSA/biotin surface, the nanopillar is designed to

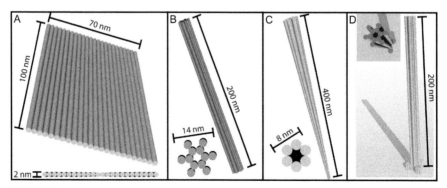

FIGURE 24.4

Sketches of the different DNA origami constructs used as scaffold for fluorescence microscopy rulers. (A) New rectangular origami (NRO), (B) 12-helix bundle (12HB), (C) 6-helix bundle (6HB), and (D) nanopillar.

stand upright. It has a length of 200 nm that enables three-dimensional superresolution microscopy by labeling the bottom and the top (and potentially any point in between) with fluorescent dyes. While a broad distribution of orientations was found on the surface, this distribution could be used to reveal the magnification induced by the mismatch between glass and buffer when an oil immersion objective was used (Schmied et al., 2013).

24.4 BRIGHTNESS REFERENCES BASED ON DNA ORIGAMI

Brightness references consist of a well-defined number of fluorescent dyes. This kind of sample enables the comparison of absolute intensities within one sample and relates the measured intensities to reference intensities in units of "absolute number of dyes." This is possible because the fluorescence of these DNA origami-based brightness references scales strictly with the number of dyes incorporated. This is ensured as long as direct dye–dye interactions are avoided. The minimal distance of 6 nm used for the data in Fig. 24.5 ensures the linearity of fluorescence with dye number (Schmied et al., 2012).

Such samples could be used as internal references, for example, by adding some of the brightness reference DNA origamis to the sample of interest—similar to fiducial markers used for drift correction. Brightness standards also facilitate the evaluation of the detector concerning the linearity of measured absolute intensities over a certain range (Schmied et al., 2012). This can be accomplished by a set of experiments with different (but known) numbers of fluorescent dyes. The absolute intensity of the spots should increase linearly with the number of dyes on the DNA

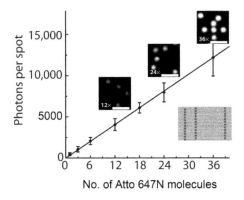

FIGURE 24.5

Sketch of a brightness reference DNA origami that is internally labeled with a variable number of dyes (36 for the sketched DNA origami). The intensity versus number of dyes plot shows a linear behavior.

Adapted with permission from Macmillan Publishers Ltd., Schmied et al. (2012), copyright 2012.

origami. If this is not the case, the factor of nonlinearity can be calculated from this kind of measurement and then be applied in the analysis of other samples such as biological specimen.

24.5 APPLICATIONS OF DNA ORIGAMI NANORULERS FOR VISUALIZING RESOLUTION

Nanorulers are easy to produce, portable and storable, and therefore an ideal tool for the quantification of optical resolution. They can be applied to check the performance of a given setup concerning different criteria. This enables the comparison with similar instruments or the performance over time. A very interesting application is the use of nanoscopic ruler with defined distances. Using the various DNA origami constructs, almost any distance at the nanoscale and different labeling densities can be realized. In the following, we exemplarily demonstrate superresolution imaging by cw-STED microscopy (Moneron et al., 2010). We then present, for the first time, nanorulers for localization-based microscopy without the need for photoinduced switching.

24.5.1 NANORULERS WITH DEFINED DISTANCES FOR SUPERRESOLUTION MICROSCOPY

To evaluate the performance of a SIM system, distances of about 150 nm and a large number of dyes (approximately 10 per mark) are needed. A STED system should resolve distances of 40–100 nm and also requires a high density of dyes. Localization-based methods can even resolve distances down to a few nanometers and require blinking or stepwise bleaching of the fluorescent dyes. The quantification of the resulting resolution of a microscope system has been targeted in different approaches. In stochastic reconstruction microscopy, the localization precision is often referred to as resolution. This is not entirely true, because it is not the localization precision of one single molecule but the successive localization of many molecules that leads to a complete image (Fitzgerald, Lu, & Schnitzer, 2012; Nieuwenhuizen et al., 2013). The localization of a large number of molecules therefore takes up to several minutes—a time period in which, for example, sample drift can occur. As a result, the resolution of a localization-based superresolution measurement is not easy to determine. Also, localization-based microscopy requires a lot of parameters to be optimized: technical parameters like laser intensity, frame rate, acquisition time, and activation laser rate if needed; sample preparation parameters like labeling density, buffer conditions including the appropriate concentrations of reducing or oxidizing chemicals, and oxygen scavenging if needed; and many other parameters. This complicates the comparison between different experiments and can lead to various experimental errors.

The determination of the achievable resolution of a STED microscope is simpler as Abbe's formula could be extended to give a comparably simple expression

(Westphal & Hell, 2005). According to the Rayleigh criterion, two point-like light sources that are further apart than the FWHM of the given peak function can be separated and will be seen as two spots. In theory, this leads to the possibility to simply calculate the resolution of a STED system. Unfortunately, the STED equation contains a parameter called saturation factor, which is a matter constant and different for each dye and also varies in different media and for different wavelengths. These constants are not easily available and have to be measured for each dye of interest (and if needed, for different wavelengths and in different media).

Most of these theoretical and practical issues can be overcome with DNA origami nanorulers. Superresolution nanorulers feature two marks with a variable but defined distance and number of dyes. In principal, any dye suitable for either localization-based microscopy (e.g., UV switchable or chemically induced blinking) or STED microscopy (switchable by a suitable STED wavelength) can be studied on a DNA origami as long as it can be chemically attached to DNA. This helps to screen conditions (which in principal can also be done by sparsely spreading dye-labeled antibodies or even free dye on a surface) and to determine the resolution of an instrument with given conditions. As the handling of the DNA origami nanorulers is simple, experimental errors rarely occur.

An example of a DNA origami nanoruler is given in Fig. 24.6. The basic construct for this nanoruler is the 12HB. It features two marks of 20 dyes each in a distance of about 150 nm (for a sketch, see Fig. 24.6A). It was externally labeled with Alexa 488 and immobilized via a biotin–NeutrAvidin linker onto a thin BSA/biotin surface. The measurement was carried out on a homebuilt cw-STED microscope with an excitation wavelength of 491 nm and a cw-STED wavelength of 592 nm. The emission between 500 and 550 nm was detected by an APD. The measurement was performed in aqueous PBS solution and no chemical photostabilization was used.

24.5.2 DNA-PAINT ON THE DNA ORIGAMI NANORULER

An emerging superresolution microscopy method is DNA-PAINT (Jungmann et al., 2010). DNA-PAINT exploits the transient binding of dye-labeled short DNA strands to docking strands as indicated in Fig. 24.7. These docking strands can be positioned precisely on a DNA origami just like for external labeling. The difference is the length of the anchor strands. For external labeling, DNA sequences of about 20 bases ensure stable binding, whereas for DNA-PAINT microscopy, transient binding is achieved by using sequences of 9–10 bases. This leads to binding times in the ms to s range (Jungmann et al., 2010). Both binding and unbinding of the labeled DNA strands—often called imager strands—can be controlled. The binding kinetics mainly depend on the concentration of imager strands in the buffer solution, while the unbinding kinetics depend on the length and sequence of the complementary DNA. Other experimental conditions, like salt concentration in the buffer and imaging conditions such as integration time of the camera, need to be adjusted carefully in order to achieve a good image quality. The binding and unbinding of the imager strands emulate blinking because only bound imager strands yield spots

FIGURE 24.6

The 150-nm ruler labeled with Alexa 488 as an example for a distance ruler: (A) sketch of the DNA origami construct; (B) confocal image of the immobilized rulers, excitation wavelength 491 nm, scale bar 500 nm; (C) corresponding cw-STED image, cw-STED wavelength 592 nm, laser power 350 mW in the back aperture of the objective, scale bar 500 nm; (D) detail of a 150 nm ruler, scale bar 150 nm; and (E) the intensity profile of (D) shows the expected distance of about 150 nm.

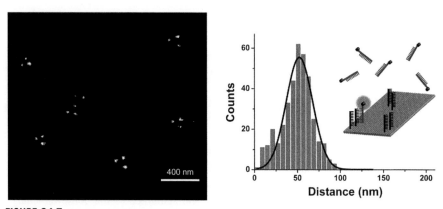

FIGURE 24.7

The DNA-PAINT triangle gives high yields of correctly folded structures on superresolution images. The image shows DNA-PAINT nanoruler imaged with a 10-nt long imager strand labeled with Atto 655. The distance histogram shows the result of the automatic analysis by the software tool CAEOBS. The resulting mean distance is 52 ± 15 nm as expected from the DNA origami design.

on the camera while diffusing imager strands are too quickly diffusing to be visualized as spots. In addition, the diffusing imager strand can exhibit lower quantum yields (Jungmann et al., 2010).

The method of DNA-PAINT offers a couple of advantages compared to more frequently used dSTORM or fPALM. First, it is practically bleaching unlimited. As the bleached dyes unbind and a new dye binds, imaging over a long time period can be accomplished. Multiplexing experiments become easier by using different DNA sequence pairs for the docking and imaging strands. The buffer conditions do not need to be adjusted to the blinking kinetics of each dye but only to adequate binding/unbinding of the imager strand. The DNA-PAINT nanoruler cannot be embedded in a polymer layer such as Mowiol because the imager strands need to diffuse freely. But tests showed that, nevertheless, these samples are very durable even over months once they are sealed and stored properly.

A very important advantage for nanorulers is that DNA-PAINT structures do not require photoinduced switching as the apparent blinking represents merely thermal dynamics. This makes superresolution easiest for unexperienced users since only a single wavelength is required and the adjustment of laser intensities is facilitated.

We created a nanoruler using DNA-PAINT microscopy using the rectangular origami (NRO) as scaffold and placing 3×2 docking strands in the shape of a regular triangle with side lengths of 60 nm (for a sketch, see Fig. 24.7). The regular triangle also simplifies the automatic analysis of the image. The nanoruler analysis program CAEOBS (Schmied et al., 2014) recognizes DNA origami structures, measures all distances between all localizations, and determines the distance between marks on DNA origami nanorulers. The use of a regular triangle improves the yields of the analysis because three identical distances are obtained from a single DNA origami. Even when one docking site is missing or not sampled, one 60 nm distance is obtained from the DNA origami. The automated analysis facilitates to obtain statistics from a reasonable number of structures in a short period of time and without bias induced by manually picking DNA origami structures for analysis.

24.6 HOW TO CHOOSE AN APPROPRIATE NANORULER FOR A GIVEN APPLICATION

As practically innumerable possibilities of different nanorulers can be designed and produced, the choice of the suitable nanoruler for a given application is crucial. Especially the number of dyes and the distance between the marks on the nanoruler need to be chosen carefully. But what is a good distance between two marks on a nanoruler to test the functionality of a system? Should one use a distance that corresponds to the resolution that is specified by the microscopy company?

As according to the Rayleigh criterion, two spots can be resolved when the distance between them is larger than the FWHM of the peak function. However, the Rayleigh criterion does not take into account a limited signal-to-background ratio; it assumes measurements without noise and pixelation. In addition, the

Rayleigh criterion is an arbitrary definition, but the question remains how the observer feels about the quality of an image. Does a structure that is resolved according to the Rayleigh criterion look resolved for the observer of a (pixelated) image?

To address this question, we carried out Monte Carlo simulations of nanoruler measurements that could, for example, represent STED measurements but the idea also applies to other techniques.

Figure 24.8 shows simulated images of nanoruler measurements with a fixed FWHM of the peak function of 70 nm and distances between the two marks varying from 70 to 100 nm (Fig. 24.8A–D). For the simulations, the point-spread function was approximated by a two-dimensional Gaussian function. The pixel size was set to 25 nm as 1/3 of the expected resolution is commonly used as pixel size in superresolution microscopy. The photon number was set to 1000 as this was found to be realistic in nanoruler measurements.

Although it is hard to determine an objective parameter of whether a nanoruler appears as resolved in a superresolution image (and not in an intensity histogram), it

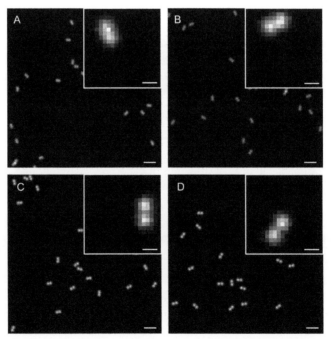

FIGURE 24.8

Simulated images of nanorulers with a FWHM of 70 nm and intermark distances of (A) 70, (B) 80, (C) 90, and (D) 100 nm. Scale bars are 400 nm in the overviews and 100 nm in the insets. Pixel size is 25 nm, and photon counts were set to 1000. These parameters correspond to a realistic cw-STED experiment as the one shown in Fig. 24.6 but underlie only shot noise—background, bleaching, drift, etc., are not taken into account.

can clearly be stated that even under optimal conditions like provided by simulations (which are only subject to shot noise but not affected by any other real-world problem such as background or photobleaching), the structures in Fig. 24.8A do not appear resolved. The structures in Fig. 24.8B appear barely resolved, and only in Fig. 24.8C and D, the observer clearly has the impression of studying dumbbell-shaped structures. This means that a microscope specified for a FWHM of 70 nm will not yield beautiful images with nanorulers featuring a distance of 70 nm. As, in any real experiment background, photobleaching, sample drift, and other obstacles are present, it is recommended to use a nanoruler with a distance of about 1.3-fold the expected FWHM. In this case, it seems appropriate to use 90 or 100 nm nanorulers for a microscope specified for 70 nm.

In conclusion, DNA origami has developed into a versatile scaffold for quantifying the abilities of fluorescence microscopes with respect to sensitivity and resolution. In this chapter, we provide an overview of the current state of applications. In addition, we present a maximal simple DNA origami nanoruler based on DNA-PAINT that does not even require photoinduced switching of dye molecules. A regular triangle as structural motif for fluorescent marks proves useful for optimizing yields of detected intermark distances with automated software. Finally, we demonstrate that it is not appropriate to use intermark distances at the limits of the optical resolution of a microscope because the expected results are not insightful for the experimenter. Instead, we suggest employing intermark distances that are of the order of 1.3-fold larger than the expected Rayleigh-limited microscope resolution.

REFERENCES

Abbe, E. (1873). Beiträge zur Theorie und der mikroskopischen Wahrnehmung. *Archiv für Mikroskopische Anatomie*, *9*, 413–468.

Andersen, E. S., Dong, M., Nielsen, M. M., Jahn, K., Subramani, R., Mamdouh, W., et al. (2009). Self-assembly of a nanoscale DNA box with a controllable lid. *Nature*, *459*(7243), 73–76.

Betzig, E., Patterson, G. H., Sougrat, R., Lindwasser, O. W., Olenych, S., Bonifacino, J. S., et al. (2006). Imaging intracellular fluorescent proteins at nanometer resolution. *Science*, *313*(5793), 1642–1645.

Chmyrov, A., Keller, J., Grotjohann, T., Ratz, M., d'Este, E., Jakobs, S., et al. (2013). Nanoscopy with more than 100,000 'doughnuts'. *Nature Methods*, *10*(8), 737–740. http://dx.doi.org/10.1038/nmeth.2556.

Cordes, T., Strackharn, M., Stahl, S. W., Summerer, W., Steinhauer, C., Forthmann, C., et al. (2010). Resolving single-molecule assembled patterns with superresolution blink-microscopy. *Nano Letters*, *10*(2), 645–651.

Douglas, S. M., Dietz, H., Liedl, T., Hogberg, B., Graf, F., & Shih, W. M. (2009). Self-assembly of DNA into nanoscale three-dimensional shapes. *Nature*, *459*(7245), 414–418. http://dx.doi.org/10.1038/nature08016. http://www.nature.com/nature/journal/v459/n7245/suppinfo/nature08016_S1.html.

Douglas, S. M., Marblestone, A. H., Teerapittayanon, S., Vazquez, A., Church, G. M., & Shih, W. M. (2009). Rapid prototyping of 3D DNA-origami shapes with caDNAno. *Nucleic Acids Research, 37*(15), 5001–5006.

Fitzgerald, J. E., Lu, J., & Schnitzer, M. J. (2012). Estimation theoretic measure of resolution for stochastic localization microscopy. *Physical Review Letters, 109*(4), 048102.

Gietl, A., Holzmeister, P., Grohmann, D., & Tinnefeld, P. (2012). DNA origami as biocompatible surface to match single-molecule and ensemble experiments. *Nucleic Acids Research, 40*, e110. http://dx.doi.org/10.1093/nar/gks326, gks326 [pii].

Gustafsson, M. G. L. (2000). Surpassing the lateral resolution limit by a factor of two using structured illumination microscopy. *Journal of Microscopy, 198*(2), 82–87. http://dx.doi.org/10.1046/j.1365-2818.2000.00710.x.

Gustafsson, M. G. L. (2005). Nonlinear structured-illumination microscopy: Wide-field fluorescence imaging with theoretically unlimited resolution. *Proceedings of the National Academy of Sciences of the United States of America, 102*(37), 13081–13086.

Heilemann, M., van de Linde, S., Schuttpelz, M., Kasper, R., Seefeldt, B., Mukherjee, A., et al. (2008). Subdiffraction-resolution fluorescence imaging with conventional fluorescent probes. *Angewandte Chemie (International Ed. in English), 47*(33), 6172–6176.

Hein, B., Willig, K. I., & Hell, S. W. (2008). Stimulated emission depletion (STED) nanoscopy of a fluorescent protein-labeled organelle inside a living cell. *Proceedings of the National Academy of Sciences of the United States of America, 105*(38), 14271–14276.

Hell, S. W. (2007). Far-field optical nanoscopy. *Science, 316*(5828), 1153–1158. http://dx.doi.org/10.1126/science.1137395.

Hell, S. W., & Wichmann, J. (1994). Breaking the diffraction resolution limit by stimulated emission: Stimulated-emission-depletion fluorescence microscopy. *Optics Letters, 19*(11), 780–782. http://dx.doi.org/10.1364/ol.19.000780.

Hess, S. T., Girirajan, T. P. K., & Mason, M. D. (2006). Ultra-high resolution imaging by fluorescence photoactivation localization microscopy. *Biophysical Journal, 91*(11), 4258–4272.

Huang, B., Bates, M., & Zhuang, X. (2009). Super-resolution fluorescence microscopy. *Annual Review of Biochemistry, 78*, 993–1016.

Huang, B., Wang, W., Bates, M., & Zhuang, X. (2008). Three-dimensional super-resolution imaging by stochastic optical reconstruction microscopy. *Science, 319*(5864), 810–813.

Jahn, K., Tørring, T., Voigt, N. V., Sørensen, R. S., Bank Kodal, A. L., Andersen, E. S., et al. (2011). Functional patterning of DNA origami by parallel enzymatic modification. *Bioconjugate Chemistry, 22*(4), 819–823. http://dx.doi.org/10.1021/bc2000098.

Juette, M. F., Gould, T. J., Lessard, M. D., Mlodzianoski, M. J., Nagpure, B. S., Bennett, B. T., et al. (2008). Three-dimensional sub-100 nm resolution fluorescence microscopy of thick samples. *Nature Methods, 5*(6), 527–529.

Jungmann, R., Steinhauer, C., Scheible, M., Kuzyk, A., Tinnefeld, P., & Simmel, F. C. (2010). Single-molecule kinetics and super-resolution microscopy by fluorescence imaging of transient binding on DNA origami. *Nano Letters, 10*, 4756–4761. http://dx.doi.org/10.1021/nl103427w.

Klar, T. A., Jakobs, S., Dyba, M., Egner, A., & Hell, S. W. (2000). Fluorescence microscopy with diffraction resolution barrier broken by stimulated emission. *Proceedings of the National Academy of Sciences, 97*(15), 8206–8210.

Lin, C., Jungmann, R., Leifer, A. M., Li, C., Levner, D., Church, G. M., et al. (2012). Submicrometre geometrically encoded fluorescent barcodes self-assembled from DNA. *Nature Chemistry, 4*(10), 832–839. http://dx.doi.org/10.1038/nchem.1451.

Löwe, F., Rohr, M., Boegehold, H., & Eppenstein, O. (1927). Besondere optische Instrumente. In H. Boegehold, O. Eppenstein, H. Hartinger, F. Jentzsch, H. Kessler, & F. Löwe, et al. *Geometrische Optik. Optische Konstante. Optische Instrumente; Vol. 18*. (pp. 299–622). Berlin, Heidelberg: Springer.

Meyer, L., Wildanger, D., Medda, R., Punge, A., Rizzoli, S. O., Donnert, G., et al. (2008). Dual-color STED microscopy at 30-nm focal-plane resolution. *Small*, *4*(8), 1095–1100. http://dx.doi.org/10.1002/smll.200800055.

Moerner, W. E., & Kador, L. (1989). Optical-detection and spectroscopy of single molecules in a solid. *Physical Review Letters*, *62*(21), 2535–2538.

Moneron, G., Medda, R., Hein, B., Giske, A., Westphal, V., & Hell, S. W. (2010). Fast STED microscopy with continuous wave fiber lasers. *Optics Express*, *18*(2), 1302–1309. http://dx.doi.org/10.1364/oe.18.001302.

Nieuwenhuizen, R. P. J., Lidke, K. A., Bates, M., Puig, D. L., Grunwald, D., Stallinga, S., et al. (2013). Measuring image resolution in optical nanoscopy. *Nature Methods*, *10*(6), 557–562. http://dx.doi.org/10.1038/nmeth.2448. http://www.nature.com/nmeth/journal/v10/n6/abs/nmeth.2448.html#supplementary-information.

Orrit, M., & Bernard, J. (1990). Single pentacene molecules detected by fluorescence excitation in a p-terphenyl crystal. *Physical Review Letters*, *65*(21), 2716–2719.

Rothemund, P. W. K. (2006). Folding DNA to create nanoscale shapes and patterns. *Nature*, *440*(7082), 297–302. http://dx.doi.org/10.1038/nature04586.http://www.nature.com/nature/journal/v440/n7082/suppinfo/nature04586_S1.html.

Rust, M. J., Bates, M., & Zhuang, X. (2006). Sub-diffraction-limit imaging by stochastic optical reconstruction microscopy (STORM). *Nature Methods*, *3*(10), 793–795.

Schmied, J. J., Forthmann, C., Pibiri, E., Lalkens, B., Nickels, P., Liedl, T., et al. (2013). DNA origami nanopillars as standards for three-dimensional superresolution microscopy. *Nano Letters*, *13*(2), 781–785. http://dx.doi.org/10.1021/nl304492y.

Schmied, J. J., Gietl, A., Holzmeister, P., Forthmann, C., Steinhauer, C., Dammeyer, T., et al. (2012). Fluorescence and super-resolution standards based on DNA origami. *Nature Methods*, *9*(12), 1133–1134. http://dx.doi.org/10.1038/nmeth.2254. http://www.nature.com/nmeth/journal/v9/n12/abs/nmeth.2254.html#supplementary-information.

Schmied, J. J., Raab, M., Forthmann, C., Pibiri, E., Wünsch, B., Dammeyer, T., et al. (2014). DNA origami based standards for quantitative fluorescence microscopy. *Nature Protocols*. http://dx.doi.org/10.1038/nprot.2014.079.

Seeman, N. C. (1982). Nucleic-acid junctions and lattices. *Journal of Theoretical Biology*, *99*(2), 237–247.

Shen, W., Zhong, H., Neff, D., & Norton, M. L. (2009). NTA directed protein nanopatterning on DNA origami nanoconstructs. *Journal of the American Chemical Society*, *131*(19), 6660–6661. http://dx.doi.org/10.1021/ja901407j.

Shroff, H., Galbraith, C. G., Galbraith, J. A., & Betzig, E. (2008). Live-cell photoactivated localization microscopy of nanoscale adhesion dynamics. *Nature Methods*, *5*(5), 417–423.

Sobczak, J. P., Martin, T. G., Gerling, T., & Dietz, H. (2012). Rapid folding of DNA into nanoscale shapes at constant temperature. *Science*, *338*(6113), 1458–1461. http://dx.doi.org/10.1126/science.1229919.

Stein, I. H., Schuller, V., Bohm, P., Tinnefeld, P., & Liedl, T. (2011). Single-molecule FRET ruler based on rigid DNA origami blocks. *Chemphyschem*, *12*(3), 689–695. http://dx.doi.org/10.1002/cphc.201000781.

Steinhauer, C., Forthmann, C., Vogelsang, J., & Tinnefeld, P. (2008). Superresolution microscopy on the basis of engineered dark states. *Journal of the American Chemical Society*, *130*(50), 16840–16841.

Steinhauer, C., Jungmann, R., Sobey, T. L., Simmel, F. C., & Tinnefeld, P. (2009). DNA origami as a nanoscopic ruler for super-resolution microscopy. *Angewandte Chemie (International Ed. in English), 48*(47), 8870–8873.

Thompson, M. A., Casolari, J. M., Badieirostami, M., Brown, P. O., & Moerner, W. E. (2010). Three-dimensional tracking of single mRNA particles in Saccharomyces cerevisiae using a double-helix point spread function. *Proceedings of the National Academy of Sciences of the United States of America, 107*(42), 17864–17871. http://dx.doi.org/10.1073/pnas.1012868107.

van de Linde, S., Heilemann, M., & Sauer, M. (2012). Live-cell super-resolution imaging with synthetic fluorophores. *Annual Review of Physical Chemistry, 63*, 519–540. http://dx.doi.org/10.1146/annurev-physchem-032811-112012.

Vogelsang, J., Steinhauer, C., Forthmann, C., Stein, I. H., Person-Skegro, B., Cordes, T., et al. (2010). Make them blink: Probes for super-resolution microscopy. *Chemphyschem, 11*, 2475–2490. http://dx.doi.org/10.1002/cphc.201000189.

Westphal, V., & Hell, S. W. (2005). Nanoscale resolution in the focal plane of an optical microscope. *Physical Review Letters, 94*(14), 143903.

Westphal, V., Rizzoli, S. O., Lauterbach, M. A., Kamin, D., Jahn, R., & Hell, S. W. (2008). Video-rate far-field optical nanoscopy dissects synaptic vesicle movement. *Science, 320*(5873), 246–249.

CHAPTER 25

Imaging and physically probing kinetochores in live dividing cells

Jonathan Kuhn[*,†], Sophie Dumont[*,†,‡]

[*]Department of Cell & Tissue Biology, University of California, San Francisco, California, USA
[†]Tetrad Graduate Program, University of California, San Francisco, California, USA
[‡]Department of Cellular & Molecular Pharmacology, University of California, San Francisco, California, USA

CHAPTER OUTLINE

Introduction	468
The Kinetochore	468
Mammalian Cells: Challenges	469
Chapter Overview	469
25.1 Spindle Compression to Image and Perturb Kinetochores	469
25.1.1 Historical Context	469
25.1.2 Motivation	470
25.1.3 Methods	471
25.1.3.1 Choice of Cell Line	471
25.1.3.2 Cell Culture	471
25.1.3.3 Agarose Pad Preparation	471
25.1.3.4 Experimental Setup	472
25.1.3.5 Before Spindle Compression	472
25.1.3.6 Spindle Compression	474
25.1.3.7 Choice of Compression Levels	474
25.1.3.8 After Spindle Compression	476
25.1.3.9 Troubleshooting Tips	476
25.2 Imaging Kinetochore Dynamics at Subpixel Resolution Via Two-Color Reporter Probes	477
25.2.1 Historical Context	477
25.2.2 Motivation	477
25.2.3 Methods	478
25.2.3.1 Gaussian Fitting for Subpixel Resolution	478
25.2.3.2 Choice of Cell Line and Reporter Probes	478
25.2.3.3 Expression of Reporter Probes	479
25.2.3.4 Experimental Setup	481
25.2.3.5 Before Live Cell Imaging: Two-color Bead Registration	481

| 25.2.3.6 Subpixel Resolution Kinetochore Imaging Via Two-color Reporter Probes .. 482
| 25.2.3.7 Data Analysis for Subpixel Resolution Kinetochore Imaging ... 482
| 25.2.3.8 Key Considerations for Interpretation of Interprobe Distances ... 483
Conclusion and Outlook ... 484
Acknowledgments .. 485
References ... 485

Abstract

The kinetochore mediates chromosome segregation at cell division. It is the macromolecular machine that links chromosomes to spindle microtubules, and is made of more than 100 protein species in mammalian cells. Molecular tools are presently revealing the biochemical interactions and regulatory mechanisms that ensure proper kinetochore function. Here, we discuss two approaches for imaging and physically probing kinetochores despite mitotic cell rounding and rapid kinetochore dynamics. First, we describe how mild spindle compression can improve kinetochore imaging and how stronger compression can mechanically perturb the spindle and kinetochores. Second, we describe how simultaneously imaging two-colored kinetochore reporter probes at subpixel resolution can report on kinetochore structural dynamics under cellular forces. We hope that the experimental details we provide here will make these two approaches broadly accessible and help move forward our understanding of kinetochore function—and make these approaches adaptable to the study of other cellular structures.

INTRODUCTION
THE KINETOCHORE

During cell division, the two daughter cells must inherit exactly one copy of each chromosome. Errors can lead to cell death or cancer in somatic cells or developmental disorders in the germ line. Chromosome segregation is mediated by the kinetochore, a 100-nm sized macromolecular machine that anchors chromosomes to microtubules in the spindle. The kinetochore regulates chromosome segregation and generates forces for chromosome movement. We now know most of the proteins that make up the kinetochore—more than 100 of them in mammalian cells (Cheeseman & Desai, 2008)—and are currently uncovering the kinetochore's underlying biochemical interactions and regulatory mechanisms. In parallel, we have begun to elucidate how kinetochores generate and respond to mechanical force. Mechanical forces assemble the spindle (Karsenti & Vernos, 2001), move chromosomes within it (Nicklas, 1983), and stabilize and correct kinetochore–microtubule attachments (Nicklas & Koch, 1969). Force has also been proposed to regulate chromosome segregation (Li & Nicklas, 1995). To understand how kinetochores generate

and respond to force, we need approaches for imaging kinetochore movement and structural dynamics under different forces, and approaches for externally perturbing forces. Here, we focus on two such approaches that are conceptually simple and can be applied to live mammalian cells.

MAMMALIAN CELLS: CHALLENGES

While there are many powerful genetic and biochemical techniques available in mammalian cells, the facts that mammalian cells round up at mitosis and that kinetochores are located deep within the cell make imaging and mechanical perturbations based on physical contact (such as with microneedles) difficult. In addition, kinetochores move rapidly, often in and out of a chosen focal plane over time, making it difficult to follow their movement over long periods. Kinetochores can also change their tilt angles with respect to the coverslip over time, confounding attempts to image molecular-scale rearrangements within kinetochores.

CHAPTER OVERVIEW

In this chapter, we first describe a simple approach utilizing an agarose pad and micromanipulator for compressing dividing mammalian cells and their spindles. Mild compression brings kinetochores closer to the coverslip to improve imaging and brings the spindle and kinetochore–microtubule axis roughly parallel to the coverslip. In turn, medium compression directly flattens the spindle, confining all kinetochores to a smaller volume, bringing more kinetochores into the same focal plane, and limiting kinetochore movement in and out of focus. Even stronger compression can limit chromosome movements, externally controlling—and increasing—the cellular forces that kinetochores experience. Second, we describe the use of simultaneous two-color subpixel imaging of kinetochore reporter probes. In combination with mild compression to help confine and align kinetochores, this allows monitoring structural kinetochore dynamics in real time under different cellular forces.

25.1 SPINDLE COMPRESSION TO IMAGE AND PERTURB KINETOCHORES

25.1.1 HISTORICAL CONTEXT

Several mechanical approaches have been used to probe chromosome segregation in live cells: some to improve imaging and others to mechanically perturb mitotic cells and their macromolecular machines. Examples of mechanical approaches to improve live cell imaging include coating coverslips (e.g., with poly-L-lysine) to help keep dividing cells flat, confining dividing cells in PDMS devices of different heights (Le Berre, Aubertin, & Piel, 2012), and laying an agar pad on top of a cell to reduce mitotic rounding and movement (Fukui, Yumura, & Yumura, 1987; Pereira, Matos, Lince-Faria, & Maiato, 2009). Examples of physical perturbation approaches include

microneedles to exert and measure tension on individual chromosomes and kinetochores in insect spermatocyte cells (Nicklas, 1983; Nicklas & Staehly, 1967); optical tweezers to move chromosomes inside mammalian cells (Liang, Wright, He, & Berns, 1991); and laser ablation to probe kinetochore motility (Khodjakov & Rieder, 1996), kinetochore signaling (Rieder, Cole, Khodjakov, & Sluder, 1995), and spindle mechanics (Snyder, Armstrong, Stonington, Spurck, & Pickett-Heaps, 1991). We note that outside live cells, optical tweezers have given us unprecedented access to kinetochore–microtubule attachment mechanics (Akiyoshi et al., 2010).

25.1.2 MOTIVATION

Here, we describe how spindles can be compressed in live mammalian cells using a micromanipulator to controllably and reversibly press an agarose pad down on the cell (Fig. 25.1). Unlike some methods of mechanical perturbation, spindle compression is compatible with high-resolution live imaging and indeed improves image

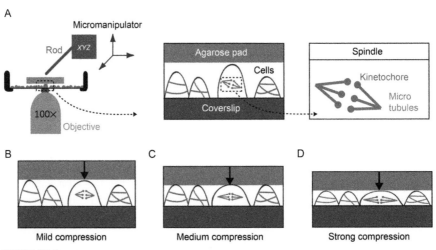

FIGURE 25.1

Spindle compression. (A) Experimental sketch for spindle compression. A micromanipulator presses a rod down on an agarose pad to compress the cells below it. (B) Mild compression flattens the cell, brings the spindle and kinetochores closer to the coverslip, and aligns the spindle with the coverslip axis—making it easier to follow kinetochores over time (Dumont, Salmon, & Mitchison, 2012). (C) Medium compression (Dumont & Mitchison, 2009) widens and lengthens the spindle, does not affect kinetochore motion and tension, and improves imaging by bringing more kinetochores into focus and limiting their movement in and out of the focal plane. (D) Strong compression improves imaging and pins down some of the chromosomes to the coverslip, preventing them from moving and resulting in interkinetochore distances significantly above the normal range (Dumont et al., 2012).

Part (A) adapted from Dumont et al. (2012).

quality. Furthermore, spindle compression requires little equipment besides a micromanipulator and is fully compatible with cell health. Mild compression has been used to improve conditions for subpixel kinetochore imaging (Dumont et al., 2012), medium compression to study the response of spindle size to mechanical force (Dumont & Mitchison, 2009), and strong compression to exert extraordinary forces on kinetochores (Dumont et al., 2012). In the succeeding text, we provide protocols for culturing cells in preparation for compression and for preparing agarose pads, outline the experimental setup we use for compression, and provide advice on executing and monitoring compression. We end this section with tips for troubleshooting common issues.

25.1.3 METHODS
25.1.3.1 Choice of cell line
Protocols in this chapter will focus on one type of mammalian cells: rat kangaroo kidney epithelial (Ptk2) cells. These already remain relatively flat at mitosis and have a small number of chromosomes—just 13 of them (Humphrey & Brinkley, 1969)—that are large and thus easy to image and distinguish from one another. They are amenable to RNAi, transfections, and other molecular techniques (Guimaraes, Dong, McEwen, & Deluca, 2008; Stout, Rizk, Kline, & Walczak, 2006). Based on our experience, we anticipate that compression will work in a variety of cell types and is easiest in flatter cells.

25.1.3.2 Cell culture
We culture Ptk2 cells in MEM (Invitrogen 11095) supplemented with sodium pyruvate (Invitrogen 11360), nonessential amino acids (Invitrogen 11140), penicillin/streptomycin, and 10% qualified and heat-inactivated fetal bovine serum (Invitrogen 10438). We plate cells on #1.5 25 mm round coverslips (HCl-cleaned and poly-L-lysine-coated) and image them in Leibovitz's L-15 medium with L-glutamine without phenol red (Invitrogen 21083) with antibiotics and serum as in the preceding text. When culturing Ptk2 cells, we recommend keeping cell confluency between 40% and 90%. When plating cells on coverslips for imaging, we typically dilute them to about 60% confluency and grow them for two days prior to imaging. Hallmarks of healthy cells include a high fraction of mitotic cells (rapidly growing population), and flat cells (including mitotic ones) that establish strong junctions with neighbors and display a "football-shaped" spindle area free of mitochondria, reflecting high microtubule density.

25.1.3.3 Agarose pad preparation
Begin by mixing a solution of PBS and 2% ultrapure agarose (Invitrogen 15510). The agarose concentration is chosen such that the pad is rigid enough to compress a large area of cells and compliant enough for compression to be robust, easy, and safe to perform. Boil this solution in the microwave until clear. Let cool for 5 min, and then,

use a plastic bulb pipet to fill a 60-mm plastic tissue culture dish with agarose solution around 2–3 mm deep (6–8 ml). Let the agarose solution cool until it appears "cloudy" and has solidified. Cut the agarose into 10–15 mm wide squares, making sure to exclude any piece of agarose that touches the edge of the plate and curves up (such that the pad is uniformly thick). Store these squares in imaging media (described earlier in the text) and let them sit overnight at 4 °C before using, so that they can equilibrate with the imaging media. At 4 °C, the pads will last at least one week. Before using any agarose pads on cells, warm them to the imaging temperature (we use 29–30 °C) immediately before imaging. If combining compression with pharmacological treatments (e.g., taxol), incubate the pads overnight in imaging media supplemented with the desired drug concentration. Note that adding a drug to, or washing a drug out from, a currently compressed cell may not be possible on a rapid timescale.

25.1.3.4 Experimental setup
We perform live imaging on a Nikon Eclipse Ti inverted microscope with 100×1.45 Ph3 oil objective through a $1.5 \times$ lens yielding 105 nm/pixel. Before, during, and after compression, we image cells by phase contrast and spinning disk confocal (Yokogawa CSU-X1) fluorescence imaging every few seconds on an Andor iXon3 camera, and keep cells in focus with the Nikon Perfect Focus System. We mount an oil hydraulic fine micromanipulator (Narishige MO-202) and coarse manipulator directly to our automated stage (ASI MS-2000 XYZ) (Fig. 25.2). We attach a metal rod (2 mm wide) to the fine micromanipulator to directly contact the agarose pad. We image cells at 29–30 °C in a homemade heated aluminum coverslip holder accepting 25 mm round coverslips that allows access of the micromanipulator rod to the coverslip at shallow angles. To facilitate access of the rod to the coverslip, it is easier to use a low numerical aperture (NA) condenser (we use 0.52 NA).

25.1.3.5 Before spindle compression
Mount the coverslip in its temperature-controlled holder, fill the holder with 3–4 ml of 30 °C media, and mount the holder on the microscope. Use phase contrast imaging to locate a good cell for compression and imaging, and center it in the field of view. The ideal cell to compress (Fig. 25.3) will be as flat as possible prior to compression so that additional flattening perturbs it as little as possible, will have significant contact with neighboring cells yet have cell-free space around it to flatten (an area about 80% confluent is ideal for this), and have a clear spindle region. It is critical that the cell to be compressed is away from the coverslip edges so that the agarose pad can be centered over it and the micromanipulator rod can access it (Fig. 25.2). After finding a good cell, gently deposit the agarose pad on top of the coverslip by placing it in the media. Once the pad has dropped onto the coverslip, gently nudge the side with tweezers to put the center of the pad directly above the objective. Next, position the micromanipulator rod by hand so that the rod end is directly above the objective and is touching the media but not the pad. Position the rod at as shallow an angle as possible (Fig. 25.2). Take care to ensure that the micromanipulator Z-control knob is adjusted

FIGURE 25.2

Experimental setup for spindle compression. The shallow angle of the micromanipulator rod and coverslip holder walls allows the rod access to the agarose pad (highlighted with a white dotted rectangle). The micromanipulator is attached directly to the stage and positioned in the center of the objective and pad.

 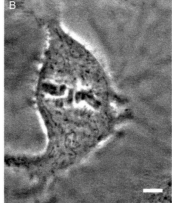

FIGURE 25.3

Choosing a cell for spindle compression. Phase contrast images of an (A) ideal and (B) nonideal Ptk2 cell for spindle compression. An ideal cell remains flat at mitosis prior to compression and has space available around it to increase its surface area upon compression. Note that in phase contrast imaging, a healthy spindle appears as a clear "football-shaped" region around chromosomes.

to the top of its range, so that the rod will have sufficient range to reach the pad. Then, finely adjust the position of the rod using fine micromanipulator X- and Y-control knobs to ensure it is centered above the cell (looking through the Bertrand lens may be helpful).

25.1.3.6 Spindle compression

Once the rod is centered, slowly begin lowering it using the micromanipulator Z-control knob. If imaging is needed during compression, we typically send 80% of phase contrast imaging light to the camera and 20% to microscope eyepieces. As the micromanipulator rod is lowered, the phase contrast image may begin to darken; if so, the condenser must be lowered as the rod is lowered to preserve Köhler illumination. Continue lowering the rod until particles in the media begin to rush (as seen through the eyepieces), reflecting first contact of the rod with the pad. From this point, only lower the rod a few microns at a time. The first sign that downward force is being exerted on the cell is that the spindle and chromosomes will spread outward. Adjustments to the focal plane are also typically necessary during compression as the position of the spindle with respect to the coverslip changes.

25.1.3.7 Choice of compression levels

We consider three compression levels, each with a different effect and purpose. Compression extent is fully under micromanipulator control and is reversible. The extent of compression can simply be monitored by the surface area of the cell as viewed in phase contrast imaging and can be further characterized by monitoring spindle thickness via 3D imaging (Z-stacks). While we do not know the precise amount of force that compression applies to the spindle, we estimate it to be on the order of hundreds of nanonewtons (Dumont et al., 2009):

(i) To achieve mild compression (Fig. 25.1B), lower the rod but stop right when the cell begins to bleb. This level of compression (typically 100–150 μm of micromanipulator travels from the point of first contact of the rod and pad) flattens the cell mildly, brings the spindle and kinetochores closer to the coverslip without flattening the spindle, and aligns the spindle with the coverslip axis without affecting chromosome motion—making it easier to follow kinetochores over time. The response of the cells to this compression level is reversible when the compression force is removed.

(ii) To achieve medium compression (Fig. 25.1C), continue lowering the rod for a few microns after the cell begins to bleb (after which it may or may not continue to bleb). Medium compression flattens the spindle: it widens the spindle (passively, over seconds) and lengthens it (actively, over minutes) up to 40% and does not affect kinetochore motility dynamics or interkinetochore distance, a proxy for kinetochore tension (Dumont et al., 2009). Medium compression improves imaging (Fig. 25.4): it confines all kinetochores to a smaller volume to image, brings more kinetochores into the same focal plane, and limits kinetochore movement in and out of the focal plane. For example,

in one study, we found that Ptk2 spindles were about 5–7 μm in height (from top to bottom kinetochore fibers) before and 3–4 μm in height after this level of compression (Dumont et al., 2009). As the pad is deformable, medium compression can require 10 μm or more of micromanipulator travel beyond mild compression in our conditions. The response of the cell and spindle to this compression level is typically reversible.

(iii) To achieve strong compression (Fig. 25.1D), continue lowering the rod until some chromosomes can no longer move freely because they are confined by low cell height. This can require an additional 10 μm or more of micromanipulator travel beyond medium compression in our conditions. In

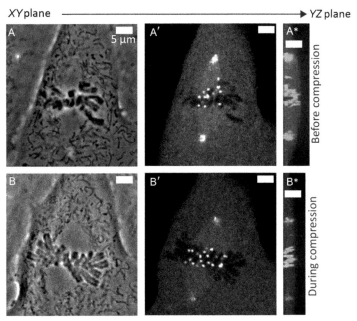

FIGURE 25.4

Images of a Ptk2 cell (A) before and (B) during medium spindle compression: phase contrast (A and B) and spinning disk confocal EYFP-Cdc20 (A′ and B′) images. Compression increases cell area, spindle width and length, number of in-focus chromosomes, and kinetochores (from about 10 to about 22). A Z-stack of confocal images was acquired (350 nm between planes), and a maximum intensity projection along the Y–Z plane (A* and B*) confirms that kinetochores are confined to a narrower volume slice during compression. Intensities should be compared with care between images in (A) and (B) as 5 min of imaging separates them; during this time, photobleaching takes place and Cdc20 localization changes as mitosis progresses (Howell et al., 2004). Intensity display scaling was adjusted for Y–Z planes to show cell shape changes as revealed by cytoplasmic EYFP-Cdc20. All X–Y images in this figure were acquired with 2 × 2 binning, yielding 210 nm/pixel.

addition to improving imaging for milder compression, strong compression effectively pins down some of the chromosomes to the coverslip, while microtubules are still exerting pulling forces on kinetochores: strong compression can prevent one kinetochore from moving, while its sister kinetochore is free to move, yielding interkinetochore distances significantly above the normal range (Dumont et al., 2012). This results in extraordinary forces being exerted on kinetochores and thus serves as a means to mechanically perturb kinetochores inside live cells. If such strong compression force is removed quickly by raising the rod rapidly, the spindle response is not reversible; however, if compression is removed more slowly (over $\gg 10$ s), the spindle responds more reversibly. For strong compression, be particularly cautious to align the rod on top of the cell and objective to avoid cracking the coverslip.

For all three compression levels, we generally lower the compression rod over 10–20 s and keep it down in position for as long as we want to image or perturb the cell. For mild and medium compression levels, anaphase entry is not significantly delayed during or after compression. Monitoring the time to anaphase entry is excellent practice.

25.1.3.8 After spindle compression

After compression is no longer needed, raise the rod upward with the micromanipulator. If other cells are to be used in the area of the compressed cell, raise the micromanipulator rod slowly to encourage reversible responses to compression removal. Importantly, never move the rod or the pad in $X-Y$ while a cell is under compression as this could shear cells off the coverslip. Always raise the micromanipulator rod before moving it in the $X-Y$ plane.

25.1.3.9 Troubleshooting tips

(i) *Poor phase contrast image in compressed cells.* Both the agarose pad and micromanipulator rod are in the transmitted light path and can thus affect phase contrast imaging. Köhler illumination should be maintained for good phase contrast generation, which in our experience may require bringing the condenser down during compression. Having about a 1.5-cm high pool of imaging media in the holder (several milliliters of media in our holder) is also helpful for this, and makes imaging more robust to media evaporation.

(ii) *Difficulty maintaining compression.* If compression is not maintained and the cell rounds up during compression, this suggests that the area being compressed is not directly over the cell. Either the rod or pad is not directly above the objective. Slowly release compression and correctly center the rod and pad in the $X-Y$ plane. Cells at the edge of the coverslip may be hard to compress, because either the rod or the center of the pad cannot reach them.

(iii) *Cell death upon compression.* Bleb expansion and retraction are often observed in compressed cells. While this is normal and to be expected, excessive blebbing and lack of bleb retraction indicate that compression is too strong for

cell health maintenance. In particular, if the cytoplasm slowly leaks or suddenly bursts—leading to cell death—this indicates that the compression level was too strong.

(iv) *Coverslip cracking upon compression.* If this occurs, it is most likely because the rod or pad is miscentered and not above the cell and objective. If the cell does not begin to compress shortly after the media rushes when the pad is brought down, raise the rod, recenter the rod and pad, and try again.

25.2 IMAGING KINETOCHORE DYNAMICS AT SUBPIXEL RESOLUTION VIA TWO-COLOR REPORTER PROBES

25.2.1 HISTORICAL CONTEXT

In the previous section, we described spindle compression as a method to improve kinetochore imaging under cellular forces and to externally perturb these forces. Here, we describe a method for monitoring the structural dynamics of kinetochores under force in live cells. Most of what we know about the global organization of mammalian kinetochores has come from electron microscopy, which reveals a multilayered structure (Dong, Vanden Beldt, Meng, Khodjakov, & McEwen, 2007): an inner plate at centromeric chromatin and outer plate near microtubule plus ends. In turn, biochemical analysis has revealed information on relative positions of different kinetochore proteins between chromatin and microtubules (Cheeseman & Desai, 2008). Until a few years ago, obtaining high-resolution positional data with molecular specificity presented a major challenge: while kinetochore proteins could be tagged with fluorescent markers, the distance between chromatin-binding and microtubule-binding kinetochore proteins (about 100 nm) is below the diffraction limit of light. Förster resonance energy transfer only informs on distances smaller than 10 nm. The application of Gaussian fitting to find the center of diffraction-limited objects (Yildiz et al., 2003) and the distance between them (Churchman, Okten, Rock, Dawson, & Spudich, 2005) now provides us with a means to use fluorescence imaging to position kinetochore proteins with respect to each other and to measure linkage deformations under different conditions.

25.2.2 MOTIVATION

Here, we describe an adaptation of SHREC (single-molecule high-resolution colocalization) (Churchman et al., 2005) to measure the distance between two groups of differently colored reporter probes within a single kinetochore in live mammalian cells, which we refer to as "intrakinetochore distance" (Wan et al., 2009). SHREC in fixed cells has revealed the architecture of the mammalian kinetochore–microtubule attachment site with 5 nm accuracy (Wan et al., 2009). Three key features make kinetochore live cell SHREC possible: (i) The high copy number of most protein species

within one kinetochore means that enough photons can be collected with genetically encoded fluorescent proteins; (ii) the natural orientation of the kinetochore–microtubule axis roughly parallel to the coverslip axis makes it possible to measure intrakinetochore distances along this axis; and (iii) the cyclical nature of kinetochore movements in mammalian metaphase chromosome oscillations makes data averaging possible by providing clear synchronization points. However, challenges to live kinetochore SHREC measurements are significant: kinetochores are found deep inside round mitotic cells, move up and down—and can tilt—with respect to the imaging plane, and move fast; in addition, not all copies of the same protein may localize to the same kinetochore site. Yet, using live kinetochore SHREC, it has been possible to relate structural dynamics and different microtubule forces (Dumont et al., 2012; Joglekar, Bloom, & Salmon, 2009). In the succeeding text, we describe cell preparation, the experimental setup, imaging, and basic data analysis guidelines for live kinetochore SHREC and mention key questions to consider in data interpretation.

25.2.3 METHODS

25.2.3.1 Gaussian fitting for subpixel resolution

If a single fluorescent molecule is imaged, it forms a diffraction-limited image of width $\lambda/(2NA)$, with λ the wavelength of light and NA the collection objective NA. If we fit the image to a 2D Gaussian, the mean corresponds to the position of the single molecule. The standard error of the mean, which reflects our ability to estimate the mean, will depend on photon noise, the effect of the detector's finite pixel size, and background noise (Thompson, Larson, & Webb, 2002; Yildiz et al., 2003). Thus, for improved accuracy, we must collect as many photons as possible and choose a camera carefully. Although Gaussian-fitting approaches were developed for single molecules, they have been applied to groups of kinetochore proteins: there are several copies of each kinetochore protein per microtubule (Johnston et al., 2010) and multiple microtubules per mammalian kinetochore (20–25 in Ptk cells; McEwen, Heagle, Cassels, Buttle, & Rieder, 1997), and thus, there are a couple to a few hundred copies of some proteins at each mammalian kinetochore. As discussed later in the text, care must be taken to understand the assumptions behind the use of a single-molecule technique for groups of molecules.

25.2.3.2 Choice of cell line and reporter probes

We focus on Ptk2 rat kangaroo kidney epithelial cells for the same reasons as for spindle compression. To measure intrakinetochore distances via live SHREC, two reporter probes (Fig. 25.5A) should be chosen such that (i) the labeled kinetochore proteins are expected to be sufficiently distant from each other (50 nm and above are good starting points)—based on protein distances in fixed cells (Wan et al., 2009) and related biochemical data—for live SHREC to robustly resolve this distance; (ii) they are fused to fluorescent proteins with nonoverlapping spectra; (iii) they can be expressed at high enough levels in cells without adversely affecting function

25.2 Imaging kinetochore dynamics at subpixel resolution

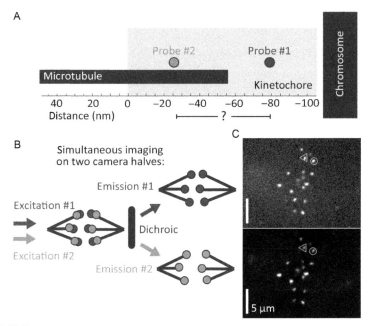

FIGURE 25.5

Simultaneously imaging two kinetochore reporter probes in live cells. (A) Reporter probes must be chosen with care, and here, we depict the expected position (Wan et al., 2009) of two probes we have used: CenpC-mCherry (probe #1) and EYFP-Cdc20 (probe #2). (B) To monitor kinetochore structural dynamics live, both probes are simultaneously imaged on each half of the camera by using a dichroic (DualView) to separate emission photons from each probe. (C) Simultaneous imaging of CenpC-mCherry (top, probe #1) and EYFP-Cdc20 (bottom, probe #2) on two camera halves. The identified kinetochore pair will be analyzed in Fig. 25.6. (See the color plate.)

Part (C) adapted from Dumont et al. (2012).

(to get high photon counts and a good estimate of the Gaussian center); and (iv) they are not known to bind anywhere else near kinetochores (e.g., to microtubules in a kinetochore-independent manner), as this could affect Gaussian fitting. In addition, to aid in data interpretation on the relationship between intrakinetochore distances and microtubule forces, we recommend choosing reporter probes that take on structural (as opposed to regulatory) roles at kinetochores when possible.

25.2.3.3 Expression of reporter probes

Two reporter probes must be expressed using either transient transfection or infection, or in stable cell lines. For example, we have recently used transient transfection to express Hec1-EGFP or EYFP-Cdc20 (outer kinetochore proteins) and CenpC-mCherry (inner kinetochore protein) in Ptk2 cells (Fig. 25.5B and C): we transfect cells on a 25 mm coverslip in a six-well plate filled with 2.5 ml

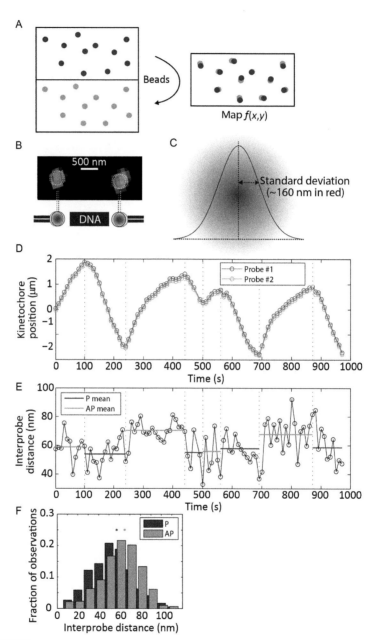

FIGURE 25.6

Measuring kinetochore interprobe distances. (A) We image two-color beads in both green and red channels and find the transform. $f(x,y)$ that maps Gaussian-fitted position differences in both channels. (B) Enlarged two-color image of the kinetochore pair identified in Fig. 25.5C (left, triangle; right, circle). (C) Each kinetochore probe leads to an image that is fit to a 2D

antibiotic-free media using 0.5 μg of each plasmid with 3 μl FuGENE 6 (Promega E2693). Cells are either plated on coverslips 24 h before transfection or plated and transfected together. Cells are imaged 36–48 h posttransfection in imaging media as described previously in the text. Cells expressing one probe will typically also express the other, and using the earlier-mentioned protocol, we find that 30–50% of cells express both probes.

25.2.3.4 Experimental setup
We use the setup described for spindle compression, with a Yokogawa CSU-X1 spinning disk confocal with 488 and 561 nm diode lasers (100–150 mW lasers, used at a fraction of their power), and add a DualView (Photometrics, Chroma 565 dcxr dichroic and ET525/50M and ET630/75M emission filters) module for simultaneous EGFP or EYFP and mCherry camera acquisition (Fig. 25.5B and C). We have confirmed the lack of channel cross talk with EGFP or EYFP and mCherry (Semrock Yokogawa dichroic Di01-T405/488/561). We use an Andor iXon3 camera with 5× preamp gain and no EM gain: EGFP or EYFP and mCherry are simultaneously excited, and emissions collected simultaneously on each camera half. Simultaneous imaging is critical because of fast kinetochore movements during mammalian mitosis (if kinetochores move at 1 μm/min, this means 17 nm each second!).

25.2.3.5 Before live cell imaging: Two-color bead registration
Before the distance between two different kinetochore protein populations can be measured with EGFP/EYFP and mCherry probes, one must map chromatic aberrations (differences in how the same object appears in two different colors) over the field of view (Fig. 25.6A). To do this, we mount scattered TetraSpeck 100 nm beads (Invitrogen T-7279) to a coverslip surface and simultaneously image the same beads in both green and red channels. We then use the 2D Gaussian-fitted centers (*lsqcurvefit*, MATLAB) of these beads in both channels to create a position-dependent 2D transform (we find that MATLAB's *cp2tform* with polynomial degree two works well) that accounts for chromatic aberrations (Churchman et al., 2005). This transform can then be applied to other bead slides to probe its error.

FIGURE 25.6—CONT'D Gaussian (which we find has a standard deviation of about 160 nm along the microtubule axis, slightly larger than 100 nm beads; Dumont et al., 2012). (D) Tracks of one kinetochore's (the right one in (B)) two probes (EYFP-Cdc20 and CenpC-mCherry, as for (E) and (F)), moving during chromosome oscillations (dashed lines, reversals). (E) Interprobe distance versus time from the tracks in (D), highlighting poleward (P, red or dark gray) and away-from-pole (AP, blue or light gray) movement. (F) As an example measurement, we show data suggesting that kinetochores are in different structural states during poleward and away-from-pole movement. Histograms of interprobe distances over different times, kinetochores and cells for poleward (red or dark gray) and away-from-pole (blue or light gray) movement: 47 ± 20 nm poleward ($n=525$) and 55 ± 19 nm away-from-pole ($n=569$). (See the color plate.)

Parts (B) and (D–F) adapted from Dumont et al. (2012).

If performance is satisfactory, it can then be used to register (i.e., correctly align and relatively position) EGFP/EYFP and mCherry kinetochore images together and ultimately measure intrakinetochore distances. In our experience, it is helpful to perform this bead registration every day before beginning imaging.

25.2.3.6 Subpixel resolution kinetochore imaging via two-color reporter probes

We use phase contrast imaging to find metaphase cells without bleaching fluorophores and then confocal imaging to assess whether both probes are expressed and whether their expression level (i.e., collected photon count) is high enough for needed localization accuracy. For CenpC-mCherry and Hec1-EGFP or EYFP-Cdc20, we typically collect 4000–7000 photons/kinetochore (which we can estimate using the electron-to-photon conversion factor obtained after camera calibration), and the signal-to-noise ratio (SNR) is typically 15–20 (SNR $=I_{max}/\sqrt{(I_{max}+b^2)}$, with I_{max} the maximum pixel photon count and b the background photon standard deviation). Once a proper cell has been identified, we perform medium compression (as described in the preceding text) to (i) bring more kinetochores in the same plane, which means faster data collection; (ii) limit out of plane movement, which allows us to follow a single kinetochore pair over long times as it experiences different forces; and (iii) help align the kinetochore–microtubule axis to the coverslip, since this is the axis along which we measure distance. We typically wait a few minutes between starting compression and starting data collection. At every time point, we acquire a phase contrast image to monitor cell health and associate kinetochores in pairs by identifying chromosomes and a simultaneous two-color confocal image to monitor the distance between the two kinetochore probes (Fig. 25.6B). Images are acquired at 105 nm/pixel (bin $=1$), and exposure times are kept as short as possible to avoid blurring the distributions due to movement. Because we attempt to follow the same kinetochore over long times as microtubule forces change, we do not typically collect Z-stacks to avoid photobleaching and thus only perform Gaussian fitting in 2D. If Z-stacks can be acquired, Gaussian fitting in 3D has the advantage of reporting on kinetochore tilt.

25.2.3.7 Data analysis for subpixel resolution kinetochore imaging

After data collection, we begin by tracking each kinetochore's position over time (SpeckleTracker, MATLAB program written by Xiaohu Wan) and then determine the centroids of the Hec1-EGFP or EYFP-Cdc20 and CenpC-mCherry probes at each time point by fitting a 2D Gaussian (*lsqcurvefit*, MATLAB) in a 10×10 pixel box (Fig. 25.6C and D). Applying the two-color bead registration map to the EGFP/EYFP and mCherry images, we then find the interprobe distance at each time (Fig. 25.6E): this distance fluctuates broadly over time, and thus, we pool together interprobe distances from different times, kinetochores and cells in conditions we believe to be similar (Fig. 25.6F). Metaphase chromosome oscillations can be used as a system where averaging can be performed over well-defined periodically recurring events: for example, in recent work, we found that the interprobe distance was different by an

average of 8 nm in kinetochores moving toward and away from the spindle pole (Fig. 25.6E and F) (Dumont et al., 2012). To validate such conclusions, it is essential to check whether individual kinetochores behave—on average—like the means do. We calculate interprobe distance as the mean of the Gaussian fit of the distance distribution and note that because the interprobe distance cannot be negative, this can overestimate the interprobe distance—particularly for small distances (Churchman, Flyvbjerg, & Spudich, 2006). In our conditions, we measure the standard deviation of the interprobe distance distribution to be about 20 nm, and this includes contributions from centroid determination with limited photon counts (4–6 nm accuracy for our conditions; Mortensen, Churchman, Spudich, & Flyvbjerg, 2010), two-color registration map estimation errors (target registration error as high as 7 nm in our tests; Churchman et al., 2005), map application to inhomogeneous environments deep inside the cell, and biological variation (Dumont et al., 2012).

25.2.3.8 Key considerations for interpretation of interprobe distances

(i) *Meaning of the Gaussian center and of interprobe distances.* It is important to keep in mind that the Gaussian-fit center of many copies of the same kinetochore protein does not necessarily correspond to the location of all protein copies (Fig. 25.7A). If protein copies are tightly clustered, mean localization will not be affected; however, if protein copies are too scattered, then assumptions behind Gaussian fitting break down (Joglekar et al., 2009; Wan et al., 2009). In an extreme example, if the protein copies were distributed in a bimodal distribution, the centroid could be in a region where few protein copies actually reside. The position of the centroid reflects the position of the center of mass of a group of proteins, not that of every molecule.

(ii) *Contributions of nonstructural factors to changes in interprobe distances.* While it is tempting to interpret changes in interprobe distance as structural changes within the kinetochore, other events may lead to interprobe distance changes. Most notably, both kinetochore tilt with respect to the coverslip and changes in protein binding sites at the kinetochore could lead to apparent interprobe changes. First, given that most microtubules terminate at the kinetochore within a 30-nm band along the microtubule axis (McEwen & Heagle, 1997) and that microtubule plus ends are located in a 400-nm diameter circle in Ptk kinetochores (McDonald, O'Toole, Mastronarde, & McIntosh, 1992), one can estimate the amount by which tilt would be expected to widen the kinetochore probe image standard deviation (Dumont et al., 2012). While such tilt has thus far been insufficient to explain observed changes in distance between Gaussian centers, its possible effects must always be considered (Fig. 25.7B). Second, dynamic changes in protein binding may always contribute to apparent interprobe distance changes (e.g., if reporter proteins bound different sites on the kinetochore over time; Fig. 25.7C), and such possibilities can be carefully evaluated by measuring changes in parameters such as protein intensities, recovery kinetics after photobleaching, and Gaussian standard deviations over time.

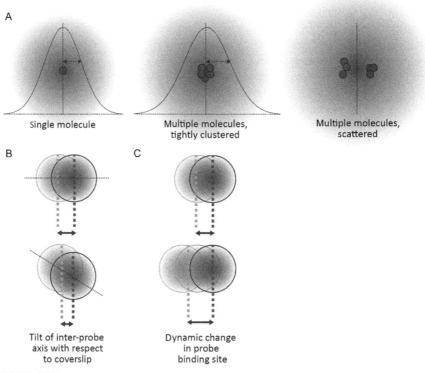

FIGURE 25.7

Considerations for interpreting interprobe distances. (A) The Gaussian-fit center of many copies of the same kinetochore protein does not necessarily correspond to the location of all protein copies. Protein copies that are tightly clustered will not affect mean localization, but if protein copies are too scattered, assumptions behind Gaussian fitting break down (Joglekar et al., 2009; Wan et al., 2009). Also, nonstructural factors can lead to apparent changes in interprobe distances, such as (B) tilt of the interprobe axis with respect to the coverslip and (C) dynamic changes in probe binding sites (such as recruitment to a new binding site, as depicted here). In the text, we provide pointers for evaluating the effects of (B and C). (See the color plate.)

CONCLUSION AND OUTLOOK

Mammalian cells round up when they divide, and many key structures that mediate division are highly dynamic. Together, these make imaging and physically probing cell division structures difficult. In this chapter, we have presented two conceptually simple methods to image and physically probe kinetochores in live dividing mammalian cells: (i) spindle compression improves imaging inside round cells, and stronger compression can be used as a tool to mechanically perturb the spindle and kinetochores

and (ii) in turn, subpixel imaging of kinetochore linkages can probe kinetochore structural dynamics under cellular forces. We hope that the experimental details we provide, as well as our open discussion of common technical and interpretation pitfalls, will make these two approaches broadly accessible—and together move forward our understanding of kinetochore function. Lastly, we note that these methods—once adapted—may help us image and physically probe other cellular structures.

ACKNOWLEDGMENTS

We thank Tim Mitchison and Ted Salmon for their conceptual and technical suggestions, Stirling Churchman and Jennifer Waters for their quantitative microscopy advice, Xiaohu Wan for sharing the SpeckleTracker MATLAB program, Jagesh Shah for the stable Ptk2 EYFP-Cdc20 line, Jennifer DeLuca for her constructs and help culturing and transfecting Ptk cells, Christopher Carroll for his constructs, and the Dumont Lab for discussions and critical reading of the manuscript. Work was supported by a NSF Graduate Research Fellowship (J.K.), NIH T32GM007810 (J. K.), NIH R00GM09433, and UCSF PBBR funds. S. D. is a Searle, Kimmel, and Rita Allen Foundation scholar and a Sloan Research fellow.

REFERENCES

Akiyoshi, B., Sarangapani, K. K., Powers, A. F., Nelson, C. R., Reichow, S. L., Arellano-Santoyo, H., et al. (2010). Tension directly stabilizes reconstituted kinetochore-microtubule attachments. *Nature*, *468*, 576–579.

Cheeseman, I. M., & Desai, A. (2008). Molecular architecture of the kinetochore-microtubule interface. *Nature Reviews. Molecular Cell Biology*, *9*, 33–46.

Churchman, L. S., Flyvbjerg, H., & Spudich, J. A. (2006). A non-Gaussian distribution quantifies distances measured with fluorescence localization techniques. *Biophysical Journal*, *90*, 668–671.

Churchman, L. S., Okten, Z., Rock, R. S., Dawson, J. F., & Spudich, J. A. (2005). Single molecule high-resolution colocalization of Cy3 and Cy5 attached to macromolecules measures intramolecular distances through time. *Proceedings of the National Academy of Sciences*, *102*, 1419–1423.

Dong, Y., Vanden Beldt, K. J., Meng, X., Khodjakov, A., & McEwen, B. F. (2007). The outer plate in vertebrate kinetochores is a flexible network with multiple microtubule interactions. *Nature Cell Biology*, *9*, 516–522.

Dumont, S., & Mitchison, T. J. (2009). Compression regulates spindle length by a mechanochemical switch at the poles. *Current Biology*, *19*, 1086–1095.

Dumont, S., Salmon, E. D., & Mitchison, T. (2012). Deformations within moving kinetochores reveal different sites of active and passive force generation. *Science*, *337*, 355–358.

Fukui, Y., Yumura, S., & Yumura, T. K. (1987). Agar-overlay immunofluorescence: High-resolution studies of cytoskeletal components and their changes during chemotaxis. *Methods in Cell Biology*, *28*, 347–356.

Guimaraes, G. J., Dong, Y., McEwen, B. F., & Deluca, J. G. (2008). Kinetochore-microtubule attachment relies on the disordered N-terminal tail domain of Hec1. *Current Biology*, *18*, 1778–1784.

Howell, B. J., Moree, B., Farrar, E. M., Stewart, S., Fang, G., & Salmon, E. D. (2004). Spindle checkpoint protein dynamics at kinetochores in living cells. *Current Biology*, *14*, 953–964.

Humphrey, R. M., & Brinkley, B. R. (1969). Ultrastructural studies of radiation-induced chromosome damage. *Journal of Cell Biology*, *42*, 745–753.

Joglekar, A. P., Bloom, K., & Salmon, E. D. (2009). In vivo protein architecture of the eukaryotic kinetochore with nanometer scale accuracy. *Current Biology*, *19*, 694–699.

Johnston, K., Joglekar, A., Hori, T., Suzuki, A., Fukagawa, T., & Salmon, E. D. (2010). Vertebrate kinetochore protein architecture: Protein copy number. *Journal of Cell Biology*, *189*, 937–943.

Karsenti, E., & Vernos, I. (2001). The mitotic spindle: A self-made machine. *Science*, *294*, 543–547.

Khodjakov, A., & Rieder, C. L. (1996). Kinetochores moving away from their associated pole do not exert a significant pushing force on the chromosome. *Journal of Cell Biology*, *135*, 315–327.

Le Berre, M., Aubertin, J., & Piel, M. (2012). Fine control of nuclear confinement identifies a threshold deformation leading to lamina rupture and induction of specific genes. *Integrative Biology: Quantitative Biosciences from Nano to Macro*, *4*, 1406–1414.

Li, X., & Nicklas, R. B. (1995). Mitotic forces control a cell-cycle checkpoint. *Nature*, *373*, 630–632.

Liang, H., Wright, W. H., He, W., & Berns, M. W. (1991). Micromanipulation of mitotic chromosomes in PTK2 cells using laser-induced optical forces ("optical tweezers"). *Experimental Cell Research*, *197*, 21–35.

McDonald, K. L., O'Toole, E. T., Mastronarde, D. N., & McIntosh, J. R. (1992). Kinetochore microtubules in PTK cells. *Journal of Cell Biology*, *118*, 369–383.

McEwen, B. F., & Heagle, A. B. (1997). Electron microscopic tomography: A tool for probing the structure and function of subcellular components. *International Journal of Imaging Systems and Technology*, *8*, 175–187.

McEwen, B. F., Heagle, A. B., Cassels, G. O., Buttle, K. F., & Rieder, C. L. (1997). Kinetochore-fiber maturation in PtK1 cells and its implications for the mechanisms of chromosome congression and anaphase onset. *Journal of Cell Biology*, *137*, 1567–1580.

Mortensen, K. I., Churchman, L. S., Spudich, J., & Flyvbjerg, H. (2010). Optimized localization analysis for single-molecule tracking and super-resolution microscopy. *Nature Methods*, *7*, 377–381.

Nicklas, R. B. (1983). Measurements of the force produced by the mitotic spindle in anaphase. *Journal of Cell Biology*, *97*, 532–548.

Nicklas, R. B., & Koch, C. A. (1969). Chromosome micromanipulation III: Spindle fiber tension and the reorientation of mal-oriented chromosomes. *Journal of Cell Biology*, *43*, 40–50.

Nicklas, R. B., & Staehly, C. A. (1967). Chromosome micromanipulation. I. The mechanics of chromosome attachment to the spindle. *Chromosoma*, *21*, 1–16.

Pereira, J., Matos, I., Lince-Faria, M., & Maiato, H. (2009). Dissecting mitosis with laser microsurgery and RNAi in Drosophila cells. *Methods in Molecular Biology*, *545*, 145–164.

Rieder, C. L., Cole, R. W., Khodjakov, A., & Sluder, G. (1995). The checkpoint delaying anaphase in response to chromosome monoorientation is mediated by an inhibitory signal produced by unattached kinetochores. *Journal of Cell Biology*, *130*, 941–948.

Snyder, J. A., Armstrong, L., Stonington, O. G., Spurck, T. P., & Pickett-Heaps, J. D. (1991). UV-microbeam irradiations of the mitotic spindle: Spindle forces and structural analysis of lesions. *European Journal of Cell Biology*, *55*, 122–132.

Stout, J. R., Rizk, R. S., Kline, S. L., & Walczak, C. E. (2006). Deciphering protein function during mitosis in PtK cells using RNAi. *BMC Cell Biology, 7*, 26.

Thompson, R. E., Larson, D. R., & Webb, W. W. (2002). Precise nanometer localization analysis for individual fluorescent probes. *Biophysical Journal, 82*, 2775–2783.

Wan, X., O'Quinn, R. P., Pierce, H. L., Joglekar, A. P., Gall, W. E., DeLuca, J. G., et al. (2009). Protein architecture of the human kinetochore microtubule attachment site. *Cell, 137*, 672–684.

Yildiz, A., Forkey, J. N., McKinney, S. A., Ha, T., Goldman, Y. E., & Selvin, P. R. (2003). Myosin V walks hand-over-hand: Single fluorophore imaging with 1.5-nm localization. *Science, 300*, 2061.

CHAPTER

Adaptive fluorescence microscopy by online feedback image analysis

26

Christian Tischer*,[1], Volker Hilsenstein*,[1], Kirsten Hanson[†], Rainer Pepperkok*

*European Molecular Biology Laboratory, Heidelberg, Germany
[†]Instituto de Medicina Molecular, Lisboa, Portugal

CHAPTER OUTLINE

Introduction ... 490
26.1 Requirements for Adaptive Feedback Microscopy ... 492
26.2 Selected Applications ... 493
 26.2.1 Automated Detection and Imaging of *Plasmodium*-infected Cells ... 493
 26.2.1.1 Motivation ... 493
 26.2.1.2 Sample Preparation .. 495
 26.2.1.3 Feedback Microscopy Implementation Using CellProfiler
 and LASAF Matrix Screener 495
 26.2.1.4 CellProfiler for Adaptive Feedback Microscopy 495
 26.2.1.5 Setting Up and Running the Experiment 496
 26.2.1.6 Results and Discussion .. 497
 26.2.2 Automated FRAP on ER Exit Sites ... 497
 26.2.2.1 Motivation and Automation Workflow Overview 497
 26.2.2.2 Sample Preparation .. 498
 26.2.2.3 Workflow and Implementation 498
 26.2.2.4 Results and Discussion .. 500
Acknowledgments .. 501
References .. 501

Abstract

Obtaining sufficient statistics in quantitative fluorescence microscopy is often hampered by the tedious and time-consuming task of manually locating comparable specimen and repeatedly launching the same acquisition protocol. Recent advances in combining fluorescence

[1]These authors contributed equally.

microscopy with online image analysis tackle this problem by fully integrating the task of identifying and locating the specimen of interest in an automated acquisition workflow. Here, we describe the general requirements and specific microscope control and image analysis software solutions for implementing such automated online feedback microscopy. We demonstrate the power of the method by two selected applications addressing high-throughput 3D imaging of sparsely parasite-infected tissue culture cells and automated fluorescence recovery after photobleaching experiments to quantify the turnover of vesicular coat proteins at ER exit sites.

INTRODUCTION

Quantitative fluorescence microscopy is a powerful tool to investigate the temporal and spatial behavior of labeled molecules in intact biological specimen. The technology has the advantage of providing information at the single cell level, and the data acquired can therefore account for biological heterogeneity in cell populations (Elowitz, Levine, Siggia, & Swain, 2002; Pelkmans, 2012). However, in order to achieve statistical significance, large numbers of cells and samples need to be imaged. High-throughput microscopy (Pepperkok & Ellenberg, 2006) based on completely computer-controlled automated microscope systems can address this need for observing large numbers of cells and samples by imaging along a predefined scan pattern using an automated scanning stage. In many cases, however, the phenotypes to be monitored are only represented in a small subpopulation of the specimen or during specific biological stages. In such experiments, the objects of interest are typically first manually identified by the microscope operator before they are imaged with experiment-specific settings. Acquiring data in this manner is very time-consuming and imposes a practical limit on the number of events that can be recorded. Further, manual identification of the object to be imaged is highly subjective and may thus lead to unpredictable variations of results.

Recent approaches address these limitations by combining high-throughput microscopy with online image analysis (Fig. 26.1A) to fully automate and integrate the identification of objects of interest and their subsequent high-content imaging (Conrad et al., 2011; Tsukada & Hashimoto, 2013). Typically, prior to the experiment, the researcher configures an image analysis algorithm to automatically detect the objects of interest in microscopy images of low resolution. During the experiment, the microscope automatically scans the sample at high speed and low resolution while sending acquired images to the analysis software (prescan). In case the analysis software detects an object of interest, it feeds the object location back to the microscope control software, which then launches a high-content imaging protocol at the given location. Once the high-content acquisition has finished, the microscope proceeds with the regular scanning of the sample at low resolution until the next object of interest is found (Fig. 26.1B).

Such microscope automation offers several advantages. First, the researcher saves time as the microscope conducts a series of experiments in the absence of human interaction. Second, in such fully automated microscopy experiments,

Introduction

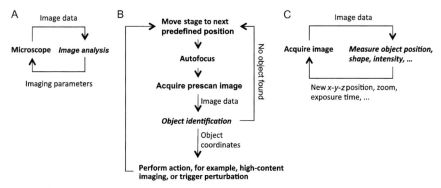

FIGURE 26.1

General concept of adaptive feedback microscopy. (A) Schematic drawing of the two-way communication between a microscope and image analysis software as necessary for adaptive feedback microscopy. (B and C) Example workflows using the communication shown in (A). Image analysis steps are shown in italics. (B) Scanning workflow: the sample is scanned in order to find objects of interest, which are then imaged at high resolution or can be perturbed, for example, by photobleaching or automated drug addition. (C) Tracking workflow: an object is followed over time and imaging modalities are continuously adapted to the object's changing shape and brightness.

the objects of interest are selected by a computer algorithm, arguably resulting in more consistent data than could be obtained by the potentially changing and biased selection criteria of a human operator.

Online feedback microscopy approaches have already been implemented for a number of applications, for example, to identify mitotic cells at low resolution and subsequently image them at high resolution, to conduct fluorescence recovery after photobleaching (FRAP) (Conrad et al., 2011), to find and image isolated cells growing on micro-patterned surfaces (Tosi, Bardia, Llado, & Colombelli, 2013), or for high-resolution imaging of specific regions in the embryonic zebra fish brain (Peravali et al., 2011).

Another scenario where microscopy benefits from online image analysis is when the location and/or shape of the observed object is changing during a time-lapse experiment (Fig. 26.1C). Using online image analysis, the acquisition parameters can be automatically adapted, for example, to track the object or to adapt z-stack settings, zoom, or illumination intensity. This approach has, for instance, been used in confocal fluorescence microscopy to follow individual cultured cells over time (Rabut & Ellenberg, 2004) or automated optogenetic manipulation of the neural activity of freely moving *Caenorhabditis elegans* (Leifer, Fang-Yen, Gershow, Alkema, & Samuel, 2011; Stirman et al., 2011).

In this chapter, we discuss general requirements, specific implementations, and selected applications of such adaptive feedback microscopy.

26.1 REQUIREMENTS FOR ADAPTIVE FEEDBACK MICROSCOPY

A microscope system must meet a number of requirements to be suitable for adaptive feedback microscopy implementation. First, microscope components must be fully automated, such that sample location (stage position) and imaging parameters can be changed via software. Many commercially available microscopes satisfy this requirement. Second, there must be a way to establish a link between online image analysis and microscope control such that a two-way feedback can be implemented. This link must be flexible enough to allow microscope settings to be conditionally altered, for example, by a scripting language. In practice, this requirement is more difficult to meet, as some microscope systems can only be controlled through vendor-supplied, closed software packages. Existing solutions for feedback microscopy broadly fall into two categories (Table 26.1). One category integrates both microscope control and image analysis and offers basic scripting to define workflows. The second interfaces external software to the microscope control software through a third-party interface. In these solutions, the external software performs the image analysis and triggers microscope actions in response to events detected in the images. Most of the more complex point-scanning confocal microscopes fall into the latter category with some vendors offering a third-party interface. As these interfaces are not standardized and generally differ significantly in their architecture, microscope-specific solutions must be implemented. One approach to this is to develop modules that handle the communication with the

Table 26.1 Examples of Software Solutions for Adaptive Feedback Microscopy

Software integrating microscope control and image analysis		
Software	References	Comments
Labview	Leifer et al. (2011), National-Instruments (2014), Stirman et al. (2011)	Drivers for many instruments available; graphical programming; easy GUI creation
Metamorph	Molecular-Devices (2013)	Drivers for many instruments available; journaling to develop automated workflows
MATLAB	Chung, Crane, and Lu (2008), Mathworks (n.d.), Pologruto, Sabatini, and Svoboda (2003)	Strong image processing capabilities; often used in biological community
Micro-Manager	Edelstein, Amodaj, Hoover, Vale, and Stuurman (2010), Ron Vale (n.d.)	Drivers for many instruments available; ImageJ or MATLAB integration for image analysis
Meta-Systems	Metasystems (n.d.)	Integrated commercial solution; Metafer module dedicated to finding metaphase cells

Continued

Table 26.1 Examples of Software Solutions for Adaptive Feedback Microscopy—cont'd

Microscope control software interfacing to external image analysis		
Microscope control/ communication interface	**References**	**Comments**
Zeiss ZEN Black/Visual Basic API	Zeiss (2012a)	For Zeiss 780 confocal microscopes; Visual Basic API provides control to all relevant hardware components
Zeiss ZEN Blue/ IronPython API	Zeiss (2012b)	For Zeiss wide-field microscopes; IronPython API provides direct control to all relevant hardware components
Leica LASAF/Matrix Screener (TCP IP Communication)	Leica-Microsystems (2014)	Matrix Screener enables multiwell scanning. Matrix Screener listens to TCP/IP commands that trigger execution of specific acquisition "Jobs" as defined in LASAF

Image analysis software interfacing with microscope control software		
Software	**References**	**Comments**
ImageJ/FIJI	Rasband (1997), Schindelin et al. (2012)	Open source; Java-based; scripting and GUI
CellProfiler	Carpenter et al. (2006)	Open source; Python-based; GUI for construction of analysis workflows; cell object logic; batch analysis; currently limited to 2D data

microscope for scriptable image analysis packages. In our lab, we have created such modules for ImageJ (Rasband, 1997) to interface with the Zeiss ZEN software through its Visual Basic (VB) API (Zeiss, 2012a) and for CellProfiler (Carpenter et al., 2006) to interface to Leica LASAF with Matrix Screener (Leica-Microsystems, 2014). In the following, we present selected applications of feedback microscopy implemented using these modules.

26.2 SELECTED APPLICATIONS
26.2.1 AUTOMATED DETECTION AND IMAGING OF *PLASMODIUM*-INFECTED CELLS
26.2.1.1 Motivation
Plasmodium parasites, the causative agents of malaria, undergo the first obligate step in the mammalian phase of their life cycle in the liver. After a motile sporozoite invades a hepatocyte, the parasite becomes sessile and enters a replicative phase,

ultimately giving rise to thousands of progeny, while enclosed in a parasitophorous vacuole (Prudêncio, Rodriguez, & Mota, 2006). These progeny, called merozoites, will be released into the bloodstream where they infect red blood cells, initiating the next step in infection and the symptoms and syndromes of malaria.

The complete liver-stage cycle from invasion to production of infectious merozoites of the rodent parasites *P. berghei* and *P. yoelii* can be recapitulated by infecting hepatoma cell lines *in vitro*. However, the infection efficiency is quite low with infected cells comprising 1% of the total hepatoma cell population in typical experiments (Fig. 26.2A).

Because infected cells in a whole tissue culture cell population are very rare, manually imaging a large number of parasites and their host cells at high resolution is time-consuming and laborious. Simple automation, where an automated microscope would exhaustively image a given area completely (e.g., a coverslip) at the high resolution required for optimal phenotypic characterization of the *Plasmodium* liver stage, would be extremely inefficient; most of the instrument time and the data storage would be dedicated to generating and storing images that are of no interest.

With feedback microscopy, in which an initial low-resolution scan of the sample is acquired rapidly, parasites are identified based on their immunofluorescence signatures using an online image analysis routine, and a high-resolution, multichannel imaging protocol is then automatically launched for each detected parasite. In our facility, this work is performed on a Leica SP5 confocal microscope using Leica LASAF software with the Matrix Screener option. The online image analysis is performed using CellProfiler, and the communication link between image analysis and microscope depends on a pair of custom-developed CellProfiler modules.

FIGURE 26.2

Imaging of *P. berghei* infected cells in HepG2 cell culture. (A) Cells successfully infected with *P. berghei* are rare in the overall population. Infected cells (indicated by arrows) can be identified through the HSP70 assay (green), while the total cell population is visible in blue using Hoechst as a nuclear marker. (B–E) High-resolution images captured using our automated workflow showing three samples of *P. berghei* during liver-stage development. The additional markers used are UIS4 (shown in red) and MSP1 (shown in white). The immunostaining is described in Prudêncio, Mota, and Mendes (2011). (See the color plate.)

26.2.1.2 Sample preparation

A population of hepatoma cells, typically HepG2 or Huh7, is seeded in a multiwell plate and subsequently infected with freshly isolated *Plasmodium* sporozoites. Infection is allowed to proceed until the desired time point during development, when the cells are PFA-fixed. The cells are labeled with Hoechst, which is crucial for the low-resolution focus steps, and a parasite-specific antibody, which is used for recognizing infected cells during subsequent imaging steps; 2E6, which recognizes HSP70 and labels the parasite soma throughout liver-stage development, is one possibility, though other *Plasmodium*-specific antibodies could also be used (Prudêncio et al., 2011). Additional antibodies that recognize parasite or host cell components of interest are also included in the staining cocktail.

26.2.1.3 Feedback microscopy implementation using CellProfiler and LASAF Matrix Screener

The Leica LASAF software with Matrix Screener option provides support for automated imaging of samples according to a variety of spatial layouts of scan fields, including user-defined patterns that can be configured through a graphical user interface.

Scan and imaging settings such as scan speed, zoom, laser power, photomultiplier voltage, and spectral filter ranges can be stored as so-called jobs in LASAF Matrix Screener. Several such jobs (e.g., low-resolution focusing jobs and high-resolution imaging or photobleach jobs) can be grouped and saved into job patterns. Executing a job pattern will invoke all the imaging jobs contained therein in a sequential order. Both job patterns and individual jobs are identified via user-defined names by external software packages.

Following the definition of a spatial layout in Matrix Screener, each scan field can be assigned a job or a pattern individually. Additional attributes can also be assigned to scan fields, for example, they can be marked as drift compensation fields at which an autofocus job is called.

The interface for third-party software provided by Matrix Screener is based on a TCP/IP communication protocol with Matrix Screener acting as a server to which external clients can connect.

In Leica terminology, this is called the computer-aided microscopy (CAM) server. When an image job has been executed, the server notifies the connected clients about the file path of the captured image. The server can also receive commands from the clients. Most importantly, a client can trigger the execution of job patterns at specific locations. A special "wait" job that can be added to a job pattern facilitates the synchronization of the acquisition with the online image analysis. This "wait" job will halt the automated prescanning until the online image analysis routine notifies the server that it has finished analyzing the current position.

26.2.1.4 CellProfiler for adaptive feedback microscopy

CellProfiler (Carpenter et al., 2006) is normally used for batch analysis of large image sets. Here, we use it for identifying objects of interest. It offers a modular approach to image analysis in which individual building blocks, each addressing

a well-defined task, can be combined to form an image analysis pipeline. CellProfiler also has a consistent object logic through which objects detected by segmentation modules are available downstream in the pipeline for taking measurements, object filtering, and object classification.

In order to use CellProfiler for adaptive feedback microscopy, we developed two additional CellProfiler modules:

- A *LeicaWaitForImage* module: This module listens for notification about new images from the microscope on the TCP/IP connection and reads the prescan images as they become available.
- A *LeicaImageObject* module: In this module, an object of interest set that has been identified by the image analysis pipeline can be selected, and the user can specify the name of an imaging job pattern defined in Matrix Screener. The module sends the well and pixel coordinates of all objects in the set to the microscope and triggers imaging of the specified job pattern at these coordinates.

These two modules are compatible with CellProfiler version 2.0.11710 and can be downloaded at https://github.com/VolkerH/MatrixScreenerCellprofiler.

For feedback microscopy, we place these two modules at the beginning and the end of an analysis pipeline, respectively, enclosing the image analysis steps for finding the objects of interest. For parasite identification, the image analysis consists of a simple adaptive thresholding algorithm on the HSP70 signal followed by a classification into large and small parasites.

26.2.1.5 Setting up and running the experiment

We use the protocol for imaging *P. berghei* as a concrete example to illustrate the individual steps of setting up an online feedback microscopy experiment using the combination of Matrix Screener and CellProfiler:

1. *Set up an automated scan layout in the Matrix Screener software that reflects the plate or slide layout.* For this project, we set up a pattern with 30 subpositions per well.
2. *Set up an autofocus job for the prescan imaging routine.* Since infected cells are rare, we set up a job that focuses on the hepatoma cell nuclei using the Hoechst channel (excitation at 405 nm). The imaging is performed using a $63\times$ NA 1.2 water-immersion lens. To optimize speed, we use a very low resolution of 64×64 pixels at zoom 1. This focus job is used by Matrix Screener to acquire a focus map of the sample before image acquisition and for drift compensation during a scan.
3. *Set up an imaging job pattern containing a prescan job for identifying regions of interest at low resolution.* Here, we use 256×256 pixels at zoom 1 in the 488 nm excitation channel of the parasite marker (HSP70). For synchronization with the image analysis, we also add a "WaitForCAM" job to the job pattern.
4. *Set up one or more high-resolution imaging job patterns.* For imaging the parasite-infected cells at high resolution, we set up imaging job patterns in Matrix Screener containing excitation channels for all our markers of interest. Each

pattern consists of an autofocus job, focusing on the parasite itself at high magnification (e.g., zoom 6), followed by a high-resolution sequential scan job containing excitation lines for all our markers of interest (typically 512×512 pixels, zoom 6, 4 channels). Working with two independent high-resolution job patterns has the advantage that the CellProfiler pipeline can invoke the most suitable job pattern according to a classification of the object of interest. Thus, different focus algorithms and scan settings according to the classification of the object of interest can be used, for example, each "small" object could trigger a high-resolution scan of a single focal plane, while a "large" object would trigger imaging an entire z-stack.

5. *Assign the prescan job (defined in step 3) to all fields to be imaged as defined in the spatial layout (defined in step 1).*
6. *Acquire a focus map using Matrix Screener.* The focus map captures the topology of the sample and is used for Z-positioning of the stage during the prescan.
7. *Launch the image analysis client.* In our case, we invoke CellProfiler with the image analysis pipeline described in the preceding text.
8. *Start the Matrix Screener scan.*

Once CellProfiler and the Matrix Screener scan are running, each new prescan image is read by the *LeicaWaitForImage* module and analyzed by CellProfiler, while the Matrix Screener pauses image acquisition. Two *LeicaImageObject* modules send the coordinates of the identified parasites to the microscope, trigger one of two high-resolution acquisition job patterns according to the size of the parasite, and notify Matrix Screener to continue with the prescan.

26.2.1.6 Results and discussion

The feedback microscopy approach described here allows imaging of a large number of cells infected with *Plasmodium* liver-stage parasites at high resolution without human intervention, for extended periods of time.

With the protocol and settings described in the preceding text, a throughput of approximately 50 parasites per hour can be achieved. Some example high-resolution scans of *P. berghei* parasites acquired using our automated workflow are shown in Fig. 26.2B–D. The presented combination of Matrix Screener and CellProfiler for image analysis feedback microscopy is currently used in several distinct applications in our laboratory. Adapting the workflow for the identification of the objects of interest to different applications is easily possible due to the modularity of CellProfiler. Also, it is possible in principle to port the modules for interfacing with the microscope to software interfaces of other microscope systems.

26.2.2 AUTOMATED FRAP ON ER EXIT SITES

26.2.2.1 Motivation and automation workflow overview

A crucial step during secretory transport is the export of cargo from the endoplasmic reticulum (ER) occurring at specialized domains called ER exit sites (ERES). At ERES, cargo molecules are packaged into coated vesicles for transport to the

Golgi complex. Vesicle budding at ERES is driven by the assembly of the COPII vesicular coat protein complex (Antonny, Madden, Hamamoto, Orci, & Schekman, 2001). Quantifying the turnover of COPII components at ERES by FRAP experiments in combination with mathematical modeling of the reactions involved demonstrated the possibility to derive biochemical parameters from such experiments and showed the importance of secretory cargo for COPII coat stabilization during vesicle budding (Forster et al., 2006). In order to investigate putative COPII coat assembly regulatory proteins, we aim to use this approach while systematically knocking down proteins previously identified as ER to Golgi transport regulators (Simpson et al., 2012). However, performing such experiments systematically is challenging due to the low throughput. For example, one limiting factor is the manual selection of ERES that are isolated enough for a single site FRAP experiment. In addition, during the FRAP experiment, the ERES under observation might leave the field of view or move out of focus making data analysis impossible. These factors lead to a limited throughput, which is insufficient for measuring COPII coat turnover in multiple knockdown conditions. To address this problem, we developed an automated high-throughput FRAP workflow, where the microscope scans a part of an siRNA-coated 96-well plate (Fig. 26.3A). At each position, following an autofocus routine (Fig. 26.3B), an image is acquired (Fig. 26.3C) and sent to an ImageJ macro that identifies an ERES suited for a FRAP experiment (Fig. 26.3D). The coordinates of the selected ERES are sent back to the microscope, triggering photobleaching of the ERES and imaging the fluorescence recovery (Fig. 26.3E).

26.2.2.2 Sample preparation
HeLa Kyoto cells stably expressing the COPII component Sec23A-YFP are grown for 60 h in a 96-well plate coated with siRNAs (Erfle, Simpson, Bastiaens, & Pepperkok, 2004). The siRNAs are chosen to downregulate target proteins previously identified as ER to Golgi transport regulators (Simpson et al., 2012). Prior to imaging, the cell culture medium is replaced by imaging medium without phenol red.

26.2.2.3 Workflow and implementation
We use a Zeiss LSM 780 confocal microscope controlled by the ZEN 2010 software, the Visual Basic (VB) programming interface to ZEN, and an ImageJ macro for automated detection of ERES. The VB macro manages the workflow by calling functions in ZEN 2010 and communicating with ImageJ via Windows Registry entries (Conrad et al., 2011). The VB macro and the commented ImageJ macro code are available for download at https://github.com/tischer/AutomatedMicroscopy.

To set up the workflow, we begin by defining a "Track" (similar to a "Job" in Leica Matrix Screener) in the ZEN software for Sec23A-YFP (ERES) imaging and configuring this as the "Acquisition Track" in the VB macro (the macro is launched from the Macro menu in the ZEN software). Subsequently, we configure a track for autofocusing (AF). Here, we measure the reflection of a 561 nm laser at

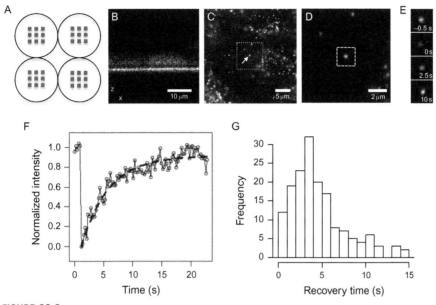

FIGURE 26.3

Workflow of automated ERES FRAP. Experiments are performed on a Zeiss LSM 780 microscope equipped with a 63 × NA1.4 oil-immersion lens. (A) Schematic drawing depicting the automated multiposition scanning of selected wells of an siRNA-coated 96-well plate. (B) X–Z autofocus scan showing the reflection of a 561 nm laser on the coverslip medium interface (also, the cells above the coverslip reflect some of the light). For efficient collection of the reflection, we employ the 488 nm main beam splitter (MBS), which transmits most of 561 nm; note that the weak 561 nm reflection of the 488 MBS is sufficient to create the reflection image. The image in (C) is acquired at a user-defined offset of 2.5 μm to the reflection image. (C) Image of HeLa Kyoto cells expressing Sec23A-YFP. YFP is excited with a 488 nm laser and emission collected from 490 to 600 nm. The pinhole is adjusted to an optical section of 2.4 μm. Automated online analysis by an ImageJ macro selects an ERES suited for a FRAP experiment (arrow) and reports the x–y coordinates back to the microscope, which centers the ERES and zooms in (dotted rectangle) to start the FRAP experiment. (D) First frame of the FRAP experiment. The dashed rectangle depicts the bleach ROI. Imaging is performed using the same beam path as in (C). Bleaching is performed after five frames (dt=0.25 s) with the 488 nm laser power adjusted to bleach about 60% of the signal. (E) Montage of the bleach ROI at selected time points. Times are given relative to first postbleach image. (F) Recovery trace (connected black dots) of a photobleached ERES with a single exponential curve fit (dashed line; fitted recovery time is 4.65 s). Prebleach intensity values are normalized to one and the first time point after bleaching to zero. (G) Histogram of fitted recovery times of 172 experiments subjected to control siRNA.

the bottom of the glass coverslip (Fig. 26.3B). The AF range, the step size and the z-offset to the imaging plane are configured in the VB macro. Next, we configure acquisition modalities for FRAP imaging such as time lapse, zoom, and pixel number in the VB macro. Bleaching settings such as laser power and bleach ROI shape are defined in the ZEN software. Finally, we set up automated plate scanning in the Grid Scan tab of the VB macro.

Following the definition of these settings, we launch the ImageJ macro for ERES detection. The macro combines standard ImageJ functionality with our custom ImageJ plug-ins. The plug-in "Microscope Communicator" handles communication of ImageJ with the VB macro. This plug-in is used at the beginning and end to retrieve the image to be analyzed and send back the coordinates of selected ERES, respectively. In addition, we developed a "Filter particles" plug-in for selecting a subset of ERES that satisfy specific intensity, shape, and position criteria. In summary, the image analysis comprises the following steps:

- Retrieve image from microscope
- Gaussian smoothing
- Particle detection by local threshold
- Measure particle's intensity, area, and position
- Filter particles according to the following:
 - Intensity
 - Area
 - Distance to neighboring particles
 - Intensity in neighborhood
 - Distance to image center
- Randomly select one of the filtered particles
- Report (x,y) particle coordinates to the microscope (VB program)

The filtering steps select particles that are sufficiently isolated for a single site photobleaching experiment. Filtering particles based on their distance to the image center is a means to exclude particles at the image boundary.

Loading and analyzing one image was optimized to take about 2–3 s. This timing is sufficiently fast to avoid fast-moving ERES leaving the area of analysis before or during the experiment. Once parameters are set, the macro is launched to analyze images acquired by the LSM 780 microscope. Finally, the workflow is started from the VB macro.

26.2.2.4 Results and discussion

Using the aforementioned workflow, we ran automated FRAP experiments of ERES at a throughput of 100 experiments per hour. Similar to experiments with manual ERES selection, about 30–50% of the data are of sufficient quality to extract recovery kinetics (Fig. 26.3F and G). The automated workflow increases the throughput per hour compared with manual acquisition by about 20-fold, and the microscope can run for extended periods without human supervision. This increase in throughput allows for systematic comparison of different siRNA treatments and may enable

advanced readouts such as correlating COPII kinetics with parameters like ERES size or intracellular position.

The main limitation remaining is the high mobility of some ERES. While lateral motion may be addressed by postacquisition tracking of the bleached ERES, axial motion is a bigger challenge, as it can be difficult to distinguish intensity change from in/out of focus motions. This problem may be overcome by acquiring 3D stacks during the recovery phase of the experiment.

Another optimization of the procedure may be to implement a cell selection step prior to the ERES selection step, because often not all cells respond uniformly to an siRNA treatment. However, if the morphological phenotype caused by the siRNA is known, one can "teach" the software to only perform FRAP experiments on cells of this phenotype.

In order to capture sufficient photons from the relatively weak ERES YFP emission, we use a high-NA oil-immersion lens. However, scanning of multiple wells without losing the immersion oil might be a challenge. In our experience, repeatedly scanning 11 neighboring wells in a 96-well plate with 6×6 subpositions in each well for several hours is possible without problems due to loss of contact with the immersion oil. However, imaging an entire 96-well plate may require specific measures to prevent the immersion oil film from tearing or creating air bubbles during the experiment.

The workflow described here can be readily adapted to perform automated FRAP on structures other than ERES. The only modification required is to adapt the ImageJ macro that identifies the structure of interest.

ACKNOWLEDGMENTS

We would like to thank Antonio Politi and Kota Miura for their support with Visual Basic and ImageJ programming, respectively. Moreover, we thank Martin Neukam and Fatima Verissimo for their experimental contributions to the ERES FRAP project. We are grateful to Frank Sieckmann (Leica Microsystems) for the support with interfacing to Leica Matrix Screener.

REFERENCES

Antonny, B., Madden, D., Hamamoto, S., Orci, L., & Schekman, R. (2001). Dynamics of the COPII coat with GTP and stable analogues. *Nature Cell Biology, 3*, 531–537. http://dx.doi.org/10.1038/35078500.

Carpenter, A. E., Jones, T. R., Lamprecht, M. R., Clarke, C., Kang, I. H., Friman, O., et al. (2006). Cell Profiler: Image analysis software for identifying and quantifying cell phenotypes. *Genome Biology, 7*, R100. http://dx.doi.org/10.1186/gb-2006-7-10-r100.

Chung, K., Crane, M. M., & Lu, H. (2008). Automated on-chip rapid microscopy, phenotyping and sorting of C. elegans. *Nature Methods, 5*, 637–643. http://dx.doi.org/10.1038/nmeth.1227.

Conrad, C., Wünsche, A., Tan, T. H., Bulkescher, J., Sieckmann, F., Verissimo, F., et al. (2011). Micropilot: Automation of fluorescence microscopy-based imaging for systems biology. *Nature Methods, 8*, 246–249. http://dx.doi.org/10.1038/nmeth.1558.

Edelstein, A., Amodaj, N., Hoover, K., Vale, R., & Stuurman, N. (2010). Computer control of microscopes using μManager. *Current Protocols in Molecular Biology*, . http://dx.doi.org/10.1002/0471142727.mb1420s92, edited by Frederick M. Ausubel . . . [et al.], Chapter 14 (October), Unit 14.20.

Elowitz, M. B., Levine, A. J., Siggia, E. D., & Swain, P. S. (2002). Stochastic gene expression in a single cell. *Science, 297*, 1183–1186. http://dx.doi.org/10.1126/science.1070919.

Erfle, H., Simpson, J. C., Bastiaens, P. I. H., & Pepperkok, R. (2004). siRNA cell arrays for high-content screening microscopy. *BioTechniques, 37*(3), 454–458. 460, 462, http://www.ncbi.nlm.nih.gov/pubmed/15470900.

Forster, R., Weiss, M., Zimmermann, T., Reynaud, E. G., Verissimo, F., Stephens, D. J., et al. (2006). Secretory cargo regulates the turnover of COPII subunits at single ER exit sites. *Current Biology, 16*, 173–179. http://dx.doi.org/10.1016/j.cub.2005.11.076.

Leica-Microsystems. (2014). Leica LASAF. http://www.leica-microsystems.com/products/microscope-software/life-sciences/las-af-advanced-fluorescence/.

Leifer, A. M., Fang-Yen, C., Gershow, M., Alkema, M. J., & Samuel, A. D. T. (2011). Optogenetic manipulation of neural activity in freely moving Caenorhabditis elegans. *Nature Methods, 8*, 147–152. http://dx.doi.org/10.1038/nmeth.1554.

Mathworks. (n.d.). MATLAB. http://www.mathworks.com/.

Metasystems. (n.d.). Msearch. http://www.metasystems-international.com/metafer/msearch.

Molecular-Devices. (2013). Metamorph. http://www.moleculardevices.com/products/software/meta-imaging-series/metamorph.html.

National-Instruments. (2014). National Instruments. http://www.ni.com/labview/.

Pelkmans, L. (2012). Using cell-to-cell variability—A new era in molecular biology. *Science, 336*(6080), 425–426. http://dx.doi.org/10.1126/science.1222161.

Pepperkok, R., & Ellenberg, J. (2006). High-throughput fluorescence microscopy for systems biology. *Nature Reviews Molecular Cell Biology, 7*, 690–696. http://dx.doi.org/10.1038/nrm1979.

Peravali, R., Gehrig, J., Giselbrecht, S., Lütjohann, D. S., Hadzhiev, Y., Müller, F., et al. (2011). Automated feature detection and imaging for high-resolution screening of zebrafish embryos. *BioTechniques, 50*, 319–324. http://dx.doi.org/10.2144/000113669.

Pologruto, T. A., Sabatini, B. L., & Svoboda, K. (2003). ScanImage: Flexible software for operating laser scanning microscopes. *Biomedical Engineering Online, 2*, 13. http://dx.doi.org/10.1186/1475-925X-2-13.

Prudêncio, M., Mota, M. M., & Mendes, A. M. (2011). A toolbox to study liver stage malaria. *Trends in Parasitology, 27*(12), 565–574. http://dx.doi.org/10.1016/j.pt.2011.09.004.

Prudêncio, M., Rodriguez, A., & Mota, M. M. (2006). The silent path to thousands of merozoites: The Plasmodium liver stage. *Nature Reviews Microbiology, 4*(11), 849–856. http://dx.doi.org/10.1038/nrmicro1529.

Rabut, G., & Ellenberg, J. (2004). Automatic real-time three-dimensional cell tracking by fluorescence microscopy. *Journal of Microscopy, 216*, 131–137. http://dx.doi.org/10.1111/j.0022-2720.2004.01404.x.

Rasband, W. (1997). ImageJ. http://rsbweb.nih.gov/ij/.

Ron Vale. (n.d.). Micro-Manager. http://www.micro-manager.org/.

Schindelin, J., Arganda-Carreras, I., Frise, E., Kaynig, V., Longair, M., Pietzsch, T., et al. (2012). Fiji: An open-source platform for biological-image analysis. *Nature Methods, 9*, 676–682. http://dx.doi.org/10.1038/nmeth.2019.

Simpson, J. C., Joggerst, B., Laketa, V., Verissimo, F., Cetin, C., Erfle, H., et al. (2012). Genome-wide RNAi screening identifies human proteins with a regulatory function in the early secretory pathway. *Nature Cell Biology*, *14*, 764–774. http://dx.doi.org/10.1038/ncb2510.

Stirman, J. N., Crane, M. M., Husson, S. J., Wabnig, S., Schultheis, C., Gottschalk, A., et al. (2011). Real-time multimodal optical control of neurons and muscles in freely behaving Caenorhabditis elegans. *Nature Methods*, *8*, 153–158. http://dx.doi.org/10.1038/nmeth.1555.

Tosi, S., Bardia, L., Llado, A., & Colombelli, J. (2013). ImageJ driven intelligent high-content imaging. In *Poster at EuBIAS 2013, Barcelona*.

Tsukada, Y., & Hashimoto, K. (2013). Feedback regulation of microscopes by image processing. *Development, Growth & Differentiation*, *55*, 550–562. http://dx.doi.org/10.1111/dgd.12056.

Zeiss. (2012a). ZEN Black. http://microscopy.zeiss.com/microscopy/en_us/products/microscope-software/zen-2012.html.

Zeiss. (2012b). ZEN Blue. http://forums.zeiss.com/microscopy/community/.

CHAPTER

Open-source solutions for SPIMage processing

27

Christopher Schmied, Evangelia Stamataki, Pavel Tomancak
Max Planck Institute of Molecular Cell Biology and Genetics, Dresden, Germany

CHAPTER OUTLINE

Introduction	506
Brief Overview of Light Sheet Microscopy Flavors	506
Applications of Light Sheet Microscopy	508
27.1 Prerequisites	**509**
27.1.1 Parameters of Example Dataset	509
27.1.2 Fluorescent Beads as Fiducial Markers for Registration	510
27.1.3 Installation and Configuration of Fiji	510
27.1.4 Hardware Requirements	511
27.1.5 File formats Preprocessing and Naming Conventions	511
27.2 Overview of the SPIM Image-Processing Pipeline	**512**
27.3 Bead-Based Registration	**513**
27.3.1 Workflow	515
27.3.2 Results	517
27.4 Multiview Fusion	**518**
27.4.1 Content-Based Multiview Fusion	518
27.4.1.1 Workflow	*518*
27.4.1.2 Results	*521*
27.4.2 Multiview Deconvolution	521
27.4.2.1 Workflow	*522*
27.4.2.2 Results	*523*
27.5 Processing on a High-Performance Cluster	**524**
27.6 Future Applications	**525**
References	527

Abstract

Light sheet microscopy is an emerging technique allowing comprehensive visualization of dynamic biological processes, at high spatial and temporal resolution without significant damage to the sample by the imaging process itself. It thus lends itself to time-lapse observation of

fluorescently labeled molecular markers over long periods of time in a living specimen. In combination with sample rotation light sheet microscopy and in particular its selective plane illumination microscopy (SPIM) flavor, enables imaging of relatively large specimens, such as embryos of animal model organisms, in their entirety. The benefits of SPIM multiview imaging come to the cost of image data postprocessing necessary to deliver the final output that can be analyzed. Here, we provide a set of practical recipes that walk biologists through the complex processes of SPIM data registration, fusion, deconvolution, and time-lapse registration using publicly available open-source tools. We explain, in plain language, the basic principles behind SPIM image-processing algorithms that should enable users to make informed decisions during parameter tuning of the various processing steps applied to their own datasets. Importantly, the protocols presented here are applicable equally to processing of multiview SPIM data from the commercial Zeiss Lightsheet Z.1 microscope and from the open-access SPIM platforms such as OpenSPIM.

INTRODUCTION

BRIEF OVERVIEW OF LIGHT SHEET MICROSCOPY FLAVORS

The basic principle of light sheet microscopy is that optical sectioning is achieved by illuminating the sample from the side with a thin sheet of laser light that will excite the fluorophores in the sample only in a relatively narrow plane. Photons emitted by these fluorophores are captured by a detection objective oriented perpendicularly to the light sheet and imaged onto a detection device such as a CCD camera (Fig. 27.1A). Thus, light sheet microscopy allows very fast acquisition, offering high temporal resolution. Since only the observed plane is illuminated, bleaching and phototoxicity are reduced to a minimum (Huisken, Swoger, Del Bene, Wittbrodt, & Stelzer, 2004).

The realization of this theta microscopy principle (Stelzer & Lindek, 1994) varies among the various types of light sheet microscopes. The illumination and detection axes may be fixed, with the detection objective permanently focused to the center of the light sheet, and the sample is moved through the focal volume to achieve 3D acquisition (Huisken et al., 2004). Alternatively, the light sheet is scanned axially through the sample, and the focus of the detection objective is continuously adjusted with a fine motor (Krzic, Gunther, Saunders, Streichan, & Hufnagel, 2012; Tomer, Khairy, Amat, & Keller, 2012) or using an electrically tunable lens (Fahrbach, Voigt, Schmid, Helmchen, & Huisken, 2013).

The light sheet itself can be static, formed by a cylindrical lens, the so-called selective plane illumination microscopy (SPIM; Huisken et al., 2004), or it can be generated dynamically by scanning a point source of laser light at high frequency across the sample, the so-called digital scanned laser light sheet fluorescence microscopy (DSLM; Keller & Stelzer, 2008). The static light sheet may be pivoted at high frequency parallel to the imaging plane, which leads to the reduction of the notorious stripe artifacts caused by absorption and scattering of the illumination light sheet across the field of view (Huisken & Stainier, 2007). The dynamic light sheet can

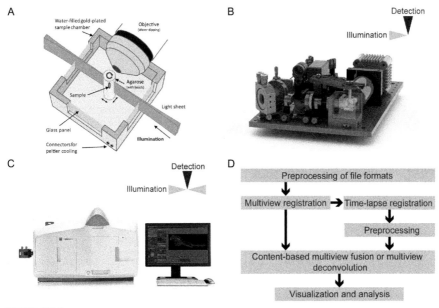

FIGURE 27.1

Illustration of the SPIM principle. (A) The sample is suspended in an agarose column and immersed in a buffer. A thin laser light sheet with a concave geometry is illuminating the sample. A water-immersion lens is positioned perpendicular to the light sheet, and the emitted light is captured on a CCD or sCMOS camera. By moving the sample through the light sheet, stacks are acquired. Rotation allows the acquisition of multiple views. (B) OpenSPIM—an open-access platform for light sheet microscopy. (C) Zeiss Lightsheet Z.1—a commercial realization of light sheet microscope from Carl Zeiss Microscopy. (D) Workflow of the Fiji SPIM image-processing pipeline.

Figure (A) from Preibisch, Saalfeld, Rohlfing, and Tomancak (2009). Figure (B) adapted from Pitrone et al. (2013). Figure (C) © Copyright of Carl Zeiss Microscopy GmbH

be modulated by structured illumination, which leads to the reduction of the background and increase in signal-to-noise ratio (Keller et al., 2010). An axicon element can be included in the illumination beam path leading to a formation of a self-reconstructing Bessel beam that provides a more uniform illumination across the field of view and reduced light sheet thickness resulting in higher z resolution of the acquisition (Planchon et al., 2011).

In the DSLM mode, a two-photon light sheet can be formed, which provides better penetration into thick biological specimen (Truong, Supatto, Koos, Choi, & Fraser, 2011). Uniformity of illumination across the field of view can be increased by bringing the light sheet into the sample from two sides sequentially or even simultaneously, the so-called dual-sided illumination principle (Huisken & Stainier, 2007). Finally, sample rotation provides the ability to image the same specimen from

multiple angles and to cover the "dark side" of the sample that happens to be away from the detection lens. The need for rotation can be partially ameliorated by building a second detection axis that positions the detection lens physically on the dark side of the specimen, the so-called dual-sided detection principle (Huisken et al., 2004; Krzic et al., 2012; Tomer et al., 2012).

The detection arm of a light sheet microscope can be equipped with a regular CCD camera, EM-CCDs providing better sensitivity, or more recently sCMOS cameras with large chips and fast readout times. The magnification of the detection lens has to match the numerical aperture (NA) of the illumination optics.

With higher NA of the illumination objective, the light sheet is thinner in the center of the field of view but thicker at its borders, thus reducing the usable field of view. A thicker light sheet is more uniform across a larger area and increases the field of view.

Light sheet microscopy remains an active field in optical technology development. Detailed discussion of all light sheet microscopy variations developed so far is beyond the scope of this chapter, and we recommend the many excellent reviews written by the movers of the light sheet field (Huisken & Stainier, 2009; Keller, 2013; Reynaud, Krzic, Greger, & Stelzer, 2008) and Chapter 11 of this book.

APPLICATIONS OF LIGHT SHEET MICROSCOPY

The broad range of light sheet arrangements results in a diverse application of the technology. Light sheets are instrumental in monitoring fast biological processes such as beating hearts (Arrenberg, Stainier, Baier, & Huisken, 2010), neuronal activity in intact fish brain (Ahrens, Orger, Robson, Li, & Keller, 2013), and movements of RNA molecules in embryos (Siebrasse, Kaminski, & Kubitscheck, 2012). The most advanced structured illumination Bessel beam microscopes developed by Erik Betzig have impressively demonstrated that the light sheet paradigm will be instrumental in systems level monitoring of cell biological processes in living cells including cortical dynamics, endocytosis, or cell division (Gao et al., 2012). But these cutting-edge microscopes are not yet broadly available, and the details of data processing required remain rather opaque.

From the beginning, light sheet microscopy has been applied in a spectacular manner to monitoring of developmental processes in intact embryos (Keller, Schmidt, Wittbrodt, & Stelzer, 2008), and this particular application is the focus of this chapter. Development forms a complex multicellular organism from a single cell through cell proliferation, cell differentiation, and morphogenesis. In order to study these relatively fast and transient processes and the underlying genetic programs that control them, we require the ability to image living embryos with high spatiotemporal resolution throughout embryogenesis (Megason & Fraser, 2007). Specifically, SPIM is ideal for this particular application. SPIM is capable of imaging large specimens with single-cell resolution. It provides fast acquisition with a minimum of phototoxicity and bleaching of the labeled molecular markers. Moreover, by combining stacks acquired from several angles, SPIM can achieve isotropic resolution and allows capturing a single living embryo in its entirety.

The SPIM technology is mature, and it is available both as a commercial product and as prototypes developed by individual labs or public open-access communities (Gualda et al., 2013; Pitrone et al., 2013). Thus, many researchers are or, in the near future, will be acquiring SPIM data and need to be aware of the image analysis challenges awaiting them and become equipped to solve them, which is the purpose of this chapter.

In SPIM, the suspended sample, typically mounted in agarose inside a glass capillary (for review on sample mounting, see Reynaud et al. (2008)), can be moved and rotated freely through the light sheet, which allows acquisition of 3D stacks of 2D planes from multiple angles (in SPIM jargon referred to as views). By imaging the sample from different angles, limitations in penetration depth and degradation of the signal can be at least partially circumvented. Registration of the views and their combination into a single output image (so-called fusion) enables the reconstruction of the sample with nearly isotropic resolution (Preibisch, Saalfeld, Schindelin, & Tomancak, 2010; Swoger, Verveer, Greger, Huisken, & Stelzer, 2007).

In this guide, we will discuss how to process raw time-lapse, multiview SPIM data in order to visualize and analyze them. We are going to use the output of two distinct systems as examples: One is an open-source platform for light sheet microscopy OpenSPIM (Pitrone et al., 2013; Fig. 27.1B) and the other one is a commercially available system from Carl Zeiss Microscopy marketed under the name Lightsheet Z.1 (Fig. 27.1C). OpenSPIM implements single-sided illumination and single-sided detection and is limited to single-channel imaging, while Lightsheet Z.1 offers dual-sided illumination, multichannel acquisition, and much more. From the point of view of image processing, it is important to note that both systems use sample rotation to achieve multiview imaging.

Our pipeline, presented in the succeeding text, is not limited by the use of a specific system and can easily be applied to other SPIM applications. It has been released in the open-source platform Fiji Is Just ImageJ (Fiji; Schindelin et al., 2012), a freely available distribution of ImageJ, which greatly facilitates its adaptation to various multiview imaging scenarios. Importantly, the open-source nature of all the software discussed here makes it possible to deploy the individual steps of the processing pipeline on a cluster computer. The sheer amount of image data produced by light sheet microscopes is tremendous, it rivals the data volumes produced in particle physics, and biologists are not ready to deal with this data deluge. In "Cluster Processing," we discuss parallelization of SPIM image processing on high-performance computing hardware.

27.1 PREREQUISITES
27.1.1 PARAMETERS OF EXAMPLE DATASET

We will discuss all processing steps using an SPIM recording of a *Drosophila melanogaster* embryo acquired with the Zeiss Lightsheet Z.1. To visualize cell behavior during embryogenesis, we have used a transgenic fly line expressing histone H2Av labeled with mRFPruby (Fischer, Haase, Wiesner, & Müller-Taubenberger, 2006).

The same procedure applies for the data from OpenSPIM with the exception of handling transformation of the file formats described in "Section 27.1.5."

The embryo was imaged with a Zeiss $20\times/1.0$ water-immersion Plan Apochromat objective lens with 0.8 zoom at 25 °C. 1.5 mW of the 561 nm laser was used for the first 67 time points; the power was later increased to 2.5 mW. Each view contains 130 slices with a step size of 1 µm. 6 views at 60° angles were recorded per time point. The embryo was imaged continuously for over 18 h, with each time point taking 90 s to acquire. 715 time points were recorded. Exposure time was 20 ms per slice. Each slice consists of 1920×1060 pixels with a pixel size of 0.2859 µm and a bit depth of 16 bits. We used dual-sided illumination with Zeiss $10\times/0.2$ illumination lenses. The light sheet thickness was 4.03 µm at the center of the field of view and 13.3 µm at the borders. Both sides were fused as a preprocessing step directly after acquisition using a mean fusion in the ZEN software. This reduces the size of the acquired recording by half to 5.63 TB.

27.1.2 FLUORESCENT BEADS AS FIDUCIAL MARKERS FOR REGISTRATION

For purposes of multiview registration, we included a 1:10,000 dilution of fluorescent microspheres (FY050 Estapor microspheres from Merck Millipore) with a diameter of 500 nm in the agarose mounting medium. These beads were excited with the 561 nm laser and have their predominant peak of emission around 680 nm. The beads should be selected such that they can be excited and imaged in the chosen channel but without using their dominant excitation and emission wavelengths. Thus, they are still visible and can be segmented but do not dominate the image.

We recommend using the FY050 beads for imaging GFP or YFP alone since their fluorescence is weaker than the signal when excited with the 488 nm lasers. These beads have a strong fluorescence when excited with the 561 nm laser used for imaging mRFPruby. Thus, we recommend the FZ050 beads when imaging mRFPruby alone or GFP and mRFPruby in two channels.

27.1.3 INSTALLATION AND CONFIGURATION OF FIJI

We will be using Fiji for all SPIM image data processing steps (SPIMage processing). Fiji is a Java open-source biological image analysis platform (Schindelin et al., 2012) that is freely available to download and install on any computer platform including PC, Mac OS X, and Linux (http://fiji.sc). Fiji is a modular software that uses the system of the so-called plug-ins, independent software modules that are linked to the main program and extend it in some useful way. It is important to note that Fiji uses an update mechanism that allows continuous renewal of the program on the user's computer with the latest versions of the plug-ins and the addition of new functionality. These plug-ins, collectively, together with the Fiji's core (which is nothing else but ImageJ; Schneider, Rasband, & Eliceiri, 2012), represent the Fiji distribution. The plug-ins required for SPIMage processing are part of the Fiji distribution and can be found

upon download in the main Fiji *Plugins menu* in the subfolder *SPIM Registration*. We recommend updating Fiji before attempting any reconstruction.

27.1.4 HARDWARE REQUIREMENTS

Multiview SPIM image processing is computationally expensive due to the size of the image dataset. Typical acquisition will consist of multiple views of 100–400 MB each. Those large images have to be at least temporarily held in memory, usually in multiple copies, and rotated, which increases the effective size dramatically. Therefore, we recommend investing in *RAM*. Most of the Fiji code involved in SPIMage processing is in Java and is multithreaded (i.e., will make use of multiple cores when available); thus, investing in *multicore processors* is also advisable. The output of the SPIMage processing may increase the already substantial total raw data volume, and so, it is prudent to plan for ample *hard drive space*. Multiview deconvolution, 3D rendering, and in general visualization of SPIM data are placing high demands on graphics hardware (GPU). We recommend investing in *CUDA capable graphics cards* such as NVIDIA Tesla or Quadro or GeForce. Moving large amounts of data characteristic to SPIM data to and from the computer takes time, and every network bottleneck between the end points should be removed starting with a 10 gigabit network interface. The processing described in this tutorial is performed on the following hardware configuration:

> Processor: *Two Intel Xeon Processor E5-2630 (six-core, 2.30 GHz Turbo,* 15 MB, 7.2 GT/s)
> Memory: *128 GB* (16 × 8 GB) 1600 MHz DDR3 ECC RDIMM
> Hard drive: *4 × 2TB* 3.5 inch Serial ATA (7.200 Rpm) hard drive
> HDD controller: PERC H310 SATA/SAS controller for Dell Precision
> HDD configuration: C1 SATA 3.5 inch, 1–4 hard drives
> Graphics: *Dual 2 GB NVIDIA Quadro 4000* (2 cards w/2DP and 1DVI-I each; 2DP-DVI and 2DVI-VGA adapter; MRGA17H)
> Network: Intel X520-T2 Dual Port *10GbE Network Interface Card*

27.1.5 FILE FORMATS PREPROCESSING AND NAMING CONVENTIONS

The first step and a prerequisite for the SPIMage processing pipeline in Fiji is to be able to open the image files. This is not a trivial task, since the paradigm of SPIM multiview imaging is relatively new and both commercial and open-source platforms did not yet incorporate the extra dimension into their data models. Moreover, SPIM acquisitions tend to be long-term, time-lapse, multiview, and multichannel acquisitions, which may be stored on the hard drive in countless permutations (for instance, one file for every dimension, one file per time point, or one file per view). Fiji relies on the Bio-Formats library (Goldberg et al., 2005) to import image data. SPIM registration Fiji plug-ins are currently working only with *.tif* or *.lsm* file types. In order to work with files from Lightsheet Z.1, it is necessary to open the files in Fiji and resave them as regular *.tif* files. This is easy to do manually for a single multiview

acquisition but becomes impractical for any larger time-lapse recordings. Fortunately, Fiji possesses a powerful macro language that makes it relatively straightforward to automate this task. The exact description of how to do that is beyond the scope of this manuscript; detailed instructions on how to open *.czi* files and resave them as *.tif files* can be found here (http://openspim.org/Pre-processing). Note that the same resaving procedure applies for OpenSPIM and Lightsheet Z.1 data.

The issue of file formats is closely connected to the issue of naming convention for the files. The SPIM plug-ins currently rely on encoding the information about the basic metadata about the experiment (i.e., which time point, view, or channel the file contains) in the file name. Although other possibilities are feasible, we recommend using the following naming convention:

spim_TL<*number*>_**ch**<*number*>_**Angle**<*number*>.tif

The numbers are usually zero-padded (i.e., 001, 002, and 003). Note that channels and angles can be discontinuous, while the time points usually represent a series of integers. The renaming into this naming convention is encoded in the macro script used for resaving from *.czi* to *.tif* (http://openspim.org/Pre-processing).

27.2 OVERVIEW OF THE SPIM IMAGE-PROCESSING PIPELINE

In order to reconstruct the sample, we need to register and fuse the acquired multiple views into a single output volume. We use subresolution fluorescent beads embedded in the rigid agarose medium as fiduciary markers to achieve this registration (Preibisch et al., 2009, 2010). Additionally, we exploit the beads to measure the point spread function (PSF) of the system to constrain the multiview deconvolution algorithm (Preibisch, Amat, Stamataki, Sarov, Singer, Myers & Tomancak, 2014).

Practically, the processing pipeline consists of the following steps (Fig. 27.1D):

1. *Multiview registration* (bead-based registration): During the first steps, the beads in each view are segmented. Then, the segmented beads are matched between the different views, and the views are registered resulting in a transformation model for each view that is able to arrange the views optimally in 3D space with respect to each other.
2. *Time-lapse registration* (bead-based registration): When dealing with time-lapse data, each time point of the recording is registered onto a reference time point. This allows compensating for slight differences in the positioning of each time point due to agarose deformation or sliding out of the capillary. This step is necessary for smooth visualization of the recording and tracking of labeled components across time.
3. *Preprocessing before* content-based multiview fusion/ multiview deconvolution (multiview fusion): Since the content-based multiview fusion/ multiview deconvolution processes are very memory-intensive, it is beneficial to first define a minimal area of interest using downsampled data. The region beyond this minimal area will not contribute to the fusion, and thus, it reduces the memory footprint and the required processing time.

4. Content-based multiview fusion/ multiview deconvolution (multiview fusion): The 3D images of the individual views are then fused together into a single output image by either content-based multiview fusion or multiview deconvolution using the transformation parameters from registration (step 1) and using the crop area defined in step 3.

It should be noted that while multiview registration must always precede fusion or deconvolution, the time-lapse registration could be performed out of order, immediately after multiview registration or after the fusion. The pipeline as presented in Fig. 27.1D is the most efficient order when dealing with massive time-lapse data. Some steps of the pipeline in Fig. 27.1D can be parallelized (steps 1 and 4), that is, each time point can be processed by a separate computer, and we describe how to leverage such distributed hardware in "cluster processing."

27.3 BEAD-BASED REGISTRATION

The first step in SPIMage processing is to register the 3D stacks of the same specimen acquired from different angles. This is achieved by fixing one of the views in 3D space and registering all other views to it. The axial resolution in SPIM is limited by the width of the light sheet and is significantly lower compared to the lateral resolution, which is determined by the NA of the objective lens. Thus, the stacks of individual views are highly anisotropic. The signal degrades along the illumination axis, because the light sheet gets absorbed and scattered by the specimen (Fig. 27.2A). To partially compensate for signal degradation along the illumination axis, it is possible to illuminate the sample from both sides sequentially; however, it does not completely remove the degradation depending on optical properties of the sample. Moreover, in SPIM, the signal degrades along the detection axis, similarly to a confocal, as the emitted light has to pass through the sample to reach the objective lens and is thus scattered and absorbed. Parts of the sample, which are further away from the objective lens, will be increasingly blurry (Fig. 27.2A). Finally, the specimen is typically alive and labeled components change position. In combination with anisotropy and signal degradation, this makes registration using sample intensities problematic (Preibisch, Ejsmont, Rohlfing, & Tomancak, 2008; Preibisch, Rohlfing, Hasak, & Tomancak, 2008; Swoger et al., 2007).

The bead-based registration plug-in solves the problem by uncoupling the registration from sample intensities by using subresolution fluorescent beads included in the rigid agarose medium as fiduciary markers (Preibisch et al., 2009, 2010). It consists of three principal steps: finding the beads, establishing which beads are the same between the different pairs of views, and minimizing the displacement of the corresponding beads.

For bead segmentation, we use a standard image-processing algorithm, *difference of Gaussian*, to detect local maxima in the image. For matching beads across views, we construct *local geometric descriptors*, which are essentially constellations of four beads expressed in relative, local coordinate systems that allow finding similar constellations in other views independent of rotation and translation (Fig. 27.2B).

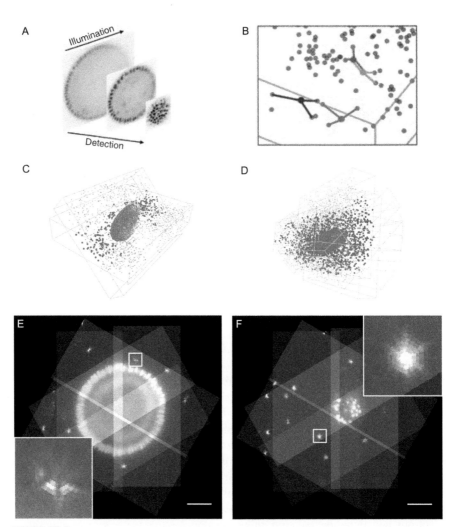

FIGURE 27.2

Multiview registration. (A) Degradation of the signal along the illumination and the detection axes. (B) Segmented beads in a 3D volume. Each bead (gray) is described by a local descriptor using the location of the three nearest neighbors in respect to the described bead. Four beads with their 3 nearest neighbors are highlighted by connecting lines. (C) Schematic of two views that are registered onto each other. The boundary box of each view and the sample are depicted in light gray. Bead correspondences are shown as dark grey dots. (D) An affine transformation model is used to register all views onto a fixed reference view. (E and F) Overlap of the different views in the reconstruction. The insets in each panel show the overlapping PSFs of the beads. In certain parts of the reconstruction, only a subset of the views might contribute to the reconstruction (E), whereas for the tips of the embryos, nearly all six views contributed (F). Scale bars represent 50 μm.

Figures (A and B) from Preibisch et al. (2010) and (C and D) from Preibisch et al. (2009).

Since this process is likely to produce spurious matches (bead constellations that are similar by chance), we use the *random sample consensus* (*RANSAC*; Fischler & Bolles, 1981) algorithm to exclude all false correspondences. The basic assumption of RANSAC is that all true correspondences are agreeing on one transformation model (Fig. 27.2C green dots), whereas each false correspondence will point to a different transformation model (Fig. 27.2C red dots). Finally, the true corresponding bead descriptors between the different views are used to identify the affine transformation of each view that minimizes their displacement. A *global optimization* using an iterative optimization algorithm is used to determine the optimal transformation model to match all views onto a fixed view as a common reference (Fig. 27.2D).

27.3.1 WORKFLOW

In practice, the registration process is performed using the *bead-based registration* plug-in. For detailed cookbook-style tutorial, see http://openspim.org/Registration and http://openspim.org/Timelapse_Registration.

1. We first select the segmentation method. *Difference of mean* is in most cases sufficient and has the benefit of running faster compared with *difference of Gaussian*. It is definitely the method of choice when attempting to define the segmentation parameters interactively.
2. Next, we load the raw data, named according to the naming convention described in Section 27.1.5 (Fig. 27.3A–C top part of each screenshot). Initially, we will process a single time point. For a long time series, it is reasonable to select a time point in the middle of the time series.
3. During the first run through the registration pipeline, we will determine the best bead segmentation parameters. We are doing this interactively on one representative angle of one time point of our dataset (Fig. 27.3A). The plug-in will load the selected stack in a window. The effect of the selected segmentation settings can be observed in the stack window with the segmented beads circled in green. For typical subresolution fluorescent beads, the default radius settings ($r_1 = 2$ and $r_2 = 3$) are sufficient, and only the threshold needs to be adjusted. The lower the threshold, the more beads will be detected. The aim is to segment as many beads as possible, without getting too much false detection in or around the sample and multiple detections on one bead. Note that detections inside the sample are unavoidable and will not compromise the registration.
4. After selecting the parameters, we execute the registration on the selected time point. The plug-in will first open each view and run the segmentation algorithm selected in step 1. This should result in several thousand detections for each view. Since the overlap of the views is typically limited and many detections represent densely packed structures inside the specimen, only a fraction of these detections will form descriptors that can be matched between views. Some of these will be similar by chance and will be excluded by RANSAC as false correspondences. The *ratio of true versus false correspondences* is reported by the algorithm and should be ideally over 90%, and the total *number of true correspondences* should be as high as possible.

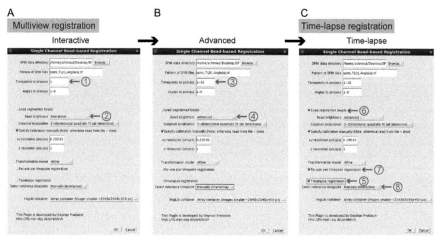

FIGURE 27.3

Overview of the registration process. Shown are screenshots of the bead-based registration plug-in window in Fiji. (A) During the initial run, we select a single time point (*1*) and launch the interactive bead segmentation window (*2*). (B) In the second run, we apply the segmentation parameters to all time points (*3*) in the time series by selecting the "advanced" segmentation option (*4*). (C) In the final run, we perform time-lapse registration (*5*) while reusing the bead segmentations (*6*) and registration (*7*) from the previous run. We are choosing the reference time point interactively (*8*).

In the final phase of the registration run, the global optimization will find the best affine transformation model that minimizes the displacement of true correspondences. The result of the global optimization is reported as *average displacement* of the corresponding bead descriptors, and it should be as low as possible, typically less than one pixel. If the number of true correspondences is low or average displacement high, one should try a different segmentation threshold. If the number of true correspondences cannot be increased over the built-in threshold of 12 per pair of views, it may be necessary to repeat the imaging experiment with more beads. It is important to note that it is not necessary that all views are connected to all other views; it is in principle sufficient that the views are connected pair-wise forming a closed chain.

5. Once a good segmentation threshold is identified, we can apply the selected parameter to the whole recording and perform the multiview registration on each time point using the advanced bead segmentation option (Fig. 27.3B). The actual output of the registration process will be coordinates of the geometric descriptors and *affine transformation matrices*. The files containing these numbers will be stored in a new directory called /registration, which will be created in the directory that contains the raw data.

6. The exact relative positioning of each time point may vary over time due to imprecise motor movements or slight drift of the agarose column inside the capillary. These differences in positioning would appear as drift if played as a time-lapse

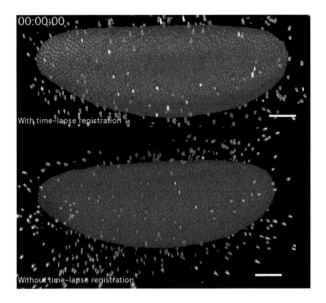

MOVIE 1

Time-lapse registration. Renderings of the Lightsheet Z.1 recording after content-based multiview fusion with time-lapse registration (upper panel) and without time-lapse registration (lower panel). Registration onto the reference time point stabilizes the recording and removes the drift introduced by imprecise motor movements and movement of the agarose.

movie (Movie 1 on http://dx.doi.org/10.1016/B978-0-12-420138-5.00027-6). To counteract this, we perform a *time-lapse registration*. In this step, we register all time points onto a reference time point. The time-lapse registration uses the same *bead-based registration* plug-in and works analogous to the multiview registration exploiting the beads segmented in the previous run (Fig. 27.3C). The reference time point can be selected manually, and it is advisable to select the same time point on which we optimized the segmentation parameters in the middle of the time series. At the end of the time-lapse registration, the plug-in will display a graph of the average, minimum, and maximum correspondence displacements. At this point, we can optionally select the time point with the lowest average displacement and rerun the registration using that time point as a reference. The output is, similarly to the registration for each time point, an affine transformation matrix stored in the /*registration* subdirectory. The new registration files have a suffix (e.g., *.to_<reference_timepoint>*) to indicate that they contain the time-lapse registration data.

27.3.2 RESULTS

The results of bead-based registration are affine transformation matrices that minimize the displacement of potentially thousands of corresponding bead descriptors surrounding the imaged specimen. Figure 27.2E and F shows sections through the data orthogonal to the rotation axis after the transformation matrices were applied

to the raw 3D image stacks. The data are not combined but simply displayed on top of each other with each view having assigned a different color. The insets show that the color-coded axially elongated PSFs of the beads overlap, which is the principle of the bead-based registration method. Note that the inset in Fig. 27.2E is composed of PSFs from three views, while the inset in Fig. 27.2F is made of four overlapping PSFs. Similarly, the boxes that represent the data indicate that there are areas of the specimen covered by two, three, four, and very rarely five views. Only at the tip of the specimen do the three- and four-way overlaps contribute to data (Fig. 27.2F); most of the specimen in the center slice is covered by two or maximally three views (Fig. 27.2E). Such limited view overlap is typical for multiview SPIM recording since imaging far beyond the equator of the sample does not usually contribute useful information. Therefore, we typically stop the imaging approximately halfway through the sample, which also decreases acquisition time. Nevertheless, as long as there are beads in the overlapping areas of the views, the registration will succeed.

27.4 MULTIVIEW FUSION

After successful registration, it is necessary to combine the data into a single three-dimensional output volume. Several strategies to achieve that task have been published (Rubio-Guivernau et al., 2012; Swoger et al., 2007; Temerinac-Ott, Ronneberger, Nitschke, Driever, & Burkhardt, 2011; Temerinac-Ott et al., 2012), ranging from simple averaging of the values to sophisticated multiview deconvolution strategies. We focus here on the two fusion methods implemented in Fiji, namely, *content-based multiview fusion* (Preibisch, Rohlfing, et al., 2008) and *efficient Bayesian-based multiview deconvolution* (Preibisch et al., 2014).

27.4.1 CONTENT-BASED MULTIVIEW FUSION

The transformation parameters determined in the multiview registration are the prerequisite to fuse the views into a single isotropic image (Fig. 27.4A). The views in multiview acquisition are typically overlapping only partially (Fig. 27.4B), and the deeper we image inside the specimen, the more blurry the images become due to light scattering along the illumination and detection axes (Fig. 27.3A). Therefore, simple addition or averaging of the values from the different views in the registered volume would lead to degradation of the sharp data from one view with the blurred data from the other view. The content-based multiview fusion attempts to prevent this degradation by evaluating local information content or entropy in the overlapping parts of the multiview acquisition and suppressing the blurry data with low entropy or in other words by maximizing the contribution of the sharp parts to the output image (Fig. 27.4C–E).

27.4.1.1 Workflow
Practically, the *content-based multiview fusion* is implemented by a dedicated plug-in accessible from the SPIM Registration Method submenu in Fiji. For detailed cookbook-style tutorial, see http://openspim.org/Fusion.

27.4 Multiview fusion

FIGURE 27.4

Content-based multiview fusion. (A) 3D stacks acquired from different angles are fused into a single 3D volume. (B) Schematic representation of the overlap between the six different views in our example dataset. (C) y–z section of Lightsheet Z.1 data after content-based multiview fusion without blending. The line artifacts are visible (*white arrowheads, inset*). (D) y–z section after content-based multiview fusion with blending but without content-based weights (*insets*). (E) y–z section after content-based multiview fusion using the content-based weights (*inset*). Scale bars represent 50 μm.

Figure (A) from Preibisch et al. (2010)

1. Similarly to multiview registration, the content-based multiview fusion is realized by two consecutive runs of the content-based multiview fusion plug-in. The algorithm is very memory-intensive because the input 3D stacks are rotated using the transformation matrices from registration and thus the size of the bounding box of the output volume increases dramatically. The data outside the specimen are important for the registration since they contain the beads but should be excluded from the fusion to reduce processing time. Therefore, in the first run of the plug-in, the processing is done on a single time point *downsampled 2–4 times*, and the fusion is applied without any computationally intensive steps such as blending (see in the succeeding text) and content-based weights (Fig. 27.5A). Running the plug-in using these parameters is equivalent to performing fusion by averaging the values from each view, and due to downsampling, it runs interactively even for large input data.

FIGURE 27.5

Overview of the content-based multiview fusion. (A) Screenshot of the first run of the fusion plug-in on downsampled data (*1*). This run is meant to define the minimal crop area containing the sample. The output will not be saved (*2*). (B) The second run through the same plug-in with blending (*3*) and content-based multiview fusion (*4*) turned on, downsampling turned off (*5*), and crop parameters entered (*6*). The results will be saved into an output directory (*7*).

2. From the prefused data, we determine the coordinates of the bounding box, which only includes the sample. It is very important to use the reference time point of the time-lapse registration to determine the correct cropping parameters for a time-lapse recording. The bounding box would be different for the registration derived from processing of a single time point and from time-lapse registration. We use the core Fiji tools to collect the coordinates of the bounding cube and either write them down or record them using the macro recorder of ImageJ.

3. In the second run, we enter the recorded cropping parameters and perform the fusion without downsampling only on the part of the image defined by the crop area (Fig. 27.5B). It is important to multiply the coordinates of the crop area by the factor used in downsampling (i.e., if we downsampled 4 times, we multiply each coordinate by a factor of four). During this run, we apply *nonlinear blending* and *content-based weights*. The fusion can be applied sequentially to

multiple time points using the time-lapse registration files in the /registration directory. The resulting fused output volume is saved in a new directory/output. Each time point can be saved as a series of 2D image planes in its own directory that is named after the time point index (Fig. 27.5B). The result can be viewed either by dragging and dropping each directory into the main window of Fiji, or alternatively, it can be opened as image sequence (File → Import → Image Sequence).

27.4.1.2 Results

As discussed in "Section 27.3," in SPIM, we do not typically image the entire sample in each view. Thus, the fusion algorithm has to deal with a situation when one view ends abruptly or the other begins. Without compensation, the abrupt borders of the views result in clearly visible line artifacts in the fused image (Fig. 27.4C white arrow heads). These line artifacts are eliminated by the use of nonlinear blending (Fig. 27.4C compared with Fig. 27.4D) that smooths the transition between the views. It should be, however, noted that the blending is altering the raw image data and should not be used when quantitative information need to be extracted from the images.

Content-based multiview fusion ensures that for each view, mainly the sharpest parts are contributing to the final fused image using location-dependent weighting factors for each pixel in each view (Fig. 27.4D compared with Fig. 27.4E insets). Since the PSF of the microscope is anisotropic and axially elongated, this simple fusion approach based on the information theory necessarily degrades the quality of the output image compared to the raw single-view data viewed laterally. Multiview deconvolution addresses this shortcoming of the fusion process.

27.4.2 MULTIVIEW DECONVOLUTION

Multiview deconvolution is another fusion strategy that takes the PSFs of the SPIM system into account to combine the images of different views into a single output image. In general, deconvolution attempts to reconstruct the underlying true image that gave rise to the observed microscope image given the PSF of the imaging system. This is obviously a very demanding task; however, the multiview scenario is particularly well suited for deconvolution since the same location in the same specimen is observed multiple times from different angles, which makes the ill-posed problem of inverting the convolution process more tractable. Several approaches to multiview deconvolution have been developed; however, none are capable of processing on large input datasets (Temerinac-Ott et al., 2011, 2012). We focus therefore on the *Bayesian-based multiview deconvolution plug-in* implemented in Fiji (Fig. 27.6; Preibisch et al., 2014). This plug-in implements an optimized multiview deconvolution approach that exploits the conditional probabilities between views (i.e., by observing one view, we learn something about the other view of the same specimen), which leads to dramatic decrease in number of iterations required to reach a certain deconvolution quality compared to competing approaches. Thanks

FIGURE 27.6

Overview of the multiview deconvolution processing. (A) The initial run is performed in the debug mode (*1*), in order to determine how many iterations are necessary (*2*). The deconvolution is performed on the cropped dataset (*3*) in blocks (*4*) using the GPU (*5*). For the initial run, we will only display the resulting stacks (*6*). (B) The final run is performed on the whole time-lapse using the determined number of iterations (*7*). The debug mode is turned off (*8*) and the resulting stacks are saved (*9*).

to advanced software engineering, the multiview deconvolution plug-in in Fiji is also able to execute each iteration faster, which together with less iterations leads to dramatic improvements in computation time. It is also the only approach able to deal with partially overlapping data and very large datasets. A final speed gain can be achieved by exploiting the parallel computation on graphics devices capable of CUDA (GPU computing), making this plug-in currently the only approach able to deconvolve long-term, time-lapse, multiview SPIM data in reasonable time.

27.4.2.1 Workflow

The *Bayesian-based multiview deconvolution* is implemented by a dedicated plug-in accessible from the SPIM Registration Method submenu in Fiji. For detailed information about advanced parameters of the plug-in, see http://fiji.sc/Multi-View_Deconvolution.

1. The prerequisite for multiview deconvolution is *precise registration* of the views in multiview acquisition as described in "Section 27.3." We also need to know the *PSF of the imaging system*. Since for the purposes of registration we included subresolution fluorescent beads that effectively measure the PSF, we use the true correspondences from the registration step to construct an average PSF for each view. Alternatively, a computed PSF can be provided as an image. Finally, even with all the speedups described in the preceding text, multiview deconvolution is computationally very demanding, and thus, we need to minimize the amount of input data. We use the *crop area* defined during the fusion step described in "Section 27.4" to limit the size of the deconvolved data. This means that in a typical workflow, we first perform a fusion to extract the crop parameters before proceeding with the multiview deconvolution. It is imperative to use the same registration files for both fusion steps.
2. For some large data, it may be beneficial to perform the *deconvolution on a downsampled dataset* to further speed up the process. Fiji offers the possibility to prescale the data before launching the deconvolution by running the *Apply External Transformation* plug-in. This plug-in will prepend a transformation model to the data (e.g., a scale factor of 0.5) by directly modifying the registration output files in /registration directory. Note that this process is irreversible, and so, it is recommended to backup the registration files before downscaling. Importantly, the downscaling is applied to the data after cropping, and so, the crop area must be expressed in the coordinates of the full-scale image.
3. As before, the deconvolution plug-in is run in two rounds. During the first round, we activate the *debug mode* that will give us an opportunity to examine the results of the deconvolution after each iteration and thus help us decide how far to run the iterative deconvolution process. The only other free parameter of the method is the number of iterations, where 10–20 is a good starting point. All other parameters of the deconvolution plug-in are launched with reasonable default values and should be changed only after thoroughly understanding the principles of the method. The implementation can make use of GPUs, and it is usually necessary to perform the operation in blocks because the memory of GPUs is small compared to the size of the SPIM input data.
4. After the initial debug run, which helps us to determine the number of iterations by examining the output, we can apply the deconvolution process sequentially to an entire time series. Note that for typical SPIM datasets, even when using the power of GPUs, this may take quite some time, and therefore, we recommend to explore the possibilities of parallelizing the process on a cluster as described in the preceding text.

27.4.2.2 Results

Multiview deconvolution dramatically improves the resolution and contrast of the fused image compared to content-based multiview fusion, and the quality of the reconstructed data is superior even to single views in the axial direction (Fig. 27.7A–F). The success of the deconvolution can be monitored by the effect

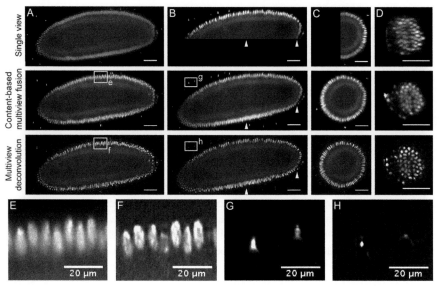

FIGURE 27.7

Multiview *deconvolution*. (A) Lateral, (B) axial, and (C and D) y–z sections through raw, fused, and deconvolved Lightsheet Z.1 data. The positions of the y–z sections are indicated with white arrowheads (B). Lightsheet Z.1 offers dual-sided illumination, and therefore, both sides of the sample are evenly illuminated (A, *single view*). The degradation of the signal in the detection axis is visible in the axial section (B, *single view*) and the y–z section of the single view (C and D, *single view*). The boxes mark areas enlarged in (E–H). (E) Blowup of nuclei after content-based multiview fusion. (F) Blowup of the same nuclei after multiview deconvolution. The resolution and contrast are greatly enhanced by the deconvolution. (G) Blowup of the PSFs of two beads after content-based multiview fusion. (H) Blowup of the same beads after multiview deconvolution. The PSFs of the beads collapse into a single point. Scale bars represent 50 μm except otherwise indicated.

it has on the fluorescent beads that are ideally collapsed to single intense points (Fig. 27.7G and H). The deconvolution is a nonlinear process that dramatically affects the signal intensity distribution, and so, it should be used with caution when applied to quantitative data analysis.

27.5 PROCESSING ON A HIGH-PERFORMANCE CLUSTER

The registration, fusion, and deconvolution pipelines are typically applied to multiview time-lapse SPIM datasets consisting of potentially hundreds of time points. While the individual steps last from minutes (registration) to hours (deconvolution on CPU) on one time point, when applied to large-scale time-lapse data, the minutes become hours and hours become days. It is therefore quite beneficial to parallelize the processing by employing many computers at the same time. Since, with the exception

of time-lapse registration, all steps of the SPIMage processing pipeline are independent from time point to time point, they can be relatively straightforwardly distributed to a cluster computer. Although Fiji is relying heavily on a graphical user interface, we exploit the trick that the screen can be simulated in memory, which allows processing on a cluster node that lacks a monitor. We have developed a set of Bash and BeanShell scripts that deploy the SPIM plug-ins to a cluster computer. The source code details are beyond the scope of this chapter and are available at http://fiji.sc/SPIM_Registration_on_cluster. The basic premise is to first perform the registration locally on a graphics workstation and collect the key parameters such as z-scaling of the data, segmentation threshold, crop area, or number of iterations for multiview deconvolution. These parameters are inserted in appropriate places in the scripts and are eventually passed to a Fiji instance executed on a cluster node using raw multiview data for a single specific time point. The scripts can be easily adapted to a different cluster hardware and software. As is the case for processing single time points, the cluster needs to have fairly state-of-the-art hardware parameters, especially when it comes to read and write operations and the amount of memory available for each node. With the appropriate hardware, it becomes possible to register, fuse, and deconvolve an entire time-lapse multiview SPIM recording as fast as the data are acquired (Fig. 27.8 and Movie 2 on http://dx.doi.org/10.1016/B978-0-12-420138-5.00027-6).

27.6 FUTURE APPLICATIONS

The SPIMage processing pipeline is a product of research at the interface between biology and computer science. Although it is already quite useful for processing multiview, time-lapse SPIM data, it is far from finished. It will be important in the future to make the input to the plug-ins more flexible, utilizing the metadata from the microscopes to automatically understand the structure of the data and to process on them directly, without format conversions. The plug-ins themselves will become more integrated so that the tedious steps of defining the crop area and moving parameters manually between the different runs are more convenient. We are working on a Big Data Viewer plug-in that uses HDF5 database to enable interactive navigation of terabyte scale, multiangle data in Fiji. Eventually, all SPIMage processing plug-ins will write the output data into the HDF5 container, and that will enable to examine various steps of the processing pipelines immediately after they are finished. This will finally realize the vision of acquiring multiview SPIM data on a microscope and immediately being able to examine the reconstruction in three dimensions. Finally, processing of the SPIM data is only the beginning. The Fiji platform is running several open-source projects to analyze large-scale microscopy datasets in developmental and cell biological contexts that involve segmentation and tracking of labeled components through space and time. These tools, manual and automated, need to be integrated on one hand with the outputs of the SPIMage processing pipeline and on the other hand with visualization and data analysis tools in Fiji and beyond. Most of the SPIMage processing is using the powerful Java image-processing library ImgLib2 (Pietzsch, Preibisch, Tomancak, & Saalfeld, 2012) that

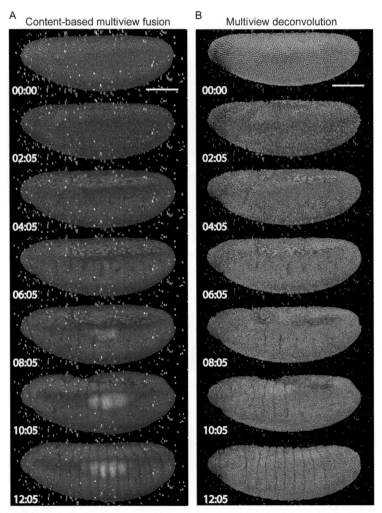

FIGURE 27.8

Processed time-lapse data. (A) Rendered time lapse of the Lightsheet Z.1 recording after content-based multiview fusion. (B) Rendered time lapse of the same recording after multiview deconvolution. The scale bars represent 100 μm.

is capable of building bridges to other open-source platforms. This enables building complex, multiplatform solutions for SPIMage processing and analysis utilizing the strengths of diverse image analysis software (Eliceiri et al., 2012). The open-source model is instrumental in this effort (Cardona & Tomancak, 2012).

We demonstrated the performance of the SPIMage processing platform on data acquired from the commercial Lightsheet Z.1 instrument. It is equally applicable to processing data from homemade SPIM systems, including the open-access hardware

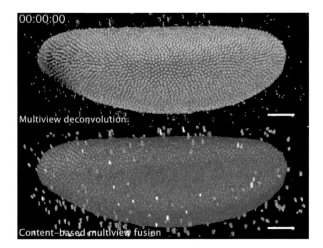

MOVIE 2

Multiview Deconvolution. The rendered Lightsheet Z.1 data after multiview devconvolution and content-based multiview fusion. The contrast and the resolution is significantly improved using multiview deconvolution.

OpenSPIM concept. The synergy of open-source software and open-access hardware ensures that the interdisciplinary research in processing of multiview microscopy data will continue bringing new ideas from computer science to the hands of biologists interested in applying the light sheet technology.

REFERENCES

Ahrens, M. B., Orger, M. B., Robson, D. N., Li, J. M., & Keller, P. J. (2013). Whole-brain functional imaging at cellular resolution using light-sheet microscopy. *Nature Methods*, *10*(5), 413–420.

Arrenberg, A. B., Stainier, D. Y., Baier, H., & Huisken, J. (2010). Optogenetic control of cardiac function. *Science*, *330*(6006), 971–974. http://dx.doi.org/10.1126/science.1195211.

Cardona, A., & Tomancak, P. (2012). Current challenges in open-source bioimage informatics. *Nature Methods*, *9*(7), 661–665. http://dx.doi.org/10.1038/nmeth.2082.

Eliceiri, K. W., Berthold, M. R., Goldberg, I. G., Ibáñez, L., Manjunath, B. S., Martone, M. E., et al. (2012). Biological imaging software tools. *Nature Methods*, *9*(7), 697–710. http://dx.doi.org/10.1038/nmeth.2084.

Fahrbach, F. O., Voigt, F. F., Schmid, B., Helmchen, F., & Huisken, J. (2013). Rapid 3D light-sheet microscopy with a tunable lens. *Optics Express*, *21*(18), 21010. http://dx.doi.org/10.1364/OE.21.021010.

Fischer, M., Haase, I., Wiesner, S., & Müller-Taubenberger, A. (2006). Visualizing cytoskeleton dynamics in mammalian cells using a humanized variant of monomeric red fluorescent protein. *FEBS Letters*, *580*(10), 2495–2502. http://dx.doi.org/10.1016/j.febslet.2006.03.082.

Fischler, M. A., & Bolles, R. C. (1981). Random sample consensus: A paradigm for model fitting with applications to image analysis and automated cartography. *Communications of the ACM*, *24*(6), 381–395. http://dx.doi.org/10.1145/358669.358692.

Gao, L., Shao, L., Higgins, C. D., Poulton, J. S., Peifer, M., Davidson, M. W., et al. (2012). Noninvasive imaging beyond the diffraction limit of 3D dynamics in thickly fluorescent specimens. *Cell*, *151*(6), 1370–1385. http://dx.doi.org/10.1016/j.cell.2012.10.008.

Goldberg, I. G., Allan, C., Burel, J.-M., Creager, D., Falconi, A., Hochheiser, H., et al. (2005). The open microscopy environment (OME) data model and XML file: Open tools for informatics and quantitative analysis in biological imaging. *Genome Biology*, *6*(5), R47. http://dx.doi.org/10.1186/gb-2005-6-5-r47.

Gualda, E. J., Vale, T., Almada, P., Feijó, J. A., Martins, G. G., & Moreno, N. (2013). OpenSpinMicroscopy: An open-source integrated microscopy platform. *Nature Methods*, *10*(7), 599–600. http://dx.doi.org/10.1038/nmeth.2508.

Huisken, J., & Stainier, D. Y. R. (2007). Even fluorescence excitation by multidirectional selective plane illumination microscopy (mSPIM). *Optics Letters*, *32*(17), 2608–2610.

Huisken, J., & Stainier, D. Y. R. (2009). Selective plane illumination microscopy techniques in developmental biology. *Development*, *136*(12), 1963–1975. http://dx.doi.org/10.1242/dev.022426.

Huisken, J., Swoger, J., Del Bene, F., Wittbrodt, J., & Stelzer, E. H. (2004). Optical sectioning deep inside live embryos by selective plane illumination microscopy. *Science*, *305*(5686), 1007–1009.

Keller, P. J. (2013). Imaging morphogenesis: Technological advances and biological insights. *Science*, *340*(6137), 1234168. http://dx.doi.org/10.1126/science.1234168 [Review].

Keller, P. J., Schmidt, A. D., Santella, A., Khairy, K., Bao, Z., Wittbrodt, J., et al. (2010). Fast, high-contrast imaging of animal development with scanned light sheet-based structured-illumination microscopy. *Nature Methods*, *7*(8), 637–642. http://dx.doi.org/10.1038/nmeth.1476.

Keller, P. J., Schmidt, A. D., Wittbrodt, J., & Stelzer, E. H. K. (2008). Reconstruction of zebrafish early embryonic development by scanned light sheet microscopy. *Science*, *322*(5904), 1065–1069. http://dx.doi.org/10.1126/science.1162493.

Keller, P. J., & Stelzer, E. H. (2008). Quantitative in vivo imaging of entire embryos with digital scanned laser light sheet fluorescence microscopy. *Current Opinion in Neurobiology*, *18*(6), 624–632. http://dx.doi.org/10.1016/j.conb.2009.03.008.

Krzic, U., Gunther, S., Saunders, T. E., Streichan, S. J., & Hufnagel, L. (2012). Multiview light-sheet microscope for rapid in toto imaging. *Nature Methods*, *9*(7), 730–733. http://dx.doi.org/10.1038/nmeth.2064.

Megason, S. G., & Fraser, S. E. (2007). Imaging in systems biology. *Cell*, *130*(5), 784–795. http://dx.doi.org/10.1016/j.cell.2007.08.031.

Pietzsch, T., Preibisch, S., Tomancak, P., & Saalfeld, S. (2012). ImgLib2—Generic image processing in Java. *Bioinformatics*, *28*(22), 3009–3011. http://dx.doi.org/10.1093/bioinformatics/bts543.

Pitrone, P. G., Schindelin, J., Stuyvenberg, L., Preibisch, S., Weber, M., Eliceiri, K. W., et al. (2013). OpenSPIM: An open-access light-sheet microscopy platform. *Nature Methods*, *10*(7), 598–599. http://dx.doi.org/10.1038/nmeth.2507.

Planchon, T. A., Gao, L., Milkie, D. E., Davidson, M. W., Galbraith, J. A., Galbraith, C. G., et al. (2011). Rapid three-dimensional isotropic imaging of living cells using Bessel beam plane illumination. *Nature Methods*, *8*(5), 417–423. http://dx.doi.org/10.1038/nmeth.1586.

Preibisch, S., Amat, F., Stamataki, E., Sarov, M., Singer, R. H., Meyers, E., et al. (2014). Efficient Bayesian-based multiview deconvolution. *Nature Methods*, In Print. http://dx.doi.org/10.1038/nmeth.2929.

Preibisch, S., Ejsmont, R., Rohlfing, T., & Tomancak, R. (2008). *Towards digital representation of Drosophila embryogenesis. IEEE.* (324–327).

Preibisch, S., Rohlfing, T., Hasak, M. P., & Tomancak, P. (2008). Mosaicing of single plane illumination microscopy images using groupwise registration and fast content-based image fusion. In *Proceedings of SPIE: Vol. 6914. Medical imaging 2008: Image processing* (p. 69140E) http://dx.doi.org/10.1117/12.770893(1).

Preibisch, S., Saalfeld, S., Rohlfing, T., & Tomancak, P. (2009). Bead-based mosaicing of single plane illumination microscopy images using geometric local descriptor matching. *SPIE Medical Imaging*, *7259*, 72592S–725102S.

Preibisch, S., Saalfeld, S., Schindelin, J., & Tomancak, P. (2010). Software for bead-based registration of selective plane illumination microscopy data. *Nature Publishing Group*, *7*(6), 418–419.

Reynaud, E. G., Krzic, U., Greger, K., & Stelzer, E. H. K. (2008). Light sheet-based fluorescence microscopy: More dimensions, more photons, and less photodamage. *HFSP Journal*, *2*(5), 266–275. http://dx.doi.org/10.2976/1.2974980.

Rubio-Guivernau, J. L., Gurchenkov, V., Luengo-Oroz, M. A., Duloquin, L., Bourgine, P., Santos, A., et al. (2012). Wavelet-based image fusion in multi-view three-dimensional microscopy. *Bioinformatics*, *28*(2), 238–245. http://dx.doi.org/10.1093/bioinformatics/btr609.

Schindelin, J., Arganda-Carreras, I., Frise, E., Kaynig, V., Longair, M., Pietzsch, T., et al. (2012). Fiji: An open-source platform for biological-image analysis. *Nature Methods*, *9*(7), 676–682. http://dx.doi.org/10.1038/nmeth.2019.

Schneider, C. A., Rasband, W. S., & Eliceiri, K. W. (2012). NIH Image to ImageJ: 25 years of image analysis. *Nature Methods*, *9*(7), 671–675. http://dx.doi.org/10.1038/nmeth.2089.

Siebrasse, J. P., Kaminski, T., & Kubitscheck, U. (2012). Nuclear export of single native mRNA molecules observed by light sheet fluorescence microscopy. *Proceedings of the National Academy of Sciences*, *109*(24), 9426–9431. http://dx.doi.org/10.1073/pnas.1201781109/-/DCSupplemental/Appendix.pdf.

Stelzer, E. H., & Lindek, S. (1994). Fundamental reduction of the observation volume in far-field light microscopy by detection orthogonal to the illumination axis: Confocal theta microscopy. *Optics Communications*, *111*(5), 536–547.

Swoger, J., Verveer, P., Greger, K., Huisken, J., & Stelzer, E. H. K. (2007). Multi-view image fusion improves resolution in three-dimensional microscopy. *Optics Express*, *15*(13), 8029–8042.

Temerinac-Ott, M., Ronneberger, O., Nitschke, R., Driever, W., & Burkhardt, H. (2011). *Spatially-variant Lucy–Richardson deconvolution for multiview fusion of microscopical 3D images. IEEE.* (pp. 899–904).

Temerinac-Ott, M., Ronneberger, O., Ochs, P., Driever, W., Brox, T., & Burkhardt, H. (2012). Multiview deblurring for 3-D images from light-sheet-based fluorescence microscopy. *IEEE Transactions on Image Processing*, *21*(4), 1863–1873. http://dx.doi.org/10.1109/TIP.2011.2181528, A Publication of the IEEE Signal Processing Society.

Tomer, R., Khairy, K., Amat, F., & Keller, P. J. (2012). Quantitative high-speed imaging of entire developing embryos with simultaneous multiview light-sheet microscopy. *Nature Methods*, *9*(7), 1–14. http://dx.doi.org/10.1038/nmeth.2062.

Truong, T. V., Supatto, W., Koos, D. S., Choi, J. M., & Fraser, S. E. (2011). Deep and fast live imaging with two-photon scanned light-sheet microscopy. *Nature Methods*, *8*(9), 757–760. http://dx.doi.org/10.1038/nmeth.1652.

CHAPTER

Second-harmonic generation imaging of cancer

28

Adib Keikhosravi, Jeremy S. Bredfeldt, Md. Abdul Kader Sagar, Kevin W. Eliceiri

Laboratory for Optical and Computational Instrumentation, University of Wisconsin at Madison, Madison, USA

CHAPTER OUTLINE

Introduction	532
28.1 SHG Physical and Chemical Background	532
28.2 SHG Instrumentation	533
28.3 Collagen Structure as a Biomarker	533
28.4 SHG in Cancer Research	535
28.4.1 Breast Cancer	535
28.4.2 Ovarian Cancer	537
28.4.3 Skin Cancer	537
28.4.4 SHG Research in Other Types of Cancer	539
28.5 Quantitative Analysis of SHG Images	541
Conclusion	541
References	542

Abstract

The last 30 years has seen great advances in optical microscopy with the introduction of sophisticated fluorescence-based imaging methods such as confocal and multiphoton laser scanning microscopy. There is increasing interest in using these methods to quantitatively examine sources of intrinsic biological contrast including autofluorescent endogenous proteins and light interactions such as second-harmonic generation (SHG) in collagen. In particular, SHG-based microscopy has become a widely used quantitative modality for imaging noncentrosymmetric proteins such as collagen in a diverse range of tissues. Due to the underlying physical origin of the SHG signal, it is highly sensitive to collagen fibril/fiber structure and, importantly, to collagen-associated changes that occur in diseases such as cancer, fibrosis, and connective tissue disorders. An overview of SHG physics background and technologies is presented with a focused review on applications of SHG primarily as applied to cancer.

INTRODUCTION

Over the past decade, second-harmonic generation (SHG) microscopy has been widely used for biology and tissue engineering research (Campagnola, 2011; Campagnola & Dong, 2011; Campagnola & Loew, 2003; Cox et al., 2003; Zipfel et al., 2003). Increasingly, SHG has been applied to investigate biomedical problems and has been used to study a wide spectrum of diseases, from different kinds of cancer to fibrosis and atherosclerosis, by providing quantitative features about disease-related collagen changes (Ajeti et al., 2011; Conklin et al., 2011; Han, Giese, & Bille, 2005; Kirkpatrick, Brewer, & Utzinger, 2007; Kwon, Schroeder, Amar, Remaley, & Balaban, 2008; Lacomb, Nadiarnykh, & Campagnola, 2008; Le, Langohr, Locker, Sturek, & Cheng, 2007; Lin et al., 2005; Lo et al., 2006; Nadiarnykh, LaComb, Brewer, & Campagnola, 2010; Provenzano et al., 2006; Sahai et al., 2005; Schenke-Layland et al., 2008; Strupler et al., 2007; Sun et al., 2008).

In 1961, Franken et al. discovered SHG as an optical nonlinear effect in quartz samples (Franken, Hill, Peters, & Weinreich, 1961). Fine and Hansen later found that tissues with collagen were able to intrinsically produce SHG when excited with the appropriate laser source (Fine & Hansen, 1971). Nearly three decades later, Campagnola et al. demonstrated the practicality of using SHG in the laser scanning microscope for cellular and tissue imaging (Campagnola, Wei, Lewis, & Loew, 1999).

In this chapter, we review SHG theory, instrumentation, and techniques. We then discuss the many kinds of cancer that have been investigated using SHG focusing on breast, ovarian, and skin cancers. We also present emerging research on other cancers such as lung adenocarcinoma (LC) and colonic and pancreatic cancers.

28.1 SHG PHYSICAL AND CHEMICAL BACKGROUND

Two-photon-excited fluorescence (TPEF) rises from the inelastic absorption of two photons. After a slight energy loss, one photon is emitted with less than twice the initial photon frequency. SHG, on the other hand, is a coherent, nonabsorptive process, which produces an emission photon at exactly twice the frequency of the excitation photon. Generally, the nonlinear polarization for a material can be expressed as

$$P = \chi^{(1)}E^1 + \chi^{(2)}E^2 + \chi^{(3)}E^3 + \cdots, \qquad (28.1)$$

where P is the total induced polarization, $\chi^{(n)}$ is the nth-order nonlinear susceptibility, and E is the electric field vector of incident light (Shen, 2003). The first term ($\chi^{(1)}E^1$) describes linear absorption, scattering, and reflection; the second term describes SHG, sum, and difference frequency generation; and the third term describes two- and three-photon absorption, third harmonic generation (THG), stimulated Raman processes, and coherent anti-Stokes Raman scattering (CARS). Considering the second term in Eq. (28.1),

$$P = \chi^{(2)}EE, \qquad (28.2)$$

we see that the second-order nonlinear polarization depends on the quantity $\chi^{(2)}$ and the field strength E squared. $\chi^{(2)}$ is the second-order nonlinear optical susceptibility and is measured experimentally in bulk samples. This quantity is nonzero only in noncentrosymmetric materials. The notable materials of biological relevance where this is the case are collagen, microtubules, and myosin, with collagen fibrils giving the strongest SHG signal and thus the focus of most SHG studies.

The expression for SHG signal strength is described in Eq. (28.3):

$$I(2\omega) \propto \left[\chi^{(2)} \frac{P}{\tau}(\omega)\right]^2 \tau, \qquad (28.3)$$

where P is the pulse energy, τ is the laser pulse width, and ω is the angular frequency of the excitation light (Campagnola, Clark, Mohler, Lewis, & Loew, 2001). A notable point here is that the SHG signal is only available during the excitation laser pulse width.

28.2 SHG INSTRUMENTATION

The schematic diagram for a typical SHG microscope is shown in Fig. 28.1 (Campagnola, 2011). In SHG, the wavelength of the excitation laser is not critical since SHG is not a resonant process (Chen, Nadiarnykh, Plotnikov, & Campagnola, 2012). Modern SHG instrumentation typically has two primary components: (1) a mode-locked femtosecond laser such as a titanium–sapphire laser and (2) a laser scanning microscope. As shown in Fig. 28.1, a complete SHG microscope that takes advantage of the full directionality of the SHG signal needs both forward and backward detection paths. This corresponds to transmission and reflection, respectively, and they need to be well aligned and calibrated in terms of detection efficiency to perform quantitative assessment (Pavone & Campagnola, 2013). The backward signal is collected using the epi-illumination path of the microscope, where the signal is first isolated using a dichroic mirror, then travels through a bandpass filter with approximately 10 nm bandwidth, and is finally detected with a photomultiplier tube. For the forward direction, the detection of the signal is performed by a high-numerical-aperture condenser or objective and filtered similar to the backward direction. Half- and quarter-wave plates are used to control the polarization of the laser at the focal point of the microscope (Campagnola, 2011).

28.3 COLLAGEN STRUCTURE AS A BIOMARKER

Collagen, the most abundant protein in vertebrates, forms the structural network of the extracellular matrix (ECM) in tissues and can vary in structure depending on type. For example, fibrillar collagen type I is composed of triple-helical

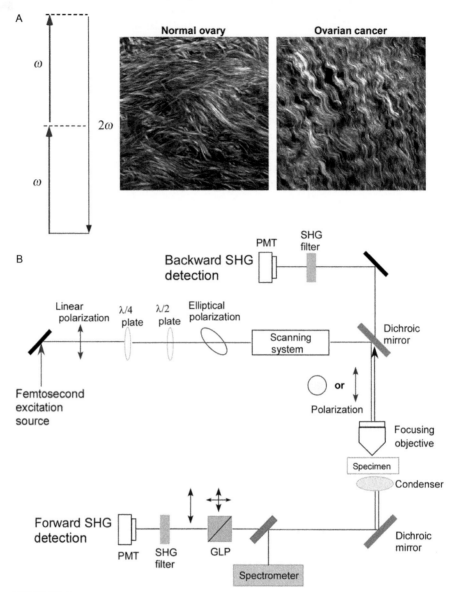

FIGURE 28.1

Overview of SHG photophysics, representative images, and instrumentation. (A) The Jablonski diagram for nonresonant SHG. Typical laser and SHG wavelengths are 900 and 450 nm, respectively. The images are representative single optical sections (field size = 170 μm) of the collagen fibers in a normal human ovary (left) and a malignant ovary (right), in which striking differences in collagen morphology are revealed by SHG. (B) Schematic of a typical SHG microscope optimized for forward and backward detection. Polarization optics in the excitation and signal paths (omitted from the backward path for figure clarity) allow detailed structural analysis of collagen organization. The forward and backward detectors are identical, and the paths are calibrated for collection and detection efficiency. PMT, photomultiplier; GLP, Glan-Laser polarizer; $\lambda/2$ and $\lambda/4$, half- and quarter-wave plates, respectively (Campagnola, 2011).

(Reprinted with permission from Campagnola, P. (2011). Second Harmonic Generation Imaging Microscopy: Applications to Diseases Diagnostics. Anal Chem 83, 3224–3231. Copyright 2011 American Chemical Society.)

macromolecules that are self-assembled into fibrils and fibers. The molecular organization, amount, and distribution of fibrillar collagen are important for the structural and mechanical properties of tissue and play an important role in several diseases including cancer. Although there are many opportunities for using collagen as a biomarker of wound healing, aging, and a diversity of diseases including atherosclerosis and diabetes (Kim, Eichler, Reiser, Rubenchik, & Da Silva, 2000; Lilledahl, Haugen, de Lange Davies, & Svaasand, 2007; Odetti et al., 1994; Tanaka, Avigad, Brodsky, & Eikenberry, 1988), we will focus here on reviewing cancer applications.

28.4 SHG IN CANCER RESEARCH
28.4.1 BREAST CANCER

Breast cancer is one of the most common cancers among American women, second only to skin cancers (American Cancer Society, 2013a, 2013b). Mammographic density is an emerging risk factor that has shown a large correlation with breast cancer risk (Brower, 2010). Since mammographic density is correlated with collagen density (Alowami, Troup, Al-Haddad, Kirkpatrick, & Watson, 2003), many studies have focused on the collagen's role in tumorigenesis and metastasis.

Differentiation between healthy cells and malignant tumors and prediction of survival rate have been investigated by Falzon et al. with respect to morphological collagen changes such as fibrillar collagen shape (Falzon, Pearson, & Murison, 2008). Keely et al. quantified the arrangement of collagen fibers in murine tumor models to investigate if collagen organization can be an early diagnostic factor for breast cancer. They characterized three reproducible "tumor-associated collagen signatures (TACS)" during defined levels of tumor progression (Provenzano et al., 2006). TACS-1 describes the dense collagen surrounding early-stage, prepalpable tumors where collagen fibers have no specific alignment. As tumors develop, the TACS-2 phenotype emerges, and we observe that collagen fibers begin to wrap around the developing tumor such that fibers are oriented parallel to the tumor–stromal boundary. Finally, in later-stage tumors, the TACS-3 pattern can be observed where collagen fibers are oriented perpendicular to the tumor–stromal boundary. Also, in TACS-3, collagen fibers are often observed to be aligned in the direction of cell invasion. Although these observations were first made in breast cancer tumor models, in 2011, a study was performed on a cohort of human breast cancer patients, and it was shown that the presence of the TACS-3 phenotype was highly correlated with patient survival (Conklin et al., 2011). Figure 28.2 illustrates the general TACS stages and gives examples of each observed in human breast biopsy tissue.

More recently, Ambekar et al. used Fourier transform SHG and polarization-resolved SHG (P-SHG) to investigate collagen structural changes at the cellular and molecular scales to evaluate the percentage of abnormal collagen fibrils from different pathological conditions such as hyperplasia, dysplasia, and malignant breast tissues from normal breast tissues (Ambekar, Lau, Walsh, Bhargava,

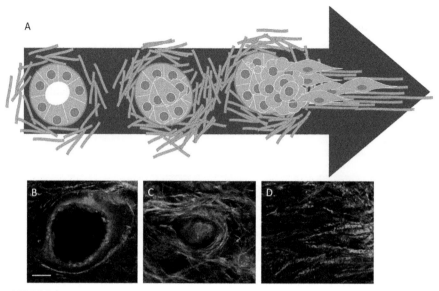

FIGURE 28.2

Illustration of the TACS stages 1–3 (A) with corresponding real examples of TACS-1, TACS-2, and TACS-3 (B–D) from the region within and surrounding a human invasive ductal carcinoma. Fresh biopsy tissue was vibratome-sectioned at 300 μm thick, *in situ* hybridization-stained for E-cadherin, and imaged with 780 nm excitation light. TPEF captured the epithelium (red) and SHG captured the collagen (green) signals. In the TACS-1 example, a region of locally dense collagen surrounds a relatively normal-looking duct (B). The TACS-2 example (C) shows straightened (taut) collagen fibers stretched around, constraining a duct, which has been filled with epithelial cells. In the example of TACS-3 (D), we observe tumor cells, which have lost most of their E-cadherin receptors, invading into a region of aligned collagen fibers. Scale bar = 50 μm. (See the color plate.)

Image courtesy of LOCI, UW-Madison.

& Toussaint, 2012). Their FT-SHG technique estimated the number of areas with aligned or randomly oriented collagen fibers and differentiated malignant tissues from other breast pathologies based on collagen fiber organization. P-SHG was used to investigate structural changes at the molecular scale by estimating the normalized tensor elements of the second-order susceptibility.

Quantitative evaluations of forward and backward SHG (F/B SHG) signals have proven useful to differentiate invasive breast cancer and to monitor the progress of collagen changes during breast carcinogenesis (Burke, Tang, & Brown, 2013). This study captured F/B SHG images throughout breast tumor progression in order to understand how this optical signature, which is influenced by fibrillar collagen microstructural properties, evolved alongside the tumor size and cell morphology that determine the grade and stage of the tumor. Although many research studies have

been conducted using SHG for breast cancer research, it is not yet established as a formal clinical method for diagnostic or prognostic use.

28.4.2 OVARIAN CANCER

Every year, there are more than 20,000 new cases of ovarian cancer in the United States and more than 15,000 deaths each year. There is currently no effective way to screen for ovarian cancer; thus, only 15% of ovarian cancers are diagnosed before metastasis has occurred. Early diagnostic tests that can detect premalignant changes could save many lives (American Cancer Society, 2011). SHG holds promise to augment existing techniques and potentially help fill this critical diagnostic need. Kirkpatrick et al. used SHG to observe a uniform epithelial layer with highly structured collagen in ovarian stroma versus varied epithelium with large cells and substantial quantifiable changes to the collagen structure in abnormal tissues (Kirkpatrick et al., 2007). Furthermore, the collagen structures of normal low-risk and normal high-risk postmenopausal ovaries are slightly different (Nadiarnykh et al., 2010).

Nadiarnykh et al. proposed a method to use characteristic anisotropy of SHG to quantify alignment of collagen molecules in fibers. They used Eq. (28.4) to calculate anisotropy:

$$\beta = \frac{I_{par} - I_{perp}}{I_{par} + 2I_{perp}} \qquad (28.4)$$

where I_{par} is the polarized SHG intensity parallel to the laser polarization and I_{perp} is the polarized SHG intensity prependicular to the laser polarization (Nadiarnykh et al., 2010). β lies between 0 and 1 for biological tissues, where 0 represents completely random organization and 1 implies completely ordered fiber organization. They calculate β as 0.88 for malignant ovary and 0.76 for normal ovary, showing that higher β for malignant tissues indicates more ordered structure. These observations are consistent with previous ovarian cancer stroma studies (Fig. 28.3).

Recently, Watson et al. used SHG imaging to study *ex vivo* mouse ovarian tissues of four different types: normal, benign abnormality, dysplasia, and carcinoma (Watson et al., 2012). In this research, they used the Fourier transform and gray-level co-occurrence matrix techniques to extract features for classification. They then used a support vector machine to classify the images. Using this approach, they reached 81.2% sensitivity for separating cancer from noncancer samples and 77.8% sensitivity for cancer versus normal tissue classification.

28.4.3 SKIN CANCER

Basal cell carcinoma (BCC) is the most prevalent skin cancer and accounts for 800,000 cases per year in the United States, with an annual incidence rate of nearly 200 for every 100,000 women and 400 for every 100,000 men (Rubin, Chen, & Ratner, 2005).

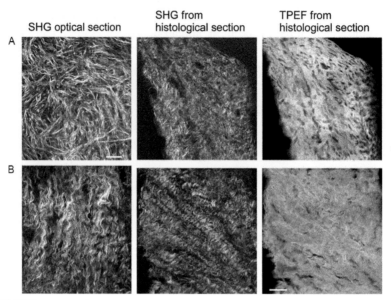

FIGURE 28.3

Representative SHG and TPEF images from normal (A) and malignant (B) ovarian biopsies. The left panels are en face SHG images of single optical sections where the tissue thickness was ~100 μm; the center and right images are SHG and TPEF images, respectively, from H&E optical sections from the same tissue as used for the en face images. Scale bar=25 μm (Nadiarnykh et al., 2010).

The combination of TPEF and SHG is particularly useful when imaging dermis tissue because the two main components of dermis (collagen and elastin) can be imaged with SHG and TPEF microscopy, respectively. Combined TPEF–SHG microscopy was applied to skin physiology and pathology and specifically to the study of normal skin (Konig & Riemann, 2003; König et al., 2005; Malone et al., 2002; Masters & So, 2001; Masters, So, & Gratton, 1998; So, Kim, & Kochevar, 1998), cutaneous photoaging (Koehler, König, Elsner, Bückle, & Kaatz, 2006), psoriasis (Konig & Riemann, 2003), and selected skin tumors, including BCC (Cicchi et al., 2007; Lin et al., 2006; Paoli, Smedh, Wennberg, & Ericson, 2008) and malignant melanoma (Dimitrow et al., 2009; Menon et al., 2009). Lin et al. used combined TPEF and SHG to identify the margin of human BCC (Lin et al., 2006). To help in the determination of this margin, this study used an index of multiphoton fluorescence (MF) and SHG co-occurance they call MFSI. After selection of the region of interest of the image, they defined this TPEF to SHG index as $MFSI = (a-b)/(a+b)$, where a is the number of thresholded TPEF pixels and b is the number of thresholded SHG pixels in the image. The MFSI index ranges from -1 to 1, corresponding to pure SHG and pure TPEF images, respectively. The highest MFSI is within the tumor masses, where the contribution of the fluorescent signal comes from the cytoplasm.

In the normal dermal stroma, the MFSI is the lowest, indicating the relatively high content of intact collagen molecules. In the cancer stroma, the MFSI is significantly higher than that of normal dermal stroma. Cicchi et al. used the combination of TPEF and SHG for the *ex vivo* investigation of healthy dermis, normal scar, and keloid tissues (Cicchi et al., 2010).

Later, Chen et al. (2010) proposed higher harmonic generation microscopy (HHGM), which is a combination of SHG and THG microscopy, for *in vivo* virtual biopsy. They used this technique for inspecting melanoma and a benign cellular proliferation called a compound nevi. Their results suggest that strong epi-THG enhancement is observable in melanoma, suggesting the possible molecular resonance enhancement through melanin. Also, they found that the absorption of melanin to the generated epi-THG light at 410 nm might cause relatively limited penetrability in dark melanoma samples. These results suggested that HHGM biopsy could be ideal for diagnosing early dysplasia melanoma and for distinguishing benign nevi and other pigmented diseases.

SHG has also shown the capability to define borders of melanoma. Thrasivoulou et al. (2011) showed that the borders of skin melanoma can be delineated quickly and accurately using SHG. In summary, these studies indicate that SHG has the potential to augment current excisional biopsy protocols for melanoma diagnosis and treatment.

28.4.4 SHG RESEARCH IN OTHER TYPES OF CANCER

Lung cancer is the second most common cancer in both men and women (not counting skin cancer; American Cancer Society, 2013b). Wang et al. (2009) used three groups of human lung tissue composed of noncancerous tissues, LC, and lung squamous cell carcinoma (SCC). Their results indicated a significant decrease in SHG signal in both LC and SCC, due to a lack of fibrillar collagen in these groups.

SHG microscopy may also be useful for probing changes in the basement membrane of colonic mucosa that are not accessible by other imaging modalities. In the first SHG study of colonic cancer, 72 colonic biopsy specimens from 32 patients showed a significant difference between the circle length and population density of the basement membrane (Zhuo et al., 2012). Later, Liu et al. (2013) used SHG–TPEF images to quantify differences between normal and cancerous mucosa and showed that SHG–TPEF ratio of normal tissue was higher than that for cancerous tissue at both the mucosa and submucosa. Both results showed the power of SHG for label-free imaging in cancer diagnosis.

In another study, Zhuo et al. (2009) performed multiple analyses of SHG and TPEF signals and found several significant differences between normal and neoplastic human esophageal stroma. In comparison with normal esophageal stroma, neoplastic stroma displayed (1) less defined and more diffuse collagen fibril structure; (2) loss of collagen, which is shown by reduced SHG pixel area; (3) reduced spacing between elastin fibers; (4) increased elastin area; and (5) reduced ratio of collagen to elastin (i.e., SHG–TPEF) signals. A similar study also showed

a reduced collagen area (i.e., ratio of SHG pixels to total pixels) in cancerous tissues compared with normal gastric tissues (Chen et al., 2011).

Cervical cancer has also been studied by Zhuo et al. (2009) through measurement of the size of epithelial cell nuclei and collagen quantity in stroma using TPEF and SHG. Recently, a study of mouse prostate tissue was conducted using different SHG excitation wavelengths producing three main results. First, the maximum SHG intensity occurred at 830 nm. Second, the cell nucleus was found to be larger in cancerous tissue compared to benign prostatic hyperplasia. Third, DNA level and arrangement might have changed, since DNA is considered to be one of the important sources of SHG in the nucleus (Huang & Zhuang, 2013; Zheng-Fei et al., 2010). Kidney tissue

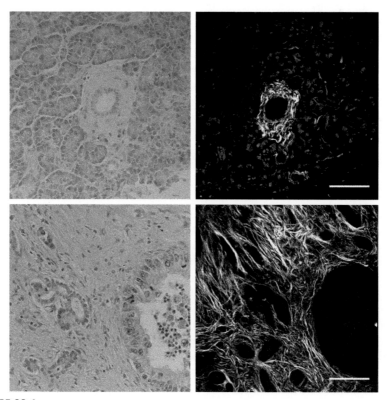

FIGURE 28.4

Top left: H&E image of a normal pancreatic ductal structure. Top right: Merged SHG (orange)/multiphoton-excited eosin fluorescence (green) image of corresponding tissue. Scale bar = 100 μm. Bottom left: H&E image of pancreatic ductal adenocarcinoma (grade 2). Bottom right: Merged SHG (orange)/multiphoton-excited eosin fluorescence (green) image of corresponding tissue. Scale bar = 100 μm. (See the color plate.)

Image courtesy of LOCI, UW-Madison.

was imaged by nonlinear multimodal optical microscopy (i.e., the combination of CARS, TPEF, and SHG) for differentiating normal kidney tissue, tumor, and necrosis (Galli et al., 2014).

For pancreatic cancer, Hu et al. (2012) showed that the density of the collagen fibers increased, which resembles the intensive stromal fibrosis manifest in pancreatic cancer patients (Chu, Kimmelman, Hezel, & DePinho, 2007). Drifka, Eliceiri, Weber, and Kao (2013) showed with SHG that there were detectable changes in collagen organization (Fig. 28.4) surrounding normal tissues versus ductal adenocarcinoma.

28.5 QUANTITATIVE ANALYSIS OF SHG IMAGES

From the time that collagen was first used as a target for SHG imaging (Fine & Hansen, 1971), researchers have tried to find quantitative parameters to help differentiate normal and diseased tissues. Although interesting features such as collagen density and alignment have been proposed by groups such as Provenzano et al. (2006, 2008), tools have not been readily available for automating density and alignment analysis of the collagen fibers in SHG images. Recently, Fourier transform, co-occurrence matrix, and characteristic anisotropy have been proposed to monitor the alignment and density of the collagen (Burke et al., 2013; Malone et al., 2002; Nadiarnykh et al., 2010). Bredfeldt et al. (2014) implemented four algorithms for extraction of quantitative information from collagen fibers. They used Gaussian, SPIRAL-TV (Harmany, Marcia, & Willett, 2012), Tubeness (Sato et al., 1998), and curvelet-denoising (Candès, Demanet, Donoho, & Ying, 2006; Starck, Candes, & Donoho, 2002) filters combined with a fiber tracking algorithm (Stein, Vader, Jawerth, Weitz, & Sander, 2008) to extract the number, length, and curvature of collagen fibers in SHG images of breast cancer tissue. They showed that the curvelet-denoising filter accompanied by the FIRE algorithm (Stein et al., 2008), which when combined is called CT-FIRE, gives the best results compared to manual fiber extraction. Further, tools for SHG quantification are needed not only to improve the direct measurement of collagen parameters but also as importantly to measure these in association with cell changes in the microenvironment. There is great interest in the tumor microenvironment, and together, advanced imaging and quantification of cell and collagen-rich ECM interactions could reveal new information on the processes surrounding tumor invasion and progression.

CONCLUSION

SHG microscopy has become a powerful modality for imaging fibrillar collagen in a diverse range of tissues. Because of its underlying physical origin, it is highly sensitive to the collagen fibril/fiber structure and, importantly, to changes that occur in diseases such as cancer, fibrosis, and connective tissue disorders. Although it has not

been utilized yet as a clinical modality, SHG has shown its ability to reveal important biological information about ECM alterations that accompany cancer progression and metastasis. As a research tool, it has great power in examining cell–matrix associations and can be used to quantitatively examine a number of collagen attributes that may be affected by cell signaling or direction force interactions.

REFERENCES

Ajeti, V., Nadiarnykh, O., Ponik, S. M., Keely, P. J., Eliceiri, K. W., & Campagnola, P. J. (2011). Structural changes in mixed Col I/Col V collagen gels probed by SHG microscopy: Implications for probing stromal alterations in human breast cancer. *Biomedical Optics Express*, *2*, 2307–2316.

Alowami, S., Troup, S., Al-Haddad, S., Kirkpatrick, I., & Watson, P. H. (2003). Mammographic density is related to stroma and stromal proteoglycan expression. *Breast Cancer Research*, *5*, R129–R135.

Ambekar, R., Lau, T.-Y., Walsh, M., Bhargava, R., & Toussaint, K. C., Jr. (2012). Quantifying collagen structure in breast biopsies using second-harmonic generation imaging. *Biomedical Optics Express*, *3*, 2021–2035.

American Cancer Society. (2011). *What are the key statistics about breast cancer?* http://www.cancer.org/acs/groups/content/@epidemiologysurveilance/documents/document/acspc-029771.pdf.

American Cancer Society (2013a). *What are the key statistics about breast cancer?* http://www.cancer.org/cancer/breastcancer/detailedguide/breast-cancer-key-statistics.

American Cancer Society (2013b). *What are the key statistics about lung cancer?* http://www.cancer.org/cancer/lungcancer-non-smallcell/detailedguide/non-small-cell-lung-cancer-key-statistics.

Bredfeldt, J. S., Liu, Y., Pehlke, C. A., Conklin, M. W., Szulczewski, J. M., Inman, D. R., Keely, P. J., Nowak, R. D., Mackie, T. R., & Eliceiri, K. W. (2014). Computational segmentation of collagen fibers from second-harmonic generation images of breast cancer. *J. Biomed. Opt.*, *19*, 16007.

Brower, V. (2010). Breast density gains acceptance as breast cancer risk factor. *Journal of the National Cancer Institute*, *102*, 374–375.

Burke, K., Tang, P., & Brown, E. (2013). Second harmonic generation reveals matrix alterations during breast tumor progression. *Journal of Biomedical Optics*, *18*, 31106.

Campagnola, P. (2011). Second harmonic generation imaging microscopy: Applications to diseases diagnostics. *Analytical Chemistry*, *83*, 3224–3231.

Campagnola, P. J., Clark, H. A., Mohler, W. A., Lewis, A., & Loew, L. M. (2001). Second-harmonic imaging microscopy of living cells. *Journal of Biomedical Optics*, *6*, 277–286.

Campagnola, P. j., & Dong, C.-Y. (2011). Second harmonic generation microscopy: Principles and applications to disease diagnosis. *Laser & Photonics Reviews*, *5*, 13–26.

Campagnola, P. J., & Loew, L. M. (2003). Second-harmonic imaging microscopy for visualizing biomolecular arrays in cells, tissues and organisms. *Nature Biotechnology*, *21*, 1356–1360.

Campagnola, P. J., Wei, M. D., Lewis, A., & Loew, L. M. (1999). High-resolution nonlinear optical imaging of live cells by second harmonic generation. *Biophysical Journal*, *77*, 3341–3349.

Candès, E., Demanet, L., Donoho, D., & Ying, L. (2006). Fast discrete curvelet transforms. *Multiscale Modeling and Simulation, 5*, 861–899.

Chen, S.-Y., Chen, S.-U., Wu, H.-Y., Lee, W.-J., Liao, Y.-H., & Sun, C.-K. (2010). In vivo virtual biopsy of human skin by using noninvasive higher harmonic generation microscopy. *IEEE Journal of Selected Topics in Quantum Electronics, 16*, 478–492.

Chen, X., Nadiarnykh, O., Plotnikov, S., & Campagnola, P. J. (2012). Second harmonic generation microscopy for quantitative analysis of collagen fibrillar structure. *Nature Protocols, 7*, 654–669.

Chen, J., Zhuo, S., Chen, G., Yan, J., Yang, H., Liu, N., et al. (2011). Establishing diagnostic features for identifying the mucosa and submucosa of normal and cancerous gastric tissues by multiphoton microscopy. *Gastrointestinal Endoscopy, 73*, 802–807.

Chu, G. C., Kimmelman, A. C., Hezel, A. F., & DePinho, R. A. (2007). Stromal biology of pancreatic cancer. *Journal of Cellular Biochemistry, 101*, 887–907.

Cicchi, R., Kapsokalyvas, D., De Giorgi, V., Maio, V., Van Wiechen, A., Massi, D., et al. (2010). Scoring of collagen organization in healthy and diseased human dermis by multiphoton microscopy. *Journal of Biophotonics, 3*, 34–43.

Cicchi, R., Massi, D., Sestini, S., Carli, P., De Giorgi, V., Lotti, T., et al. (2007). Multidimensional non-linear laser imaging of basal cell carcinoma. *Optics Express, 15*, 10135–10148.

Conklin, M. W., Eickhoff, J. C., Riching, K. M., Pehlke, C. A., Eliceiri, K. W., Provenzano, P. P., et al. (2011). Aligned collagen is a prognostic signature for survival in human breast carcinoma. *American Journal of Pathology, 178*, 1221–1232.

Cox, G., Kable, E., Jones, A., Fraser, I., Manconi, F., & Gorrell, M. D. (2003). 3-Dimensional imaging of collagen using second harmonic generation. *Journal of Structural Biology, 141*, 53–62.

Dimitrow, E., Riemann, I., Ehlers, A., Koehler, M. J., Norgauer, J., Elsner, P., et al. (2009). Spectral fluorescence lifetime detection and selective melanin imaging by multiphoton laser tomography for melanoma diagnosis. *Experimental Dermatology, 18*, 509–515.

Drifka, C. R., Eliceiri, K. W., Weber, S. M., & Kao, W. J. (2013). A bioengineered heterotypic stroma-cancer microenvironment model to study pancreatic ductal adenocarcinoma. *Lab on a Chip, 13*, 3965–3975.

Falzon, G., Pearson, S., & Murison, R. (2008). Analysis of collagen fibre shape changes in breast cancer. *Physics in Medicine and Biology, 53*, 6641.

Fine, S., & Hansen, W. P. (1971). Optical second harmonic generation in biological systems. *Applied Optics, 10*, 2350–2353.

Franken, P. A., Hill, A. E., Peters, C. W., & Weinreich, G. (1961). Generation of optical harmonics. *Physical Review Letters, 7*, 118–119.

Galli, R., Sablinskas, V., Dasevicius, D., Laurinavicius, A., Jankevicius, F., Koch, E., et al. (2014). Non-linear optical microscopy of kidney tumours. *Journal of Biophotonics, 7*, 23–27.

Han, M., Giese, G., & Bille, J. (2005). Second harmonic generation imaging of collagen fibrils in cornea and sclera. *Optics Express, 13*, 5791–5797.

Harmany, Z. T., Marcia, R. F., & Willett, R. M. (2012). This is SPIRAL-TAP: Sparse poisson intensity reconstruction algorithms—Theory and practice. *Transactions on Image Processing, 21*, 1084–1096.

Hu, W., Zhao, G., Wang, C., Zhang, J., & Fu, L. (2012). Nonlinear Optical Microscopy for Histology of Fresh Normal and Cancerous Pancreatic Tissues. *PLoS ONE, 7*, e37962.

Huang, Y., & Zhuang, Z. (2013). Second harmonic microscopic imaging and spectroscopic characterization in prostate pathological tissue. *Scanning*.

Kim, B.-M., Eichler, J., Reiser, K. M., Rubenchik, A. M., & Da Silva, L. B. (2000). Collagen structure and nonlinear susceptibility: Effects of heat, glycation, and enzymatic cleavage on second harmonic signal intensity. *Lasers in Surgery and Medicine*, *27*, 329–335.

Kirkpatrick, N. D., Brewer, M. A., & Utzinger, U. (2007). Endogenous optical biomarkers of ovarian cancer evaluated with multiphoton microscopy. *Cancer Epidemiology, Biomarkers and Prevention*, *16*, 2048–2057.

Koehler, M. J., König, K., Elsner, P., Bückle, R., & Kaatz, M. (2006). In vivo assessment of human skin aging by multiphoton laser scanning tomography. *Optics Letters*, *31*, 2879–2881.

Konig, K., & Riemann, I. (2003). High-resolution multiphoton tomography of human skin with subcellular spatial resolution and picosecond time resolution. *Journal of Biomedical Optics*, *8*, 432–439.

König, K., Schenke-Layland, K., Riemann, I., & Stock, U. A. (2005). Multiphoton autofluorescence imaging of intratissue elastic fibers. *Biomaterials*, *26*, 495–500.

Kwon, G. P., Schroeder, J. L., Amar, M. J., Remaley, A. T., & Balaban, R. S. (2008). Contribution of macromolecular structure to the retention of low-density lipoprotein at arterial branch points. *Circulation*, *117*, 2919–2927.

Lacomb, R., Nadiarnykh, O., & Campagnola, P. J. (2008). Quantitative second harmonic generation imaging of the diseased state osteogenesis imperfecta: Experiment and simulation. *Biophysical Journal*, *94*, 4504–4514.

Le, T. T., Langohr, I. M., Locker, M. J., Sturek, M., & Cheng, J.-X. (2007). Label-free molecular imaging of atherosclerotic lesions using multimodal nonlinear optical microscopy. *Journal of Biomedical Optics*, *12*, 054007.

Lilledahl, M. B., Haugen, O. A., de Lange Davies, C., & Svaasand, L. O. (2007). Characterization of vulnerable plaques by multiphoton microscopy. *Journal of Biomedical Optics*, *12*, 044005.

Lin, S.-J., Jee, S.-H., Kuo, C.-J., Wu, R.-J., Lin, W.-C., Chen, J.-S., et al. (2006). Discrimination of basal cell carcinoma from normal dermal stroma by quantitative multiphoton imaging. *Optics Letters*, *31*, 2756–2758.

Lin, S.-J., Wu, R.-, Jr., Tan, H.-Y., Lo, W., Lin, W.-C., Young, T.-H., et al. (2005). Evaluating cutaneous photoaging by use of multiphoton fluorescence and second-harmonic generation microscopy. *Optics Letters*, *30*, 2275–2277.

Liu, N., Chen, J., Xu, R., Jiang, S., Xu, J., & Chen, R. (2013). Label-free imaging characteristics of colonic mucinous adenocarcinoma using multiphoton microscopy. *Scanning*, *35*, 277–282.

Lo, W., Teng, S.-W., Tan, H.-Y., Kim, K. H., Chen, H.-C., Lee, H.-S., et al. (2006). Intact corneal stroma visualization of GFP mouse revealed by multiphoton imaging. *Microscopy Research and Technique*, *69*, 973–975.

Malone, J. C., Hood, A. F., Conley, T., Nürnberger, J., Baldridge, L. A., Clendenon, J. L., et al. (2002). Three-dimensional imaging of human skin and mucosa by two-photon laser scanning microscopy. *Journal of Cutaneous Pathology*, *29*, 453–458.

Masters, B., & So, P. (2001). Confocal microscopy and multi-photon excitation microscopy of human skin in vivo. *Optics Express*, *8*, 2–10.

Masters, B. R., So, P. T. C., & Gratton, E. (1998). Optical biopsy of in vivo human skin: Multiphoton excitation microscopy. *Lasers in Medical Science*, *13*, 196–203.

Menon, U., Gentry-Maharaj, A., Hallett, R., Ryan, A., Burnell, M., Sharma, A., et al. (2009). Sensitivity and specificity of multimodal and ultrasound screening for ovarian cancer,

and stage distribution of detected cancers: Results of the prevalence screen of the UK Collaborative Trial of Ovarian Cancer Screening (UKCTOCS). *Lancet Oncology, 10,* 327–340.

Nadiarnykh, O., LaComb, R. B., Brewer, M. A., & Campagnola, P. J. (2010). Alterations of the extracellular matrix in ovarian cancer studied by second harmonic generation imaging microscopy. *BMC Cancer, 10,* 94.

Odetti, P., Pronzato, M. A., Noberasco, G., Cosso, L., Traverso, N., Cottalasso, D., et al. (1994). Relationships between glycation and oxidation related fluorescences in rat collagen during aging. An in vivo and in vitro study. *Laboratory Investigation, 70,* 61–67.

Paoli, J., Smedh, M., Wennberg, A.-M., & Ericson, M. B. (2008). Multiphoton laser scanning microscopy on non-melanoma skin cancer: Morphologic features for future non-invasive diagnostics. *Journal of Investigative Dermatology, 128,* 1248–1255.

Pavone, F. S., & Campagnola, P. J. (2013). *Second harmonic generation imaging.* Boca Raton: CRC Press.

Provenzano, P. P., Eliceiri, K. W., Campbell, J. M., Inman, D. R., White, J. G., & Keely, P. J. (2006). Collagen reorganization at the tumor-stromal interface facilitates local invasion. *BMC Medicine, 4,* 38.

Provenzano, P. P., Inman, D. R., Eliceiri, K. W., Knittel, J. G., Yan, L., Rueden, C. T., et al. (2008). Collagen density promotes mammary tumor initiation and progression. *BMC Medicine, 6,* 11.

Rubin, A. I., Chen, E. H., & Ratner, D. (2005). Basal-cell carcinoma. *New England Journal of Medicine, 353,* 2262–2269.

Sahai, E., Wyckoff, J., Philippar, U., Segall, J. E., Gertler, F., & Condeelis, J. (2005). Simultaneous imaging of GFP, CFP and collagen in tumors in vivo using multiphoton microscopy. *BMC Biotechnology, 5,* 14.

Sato, Y., Nakajima, S., Shiraga, N., Atsumi, H., Yoshida, S., Koller, T., et al. (1998). Three-dimensional multi-scale line filter for segmentation and visualization of curvilinear structures in medical images. *Medical Image Analysis, 2,* 143–168.

Schenke-Layland, K., Xie, J., Angelis, E., Starcher, B., Wu, K., Riemann, I., et al. (2008). Increased degradation of extracellular matrix structures of lacrimal glands implicated in the pathogenesis of Sjögren's syndrome. *Matrix Biology, 27,* 53–66.

Shen, Y. R. (2003). *The principles of nonlinear optics.* Hoboken, NJ: Wiley-Interscience.

So, P., Kim, H., & Kochevar, I. (1998). Two-photon deep tissue ex vivo imaging of mouse dermal and subcutaneous structures. *Optics Express, 3,* 339–350.

Starck, J.-L., Candes, E. J., & Donoho, D. L. (2002). The curvelet transform for image denoising. *IEEE Transactions on Image Processing, 11,* 670–684.

Stein, A. M., Vader, D. A., Jawerth, L. M., Weitz, D. A., & Sander, L. M. (2008). An algorithm for extracting the network geometry of three-dimensional collagen gels. *Journal of Microscopy, 232,* 463–475.

Strupler, M., Pena, A.-M., Hernest, M., Tharaux, P.-L., Martin, J.-L., Beaurepaire, E., et al. (2007). Second harmonic imaging and scoring of collagen in fibrotic tissues. *Optics Express, 15,* 4054–4065.

Sun, W., Chang, S., Tai, D. C. S., Tan, N., Xiao, G., Tang, H., et al. (2008). Nonlinear optical microscopy: Use of second harmonic generation and two-photon microscopy for automated quantitative liver fibrosis studies. *Journal of Biomedical Optics, 13,* 064010-1–064010-7.

Tanaka, S., Avigad, G., Brodsky, B., & Eikenberry, E. F. (1988). Glycation induces expansion of the molecular packing of collagen. *Journal of Molecular Biology, 203*, 495–505.

Thrasivoulou, C., Virich, G., Krenacs, T., Korom, I., & Becker, D. L. (2011). Optical delineation of human malignant melanoma using second harmonic imaging of collagen. *Biomed. Opt. Express, 2*, 1282–1295.

Wang, C.-C., Li, F.-C., Wu, R.-J., Hovhannisyan, V. A., Lin, W.-C., Lin, S.-J., So, P. T. C., & Dong, C.-Y. (2009). Differentiation of normal and cancerous lung tissues by multiphoton imaging. *J. Biomed. Opt., 14*, 044034.

Watson, J. M., Rice, P. F., Marion, S. L., Brewer, M. A., Davis, J. R., Rodriguez, J. J., et al. (2012). Analysis of second-harmonic-generation microscopy in a mouse model of ovarian carcinoma. *Journal of Biomedical Optics, 17*, 076002.

Zheng-Fei, Z., Han-Ping, L., Zhou-Yi, G., Shuang-Mu, Z., Bi-Ying, Y., & Xiao-Yuan, D. (2010). Second-harmonic generation as a DNA malignancy indicator of prostate glandular epithelial cells. *Chinese Physics B, 19*, 049501.

Zhuo, S., Chen, J., Luo, T., Jiang, X., Xie, S., & Chen, R. (2009). Two-layered multiphoton microscopic imaging of cervical tissue. *Lasers Med. Sci., 24*, 359–363.

Zhuo, S., Yan, J., Chen, G., Shi, H., Zhu, X., Lu, J., et al. (2012). Label-free imaging of basement membranes differentiates normal, precancerous, and cancerous colonic tissues by second-harmonic generation microscopy. *PLoS One, 7*, e38655.

Zipfel, W. R., Williams, R. M., Christie, R., Nikitin, A. Y., Hyman, B. T., & Webb, W. W. (2003). Live tissue intrinsic emission microscopy using multiphoton-excited native fluorescence and second harmonic generation. *Proceedings of the National Academy of the United States of America, 100*, 7075–7080.

Index

Note: Page numbers followed by *f* indicate figures, *t* indicate tables and *b* indicate boxes.

A

Achromat lenses, 23
3-Aminopropyl trimethoxysilane (APTMS), 378
Automated online feedback microscopy
 detection and imaging
 automated workflow, 494*f*, 497
 CellProfiler (*see* CellProfiler and LASAF Matrix screener)
 infecting hepatoma cell lines, 494, 494*f*
 merozoites, 494
 sample preparation, 495
 ER exit sites (ERES)
 COPII components, 497–498
 definition, 497–498
 extract recovery kinetics, 499*f*, 500–501
 FRAP workflow, 497–498, 499*f*
 sample preparation, 498
 vesicle budding, 497–498
 workflow and implementation, 498–500
 microscope and image analysis software, 490, 491*f*
 requirements, 492–493, 492*t*
 scanning workflow, 490, 491*f*
 tracking workflow, 491, 491*f*

B

Basal cell carcinoma (BCC), 537
Bead-based registration
 data orthogonal, 514*f*, 517–518
 global optimization, 513–515, 514*f*
 illumination and detection axis, 513, 514*f*
 local geometric descriptors, 513–515, 514*f*
 random sample consensus, 513–515, 514*f*
 registration process, 515–517, 516*f*
 subresolution fluorescent beads, 513
Benchmarking
 fluorophore intensity, 136
 inputs
 biological samples, 143
 laser power, sample, 137–138, 138*f*
 photomultiplier tubes (*see* Photomultiplier tubes)
 sample-driven parameters, 143–144
 three-dimensional sample, dispersive properties, 141–143
 outputs
 depth of acquisition, 148–149
 PSF, 144–146
 SNR and total intensity, 146–148, 147*f*
Blind deconvolution, 185
Breast cancer
 F/B SHG, 536–537
 mammographic density, 535
 P-SHG and FT-SHG, 535–536
 TACS, stages of, 535

C

CAEOBS, 461
Camera
 parameters
 amplification, 41–43, 43*f*
 bit depths, 40, 41*f*
 digital gray value, 40
 digitizer, 40
 dynamic range, 40–41
 fixed-pattern noise, 39–40
 noise, 37
 Poisson noise, 37–38, 38*f*
 quantum efficiency, 37
 read noise, 39
 sCMOS considerations, 43–44
 thermal noise, 39
 performance testing
 photon transfer theory, 44–46
 PTC (*see* Photon transfer curve)
Cell-line-specific photostability
 cell-to-cell variation, 107
 data collected quality, 107
 filter sets, 107
 H2B fusions, 107
 image cells, 108
 photobleaching curves, 108
 temperature and atmosphere, 107
CellProfiler and LASAF Matrix screener
 experimental setup, 496–497
 image analysis, 494
 implementation, 495
 LeicaImageObject module, 496
 Leica SP5 confocal microscope, 494
 LeicaWaitForImage module, 496
Cervical cancer, 540–541

547

Colocalization
 evaluation
 connexity analysis, 404
 Costes' randomization, 400–401, 402
 k coefficients, 399
 Manders coefficient, 399
 overlap coefficient, 399
 Pearson correlation coefficient, 398
 Spearman's coefficient, 401
 thresholding method, 400
 Van Steensel's method, 400
 image segmentation, 403–404
 indicators, 397
 quantifiers, 397
 distance based, 405–406
 overlap based, 404–405
Computer-aided microscopy (CAM), 495
Confocal laser-scanning microscope (CLSM), 114
Continuous wave (cw) STED microscopy, 458
Convolution (\otimes), 181, 184
Costes' randomization, 400–401, 402
Counting molecules
 methods
 FCS, 349–351
 fluorescence standard method, 354–356
 integrated intensity, 349, 350f
 microscope alignment and sample preparation, 348–349
 photobleaching, 351–352
 postacquisition image analysis, 348–349
 standard curve, 352–354, 353f
 γ-tubulin microtubule nucleation structure, 354
 yeast kinetochore spots, 349
 ratiometric comparison analysis
 budding yeast imaging protocol, 358
 dark noise, 357
 depth correction, 359
 Gaussian curve, 360
 GFP spot, 358, 359
 light leakage, 357
 light noise, 357
 photobleaching correction factor, 360
 potential systematic errors, 356–357
 sample buffer noise, 357

D

Dark noise, 139
Data analysis
 FA turnover analysis
 curve fitting, 342–344
 GRG Nonlinear engine, 344
 Microsoft Excel "Solver", 342–344, 343f
 nonparametric statistics, 344
 outcomes, 344, 345f
 photobleaching curve, 342
 steeper disassembly fit, 344
 three different phases, 341–342
Deconvolution, 404
DNA curtains
 flow cell assembly, 220–221
 lipid bilayer, 221–222
 lipid diffusion barrier, 219–220, 220f
 protein–DNA interactions
 ATP hydrolysis-driven DNA translocation, 230f, 231
 binding site distribution histogram, 228f
 nucleic acids, 231–232
 protein–protein colocalization, 231
 target search mechanisms, 227–230
 TIRFM, 219–220
 types of
 double-tethered curtains, 223–225, 224f
 PARDI, 223–225, 224f
 single-tethered curtains, 223, 224f
 ssDNA curtains, 225–226
DNA origami nanorulers
 advantage, 451
 brightness references, 457–458, 457f
 DNA-PAINT microscopy, 459–461, 460f
 fluorescent beads, 451
 FWHM, 462–463, 462f
 12-helix bundle (12HB), 456, 456f
 labelling
 bioassay study, 452–453
 biotin-modified, 455
 enzymatic, 454–455
 external, 453–454, 454f
 internal, 453, 453f
 molecular breadboard, 452–453
 steric constraints, 455
 subsequent, 453–454
 light microscopy, 450–463
 nanopillar, 456–457, 456f
 new rectangular origami (NRO), 456, 456f
 principle, 452, 452f
 Rayleigh criterion, 461–462
 SHB, 456
 six-helix bundle (6HB), 455–456, 456f
 for STED, 456
 for superresolution microscopy, 450–451, 458–459
DNA-PAINT microscopy, 459–461, 460f

E

Endoplasmic reticulum exit sites (ERES)
 COPII components, 497–498
 definition, 497–498

extract recovery kinetics, 499f, 500–501
FRAP workflow, 497–498, 499f
sample preparation, 498
vesicle budding, 497–498
workflow and implementation, 498–500

F

F/B SHG. *See* Forward and backward SHG (F/B SHG)
Fluorescence-activated cell sorting (FACS), 189
Fluorescence correlation spectroscopy (FCS), 349–351
Fluorescence filters
　anhydrous ethanol/isopropyl alcohol, 64
　dichroic/polychroic mirrors, 64
　hard-coated filters, 64
　orientation, 64
　soft-coated filters, 64
Fluorescence intensities
　microscope aspects
　　laser stability, 120–121, 122f
　　nonuniform field illumination, 121
　　offsets and saturation, 121
　sample aspects
　　coverslips, 123
　　mounting media, 121–122
　　sample labeling, 123
Fluorescence interference contrast (FLIC) microscopy, 237
Fluorescence recovery after photobleaching (FRAP), 336, 497–498, 499f
Fluorescence standard method, 354–356
Fluorescent microscopy
　environmental control
　　gas control, 85
　　humidifiers, 85
　　imaging chambers, 60–62, 85–86
　　media composition and pH, 84–85
　　temperature, 83–84
　　tissue culture medium, 85
　excitation light, 78
　ground-state depletion, 78
　live cell imaging
　　camera, 81
　　excitation and emission light path, 79
　　focus drift, 82
　　motorized stage, 82
　　objective lens, 81
　　shutters, 81
　photobleaching, 78–79
　probes, 92–93
　proteins
　　influencing factors, 88

　　photobleaching, 89, 90–92
　　spectra and filter sets, 87
　　tag placement, 88, 89f
Fluorescent proteins
　evaluation performance
　　cell-line-specific photostability, 107–108
　　fusion, 108
　influencing factors, 88
　optical and physical properties
　　brightness determinants, 100–101
　　ion sensitivity, 98
　　monomeric FP, 98–99
　　photostability, 98
　　wavelength determinants, 99
　photobleaching, 89, 90–92
　photostability complexities
　　multiple photobleaching pathways, 102
　　photobleaching behaviors, 102–106
　　standard measuring and reporting, 106
　spectra and filter sets, 87
　tag placement, 88, 89f
Fluorinated ethylene propylene (FEP) tubes, 204f, 205, 206f
Fluor lenses, 24
Focal adhesion (FA) turnover analysis
　actomyosin-mediated pulling forces, 335–336
　cell–cell contacts, 337
　cell migration, 335–336
　data analysis
　　curve fitting, 342–344
　　GRG Nonlinear engine, 344
　　Microsoft Excel "Solver", 342–344, 343f
　　nonparametric statistics, 344
　　outcomes, 344, 345f
　　photobleaching curve, 342
　　steeper disassembly fit, 344
　　three different phases, 341–342
　FP-tagged protein, 337–338
　FRAP data, 336
　image analysis, 338f, 340–341
　life cycle, 335–336
　paxillin–mCherry expression, 338–339, 338f
　quantitative analysis, 335–336
　spatial and temporal control, 335–336
　spinning-disk confocal microscopy, 339–340
Forward and backward SHG (F/B SHG), 536–537
Fourier transform SHG (FT-SHG), 535–536
Fourier transform traction cytometry (FTTC), 374
Full width at half maximum (FWHM), 321, 402, 450–451, 462f

G

Graphical user interface (GUI)
 2D analysis, 421–423
 3D analysis, 422f, 423

H

Higher harmonic generation microscopy (HHGM), 539
High-resolution traction force microscopy (TFM)
 airstream incubator, 376
 arbitrary geometries and nonlinear gel responses, 373–374
 CCD camera, 376
 cell culture and sample preparation, 381–382
 cellular traction forces, 368
 data processing
 predefined line, 392
 traction forces quantification, 390, 391f
 whole-cell traction, 390–392
 definition, 370
 elastic deformations, 369
 fluorescent beads, 370–372, 372f
 FTTC, 374
 functionalize polyacrylamide substrates, 380–381
 multiwavelength laser, 376
 PAAG, 369
 perfusion chamber
 bead imaging, 385
 cells removal, 385
 DIC components, 383
 equipment and materials, 383
 GFP-tagged focal adhesion marker, 383
 intermediate magnification module, 383
 laser illumination and spinning-disk confocal imaging mode, 384
 polyacrylamide substrates, fiducial markers
 acrylamide/bisacrylamide solutions, 378, 379t
 APTMS solution, 378
 equipment and materials, 377–378
 microscope slides preparation, 379
 polyacrylamide gel preparation, 380
 squeaky clean coverslip, 378
 quantifying deformation, 385–386
 reconstruct traction, Reg-FTTC
 alleviating spectral leakage, 390
 computational procedure, 387–388
 Tikhonov regularization parameter, 388, 389f
 spatial resolution, 370–372, 371f
 spinning-disk confocal scanner, 375
 Tikhonov regularization, 374
 traction reconstruction principles, 372–373

I

Image acquisition, SAIM
 intensity profiles, 247, 248f
 raw interference and height reconstruction, 248–249, 249f
 redundancy, 247–248
Image segmentation, 403–404
Interferometric photoactivated localization microscopy (IPALM)
 achromatic doublet lens, 288
 beam splitter, 287
 calibration curve, 288–290
 imaging depth with astigmatic defocusing, 290
 mirrors, 287
 principles, 286–287, 286f
 sample holder assembly, 287
Iterative method, 185

K

Kinetochore
 chromosome segregation, 468–469
 coating coverslips, 469–470
 spindle compression
 agarose pad preparation, 471–472
 cell culture, 471
 cell selection, 472–474, 473f
 experimental setup, 472, 473f
 Köhler illumination, 474
 levels of, 474–476
 micromanipulator rod removal, 476
 Ptk2 cells, 471
 troubleshooting tips, 476–477
 subpixel resolution kinetochore imaging
 CenpCmCherry probe, 479–481
 data analysis, 480f, 481
 experimental setup, 481
 Förster resonance energy transfer, 477
 Gaussian fitting, 477, 478
 Hec1-EGFP/EYFP-Cdc20 probe, 479–481, 479f
 interprobe distances, 483
 SHREC, 477–478
 transient transfection, 479–481
 two-color bead registration, 480f, 481–482
 two-color reporter probes, 482
Kruskal–Wallis analysis, 344

L

Light sheet microscopy
 data acquisition
 imaging parameters, 209–210
 light sheet alignment, 199f, 207–209
 sample orientation, 207

datasets
 high speed and large SPIM, 210–211, 211f
 image analysis, 212
 image enhancement, 211
 multiview fusion, 211–212
implementation
 double-sided illumination, 200f, 202
 iSPIM, 200f, 202–203
 light sheet properties, 198–199, 199f
 multiview acquisition, 202, 202f
 objective lenses, 203
 orthogonal optical arrangement, 196f, 201
 refractive index-matching, 200f, 201
 second illumination arm, 200f, 201–203
 upright configuration, 199–201, 200f
mounting strategies
 FEP tubes, 204f, 205, 206f
 solid gel cylinder, 203–205, 204f
principle, 195, 196f
 lateral resolution, 197f, 198
 light sheet illumination, 195–196, 197f
 wide-field detection, 196–198, 197f
SPIM, 194–195
Localization microscopy
 axial drift, 264–265
 data analysis and image reconstruction, 265
 dual-color superresolution imaging, 267, 268f
 genetic tagging and immunocytochemistry, 255
 highly sensitive camera and stability, 264–265
 labeling strategy
 Cy5 and analog Alexa Fluor 647, 258
 fluorophore brightness and labeling density, 257
 GFP and RFP, 258–259
 linkage error, 259–260, 259f
 Nyquist theorem, 257
 organic dyes, 258
 PAFPs, 257–258
 SNAP-tag technology, 259
 spheroplasting, 258
 Nic96, 265
 nuclear pore complex, 255
 photoactivatable/photoswitchable fluorescent proteins, 254–255
 point spread function, 254
 principles, 254, 255f
 ring structure, 262f, 265, 266f
 sample preparation
 anti-GFP nanobodies labeling, 263
 ConA-coated coverslips, 260–261
 ConA-cross-linked coverslips, 261
 ConA labeling, 263
 ConA staining, 264
 mEOS3.2 *vs.* mMaple, 262, 262f
 nanobody/SNAP-tag staining, 264
 secreting extracellular matrix components, 255, 261f
 SNAP-tag and nanobody labeling, 266f, 267
 yeast strain library, 256
 yeast strain preparation, 256–257
Lung cancer, 539

M

Manders coefficient, 399
Mean square displacement (MSD), 417
Microscope
 CCD/CMOS camera, 64–65
 cleaning, 58–66
 dirty optics, 56, 56f
 dust removal, 65–66
 fluorescence filters
 dichroic/polychroic mirrors, 64
 excitation and emission filters, 63–64, 63f
 maintenance and testing
 color registration, 71–72
 computer maintenance, 66
 DIC optics, 67
 illumination, 71
 intensity measurement, 67–71
 Koehler alignment, 66–67
 motorized components and software, 73–74
 point spread function measurement, 73
 transmitted light pathway, 66–67
 vibration, 72–73
 new system installation, 74
 objective lens care
 air blowers, 61–62
 with coverslips, 60
 debris, 62
 "drop and drag" method, 62
 immersion media, 58–66
 inverted microscope eyepiece, 61, 61f
 laboratory wipe, 59f, 60–61, 60f
 specimen surface clean, 59
 spring-mounted head, 59f, 61
 temperature, 62
 unscrewing lens, 57t, 60
 recommended maintenance supplies, 56, 57t
Multichannel structured illumination microscopy
 chromatic shifts, 328, 329f
 colocalization, 328
 quantitative analysis, 319f, 328–330
 set up multicolor SIM, 327
Multiphoton microscopy
 benchmarking

Multiphoton microscopy (*Continued*)
 inputs, 136–144
 outputs, 144–149
 purchasing decision, 150–151
 troubleshooting/optimizing, 150
Multiview deconvolution process
 Bayesian-based multiview deconvolution, 521–523, 522f
 crop area, 523
 debug mode, 523
 downsampled dataset, 523
 external transformation, 523
 results, 523–524, 524f
Multiview fusion
 blending and content-based weights, 520, 520f
 content-based image fusion, 518–521, 519f
 nonlinear blending, 519f, 521
 reference time point, 520
 transformation matrices, 519

N

Nikon NIS-Elements AR (v4.22) software, 340–341
Nuclear pore complex (NPC), 255
Numerical aperture (NA), 179, 179f, 180

O

Objective lenses
 care and cleaning of, 32–34, 33f
 correction collar, 28, 28f
 cover glass, 29, 30f
 DIC imaging, 31
 immersion media, 30–31
 nomenclature, 25, 26f
 optical aberrations
 off-axis aberrations, 22
 on-axis aberrations, 22
 optical path length
 coverslip thickness, 27–28
 spherical aberration, 27
 optical transmission and image intensity, 25–27
 optical tweezers, 32
 types
 achromat lenses, 23
 apochromats, 24
 fluor lenses, 24
 numerical aperture, 25, 25f
 plan achromat lenses, 23–24
 water dipping lens *vs.* standard water immersion, 31
Off-axis aberrations, 22
On-axis aberrations, 22
Optical tweezers, 32
Ovarian cancer, 537
Overlap coefficient, 399

P

Pancreatic cancer, 541
Parallel array of double-tethered isolated (PARDI), 223–225, 224f
Pearson correlation coefficient (PC), 398
 Costes' randomization, 400–401
 Van Steensel's method, 400
PEC*PAD®, 64, 65
Photoactivated localization microscopy (PALM), 236
 3D superresolution, 275–277
 2D superresolution microscopy, 275
 fiducial-based alignment, 283–285
 fluorophore choice and sample preparation
 advantages and limitations, 279–280, 280t
 cells fixation, 282
 ON–OFF ratio, 279–280
 instrumentation for
 EMCCD cameras, 277–279
 filters for, 277, 278t
Photobleaching, 351–352
 mCherry, 90–92
 quantitative fluorescence microscopy, 14
 spinning disk confocal microscope, 90, 91f
 tdTomato, 90–92
 transfect cells, 90
Photomultiplier tubes (PMTs)
 dark noise, 139
 fixed PMT voltage, 139–140
 frame averaging, 139
 shot noise, 139
 voltage range, 140
Photon counting histogram (PCH) analysis, 351
Photon transfer curve (PTC)
 collection protocol
 camera port selection, 47
 FPN "quality factor", 51
 image arithmetic, 50, 50b
 mean grayscale value calculation, 47
 mean pixel intensity calculation, 49
 read noise and Poisson noise, 51
 signal levels calculation, 50
 uniform illumination, 47, 49, 49b
Photon transfer theory, 44–46
Photostability complexities
 multiple photobleaching pathways, 102
 photobleaching behaviors
 dominant components, 103
 exposure regimen, 104f

illumination intensity, 103–106
 reversible dimming, 105f
 wide-field photobleaching curves, 103f
 standard measuring and reporting, 106
pH-sensitive ratiometric dyes
 acid-loading approach, 431–432
 advantages, 433
 CCL-39 fibroblasts, 431–432, 432f
 fluorescence intensity, 431–432
 limitations, 433
 minimum dye concentration, 431
 NH_4^+ prepulse technique, 431–432
Plan achromat lenses, 23–24
Point spread function (PSF), 180–181, 181f, 182f, 254
 in nondispersive media, 144, 145f
 spherical aberration, 144–145
Poisson noise, 178
Polarization-resolved SHG (P-SHG), 535–536
Polyacrylamide hydrogels (PAAG), 369
Postacquisition image analysis, 348–349

Q

Quantitative confocal microscopy
 CLSM designs, 118
 controls
 antibody titration curves, 125
 binding (nonspecific), 125
 biological samples, 127
 blind imaging, 127
 flat-field images, 127
 FPs, 127
 isotype, 126
 unlabeled sample, 125
 image collection, 116–117, 117f
 imaging toolkit
 chroma slides, 118
 familiar test slide, 119
 micrometer, 119
 mirror slide, 119
 power meter, 118
 subresolution microsphere slide, 118
 tetraSpeck microsphere slide, 118
 interaction and dynamics
 cross talk, 123
 spectral imaging, 125
 time-lapse imaging, 120f, 124–125
 localization and morphology, 119–120
 nonuniform field illumination correction
 (Protocol 3), 129–130
 out-of-focus blur, 114, 115f
 principle, 114–116, 116f

PSFS measuring instrument (Protocol 1), 127–128
quantifying intensity (see Fluorescence intensities)
short and long-term laser power stability testing (Protocol 2), 129
spectral accuracy (Protocol 5), 130–131
spectral unmixing algorithm (Protocol 6)
 channel multi-PMT method, 131–132
 separation/unmixing, 132
 spectral detection method, 132
tetraspeck beads (Protocol 4), 130
Quantitative deconvolution microscopy
 applications of, 190–191
 assessing linearity, 189
 deblurring, 183, 183f
 Fourier spectrum, 187–189, 188f
 Fourier transform, 184–185
 image quality
 geometry, 186
 intensity, 186
 optics, 187
 image restoration, 184
 iterative methods, 185
 magnification, 178
 numerical aperture, 179, 179f, 180
 objective lenses, 179, 179t
 Poisson noise, 178
 PSF, 180–181, 181f, 182f
 SNR, 178, 178t
Quantitative fluorescence microscopy
 accuracy and precision, 2–3, 2f
 background, 4
 camera parameters
 amplification, 41–43, 43f
 bit depths, 40, 41f
 digital gray value, 40
 digitizer, 40
 dynamic range, 40–41
 fixed-pattern noise, 39–40
 noise, 37
 Poisson noise, 37–38, 38f
 quantum efficiency, 37
 read noise, 39
 sCMOS considerations, 43–44
 thermal noise, 39
 CCD and CMOS cameras, 36–37
 3D z-series images, 15
 image intensity values vs. image display, 5–6, 6f
 imaging modality choice, 7–8
 mean error bars, 16

Quantitative fluorescence microscopy (*Continued*)
 optical resolution, 7
 performance testing
 photon transfer theory, 44–46
 PTC (*see* Photon transfer curve)
 postacquisition corrections
 background subtraction, 12–13
 flat-field correction, 13–14
 photobleaching, 14
 storing and processing images, 14–15
 sampling
 2D sampling, 10–11, 10*f*
 3D sampling, 11–12
 temporal, 12
 typical time-lapsed imaging experiment, 8–10, 9*f*
 signal-to-noise ratio (SNR)
 detector capacity, 5
 frame averaging, 5
 pixel intensity values, 4
 Poisson counting statistics, 5
 specimen health, 15

R

Ratiometric pH probes
 acid-loading approach, 431–432
 advantages, 433
 buffer solutions, 438–440
 CCL-39 fibroblasts, 431–432, 432*f*
 cultured cells preparation
 dye loading, 440–441
 genetically coded pH biosensors, 442
 genetically encoded pH biosensors, 441
 whole-mount tissue, 442
 fluorescence intensity, 431–432
 generating nigericin calibration curves, 443–444, 443*t*
 genetically encoded pH sensors
 advantages, 434–435
 fusing ecliptic pHluorin and pH-insensitive mCherry, 433–434, 434*f*
 limitations, 434–435
 intracellular pH (pHi) measurement
 pK_a values, 435
 region of interest (ROI), 435
 subcellular pH measurements, 436–438
 in tissues, 438
 limitations, 433
 minimum dye concentration, 431
 NH$^+$4 prepulse technique, 431–432
 ratiometric analysis, 444–445
 single/dual-fluor sensors, 442–443

supereclyptic pHluorin and mCherry signals, 442–443
Regions of interest (ROI), 402

S

SC. *See* Spearman's coefficient (SC)
Scanning angle interference microscopy (SAIM)
 experimental methods and instrumentation
 cell culture and transfection, 243–244
 image acquisition, 247–249
 microscope calibration and configuration, 246–247
 objective and camera, 241–242
 reflective substrates preparation, 242
 samples immunolabeling, 244–246
 schematic diagram, 241, 241*f*
 fluorophores excitation
 experimental parameters, 239, 240*t*
 probability of, 239
 reflective silicon substrate selection, 239
 image analysis and reconstruction, 250
 superresolution optical imaging
 3-D single-molecule localization microscopy (SMLM), 236
 FLIC, 237
 hardware requirements, 237–238
 PALM, 236
 STORM, 236
 structured illumination microscopy (SIM), 236–237
Second-harmonic generation (SHG) microscopy, 531–546
 in cancer research
 breast cancer, 535–537
 cervical cancer, 540–541
 lung cancer, 539
 ovarian cancer, 537
 pancreatic cancer, 541
 skin cancer, 537–539
 collagen structure, biomarker, 533–535
 F/B SHG, 536–537
 FT-SHG, 535–536
 images, quantitative analysis, 541
 instrumentation, 533, 534*f*
 physical and chemical background, 532–533
 P-SHG, 535–536
 signal strength, 533
 TPEF and, 538–540, 538*f*
Selective plane illumination microscopy (SPIM)
 applications, 508–509, 525–527
 bead-based registration
 data orthogonal, 514*f*, 517–518
 global optimization, 513–515, 514*f*

Index

illumination and detection axis, 513, 514f
local geometric descriptors, 513–515, 514f
random sample consensus, 513–515, 514f
registration process, 515–517, 516f
subresolution fluorescent beads, 513
biological applications, 194–195
CCD camera, 506, 507f
dual-sided illumination principle, 507–508
file formats preprocessing, 511–512
fluorescent beads, 510
hardware requirements, 511
image processing pipeline, 507f, 512–513
installation and configuration, FIJI, 510–511
multiview deconvolution
 Bayesian-based multiview deconvolution, 521–523, 522f
 crop area, 523
 debug mode, 523
 downsampled dataset, 523
 external transformation, 523
 results, 523–524, 524f
multiview fusion
 blending and content-based weights, 520, 520f
 content-based image fusion, 518–521, 519f
 nonlinear blending, 519f, 521
 reference time point, 520
 transformation matrices, 519
numerical aperture, 508
parameters, 509–510
phototoxicity, 195
processed time-lapse data, 524–525, 526f, 527
static and dynamic light sheet, 506–507
theta microscopy principle, 506
Shannon–Nyquist–Whittaker theorem, 396
SHG microscopy. *See* Second-harmonic generation (SHG) microscopy
Shot noise, 139
Signal-to-noise ratio (SNR), 178, 178t, 482
 detector capacity, 5
 frame averaging, 5
 pixel intensity values, 4
 Poisson counting statistics, 5
SIM. *See* Structured illumination microscopy (SIM)
Single-molecule high-resolution colocalization (SHREC), 477–478
Single-molecule localization-based methods. *See* Localization microscopy
Skin cancer, 537–539
Sparkle®, 58–59
Spearman's coefficient, 401
Spherical aberration (SA)
 definition, 324–325
 Nikon TIRF objective, 320f, 325

procedural steps, 325–327
refractive index, 320f, 325
Spinning-disk confocal microscope (SDCM), 339–340
advantages, 155–156
CSU, 154–155
disadvantages, 156–157, 156f
EMCCD, 166
illumination
 Borealis implementation, 158
 CSU-X1 design, 158, 159f
 Gaussian intensity distribution, 157–158
 MMFs, 161
 NIR-SDCM, 161
 with single-mode, 158–159, 160f
lasers, 157
limitation, 154
optical sectioning and FOV
 camera sensor-chip areas *vs*. CSU-X1 field aperture, 162–163, 163f
 CSU-W1, 163–166, 164t, 165f
 pinholes positioning, 153–154
 schematic layout of, 154, 155f
sCMOS, 166
Stimulated emission depletion (STED) microscopy, 456
Stochastic optical reconstruction microscopy (STORM), 236, 450
Structured illumination microscopy (SIM), 236–237, 450
blocking out-of-focus light, 296
3D SIM
 image formation, 302–303, 303f
 technical implementation, 305–306, 306f
 theory, 303–305, 304f
fine interference patterns, 296
FWHM measurement, 320f, 321
illumination pattern, 317, 319f
live HeLa cell imaging
 3D SIM applications, 307–309, 308f
 TIRF SIM application, 307, 308f
multichannel SIM
 chromatic shifts, 328, 329f
 colocalization, 328
 quantitative analysis, 319f, 328–330
 set up multicolor SIM, 327
Nikon SIM (N-SIM), 316–317
photoactivatable proteins, 316
reconstruction artifacts, 310–311
sample preparation
 fixation, 323
 fluorophore and staining, 322
 index matching and embedding, 323–324

Structured illumination microscopy (SIM) (*Continued*)
 requirements, 322
 shift-invariant lateral imaging, 310
 sinusoidal stripe pattern, 317, 318*f*
 spatial and temporal resolution, 296
 spherical aberration (SA)
 definition, 324–325
 Nikon TIRF objective, 320*f*, 325
 procedural steps, 325–327
 refractive index, 320*f*, 325
 structured illumination theory
 Abbe diffraction limit, 299*f*, 300
 circular extended passband, 299*f*, 300
 2D image formation, 297–298, 298*f*
 fine stripe pattern, 298–299, 299*f*
 low-pass-filtered Fourier transform, 298–299, 299*f*, 300
 TIRF, 301
 superresolution techniques, 296
 time-lapse imaging, 316, 330, 331*f*
 two adjacent actin bundles, 319*f*, 321
 widefield technique, 296

T

TACS. *See* Tumor-associated collagen signatures (TACS)
THG. *See* Third harmonic generation (THG)
Third harmonic generation (THG), 539
Time-lapse registration, 516, 516*f*
Total internal reflection fluorescence microscopy (TIRFM), 8, 58, 219–220, 301
TPEF. *See* Two-photon-excited fluorescence (TPEF)
Tumor-associated collagen signatures (TACS), 535, 536*f*
Two-photon-excited fluorescence (TPEF), 532–533, 538–540, 538*f*

U

User-friendly tools
 automated classification, cell motion types
 area change, 411–415
 boundary points, 413, 414*f*
 displacement vectors, 412*f*, 413
 parameter space, 415, 415*f*, 416*f*
 polarization parameter, 411–415
 visual inspection, 411
 geometry-based segmentation, clusters, 418–420
 GUI
 2D analysis, 421–423
 3D analysis, 422*f*, 423
 morphodynamics classification
 analysis, 417–418
 batch processing, 417
 display windows, 416–417
 MSD, 417
 SquigglyMorph, 415–416
 SegmentMe, 424, 425*f*

V

Van Steensel's method, 400

W

Whatman® paper, 60
Widefield microscopy, 114, 115*f*
Widefield *vs.* Quantitative confocal microscopy, 114, 115*f*

Z

Zeiss LSM 780 confocal microscope, 498
Zero padding, 390

Volumes in Series

Founding Series Editor
DAVID M. PRESCOTT

Volume 1 (1964)
Methods in Cell Physiology
Edited by David M. Prescott

Volume 2 (1966)
Methods in Cell Physiology
Edited by David M. Prescott

Volume 3 (1968)
Methods in Cell Physiology
Edited by David M. Prescott

Volume 4 (1970)
Methods in Cell Physiology
Edited by David M. Prescott

Volume 5 (1972)
Methods in Cell Physiology
Edited by David M. Prescott

Volume 6 (1973)
Methods in Cell Physiology
Edited by David M. Prescott

Volume 7 (1973)
Methods in Cell Biology
Edited by David M. Prescott

Volume 8 (1974)
Methods in Cell Biology
Edited by David M. Prescott

Volume 9 (1975)
Methods in Cell Biology
Edited by David M. Prescott

Volume 10 (1975)
Methods in Cell Biology
Edited by David M. Prescott

Volume 11 (1975)
Yeast Cells
Edited by David M. Prescott

Volume 12 (1975)
Yeast Cells
Edited by David M. Prescott

Volume 13 (1976)
Methods in Cell Biology
Edited by David M. Prescott

Volume 14 (1976)
Methods in Cell Biology
Edited by David M. Prescott

Volume 15 (1977)
Methods in Cell Biology
Edited by David M. Prescott

Volume 16 (1977)
Chromatin and Chromosomal Protein Research I
Edited by Gary Stein, Janet Stein, and Lewis J. Kleinsmith

Volume 17 (1978)
Chromatin and Chromosomal Protein Research II
Edited by Gary Stein, Janet Stein, and Lewis J. Kleinsmith

Volume 18 (1978)
Chromatin and Chromosomal Protein Research III
Edited by Gary Stein, Janet Stein, and Lewis J. Kleinsmith

Volume 19 (1978)
Chromatin and Chromosomal Protein Research IV
Edited by Gary Stein, Janet Stein, and Lewis J. Kleinsmith

Volume 20 (1978)
Methods in Cell Biology
Edited by David M. Prescott

Advisory Board Chairman
KEITH R. PORTER

Volume 21A (1980)
Normal Human Tissue and Cell Culture, Part A:
 Respiratory, Cardiovascular, and Integumentary Systems
Edited by Curtis C. Harris, Benjamin F. Trump, and Gary D. Stoner

Volume 21B (1980)
Normal Human Tissue and Cell Culture, Part B: Endocrine, Urogenital, and Gastrointestinal Systems
Edited by Curtis C. Harris, Benjamin F. Trump, and Gray D. Stoner

Volume 22 (1981)
Three-Dimensional Ultrastructure in Biology
Edited by James N. Turner

Volume 23 (1981)
Basic Mechanisms of Cellular Secretion
Edited by Arthur R. Hand and Constance Oliver

Volume 24 (1982)
The Cytoskeleton, Part A: Cytoskeletal Proteins, Isolation and Characterization
Edited by Leslie Wilson

Volume 25 (1982)
The Cytoskeleton, Part B: Biological Systems and *In Vitro* Models
Edited by Leslie Wilson

Volume 26 (1982)
Prenatal Diagnosis: Cell Biological Approaches
Edited by Samuel A. Latt and Gretchen J. Darlington

Series Editor
LESLIE WILSON

Volume 27 (1986)
Echinoderm Gametes and Embryos
Edited by Thomas E. Schroeder

Volume 28 (1987)
***Dictyostelium discoideum:* Molecular Approaches to Cell Biology**
Edited by James A. Spudich

Volume 29 (1989)
Fluorescence Microscopy of Living Cells in Culture, Part A: Fluorescent Analogs, Labeling Cells, and Basic Microscopy
Edited by Yu-Li Wang and D. Lansing Taylor

Volume 30 (1989)
Fluorescence Microscopy of Living Cells in Culture, Part B: Quantitative Fluorescence Microscopy—Imaging and Spectroscopy
Edited by D. Lansing Taylor and Yu-Li Wang

Volume 31 (1989)
Vesicular Transport, Part A
Edited by Alan M. Tartakoff

Volume 32 (1989)
Vesicular Transport, Part B
Edited by Alan M. Tartakoff

Volume 33 (1990)
Flow Cytometry
Edited by Zbigniew Darzynkiewicz and Harry A. Crissman

Volume 34 (1991)
Vectorial Transport of Proteins into and across Membranes
Edited by Alan M. Tartakoff

Selected from Volumes 31, 32, and 34 (1991)
Laboratory Methods for Vesicular and Vectorial Transport
Edited by Alan M. Tartakoff

Volume 35 (1991)
Functional Organization of the Nucleus: A Laboratory Guide
Edited by Barbara A. Hamkalo and Sarah C. R. Elgin

Volume 36 (1991)
***Xenopus laevis:* Practical Uses in Cell and Molecular Biology**
Edited by Brian K. Kay and H. Benjamin Peng

Series Editors
LESLIE WILSON AND PAUL MATSUDAIRA

Volume 37 (1993)
Antibodies in Cell Biology
Edited by David J. Asai

Volume 38 (1993)
Cell Biological Applications of Confocal Microscopy
Edited by Brian Matsumoto

Volume 39 (1993)
Motility Assays for Motor Proteins
Edited by Jonathan M. Scholey

Volume 40 (1994)
A Practical Guide to the Study of Calcium in Living Cells
Edited by Richard Nuccitelli

Volume 41 (1994)
Flow Cytometry, Second Edition, Part A
Edited by Zbigniew Darzynkiewicz, J. Paul Robinson, and Harry A. Crissman

Volume 42 (1994)
Flow Cytometry, Second Edition, Part B
Edited by Zbigniew Darzynkiewicz, J. Paul Robinson, and Harry A. Crissman

Volume 43 (1994)
Protein Expression in Animal Cells
Edited by Michael G. Roth

Volume 44 (1994)
***Drosophila melanogaster:* Practical Uses in Cell and Molecular Biology**
Edited by Lawrence S. B. Goldstein and Eric A. Fyrberg

Volume 45 (1994)
Microbes as Tools for Cell Biology
Edited by David G. Russell

Volume 46 (1995)
Cell Death
Edited by Lawrence M. Schwartz and Barbara A. Osborne

Volume 47 (1995)
Cilia and Flagella
Edited by William Dentler and George Witman

Volume 48 (1995)
***Caenorhabditis elegans:* Modern Biological Analysis of an Organism**
Edited by Henry F. Epstein and Diane C. Shakes

Volume 49 (1995)
Methods in Plant Cell Biology, Part A
Edited by David W. Galbraith, Hans J. Bohnert, and Don P. Bourque

Volume 50 (1995)
Methods in Plant Cell Biology, Part B
Edited by David W. Galbraith, Don P. Bourque, and Hans J. Bohnert

Volume 51 (1996)
Methods in Avian Embryology
Edited by Marianne Bronner-Fraser

Volume 52 (1997)
Methods in Muscle Biology
Edited by Charles P. Emerson, Jr. and H. Lee Sweeney

Volume 53 (1997)
Nuclear Structure and Function
Edited by Miguel Berrios

Volume 54 (1997)
Cumulative Index

Volume 55 (1997)
Laser Tweezers in Cell Biology
Edited by Michael P. Sheetz

Volume 56 (1998)
Video Microscopy
Edited by Greenfield Sluder and David E. Wolf

Volume 57 (1998)
Animal Cell Culture Methods
Edited by Jennie P. Mather and David Barnes

Volume 58 (1998)
Green Fluorescent Protein
Edited by Kevin F. Sullivan and Steve A. Kay

Volume 59 (1998)
The Zebrafish: Biology
Edited by H. William Detrich III, Monte Westerfield, and Leonard I. Zon

Volume 60 (1998)
The Zebrafish: Genetics and Genomics
Edited by H. William Detrich III, Monte Westerfield, and Leonard I. Zon

Volume 61 (1998)
Mitosis and Meiosis
Edited by Conly L. Rieder

Volume 62 (1999)
Tetrahymena thermophila
Edited by David J. Asai and James D. Forney

Volume 63 (2000)
Cytometry, Third Edition, Part A
Edited by Zbigniew Darzynkiewicz, J. Paul Robinson, and Harry Crissman

Volume 64 (2000)
Cytometry, Third Edition, Part B
Edited by Zbigniew Darzynkiewicz, J. Paul Robinson, and Harry Crissman

Volume 65 (2001)
Mitochondria
Edited by Liza A. Pon and Eric A. Schon

Volume 66 (2001)
Apoptosis
Edited by Lawrence M. Schwartz and Jonathan D. Ashwell

Volume 67 (2001)
Centrosomes and Spindle Pole Bodies
Edited by Robert E. Palazzo and Trisha N. Davis

Volume 68 (2002)
Atomic Force Microscopy in Cell Biology
Edited by Bhanu P. Jena and J. K. Heinrich Hörber

Volume 69 (2002)
Methods in Cell–Matrix Adhesion
Edited by Josephine C. Adams

Volume 70 (2002)
Cell Biological Applications of Confocal Microscopy
Edited by Brian Matsumoto

Volume 71 (2003)
Neurons: Methods and Applications for Cell Biologist
Edited by Peter J. Hollenbeck and James R. Bamburg

Volume 72 (2003)
Digital Microscopy: A Second Edition of Video Microscopy
Edited by Greenfield Sluder and David E. Wolf

Volume 73 (2003)
Cumulative Index

Volume 74 (2004)
Development of Sea Urchins, Ascidians, and Other Invertebrate Deuterostomes: Experimental Approaches
Edited by Charles A. Ettensohn, Gary M. Wessel, and Gregory A. Wray

Volume 75 (2004)
Cytometry, 4th Edition: New Developments
Edited by Zbigniew Darzynkiewicz, Mario Roederer, and Hans Tanke

Volume 76 (2004)
The Zebrafish: Cellular and Developmental Biology
Edited by H. William Detrich, III, Monte Westerfield, and Leonard I. Zon

Volume 77 (2004)
The Zebrafish: Genetics, Genomics, and Informatics
Edited by William H. Detrich, III, Monte Westerfield, and Leonard I. Zon

Volume 78 (2004)
Intermediate Filament Cytoskeleton
Edited by M. Bishr Omary and Pierre A. Coulombe

Volume 79 (2007)
Cellular Electron Microscopy
Edited by J. Richard McIntosh

Volume 80 (2007)
Mitochondria, 2nd Edition
Edited by Liza A. Pon and Eric A. Schon

Volume 81 (2007)
Digital Microscopy, 3rd Edition
Edited by Greenfield Sluder and David E. Wolf

Volume 82 (2007)
Laser Manipulation of Cells and Tissues
Edited by Michael W. Berns and Karl Otto Greulich

Volume 83 (2007)
Cell Mechanics
Edited by Yu-Li Wang and Dennis E. Discher

Volume 84 (2007)
Biophysical Tools for Biologists, Volume One: In Vitro Techniques
Edited by John J. Correia and H. William Detrich, III

Volume 85 (2008)
Fluorescent Proteins
Edited by Kevin F. Sullivan

Volume 86 (2008)
Stem Cell Culture
Edited by Dr. Jennie P. Mather

Volume 87 (2008)
Avian Embryology, 2nd Edition
Edited by Dr. Marianne Bronner-Fraser

Volume 88 (2008)
Introduction to Electron Microscopy for Biologists
Edited by Prof. Terence D. Allen

Volume 89 (2008)
Biophysical Tools for Biologists, Volume Two: In Vivo Techniques
Edited by Dr. John J. Correia and Dr. H. William Detrich, III

Volume 90 (2008)
Methods in Nano Cell Biology
Edited by Bhanu P. Jena

Volume 91 (2009)
Cilia: Structure and Motility
Edited by Stephen M. King and Gregory J. Pazour

Volume 92 (2009)
Cilia: Motors and Regulation
Edited by Stephen M. King and Gregory J. Pazour

Volume 93 (2009)
Cilia: Model Organisms and Intraflagellar Transport
Edited by Stephen M. King and Gregory J. Pazour

Volume 94 (2009)
Primary Cilia
Edited by Roger D. Sloboda

Volume 95 (2010)
Microtubules, in vitro
Edited by Leslie Wilson and John J. Correia

Volume 96 (2010)
Electron Microscopy of Model Systems
Edited by Thomas Müeller-Reichert

Volume 97 (2010)
Microtubules: In Vivo
Edited by Lynne Cassimeris and Phong Tran

Volume 98 (2010)
Nuclear Mechanics & Genome Regulation
Edited by G.V. Shivashankar

Volume 99 (2010)
Calcium in Living Cells
Edited by Michael Whitaker

Volume 100 (2010)
The Zebrafish: Cellular and Developmental Biology, Part A
Edited by: H. William Detrich III, Monte Westerfield and Leonard I. Zon

Volume 101 (2011)
The Zebrafish: Cellular and Developmental Biology, Part B
Edited by: H. William Detrich III, Monte Westerfield and Leonard I. Zon

Volume 102 (2011)
Recent Advances in Cytometry, Part A: Instrumentation, Methods
Edited by Zbigniew Darzynkiewicz, Elena Holden, Alberto Orfao, William Telford and Donald Wlodkowic

Volume 103 (2011)
Recent Advances in Cytometry, Part B: Advances in Applications
Edited by Zbigniew Darzynkiewicz, Elena Holden, Alberto Orfao, Alberto Orfao and Donald Wlodkowic

Volume 104 (2011)
The Zebrafish: Genetics, Genomics and Informatics 3rd Edition
Edited by H. William Detrich III, Monte Westerfield, and Leonard I. Zon

Volume 105 (2011)
The Zebrafish: Disease Models and Chemical Screens 3rd Edition
Edited by H. William Detrich III, Monte Westerfield, and Leonard I. Zon

Volume 106 (2011)
Caenorhabditis elegans: Molecular Genetics and Development 2nd Edition
Edited by Joel H. Rothman and Andrew Singson

Volume 107 (2011)
Caenorhabditis elegans: Cell Biology and Physiology 2nd Edition
Edited by Joel H. Rothman and Andrew Singson

Volume 108 (2012)
Lipids
Edited by Gilbert Di Paolo and Markus R Wenk

Volume 109 (2012)
Tetrahymena thermophila
Edited by Kathleen Collins

Volume 110 (2012)
Methods in Cell Biology
Edited by Anand R. Asthagiri and Adam P. Arkin

Volume 111 (2012)
Methods in Cell Biology
Edited by Thomas Müler Reichart and Paul Verkade

Volume 112 (2012)
Laboratory Methods in Cell Biology
Edited by P. Michael Conn

Volume 113 (2013)
Laboratory Methods in Cell Biology
Edited by P. Michael Conn

Volume 114 (2013)
Digital Microscopy, 4th Edition
Edited by Greenfield Sluder and David E. Wolf

Volume 115 (2013)
Microtubules, *in Vitro*, 2nd Edition
Edited by John J. Correia and Leslie Wilson

Volume 116 (2013)
Lipid Droplets
Edited by H. Robert Yang and Peng Li

Volume 117 (2013)
Receptor-Receptor Interactions
Edited by P. Michael Conn

Volume 118 (2013)
Methods for Analysis of Golgi Complex Function
Edited by Franck Perez and David J. Stephens

Volume 119 (2014)
Micropatterning in Cell Biology Part A
Edited by Matthieu Piel and Manuel Théry

Volume 120 (2014)
Micropatterning in Cell Biology Part B
Edited by Matthieu Piel and Manuel Théry

Volume 121 (2014)
Micropatterning in Cell Biology Part C
Edited by Matthieu Piel and Manuel Théry

Volume 122 (2014)
Nuclear Pore Complexes and Nucleocytoplasmic Transport - Methods
Edited by Valérie Doye

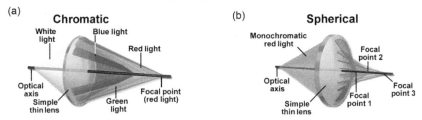
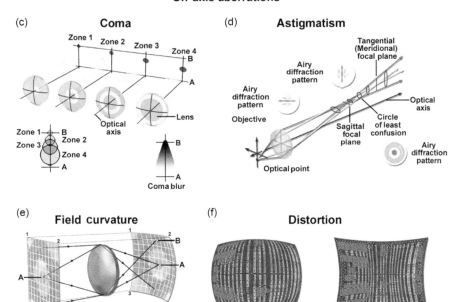

PLATE 1 (Fig. 2.1 on page 21 of this volume).

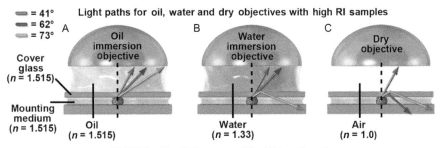

PLATE 2 (Fig. 2.6 on page 30 of this volume).

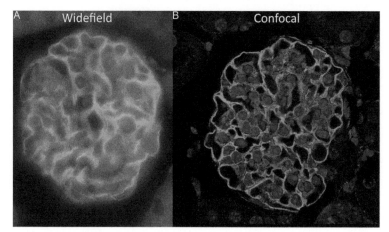

PLATE 3 (Fig. 7.1 on page 115 of this volume).

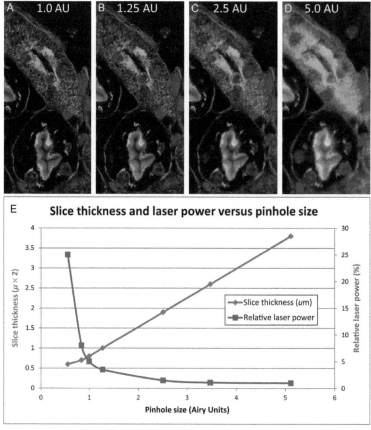

PLATE 4 (Fig. 7.3 on page 117 of this volume).

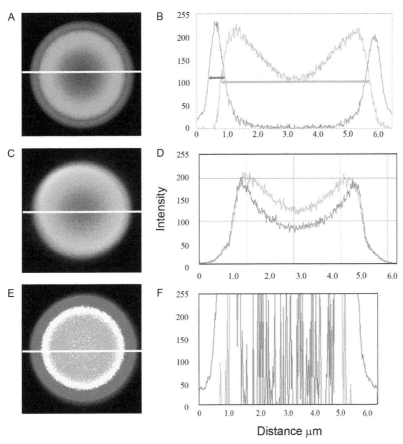

PLATE 5 (Fig. 7.7 on page 126 of this volume).

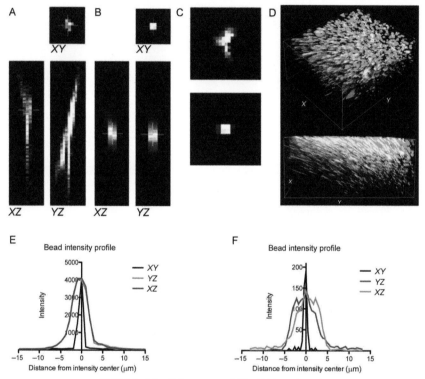

PLATE 6 (Fig. 8.3 on page 145 of this volume).

PLATE 7 (Fig. 9.2 on page 156 of this volume).

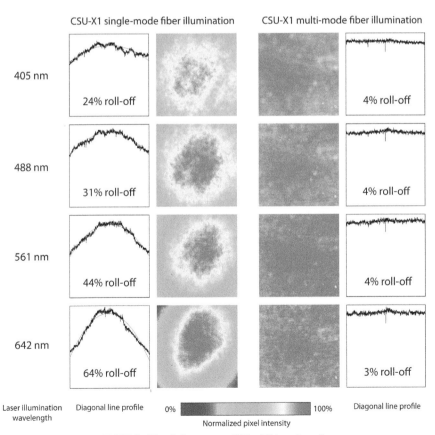

PLATE 8 (Fig. 9.3 on page 159 of this volume).

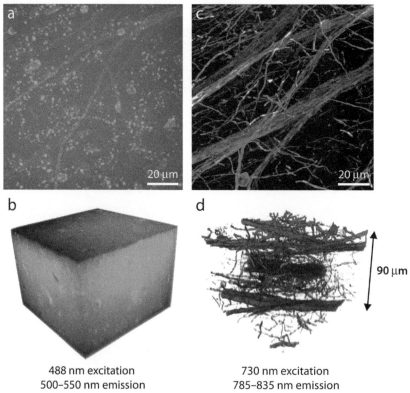

488 nm excitation
500–550 nm emission

730 nm excitation
785–835 nm emission

PLATE 9 (Fig. 9.5 on page 162 of this volume).

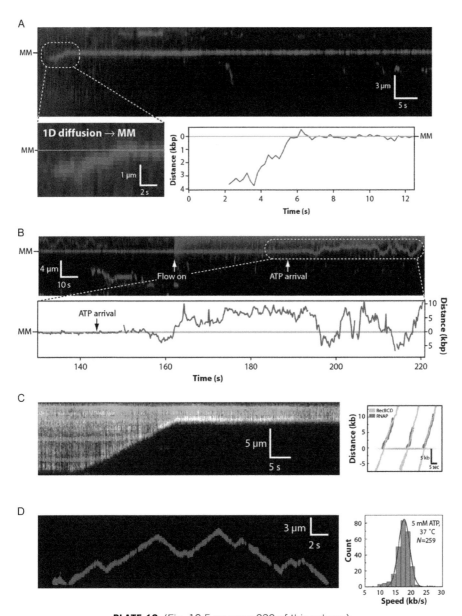

PLATE 10 (Fig. 12.5 on page 230 of this volume).

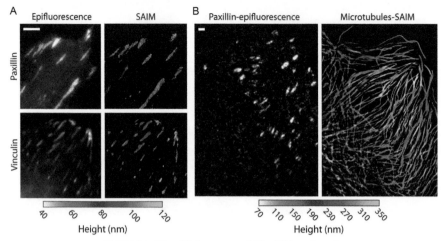

PLATE 11 (Fig. 13.2 on page 245 of this volume).

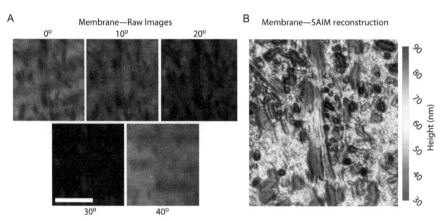

PLATE 12 (Fig. 13.5 on page 249 of this volume).

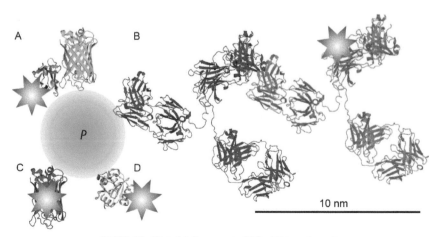

PLATE 13 (Fig. 14.2 on page 259 of this volume).

Increasing bud/mother ratio

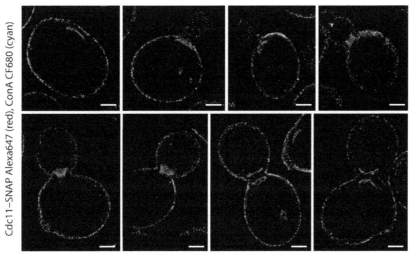

PLATE 14 (Fig. 14.6 on page 268 of this volume).

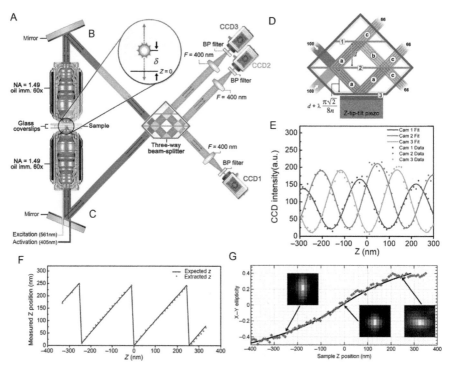

PLATE 15 (Fig. 15.3 on page 286 of this volume).

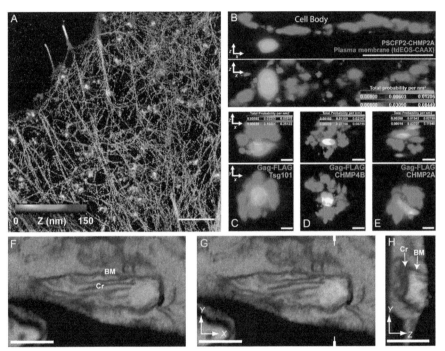

PLATE 16 (Fig. 15.4 on page 289 of this volume).

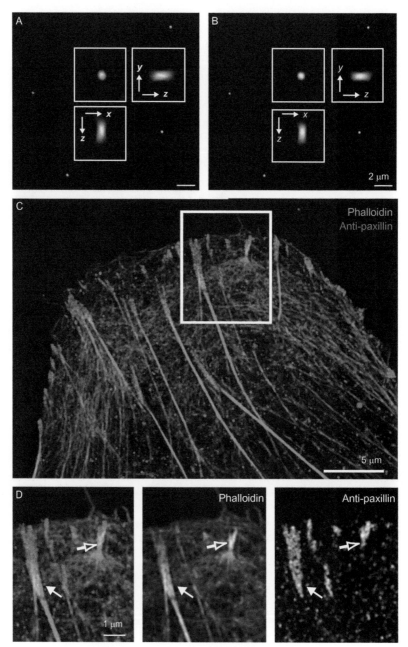

PLATE 17 (Fig. 17.4 on page 329 of this volume).

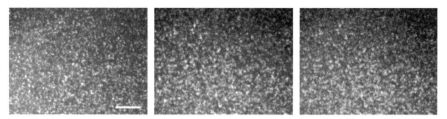

PLATE 18 (Fig. 20.2 on page 372 of this volume).

PLATE 19 (Fig. 20.4 on page 391 of this volume).

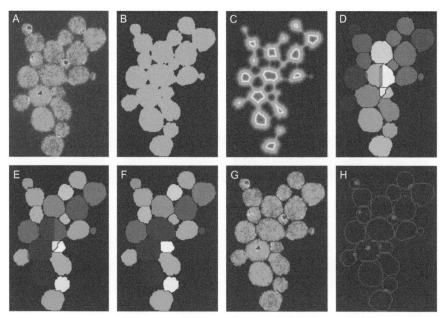

PLATE 20 (Fig. 22.6 on page 419 of this volume).

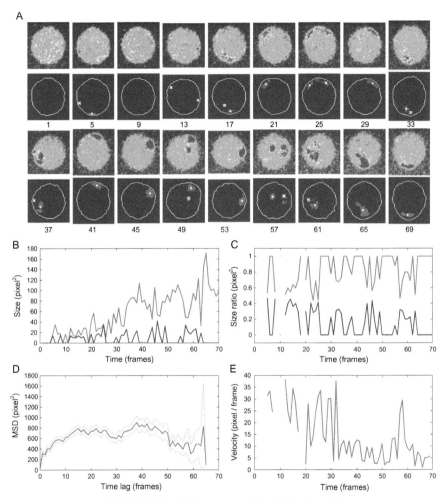

PLATE 21 (Fig. 22.8 on page 425 of this volume).

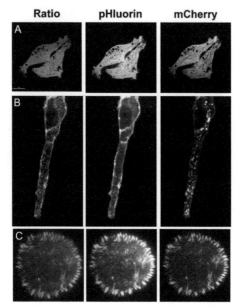

PLATE 22 (Fig. 23.2 on page 434 of this volume).

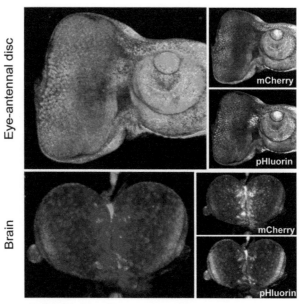

PLATE 23 (Fig. 23.4 on page 439 of this volume).

PLATE 24 (Fig. 24.1 on page 452 of this volume).

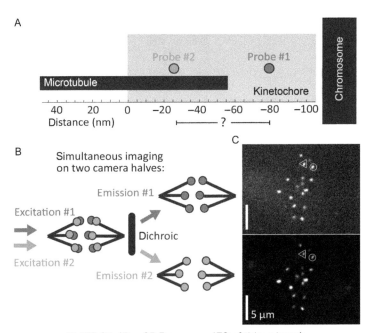

PLATE 25 (Fig. 25.5 on page 479 of this volume).

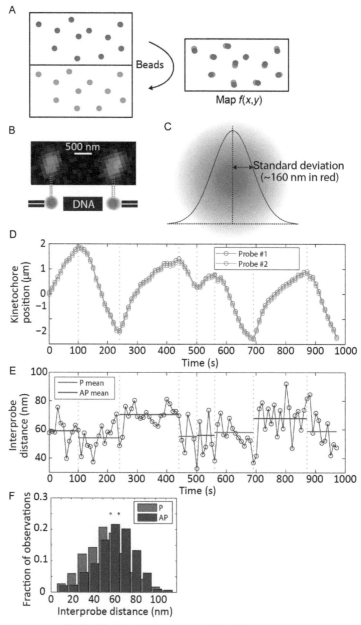

PLATE 26 (Fig. 25.6 on page 480 of this volume).

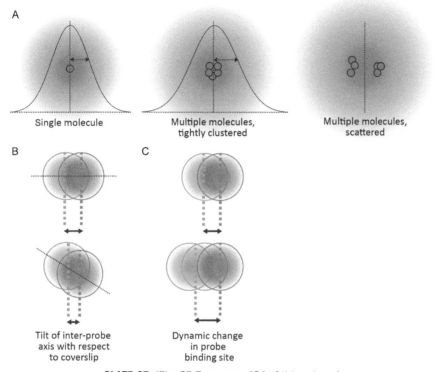

PLATE 27 (Fig. 25.7 on page 484 of this volume).

PLATE 28 (Fig. 26.2 on page 494 of this volume).

PLATE 29 (Fig. 28.2 on page 536 of this volume).

PLATE 30 (Fig. 28.4 on page 540 of this volume).

CPI Antony Rowe
Chippenham, UK
2016-08-19 21:19